GIAN LORENZO BERNINI

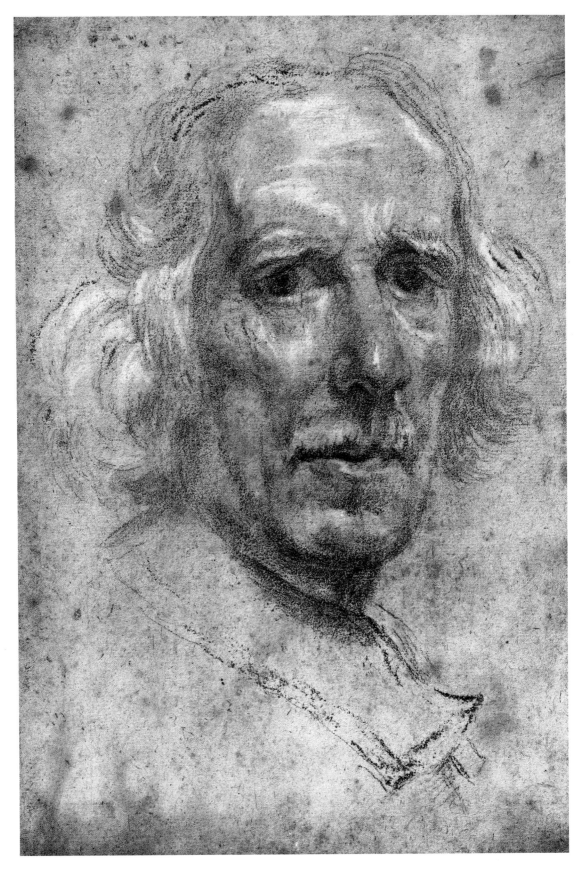

SELF-PORTRAIT OF BERNINI
Black chalk drawing, about 1665. Royal Library, Windsor Castle

RUDOLF WITTKOWER

GIAN LORENZO BERNINI

THE SCULPTOR OF
THE ROMAN BAROQUE

Third edition, revised by Howard Hibbard, Thomas Martin
and Margot Wittkower

PHAIDON · OXFORD

33824

Phaidon Press Limited,
Littlegate House, St Ebbe's Street, Oxford, OX1 1SQ

First published 1955
Third edition 1981

British Library Cataloguing in Publication Data
Wittkower, Rudolf
 Gian Lorenzo Bernini. – 3rd ed., enl.
 I. Bernini, Gian Lorenzo
 I. Title II. Hibbard, Howard
 III. Martin, Thomas IV. Wittkower, Margot
 730′.92′4 NB623.B5
 ISBN 0-7148-2193-4

Printed in Great Britain by Butler and Tanner Ltd., Frome, Somerset

IN MEMORY OF

THE CENTENARY OF MY FATHER'S BIRTH

HENRY WITTKOWER

9 May 1866 – 28 June 1941

CONTENTS

PREFACE

Rubens, Caravaggio, Rembrandt, Velasquez and Poussin have found their interpreters and a large appreciative public. Only Bernini, once the brightest star amongst the great artists of the seventeenth century, still suffers from comparative neglect. But his fortunes seem to be changing. Not to mention the small coterie of art historians, the general public is beginning to see again the quality of his art and to sympathize with its intentions. In the present volume I have made an attempt at interpreting Bernini's sculptural work in the spirit in which, I believe, it was created. He was the most fertile and most accomplished artistic exponent of seventeenth-century Catholicism, and the strength of his own religious convictions no less than the general fervour of post-Tridentine Catholicism form the background against which his art must be seen.

The book deals only with Bernini as sculptor. A more ambitious plan to include his architecture and other activities had to be abandoned, since any adequate discussion would have gone far beyond the limits of a single volume. In keeping with the well-established tradition of the Phaidon monographs my task was a double one, namely to sketch Bernini's achievement in an Introduction and to supply the critical material in a *catalogue raisonné* of his works. Many readers will be aware of my peculiar difficulties: the vastness of Bernini's sculptural enterprises is without parallel in the history of western art; in addition, we are better informed about him and his work than about most other artists of the past. It was therefore not possible to discuss all Bernini's sculpture in the Introduction, nor to use all available material in the Catalogue. For the Introduction I have chosen a systematic arrangement, since I aimed at an exposition of the principles of his art rather than at a biographical narrative. The Catalogue, however, lists the works, as far as possible, in chronological sequence. As regards the principles guiding me in its compilation the reader may be referred to the 'Preamble', p. 172. But I would like to mention one point which is stated there more explicitly. The transitions between a work entirely by Bernini and one entirely by a studio hand are extraordinarily fluid. In looking through the illustrations, the reader may be surprised to find works included which are evidently not executed by Bernini. In these as well as in less problematical cases the degree of his collaboration and supervision is specified in the catalogue entries.

For reasons of space, a number of critical, stylistic and iconographical arguments which some readers might have wished to see elaborated in the Introduction, had to be briefly mentioned in the Catalogue. In any case, Introduction and Catalogue complement each other and for fuller information should be read in conjunction. No conclusions as to authenticity should be drawn from the division between plates and text illustrations, but amongst the latter are the less important works together with some supplementary material such as bozzetti and drawings.

My thanks are due to a great number of friends who helped me in one way or another during the preparation of the book. I wish to mention, in particular, Dr. Italo Faldi, who put his time and knowledge unreservedly at my disposal during a recent hectic visit to Rome, and Dr. Ilaria Toesca, who spent days in combing through photographic archives; both answered patiently a veritable flood of urgent inquiries. John Fleming, Irving Lavin, and Mlle Charageat of the Sculpture Department of the Louvre supplied valuable learned information. Peggy Martin was a constant help. She and Robert Ratcliffe read the manuscript and made valuable suggestions. It is due to Sheila Somers's discerning criticism, when the galleys were at hand, that I was spared some blunders. She also evened out my style and introduced many felicitous phrases. St. John Gore was a great help in reading the proofs.

I am especially grateful for the liberality with which Principi Enrico and Urbano Barberini, Principe Doria and Professor Antonio Muñoz opened their houses and allowed photographs to be taken. For the use of photographs I have to thank Mr. Perry B. Cott, Dr. Carl Lamb, Dr. Lehmann-Brockhaus, Professor Giuseppe Marchini, Mr. L. von Matt, Professor Paola della Pergola and Mr. D. Wright. Mr. Pope-Hennessy fulfilled all my wishes in the Victoria and Albert Museum and Commendatore Ferdinando Forlati supplied the photographs of the Venetian monuments. I am much indebted to Mr. O. Fein of the Warburg Institute, whose expert knowledge as a photographer has greatly contributed to the book.

Finally, I gratefully put on record that without Dr. Horovitz's enthusiastic support this book could never have been published in its present form. He arranged, amongst others, a photographic campaign in Rome with Mrs. Schneider-Lengyel as photographer. Her contribution, the backbone of the illustrations in this book is specified on p. 278. Dr. I. Grafe, who saw the book through the press and compiled the Index, was as always an untiring and understanding collaborator.

The book is the result of a lifetime's study of the subject and I do not wish to conclude the preface without mentioning that it is impossible for me to estimate how much I owe to the many clarifying discussions with my wife and to her constant vigilance.

1955 R.W.

PREFACE TO THE SECOND EDITION

I began revising this book exactly a decade after its first appearance. My task was not an easy one, because of the extraordinary number of new contributions published in the course of the intervening ten years. More than fifty items had to be added to the Bibliography of 1955. The introductory text reappears here with only minor alterations, but I have attempted to incorporate in the *catalogue raisonné* the new research of others as well as my own. Hardly a page remained without some changes. Of the original eighty-one catalogue entries twenty-seven

have been substantially recast or wholly rewritten and two entries are entirely new (78a, 82), but it seemed advisable to maintain the original catalogue numbers. The Plates have been revised and in a number of cases, it is hoped, improved, and four new ones have been added. The Figures in the catalogue part have been increased from 98 to 128.

At the time of the first edition it was hardly necessary to expose the reader to polemical discussions in the catalogue entries. Owing to the mass of new research published in recent years, controversies cannot be avoided in the new edition and consequently a number of entries have grown rather long. But I felt it my duty to be explicit when I could not share viewpoints, dates and attributions submitted in recent publications. Even so, arguments had often to be unduly contracted or even suppressed in order to avoid exorbitant length.

When writing the text of the first edition, I had the Bernini chapter in my Pelican volume *Art and Architecture in Italy 1600–1750* (1958, revised edn. 1965) at the back of my mind. Much that I had to reserve for the more comprehensive book therefore remained unsaid. I hope I will not be accused of auto-propaganda if I invite those readers who want to know more about my views on many aspects of Bernini's art, not touched upon in the present volume, to turn to the pages of the other work.

I could not have finished this new edition without the resourceful help of friends and colleagues, among them Per Bjurström, Anthony Blunt, Ian Lowe and Carl Nordenfalk. I owe a great debt of gratitude to my pupils Mira P. Merriman and Mark Weil, who supplied most valuable information. My special thanks go to Italo Faldi for allowing me to publish an important discovery of his, to Ilaria Toesca-Bertelli for answering patiently an avalanche of inquiries, to Jennifer Montagu for letting me use some of her own finds, and to Howard Hibbard not only for a steady supply of most welcome corrections and notes but above all for the work he undertook on my behalf in the Roman State Archive in pursuance of the correct data for the angels on Ponte S. Angelo. I am indebted for help over photographs to Carlo Bertelli in Rome, Harald Olsen in Copenhagen, Felice Stampfle in New York, and Mr. J. M. Trusted in London, who gave me permission to publish the Bernini bozzetto in his collection.

Finally, I wish to thank once again my publishers, who accepted without a murmur my extravagant requests for expansion in a most congenial spirit of collaboration.

1966 R.W.

PREFACE TO THE THIRD EDITION

Slightly more than a quarter of a century after its first appearance and fifteen years after the publication of the second, enlarged edition, this book is still the only monograph exclusively devoted to Bernini's sculptural work.

In the intervening years the interest in Bernini's own creations and those of his collaborators and studio hands has by no means abated. Much new archival material has come to light and has firmly established previously unknown or uncertain dates as well as the authorship of works hitherto only tentatively ascribed to the master or his assistants. Where documentary evidence is still missing, various new attributions have been suggested, based—more or less convincingly—on stylistic criteria. A third edition, taking account of this recent literature, therefore seemed desirable.

The late Rudolf Wittkower's study has become a classic. For this as well as for practical reasons the publishers and editors have decided not to alter the text or catalogue entries, but to bring out a photographic reprint of the second edition and to add, as far as it was available, the relevant new literature in a separate section, Addenda to the Catalogue (pp. 273ff.). Asterisks placed beside the catalogue entries refer to the corresponding numbers in this section, where mention is made of books and essays published between 1966 and 1980.

A few entries have been added under the heading: *New attributions not mentioned elsewhere* (p. 278). The reader should also consult two works which, because of their compass, affect many or most of the appended entries. The first, M. & M. Fagiolo dell'Arco, *Bernini, Una introduzione al gran teatro del barocco* (Rome, 1967), was described by Wittkower in the third edition of his *Art and Architecture in Italy 1600-1750* (Harmondsworth, 1973) as 'an almost complete, intelligent survey of Bernini's entire activity, based on a remarkable knowledge of the literature; bibliography of almost 700 items.' The second is H. Kauffmann, *Giovanni Lorenzo Bernini: Die figurlichen Kompositionen* (Berlin, 1970), described by Wittkower as 'the most important Bernini publication of recent years; tendency towards iconographic investigations. The author's earlier Bernini papers have been incorporated.'

New York, 1981 M.W.

Errata

p. 180 left-hand column line 41: for '1596' read '1956'
p. 217 right-hand column line 25: for 'Fig. 62' read 'Fig. 63'
p. 227 right-hand column line 5: for 'Fig. 66a' read 'Fig. 77'
p. 259 right-hand column line 34: for 'Truth' read 'Charity'
 line 39: for 'Charity' read 'Truth'
p. 271 right-hand column line 43: for 'Decan' read 'Dean'

GIAN LORENZO BERNINI

At the climax of his fame Bernini prophesied that after he had died his reputation would decline. He was right. During the last hundred and fifty years his star has lost much of its brilliance. What Winckelmann, the classicist doctrinaire, had begun, Ruskin, the medieval revivalist, completed. To Ruskin it seemed 'impossible for false taste and base feeling to sink lower'. As if this slaughter of a great master's fame upon the altar of dogmatic ideas was not enough, those who in more recent times fanatically advocated 'truth to material' and 'functional art' regarded Bernini and all he stood for as the Antichrist personified. The quotation at the head of this page reveals with unanswerable logic the fallacy of the reproof. It may not be by chance that Bernini's name, next to Rodin's, came to Henry Moore's mind when writing his lines; for basic tendencies of modern sculpture, though not, of course, its formal language, were anticipated by the great Baroque artist. His vision of space, his attempt to draw the beholder physically and emotionally into the 'aura' of his figures, closely corresponds to modern conceptions. It seems that such similarity of approach engenders a willingness to see his art with fresh eyes.

Early Works and Borghese Patronage

In 1644, while in Rome, John Evelyn wrote in his Diary: 'Bernini . . . gave a public opera wherein he painted the scenes, cut the statues, invented the engines, composed the music, writ the comedy, and built the theatre.' He was, to be sure, an artist of all-round performance, an 'uomo universale', in line of succession to the great Renaissance artists—and probably the last link in that chain. Some of his comedies survive, but only one has been published. A mere handful of sketches and some prints are the sole testimonies to his stage designs and occasional works, such as festival decorations, fireworks, carnival cars and catafalques. Of his paintings— well over a hundred according to contemporary sources—few have so far been traced. His claim to greatness rests nowadays entirely on his work as architect and sculptor; and it was sculpture that he, like Michelangelo before him, regarded as his real calling.

The circumstances were rare and auspicious: here was an artist with an immensely fertile imagination, an unlimited working capacity, an unequalled facility of handling marble, a gift for organizing sculptural tasks on the grandest scale, and he was given opportunities without

parallel in the history of art through the lavish patronage of the great seventeenth-century popes and their families. Compared with the extent of his production, even the life work of a Michelangelo or a Rodin appears small. It was he more than any other artist who gave Rome its Baroque character. And it was his new conception of the saint, of the portrait bust, of the equestrian statue, of tombs and fountains, among many other new creations, that determined the development of Italian and even European sculpture for more than a hundred years.

Bernini was born at Naples on 7 December 1598, the son of a Florentine father and a Neapolitan mother, and the mixture of Tuscan precision and Neapolitan temperament may be traced in his character and personality. Much later his son Domenico talks of him as 'aspro di natura, fisso nelle operazioni, ardente nell'ira'—stern by nature, steady in his work, passionate in his wrath. The family moved to Rome in about 1605, and it was there that Gian Lorenzo lived until his death in 1680. Tied as he was to Rome by vast enterprises, the only major break in his routine was a six months' stay in Paris in 1665, at the height of his fame, following Louis XIV's invitation to redesign the Louvre.

There is no doubt that he was a prodigy, even if the account of his earliest exploits as a sculptor, given two generations later by the aged Bernini himself, was somewhat exaggerated. In any case, his earliest surviving work, the small group of the infant Zeus and a little Satyr being nursed by the goat Amalthea (Plate 1), dating from about 1615, is remarkably accomplished for a boy of sixteen. It is characteristic of Bernini's beginnings that until fairly recently this group was regarded as antique, not only because of the classical subject matter, illustrating a passage in Virgil's Georgics, but above all because the uncompromisingly realistic treatment of the surface is akin to Hellenistic works. Shortly afterwards he created his first religious statues, the under life-size figures of St. Lawrence, his patron saint, and St. Sebastian, the first evidence of Barberini patronage (Plates 4 and 5). Both works show a high degree of technical perfection, the St. Sebastian, in particular, having a warm alabaster-like surface quality. Both derive from Mannerist formulas, but the anatomical precision and an infallible sense for the organic coherence and structure of the human body raise these figures far above the mass of contemporary stereo-typed productions. Bernini here recaptured something of Michelangelo's dynamic vigour: the 'Dawn' of the Medici Chapel and the Christ of the Florentine Pietà indicate the spiritual parentage of this style. St. Lawrence seems to be the earlier figure; it bears the stamp of juvenile experi-ment. And yet the attempt to represent leaping flames in sculpture is a *tour de force* revealing the indomitable spirit of the youth who, later in life, was always to regard the seemingly impossible as a challenge to his ingenuity.

A similar experimental approach is patent in the busts of the Saved and Condemned Souls (Plates 6–7), the one a maiden with an expression of ecstatic delight looking up, like Reni's saints as if listening to angelic music, the other a young man unrestrained in his anguish, staring down as if seeing and at the same time experiencing the horrors of Hell. Such an intensity of realistic penetration, such verisimilitude and psychological analysis had had no parallel in Italian sculpture. Before the 'Anima Dannata' works by Caravaggio come to mind such as the 'Medusa',

the 'Boy bitten by a Lizard' or the head of Isaac in the 'Sacrifice of Abraham'. The two latter were in the Villa Borghese and therefore probably well known to Bernini. Although the Caravaggio heads appear restrained and almost conventional in comparison with the 'Anima Dannata' they may well have stimulated Bernini's interest in rendering the expression of terror, for the open mouth with the meticulous representation of the tongue and teeth is a characteristic 'emblem' of Caravaggio's imagery. Distinguished essays in the study of physical reaction to contrasting emotions, these two busts prepare the way for the heads of Neptune (Plate 18), Pluto (Plate 17) and David (Plate 27) as well as for that of St. Bibiana (Plate 42). One should not, however, make the mistake of dating these busts too late. They are closely linked with the earliest group of works, although certain features point forward as, for instance, the hair of the Damned Soul which is arranged in very plastic and lively locks. Like that of the Neptune it reveals the study of figures such as the Dying Gaul.

Gian Lorenzo's father, Pietro, a gifted but facile late Mannerist sculptor, was engaged for a number of years after his arrival in Rome on work in S. Maria Maggiore for the Borghese Pope Paul V. It was through this fortunate circumstance that the talent of Gian Lorenzo, still in his childhood, was brought to the attention of the Pope and of his wealthy and powerful nephew, the Cardinal Scipione Borghese. The 'Goat Amalthea' was the first work done for the family, followed soon afterwards by the penetrating portrait bust of the Pope (Plate 8) in which Bernini discarded the last residues of Mannerist formlessness. From then on and for the next six years (1618–24) we find him working mainly for the Cardinal. Owing to his patronage, the young sculptor's further career was set on a firm foundation once and for all. The *conoscenti* were startled by his output and genius: three life-size groups, illustrating classical subjects, came from his studio in quick succession, the 'Aeneas and Anchises', the 'Rape of Proserpina', the 'Apollo and Daphne', and, in addition, the figure of David. With these works Bernini inaugurated a new era in the history of European sculpture.

The first of these groups, the Aeneas and Anchises (Plates 9, 10, 15 and 16), executed between 1618 and 1619, is still transitional. Never before had Bernini worked on a marble block of this size, and it is likely that the father was not sparing with advice. In any case, the vertical build-up of the composition and the twirling movement of the bodies are more thoroughly linked with the Mannerist tradition than his earliest works. Characteristically, the pose of Aeneas derives from Michelangelo's most Mannerist statue, the Christ in S. Maria sopra Minerva. Moreover, a Mannerist instability is revealed by the stances of Aeneas and his little son Ascanius (Plate 16), who seem to slide about on the oval plinth, and by the pose of Anchises, perched precariously on Aeneas' shoulder. But much more significant than such Mannerist reminiscences, there is to be found in these figures an active play of muscles and sinews under the skin, an energy and elasticity in the movement of an arm, in the grip of a hand or the bending of a knee, which contrast decisively with the boneless and structureless figures made by his father Pietro. Unlike the soft and painterly handling of marble in the latter's work, the firm and precise chiselling of a head like that of Aeneas with the hair blocked out in solid masses—evidently just anticipating the

'Anima Dannata'—derives from Hellenistic sculpture. Such works pointed the way to new sculptural surface values. We are witnessing the birth of a realistic style, ushered in by the invigorating study of classical antiquity.

Before creating the next group for Scipione Borghese, Bernini executed for Cardinal Alessandro Peretti the 'Neptune and Triton' (Plates 11, 18 and 21), now in the Victoria and Albert Museum, which once crowned a large fish pond in the garden of the Cardinal's Villa Montalto. It is this group that provides a link between the semi-Mannerist 'Aeneas and Anchises' and the fully developed 'Pluto' and 'David'. The 'Neptune and Triton', to be dated 1620, is Bernini's first work where the silhouette is broken, where the climax of a transitory action is given and where the action extends beyond the physical limits of the marble block. By illustrating Virgil's *Quos Ego*, for which a long pictorial tradition existed, Bernini chose to represent a distinct and dramatic moment in the life of the sea-god. The circumstances of the scene may be recalled: Juno had incited the wind-god Aeolus to let loose a storm on the Trojan fleet; Neptune, seeing his protégé Aeneas in danger, appeared and, swinging his trident in Olympian wrath, ordered the seas to be still. The god's expression, attitude and gestures could hardly be more appropriate: he turns his angry look towards the water, which gushes forth at his feet, imposing his command by thrusting down with his trident. The whole pond was thus turned into his field of action, and the spectator was drawn into an imaginary world, laden with emotions and literary associations.

Neptune is still akin to Aeneas, not only as regards the pliancy of the body and the rather elongated build of the trunk, but even in respect of the pose (in reverse), the restricted width of the stride and the smallness of the plinth—which is formed by a shell in the case of the Neptune. On the other hand, the figure is close to the Pluto (Plate 12) and the David (Plate 13) as can be seen in the similarity of the contrapposto and the filling of the gap between the legs; in the one case this is achieved by the Triton (Plate 21), in the others by the Cerberus and the piece of armour (Plate 23). But compared with the extremely energetic stride of both the Pluto and the David, the stance of the Neptune appears somewhat hesitant and restrained. Moreover, the sweeping movement animating the later statues is still missing.

Pluto is shown storming forward at the instant of his violent snatch at Proserpina. Bernini interpreted this old rape-theme as a conflict between brutal lust and desperate anguish (Plates 17, 20), emphasizing the contrasting feelings of the two figures by various compositional subtleties; although the struggling Proserpina is held tight in Pluto's iron grasp their bodies seem to burst asunder, and this dual movement is reinforced by the drawing-close and thrusting-away of Pluto's and Proserpina's almost parallel arms. Representations of such rape scenes depended on Bernini's new, dynamic conception for the next hundred and fifty years.

Unlike the Aeneas and Neptune groups, the precedent of an ancient statue lies behind each of the three later Borghese works. In the case of the Pluto it is a torso found in about 1620 and later restored by Algardi into a 'Hercules killing the Hydra' (Capitoline Museum); in the case of the David it is the Borghese Warrior, now in the Louvre, but until 1798 in the Villa Borghese;

and in that of the Apollo (Plate 14) it is obviously the Belvedere Apollo. Although a head like that of Proserpina (Plate 20) suggests an indebtedness to the heads of the Niobids, realistic details such as the marble tears on her cheeks or the cavity of the open mouth lead away from antiquity and into the world of contemporary painting. It has been rightly pointed out that this head is reminiscent of Guido Reni rather than of Caravaggio. One can, however, get a step nearer to Bernini's ultimate source of inspiration. As he often told the Sieur de Chantelou in Paris, he had a boundless admiration for Annibale Carracci. In the Pluto and Proserpina group Bernini saw classical antiquity with Annibale's eyes. The voluptuous, yet cold beauty of Proserpina's body finds close analogies on the ceiling of the Farnese Gallery as does the over-developed anatomy of her seducer. His head, moreover, with the non-classical hair and beard, somewhat reminiscent of brush-wood, is a precise counterpart in marble to the feigned marble caryatids in the Gallery. And even the Cerberus is an adaptation from Paris's dog in the fresco of the ceiling. Accurate realistic observation and genuine classical influence subordinated to Annibale's disciplined interpretation of the antique—that was the formula by which Bernini rid his style of the last vestiges of Mannerism.

Similarly the David (Plates 13, 23, 25 and 27), dating from 1623, is still deeply indebted to the Farnese ceiling. The figure reflects a close study of the Polyphemus in 'Polyphemus killing Acis'. And here we can see more clearly why Annibale's art struck such deep chords in the young sculptor. Almost alone among his contemporaries, he found in it the representation of unambiguous and energetic action; he found physical concentration rendered at the split-second before release. That was precisely what Bernini needed. He chose for his David a similar dramatic moment. The tension before imminent action fills the whole figure, from the toes which are firmly pressed against the ground to the eyes which seem to transfix his antagonist. Polyphemus, too, aims at a far-off victim, but the distance between them belongs to the imaginary space of the painting. Goliath, however, at whom David's stone is aimed, must be imagined as standing in the space in which the spectator moves. This imaginary opponent is the necessary comple-ment to the figure of David, whose action would be senseless without postulating the existence of the enemy. Thus the spiritual focus of the statue is somewhere in space, outside the statue itself—in other words, the boundary between the stone figure and the space in which we live and move has been abolished.

Like the groups of this period, Bernini's David has only one principal view, and this insistence on a single viewpoint remained a fundamental principle of Bernini and, indeed, of most seventeenth-century sculptors. In the case of the David the main view lies exactly on the central axis of the figure and on the eye level of an average person. Although the movement in depth and the rich spatial qualities of the David naturally lead to a number of subordinate views, only from the correct standpoint is the movement entirely homogeneous and the great sweep fully effective, going through leg, body and neck, and counterbalanced by the turn of the head and the arm holding the stone in the sling. The intensity of the movement, the sophisticated render-ing of texture (Plate 25) and the almost violent realism far surpass that of Annibale's

Polyphemus. Utmost concentration and energy are epitomized in the head with its compressed lips, the strained muscles around the mouth, the inflated nostrils, the knitted brow and the piercing eye (Plate 27)—clearly incorporating physiognomical studies made before a mirror.

With this impression fresh in mind, the Apollo and Daphne group, begun before the David and finished after it, looks like an anticlimax (Plates 14, 19, 24 and 26); for here the classicizing idealization of the figures and the smoothness and perfection of the surfaces seem to be far removed from any realism. And yet the interpretation of the event could hardly be more realistic. With an unprecedented directness Bernini represented the transitory moment of the metamorphosis itself (Plate 24). Nothing like it had been attempted in sculpture before. This is a painter's subject and there cannot be any doubt that Bernini was stimulated by painted or engraved representations. If his approach to the subject is essentially non-classical, the same is true of the psychological complication, the conflict between sensations and physical reactions to be found in the group. Daphne turns back horror-stricken because she feels the hand of the pursuer, but is not aware of the simultaneous transformation of her body. Apollo, however, notices with amazement the transformation at the very moment when he seemed to be sure of his victim; but his body has not had time to react and he is still chasing what he suddenly sees to be unattainable. Similar psycho-physical subtleties, unknown in antiquity, were to gain even greater importance in Bernini's later work.

Psychologically and technically, Bernini reached in this group the summit of his early style, and he never again attempted such elegant and brilliant handling of a sculptural problem. His tremendous virtuosity as a craftsman made him delight in difficulties which up to then had seemed beyond the reach of sculpture, such as the figure of Daphne who appears to float in the air or the laurel leaves sprouting freely into space. What he himself was aiming at can be gathered from a remark made many years later in Paris when he proudly mentioned the lightness he had achieved in the hair of Daphne.

Nowadays wrongly shown free-standing in the rooms of the Galleria Borghese, the works for Scipione Borghese were originally set against walls, so that their principal view was clearly displayed. In this respect Bernini followed the Renaissance precedent, for the climax of an action can be fully revealed from one main aspect alone. In other respects, however, he departed from Renaissance tradition. Every Renaissance sculpture is encompassed by the marble block, and the cube of the block constitutes its physical as well as its spiritual limits. The block-shape seemed to impose no limitations on the imagination of the late sixteenth-century Mannerist sculptors. They invented freely, unimpeded by material restrictions. Thus contours of figures were broken up and extremities made to stick out. This new freedom, expressive of a deep spiritual change, led also to multiple viewpoints in sculpture. While Bernini could not accept the many views of Mannerist statuary, which prevent the perception at a glance of one centre of energy and one climax of action, he did not return to the Renaissance limitations dictated by the block-form, because he wanted to wed his statues to the surrounding space. By combining the single viewpoint of the Renaissance with the freedom achieved by the Mannerists, Bernini

laid the foundation for a new conception of sculpture in which all elements are complementary: the single viewpoint and energetic action, the choice of a transitory moment, the breaking down of the restrictions imposed by the block, the elimination of different spheres for statue and spectator, and intense realism and subtle differentiation of texture. These were the means by which Bernini made the beholder an emotional participant in the spectacle before his eyes.

Religious Imagery

Just as the Apollo and Daphne group was nearing completion, circumstances led to a decisive change in Bernini's fortunes. On 6 August 1623, Maffeo Barberini ascended the papal throne as Urban VIII, after the death of Gregory XV, Ludovisi, whose pontificate had lasted only twenty-nine months. Urban had set his mind on using Bernini's genius to capacity. He is reported to have called the artist and addressed him thus: 'It is your great good luck, Cavaliere, to see Maffeo Barberini pope; but We are even luckier in that the Cavaliere Bernini lives at the time of Our pontificate.' In the summer of 1624, by order of the Pope, Bernini began work simultaneously in St. Peter's and in the little church of S. Bibiana.

Early in 1624 the body of the martyr Saint had been found, and Urban used this occasion to have her church restored and decorated. Agostino Ciampelli and Pietro da Cortona painted scenes from her life along the walls of the nave; Bernini was in charge of the restoration, built the new façade and provided the statue of the Saint behind the high altar. This was his first important commission for a religious work (Plates 40, 42, Fig. 27). He represented the Saint at the supreme moment of her life, the joyful and devout acceptance of her martyrdom. Like Christ, she was scourged while bound to a column. Her left hand is holding the martyr's palm; the right arm rests on the column shaft, symbol of her martyrdom and, at the same time, a telling emblem of Courage. Although isolated under a classical aedicula of Bernini's design, the figure is not centred upon itself. St. Bibiana is shown in silent communion with God the Father who appears from on high, spreading out His arms as if to receive her into the Kingdom of saints. Thus the lyrical bend of the head, the half-open mouth, the upward glance—once again reminiscent of Guido Reni—as well as the transitory gesture of the raised right hand denote the instant of her blissful union with God. The rocky ground and the sprouting bush locate the event, as it were, in time and space. Even her mantle seems to participate in the excitement: some of the folds, especially those above the left hand, are freed from the law of gravity. The saint's devotional fervour determines the fall of the drapery, the movement of the body, and the expression of the face.

What appears to distinguish this work from the Borghese groups with their intense physical exertions is its comparative restraint. But the analysis shows that Bernini's approach to sculpture had not changed. The different subject-matter merely required a different interpretation. Instead

of extroverted energies, he had to render spiritual rapture; instead of revealing the climax of an action, he represented the summit of sublime emotions. Religious enthusiasm had never found such realization in Renaissance or post-Renaissance sculpture, and Bernini's ability to portray it singled him out as the chief visual interpreter of the Catholic Restoration.

He himself was a devout Catholic and remained to the end of his life an ardent follower of Jesuit teaching. He practised the *Spiritual Exercises* of St. Ignatius of Loyola, which were designed to stimulate a vivid apprehension of any given subject for meditation through an extremely vivid appeal to the senses. Religious imagery had to fulfil precisely the same purpose. By looking at Bernini's realistic St. Bibiana the beholder finds himself face to face with the gnosis of an individual saint rather than with a supra-personal cult image. His sympathy is roused, he feels with her and tries to identify himself with her experience. He receives even more than he is immediately aware of, for with her he shares emotions of universal significance. Herein seems to lie the secret of Bernini's spectacular success: it is through emotional identification with the mood symbolized in a figure that the faithful are led to submit to the ethos of the triumphant Counter-Reformation. The devotion and humility to be found in Bernini's St. Bibiana corresponded exactly with the religious sensations which the Church expected from the faithful. For that reason Bernini's statue remained the prevalent prototype of female saints till the second half of the eighteenth century.

The next step in the development of figures of saints was the monumental statue of Longinus, executed between 1629 and 1638 for one of the niches under the crossing of St. Peter's (Plates 41, 43, Fig. 34). Longinus is shown as the Roman centurion in an idealized armour which almost disappears under the turbulent mass of the mantle. As in the case of St. Bibiana, Bernini chose for representation the crucial test of Longinus' life—this time the moment of conversion when he exclaimed as he looked up at the Cross: 'Truly this man was the Son of God.' He is therefore divested of the emblems of his military status, helmet and sword, which lie at his feet. Bernini was the only one of the four sculptors engaged on the statues for these niches who created a telling relationship between the figure and the wide expanse of the dome. Longinus looks up towards the heavenly light streaming in from above, stretching out both arms in a paroxysm of devotion. The vibrating cataracts of the drapery and the ample gesture help to give the statue sufficient substance to fill the wide niche; the outstretched arms form, at the same time, one side of a spatial triangle the base of which consists of the holy lance. The importance of the lance is further stressed by the drapery fanning out towards it from a nodal point. With consummate skill Bernini solved the sculptural problem presented by the thin shaft. Far from being an awkward attribute, this tightly grasped image of the relic preserved in the church supplies the *raison d'être* of the composition.

The Longinus is representative of Bernini's fully developed religious statues. As time went on, he further intensified their mystical and devotional quality. Every later commission confronted him, of course, with new problems and required new modes of expression. His statues of Daniel and Habakkuk in the Chigi Chapel of S. Maria del Popolo are a case in point (Plates

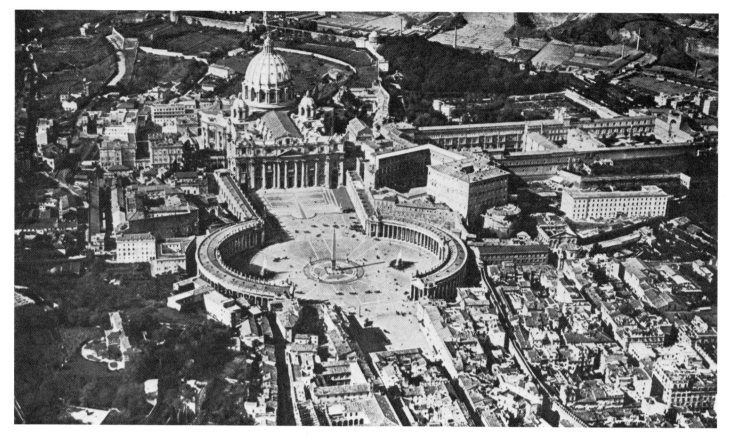

I. AERIAL VIEW OF THE SQUARE OF ST. PETER'S AND THE BASILICA

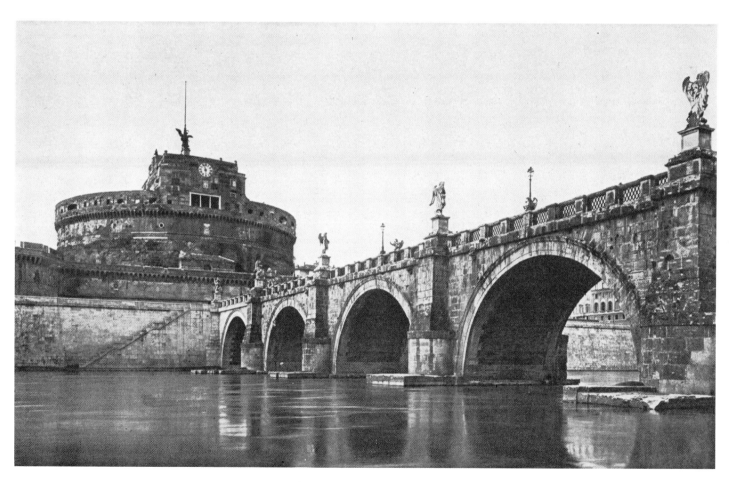

II. PONTE S. ANGELO

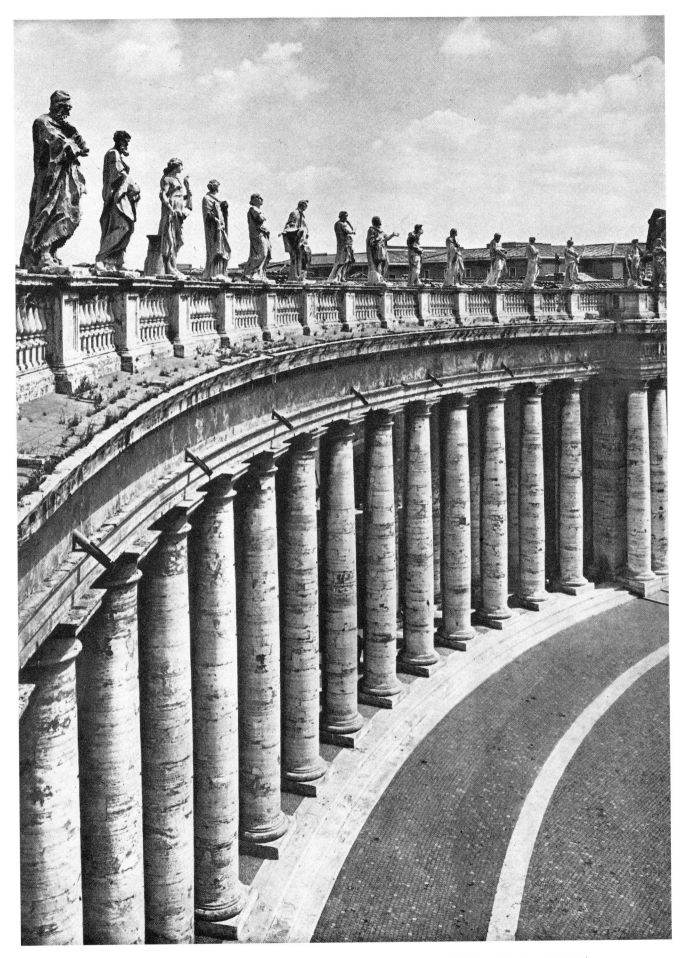

III. THE SOUTHERN ARM OF THE COLONNADE, SQUARE OF ST. PETER'S

85–7). They are Bernini's sculptural contribution to the large-scale redecoration of the whole church executed under his direction by order of the new Pope Alexander VII from 1655 onwards. The Chigi Chapel had been built and decorated by Raphael for Agostino Chigi, Alexander VII's ancestor, as a sepulchral chapel for the family. In two of the four niches stood Lorenzetto's statues of Jonah and Elijah, prefigurations of the Resurrection. Bernini's Daniel and Habakkuk, placed in two niches diagonally across the chapel, complete the sixteenth-century programme. 'Daniel in the Lion's Den' is a venerable symbol of miraculous salvation by the Grace of God, already used by the painters of the Catacombs. Bernini's Daniel, shown in fervent prayer, is thus theologically in line of descent from early Christianity. Habakkuk was not often represented after the Middle Ages. The story connecting the two prophets is told in 'Bel and the Dragon', which forms part of the Greek Book of Daniel. An angel seized the prophet Habakkuk by a lock of his hair and carried him to Daniel in order to bring him the food which Habakkuk had wanted to take to labourers in the field. The Chigi Library contained the only known Septuagint text of Daniel and it was Alexander VII who recognized its importance. In commissioning Bernini to represent the two prophets, the Pope was in all likelihood prompted by this discovery. Bernini supported the story by dramatic emphasis of gestures. Habakkuk points in the direction of his original destination while the angel, with a persuasive smile, shows him the place to which he wants to remove him. The whole space of the chapel has become the setting for this story.

The difference in the interpretation of the two figures will now be understood. The spiral of Daniel's body and the twisted, turbulent drapery, meant to express inspired faith, contrast sharply with Habakkuk's more worldly attitude—similar to the contrappostal pose of the Danube from the Four Rivers Fountain—and with the sober arrangement of his mantle. At the very moment of initiation, Habakkuk is still concerned with physical rather than spiritual matters. Moreover, since the group occupies the niche to the right of the altar, Bernini deliberately planned it as a counterpart of Lorenzetto's Jonah. And yet he departed from the simple frontality of the Renaissance figure by developing his theme in terms of a highly sophisticated play of contrasting spatial planes and movements.

An intensification of the visionary quality will be noticed in the statues of Mary Magdalen and St. Jerome in the Chigi Chapel of Siena Cathedral (1661–3, Plates 89–92). Traditional symbols of penitence, the figures show two different aspects of this religious attitude: Mary Madgalen contrition and remorse, Jerome mystical surrender. Burdened by her sins, Mary Magdalen's body is twisted in agony. Her left leg is groping, dragged along on the ground, but the right foot rests firmly on the jar of ointment (her customary attribute) with which she had anointed the Saviour. Her head rests, exhausted, on her fervently clasped hands. Her face mirrors the despair of her soul, but her eyes turn towards heaven hopeful of salvation; and her mouth, too, seems to quiver between a moan and a sigh of relief. Similar suspense is manifest in the sweep and counter-sweep of two ropes of tightly twisted folds which cut right across her body.

Like Mary Magdalen, St. Jerome places one foot on his attribute, the lion. Compositionally a counterpart, the figure is conceived spiritually as a contrast to the Magdalen: instead of out-poured feelings, his mind is turned inwards. This is the traditional way of representing the penitent St. Jerome, who is always shown absorbed in contemplation of the Cross. Bernini, however, departed from the tradition in one important respect. Jerome's head, with the half-open mouth and closed eyes expressing deep concentration, leans against the Cross, but its presence is the result rather than the cause of the Saint's vision. According to the laws of gravity the Cross could never be in the position in which we see it; for the fingers of the left hand touch the cross-beam without supporting it, while the right hand is clasping the drapery and not the foot of the Cross. Thus the Cross exists only by virtue of St. Jerome's power of mystical introspection and will disappear when the Saint awakens from his trance.

In the Angels for the Ponte S. Angelo (1668–71, Plates 103–9) Bernini achieved his pro-foundest expression of spirituality. Unlike the attributes of the two Sienese figures, the objects they carry supply the key-note to their passionate intensity. Their grief over the suffering of Christ is inconsolable. The Angels with the Crown of Thorns and the Superscription, finished in 1669 and now in S. Andrea delle Fratte, were again devised as complements (Figs. 106, 107) as well as contrasts. The Angel with the Crown of Thorns is a manly and heroic type; the other, delicate and tender, expresses sensibility of a more lyrical kind, and the arrangement of the garments corresponds precisely to their different mood. Far from any laws of gravity, the drapery of the one forms a tense and powerful arc—echoing, and acting as foil to, the Crown of Thorns—while that of the other is crumpled into masses of nervous folds which roll up restlessly at the lower end, reflecting the highly strung state of mind of the angel. In compliance with Pope Clement IX's special order for their better preservation, these two angels were never placed on the Ponte S. Angelo. Of the replicas, which he commissioned, Bernini himself designed and largely executed the Angel carrying the Superscription. In this new, deeply moving creation he combined the wind-blown drapery of the Angel with the Crown, reminiscent of the angels at the sides of the Cathedra (Plate 94), with turbulent curved folds which beat against the body like large breakers.

Kneeling angels in attitudes of intense devotion occupied Bernini over a great many years. His first variations on this theme were carried out in the 1620's above the high altar of S. Agostino (Fig. 28). They occur again, but transformed, in early stages of the Cathedra design as well as in drawings, and were given their final and most sublime realization in the Chapel of the Blessed Sacrament in St. Peter's (1673–4, Plate 119, Fig. 117). This was planned at one stage with many angels surrounding the tabernacle, like a terrestrial embodiment of the army arrayed round the throne of God (1 Kings xxiii. 19). The finished work with only two angels is no more than a fragment of the much larger scheme. Bernini seems to have regarded the task as so im-portant that, despite his age, he carried out the full-scale models of the angels himself. The reason for this is not difficult to divine: nobody but he was capable of rendering these superior beings in their state of immutable happiness; remote from human passions, with an angelic smile on

their faces, they are wholly absorbed in adoration. They form a deliberate contrast to the severe architecture of the domed circular tabernacle in which the Sacrament is reserved. A version of Bramante's Tempietto, but glowing with gold and lapis lazuli, form and colour here express symbolically the immaterial perfection, the beauty and radiance of God. There can hardly be any doubt that Bernini knew and was stimulated by the writings of Dionysius the Areopagite on the hierarchy of angels. It is well to remember that this classic of early Christianity had re-appeared in 1634 in a Latin translation with a title-page by Rubens.

In 1674, the year in which the altar of the Sacrament was unveiled, Bernini finished another important work, the figure of the Blessed Lodovica Albertoni in S. Francesco a Ripa (Plates 120–1, Fig. 114). Shown in her last earthly moments, she presses both hands against her body; her lips are parted in the last sigh, while her head with dying gaze sinks back on to the high-piled pillow. The figure is lying on a couch, and its outstretched horizontal is an important element of the composition. Emphasis on horizontals and verticals is characteristic of Bernini's late style. The diagonal, so important for the expression of emotions during his middle period (Plate 72), has disappeared, and all the significant movements are emphatically angular—an angularity which contrasts with the supple modelling of an almost Correggiesque delicacy. The pang of death is apostrophized in a masterly fashion in the motif (above the left hand) of the vertically erected fold of the mantle, intensified in its effect by the horizontal staccato of deeply undercut parallel folds, which in turn dissolve into the long horizontal piece of drapery between the legs. The violence with which these basic directions come together tends to increase the passionate spirituality of the figure.

A turn towards an austere and, one is tempted to say, classical framework for his compositions will be found in Bernini's work from the 1660's onwards. But this change is not confined to Bernini; the style of other great masters born about 1600 undergoes a similar transformation at the same period. It is to be found in the late architectural development of both Borromini and Pietro da Cortona, as well as in the late style of Poussin and Rembrandt, to name only the most eminent examples. In spite of the vast differences in the art of these masters, the severity of their compositions tends to enhance the dramatic and emotional impact.

Portrait Busts

Bernini's achievement in the field of portraiture was no less revolutionary than in that of religious imagery. It was he who created the Full Baroque portrait bust. His development towards a new conception of portraiture can be followed step by step from the very beginning of his career. This historic series of busts opens with that of Monsignor Santoni in S. Prassede (Plate 2, Fig. 1). Although the type with the merest indication of the body is traditional, this work by the young artist of seventeen already reveals a psychological penetration rare or even unknown in

contemporary Rome. Closely allied in style, but slightly later, is the bust of Giovanni Vigevano (Plate 3, Fig. 2). Old age is characterized in a masterly way. As in the Santoni bust, deep holes produce the effect of colour in the eyes; and as so often with Bernini, pronounced realism and a deliberate return to classical models go hand in hand. The motif of showing one hand emerging from a loop of the mantle—repeated twenty years later in the Baker bust (Plate 64)—is found on Roman tombstones. This is Bernini's first attempt to overcome the old problem, always present in busts, of the truncated chest.

With the sturdy and plain realistic characterization of Pope Paul V (Plate 8, Figs. 3, 4) a new phase begins, and during the 1620's Bernini remained on the whole faithful to this approach to portraiture (Plates 28–33, Figs 5–11, 29 and 30). The busts of this period are all pensive and reserved in expression, introverted rather than extroverted. Their garments fall in simple plastic folds, which in no way detracts from the concentrated meditation in the heads. In some of the busts of the 1620's the body begins to gain in importance; but the comparison between the Montoya and the Francesco Barberini (Plates 29, 30, 34, Figs. 15, 29) shows that there was no radical change of conception, in spite of the five or six years that separate them. A case may, however, be made out for regarding the Agostino Valier and the Francesco and Antonio Barberini (Figs. 10, 29 and 30), all belonging to the later twenties, as a distinct group. They display a sober matter-of-fact quality, anticipated in the Giovanni Dolfin (Fig. 8) and the first Urban VIII (Plate 32). It is also in the Pietro and Agostino Valier and, above all, in the Antonio Barberini, the latter almost a freak in Bernini's œuvre, that Bernini began to experiment with an emphasis on considerably enlivened draperies.

Not all these busts are of equal importance or quality. Firmly established as the first portrait sculptor in Rome with the papal busts of Paul V and Gregory XV (Plates 8, 28), Bernini was overburdened in these years with portrait commissions which he had to regard as a sideline when in 1624 work began on the Baldacchino. It is, therefore, not by chance that the highlights in this field, the Montoya and Bellarmine busts (Plates 29, 31, Figs. 7, 15), date from before that time.

As one would expect, a splendid series of portraits exists of his great papal patron Urban VIII, beginning with the dynamic bust of 1623-4 (Plate 32) which, in fact, foreshadows the development of the 1630's. Among the later busts of the Pope those in the collection of Principe Enrico Barberini (Plate 39, Fig. 17)—of which a splendid bronze exists in the Vatican Library (Plate 36) —and in the Palazzo Spada (Plate 37) excel by psychological insight and compassionate qualities. There exists another case—Velasquez's portraits of Philip IV—where a similarly moving characterization resulted from the bond of deep sympathy uniting over many years a great artist and his illustrious patron. The most authoritative bust of the aged Pope was apparently the one known through several bronzes cast from Bernini's model of about 1640. One of the casts, now in the Louvre (Fig. 20), may have reached Paris in Urban's life-time as a present to the French King. Contrary to the opinions of most critics, the well-known marble in the Palazzo Barberini (Fig. 19) has to be dated in the last years of the Pope's reign, but it has no claim to

particular distinction, being mainly by the hand of an assistant. The over life-size bust at Spoleto of 1640–4 (Plate 50) is in a class of its own for monumental grandeur and sculptural energy. Though designed for a far viewpoint, the quality of the surface treatment is of the highest order and there can be little doubt that the chasing was done by Bernini himself. A comparison of the low reliefs of SS. Peter and Paul 'embroidered' on the papal cope (Figs. 25, 26) with those of the early papal busts (Plates 8, 28, Figs. 3–5) gives the measure of the stylistic freedom Bernini had achieved in the intervening two decades.

At the time of the Longinus there is a marked change in Bernini's approach to portraiture, the result of which is first apparent in the bust of Cardinal Scipione Borghese of 1632 (Plate 57, Figs. 36, 37). The spontaneous expression of the face with the half-open mouth and the lively gaze show the cardinal as if he were engaged in animated conversation, precisely as the 'snapshot' sketch in the Morgan Library does (Plate 56). In contrast to the interpretation of most of the earlier busts, Scipione Borghese is characterized as an extrovert, communicative type, and the transitoriness of the psychological moment caught in stone is supported by the painterly treatment of the surface. Light and shade play on the fleshy parts of the face and on the drapery, and the beholder feels that in the twinkling of an eye not only might the expression and attitude change but also the folds of the casually arranged mantle.

Similarly, the famous bust of Costanza Bonarelli, with whom Bernini had a stormy love affair, has an almost terrifying punch (Plate 61, Fig. 43). A fierce and sensual woman is shown in the grip of passion, and since the shoulders and breasts, loosely covered by a chemise, are handled like a mere sketch, the beholder's attention is fully absorbed by this 'speaking' likeness. As in his mythological and religious works, the spiritual barrier between the onlooker and the portrait bust has fallen and contact is immediate and direct. Like Rubens in his painted portraits, Bernini interprets for us a new type of people: they seek contact with others and need partners to bring their faculties to life. It was this type of portraiture—alert, penetrating and instantaneously engaging the spectator—that Baroque sculptors endeavoured to imitate and emulate.

In the case of other slightly later portraits the beholder's interest is heightened and appeal even made to his sense of humour by the piquancy of the characterization. Nobody can suppress a benevolent smile in front of Thomas Baker's perfumed, somewhat ridiculous elegance, which is brought home by overstressing accessories like the ample hair-style and the Venetian lace (Plates 64, 66), or in front of the braggadocio Paolo Giordano Orsini (Plate 67, Fig. 44), whose forelock, nose and moustache reveal him for ever. And one wonders whether his Duchess (Fig. 45), who at the time of the bust had long passed the prime of her youth, was resigned to, or amused by, a life spent at his side. Hand in hand with this kind of psychological refinement goes a classicizing tendency, characteristic of these years, which is evidenced by the smooth handling of the skin and, above all, by the consistent use of the 'blank' eye. In this connection the strongly classicizing Medusa (Plate 65) should be mentioned; it clearly belongs to the same period. The polished face, which shows close analogies to that of Isabella Orsini, is contrasted with the weighty

crown of snakes in a way that is reminiscent of Thomas Baker, who is similarly smothered by the mass of his hair.

The Baker and the Orsini busts were executed in a varying degree with the help of studio hands. Nor is the controversial bust of Richelieu (Fig. 46), made between 1640 and 1641, entirely by Bernini's own hand. And yet this bust holds a key position in the development towards Bernini's later style of portraiture. For it was here as well as in the approximately contemporary model for the Louvre bronze of Urban VIII (Fig. 20), that he first incorporated a feature which he elaborated and varied constantly in his late busts: he implied by the fall of the dress that one arm is coming forward and the other moving back. In this way he attacked the problem of the truncated chest in a new manner, conveying the illusion of real movement and, by suggesting a contrappostal attitude, succeeded in giving the head increased prominence in spite of the enlarged body.

During the last thirty-five years of his life Bernini created few portrait busts, even counting those of questionable authenticity. Among the originals, however, are some of the most brilliant and sublime works of his chisel. Two almost identical energetic busts of Innocent X, both surely by his hand, have come down to us (Plate 83, Fig. 68), but no surviving bust of Alexander VII (No. 65, Figs. 22–4) appears to be authentic, not even the fine terracotta, Figure 23. Nor does it seem possible to accept the bust of Cardinal Azzolino (Figs. 127, 128) despite its distinctly Berninesque surface quality. On the other hand, the intensely emotional Gabriele Fonseca (see p. 26, Plates 116–8) and the sturdy half-figure of Clement X (Figs. 118–9), two most unconventional portraits in which the play of the hands assumes a heretofore unknown importance, denote the potentialities of his portrait style during the last decade of his life. Finally, there are the busts of two secular rulers, Francis I of Este and Louis XIV. They are of exceptional importance not only because they are entirely by Bernini's own hand and therefore most valuable documents of his manner in 1650 and 1665, but, above all, because he infused them with his conception of the worldly mission of the absolute monarch.

The bust of King Charles I, executed in 1636, had offered him an earlier opportunity of demonstrating those qualities of which a sovereign ruler should be possessed. This bust, a pawn in a political game, was a papal present to the Catholic Queen Henrietta Maria at a moment when the Vatican nursed the ill-founded hope that England might revert to the old Faith. Sufficient reliable material survives to reconstruct the original, probably destroyed in 1698 (Figs. 47, 48). In 1635, the year of Van Dyck's triple portrait from which Bernini worked, the Venetian ambassador in London, Vincenzo Gussoni, characterized the King in a despatch as 'more disposed to melancholy than joviality; yet his aspect, with his comeliness, is no less pleasing than grave'. Van Dyck, in the triple portrait, rendered in visual terms what Gussoni expressed in words. He shows the King as a refined aesthete of somewhat melancholic disposition. Bernini, however, did not accept this as an interpretation of royalty. In his bust the head was thrown sideways and raised proudly; he disregarded the slight stoop shown in Van Dyck's picture. Judging from the scrupulous copy at Windsor, every detail of the face was filled with an almost

aggressive vitality. The jawbones are broad and powerful, the nose is bolder, the beard more pointed, the eye-lids less drooping than in Van Dyck's picture; and, extending the evidence of the model, the mass of curls gives the head weight and majesty. The deliberate change of the civilian dress shown in the picture into a semi-military costume with breast-plate and sash points in the same direction. Bernini represented, in a word, a dominating, exalted personality, a haughty individual and worthy successor to the condottieri of the Renaissance. It is clear that this conception of a sparkling hero, full to the brim with resolution, was a mistaken interpretation of the timid and peace-loving sovereign. But this argument would not have carried weight with Bernini, who saw contemporary sovereigns in a direct line of spiritual succession from the great commanders of antiquity, Alexander, Caesar and Augustus.

It was these ideas that he developed further in the busts of Francis I (Plate 84, Fig. 73) and Louis XIV (Plate 101, Figs. 50, 51). The thoughts which crossed his mind and the procedure which he followed in carrying out Louis XIV's bust—probably the grandest piece of portraiture of the Baroque age—can be fully gauged from the diary entries of the Sieur de Chantelou, his faithful guide and companion during his stay in Paris. Bernini approached his problem from two different angles. On the one hand, he worked for days in the studio on ever new versions of a small clay model; on the other, he watched the King playing tennis, at cabinet meetings, or at any other of his customary occupations. He argued that this was the only way of getting to know a man's character. In rapid sketches he caught his royal patron unawares, thus, as he declared, steeping himself in, and imbuing himself with, the King's features. The clay models served a completely different purpose. They were made first and foremost to clarify what he called 'his general idea'. He argued that the portrait of the greatest king in Europe had to convey grandeur, nobility, pride, heroism and majesty, and that the rendering of an exact likeness was, to a certain extent, distinct from the visual expression of these general notions. They depend, amongst others, on the pose, the turn of the head and the arrangement of the drapery, and all this can be determined without recourse to the sitter. But the individual features also have to express royal demeanour. From the very beginning Bernini compared the head of the King to that of Alexander the Great, the accepted model of royalty. The face of the King in Bernini's bust is manifestly similar to that of Alexander as we know it from coins. By interpreting him thus as a second Alexander, he intentionally idealized his model. But the departure from reality was not motivated solely by subjective ideas of what expressed heroism and majesty in a man's face; in accordance with the convictions of his time, Bernini believed that antiquity had given permanent and final expression to certain conceptions with which modern artists had to comply.

In his view, the artist's difficulty consisted in reconciling the general with the particular. A work which did not express a general idea he declared a complete failure, while, on the other hand, the general idea could only carry conviction if it were expressed through the medium of realism. In accordance with this belief, when the bust was nearing completion, he had the King sit for him, thirteen times in all, in order to work systematically on eyes, cheeks, forehead, nose and mouth directly on the marble. During the whole process of execution he never referred

back to his models and sketches. And his comment on this point was 'I don't want to copy myself but to create an original.'

To produce the effect of colour and movement in marble appeared to him the prerequisite of a good portrait bust. Movement and the sensation of colour pervade all parts of the King's bust, the hair with its curls, carved filigree-like one above the other, the shining armour, the lace cravat and the drapery to which he wanted to give the effect of taffeta. This piece of drapery is particularly important for the illusion of movement. It seems to be floating in a strong wind towards the right, and therefore the turn of the head in the opposite direction appears sudden and spontaneous. The drapery, moreover, is an ingenious device to overcome the perennial problem of the stumps of the arms. When the bust was finished, the Venetian ambassador in Paris summarized Bernini's intentions with the remark: 'The King seems about to give a command to the Prince of Condé, or the Comte d'Arcourt, or M. de Turenne at the head of his army; the bust has real movement although it has neither arms nor legs.'

It is not usually realized that the King's bust was originally meant to be an allegorical portrait. Bernini fully subscribed to the conviction of his time that a work of the highest class had to express a *concetto*, a fitting literary allusion—the Horatian *ut pictura poesis* was also relevant in works of sculpture. But he rejected the popular form of allegorical portraiture—which depicted the *Roi Soleil* in the guise of Apollo or Alexander—and relegated the literary concept to the base. This base was never executed; a tentative reconstruction is given in Fig. 50.

The composition of the earlier bust of Francis I of Este is similar to that of Louis XIV. The direction given to the head and the look is counterbalanced by the energetic lines of the drapery which meet in the lower right-hand corner. As in the case of Louis XIV, a good deal of the impression of sudden movement and grandeur derives from this crossing of directions. But there is this difference: while in Francis I's bust diagonals play a dominant part Louis's is based on horizontals and verticals; and while the former is precariously balanced on the rounded-off lozenge-shaped trunk, the latter rests firmly on the broad horizontal sweep of the drapery. In the bust of Francis I the face and the meeting point of the drapery folds are to the left and right of the central axis, which is subtly reinforced by the long curls of the wig, so important as a means of keeping the work in equilibrium. This counterpoise of two halves is replaced in Louis XIV's bust by an emphasis on the vertical axis which is accompanied by other verticals. Even the treatment of the face reflects this difference of conception, as can be seen from a comparison of the oval forms in the earlier bust with the squareness of the jaw in the later. Moreover, in the bust of Francis I the free piece of drapery, which envelops the left shoulder with large decorative folds, forms a buoyant and majestic finale to the movement, while in that of Louis XIV the free end of the drapery coils up almost convulsively. Here, violently strained, tense plastic masses are controlled by the axially opposed directions, and this is, as has been shown before, characteristic of Bernini's late period. The stylistic differences between these two busts are exactly paralleled by the differences between the St. Teresa and the Blessed Lodovica Albertoni.

Work in St. Peter's and the Vatican

It was Bernini's tremendous achievement in the area of the Vatican that secured his reputation as the first artist of Europe. His genius was given fullest scope in his official capacity as 'Architect to St. Peter's'. Vast enterprises in and around the basilica were carried on concurrently for many years; in spite of their great variety in content and scale Bernini never lost sight of the whole, and dovetailed early and late undertakings even after an interval of half a century. His work for St. Peter's began as early as 1624 with the commission for the giant Baldacchino under the dome (Plates 44–8, Figs. IV, 62). From then on for the next fifty-six years he was almost solely responsible for the works of major importance in the church and its vicinity.

The Baldacchino, a triumphant canopy raised above the tomb of St. Peter and the papal altar, was not finished until 1633. While this work was in progress Bernini had to turn to the decoration of the piers of the crossing. Balconies were required above the large niches in the pillars for the exhibition on special occasions of the most venerated relics in the church (Fig. 35). This task, which was completed in 1640, necessitated the hollowing out of Michelangelo's cupola supports—a challenge to Bernini's skill as an engineer. Above each balcony, set on richly coloured marble between late antique twisted columns salvaged from old St. Peter's, are angels and putti who carry like trophies a marble image of the respective relic. The saints Longinus, Veronica, Helena, and Andrew, traditionally connected with the Lance, the Veil, the Cross, and St. Andrew's head, appear in the large niches as giant statues, executed by the most eminent sculptors of the period, Bernini, Duquesnoy, Mochi and Bolgi. The decision to perpetuate the relics and their protagonists in stone under the cupola had repercussions on the choice of the site for the tomb which Urban VIII wanted to have erected for himself during his life-time. Since Guglielmo della Porta's tomb of Paul III, which was standing in one of the pillars, had to be removed, it was decided to place both tombs in corresponding niches of the apse. It was for the niche on the right that Bernini executed Urban's tomb between 1628 and 1647 (Plate 49). During these years he was engaged on two important sculptural tasks, characteristic of the temper of the Catholic Restoration: the large relief of the 'Pasce Oves Meas' (1633–46, Fig. 41), symbol of the handing over of the spiritual leadership to St. Peter and, implicitly, to his successors, and the tomb of the Countess Matilda (1633–7, Fig. 38), commemorating a time-honoured victory of the Church over the temporal power. The 'Pasce Oves Meas', planned as a counterpart to, and first placed under, Giotto's Navicella inside the church, was soon transferred to its present position above the central entrance of the portico. Those who enter the church of St. Peter are reminded of the Catholic doctrine that the popes are the vicars of Christ on earth.

The marble incrustation of the pilasters of the chapels and of those under the arches of the nave followed (1645–9, Fig. 62). In contrast to the older, purely decorative incrustations, Bernini introduced meaningful symbols: putti with tiara and keys or book and sword, and others

carrying medallions with idealized portraits of the early martyred popes. This extensive cycle, the work of many hands and unequal in quality, replaced a similar series of popes which pilgrims of previous centuries had seen in mosaic in old St. Peter's.

The tempo and importance of the work carried out during the next twenty-five years almost dwarf the achievement of the earlier period. Between 1657 and 1665 Bernini erected the Cathedra Petri in the apse of the church (Fig. IV). He enshrined St. Peter's venerable seat in a gorgeous bronze throne which he raised high into the air, supported by the four Fathers of the Church, under a dazzling glory of angels. Concurrently with this, his grandest and symbolically most significant creation, he laid out the square of St. Peter's (Fig. I). Begun in 1656, essential parts had been finished when Alexander VII died in 1667. The square is not only the largest and at the same time the most subtle architectural creation of the Roman seventeenth century, but also its forest of statues finds no parallel in the Baroque age (Fig. III). Above the colonnades appears an army of giant saints and martyrs, designed by Bernini, and more than thirty of the ninety-six figures were in position by the beginning of 1667. Connected with the architecture of the square, and forming an integral part of it, is the Scala Regia, the new grand entry to the papal palace (1663–6, Fig. V). It too became the repository of important statuary: in 1670 Bernini's equestrian statue of Constantine the Great was unveiled on the landing at the foot of the main staircase, on the longitudinal axis of the portico of St. Peter's (Plate 110). Three years earlier Clement IX had commissioned Bernini and his most distinguished assistants and colleagues to set marble angels with the Instruments of the Passion on the Ponte S. Angelo, the bridge which in the seventeenth century afforded the only entry to the precincts of the Vatican from the city of Rome. Towards the end of Bernini's career, between 1672 and 1678, there followed in the church the tomb of Alexander VII (Plate 122) and, between 1673 and 1674, the altar in the *Cappella del Sacramento*, where over-life-size bronze angels kneel in veneration left and right of the Tempietto-like tabernacle (see p. 10, Plate 119).

During the execution of this extraordinary amount of work, covering the span of almost two generations and for its physical extent alone probably unmatched in the history of art, only one serious misadventure happened to Bernini. In 1637 he was commissioned to erect towers over the façade of St. Peter's in place of those which had originally been planned by Maderno. The left-hand, southern tower was built according to Bernini's design; but when cracks appeared in the façade, owing to unpredictable conditions in the foundations, the tower had to be pulled down hastily in 1646, never to be rebuilt—a disaster which almost ruined Bernini's further career.

Though undertaken without a premeditated comprehensive programme, Bernini's work in and around St. Peter's embodies more fully the spirit of the Catholic Restoration and, implicitly, that of the Baroque age, than any other complex of works of art in Europe. In ever new manifestations the perpetuity and triumph of the Church, the glory of Faith and sacrifice are given expression, and these highly charged symbols impress themselves on the beholder's eye and mind through their impetuous visual language which seems irresistible in its intensity. Let us

follow the steps of the late seventeenth-century pilgrim and share some of his experience. Crossing the Ponte S. Angelo (Fig. II) he is a witness to the *via Crucis*: angels with the Instruments of the Passion take the place of the traditional Stations of the Cross. Thus prepared, he approaches the mother church of Christianity. On entering the narrow street of the Borgo—no longer extant after the recent megalomaniac craving for unrelated large open vistas—he recognizes in the distance, exactly in his line of vision, the entrance to the papal palace. Stepping out of the narrow Borgo into the wide and festive *piazza*, symbol of the all-embracing power of the Church, his eye meets the hosts of saints and martyrs, reassuring pillars of Faith. As he stands under the portico of St. Peter's, the equestrian statue of Constantine, testimony of Christ's conquest of the worldly empire, appears to his right like an apparition and, entering the church through the central door, he views a mirage between the dark-bronze columns over St. Peter's tomb, at the farthest end of the apse—the throne in which is vested the passing on of the spiritual power to St. Peter and his successors. And walking along the nave towards this apogee of Catholic dogma, he finds himself surrounded by those early popes who bear witness to the age, struggle and victory of the Church.

It is a measure of what had happened in the fifty years between 1625 and 1675 that a pilgrim at the beginning of this period would not have found any of these stirring sights. The dynamic momentum of which the visitor is aware from beginning to end, from the Ponte S. Angelo to the Cathedra, is due in no small measure to Bernini's genius for dissolving what would appear to a classical point of view the accepted boundaries of each art. Despite the multitude of impressions any of these works may evoke, he achieves the total subordination of architecture, sculpture and decoration to an overriding spiritual conception. The Baldacchino, as a structure resting on four columns, is strictly speaking a piece of architecture. But since these columns do not carry weight related to their size, they appear to be gigantic, essentially sculpted monoliths rather than architectural members. From a nearby standpoint under the dome the emblematical, profusely applied sculptural elements impress the beholder (Plate 48), while the relation to the aediculas above the balconies becomes evident. Here the twisted bronze columns of the Baldacchino find a fourfold echo (Fig. 35), and their enormous size contains again a symbolic reference to the victory of Christianity over the pagan world to which the small marble columns belonged. The meaning of the Baldacchino entirely changes when seen from a distance, for then its decorative function as frame to the Cathedra is inevitably emphasized (Figs. IV, 62).

This fact proves that the Cathedra, begun as late as twenty-four years after the completion of the Baldacchino, was yet planned in close conjunction with it. Moreover, in a number of preparatory sketches Bernini studied the Cathedra as it would appear from the entrance of the church, seen through and framed by the columns of the Baldacchino. Thus the Cathedra was conceived as a colourful sculptured picture of enormous dimensions; but the illusion of a picturesque fata morgana exists only from the distance. As with the Baldacchino, the character of the Cathedra varies as the visitor approaches it. At one moment he may view it as if it were a fantastic improvisation placed before the architecture (Fig. IV), for he realizes that no 'normal'

high altar could have competed as successfully as the Cathedra does with the gigantic dimensions of the church. Or he may be struck by the intensely chromatic impression: the interplay of multi-coloured marble, gilt bronze, stucco, and the yellow light spreading from above; or else by the sculptural complexities of a work in which a window as well as the transitions from flat to full relief and then to free-standing figures penetrating far into space, form part of an indivisible whole (Plates 93–100). It is evident that a narrow and biased approach can never do justice to the Cathedra; it is precisely the union of traditionally separate and even contradictory categories that contributes to its evocative quality. Whatever his immediate reaction, close to the Cathedra the beholder finds himself in a world which he shares with saints and angels, and he is therefore submitted to an extraordinarily powerful emotional experience. A mystery has been given visual shape, and its comprehension rests on an act of emotional participation rather than on one of rational interpretation: high above the ground hovers the chair of St. Peter, and the greatest Latin and Greek Fathers—St. Augustine, St. Ambrose, St. Athanasius and St. Chrysostomus, who supported Rome's claim to universality—appear at the sides of the Cathedra. They do not carry it, they do not even touch the scrolls, but are linked to them by loose bands, as if to stress connections of a spiritual order. On the chair back is a relief of the 'Pasce Ove; Meas' (Plate 94), reminiscent of the monumental one over the entrance door (Fig. 41); above the chair putti carry tiara and keys (Plate 100); and finally, high up in the centre of the angelic glory, is the transparent image of the Holy Dove (Plates 97, 98). Thus there appear one above the other symbols of Christ's entrusting the office of Vicar to St. Peter; of the primacy of the papacys and of Divine inspiration, guidance and protection. A victorious and exuberant spirit fills every part of this monument; it is the grandest apotheosis of the *Ecclesia triumphans*.

For the execution of the Cathedra Bernini naturally had to rely on the help of many hands. The majority of the artists engaged on the models and stuccoes, the bronzes and decorative details were masters in their own right, such as Ercole Ferrata, Antonio Raggi, Lazzaro Morelli, Paolo Naldini and Giovan Paolo Schor. Nevertheless, the Cathedra is saturated with an intense and ecstatic spirit down to the minutest detail. Photographs reveal what is not easy to see in the church itself: the different stages of inspiration, of prophetic fervour and enthusiasm in the Fathers of the Church; the expressions and gestures of ardent devotion and of joyful and serene concentration in the putti and angels of the glory. This was possible only because of Bernini's meticulous preparation of, and attention to, every part of the immense work, and is borne out by his sketches, detailed drawings and surviving models as well as by a wealth of documents. Nor was anything left to chance in the over-all arrangement of the composition. The bundles of golden rays provide a loose and yet conspicuous frame to the whole work and link it with the adjoining niches. Placed between the broad base and the radiating glory, the chair is the absolute compositional focus. There is a subtle differentiation of scale and the crowds of figures are most carefully balanced. Movements and gestures, even in different spatial layers, are intimately related, welding the manifold components into a coherent unit. The gestures of the nervous and eloquent hands of St. Ambrose and St. Athanasius, for instance, appear like contrapuntal

expressions of the same theme (Plate 96). Often imitated but never equalled, the Cathedra is the spiritual and artistic climax of the Full Baroque. Domenico Bernini described in simple words his father's intentions: 'The two works'—he wrote—'the Square and the Cathedra are, as it were, beginning and end of the magnificence of that great church, and the eye is as much infatuated at the beginning on entering the square as at the end on seeing the Cathedra.'

Almost a generation before he planned the Cathedra, Bernini had designed the tomb of Urban VIII, which remained the most important model for papal tombs to the end of the Baroque age (Plates 49, 51-5 and 58). Bernini broke radically with the tradition to which the tombs of Urban's predecessors in S. Maria Maggiore belonged, and reverted direct to Michelangelo. As in the Medici tombs, the figures form a distinct pyramid, and in both cases the sarcophagus with the two allegories and the statue of the deceased are in different planes; and even the shape of the sarcophagus derives from Michelangelo. Before Bernini, the Medici Chapel type had been adapted to the papal tomb by Guglielmo della Porta in the tomb of Paul III, and it was undoubtedly Bernini's concern with this monument that led him back to Michelangelo. After the decision to place the tombs of Paul and Urban in corresponding niches of the apse, Bernini planned that of Urban as a counterpart to, and, at the same time, as a criticism of, the earlier tomb. The pedestal of Paul's tomb is very prominent and has a strong horizontal tendency, while its upper part with the Mannerist cartouche bearing the inscription is structurally not clear. The allegories lying in heraldic symmetry on large scrolls are rather plain versions of the Medici 'Times of the Day'; and the great mass of the pedestal overshadows the three relatively small figures so that the eye has difficulty in correlating them in a visual pyramid. In contrast to this, Bernini gave the pedestal a vertical tendency, simplified it, and greatly reduced its importance. The figures are now the dominant feature; their volumes, and particularly that of the Pope, have been considerably increased, and the allegories moving in a seemingly casual way have an appeal of a new kind. In the Medici Chapel and the tomb of Paul III the allegories seem to exist in a sphere of their own. In Bernini's tomb they are not only spatial but also spiritual mediators between the beholder and the statue of the Pope. It is their human qualities, supported by the warmth of the surface treatment and the differentiation of texture, that create the impression of real and pulsating life. The contrast between the composure and tenderness of feeling in the 'Charity' and the uncontrollable grief of the infant at her feet epitomizes the onlooker's own sensations in front of the tomb. Moreover, dynamic motifs everywhere replace static ones. Bernini even turned the old impersonal symbol of the skull, used on countless tombs of the sixteenth and early seventeenth centuries, into an active personification of Death writing Urban's name into a large book.

The tomb of Urban VIII was the first purely sculptural work into which Bernini introduced colour by using different materials. Colour for him was never a merely decorative device, but essential for illuminating the meaning and significance of his ideas. Here decorative elements of the sarcophagus, the figure of Death, and the papal statue, i.e. the parts directly concerned with the

deceased, are of dark partly gilded bronze. Unlike these with their magic colour and light effects, the white marble allegories have a distinctly this-worldly quality. By their whiteness, too, they form a transition between the observer and the papal figure which, by virtue of its colour alone, seems far removed from the sphere of the beholder. And yet this pope with the powerful gesture of benediction commands all our attention. Apart from the tomb of Paul III, statues of the blessing pope had been used on other sixteenth-century papal tombs. In none of them, how-ever, were the popes at all sharply individualized, as if to show that it was not the individual pope who was important, but the general cause of Catholicism embodied in the effigy. Bernini reversed this approach; for him the general cause was vested in a great and powerful personality. Urban is here enthroned above his sarcophagus, dignified and grand like an invincible sovereign, sure of his authority and the uniqueness of his office. Most of the papal tombs from Leo X to Paul V have no sarcophagus: the idea of a commemorative and ceremonial monument had superseded the idea of death. With his emphasis on personality, Bernini returned logically to an emphasis on the sepulchral idea, for even the most powerful wearer of the tiara is still mortal. Bernini reconciled in this work permanency and transience, supra-personal memorial and personal tomb in a manner never achieved before or after.

The figure of the pope has a monumental counterpart in the marble statue of the Palazzo dei Conservatori (Plate 69, Fig. 53). The work was unveiled in 1640, i.e. ten years after the casting of the bronze statue. It is, therefore, not Bernini's first (as is often maintained), but his second surviving statue of Urban VIII in the act of benediction. The interpretation is similar to that of the bronze, save for one important change; here the blessing gesture of the right hand is seconded by a gesture of the left hand. This double movement creates a strong diagonal, increases the expansive volume of the figure and, above all, turns into an impulsive and sudden action the solemn benediction of the earlier statue. The pope's attitude appears somewhat ambiguous, and this may be the reason why the double gesture found no following, and why Bernini himself abandoned it in the memorial statue of Alexander VII for the Cathedral at Siena which Raggi executed between 1661 and 1663 from his design (Fig. 100).

In the late tomb of Alexander VII (Plates 122–6) Bernini turned away from the balance between ceremonial and sepulchral monument struck in Urban's tomb, and stressed the concept of the impermanence of human life. Alexander is shown kneeling, bare-headed, looking straight ahead with hands folded in prayer; the almost hieratic frontality gives him an appearance of serene aloofness: he seems to be praying for the whole of Christianity. Since the monument was placed above a door, Bernini refrained from showing a sarcophagus and used the door as if it were the entrance to the burial chamber. From it seems to emerge a huge skeleton, ghostly and almost grotesque, lifting without effort the enormous jasper shroud and raising towards the pope the hour-glass which has run out. The change from the tomb of Urban is significant: there Death had taken on the role of Fame inscribing the name of the deceased in the Book of Eternity; here Death appears as *memento mori*, but he holds no terror for the pope, who remains un-perturbed in his orisons.

The idea of surrounding the pedestal on which Alexander kneels with four allegorical figures, two in front and two behind, is borrowed from free-standing tombs. Now free-standing tombs crowned by the figure of the deceased in devotional attitude had a tradition in France and Spain, but in Italy occurred only in Naples. It is, therefore, not improbable that the aged Bernini revived here memories from his early Neapolitan days. But an entirely new device—anticipated in some of Bernini's smaller tombs (Plate 68, Figs. 54, 55)—was the enormous shroud, a funeral emblem, appropriate for a sepulchral monument. Characteristically, this heavy drapery also has an important artistic function. An event which occurred in Paris in 1665 may help to clarify this. When the bust of Louis XIV was finished, Bernini placed it in the centre of a table and arranged a velvet cloth around it. He tried in this way, the Sieur de Chantelou informs us, to increase the effect of the bust. Clearly, this momentary impulse corresponded to a tendency of his late style. The drapery creates a zone which isolates the work of art from the banality of the outside world, yet, at the same time, helps to wed it to its surroundings. In another late work, the Lodovica Albertoni, Bernini made use of a coloured marble drapery (Plate 120) which again has the dual purpose of barrier and link. More complex is the case of Alexander's tomb, for the allegories, who are enveloped in the jasper shroud feigning real material, appear to belong to the human sphere, while the papal statue on its severe architectural base high above the casually arranged drapery has been far removed from the world of the beholder. It is the drapery motif that turns into a poignant visual experience the distinction between the unapproachable figure of the pope and the 'human' allegories. How erroneous are the 'impressionist' interpreters of the Baroque who regard this drapery merely as a painterly or picturesque device! It was, in actual fact, another means by which Bernini achieved a differentiation of realities as telling as that in the monument of Urban VIII.

Bernini had first given shape to certain ideas of Alexander's tomb in one of the most interesting of Baroque tombs—that of Cardinal Pimentel in S. Maria sopra Minerva (1653, Fig. 76), executed by pupils from the master's design. The Cardinal is kneeling on the sarcophagus in deep concentration and underneath, on the pedestal, are grouped four allegories. The free-standing type of tomb was here placed relief-like against a wall. A niche was not possible, and since Bernini dispensed with an architectural framework, using only a simple coloured background, the beholder's imagination is stimulated to re-translate this wall-tomb into a free-standing monument; but this is possible ideally rather than in reality, for it stands in a narrow passage where there is not sufficient distance to allow the illusion to work. A free-standing tomb transformed into a wall-tomb, arranged in such a way that the illusion of three-dimensionality is suggested but not effected—this complicated play with appearance and reality could have no sequel.

To return to the Vatican, another late work, the Constantine, requires some comment (Plates 110, 112, 114 and 115). With the Constantine Bernini established firmly a type of Baroque equestrian monument which remained in vogue until Falconet's 'Peter the Great' in Leningrad. There existed two traditional types of equestrian statues, one with the trotting horse, deriving

from the Marcus Aurelius on the Capitol, revived by Donatello in his Gattamelata and widely used by Giovanni Bologna and his school; the other with the rearing horse—also having a classical pedigree—which Leonardo had used in his designs for the Sforza monument and which, mainly owing to Rubens and Velasquez, was accepted in the Baroque state portrait of princes and sovereigns. It was Pietro Tacca who, with his Philip IV at Madrid, introduced it into Baroque sculpture. Bernini gave the type a heroic quality and invested it with drama and dynamic movement not only in his Constantine but also in the ill-starred monument of Louis XIV which stands now, transformed into a Marcus Curtius, near the solitary 'Bassin des Suisses' in the Gardens of Versailles (Plate 111). As one would expect, the rearing of Constantine's horse was conditioned by that psychological approach which Bernini brought to bear on all his works since his early youth. Constantine is overcome with amazement by the apparition of the golden cross high up in the air, and the magic effect of the heavenly sign is such that even the horse is almost thunder-struck; but in contrast to the mute belief expressed in the Emperor's face, the brute responds by neighing wildly and rearing up on his hind legs. The monument is placed in front of an enormous wind-swept drapery, and this device enhances the beholder's belief in the sudden interruption of the rider's progress and makes his fascinated recoiling and the reactions registered simultaneously by the animal an extraordinarily convincing experience.

Bernini soon afterwards adapted the formula of the Constantine to the equestrian monument commissioned by Louis XIV. But he changed the concept to suit the different purpose: the king was to appear on top of a high rock, a second Hercules who has reached the summit of the steep mountain of Virtue (Plates 111, 113, Figs. 110–112). When the monument reached Paris, five years after Bernini's death, few were aware of its meaning and none was prepared to accept its impassioned Full Baroque language.

The Cornaro Chapel, other Chapels, Churches, and the Baroque Stage

Although the extent and variety of his work in St. Peter's provide an unequalled impression of Bernini's genius, nevertheless it cannot be said that he was given there an opportunity of expressing his ultimate intentions as an artist. We have seen that right from the beginning of his career Bernini endeavoured to eliminate the barrier between the work of art and the beholder. But to draw the latter entirely into the sphere of the work, to release him from the bondage of his normal existence, to replace reality by a different, dream-like reality—that transformation could not be fully realized unless he had an opportunity of carrying out, not only a part within an existing structure, but a whole, consisting of architecture, sculpture, decoration and painting. This opportunity came when he was commissioned with a few chapels, particularly that of the Cornaro family in S. Maria della Vittoria, and with the building of three small churches.

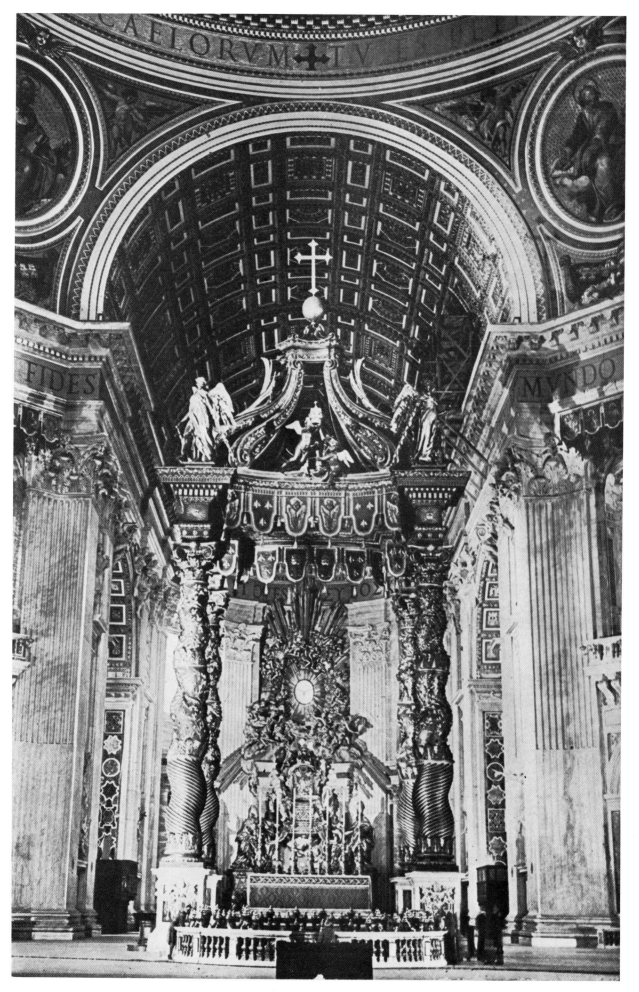

IV. THE BALDACCHINO, ST. PETER'S

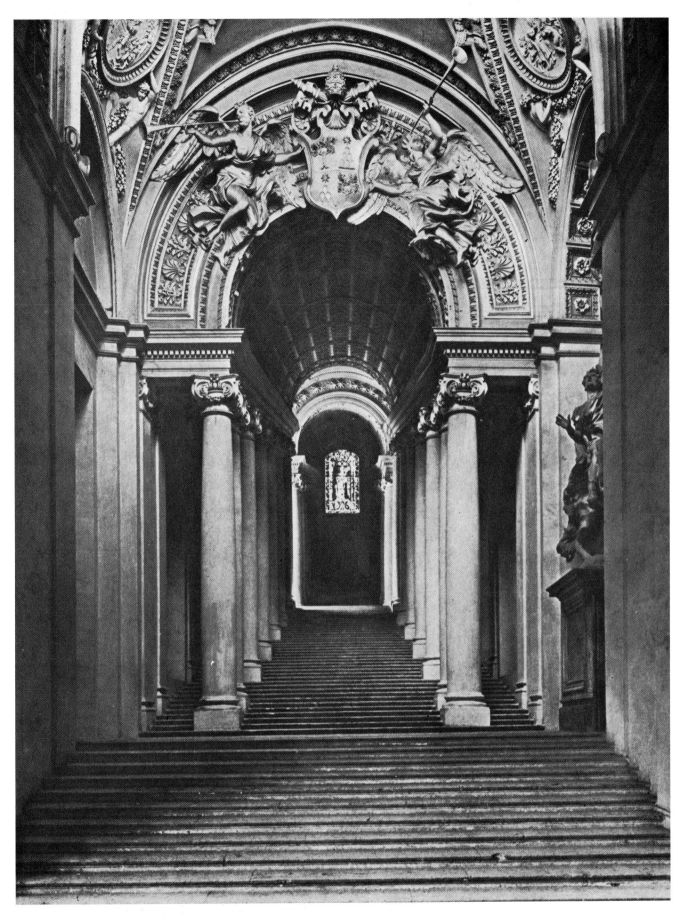

V. THE SCALA REGIA, VATICAN PALACE

The Cappella Cornaro, which cannot be photographed in its entirety, is an indivisible unit from floor to ceiling (Fig. VI, Plates 71–5). On its vaulting the painted sky opens; angels have pushed aside the clouds, so that the heavenly light issuing from the Holy Dove can reach the zone in which the mortals live. Rays of this heavenly light fall on to the group of St. Teresa, and with the light has descended the seraph whose companions appear in the clouds. In the sculptured group Bernini represented the most important—the canonical—vision of the Carmelite Saint corresponding exactly with her own account of it. She described how the angel pierced her heart repeatedly with a flaming golden arrow, whereupon, she continued, 'the pain was so great that I screamed aloud; but simultaneously I felt such infinite sweetness that I wished the pain to last eternally. It was not bodily, but physical pain, although it affected to a certain extent also the body. It was sweetest caressing of the soul by God.' With consummate skill Bernini made this scene real and visionary at the same time. The seraph, a figure of heavenly beauty, is about to pierce the heart of the Saint with the fiery arrow of love and thus effect her mystical union with Christ, the heavenly bridegroom. The Saint is swooning in an ecstatic trance, her limbs hang inert and numb, her head has sunk back, her eyes are half closed and the mouth opens in an almost audible moan. The vision takes place in an imaginary realm on a large cloud magically suspended in mid-air. Sheltered by the large canopy of greenish, grey-blue and reddish marble and placed against an iridescent alabaster background, the group is bathed in a warm and mysterious light, falling from above through a window of yellow glass hidden behind the pediment and playing on the highly polished marble surface of the two figures.

Along the side walls of the chapel, above the doors, eight members of the Cornaro family appear behind prie-dieus which have often been compared with theatre boxes. The portraits stand out almost three-dimensionally before a coloured and gilt stucco perspective in flat relief representing the interior of a church. Since the two sides are made to look like parts of the same interior, the fictitious architecture and the architecture of the real chapel seem to interpenetrate. This creates the illusion that the Cornaro family is sitting in an extension of the space in which we move. When standing on the central axis opposite the group of St. Teresa, it becomes apparent that the chapel is too shallow for the members of the Cornaro family to see the miracle on the altar. For that reason Bernini has shown them arguing, reading and pondering, certainly about what they know is happening on the altar, but which is hidden from their eyes. Under the pavement of the chapel is the family tomb chamber, and on the cover of the vault two inlaid skeletons seem to express their surprise at the miracle with lively gesticulation. Thus not only the ceiling and the walls but even the pavement forms part of a grand dynamic unit. (Figs. 66–7).

The analysis has shown that the men behind their prie-dieus and the vision of the Saint are meant to belong to different realities. We, the visitors to the chapel, are invited to look upon the members of the Cornaro family as being alive like ourselves. The distance between us and Teresa's vision is due to the imaginary space in which the group is set, the magic light falling upon it and its picture-like isolation under the framing aedicula. Much less tangible than this scene is the unfathomable infinity of the empyrean crowded with illusionistically foreshortened

angels. It is the suggestive characterization, within one integrated whole, of the different realms of Man, Saint, and Godhead that substantiates belief in the existence of this mystic hierarchy of things. Like the Cornaro family, the worshipper participates in the supra-human mystery shown on the altar, and if he yields entirely to the ingenious and elaborate directives given by the artist, he will step beyond the narrow limits of his own existence and be entranced with the causality of an enchanted world.

The Cornaro Chapel far surpasses the other chapels with which Bernini's name is connected, despite its lack of spatial depth. None of them has the same irresistible appeal: neither the earlier Raimondi Chapel in S. Pietro in Montorio with Francesco Baratta's somewhat feeble and sentimental relief of the ecstasy of St. Francis, the first example of a vision magically lit by concealed light (Figs. 59–61); nor the architecturally similar, small and unpretentious Cappella Pio in S. Agostino (after 1643); nor the tiny memorial chapel of the de Silva family in S. Isidoro with the oppressively large allegories supporting relief panels with half-figures of the deceased (Figs. 101, 102); nor, finally, the Fonseca Chapel in S. Lorenzo in Lucina, the design of which is certainly due to Bernini himself (Fig. 113). Like the Cornaro Chapel all these are sepulchrall chapels with realistic memorial portraits on both walls. But only the bust of the physician Gabriele Fonseca is by Bernini's hand—a superb work of his latest, fervently religious and mystical style (Plates 116–18). Fonseca is leaning out of a niche in an intensely devotional attitude, one nervous hand firmly pressed against his body while the other clasps the rosary in a grip as desperately hopeful as that of a drowning person holding on to a life-saving raft. The patches of dark shadow and flickering light produced by the deep folds of the gown give further support to the spiritual agitation, and the almost colouristic differentiation of skin, beard and fur heightens the impression of pulsating life. Fonseca turns towards the altar above which appears the 'Annunciation' carried by angels. It is this mystery that has called forth his devotion and spiritual surrender. An intangible bond between himself and the altar bridges the space in which the beholder moves, and since Fonseca is so realistically rendered that he evokes the sensation of being alive, he remains for ever the protagonist of those who worship in the chapel; the intensity of their prayers is prompted by his example. The aim here is similar to that of the Cornaro Chapel.

The idea of showing the bust of the dead turning in prayer to the altar was not Bernini's. In fact, a relation between the deceased, represented alive in an attitude of devotion, and the altar occurs as early as the fifteenth century, and the type remained current in Spain, France, Germany and the Low Countries. However, with the exception of Spanish Naples it was rare in Italy, and it was not until well into the sixteenth century that the bust with praying hands looking towards the altar began to appear in Rome. Bernini himself first took up the type in his early bust of Cardinal Bellarmine (Plate 31). In the original setting near the high altar of the Gesù the face was turned towards the church and the hands in the opposite direction, suggesting a link between the congregation and the altar. But these relationships are only just indicated, and a comparison between the Bellarmine and the Fonseca illustrates most vividly Bernini's development in the

course of fifty years. The Fonseca bust is by far the most intense realization of a religious concept to which numberless Roman sculptors between 1630 and 1680 contributed. Of course, the visitor knows that such busts and statues looking down from the walls commemorate people who are dead. But since all the means of realistic characterization have been employed to make them look as if they were eternally alive, the worshipper joining them in their prayers inadvertently effaces the most rigorous boundary of all, the one that separates life from death.

The principles discussed at some length in the case of the Cornaro Chapel apply also *mutatis mutandis* to Bernini's churches, erected from 1658 onwards. As befits their rural surroundings, those at Castel Gandolfo and Ariccia are simple, almost austere, and only S. Andrea al Quirinale in Rome is exuberantly decorated. But in all three churches Bernini interpreted his task in similar terms: the architecture is no more and no less than the setting for the mystery revealed to the faithful by sculptural decoration. The church at Castel Gandolfo (Figs. 92, 93) is dedicated to St. Thomas of Villanova and eight medallions with reliefs, depicting events from the saint's life, seem to hover in the wide expanse of the dome. The church at Ariccia (Figs. 94, 95) is dedicated to the Virgin, and jubilant putti and angels under the 'dome of heaven' prepare to receive her on her Assumption. They are in a zone separated from the worshipper, for they are superior beings; and since they are treated with extreme realism, they conjure up real and breathing life. The entire church is submitted to, and dominated by, one particular event, and the whole interior has become its stage. In S. Andrea al Quirinale (Figs. VII, 96, 97, 98) all the lines of the architecture converge upon the ascending figure of St. Andrew. He forms part of a ring of figures which consists of putti carrying garlands, and nude fisherman who handle nets, oars, shells and reeds—symbolic companions of the fisherman Andrew. While praying in the oval space of the church, the congregation participates in the miracle of the Saint's salvation. In the carefully separated altar-recess, inaccessible to the laity, the mystery is consummated: here the beholder sees like an apparition the band of angelic messengers bathed in visionary golden light bearing aloft the picture of the martyred Saint—assured of his heavenly reward for faith unbroken by suffering.

It is customary to interpret Bernini's art and that of the Baroque in general in terms of the Baroque theatre. To be sure, Bernini used effects first developed for the stage in works of a permanent character and in religious settings; the concealed light in the Cornaro Chapel or the carefully directed light in his churches may be recalled. What is, however, generally meant by referring in this context to the theatre is not that experience gained in the one field was usefully applied to the other—a procedure well known to students of the Middle Ages and the Renaissance—but that, through borrowing from the theatre, religious art itself became 'theatrical'; that, in short, the Baroque enthusiasm for the theatre infected even religious art. This conclusion is entirely fallacious; it was arrived at when people mistook emphatic gestures and emotional expression for the declamatory and oratorical requisites of the stage. It denies to the Roman Full Baroque, in fact, precisely those qualities of deep and sincere religious feeling which are its most characteristic aspect. The connection across space between praying figures

and the altar had, as has been shown, a specific, intensely religious meaning, and even the counterfeiting of prie-dieus had originally nothing in common with theatre boxes. There is, however, on a different level an important connection between the theatre and the art of the Baroque age. In the theatre we live in a fictitious reality, and the stronger the illusion the more readily we are prepared to surrender to it. At this period the most powerful effects were used to eliminate the border line between fiction and reality. The fire which Bernini arranged on the stage during the performance of one of his comedies and which provoked a stampede of the audience is a well-known example. Similarly, in the Cornaro Chapel, in his churches, and many other works, Bernini created a supra-real world in which the transitions seem obliterated between real and imaginary space, past and present, phenomenal and actual existence, life and death. In both cases an emotionally stirring and often overwhelming chain of 'true' impressions induced the beholder to forget his everyday existence and to participate in the pictorial reality before his eyes. This urge to use all the means of illusion in the theatre as well as in religious imagery, to try and transport the individual into another reality, seems ultimately connected with the polarity between self-reliance and authority, reason and faith, which afflicted western man seriously for the first time in the seventeenth century: it was the road of escape for those who began to doubt.

Fountains and Monuments

During the late sixteenth century, fountains began to play an important part in Rome's urban development. But it was Bernini's creations in this field—a hundred times followed or imitated—that were instrumental in transforming Rome into the great city of fountains. In contrast to Rome, Florence had a long tradition of fountains with figures, and it was this tradition that Bernini took up and revolutionized. In spite of essential changes, his early Neptune and Triton group for the Villa Montalto (Plate 11) is evidence of the link with Florentine fountains, such as Stoldo Lorenzi's Neptune in the Boboli gardens. But with his Triton fountain in the Piazza Barberini (Plates 59, 60), designed two decades later, Bernini broke entirely with the older formal tradition. Not only is the characteristically Roman massiveness of this work far removed from the decorative elegance of Florentine fountains, but the beholder is confronted with a sculptural entity, unknown before, as integral as a natural growth: this might be one of nature's own creations. Dolphins, shell and Triton have emerged from their common element and, in turn, are united by the water, which is no longer restricted to thin artificial jets; on the contrary, it follows natural laws, is blown high by the Triton, falls back and dribbles over the wavy brim of the shell into the basin below. The broken sound of the tinkling and gushing element forms an essential part of the conception. Bernini's fountains have often been called naturalistic; but this is far from the whole truth, for the idea of combining sea-god, shell and fish into an organic

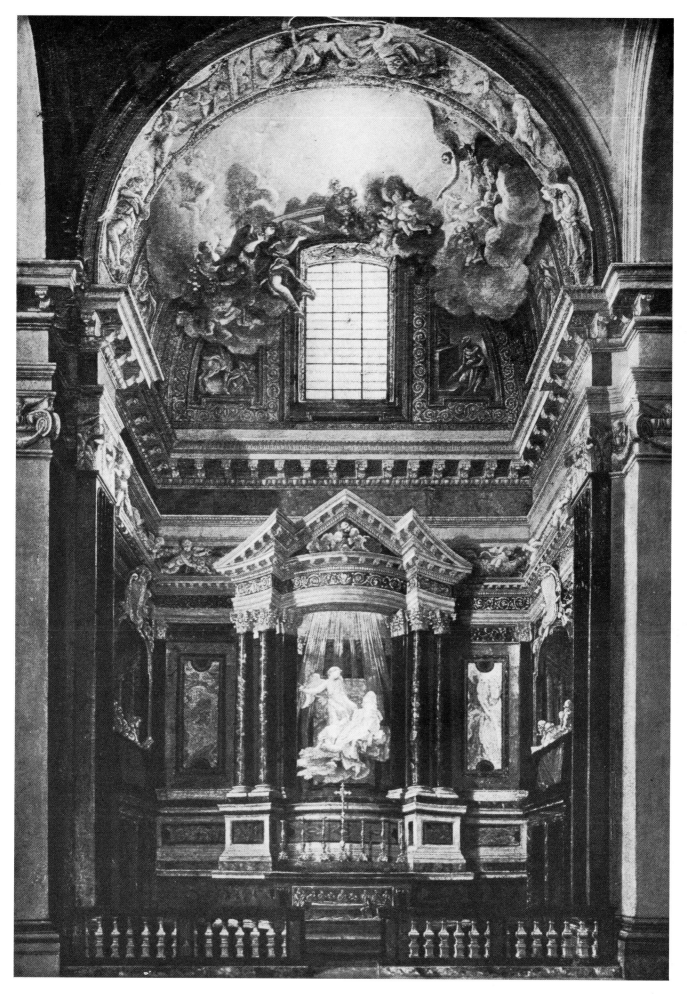

VI. THE CORNARO CHAPEL, S. MARIA DELLA VITTORIA. Eighteenth-century painting. Museum, Schwerin

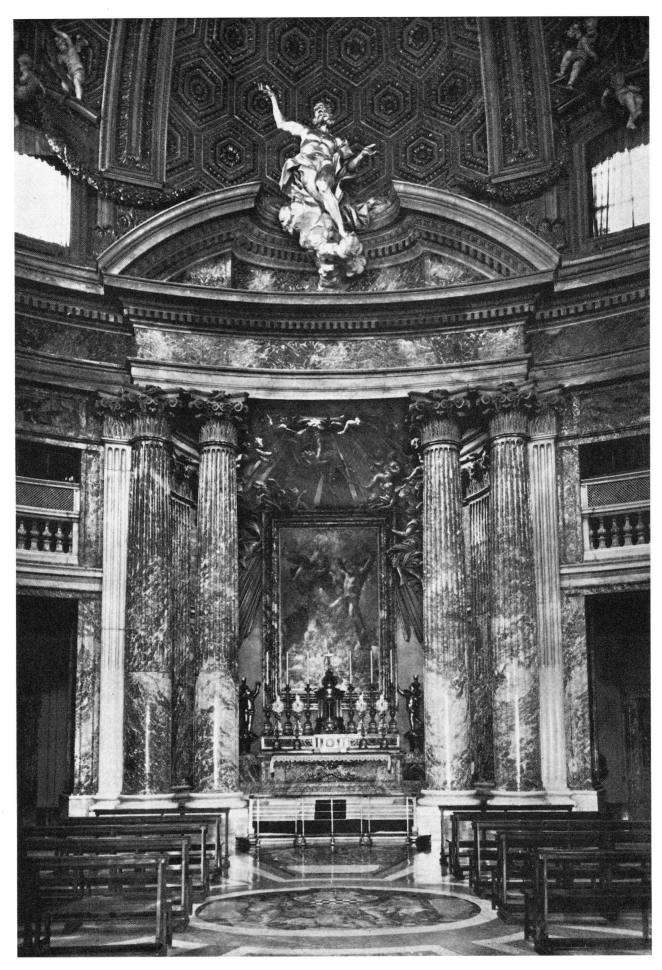

VII. S. ANDREA AL QUIRINALE

whole is truly poetical, and nobody can fail to be captivated by the fairy-tale atmosphere of such a creation.

Mention has not yet been made of the papal insignia and the cartouche with the Barberini coat of arms, which form a bulging mass inextricably entwined in the dolphins' tails. The fountain is therefore not simply an aquatic monument, but also a personal memorial. Failing explanatory inscriptions, the meaning on this level cannot be 'deciphered' with any degree of certainty. The Barberini bees were regarded as symbols of Divine Providence (Tetius) and it has been suggested that the dolphins encompassing them may be understood as emblems of princely benefaction and the Triton as propagator of Urban's glory and fame. The *concetto*, the literary meaning and poignant allusion, must not be regarded as sophisticated embellishment added to or superimposed *post festum*; it belongs intrinsically to the monument and up to a point determines the invention. In the decorations of the Balconies (Fig. 35) and the Baldacchino (Plate 48) Bernini used, in conjunction with the Barberini sun, bees, dolphins and shells as 'pure' emblems, and this indicates that there was no intellectual cleavage between religious works and a worldly fountain.

The 'Fontana del Tritone' was not Bernini's earliest fountain expressing an emblematical conceit. It was preceded by the destroyed fountains in the garden of the Villa Mattei and by the Barcaccia in the Piazza di Spagna (1627–9, Fig. 121). The design of the latter was due to Gian Lorenzo rather than to his father to whom it has often been attributed in recent years. It has the form of a ship with apparently a bow at each end, on which the papal coat of arms are proudly displayed. One can hardly doubt that Bernini is here alluding to the Ship of the Church sailing the seas under the banner of the Barberini pope. This time-honoured concept was before everyone's mind in those years, for in 1623 Matthaeus Greuter had published an engraving of Papirio Bartoli's abstruse scheme for placing a mystical Ship of the Church above the tomb of the Apostle in St. Peter's. A recent thorough analysis has shown that Bernini's ship fountain is infinitely suggestive: the water-spouting, poetically transformed man-o'-war seems to embody a reference to the Barberini Pope's counter-reformatory prowess.

The Triton fountain had a sequel about ten years later in the 'Fontana del Moro' in Piazza Navona (Plate 88, Figs. 74, 75). Bernini used the same constituent elements: maritime divinity, shell and dolphin; but all recollection of symmetry and of the architectural principle of support and weight, manifest in the Triton fountain, have disappeared. Everything is now in dramatic motion: the wriggling dolphin, firmly held by the 'Moro', tries to regain his proper element, the water; we witness a contest between the god and his prey; the curved part of the irregularly shaped shell rests precariously on the ground, the next step of the swiftly striding 'Moro' will turn it over. All this creates the impression that a unique, never-recurring moment in the 'life-story' of the sea-god has been caught, reminiscent of the transitory climax which, a generation before, Bernini had represented in the statues made for Scipione Borghese. In fact, the motif of the 'Moro' had been anticipated in the Borghese David (Plate 13), while the idea of the fountain points back via Bernini's own 'Neptune and Triton' to the sixteenth-century fountains with

Neptune and spouting dolphin by Ammannati, Giovanni Bologna and his school, where, however, the dolphin was always a maritime attribute rather than an intensely vivid co-actor.

In the centre of the Piazza Navona stands the 'Fountain of the Four Rivers', Bernini's largest and most celebrated work in this field, executed between 1648 and 1651 (Plates 78–82, Fig. VIII). The town-planning aspect of his task was extremely complicated. He had to erect a monument sufficiently large to emphasize effectively the centre of the long square without disturbing its unity; at the same time the fountain—not axially related to the façade of S. Agnese—had to be attuned to the Baroque church then only planned but not yet erected. A 'natural' rock, washed by ample springs, pierced by openings in the long and short axes and crowned by the huge Egyptian needle: barrier and link, accompaniment to the towers and contrast; expansive and varied near the ground and soaring upwards hard, uniform and thin; fountain and monument; improvisation and symbol of super-human permanency—these seeming contradictions point to the ingenious answer Bernini found for his problems.

To erect the obelisk on a plinth above a cavity is a device that startles the spectator in more than one respect. Doubt is naturally raised in the stability of the support; but the design of the plinth, which seems cut in two by an inserted transverse block (carrying the inscriptions), suggests a negligible weight above it. Although we know that the obelisk is heavy, we are made to believe that it is not; the technical problem was great: we are made to believe that it did not exist. Thus here again, as so often before, Bernini tried to blur the dividing line between appearance and reality.

Four giant marble figures are grouped around the rock, from which water gushes in every direction; they are personifications of the Danube, Nile, Ganges and Plate rivers, an old iconographical device to symbolize the four parts of the world. Characterized by appropriate animals and plants, two Rivers form a pair seen from every one of the four directions, while the Danube (i.e. Europe) and Nile support the papal coat of arms (with lilies and dove), fixed to the rock above the cave. The dove, emblem of Innocent X's family and, at the same time, of the Holy Ghost, also crowns the obelisk, traditional symbol of divine light and eternity. The whole work thus glorifies the all-embracing power of the Church under the leadership of the reigning Pamphili Pope. Like the obelisks erected in Rome during the pontificate of Sixtus V, this monument is at the same time a symbol of the triumph of the Church over paganism. Other more subtle connotations are perhaps implied. It has been pointed out that the formal arrangement of the fountain and its iconography point back to a medieval ancestry, namely to representations of the Rivers of Paradise at the foot of the mountain on which the Cross stands. Bernini's fountain may, therefore, also adumbrate the idea of the salvation of mankind under the sign of the Cross.

Never before had rock and water been combined in a spectacle of such grandeur. Rustic fountains forming grottoes or attached to walls or shaped like 'islands' were, of course, in vogue in the era of Mannerism; but they were always relegated to the garden, and their stucco stalactites and thin jets of water imitating nature, a nature artificially drained of the 'natural', have

nothing in common with Bernini's exuberant and powerful harnessing of the elements. The continuous movement of the rushing and murmuring water helped to fulfil one of Bernini's most cherished dreams: to create in his works the impression of pulsating life and real movement. It is therefore not by chance that in spite of their comparatively small number fountains occupy a prominent place in his work, and that it was in the Four Rivers Fountain that he was stimulated to one of his most ingenious and daring creations.

A monument that should by rights be mentioned in connection with the fountains is the Elephant carrying the Obelisk, executed from Bernini's design for Pope Alexander VII and unveiled in 1667 (Plate 102, Fig. VII). The ideas for the monument ran through many and diverse phases of which drawings survive. The Pope was keenly interested in Colonna's *Hypnerotomachia Poliphili* (1499) which contains a woodcut of an 'elephant and obelisk', and it was probably due to Alexander's own initiative that Bernini revived this venerable symbol which he himself had planned more than a generation before as a monument (never executed) for the garden of the Barberini palace (Fig. 105). As in the case of the Four Rivers Fountain, Bernini's particular problem lay in the attempt to create a synthesis of seemingly irreconcilable elements. To be sure, the contrast between the superb realistic elephant, rendered not without wit, and the polished monolith, the acme of lifeless precision, gives the monument its matchless pungency.

There are also close analogies of meaning between the fountains in the Piazza Navona and the Piazza Barberini and this monument. For it too must be understood as a glorification of the reigning Pope Alexander, expressed in emblematical language. A contemporary poem clothed its message in the following words: 'The Egyptian obelisk, symbol of the rays of *Sol*, is brought by the elephant to the Seventh Alexander as a gift. Is not the animal wise? Wisdom hath given to the World *solely* thee, O Seventh Alexander, consequently thou hast the gifts of *Sol*.'

Although differing in significant details of meaning, the three works, the Triton Fountain, the Four Rivers Fountain and the Elephant have this much in common—that they are personal monuments, each erected to honour one of the great popes, Urban VIII, Innocent X and Alexander VII, whose reigns span the most important forty-four years of Bernini's life and career. The emblematical implications accumulate from one monument to the next and become increasingly overt. The role of the inscriptions is indicative: the Triton fountain has none; in the overall picture of the Four Rivers Fountain they are quite insignificant; but in the Elephant monument the inscriptions, pregnant with involved conceits, are prominently displayed on the pedestal and form an integral and important part of the composition. It is a sign of Bernini's greatness that the full use of this language—nowadays so little understood—neither marred the freshness and vigour of his imagery nor forced him to follow over-trodden paths. The repertory of conventional symbols was infinite and admitted an infinite variety of realizations.

Bernini and his Period—The Organization of the Studio— Theory and Practice

Bernini's early revolutionary works arose like the phoenix from the ashes of a rather sterile period for sculpture. Representative of the state of sculpture in Rome in the early years of Paul V's reign is the decoration of the Pope's Chapel in S. Maria Maggiore, where a veneer of colourful splendour scarcely hides a vulgarity of taste, rare in the annals of Roman art. Uninfluenced by the stirring events in contemporary painting, artists such as Niccolò Cordier, Valsoldo, Ambrogio Bonvicino and Ippolito Buzio, nowadays almost forgotten even by specialists, produced here their dreary figures and reliefs. This depressing state of affairs was relieved only by one sculptor of real calibre, Francesco Mochi, nineteen years older than Bernini, who must be regarded as a forerunner; but after having for a time surrendered to the manner of the rising star, he ended his days in considerable moroseness as a stylistically retrogressive artist. Already with his early works, Bernini had reversed the existing pre-eminence of painting over sculpture. Sculpture now took the lead and for the next fifty years it maintained its supremacy. Taking a bird's-eye view of events, we see Bernini surprising the world with ever new, unexpected and immensely fertile ideas, while painters often refurbished the old fare.

During a short period in the mid and late 1630's he made concessions to a prevailing taste for classicism which, amongst the sculptors, was to be found in the works of Algardi and Duquesnoy, next to Bernini the only two masters who had at that time independent studios of importance in Rome. The tomb of Countess Matilda (Plate 62, Fig. 38) and the relief of the 'Pasce Oves Meas' (Plate 63, Fig. 41) most clearly represent this phase in Bernini's development. No other figures in his œuvre are as traditional as the Countess and the Christ of the relief, whose conventional contrappostal attitudes and sober arrangement of drapery are strikingly similar. A classicizing spirit may also be noticed in the Medusa (Plate 65), in some of the portrait busts (Plates 66, 67, Figs. 44, 45) and, above all, in the Raimondi Chapel, with its unrelieved whiteness (Figs. 59–61). Moreover, to this period belong some of the least satisfactory works of his life such as the Memorial Inscription for Urban VIII in S. Maria in Araceli (Fig. 52) and the Memorial Statue of the Pope (Plate 69), to a certain extent a rehash of the statue from the tomb (Plate 51). But no formula will do justice to Bernini's genius: at this time he also created the bust of Costanza Buonarelli, his most unconventional, most direct and least stylized work (Plate 61).

Owing to his temporary fall from papal favour, Bernini's productivity was severely curtailed during the 1640's. But it was just in these years, following his somewhat frustrating classical recession, that the pendulum swung vigorously to the other side, and he left current stylistic trends far behind. It was then that his art, vital with new ideas, arose to its full splendour: witness the Cornaro Chapel, Truth Unveiled, the Four Rivers Fountain and, opening the next

decade, the bust of Francis I of Este. In Truth Unveiled (Plates 76, 77), a fragment of a larger group, he first gave expression to his new conception of womanhood. Studied side by side with the figure of Proserpina (Plate 12), it will be seen with what determination he turned his back on the classical ideal of beauty. It was in the figure of Truth, too, that for the first time the drapery lost all semblance of real material. By comparison even the garment of the Longinus (Plate 41) appears to be linked with the conventional treatment of draperies. The Truth opened the way for his later rendering of the human body, for the Mary Magdalen (Plate 89) and the Angels with the Instruments of the Passion (Plates 103–9) as well as for the almost abstract patterning of draperies in his late works.

At the beginning of this creative period of the forties he brought a completely new approach to the problem of funeral monuments when he designed the Valtrini and Merenda memorials (Figs. 54, 55), both executed by studio hands, and the tomb of Maria Raggi (Plates 68, 70), a work of the highest quality. In all three monuments he rejected the traditional isolating architectural frame-work; and in the Valtrini and Raggi tombs a relief-portrait of the deceased is carried by Death and by putti respectively. These tombs, therefore, contain the suggestion of two different degrees of reality, that of the 'real' skeleton and the 'real' putti and that of the 'image' of the departed. Herein is rationally and realistically expressed the idea of a commemorative monument. It was three generations later, in the age of enlightenment, that this type finally supplanted that with the deceased in an attitude of devotion.

To these years also belongs Bernini's first fully developed attempt in the Cornaro Chapel to harness all the arts to the production of one overpowering effect. In the words of Bernini's biographer, Filippo Baldinucci, it was 'common knowledge that he was the first who undertook to unite architecture, sculpture and painting in such a way that they together make a beautiful whole'. This was an idea of immeasurable consequence; it was not only immediately taken up by other artists in Rome and later all over Italy, but on it depended also the whole development of Baroque art north of the Alps.

Since a work such as the Cornaro Chapel was conceived in terms of an enormous picture—and for the image on the retina it makes no difference whether architecture and sculpture are painted or real—Bernini had also to think about light in pictorial terms. Divine revelation had always been associated with light. To use rays of light as signs of spiritual enlightenment was, therefore, an old practice of painters, which acquired heightened importance in the age of the Baroque. If a way could be found to replace painted by real light and achieve in the ambient air of a chapel or church what the painter achieves in his pictures, the impact on the beholder would be enormously intensified. Bernini solved this problem first in the Raimondi Chapel (Fig. 59). Standing in the dim light of the chapel, the spectator looks into the bright light of the altar-recess where the miracle takes place. From then on Bernini always tried to use directed and often concealed light to give potency to his depiction of vision and miracle. The Cornaro Chapel and the Cathedra Petri are cases in point. He later adapted the Raimondi Chapel arrangement to the conditions of the Constantine (Plate 110) and of the Blessed Lodovica Albertoni (Plate

120) and, on a much larger scale, to the Church of S. Andrea al Quirinale (Figs. VII, 97). While this was a way of bringing home to the faithful an intensified experience of the supra-natural, it also strengthened the pictorial quality of these works: they have something of the immobility of objects in pictures despite all their vigorous movement; they seem strange, visionary, unapproachable, like apparitions from another world. It is remarkable that Bernini's intentions had never been observed by modern critics and that they were revealed for the first time in the photographs here published (Plates 110, 120, etc.).

The last phase of Bernini's development begins between 1660 and 1665, when, together with the spiritualization of expression, bodies are lengthened, extremities made very slender and draperies given a highly personal and inimitably intense inner life, as it were, of their own. The transition from what might be called the middle period to the late style may be followed in the seemingly small changes between the first and second models of the Cathedra angels (Fig. 88, Plate 94).

A study of the organization of Bernini's studio from the beginning of his career will help to understand the reaction of other sculptors to his late and latest styles. His first assistant was Giuliano Finelli, who stayed with him for some years from 1622 onwards. In 1624, with the commission for the Baldacchino, the studio became at once the most extensive in Rome and comprised every available sculptor of ability. Of those who worked for him, Andrea Bolgi and Stefano Speranza stayed on for a number of years. Already during the work on the Baldacchino Bernini gave proof of an ability to organize and supervise the activities of a large studio, equalled only by his great Northern counterpart, Rubens. While his personal contribution to the execution of works like the Baldacchino or the tomb of Urban VIII was considerable, later he sometimes hardly touched a tool himself. A prominent example is the very late tomb of Alexander VII, which yet presents in itself an unbroken stylistic unity, in spite of the almost modern division of labour. Stylistic integration depended not so much on Bernini handling the hammer and chisel himself, as on the degree of his preparatory work and the subsequent control exercised by his master mind. When the control slackened, dissonant elements crept in. A provincial commission like that for the St. Barbara in Rieti Cathedral, executed by Giovan Antonio Mari, illustrates the point (Fig. 87). In this case his interest in the execution is still noticeable, while a work such as the Visitation in S. Maria della Misericordia near Savona (Fig. 104) seems not only to have been 'hired out', but even shows few of his studio hallmarks.

From the late 1640's onwards younger sculptors like Ercole Ferrata, Lazzaro Morelli, Giovan Antonio Mari, Pietro Paolo Naldini, Antonio Raggi and others make their appearance in the studio. And later they are joined by still younger men, amongst whom Girolamo Lucenti, Michele Maglia, Giulio Cartari, Filippo Carcani and Giuseppe Mazzuoli may be mentioned. Few of them were his permanent assistants. Some, like Ferrata and Raggi, had flourishing studios of their own and were pressed into Bernini's service as occasion required; after the specific task was completed, they went their own way. In fact, from about 1650 on, and even earlier, there was hardly a sculptor in Rome who would not have experienced, at least for a time, the direct

influence of Bernini's overwhelming personality—with the result that he would work in the master's style (in the broadest sense) for the rest of his life. After Algardi's death in 1654 there was nobody to challenge his position. The centralization of much of Rome's artistic life in Bernini's hands was due to his genius; it was not set up by legislation as in Colbert's Paris. Year by year artists went to Rome, particularly from the North of Italy, hoping to get a share in the many commissions the centre of Christendom had to offer. Yet more often than not they were disappointed, and sculptors were lucky if they found a corner for themselves in Bernini's vast organization or in one of the studios more or less dependent on him. And when they returned home, they spread the new gospel. Thus it was by direct transmission that the style was disseminated throughout Italy and beyond her frontiers. This expansion gathered momentum after the middle of the century. But a process well known in the history of art repeated itself: what these artists acquired was as a rule the letter of his style and not its spirit. The depth, intensity and fervent devotional quality of his late manner escaped most of them. Like the aged Rembrandt, a giant among pygmies, he created these late works, at once highly personal and universally significant, in a world that no longer understood them.

Bernini had not a theoretical mind, but he was immensely alert, a clear thinker and profuse talker; he held firm convictions, without some knowledge of which his art cannot be fully appreciated. He was steeped in the humanism current in Italy since Alberti's days. He firmly embraced the basic tenet that the artist should be learned, often reiterated by him in his talks and epitomized in his unreserved admiration for Poussin, because he 'worked with his brain'. Decorum, which Alberti and Leonardo had defined as the appropriateness of age, sex, type, expression, gesture and dress to the character of the figure represented, dictated his approach to the subject whether a mythological group, a saint like St. Bibiana or the portrait bust of the French king. He still shared the Renaissance belief in the inherent perfection of basic geometrical forms—circle, square, hexagon and octagon—and in the absolute beauty of human proportions, using the old argument that Adam's body was created in the image of God. As regards the enigmatic problem of beauty, he tended towards sublimation rather than close imitation of nature. This he clearly stated before the students of the French Academy in his famous address, of which it has unjustly been said that he advanced academic ideas in order to please his hosts. His principal points on this occasion, that ideal beauty was made manifest in classical art and that nature was never perfect, coincided with the classical doctrine. In company with most Italian artists since the fifteenth century he regarded the authority of ancient art as unchallengeable and, like the classicists, saw in Raphael the supreme modern artist. But for all these agreements, his views did not wholly coincide with academic theory.

For him the objective beauty of an ancient work was one thing, and the idea of the subject which he conceived in his mind was another. Deeply religious, he was firmly convinced that he was the tool of God, that his art came to him through the grace of God, and he regarded therefore a felicitous idea as divinely inspired. In contrast to this metaphysical, 'Baroque' approach, the classicists held that the synthesis arrived at in the work of art resulted from a selective,

soberly rational process. They accepted the principle of the continuously repeated legend of Zeuxis, who chose the most beautiful parts from a number of virgins for his painting of Helen— a procedure ridiculed by Bernini. Classical theory could be laid down in a series of hard and fast rules, and academies were the obvious institutions where these rules should be taught. For Bernini, on the other hand, the teacher was the servant of God. 'All that we know', he said, 'comes from God and teaching others means taking His place.' Good teaching, therefore, consisted in the informal handing on of accumulated knowledge. The best lessons in art, he declared, were to be taught by practical experience in the studio. The experience he had in mind consisted in the penetrating observation of nature and the correct assessment of the problems which arise when natural phenomena are rendered through the medium of sculpture. His observations were mainly concerned with the subjective impression of nature and may be summarized in his verdict that objects are seen not simply as what they really are, but that their appearance is conditioned by their surroundings. Such discernment he regarded as of decisive importance for the artist. Similarly subjective was his approach to actual practice. He constantly meditated upon how to compensate for the lack of colour and complexion when working in white marble. Thus he explained that 'in order to represent the bluish colour which people have round their eyes, the place where it is to be seen has to be hollowed out, so as to achieve the effect of this colour'. His insistence on giving in the studio craftsmanlike advice of this kind was instrumental in keeping a free, anti-academic spirit alive in his circle.

How, then, can his metaphysical belief in his calling and his subjective approach to nature and art be reconciled with the principles of the classical doctrine, which he professed to accept? The answer may be given by referring to his working process. More than one interpreter of his art has shown that in his work Bernini made ample use of classical models and, knowing his opinions, this is what one should expect. But nevertheless it must be stressed that there is a fundamental difference between his use of ancient models and that made by more orthodox classicists. While an artist like Poussin gradually adapted a first idea to objective classical standards in a rational process, Bernini's procedure was exactly the opposite. Nobody looking at his figure of Daniel (Plate 85) can possibly guess that Bernini's point of departure was the father from the Laocoon group. In this case, however, the development can be followed from the copy after that figure and through a number of preparatory drawings to the final realization in marble. While working from the life-model, Bernini had in the beginning the classical figure at the back of his mind, but was step by step carried farther away from its spirit. In accordance with his theoretical views, he began rationally and objectively, using a venerated antique work; not until his idea developed did he give way to imaginative and subjective impulses. Little evidence remains to show how he worked himself into that state of 'divine frenzy' in which he created in rapid succession numberless sketches and clay models, twenty-two in all in the case of the Longinus.

Early in his career the finished work often remained close to the antique model. We have seen that until fairly recently the Borghese Amalthea group (Plate 1) was believed to be a

VIII. PIAZZA NAVONA

IX. ELEPHANT AND OBELISK, PIAZZA S. MARIA SOPRA MINERVA

classical work; that the Apollo of the Apollo and Daphne group (Plate 26) does not depart far from the Belvedere Apollo; nor the David from the Borghese Warrior. Even the head of the Longinus (Plate 43) is obviously styled after a Hellenistic model, namely the Borghese Centaur, now in the Louvre. But as he advanced in age, Bernini transformed his classical models to an ever greater degree. In front of a late work such as the ecstatic Angel holding the Superscription (Plate 103) the conclusion seems unavoidable that he had ceased to use classical antiquity at all as a cathartic agent. And yet the body under the agitated folds of the drapery derives from the so-called Antinous in the Vatican, a figure that was studied with devotion in the classical circle of Algardi, Duquesnoy and Poussin; indeed, it was carefully measured by the two latter artists. Bellori, mouthpiece of the classicists, published it as the quintessence of perfection, and Bernini referred to it in his Paris address with the words: 'In my early youth I drew a great deal from classical figures; and when I was in difficulties with my first statue, I turned to the Antinous as to the oracle.' His reliance on this figure, even for the late Angel, is strikingly evident in a preparatory drawing showing the Angel in the nude (Fig. 107). But the proportions of the figure, like those of the finished marble, differ considerably from the classical model. Slim, with extremely long legs and a head small in comparison with the rest of the body, the nude recalls Gothic figures. The process of ecstatic spiritualization began during an early stage of the preparatory work.

It is impossible to divorce Bernini's views on art from his religious belief. This unity of art and life, work and personality, rational convictions and devout self-surrender finds expression in the exalted vitality of his performance. It is worth recalling that he went to Mass each morning and among other devotions recited the Little Office and for forty years walked every evening to the Gesù, where he spent some time in prayer. In later years, the General of the Jesuits, Padre Giovan Paolo Oliva, was one of his closest friends, with whom he used to converse on spiritual matters; amongst his favourite books was *The Imitation of Christ* by the late medieval mystic Thomas à Kempis. Shortly before his death he placed at the foot of his bed a moving composition of the crucified Christ hovering over a sea of blood, created a few years earlier as a personal profession of faith in the cleansing of the world through the blood of Christ. His last marble, made at the age of eighty, was a *Salvator Mundi* (Fig. 120). He died on 28 November 1680.

PLATES

Unless otherwise stated, the material is marble.

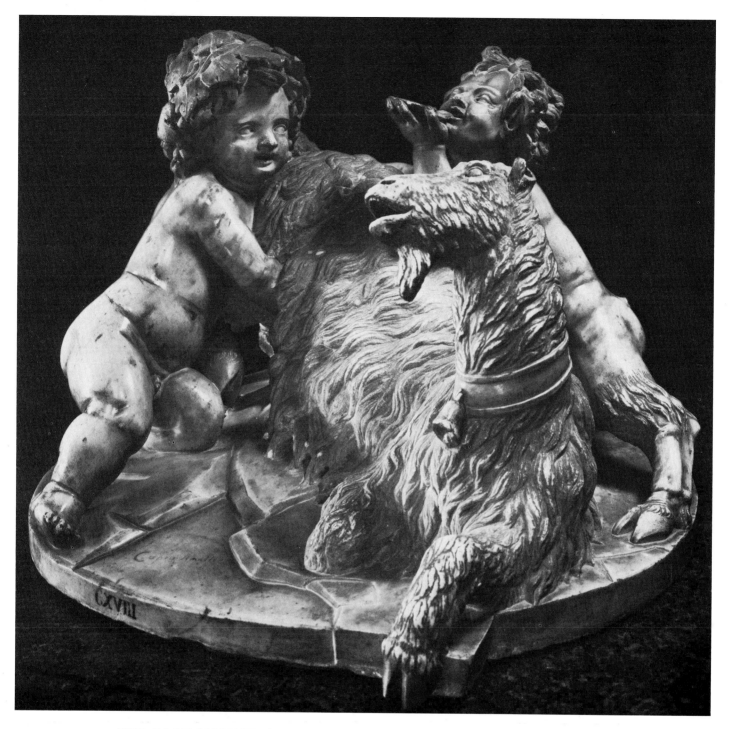

1. THE GOAT AMALTHEA NURSING THE INFANT ZEUS AND A YOUNG SATYR.
Under life-size. About 1615. Galleria Borghese, Rome (Cat. No. 1)

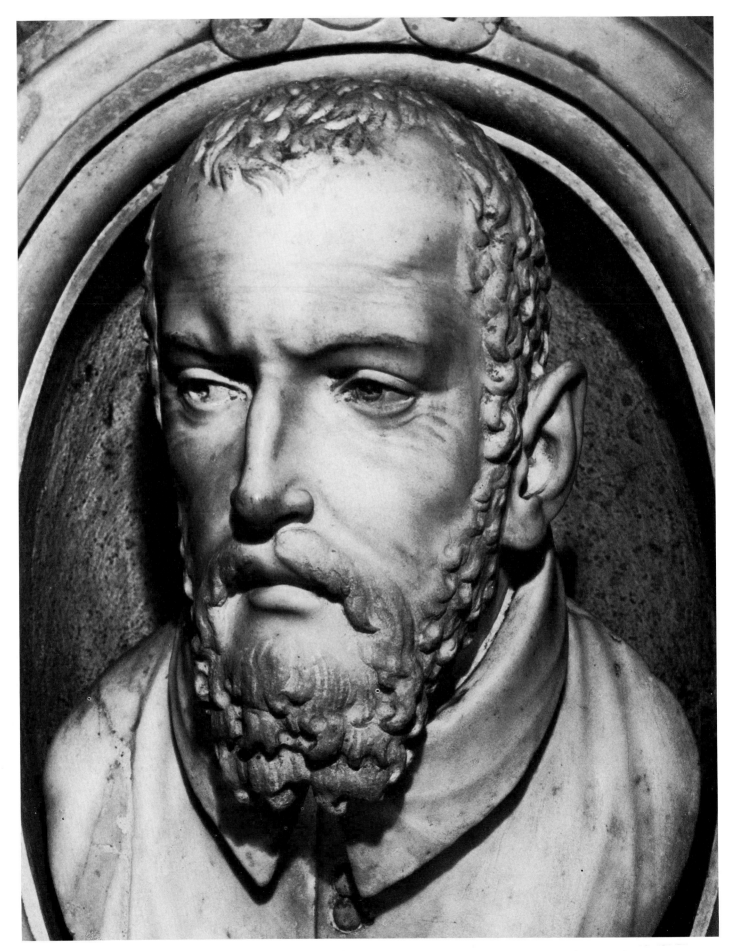

2. MONSIGNOR GIOVAN BATTISTA SANTONI. From the tomb in S. Prassede, Rome. Life-size. About 1615–16
(Cat. No. 2)

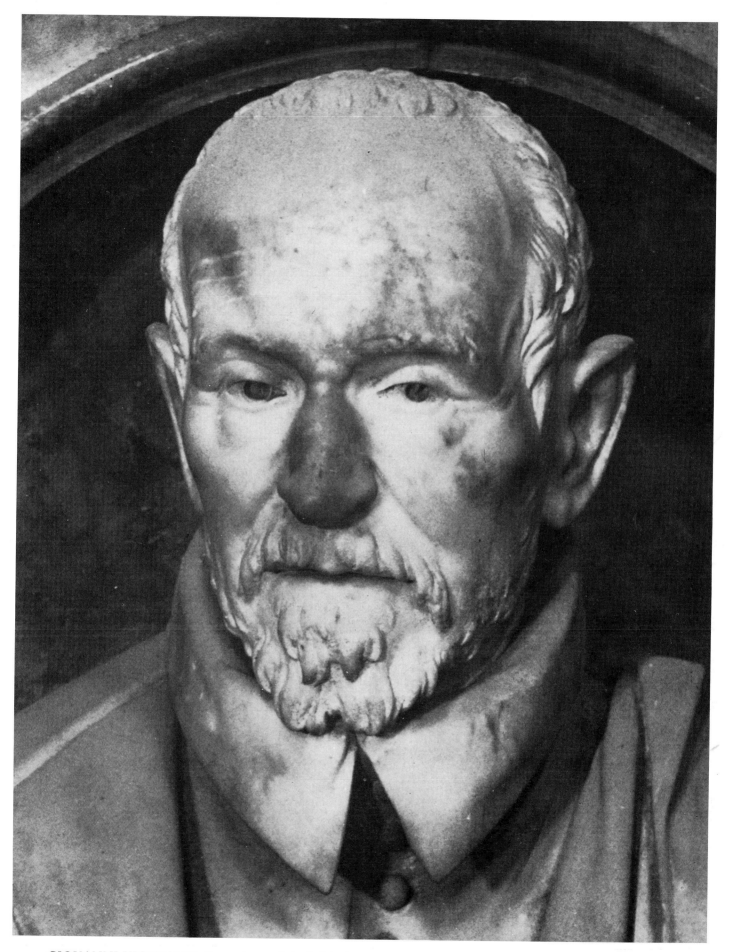

3. GIOVANNI VIGEVANO. From the tomb in S. Maria sopra Minerva, Rome. Life-size. About 1617–18 (Cat. No. 5)

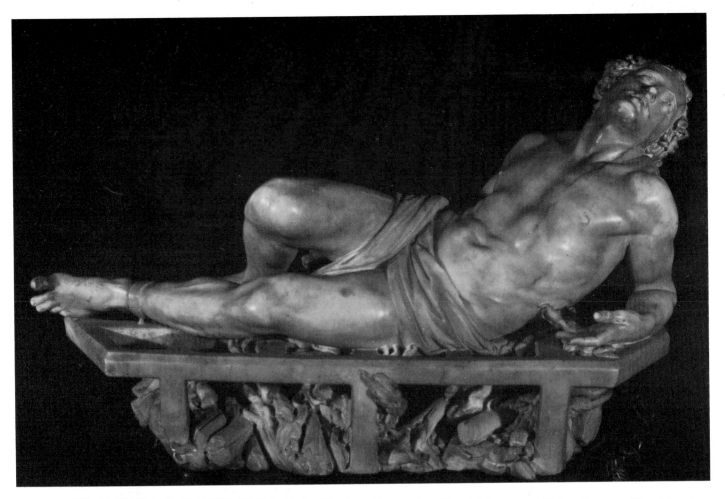

4. ST. LAWRENCE ON THE GRILL. Under life-size. About 1617. Contini Bonacossi Coll., Florence (Cat. No. 3)

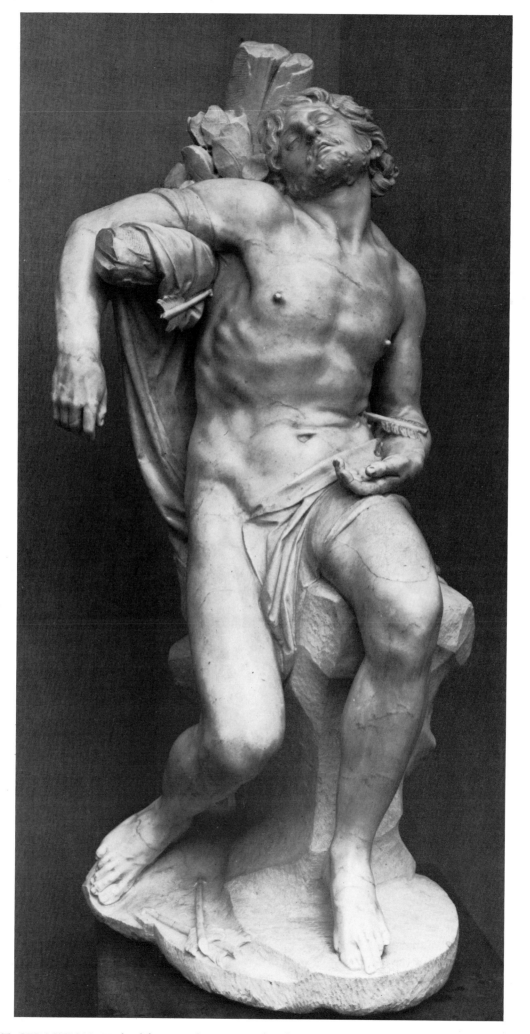

5. ST. SEBASTIAN. Under life-size. About 1617-18. Thyssen-Bornemisza Coll., Lugano (Cat. No. 4)

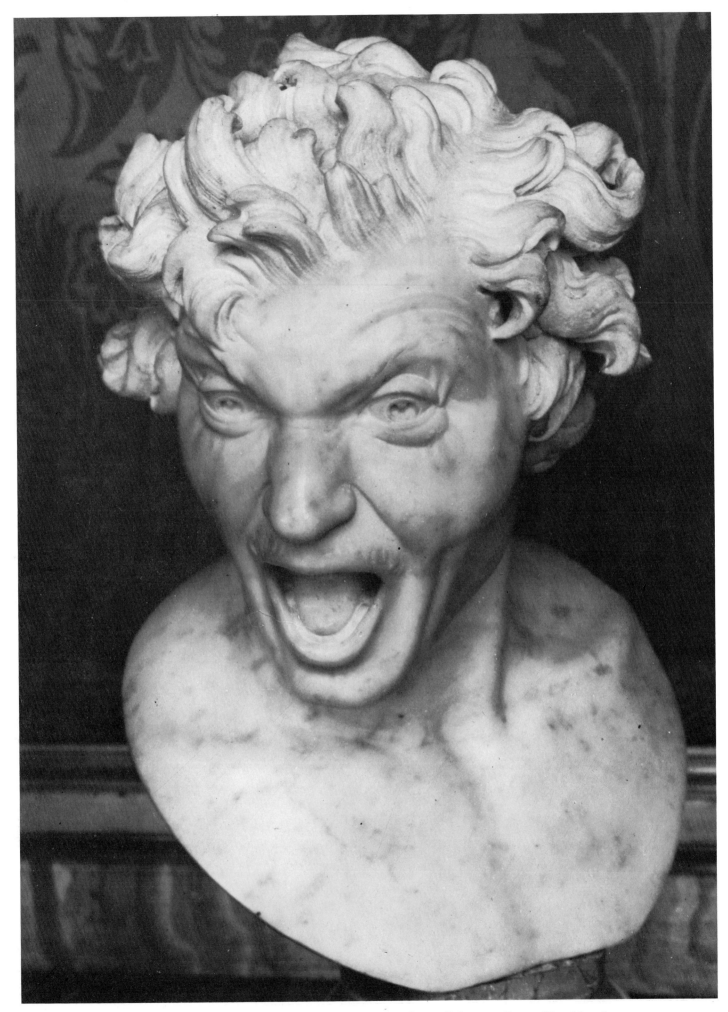

6. ANIMA DANNATA. Life-size. About 1619. Palazzo di Spagna, Rome (Cat. No. 7)

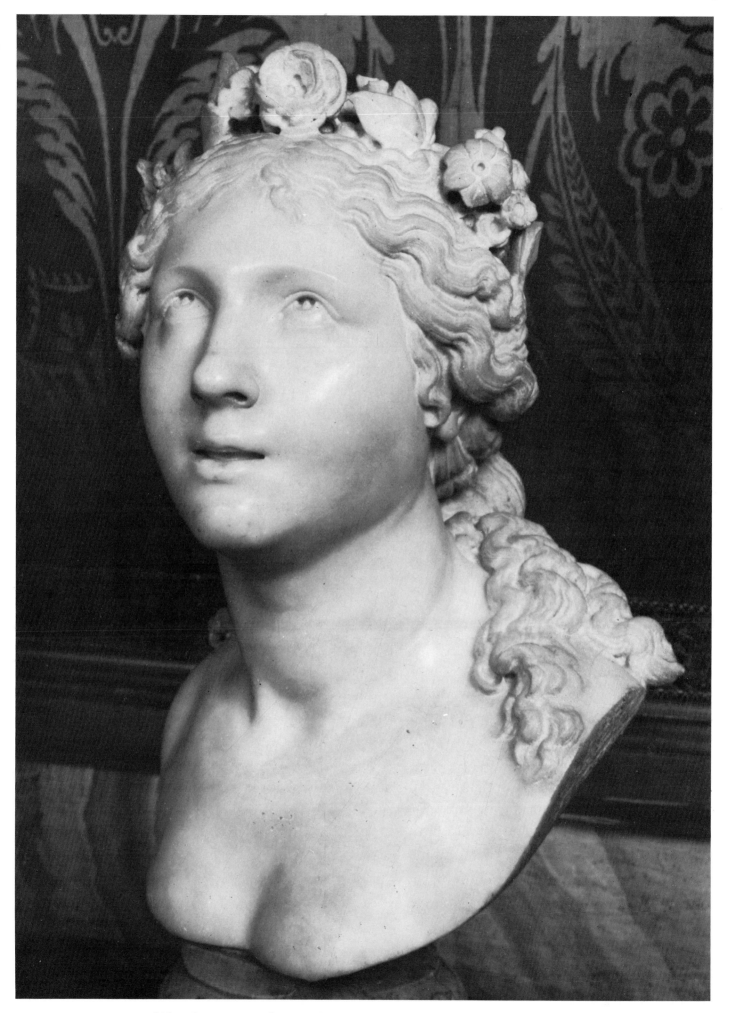

7. ANIMA BEATA. Life-size. About 1619. Palazzo di Spagna, Rome (Cat. No. 7)

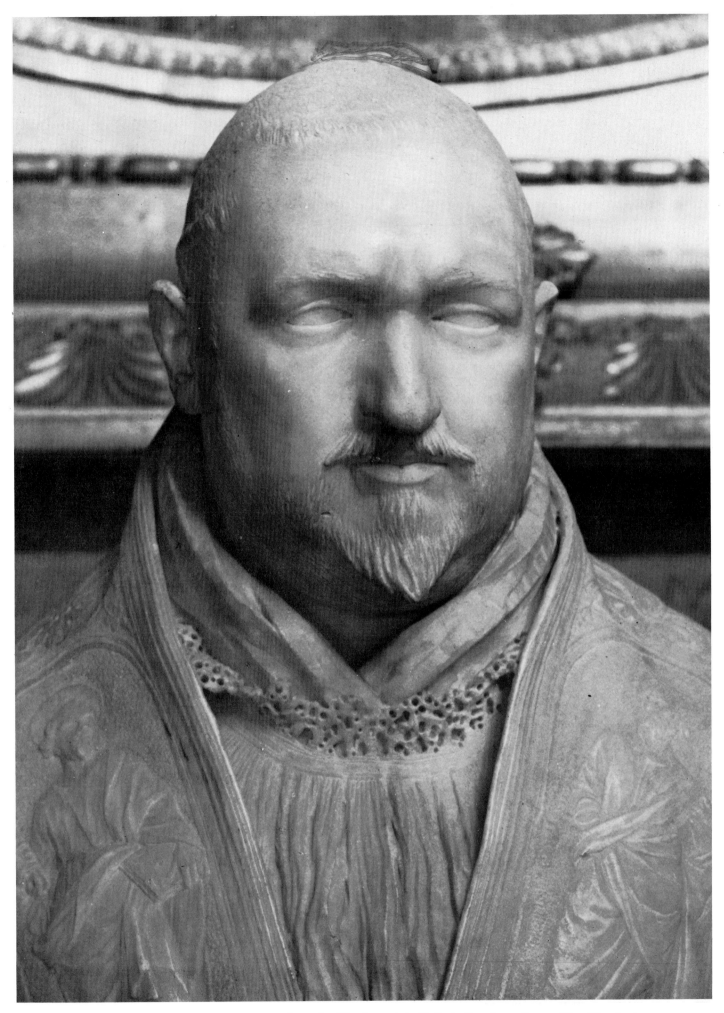

8. BUST OF POPE PAUL V. Detail. Under life-size. 1618. Galleria Borghese, Rome (Cat. No. 6-1)

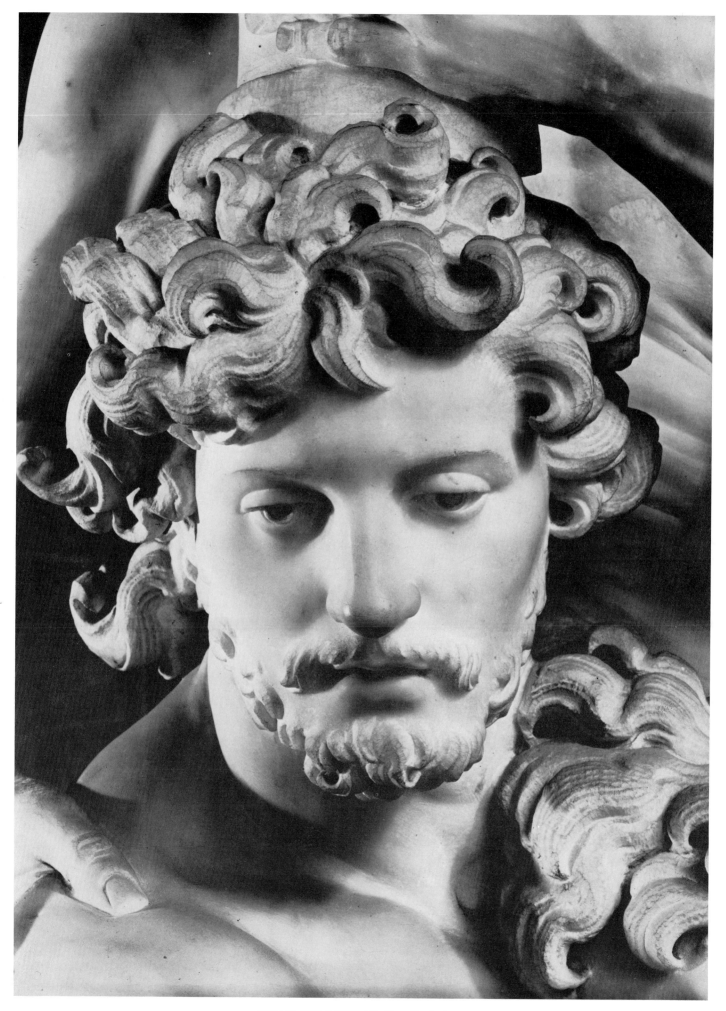

9. HEAD OF AENEAS. Detail of Plate 10

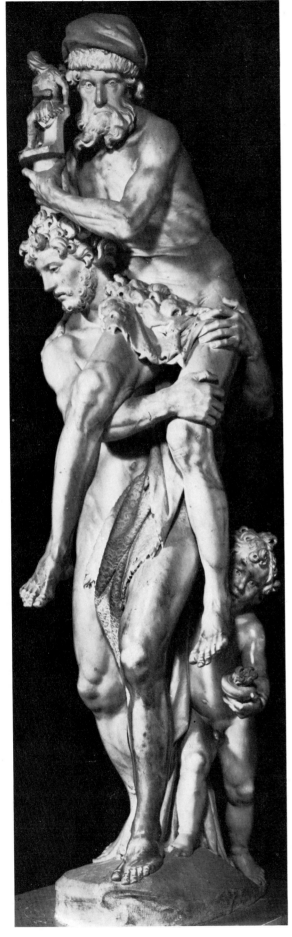

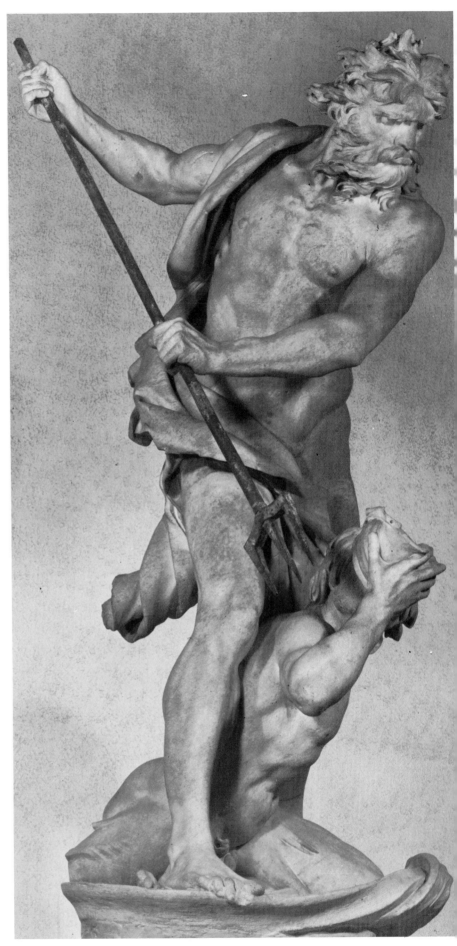

10. AENEAS, ANCHISES AND ASCANIUS.
Life-size. 1618-19. Galléria Borghese, Rome (Cat. No. 8)

11. NEPTUNE AND TRITON.
Over life-size. 1620. Victoria and Albert Museum, London (Cat. No. 9)

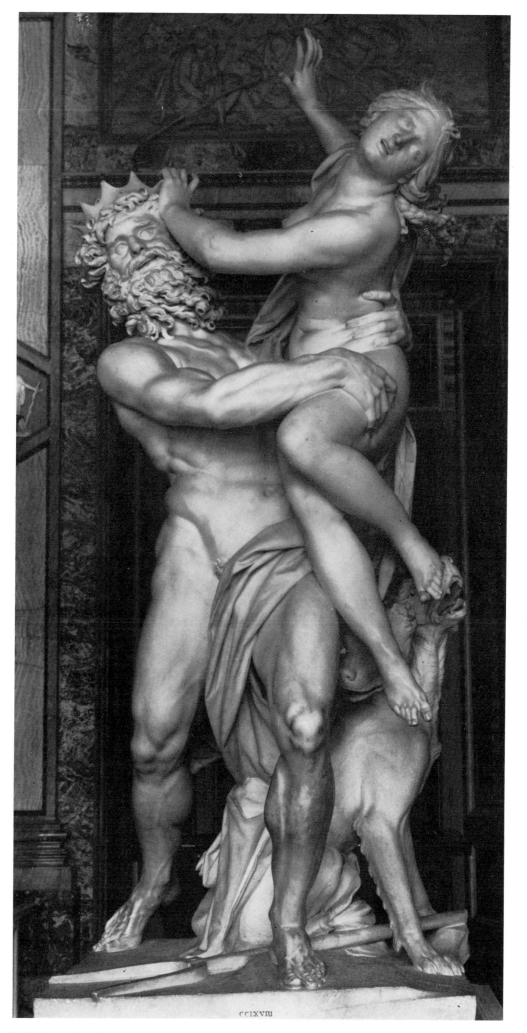

12. PLUTO AND PROSERPINA. Over life-size. 1621-22. Galleria Borghese, Rome (Cat. No. 10)

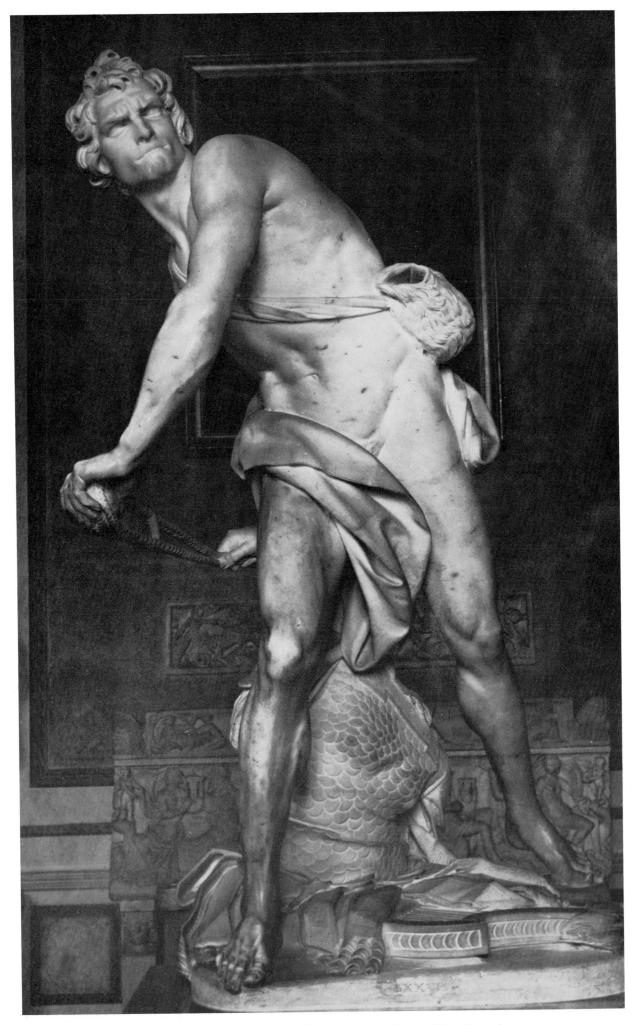

13. DAVID. Life-size. 1623. Galleria Borghese, Rome (Cat. No. 17)

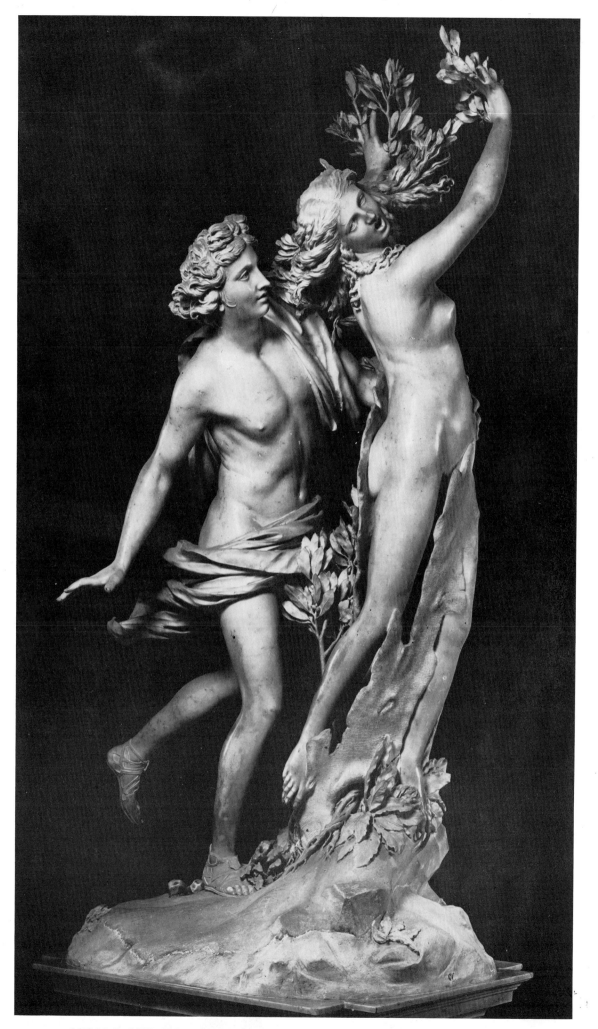

14. APOLLO AND DAPHNE. Life-size. 1622–24. Galleria Borghese, Rome (Cat. No. 18)

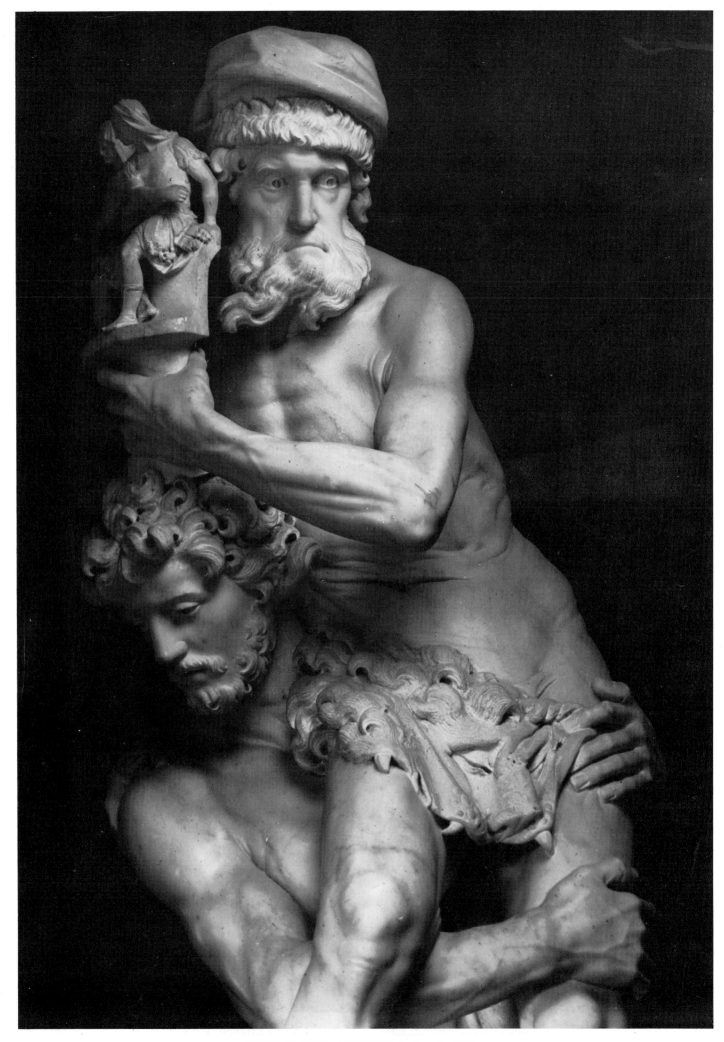

15. AENEAS AND ANCHISES. Detail of Plate 10

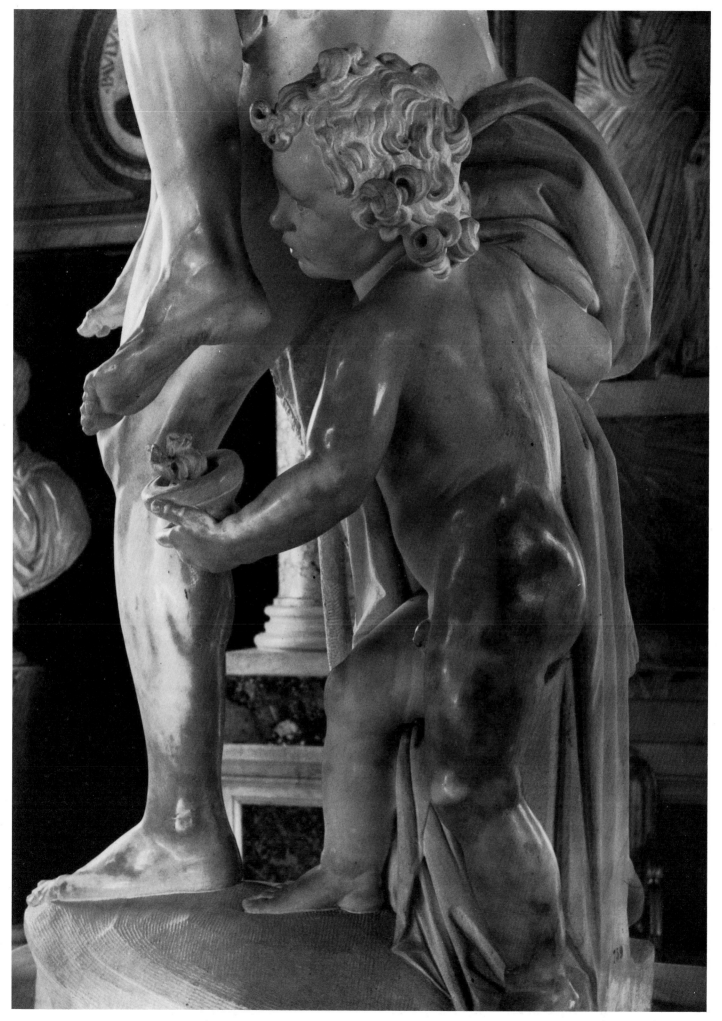

16. ASCANIUS. Detail of Plate 10

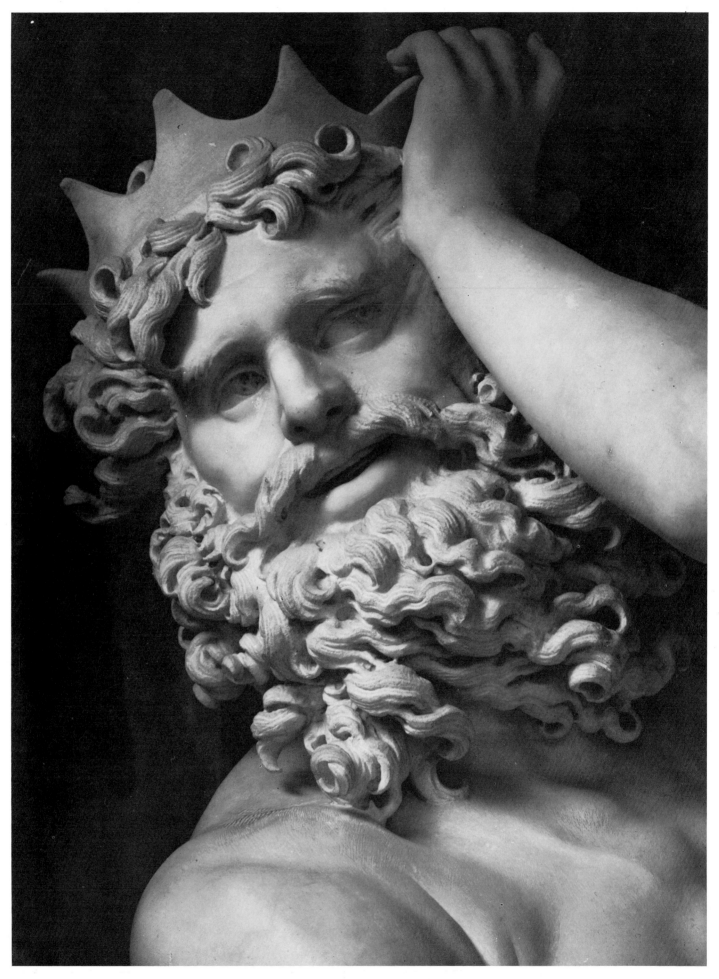

17. HEAD OF PLUTO. Detail of Plate 12

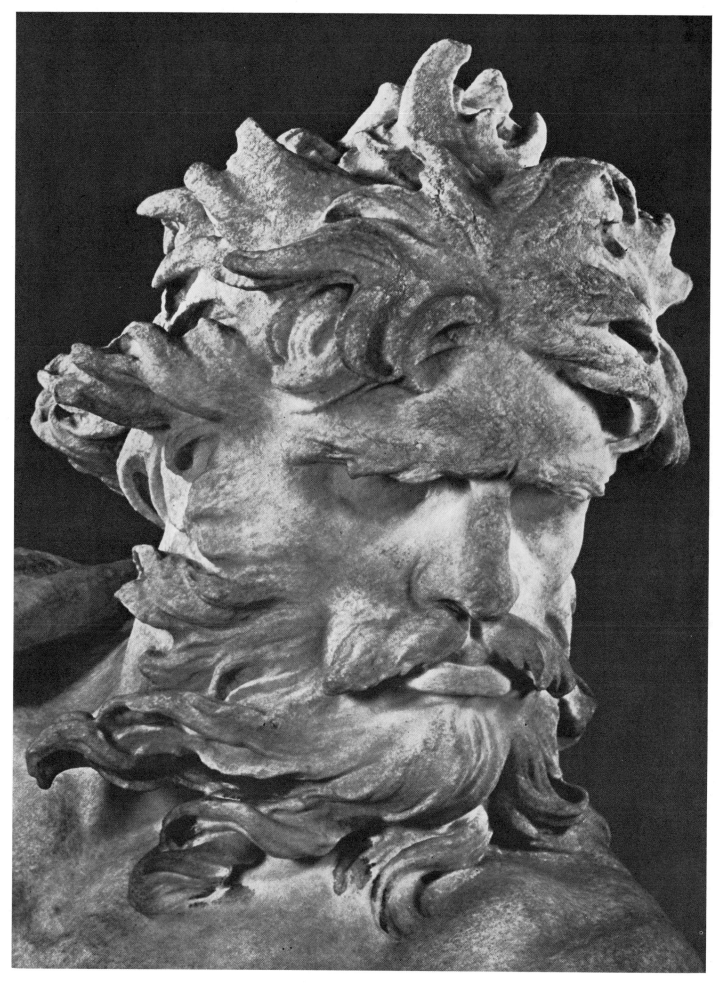

18. HEAD OF NEPTUNE. Detail of Plate 11

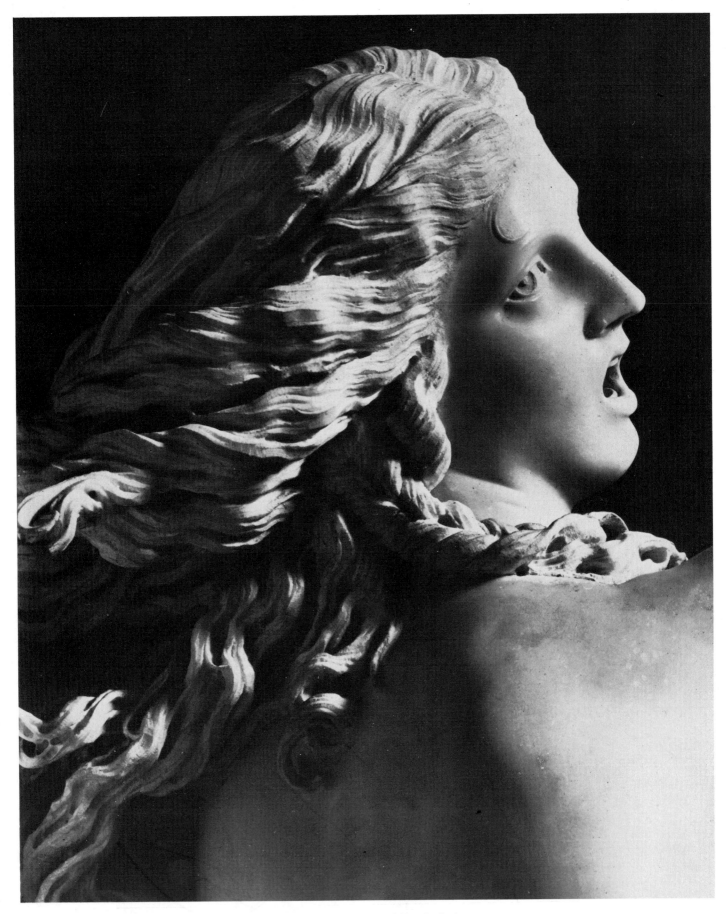

19. HEAD OF DAPHNE. Detail of Plate 14

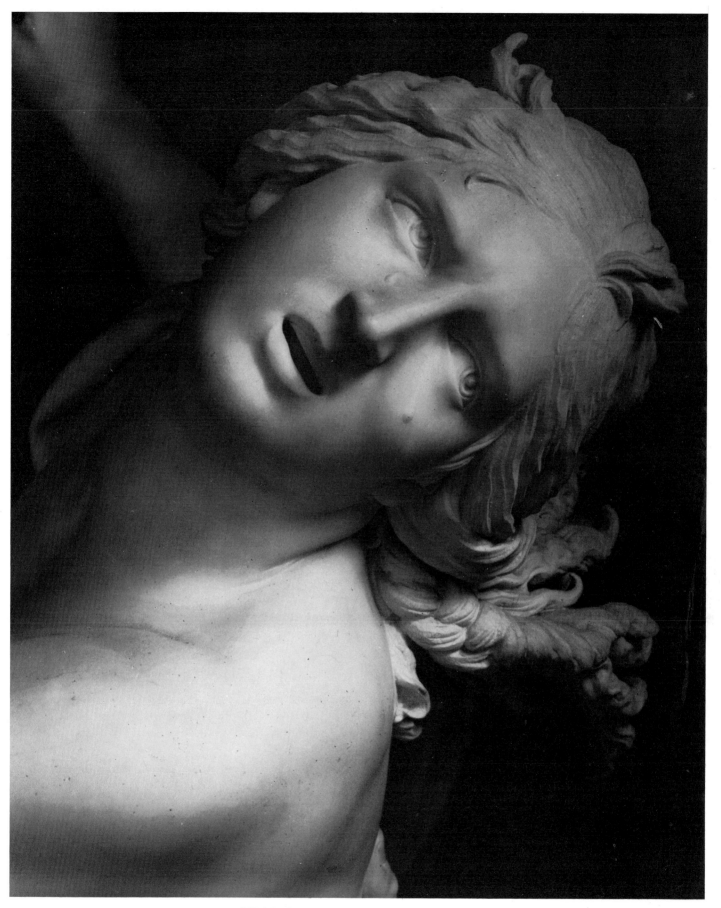

20. HEAD OF PROSERPINA. Detail of Plate 12

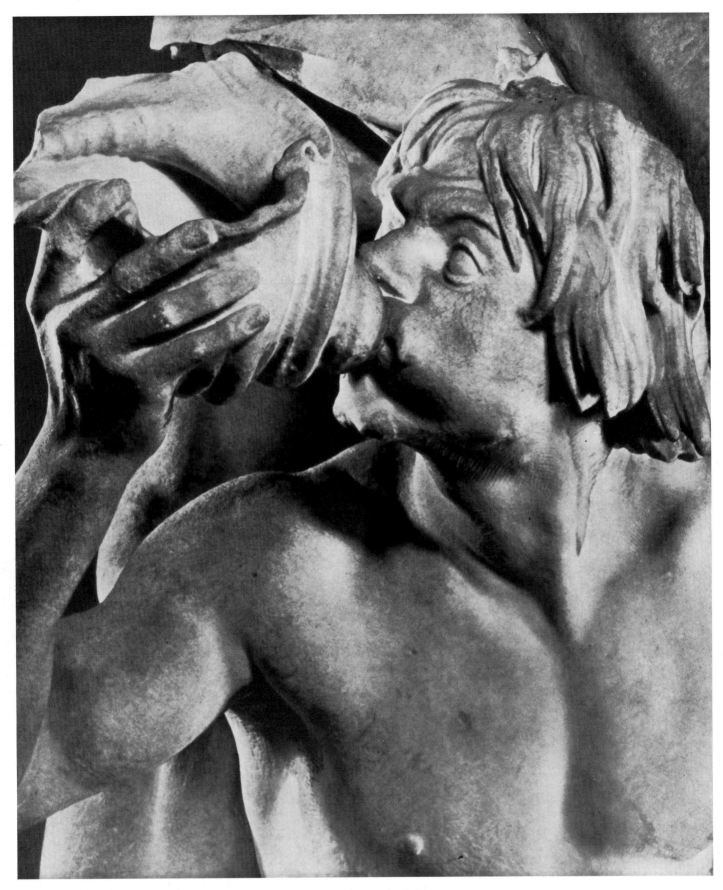

21. TRITON. Detail of Plate 11

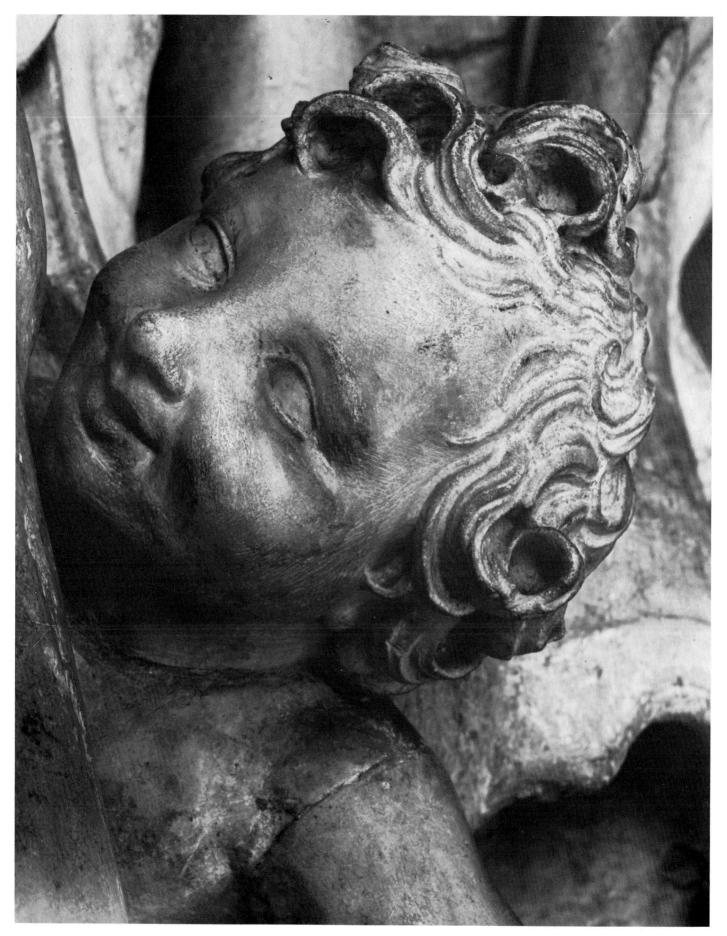

22. HEAD OF EROS. Detail from Bernini's restoration of the 'Ares Ludovisi'. About 1621-23. Museo delle Terme, Rome
(Cat. No. 11-3)

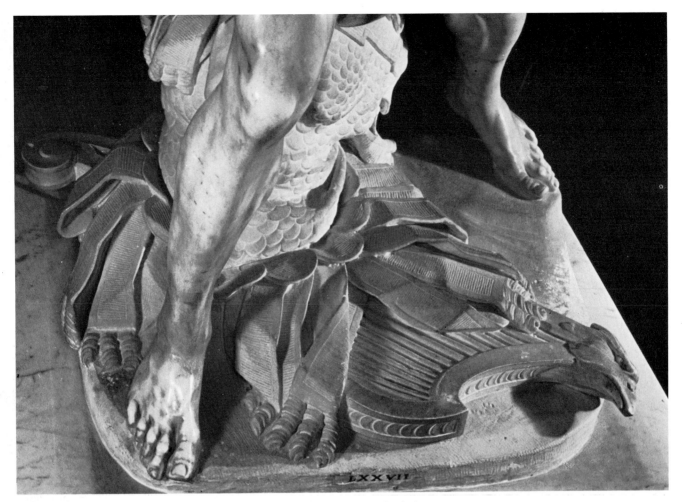

23: DAVID'S LEGS. Detail of Plate 13

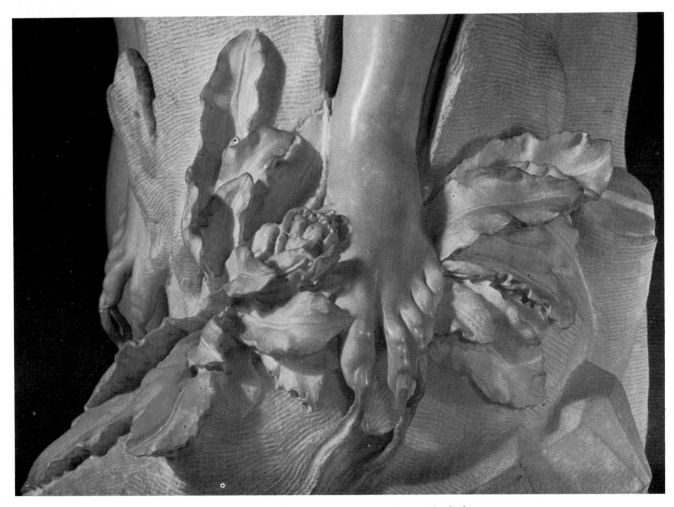

24. DAPHNE'S METAMORPHOSIS. Detail of Plate 14

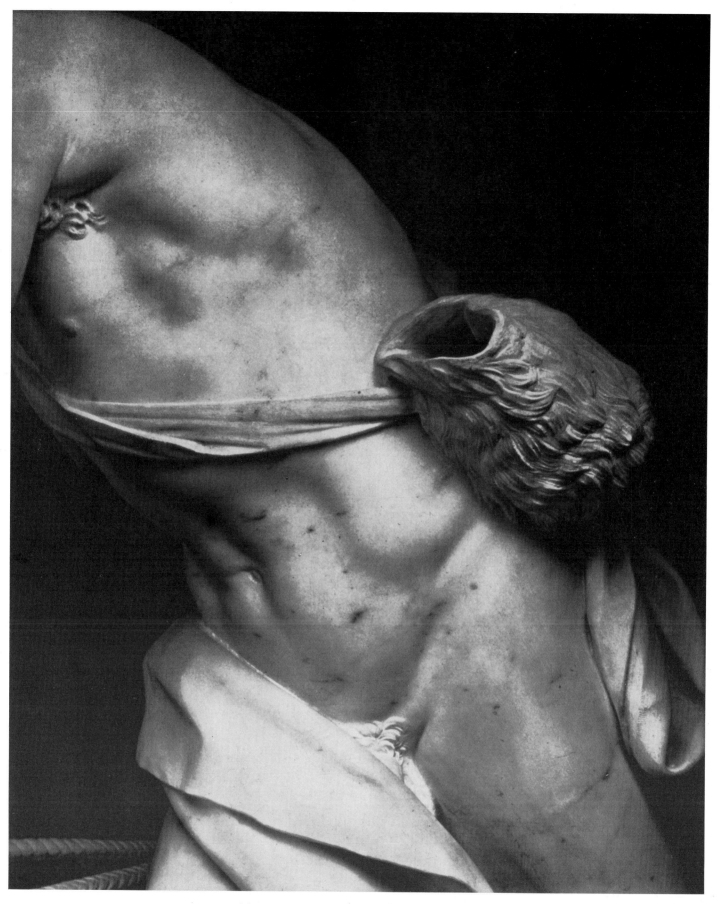

25. THE TORSO OF DAVID. Detail of Plate 13

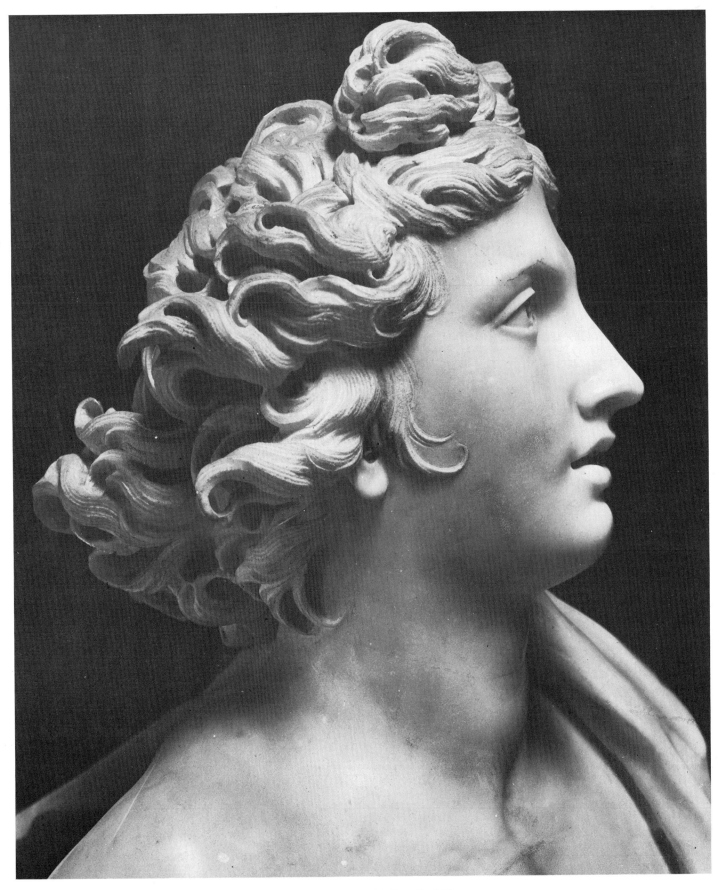

26. HEAD OF APOLLO. Detail of Plate 14

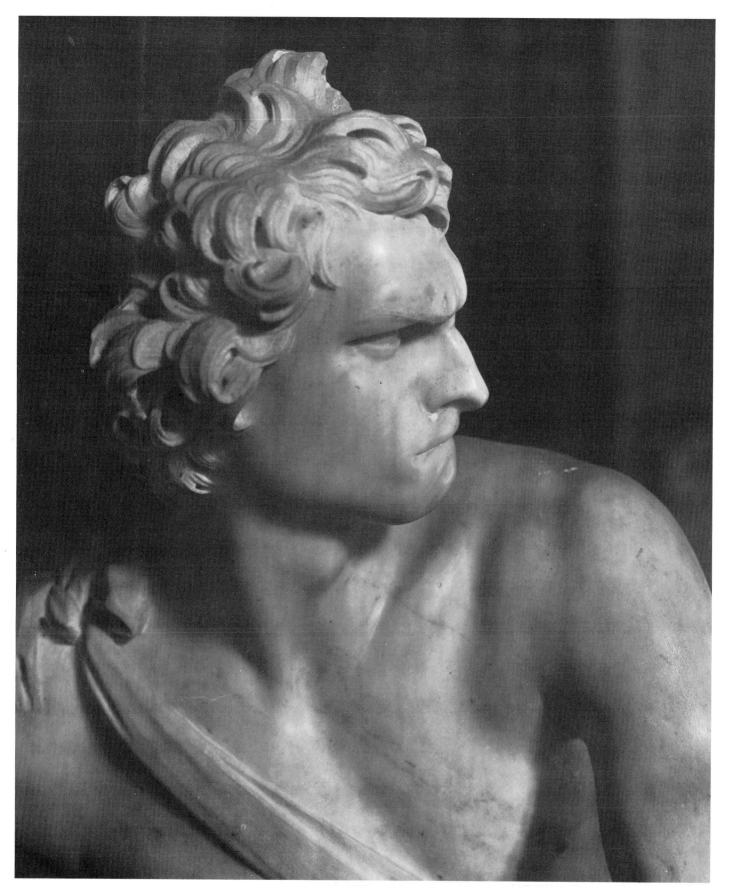

27. HEAD OF DAVID. Detail of Plate 13

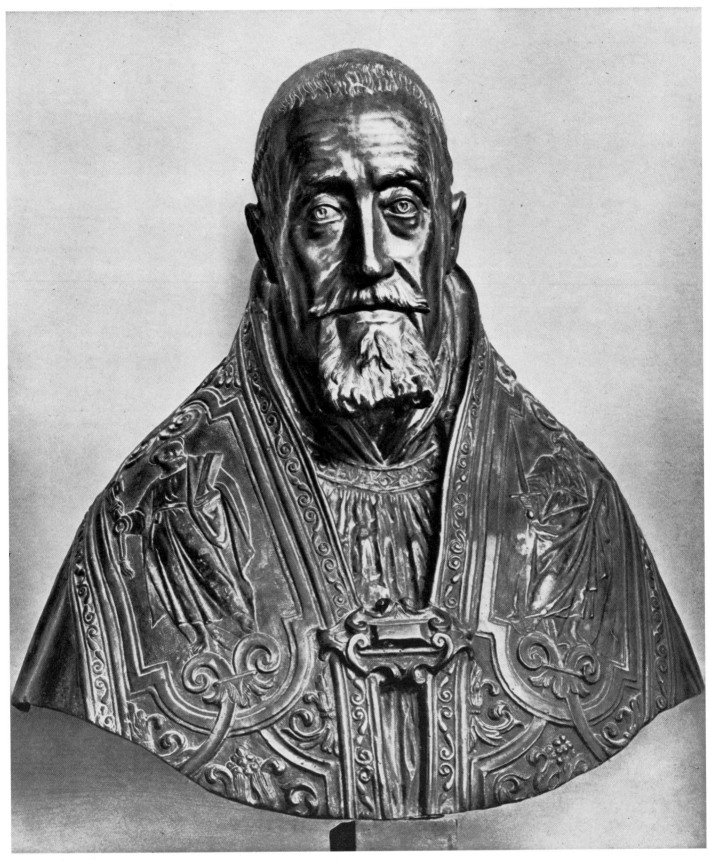

28. BUST OF POPE GREGORY XV. Bronze . Life-size. 1621-22. Formerly Antonio Muñoz Coll., Rome (Cat. No. 12-1)

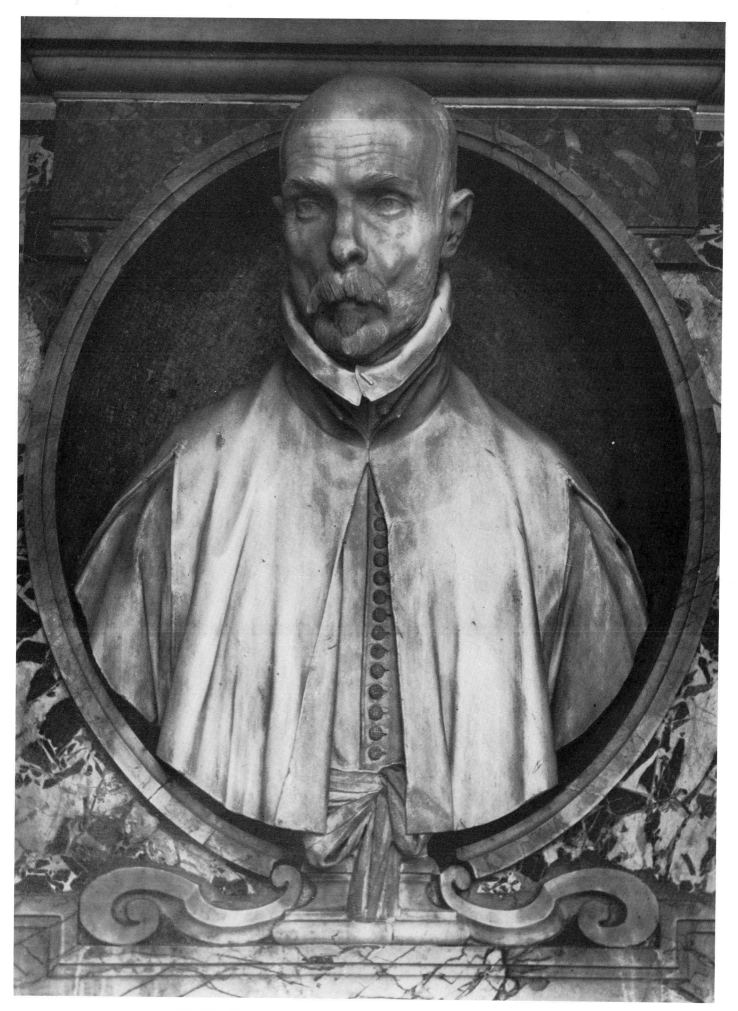

29. BUST OF MONSIGNOR PEDRO DE FOIX MONTOYA. Life-size. Probably 1621.
From the tomb in the refectory of S. Maria di Monserrato, Rome (Cat. No. 13)

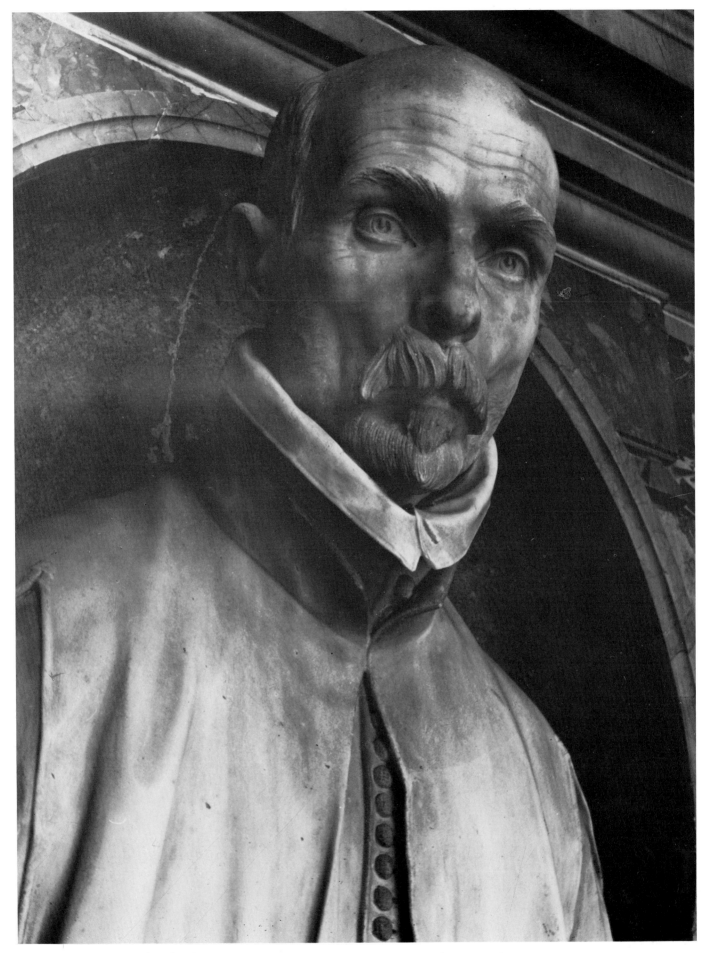

30. MONSIGNOR PEDRO DE FOIX MONTOYA. Detail of Plate 29

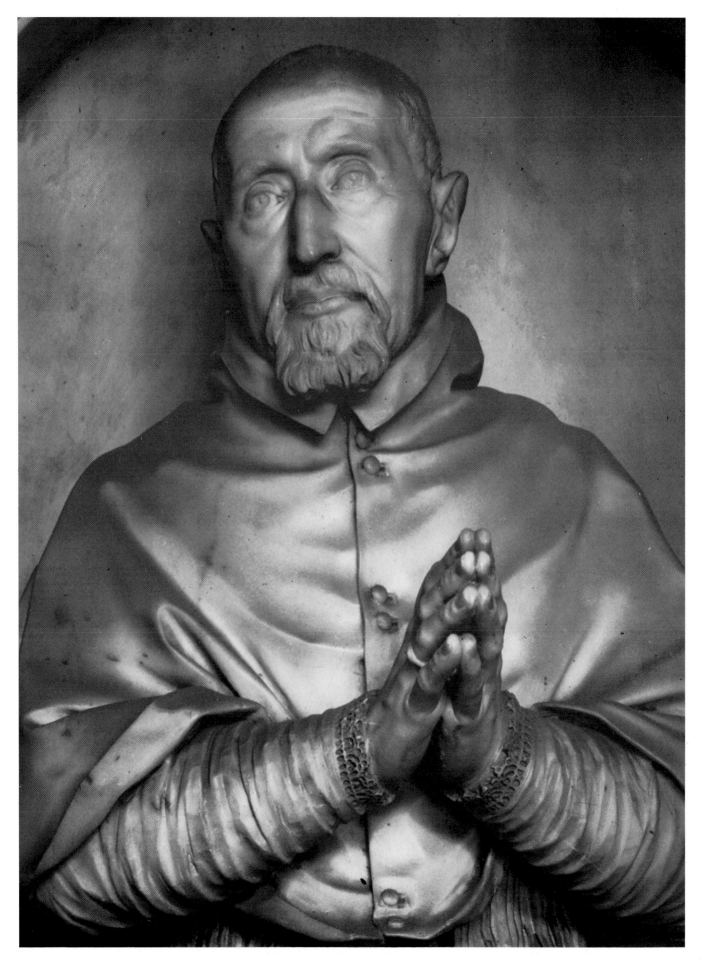

31. BUST OF CARDINAL ROBERTO BELLARMINE. Detail. Life-size. 1622. From the tomb in the Gesù, Rome (Cat. No. 15)

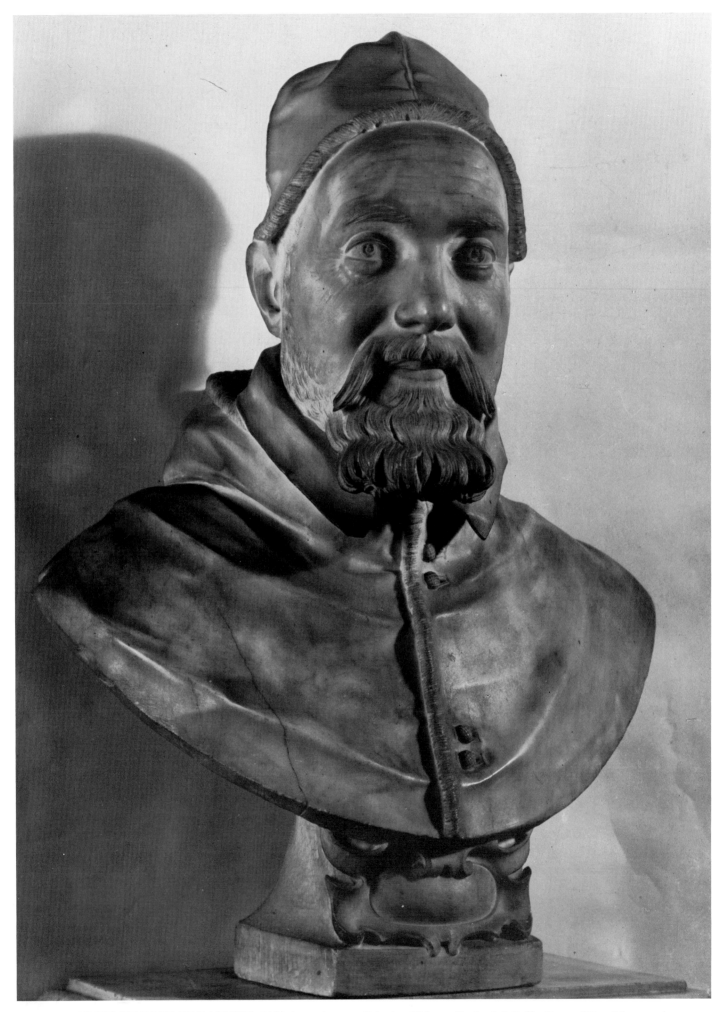

32. BUST OF POPE URBAN VIII. Life-size. 1623-24. Principe Urbano Barberini Coll., Rome (Cat. No. 19-1)

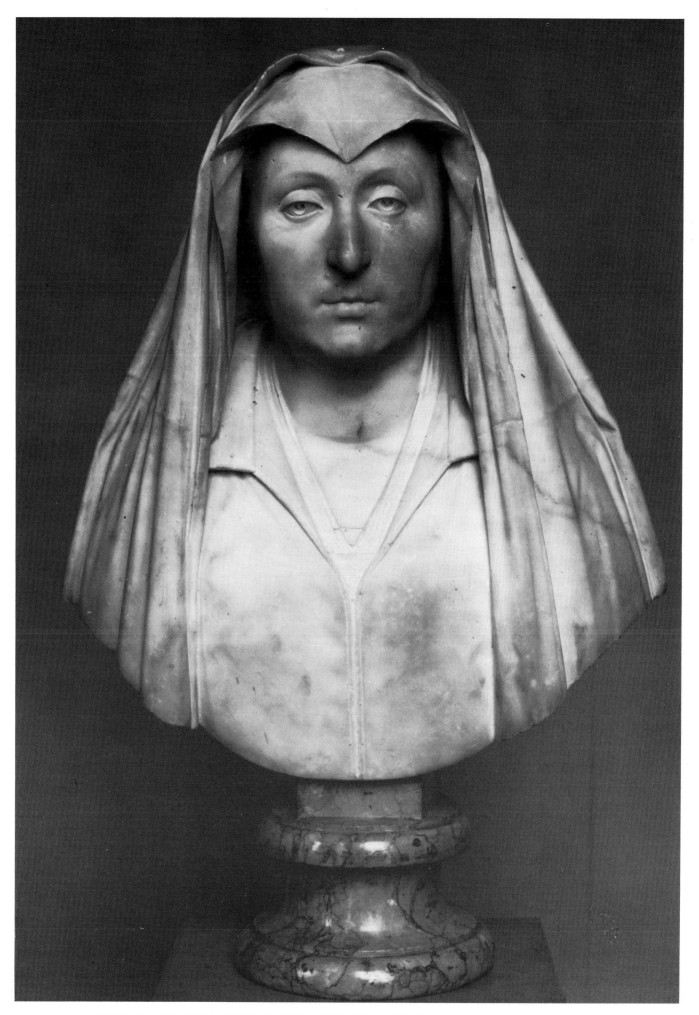

33. BUST OF CAMILLA BARBADONI, MOTHER OF POPE URBAN VIII. Life-size. 1626-27.
Royal Museum of Fine Arts, Copenhagen (Cat. No. 24-c)

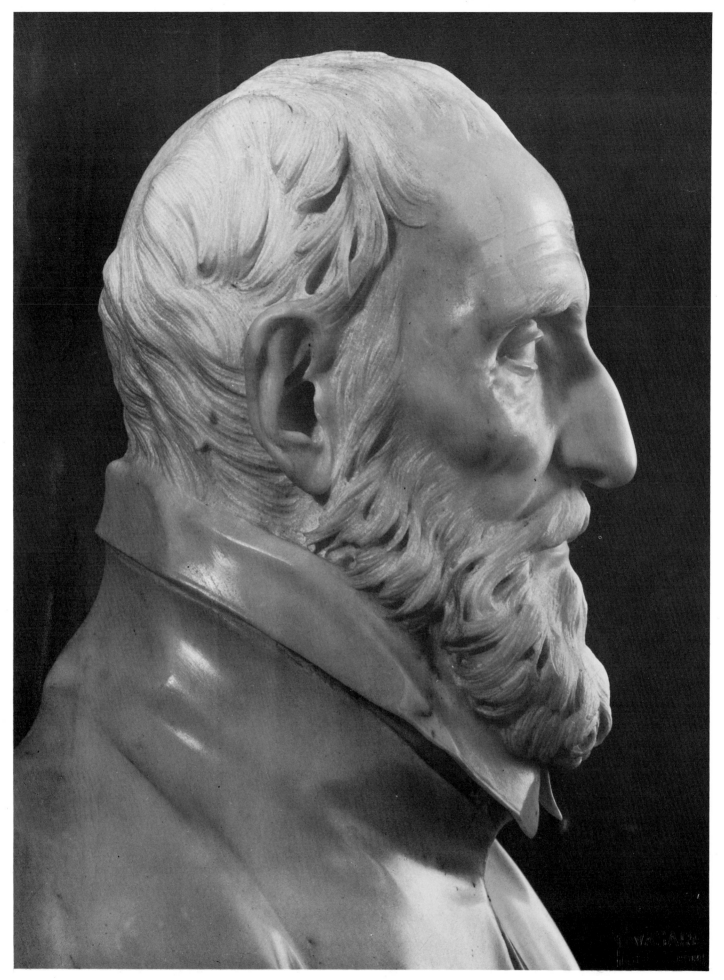

34. BUST OF FRANCESCO BARBERINI, UNCLE OF POPE URBAN VIII. Detail. Life-size. About 1626.
Samuel H. Kress Collection, National Gallery of Art, Washington, D.C. (Cat. No. 24-a)

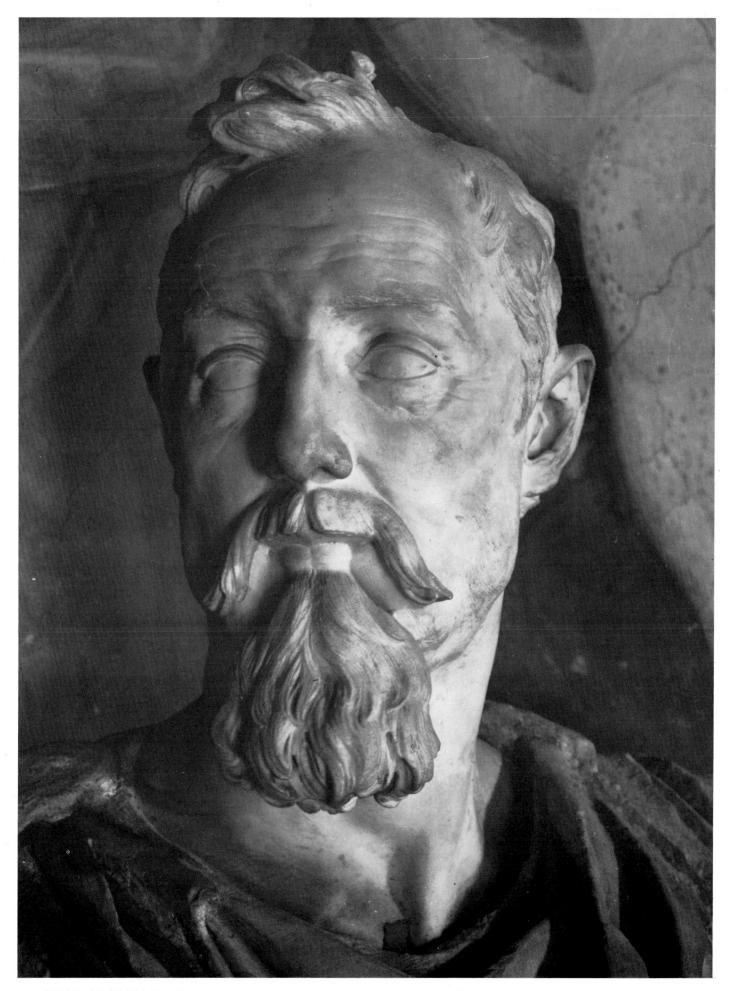

35. HEAD OF THE MEMORIAL STATUE FOR CARLO BARBERINI. Life-size. 1630. Palazzo dei Conservatori, Rome
(Cat. No. 27)

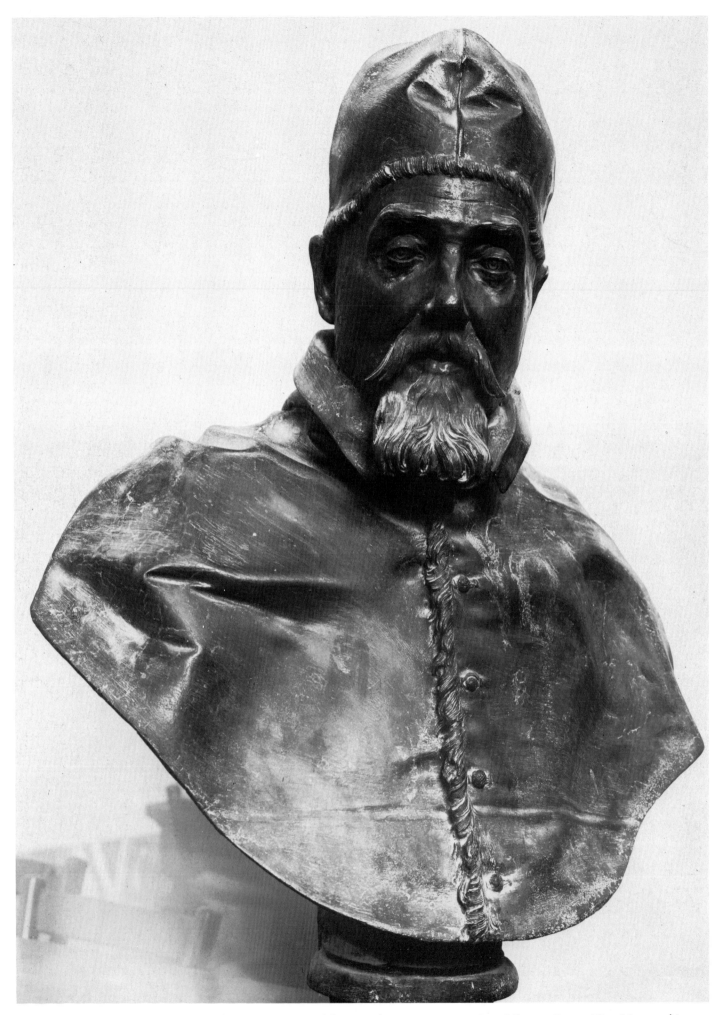

36. BUST OF POPE URBAN VIII. Bronze. Over life-size. About 1637–38. Vatican Library, Rome (Cat. No. 19-2b)

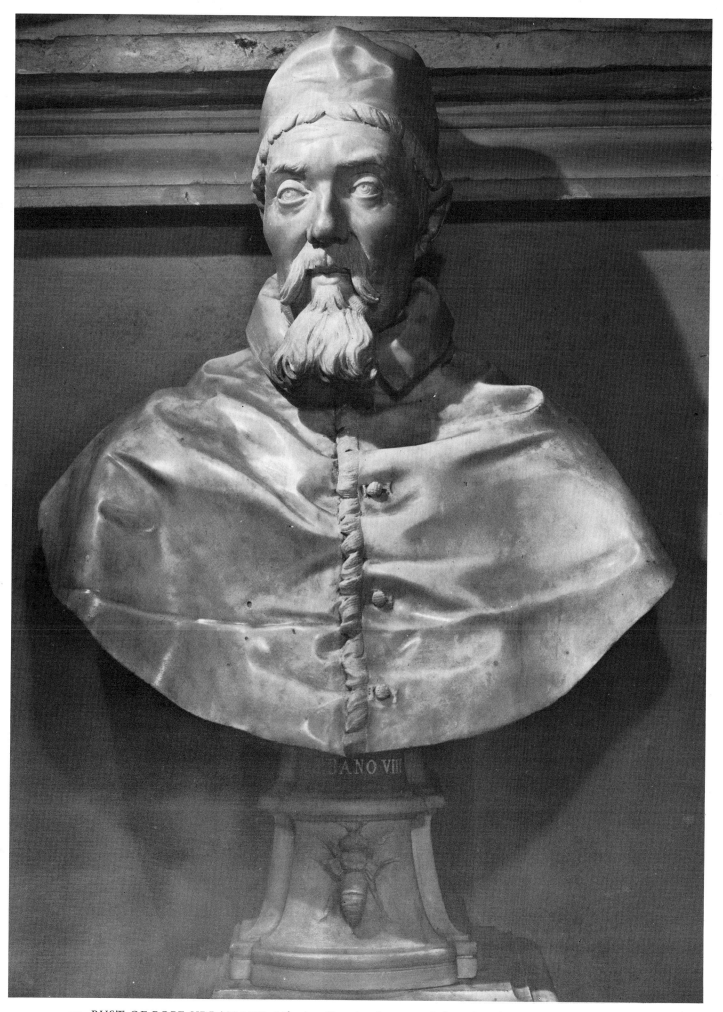

37. BUST OF POPE URBAN VIII. Life-size. Shortly after 1640. Palazzo Spada, Rome (Cat. No. 19-2c)

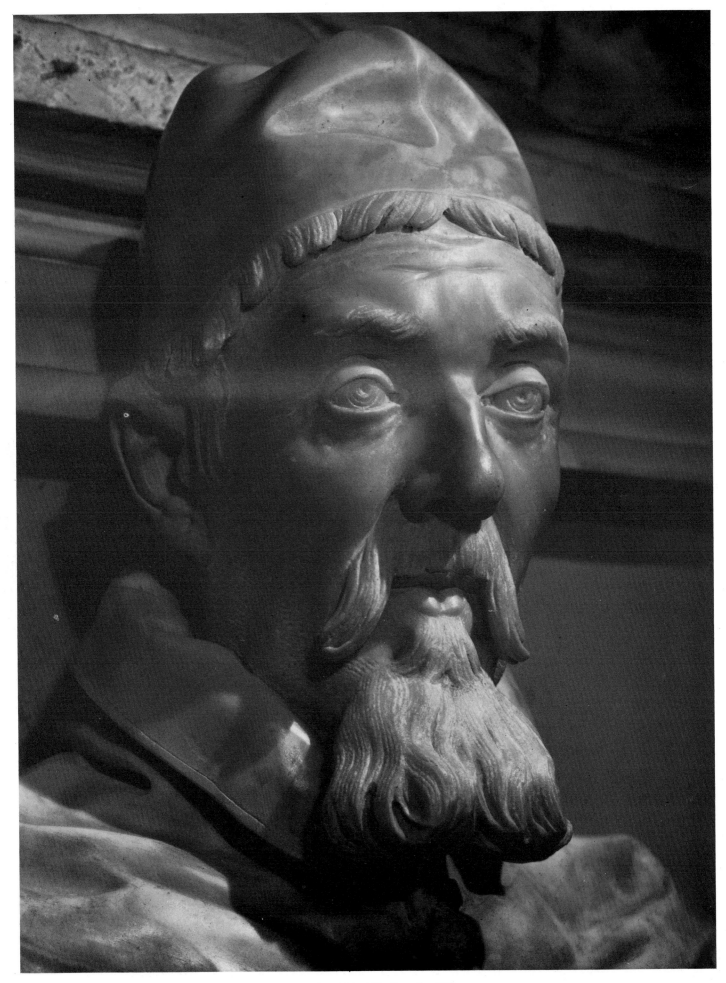

38. POPE URBAN VIII. Detail of Plate 37

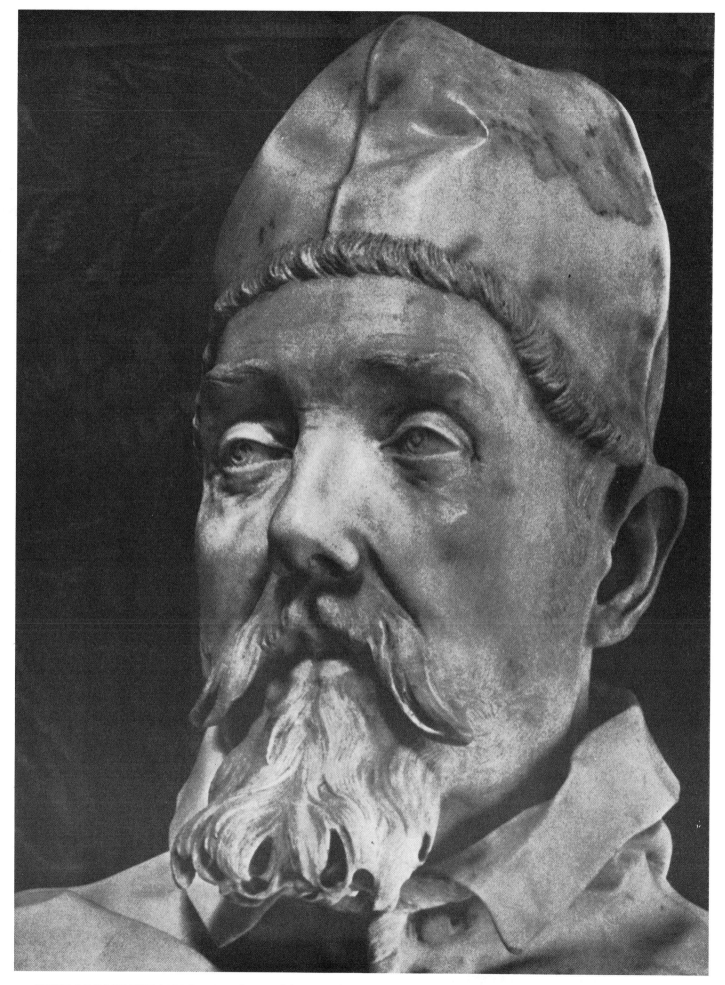

39. BUST OF POPE URBAN VIII. Detail. Over life-size. About 1637–38. Principe Enrico Barberini Coll., Rome (Cat. No. 19–2a)

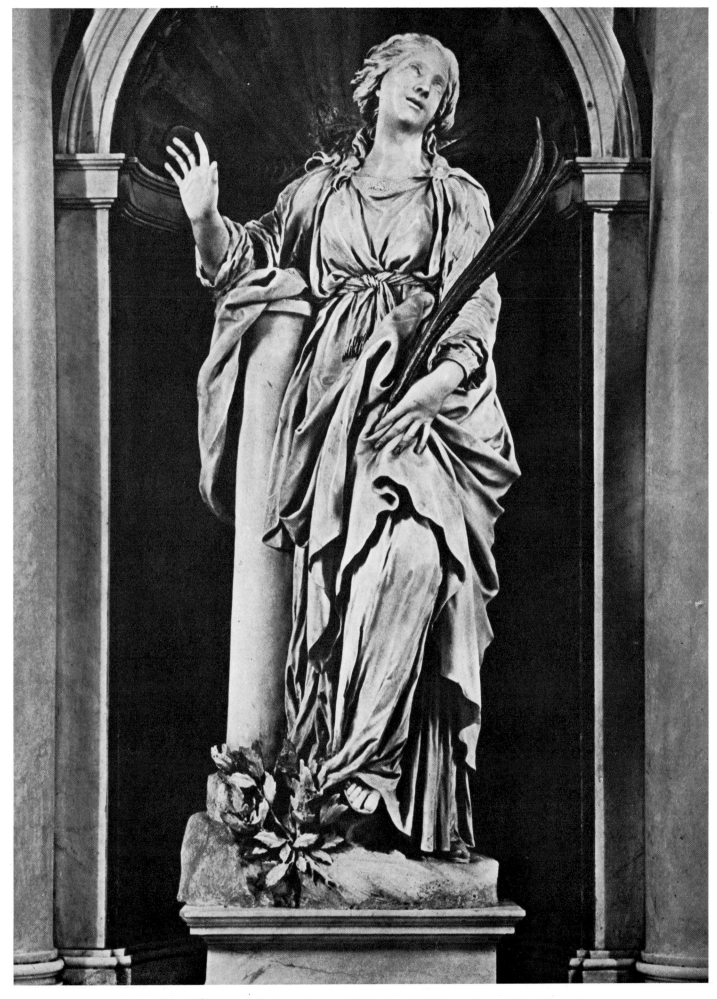

40. ST. BIBIANA. Life-size. 1624–26. High altar, S. Bibiana, Rome (Cat. No. 20)

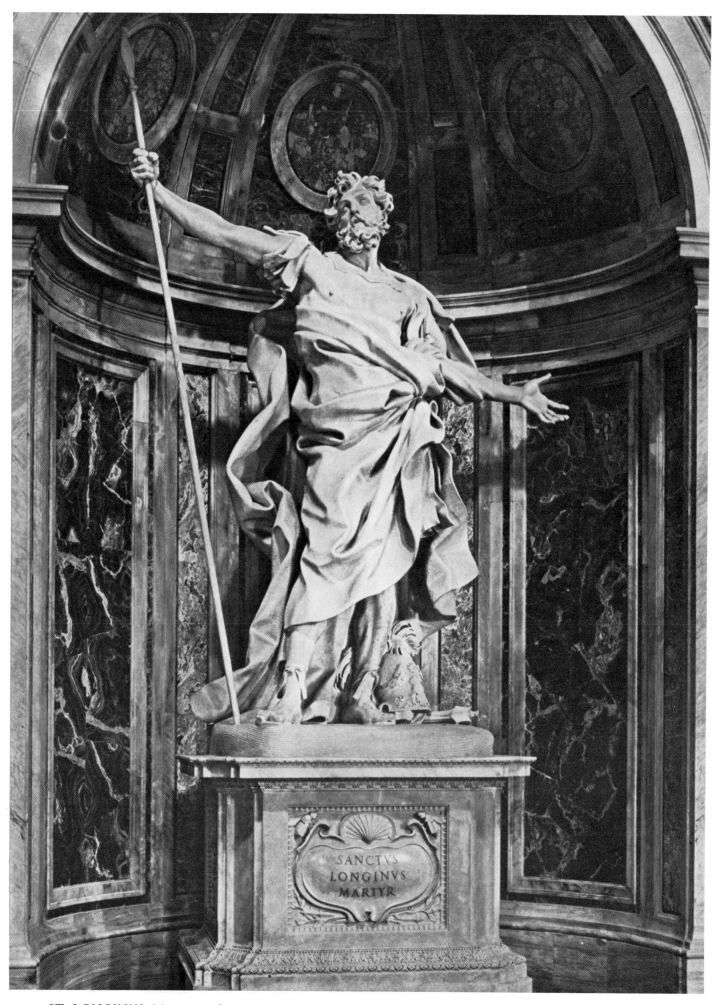

41. ST. LONGINUS. Monumental size. 1629-38. In the N.E. pillar under the dome of St. Peter's, Rome (Cat. No. 28)

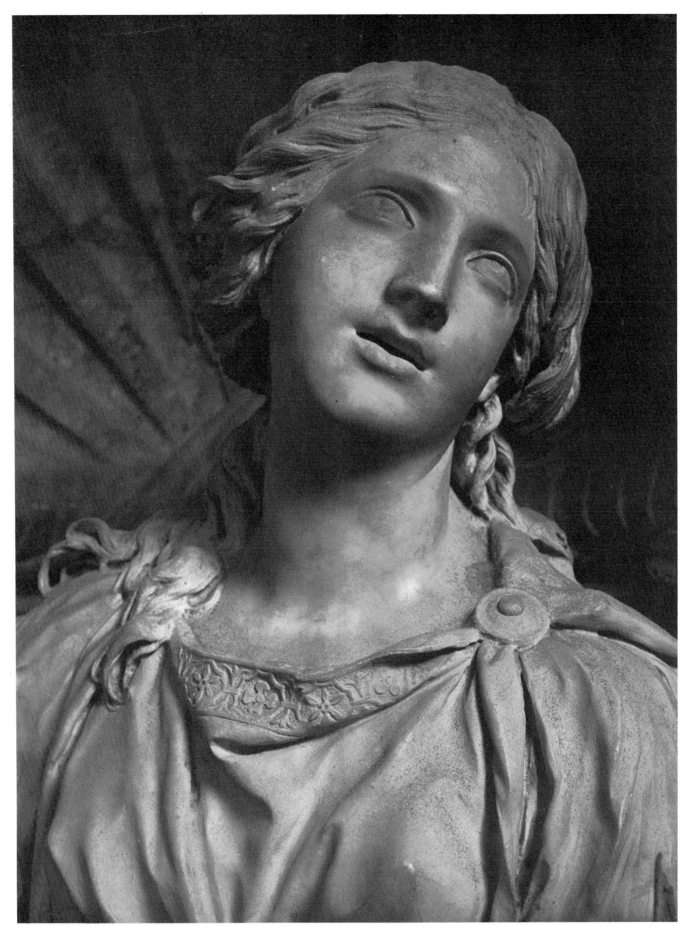

42. HEAD OF ST. BIBIANA. Detail of Plate 40

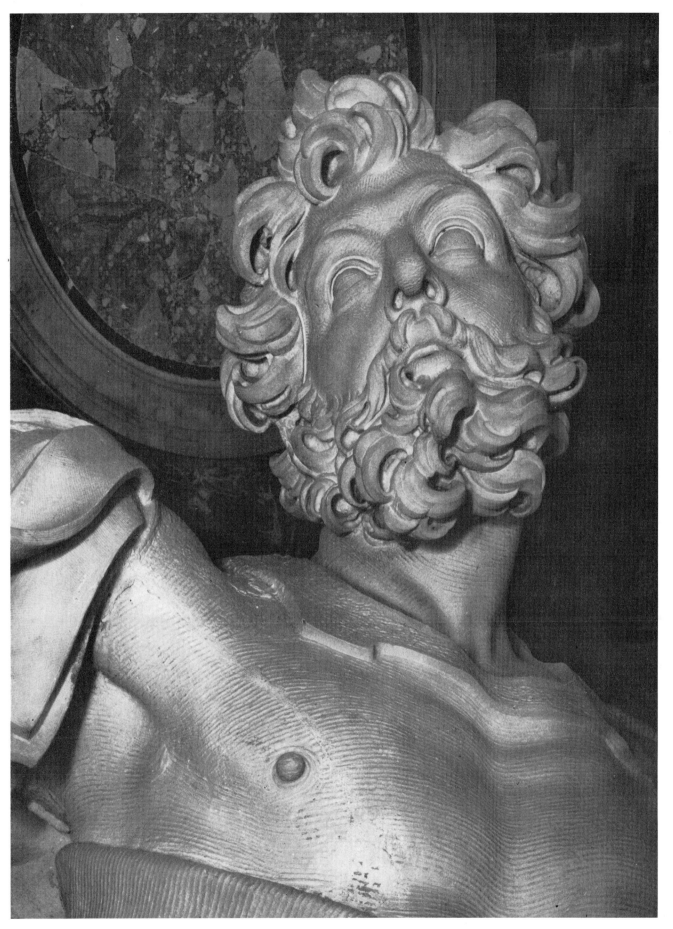

43. HEAD OF ST. LONGINUS. Detail of Plate 41

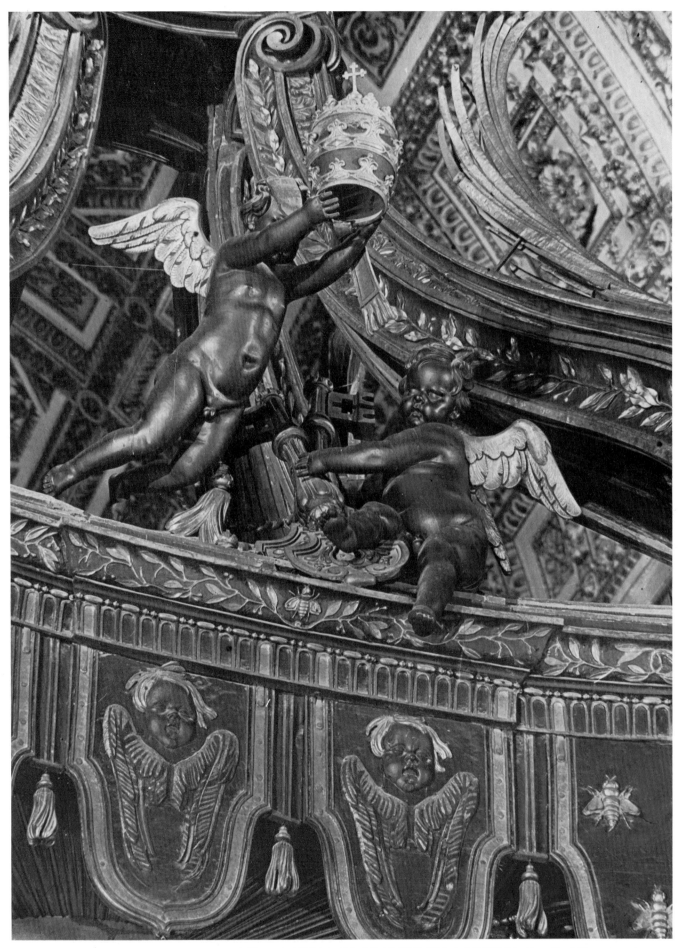

44. THE PAPAL INSIGNIA BETWEEN THE RIBS OF THE BALDACCHINO. Detail of Plate 45

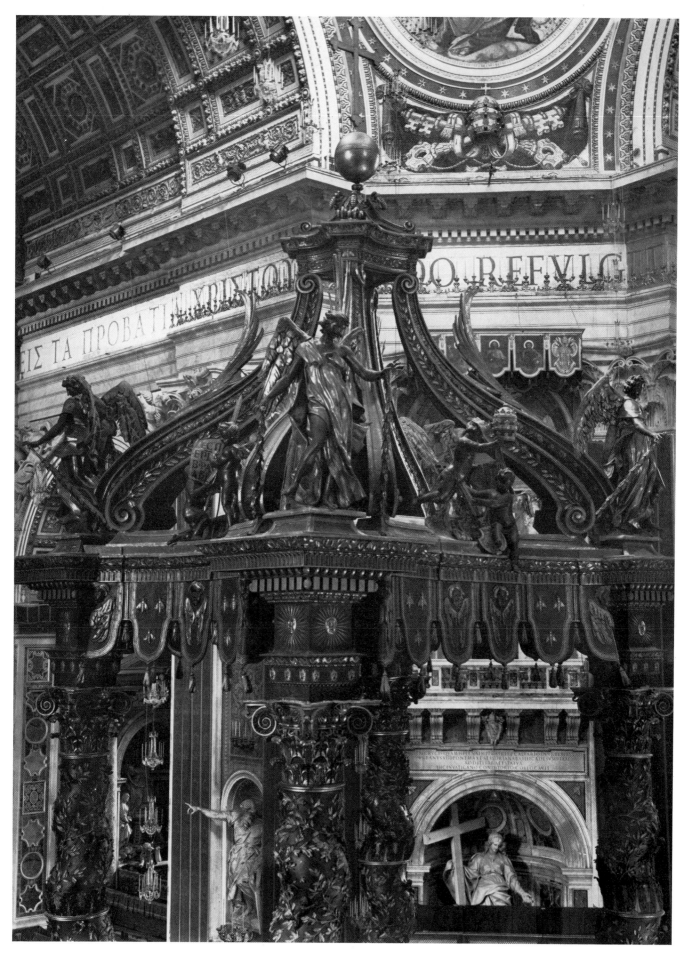

45. THE UPPER PART OF THE BALDACCHINO. Dark bronze, partly gilt. 1624-33. St. Peter's, Rome (Cat. No. 21)

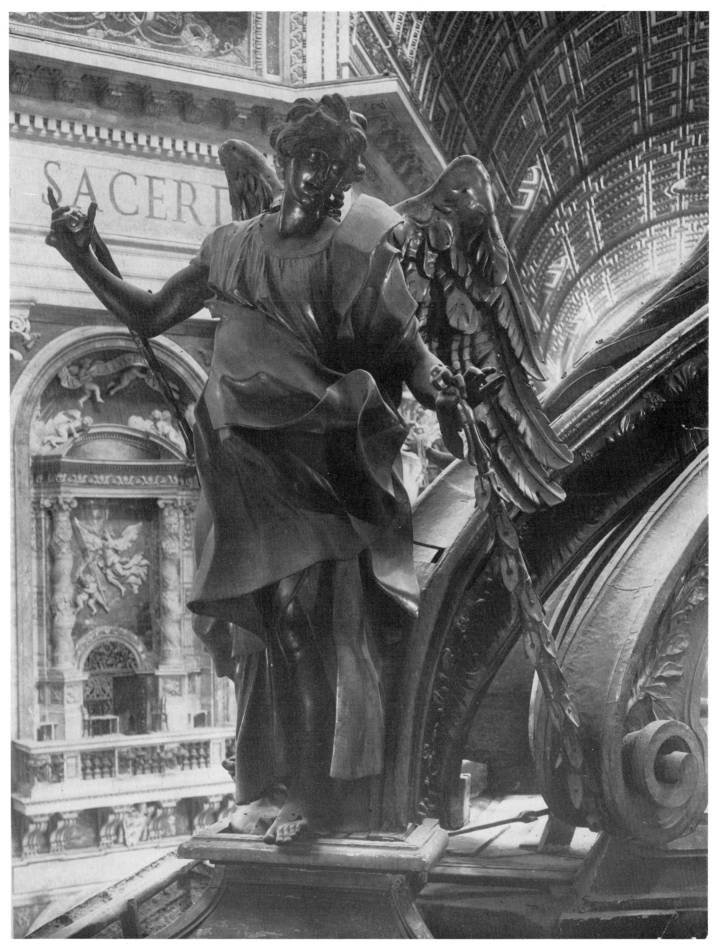

46. THE ANGEL ABOVE THE N.W. COLUMN OF THE BALDACCHINO

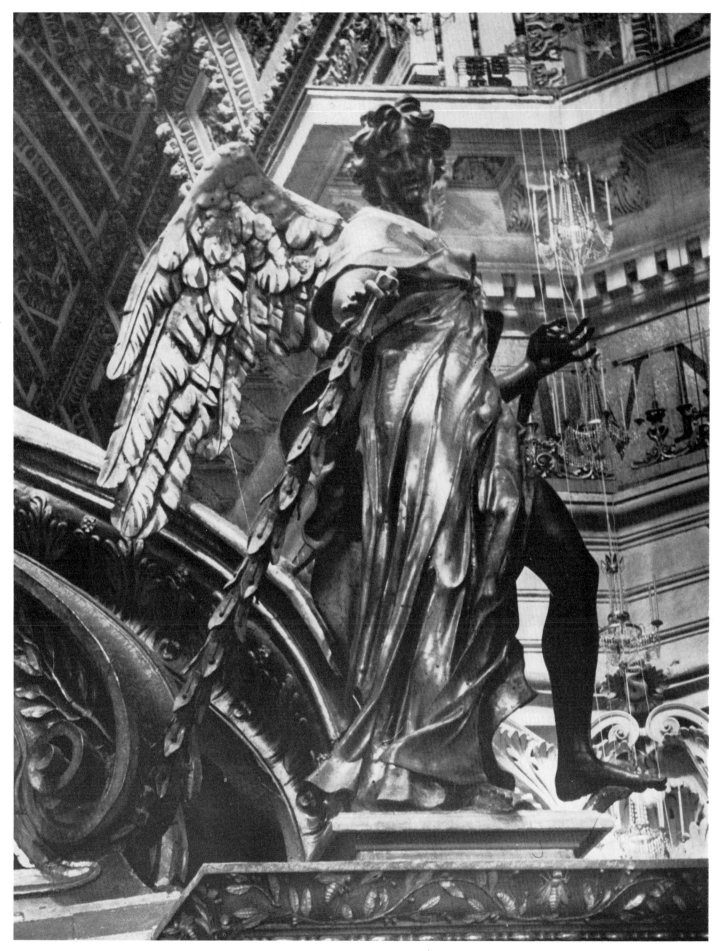

47. THE ANGEL ABOVE THE N.E. COLUMN OF THE BALDACCHINO

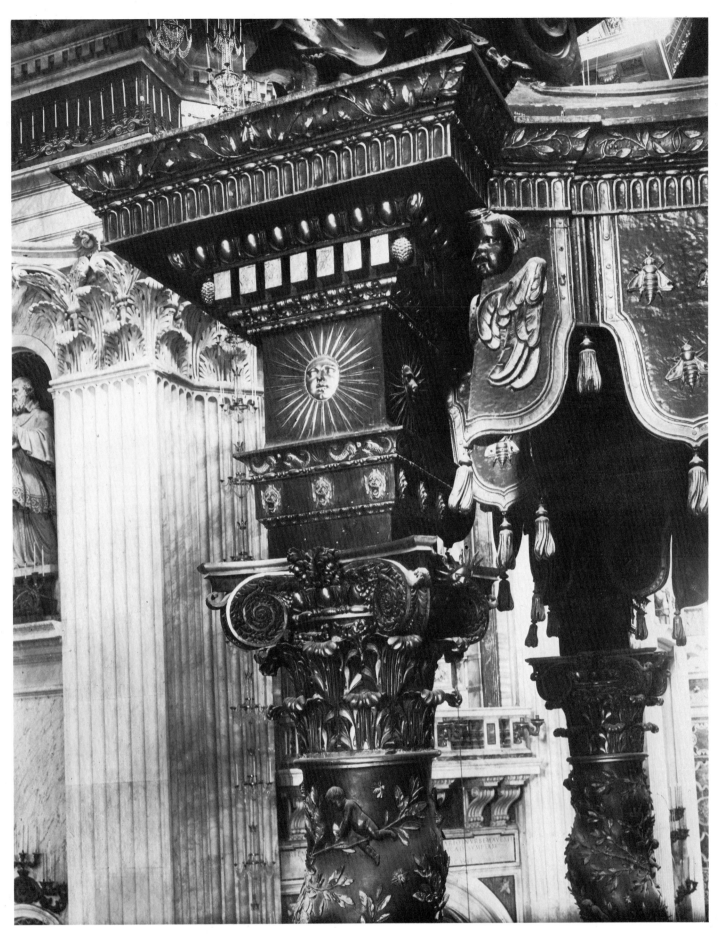

48. A COLUMN WITH ENTABLATURE FROM THE BALDACCHINO

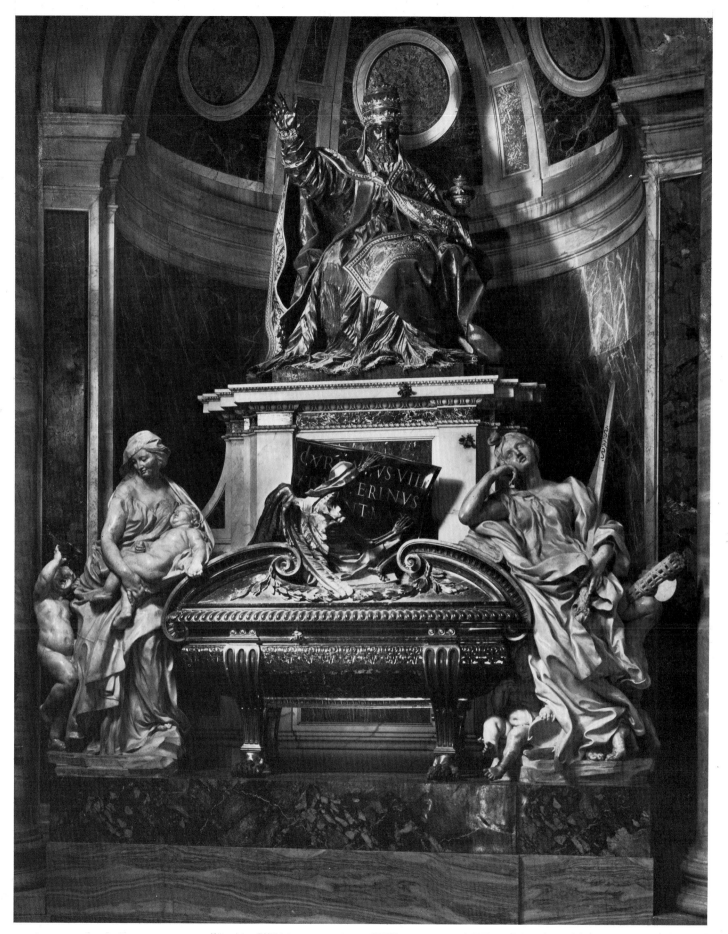

49. TOMB OF POPE URBAN VIII. Over life-size figures, marble and bronze, partly gilt. 1628–47. St. Peter's, Rome (Cat. No. 30)

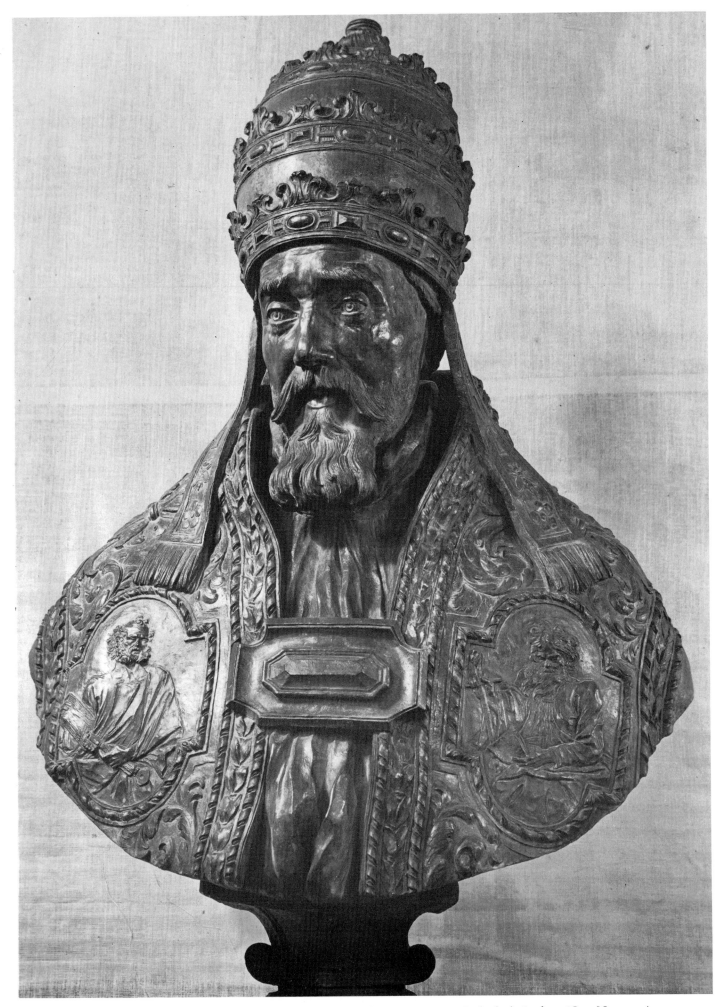

50. BUST OF POPE URBAN VIII. Bronze. Over life-size. 1640–44. Cathedral, Spoleto (Cat. No. 19-5)

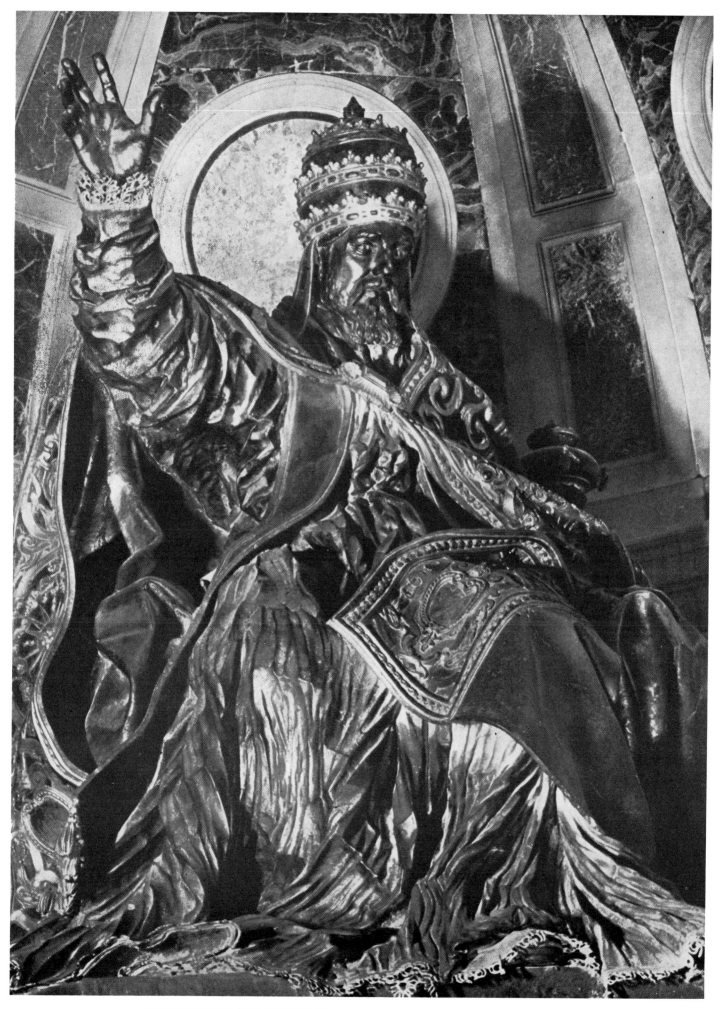

51. POPE URBAN VIII BLESSING. Detail of Plate 49. Bronze, partly gilt. 1628-31

52. PUTTO TO THE LEFT OF 'CHARITY'. Detail of Plate 49

53. HEAD OF 'CHARITY'. Detail of Plate 49

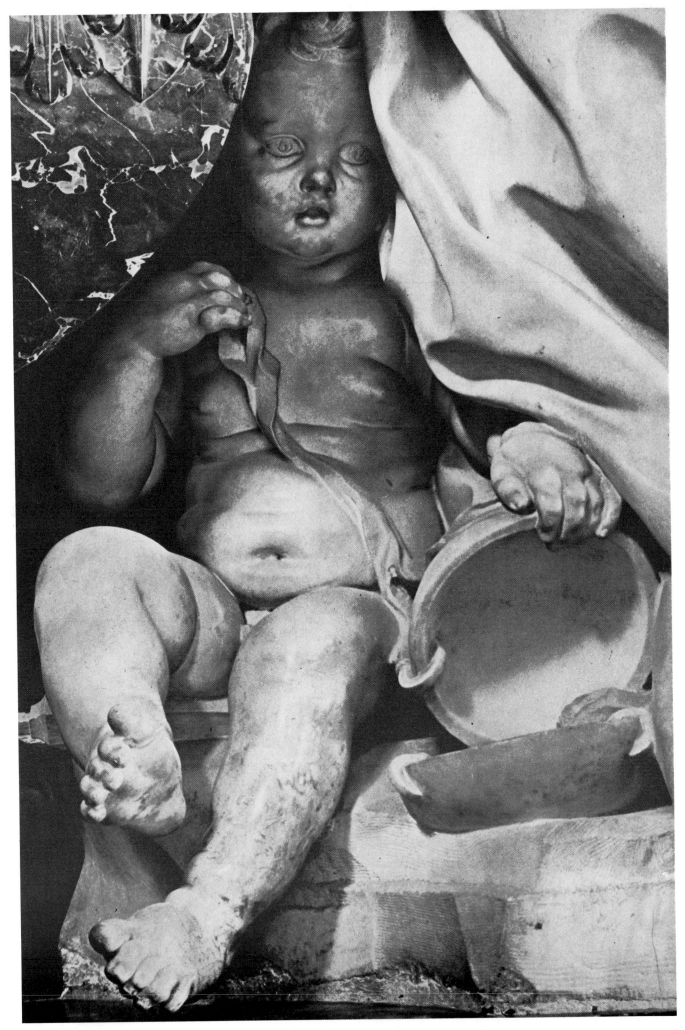

54. PUTTO TO THE LEFT OF 'JUSTICE'. Detail of Plate 49

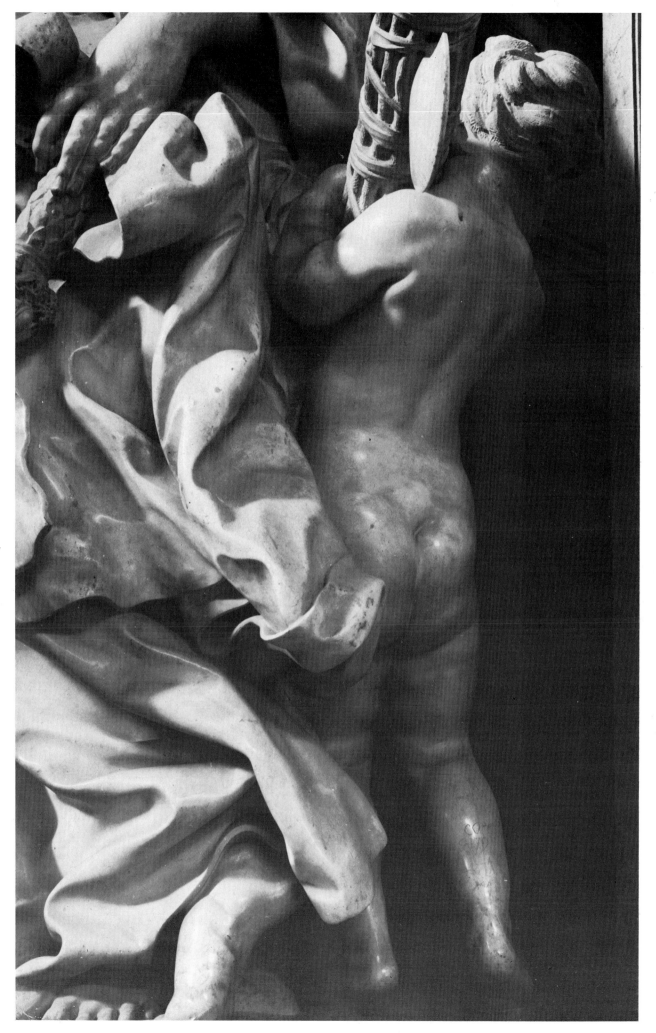

55. PUTTO TO THE RIGHT OF 'JUSTICE'. Detail of Plate 49

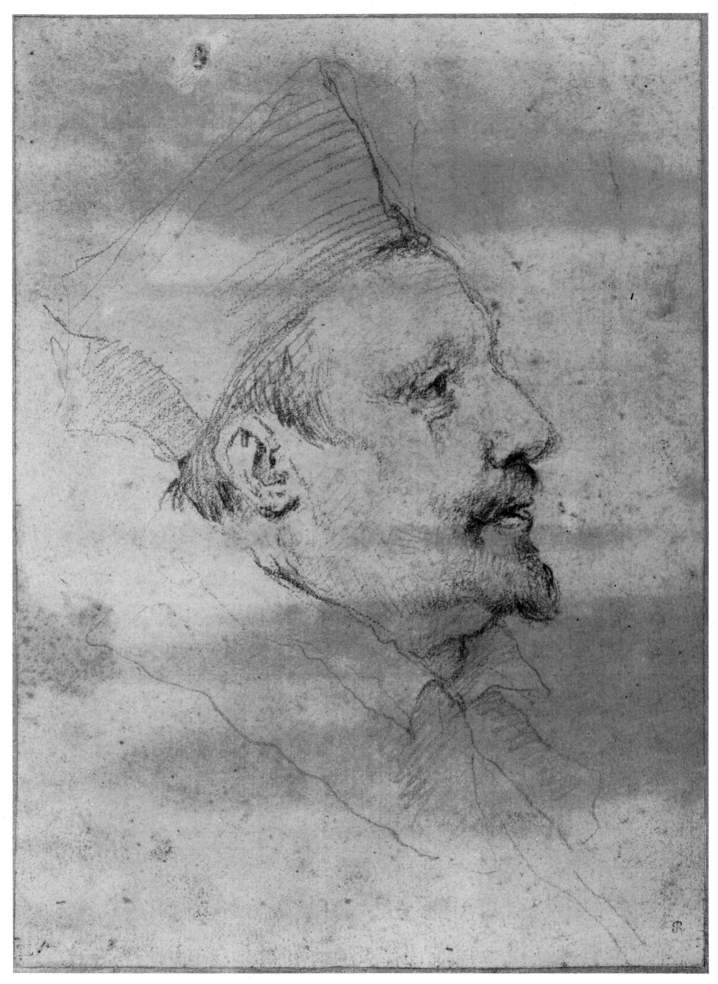

56. CARDINAL SCIPIONE BORGHESE. Drawing, black chalk. Pierpont Morgan Library, New York (Cat. No. 31)

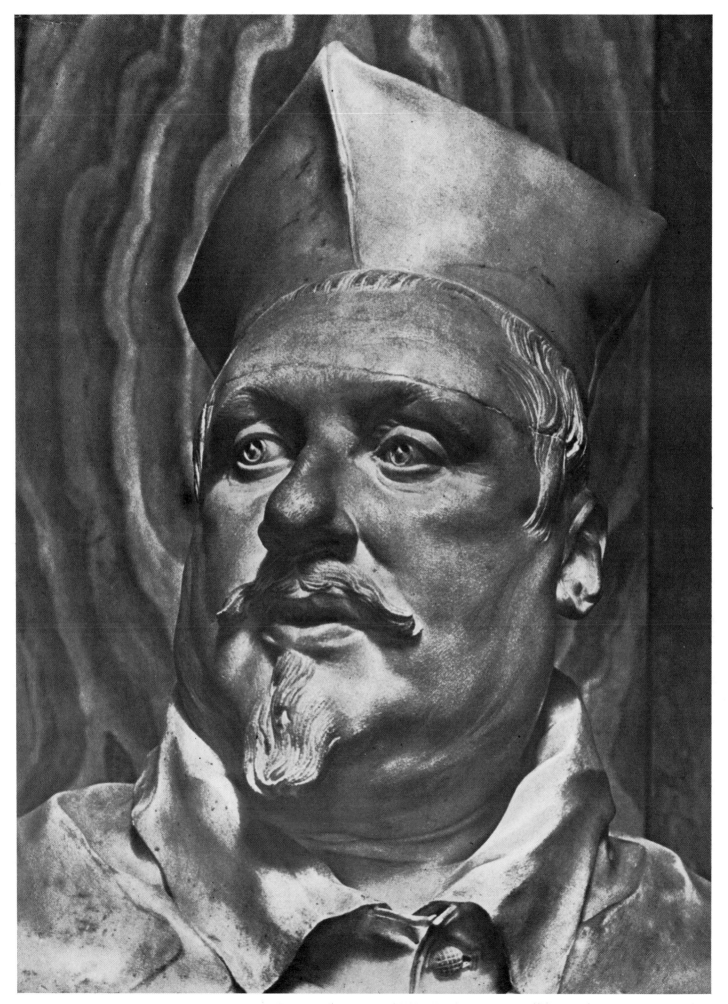

57. BUST OF CARDINAL SCIPIONE BORGHESE. Detail. Over life-size. 1632. Galleria Borghese, Rome (Cat. No. 31)

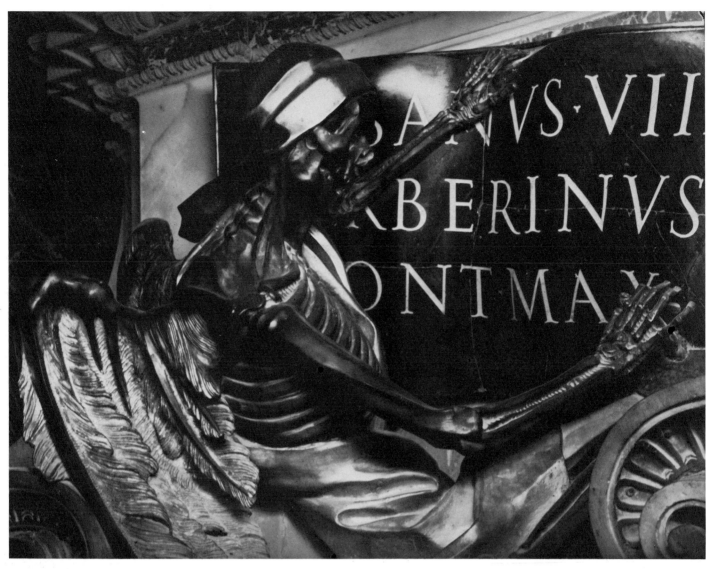

58. 'DEATH' FROM THE TOMB OF POPE URBAN VIII. Detail of Plate 49

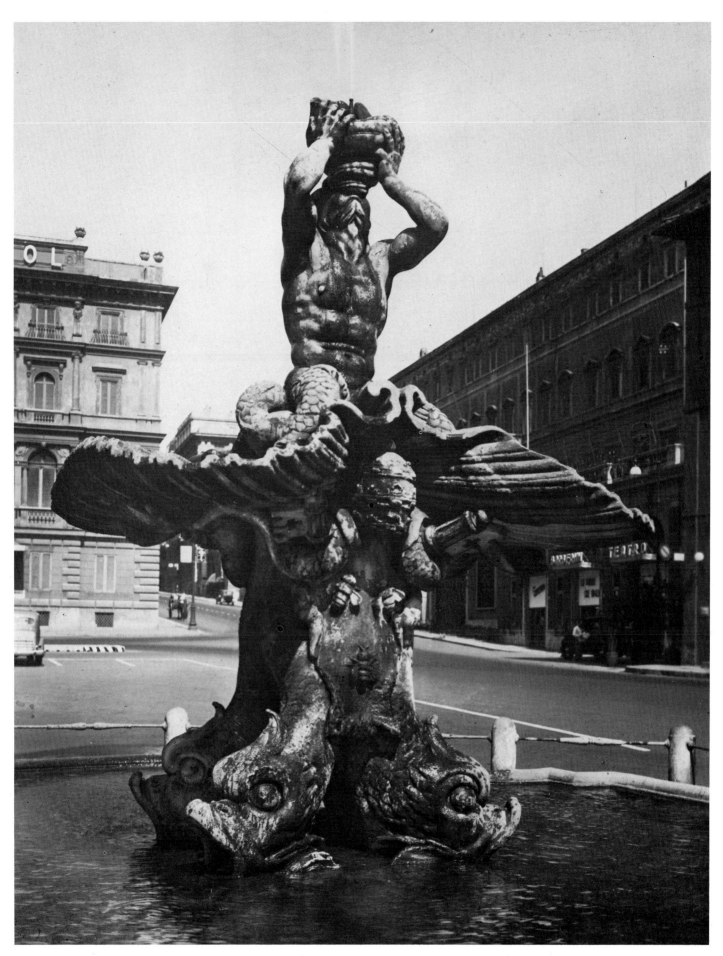

59. TRITON FOUNTAIN. Monumental size. Travertine. 1642-43. Piazza Barberini, Rome (Cat. No. 32)

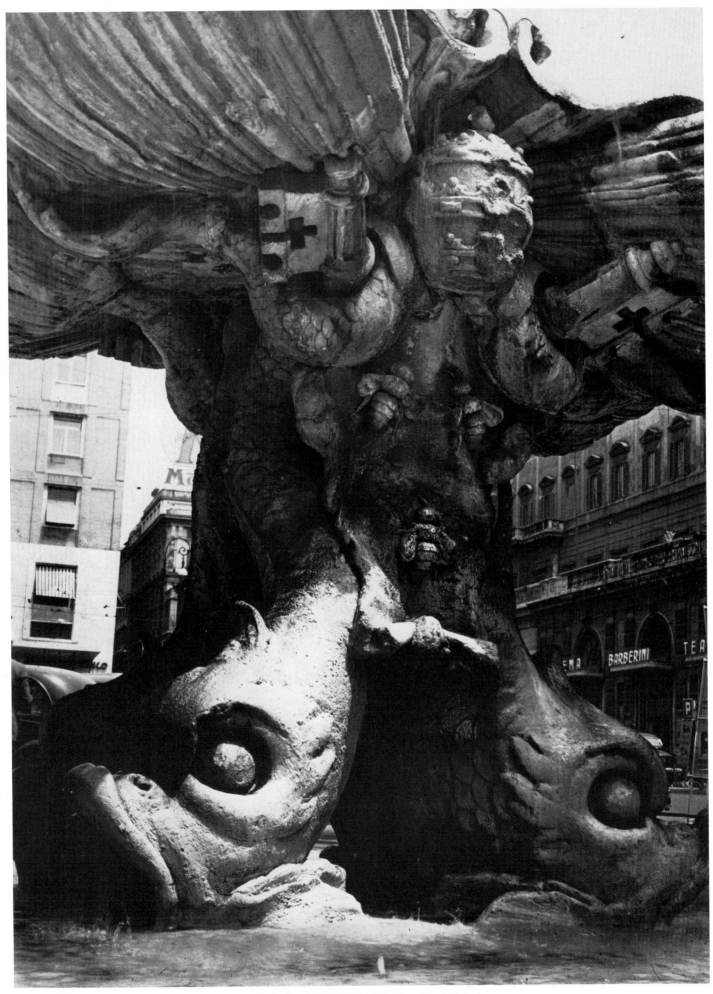

60. TRITON FOUNTAIN, Detail of Plate 59

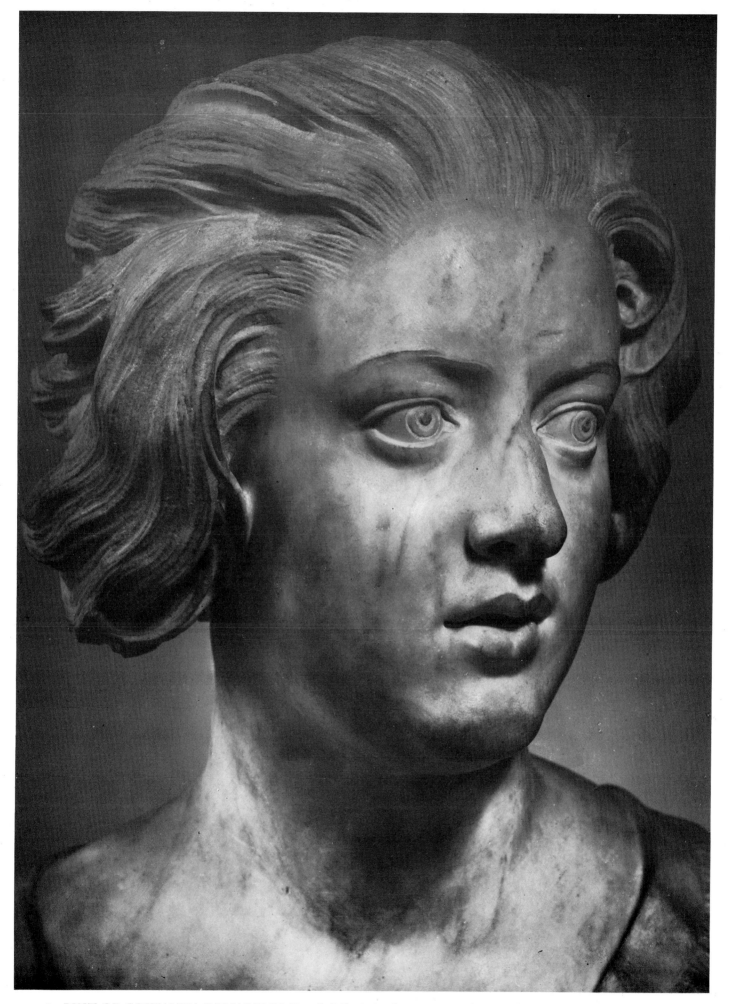

61. BUST OF COSTANZA BONARELLI. Detail. Life-size. About 1635. Museo Nazionale, Florence (Cat. No. 35)

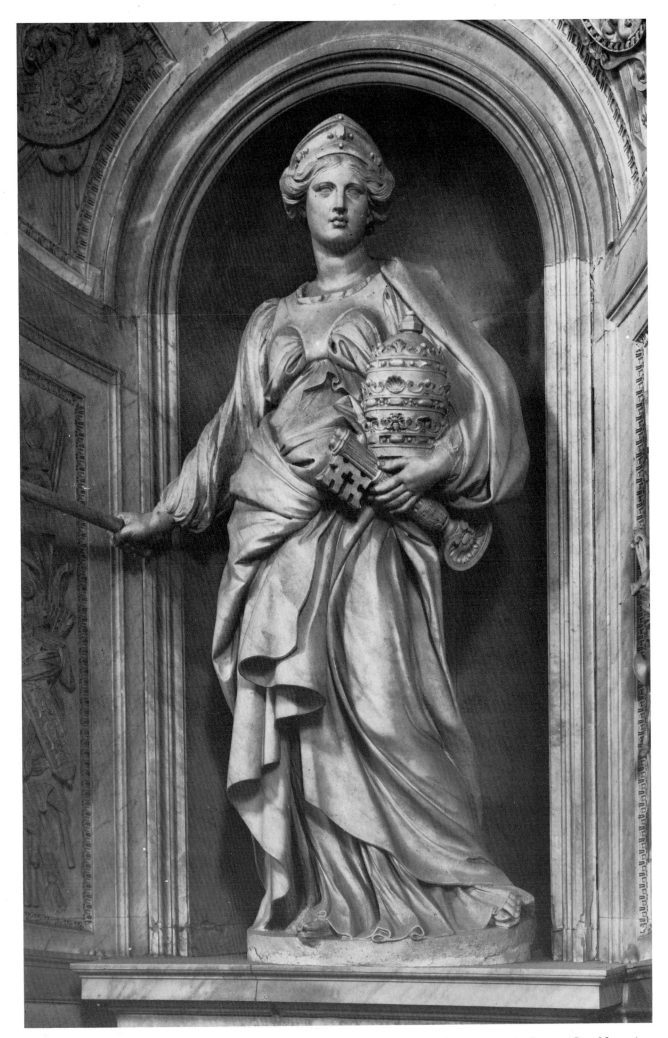

62. THE COUNTESS MATILDA. Over life-size. 1633-37. From the tomb in St. Peter's, Rome (Cat. No. 33)

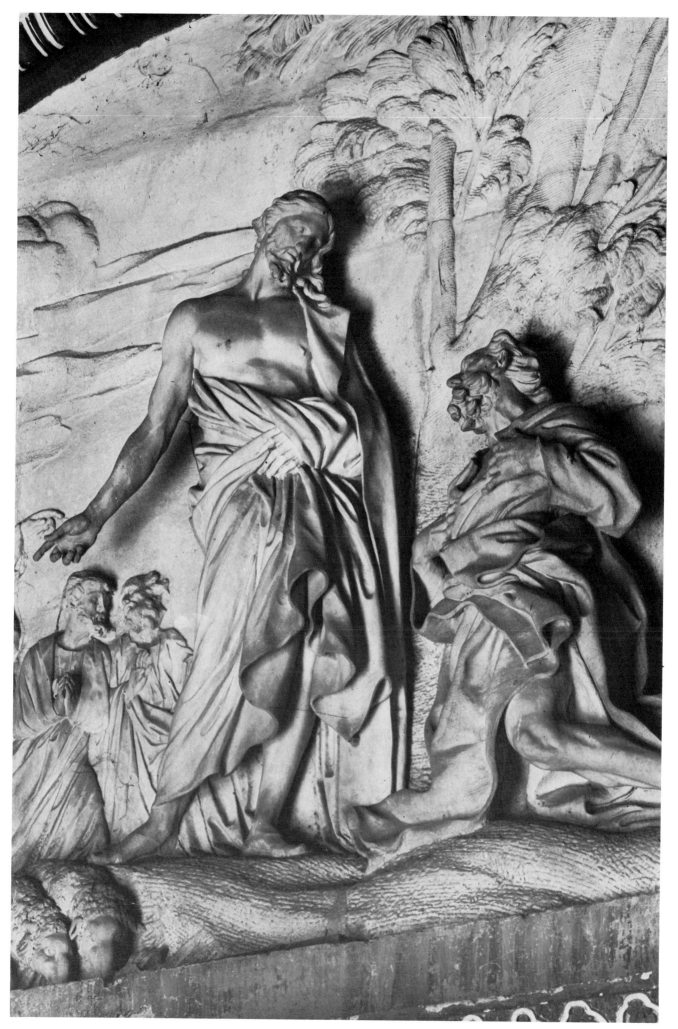

63. 'PASCE OVES MEAS'.
Detail. Over life-size. 1633-46. Relief above the central door of the portico, St. Peter's, Rome (Cat. No. 34)

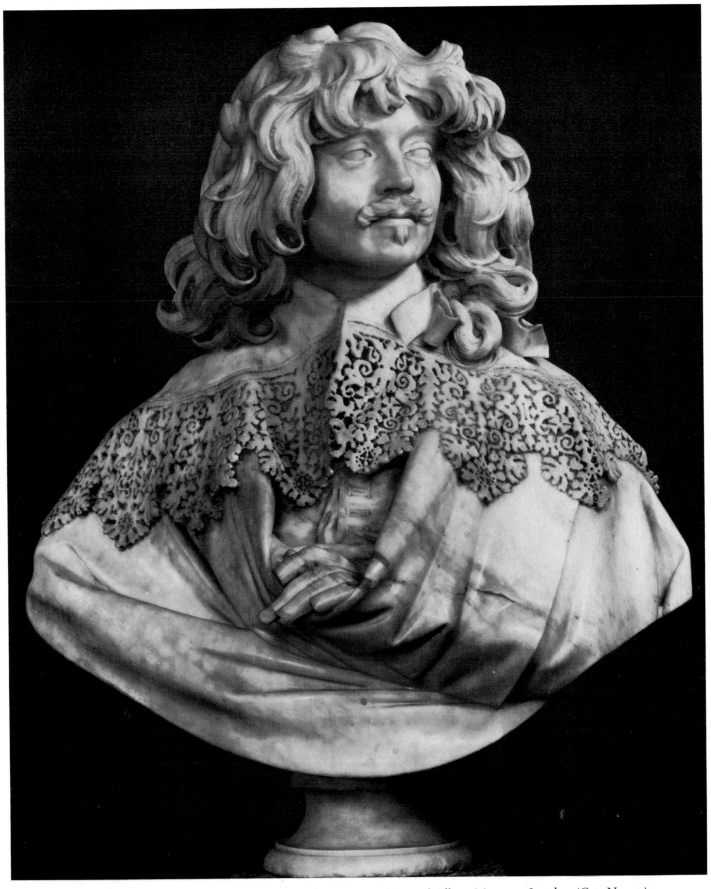

64. BUST OF THOMAS BAKER. Life-size. 1638. Victoria and Albert Museum, London (Cat. No. 40)

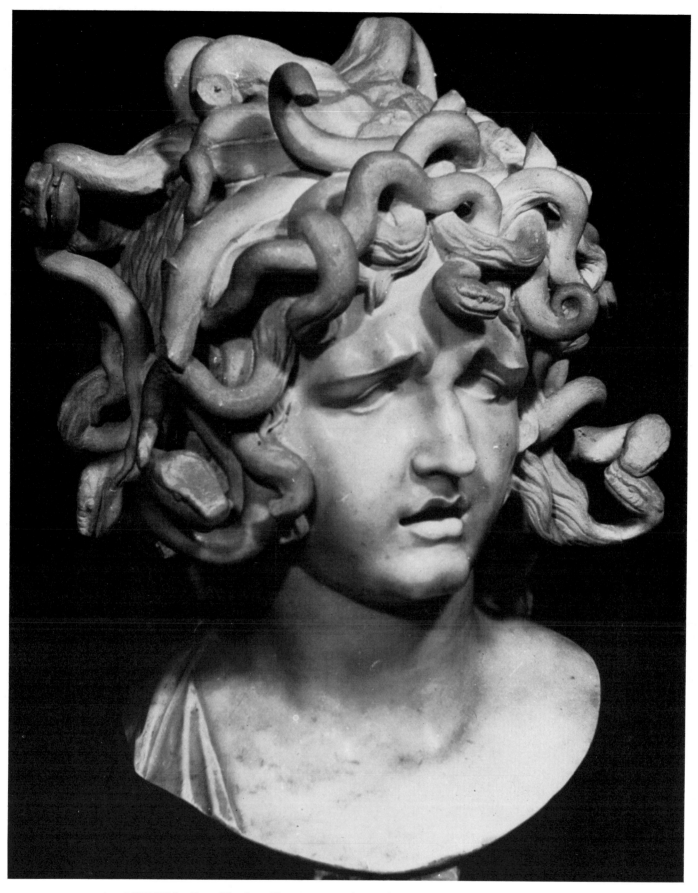

65. MEDUSA. Over life-size. About 1635. Palazzo dei Conservatori, Rome (Cat. No. 41)

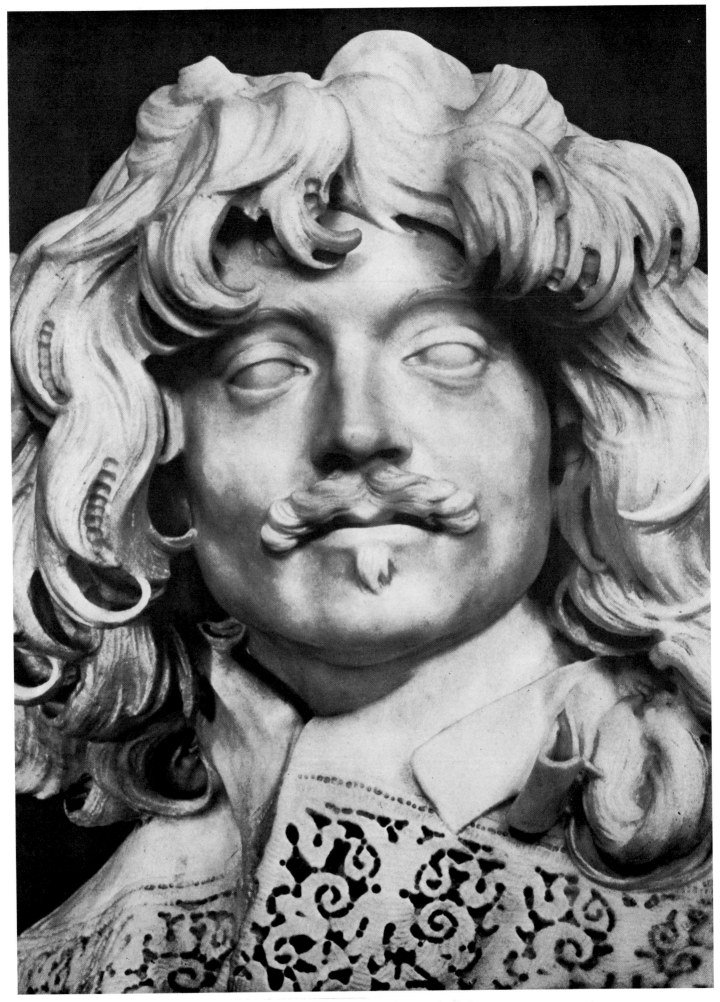

66. HEAD OF THOMAS BAKER. Detail of Plate 64

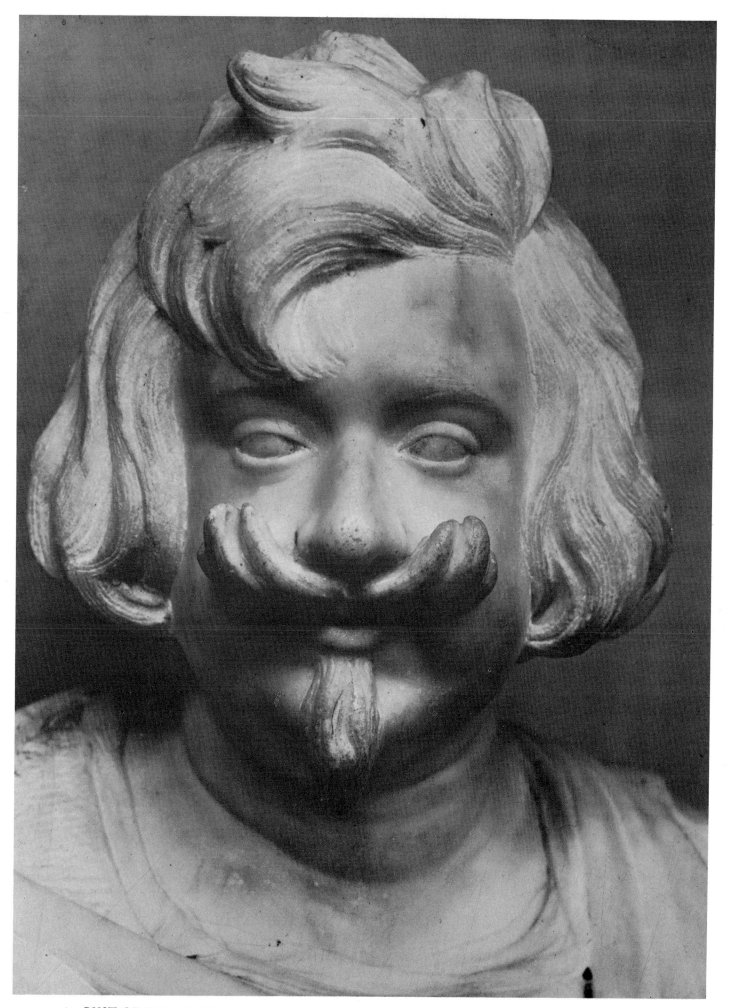

67. BUST OF PAOLO GIORDANO II ORSINI, DUKE OF BRACCIANO. Detail. Life-size. About 1635.
Castle of Bracciano (Cat. No. 36)

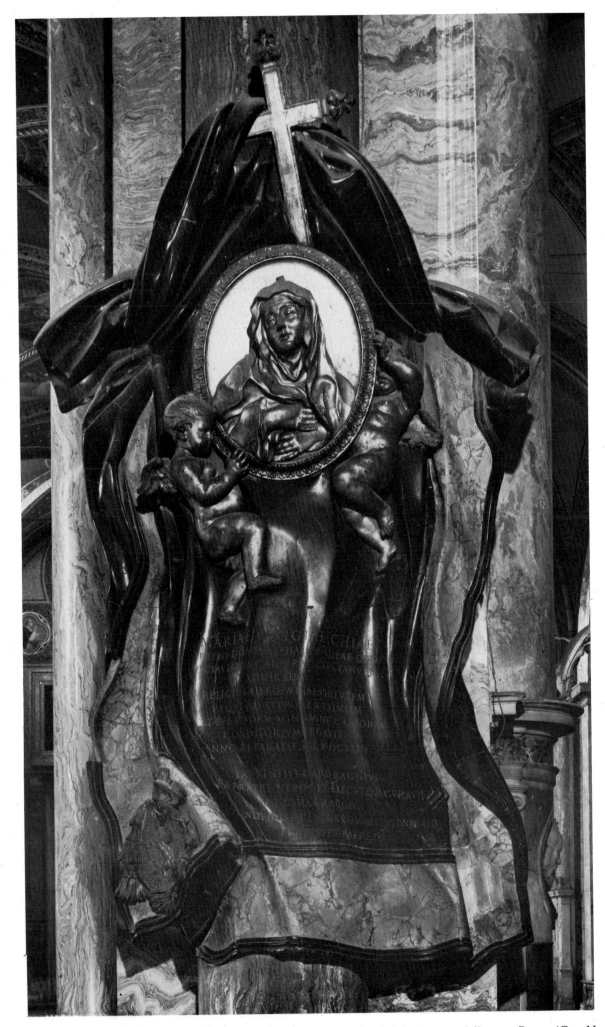

68. TOMB OF MARIA RAGGI. Life-size figures, gilt bronze. 1643. S. Maria sopra Minerva, Rome (Cat. No. 44)

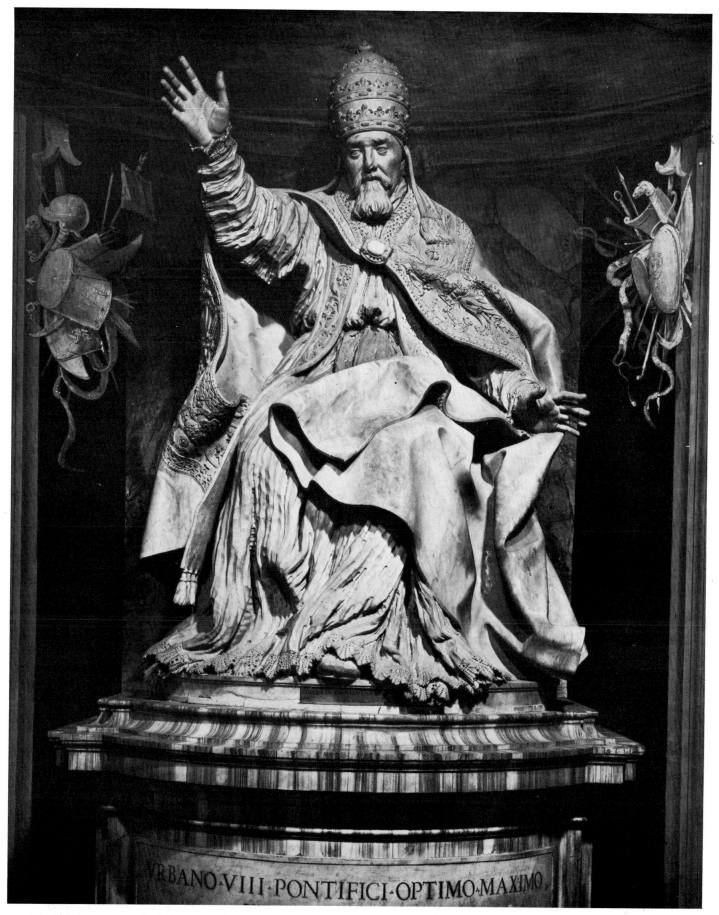

69. MEMORIAL STATUE OF POPE URBAN VIII. Monumental size. 1635-40. Palazzo dei Conservatori, Rome (Cat. No. 38)

70. TOMB OF MARIA RAGGI. Detail of Plate 68

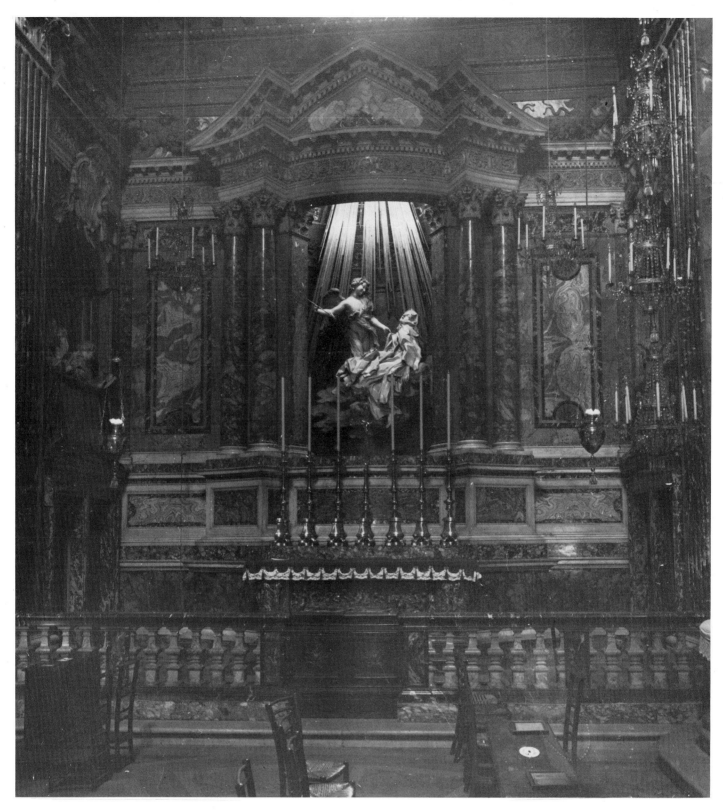

71. THE ALTAR OF ST. TERESA. Life-size figures. 1645–52. Cornaro Chapel, S. Maria della Vittoria, Rome (Cat. No. 48)

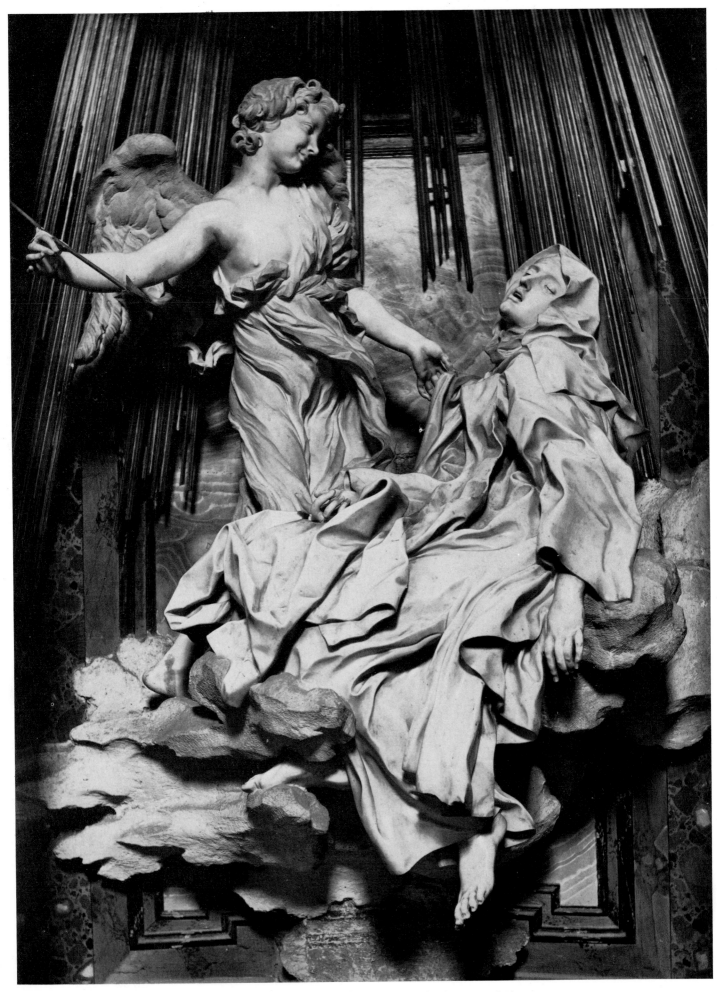

72. THE ECSTASY OF ST. TERESA. Central group of Plate 71

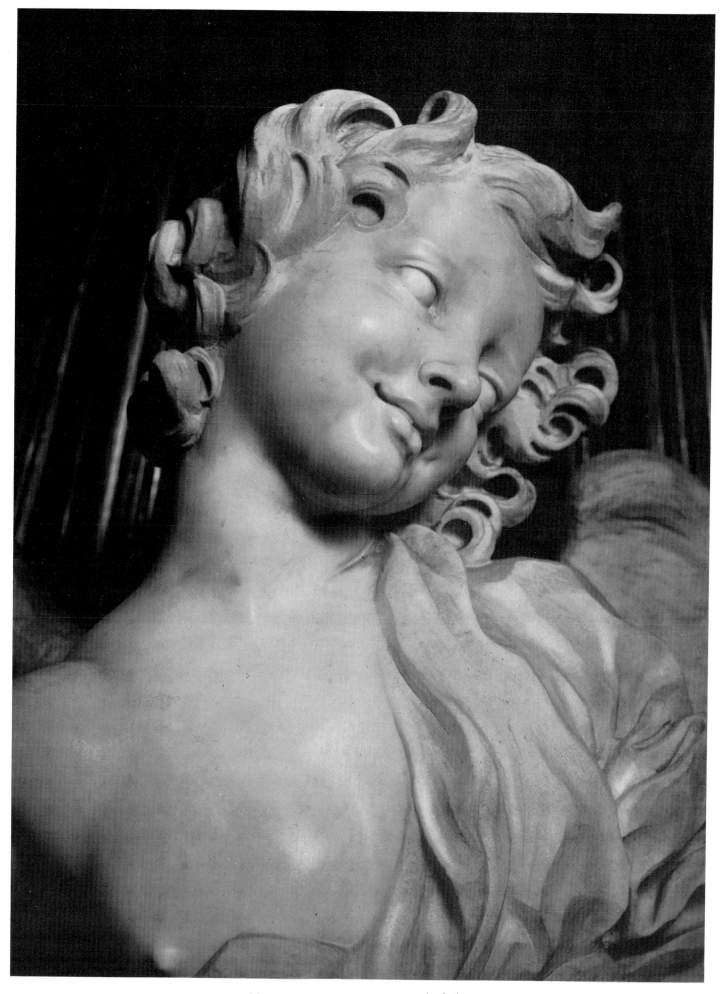

73. THE SERAPH'S HEAD. Detail of Plate 72

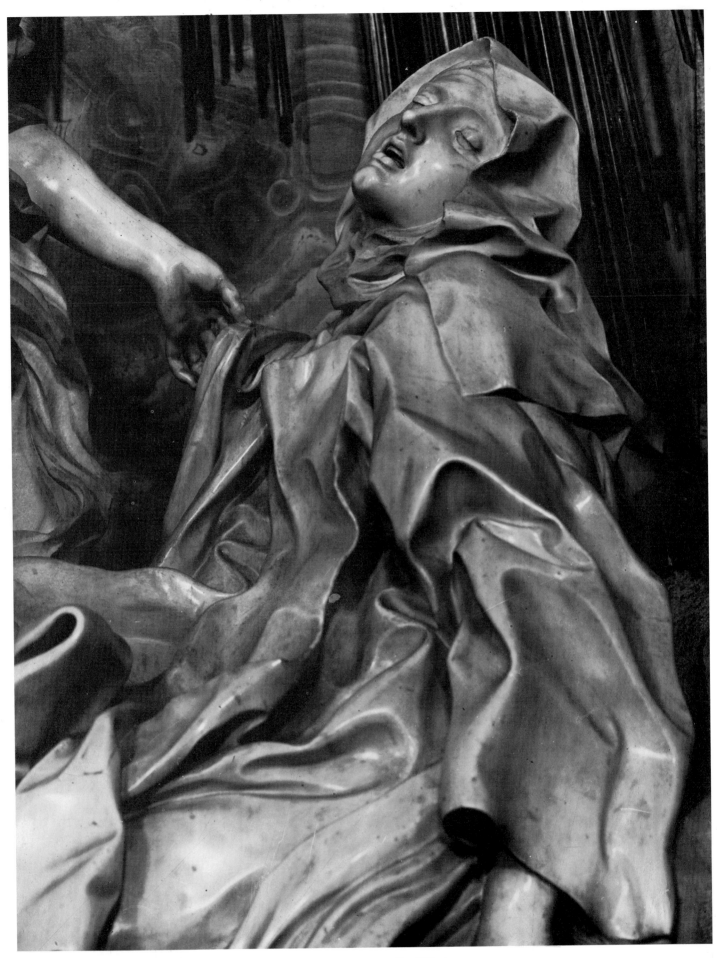

74. ST. TERESA. Detail of Plate 72

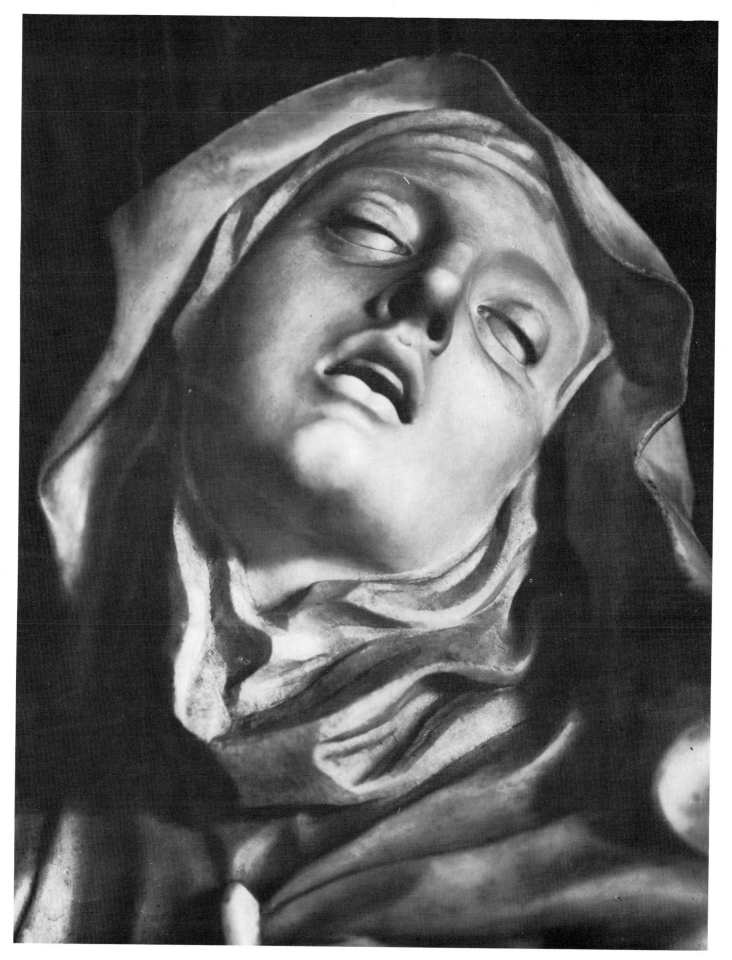

75. HEAD OF ST. TERESA. Detail of Plate 72

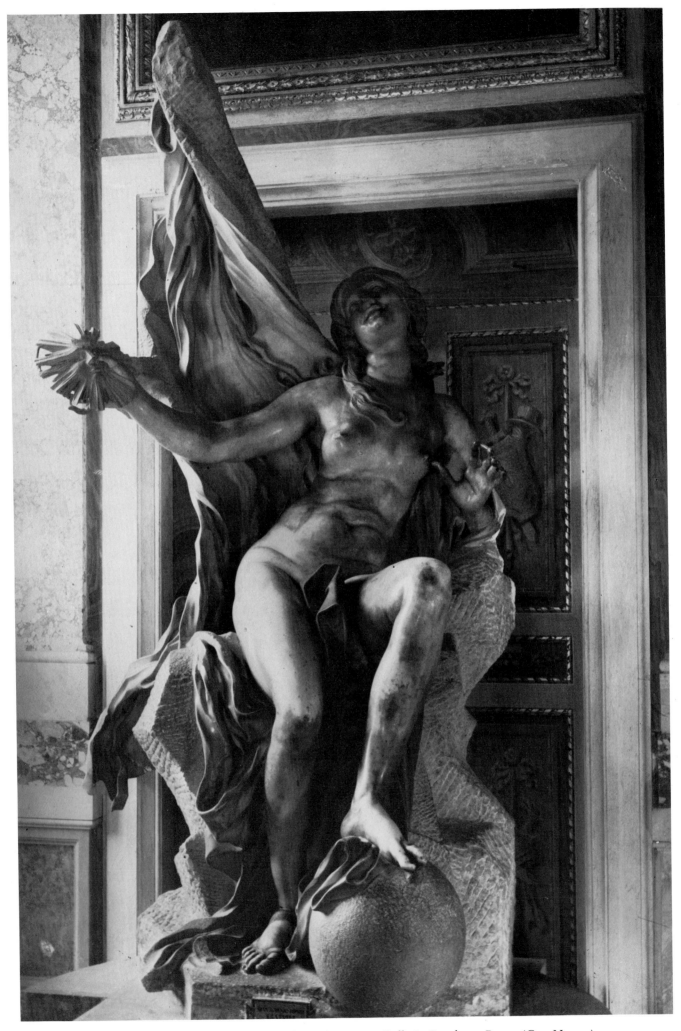

76. TRUTH UNVEILED. Over life-size. 1646–52. Galleria Borghese, Rome (Cat. No. 49)

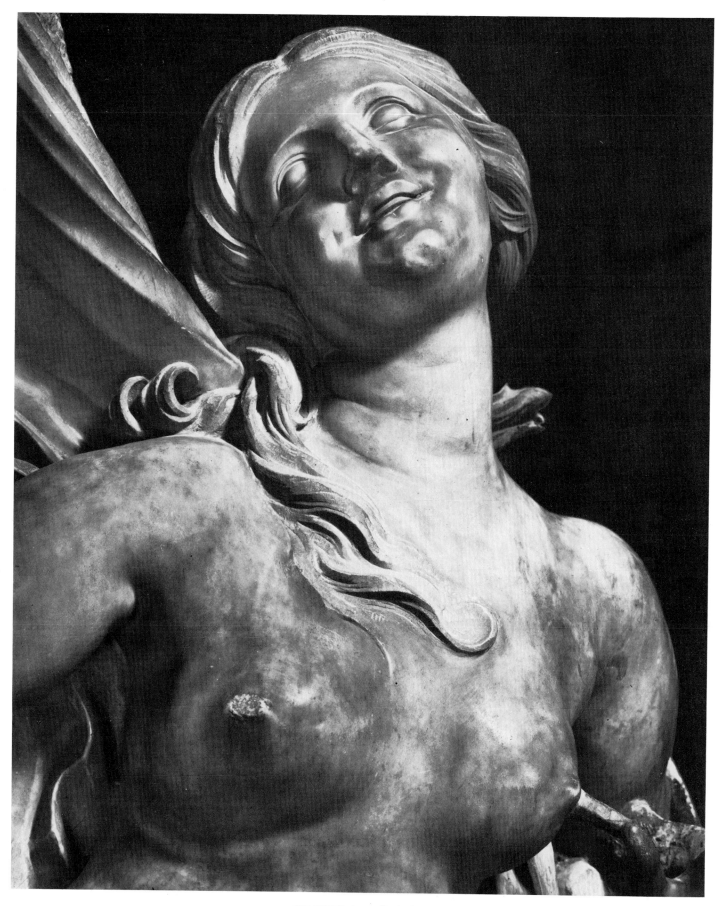

77. TRUTH. Detail of Plate 76

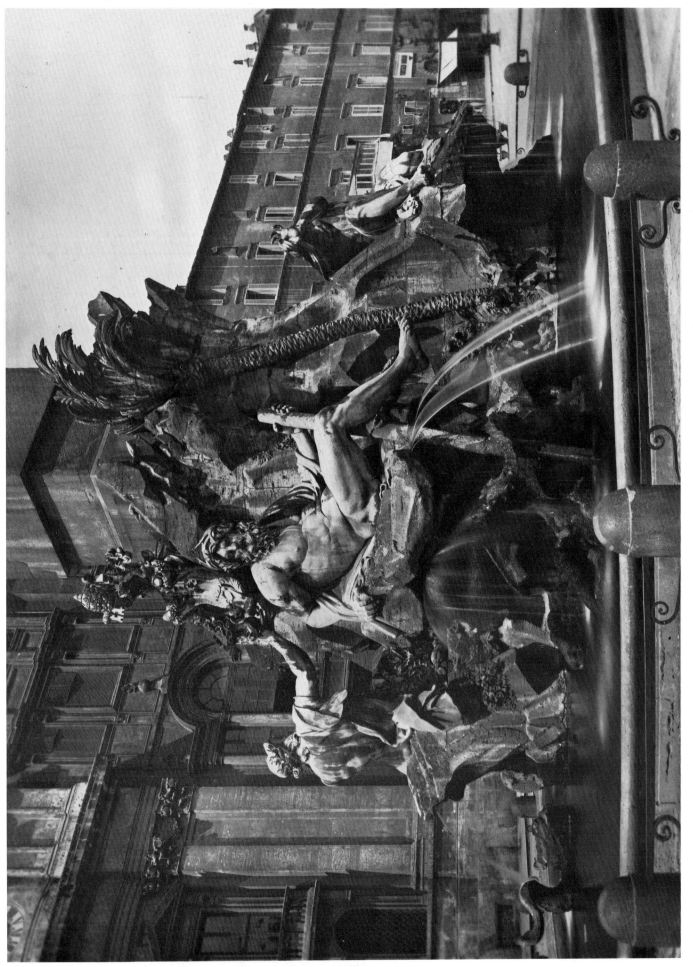

78. FOUNTAIN OF THE FOUR RIVERS. Travertine; the four giant figures: marble. 1648–51. Piazza Navona, Rome (Cat. No. 50)

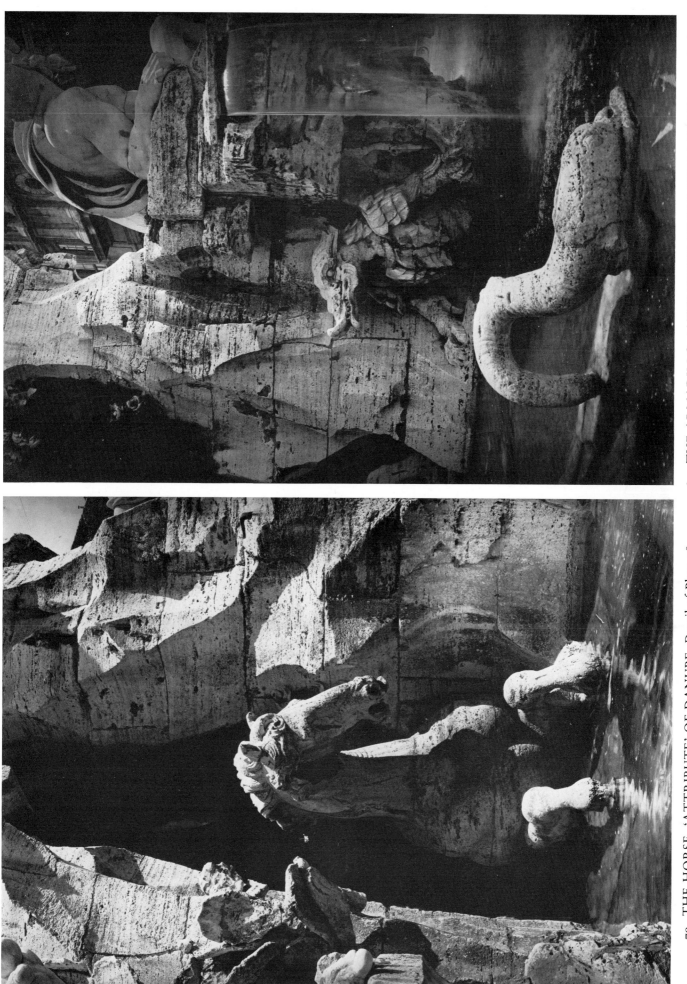

79. THE HORSE, 'ATTRIBUTE' OF DANUBE. Detail of Plate 78

80. THE ARMADILLO, 'ATTRIBUTE' OF RIO DELLA PLATA. Detail of Plate 78

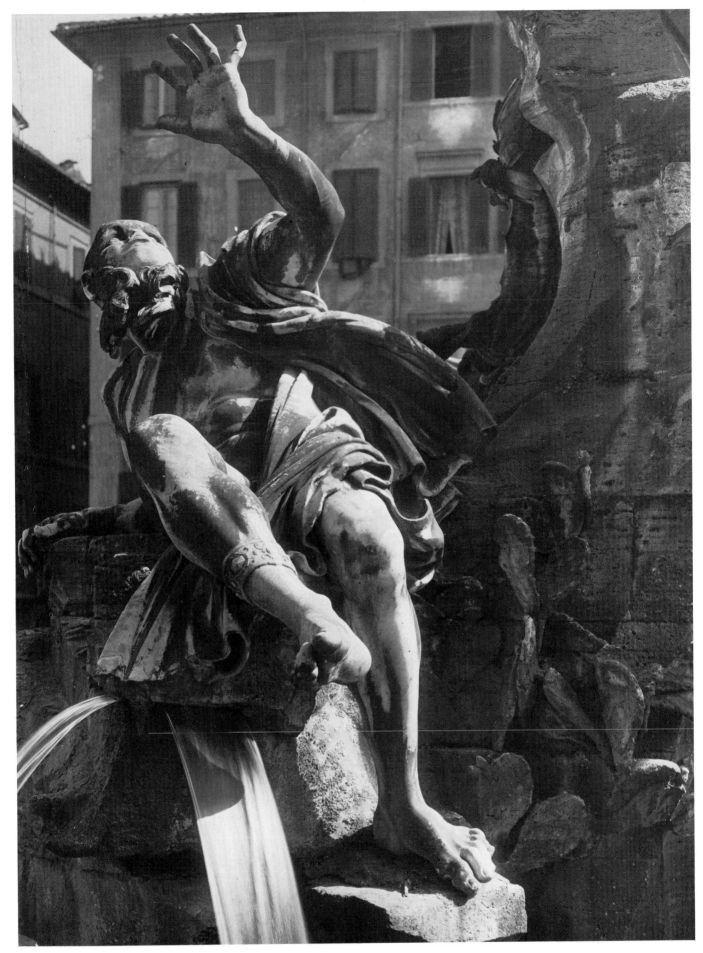

81. THE RIO DELLA PLATA. Detail of Plate 78

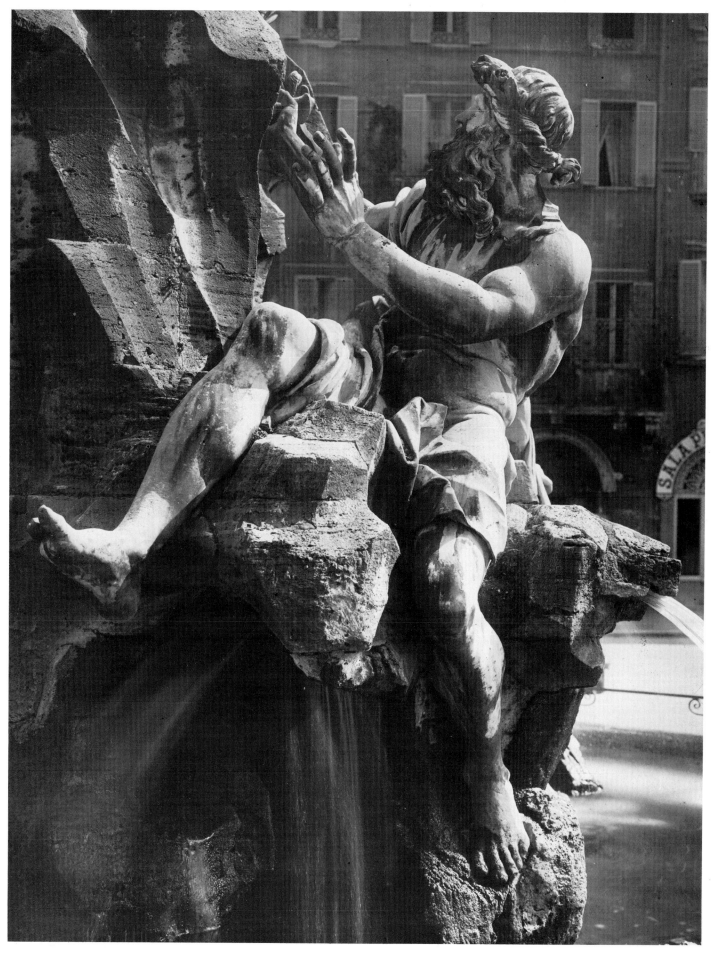

82. THE DANUBE. Detail of Plate 78

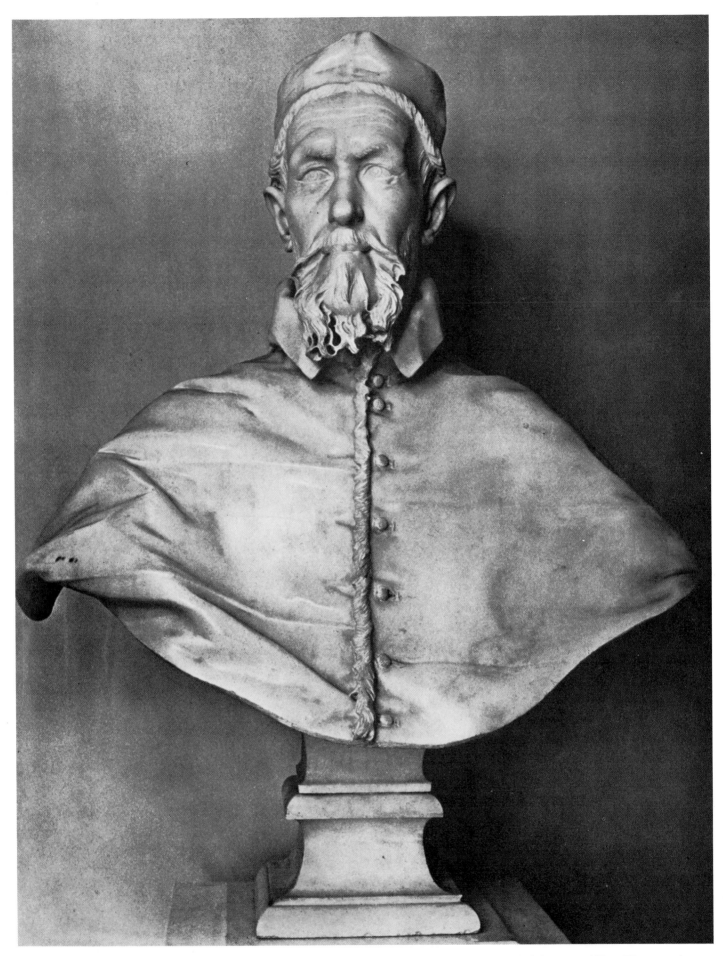

83. BUST OF POPE INNOCENT X. Over life-size. About 1650. Palazzo Doria-Pamphili, Rome (Cat. No. 51-2a)

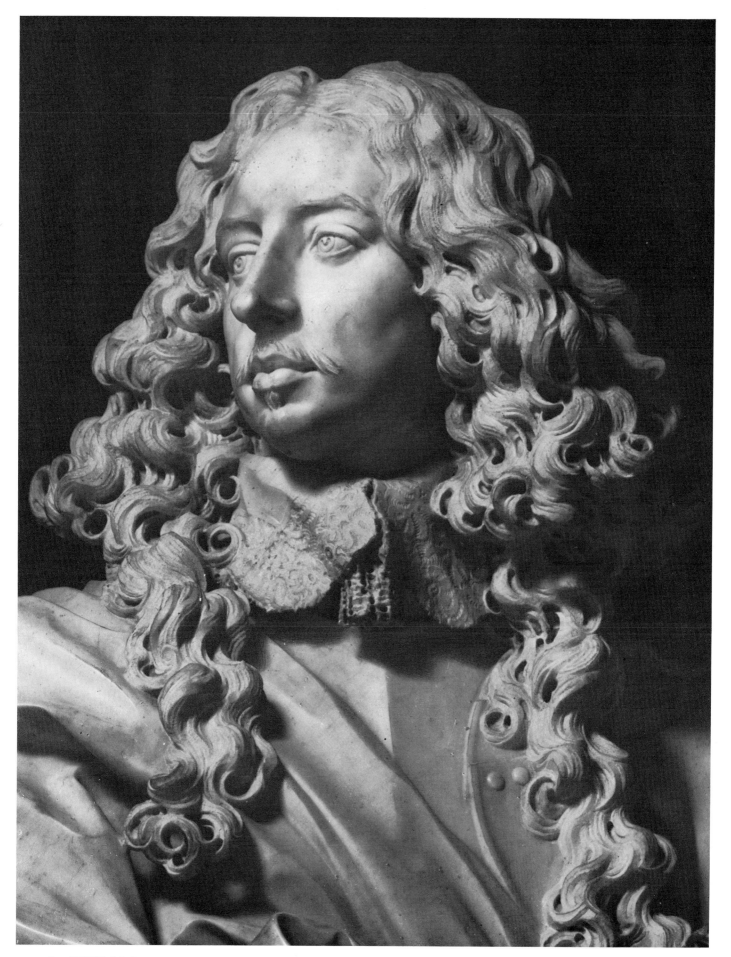

84. BUST OF DUKE FRANCIS I D'ESTE. Detail. Over life-size. 1650–51. Museo Estense, Modena (Cat. No. 54)

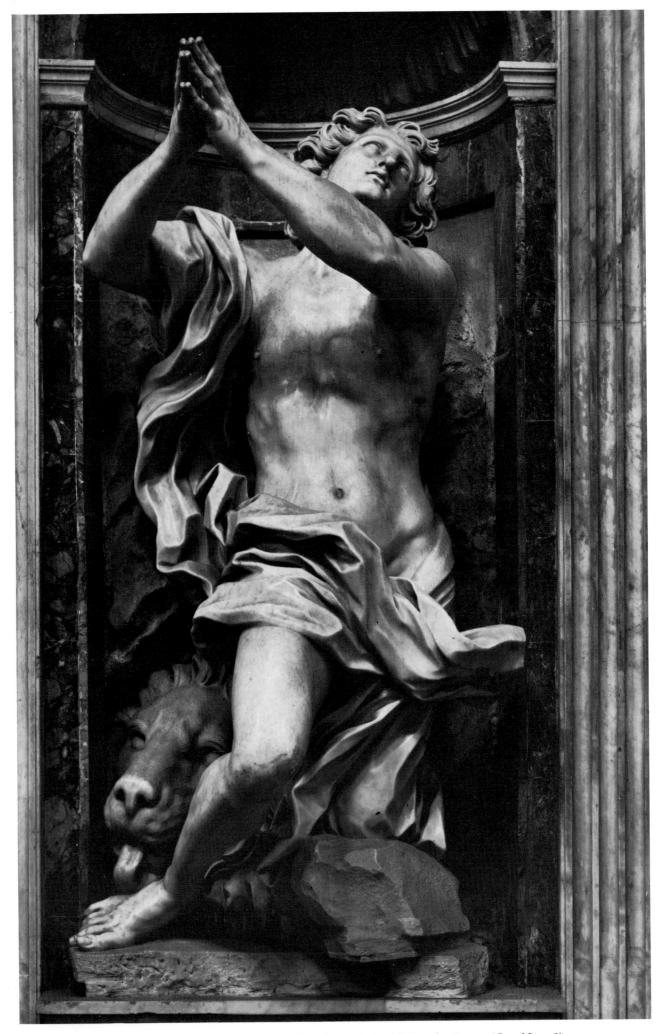

85. DANIEL. Over life-size. 1655–57. Chigi Chapel, S. Maria del Popolo, Rome (Cat. No. 58)

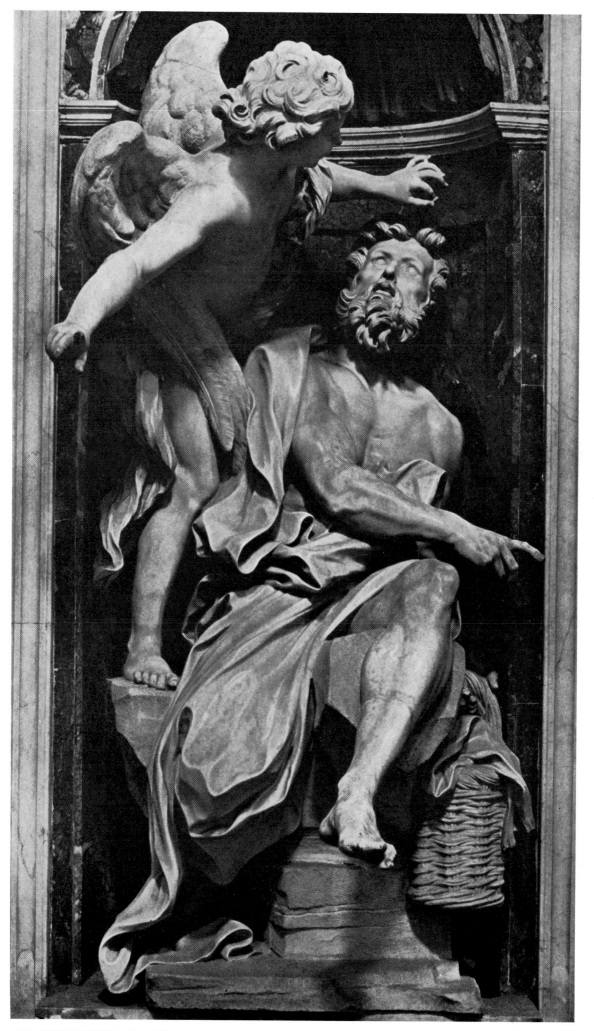

86. HABAKKUK. Over life-size. 1655–61. Chigi Chapel, S. Maria del Popolo, Rome (Cat. No. 58)

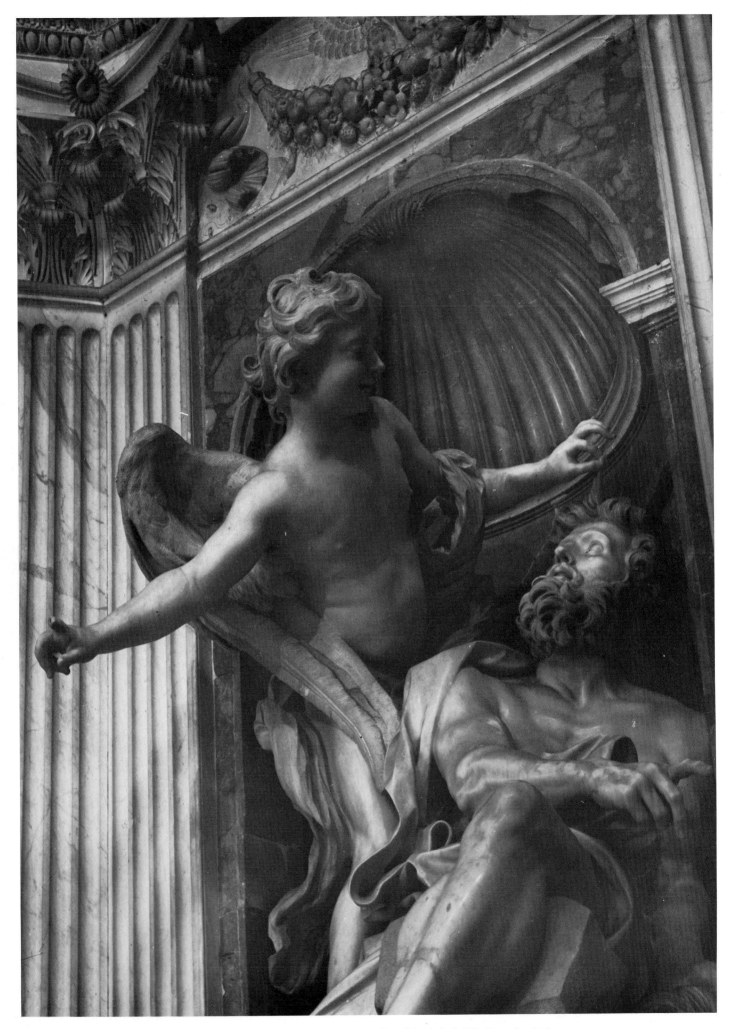

87. THE ANGEL LIFTING HABAKKUK BY A LOCK. Detail of Plate 86

88. FONTANA DEL MORO. Over life-size. 1653-55. Piazza Navona, Rome (Cat. No. 55)

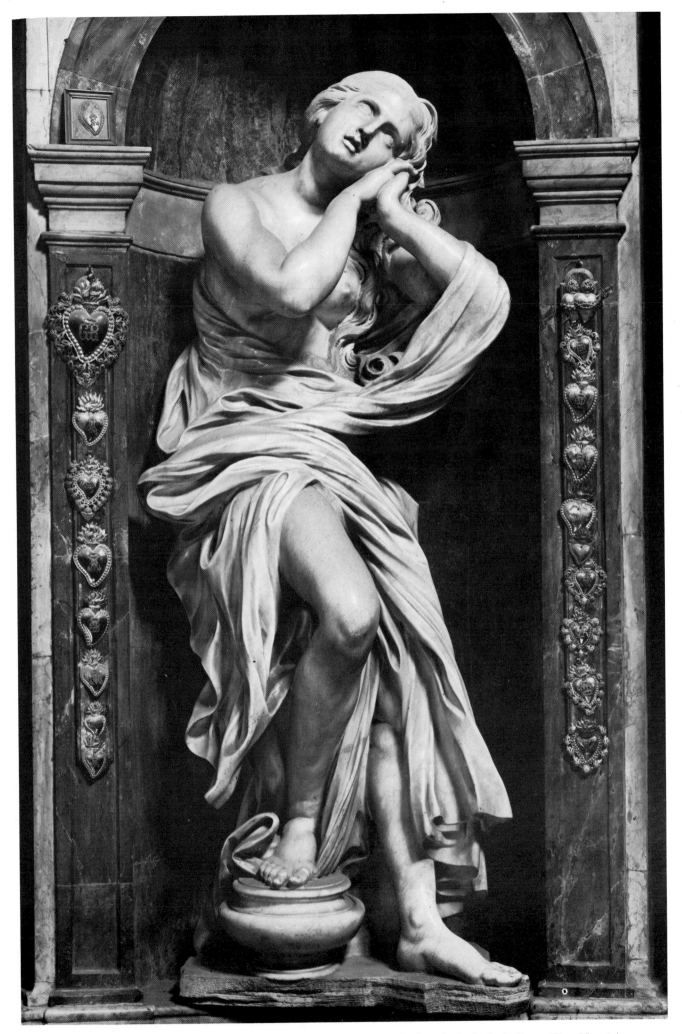

89. ST. MARY MAGDALEN. Over life-size. 1661–63. Chigi Chapel, Cathedral, Siena (Cat. No. 63)

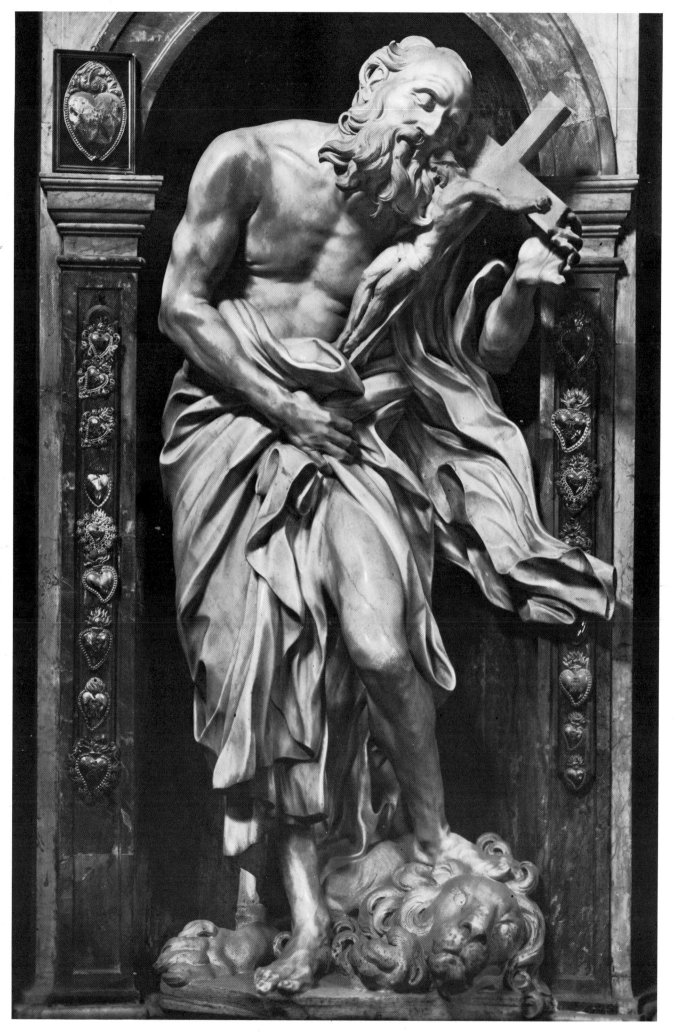

90. ST. JEROME. Over life-size. 1661-63. Chigi Chapel, Cathedral, Siena (Cat. No. 63)

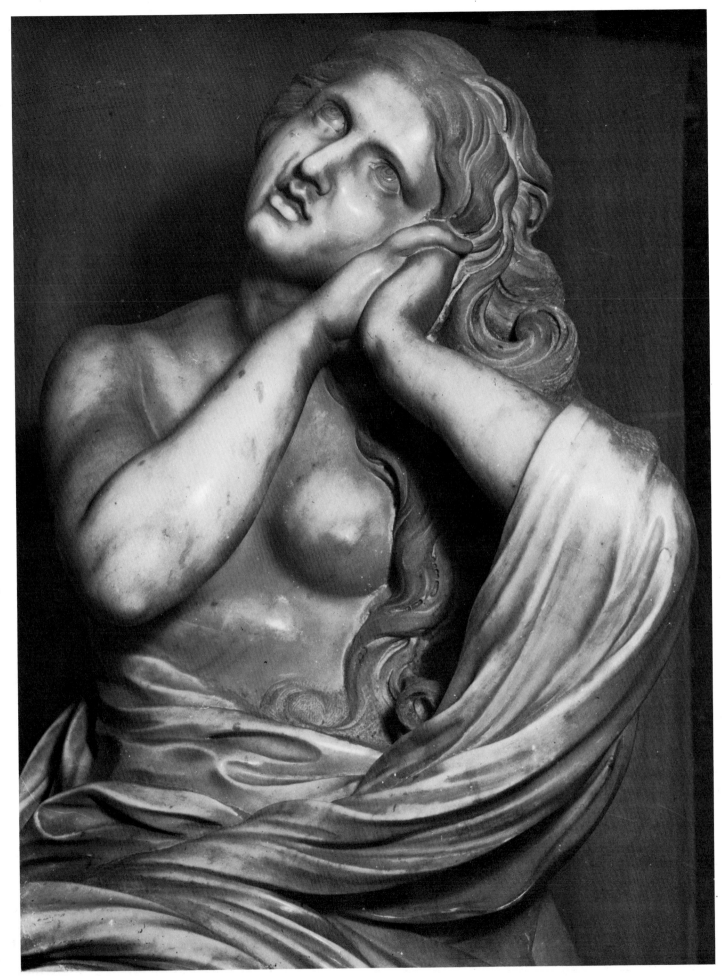

91. ST. MARY MAGDALEN. Detail of Plate 89

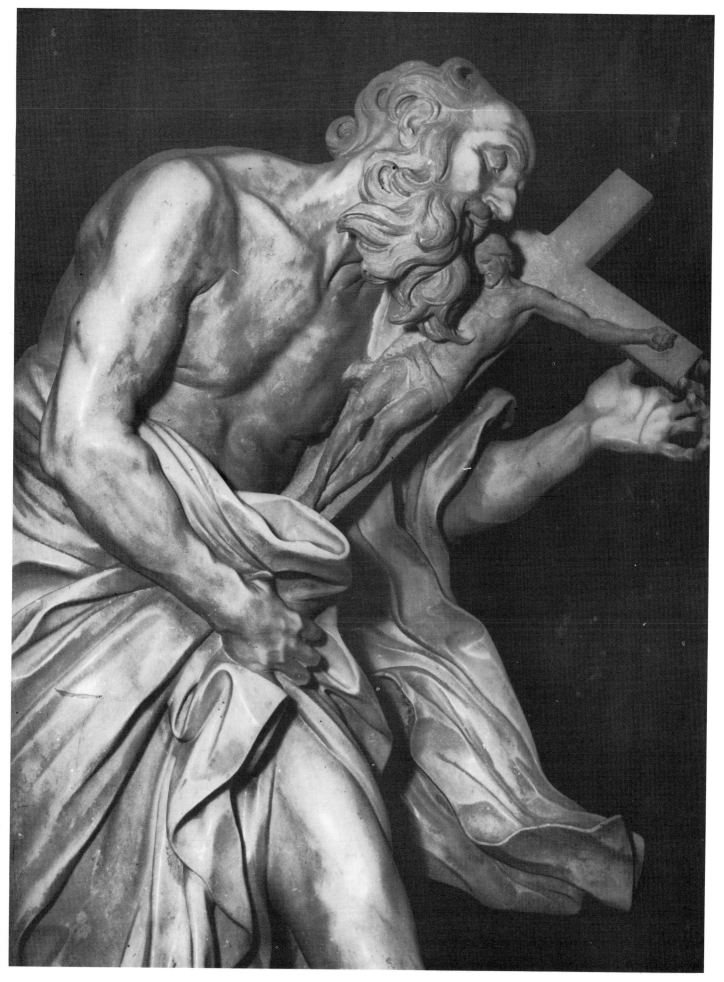

92. ST. JEROME. Detail of Plate 90

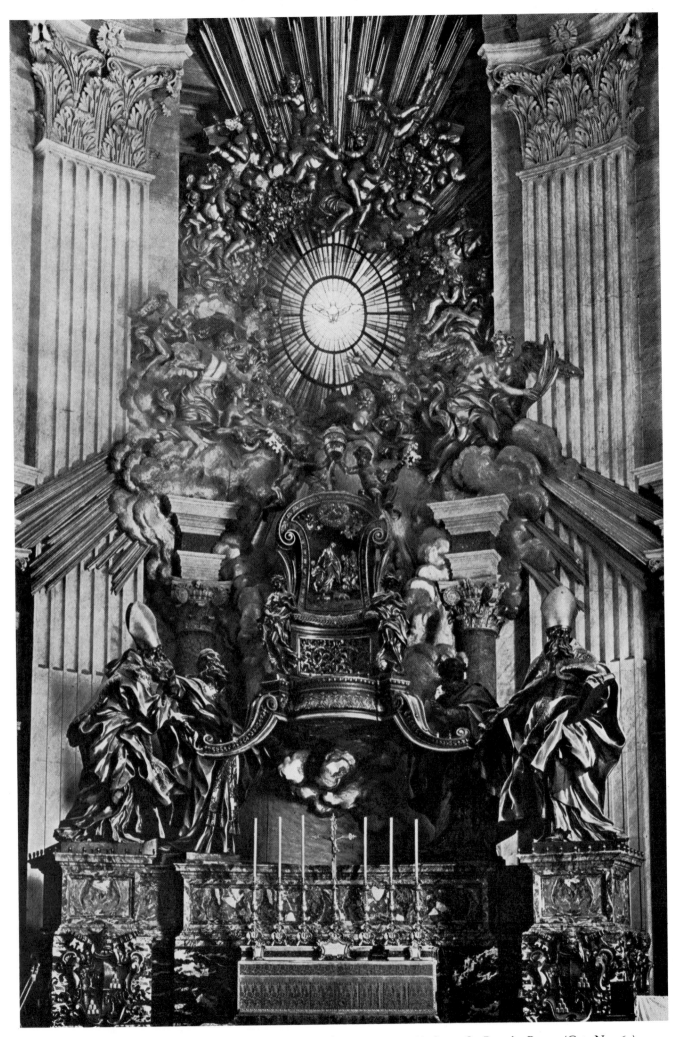

93. CATHEDRA PETRI. Marble, gilt bronze and stucco. 1657-66. Apse, St. Peter's, Rome (Cat. No. 61)

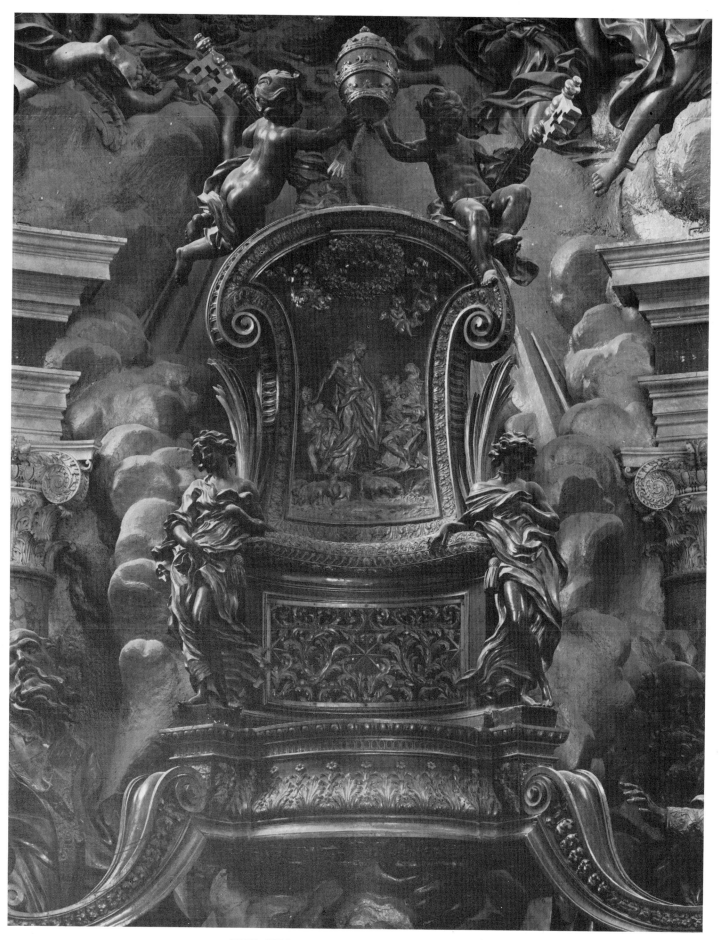

94. THE CHAIR OF ST. PETER. Detail of Plate 93

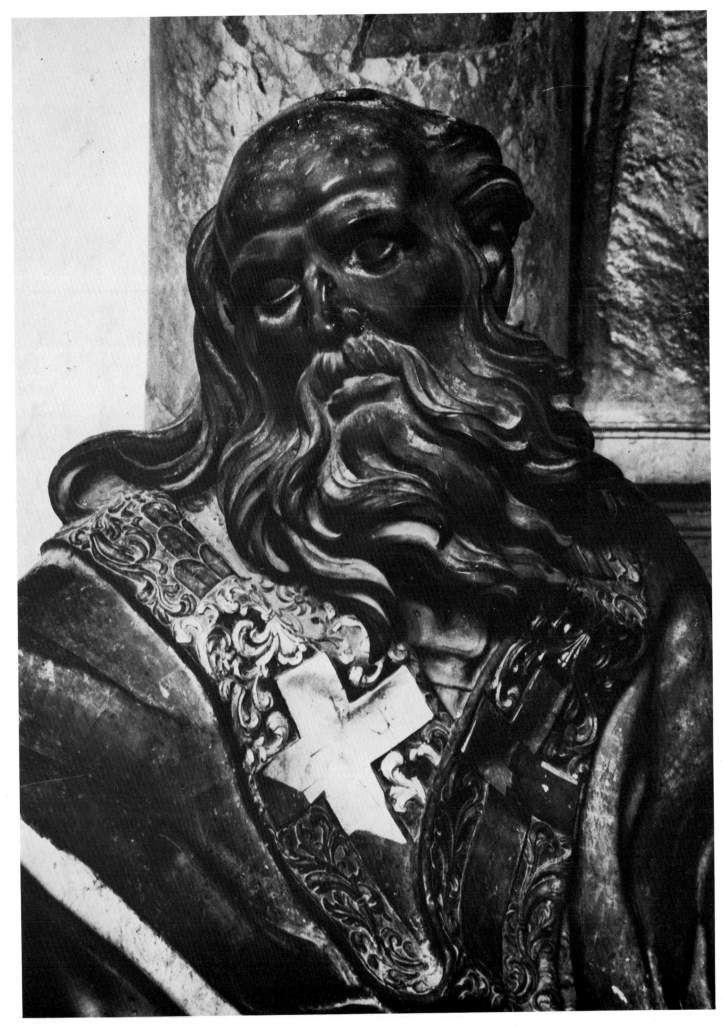

95. ST. ATHANASIUS. Detail of Plate 93

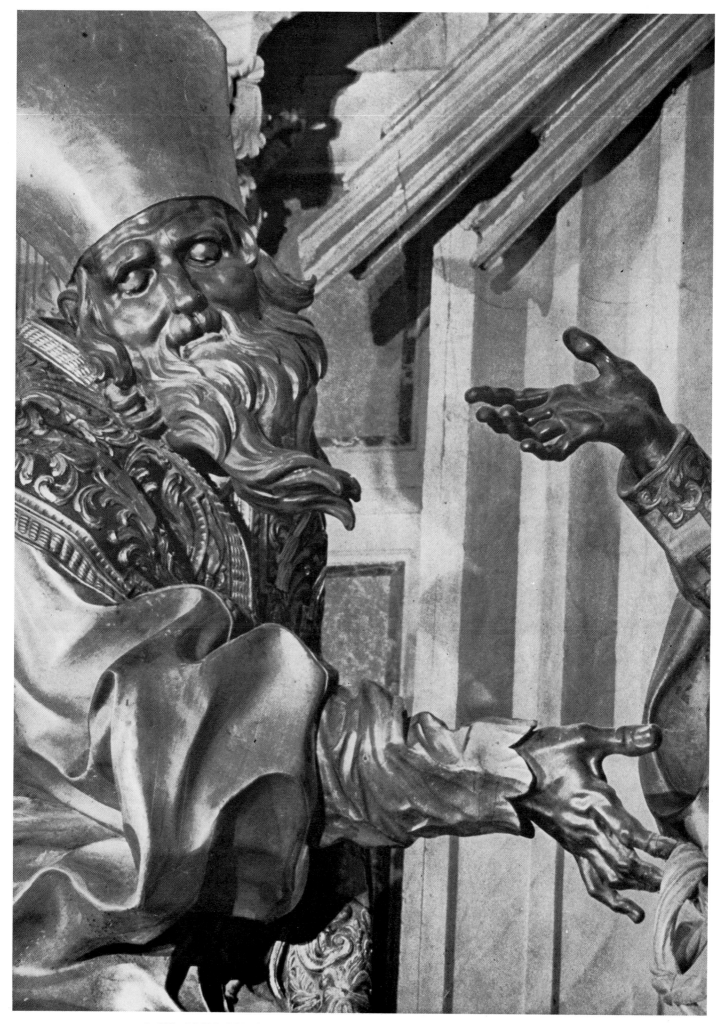

96. ST. AMBROSE AND A HAND OF ST. ATHANASIUS. Detail of Plate 93

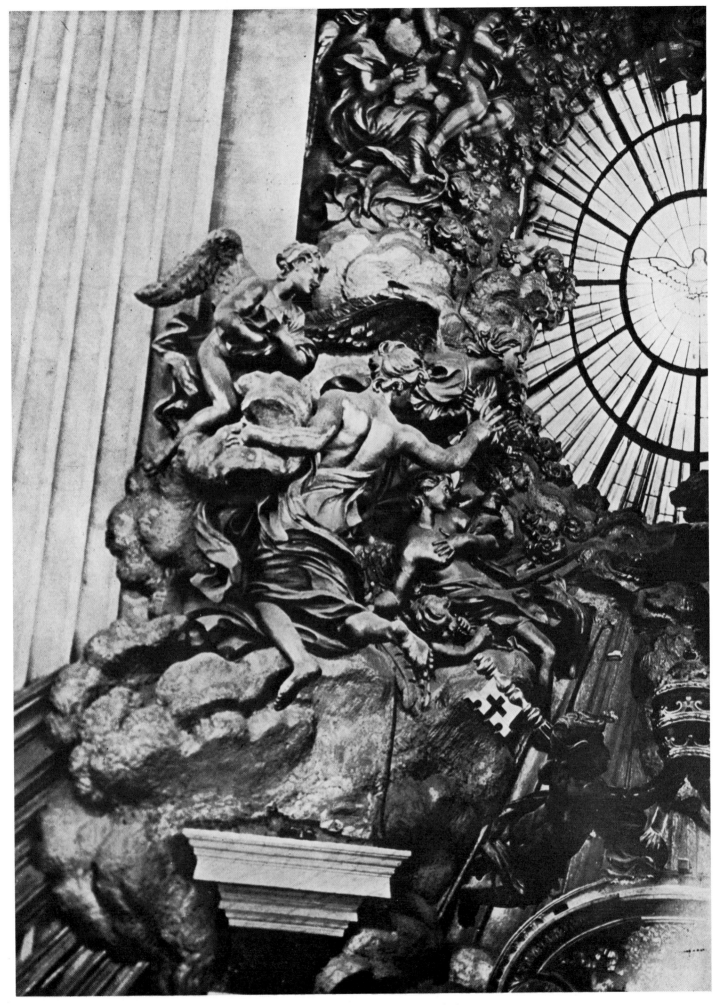

97. THE GLORY, left half. Detail of Plate 93

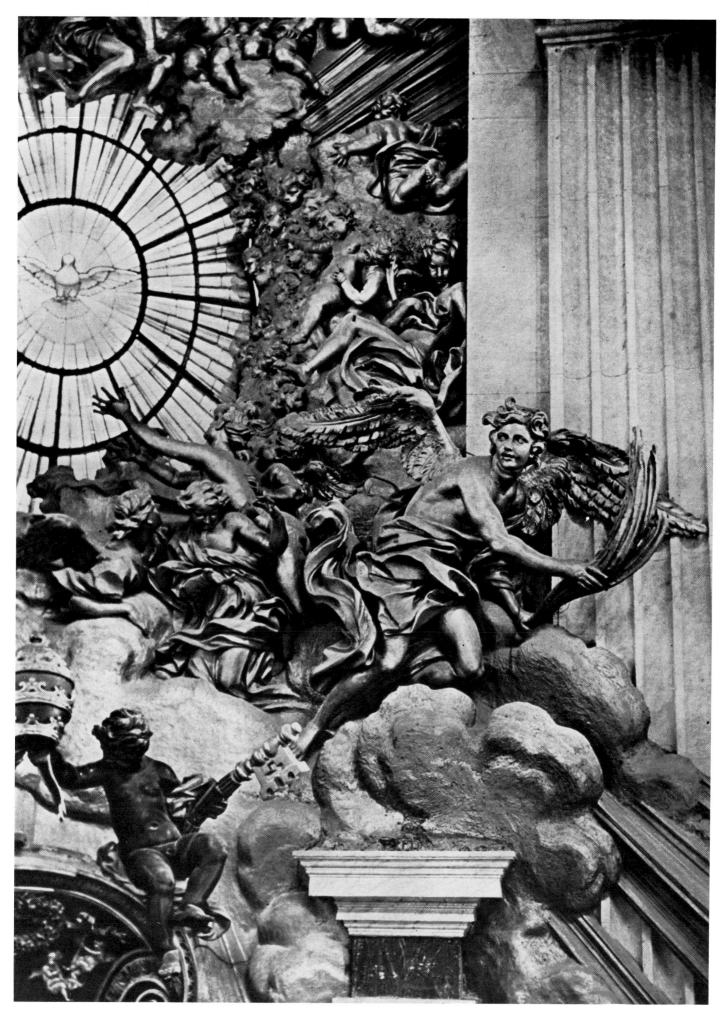

98. THE GLORY, right half. Detail of Plate 93

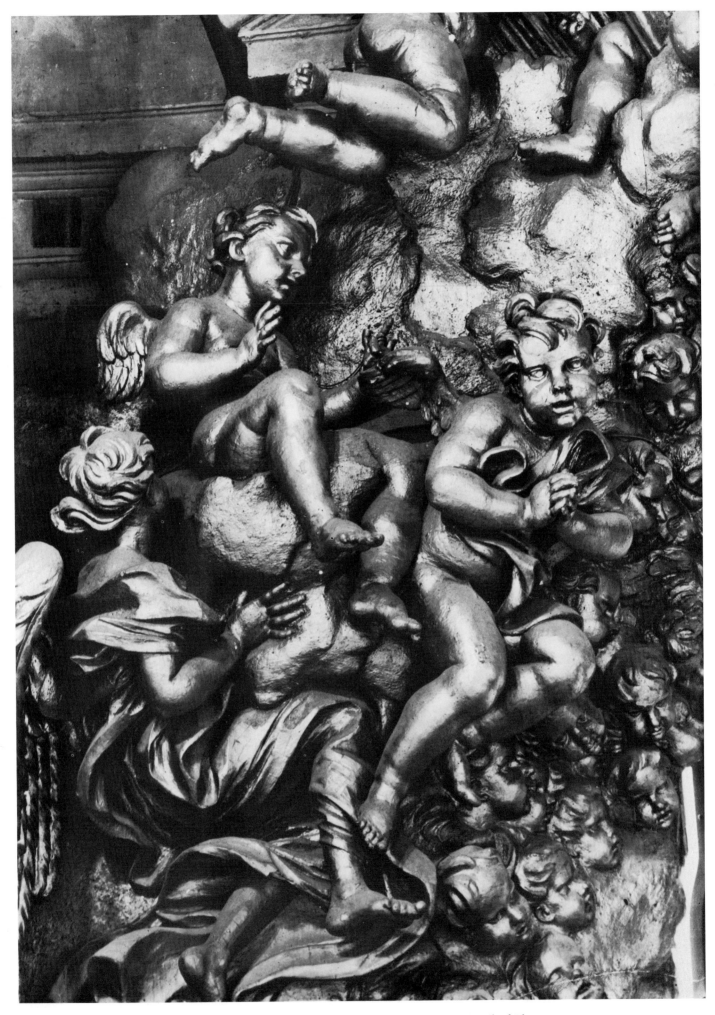

99. ANGELS AND CHERUBS FROM THE GLORY. Detail of Plate 93

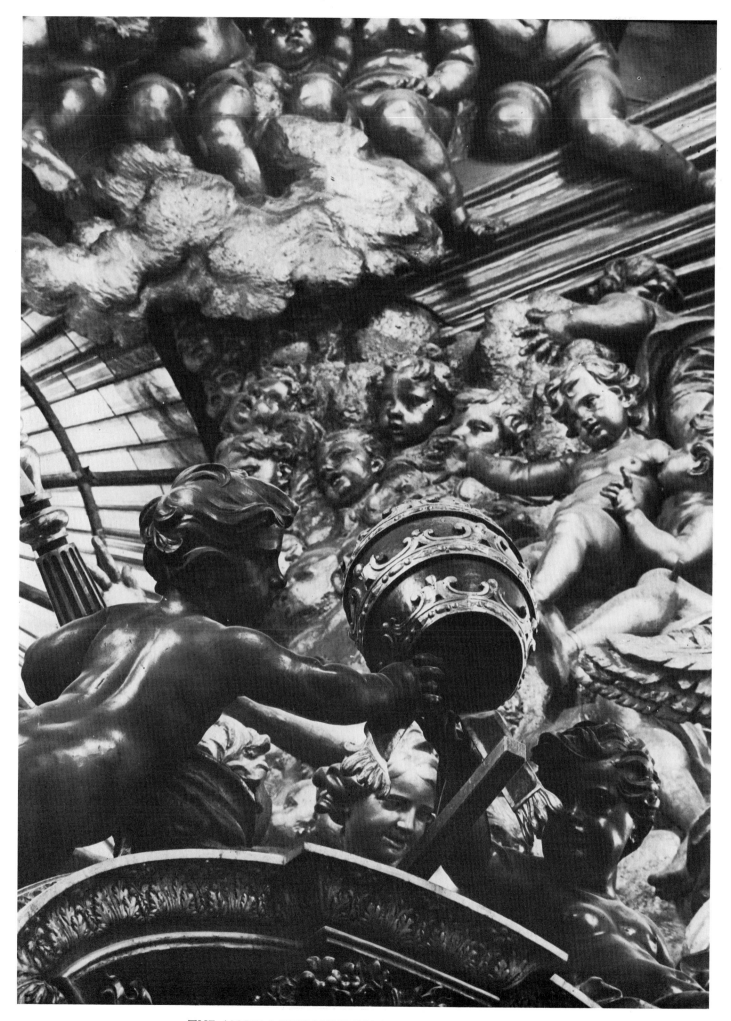

100. THE ANGELS WITH THE PAPAL INSIGNIA. Detail of Plate 93

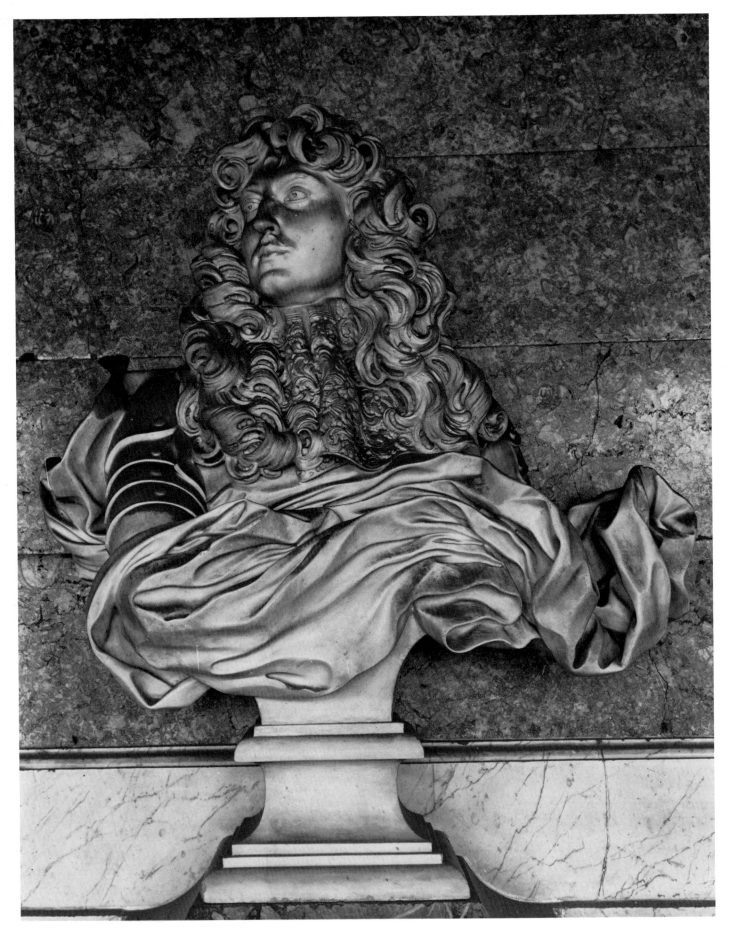

101. BUST OF LOUIS XIV. Life-size. 1665. Versailles (Cat. No. 70)

102. ELEPHANT AND OBELISK. Life-size. 1666–67. Piazza S. Maria sopra Minerva, Rome (Cat. No. 71)

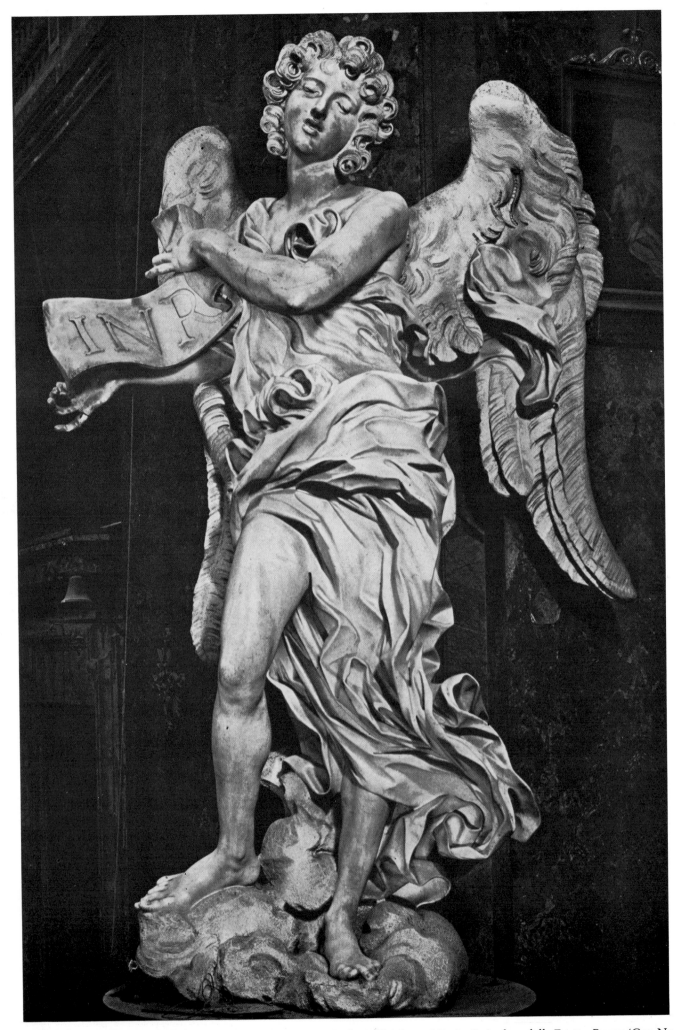

103. THE FIRST ANGEL WITH THE SUPERSCRIPTION. Over life-size. 1668-69. S. Andrea delle Fratte, Rome (Cat. No. 72)

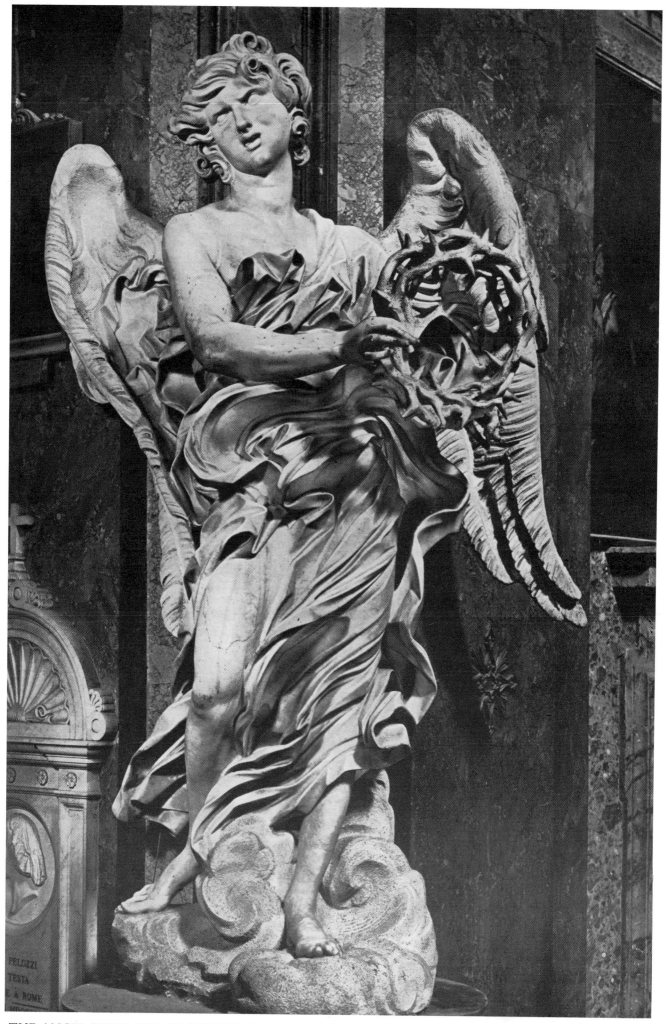

104. THE ANGEL WITH THE CROWN OF THORNS. Over life-size. 1668–69. S. Andrea delle Fratte, Rome (Cat. No. 72)

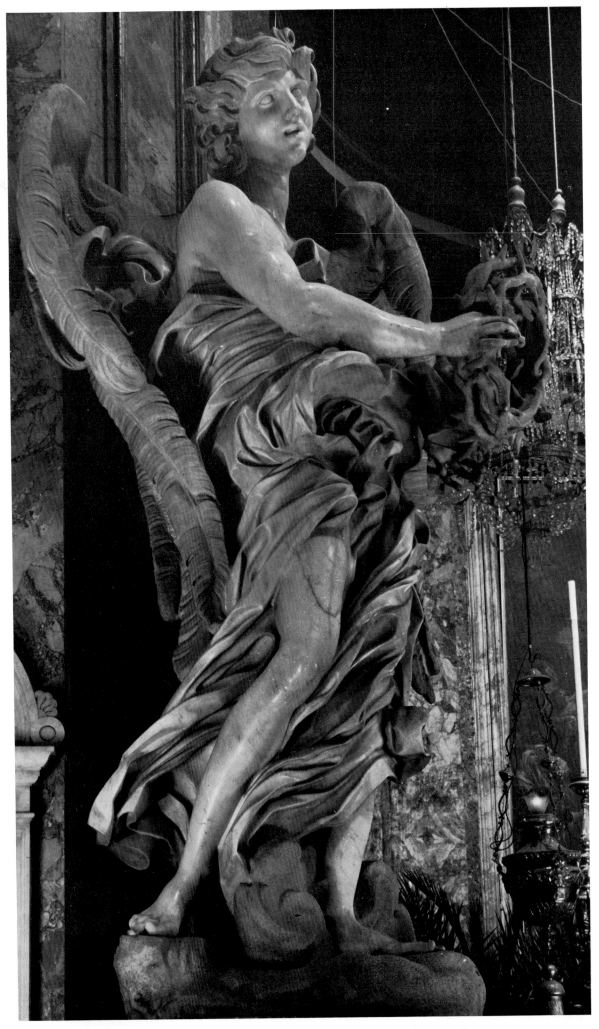

105. THE ANGEL WITH THE CROWN OF THORNS. See Plate 104

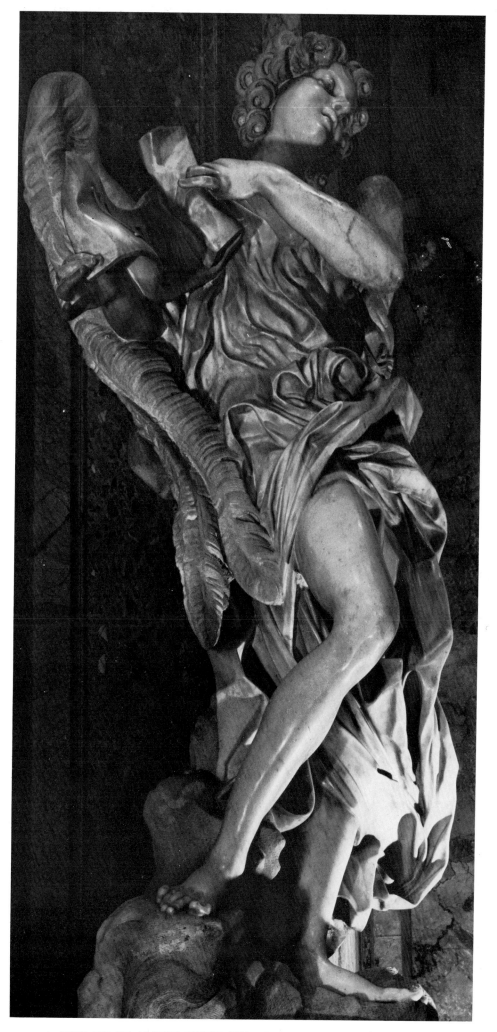

106. THE FIRST ANGEL WITH THE SUPERSCRIPTION. See Plate 103

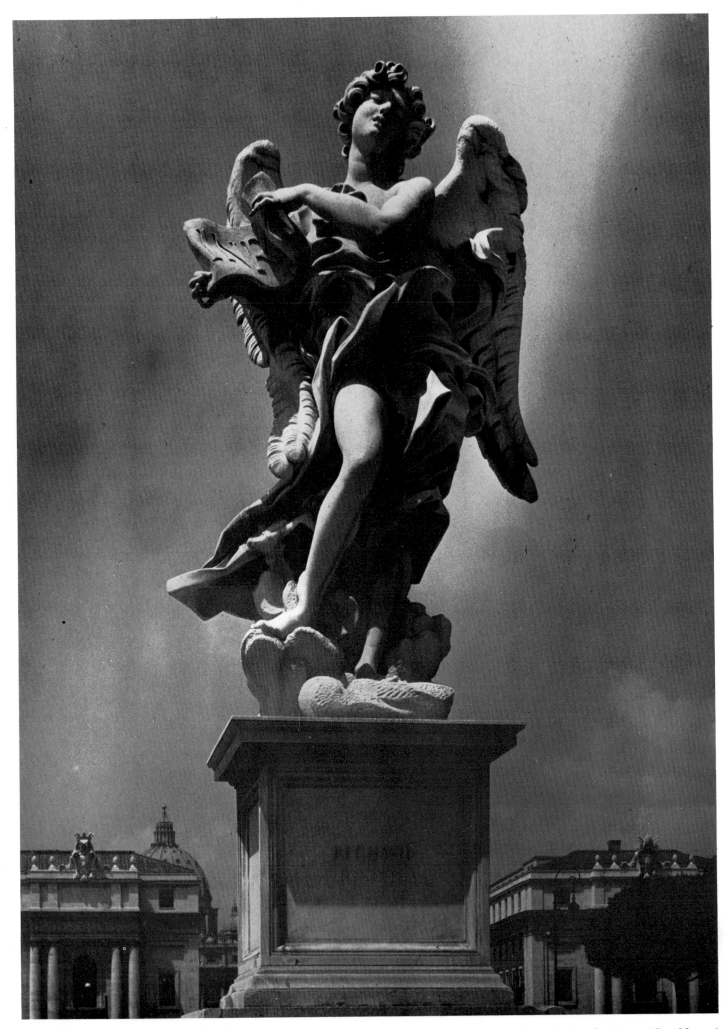

107. THE SECOND ANGEL WITH THE SUPERSCRIPTION. Over life-size. 1669–71. Ponte S. Angelo, Rome (Cat. No. 72)

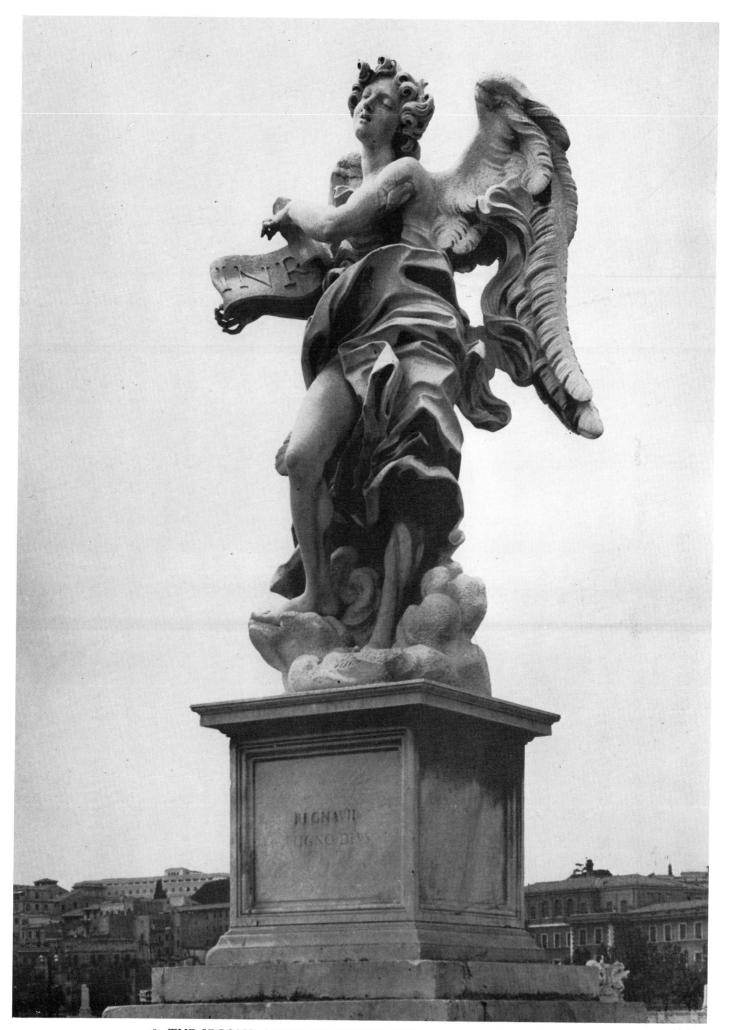

108. THE SECOND ANGEL WITH THE SUPERSCRIPTION. See Plate 107

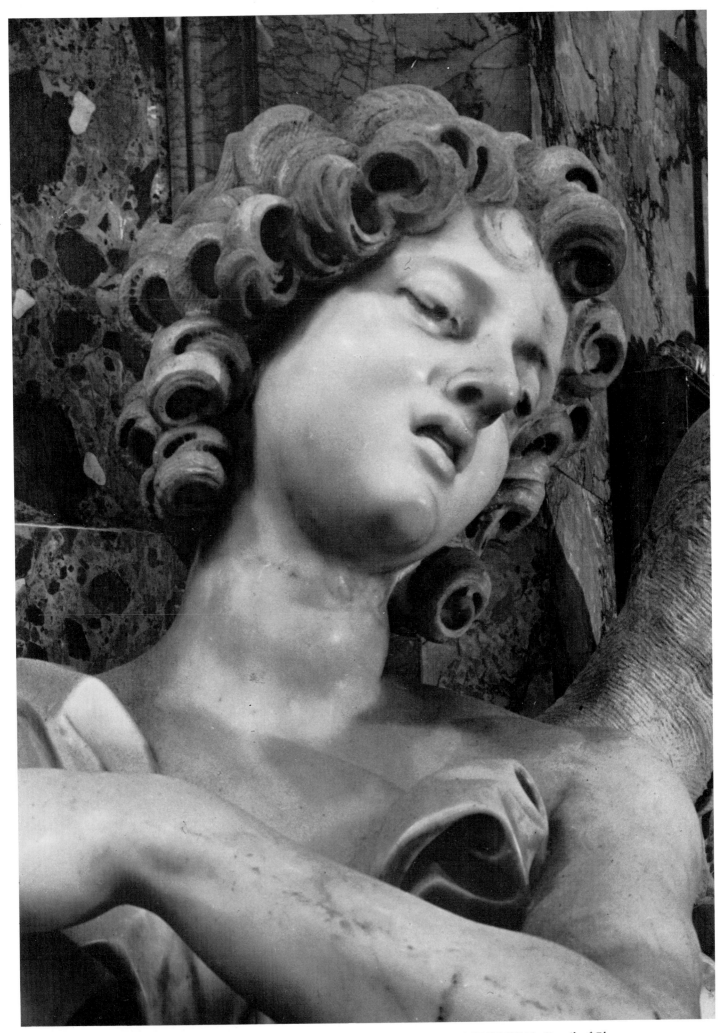

109. THE HEAD OF THE FIRST ANGEL WITH THE SUPERSCRIPTION. Detail of Plate 103

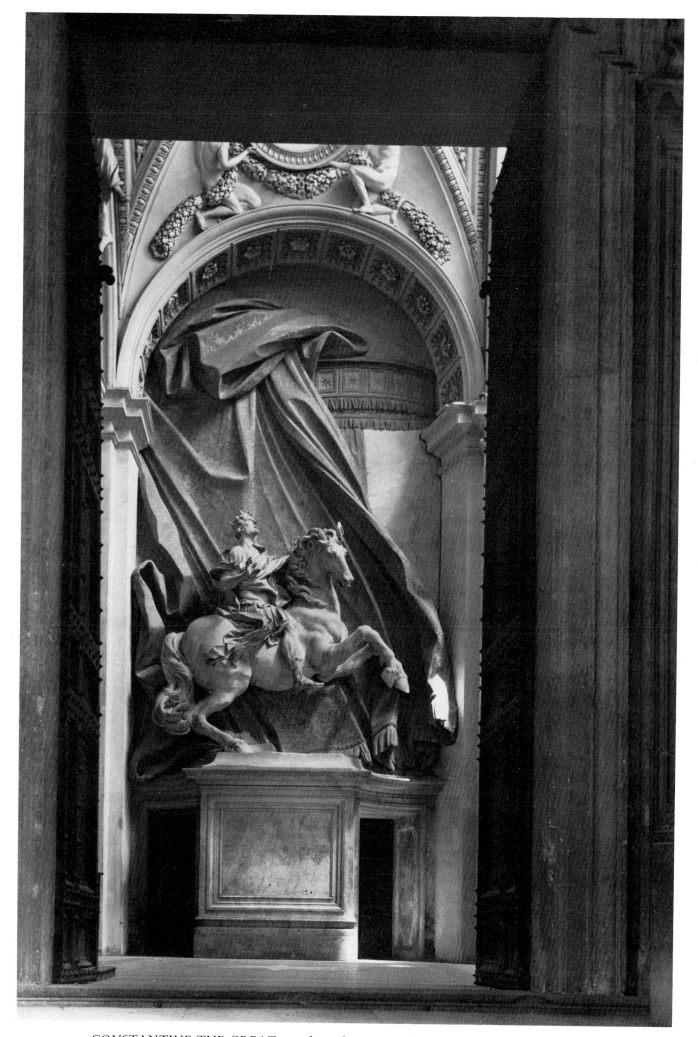

110. CONSTANTINE THE GREAT seen from the portico of St. Peter's. Monumental size. 1654–70.
Main landing, Scala Regia, Vatican, Rome (Cat. No. 73)

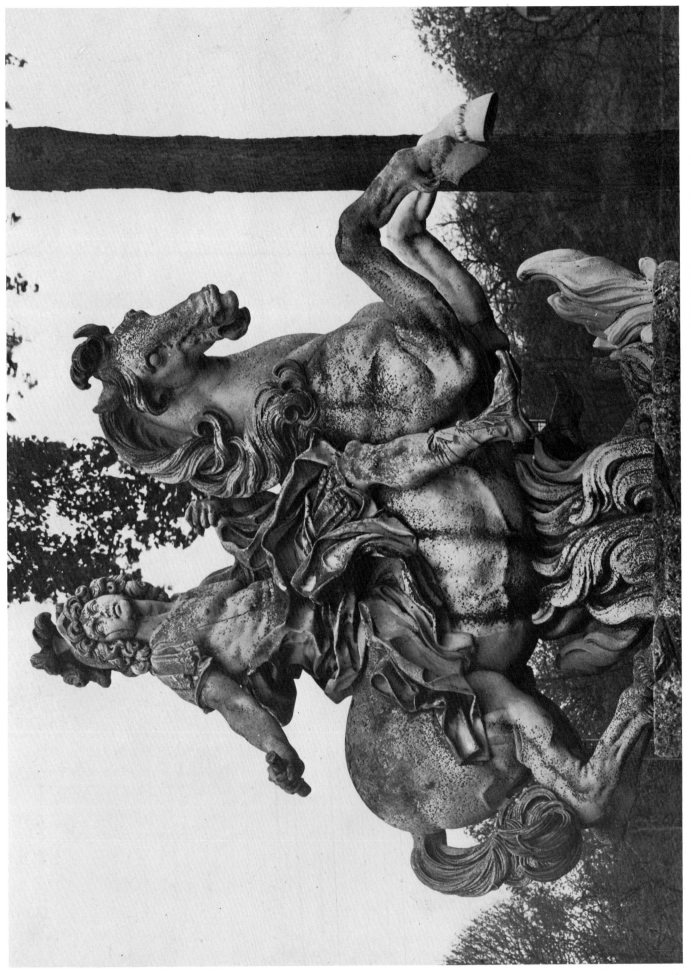

111. EQUESTRIAN STATUE OF LOUIS XIV CHANGED INTO A MARCUS CURTIUS. Monumental size. 1669–77.
Bassin des Suisses, Versailles Gardens (Cat. No. 74)

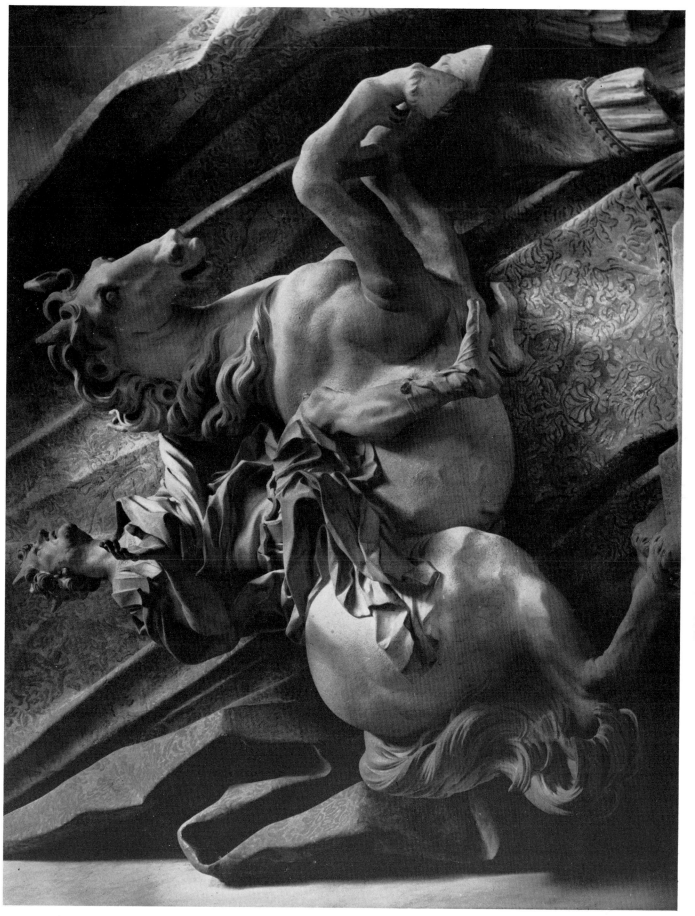

112. EQUESTRIAN STATUE OF CONSTANTINE. Detail of Plate 110

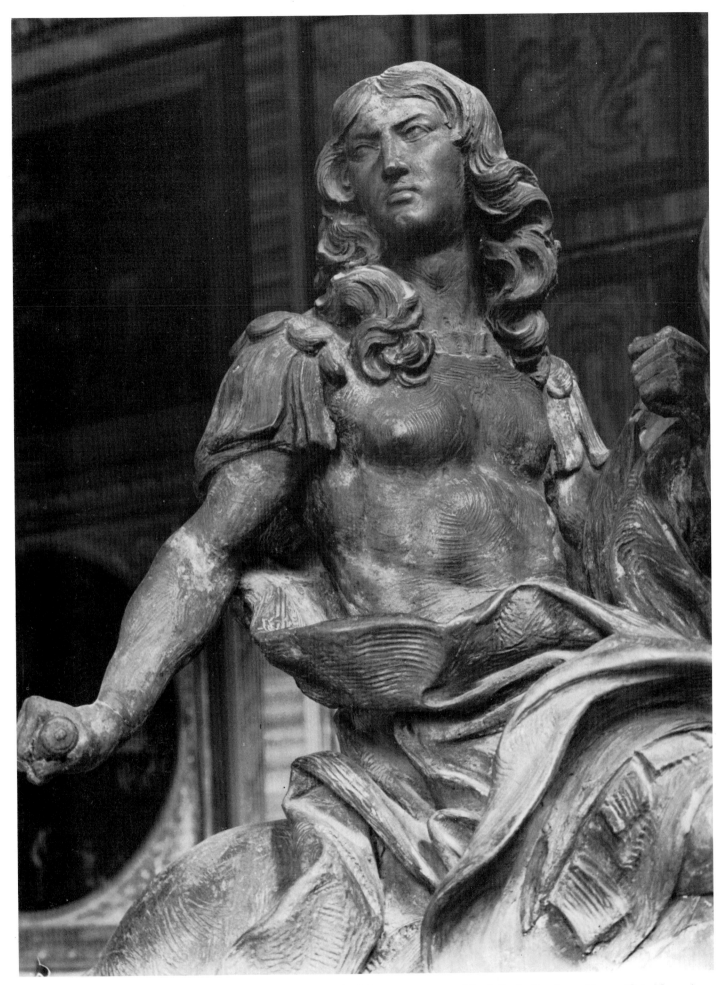

113. EQUESTRIAN STATUE OF LOUIS XIV. Detail of the terracotta model. Galleria Borghese, Rome (Cat. No. 74)

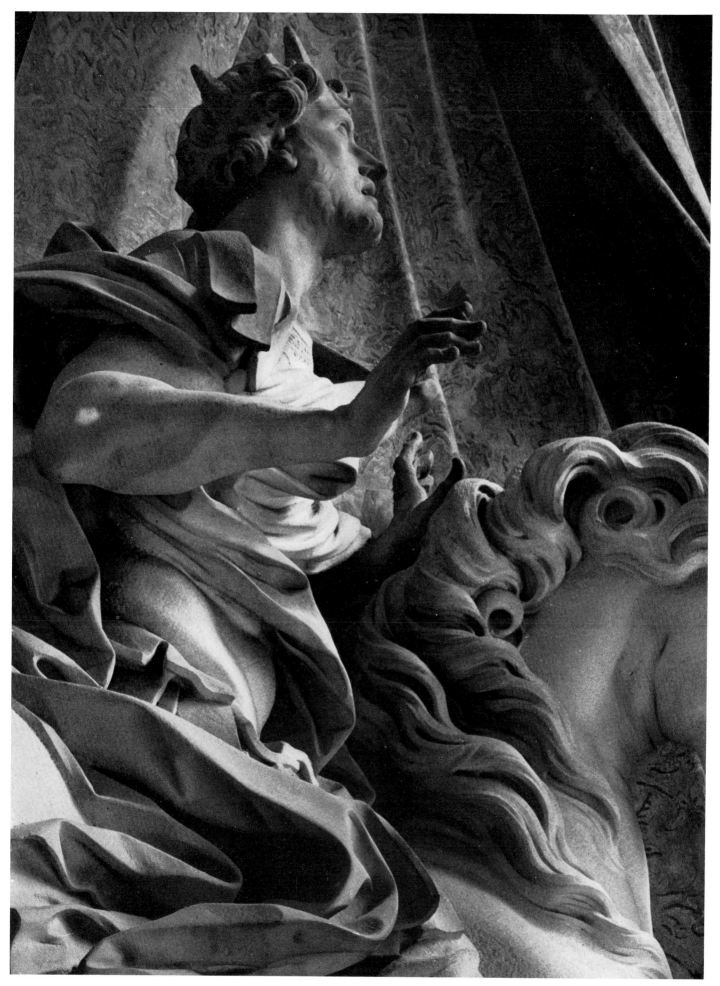

114. THE VISION OF CONSTANTINE. Detail of Plate 110

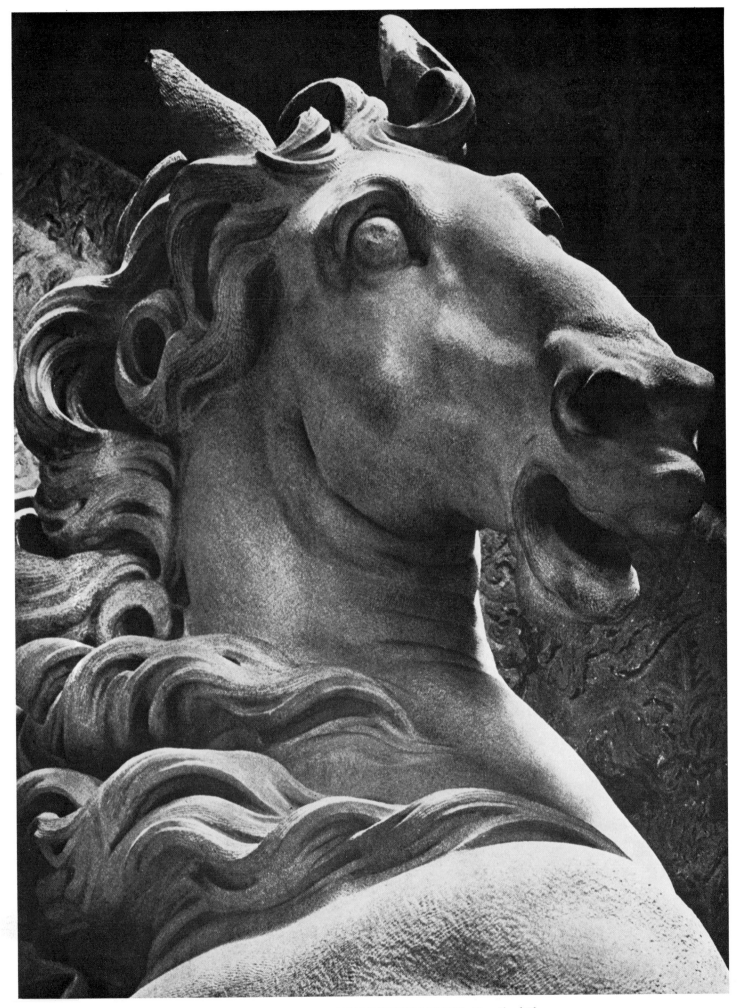

115. THE HEAD OF CONSTANTINE'S HORSE. Detail of Plate 110

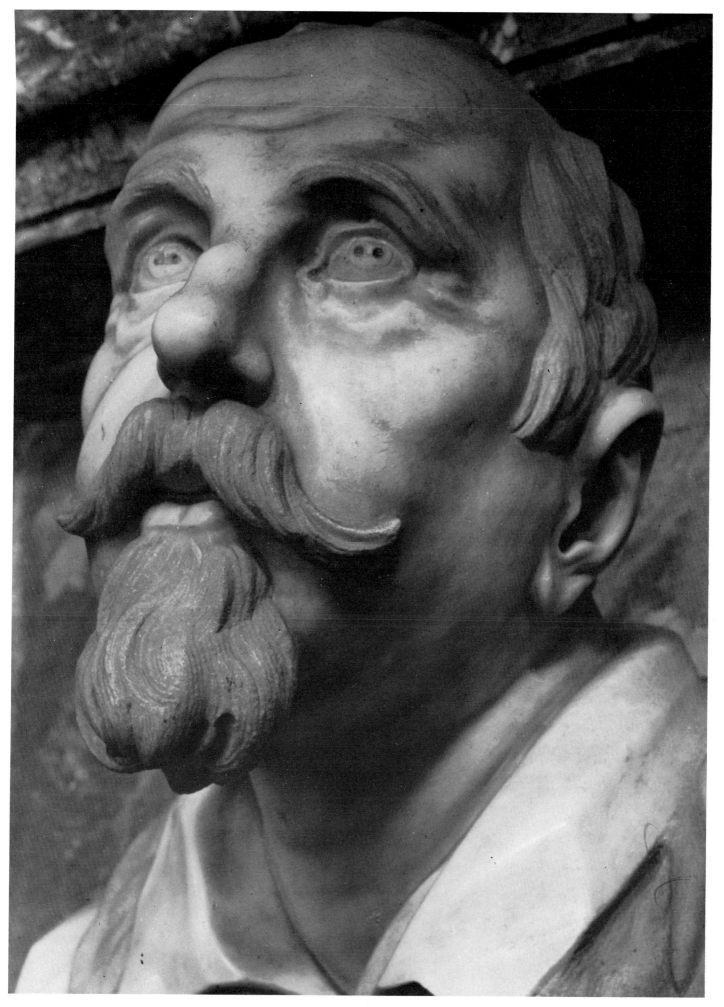

116. BUST OF GABRIELE FONSECA. Detail of Plate 117

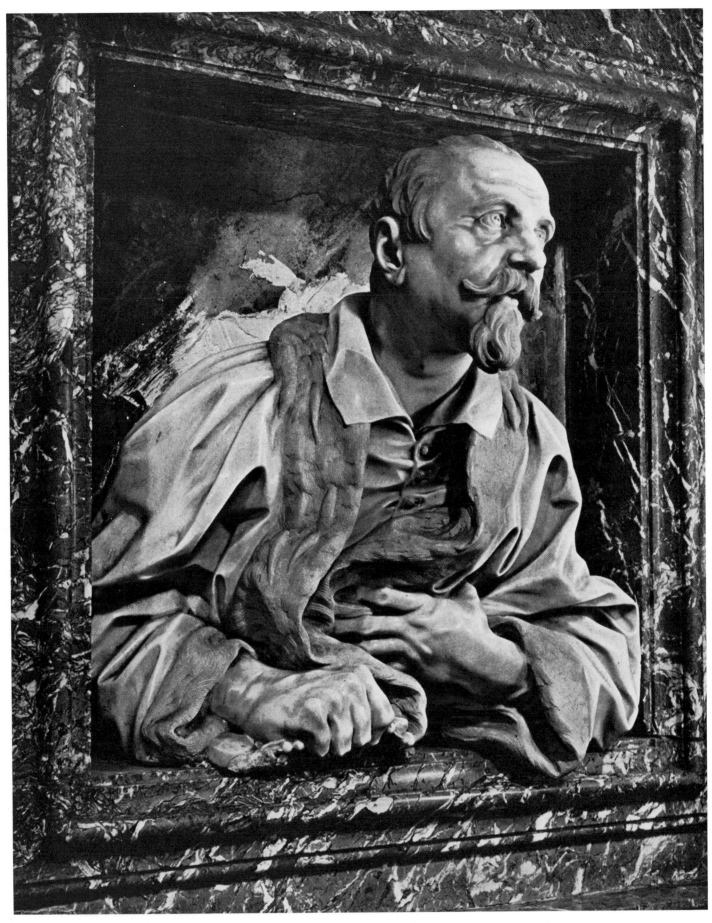

117. BUST OF GABRIELE FONSECA. Over life-size. Between 1668 and 1675.
Fonseca Chapel, S. Lorenzo in Lucina, Rome (Cat. No. 75)

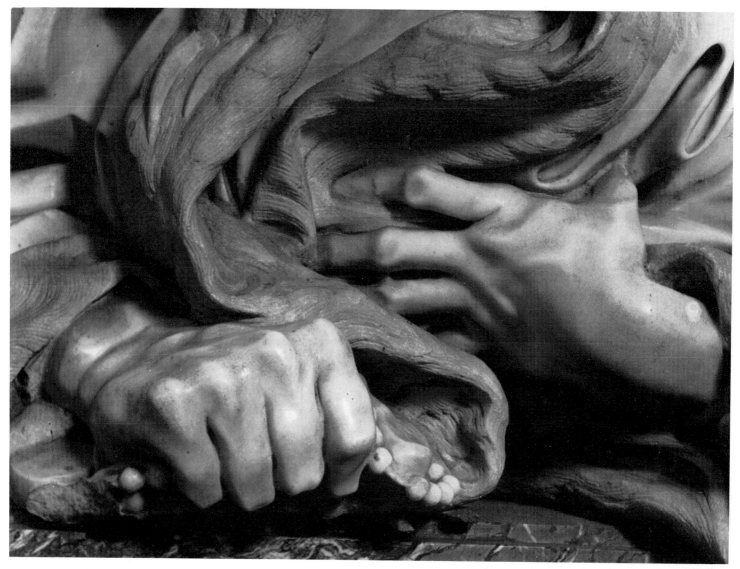

118. THE HANDS OF FONSECA. Detail of Plate 117

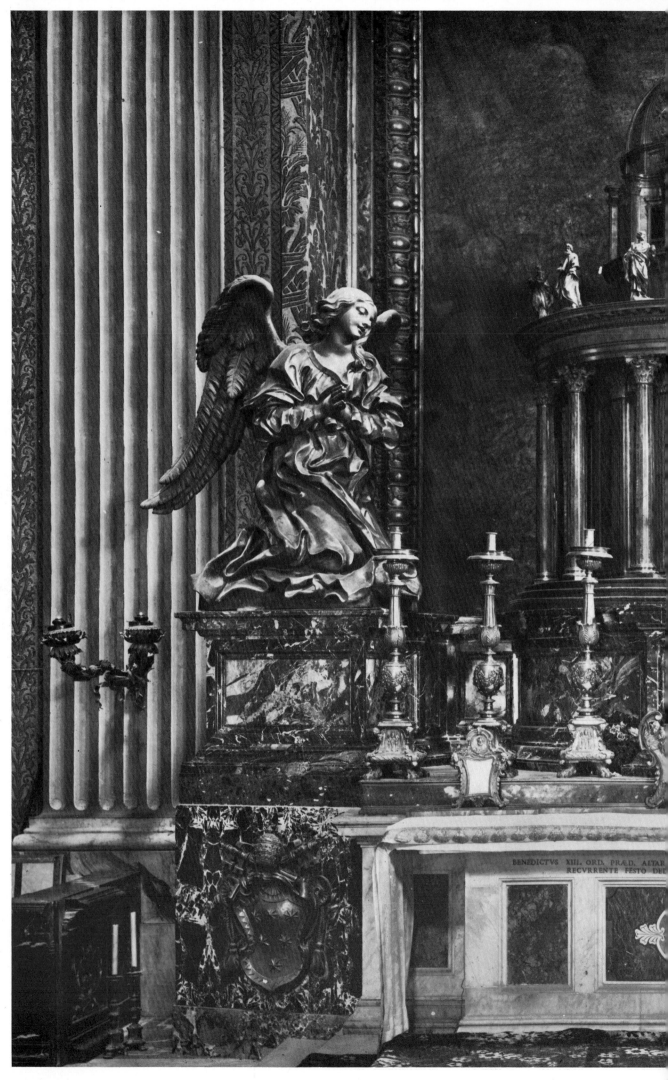

119. THE ALTAR OF THE CAPPELLA DEL SACRAMENTO

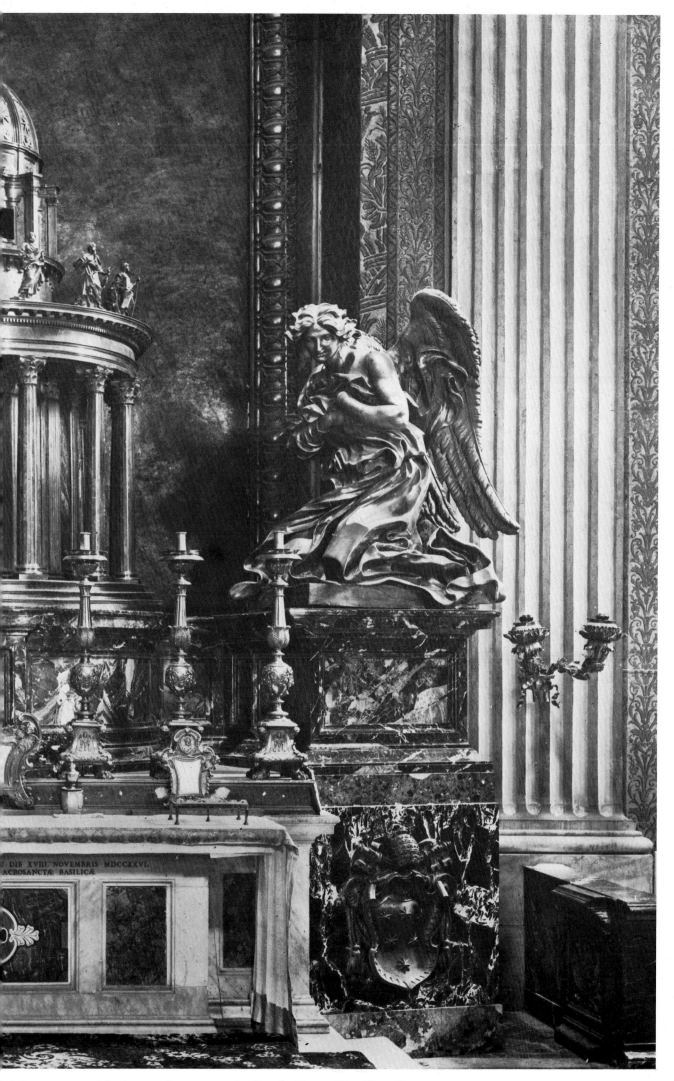

Gilt bronze. Over life-size angels. 1673-74. St. Peter's, Rome (Cat. No. 78)

120. THE ALTIERI CHAPEL WITH THE BLESSED LODOVICA ALBERTONI.
Over life-size. 1671-74. S. Francesco a Ripa, Rome (Cat. No. 76)

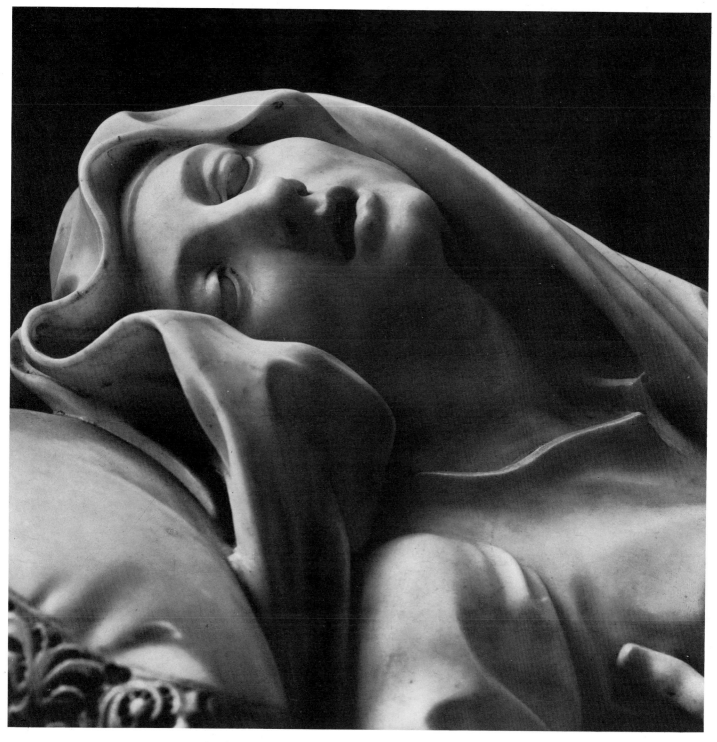

121. HEAD OF LODOVICA ALBERTONI. Detail of Plate 120

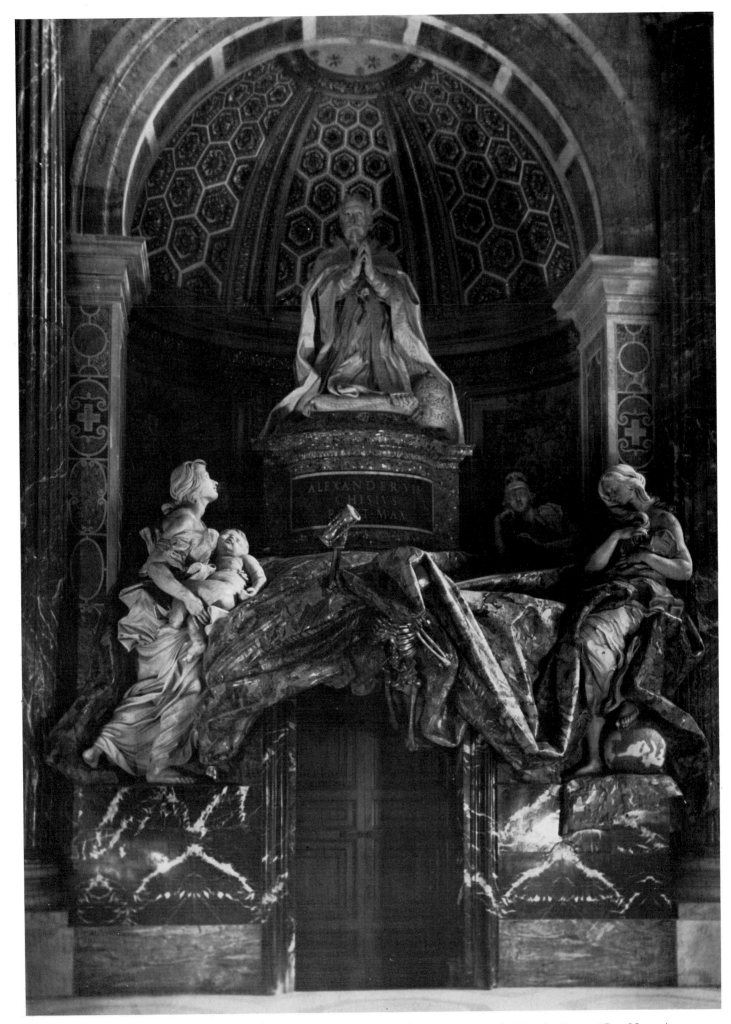

122. TOMB OF POPE ALEXANDER VII. Over life-size figures. 1671–78. St. Peter's, Rome (Cat. No. 77)

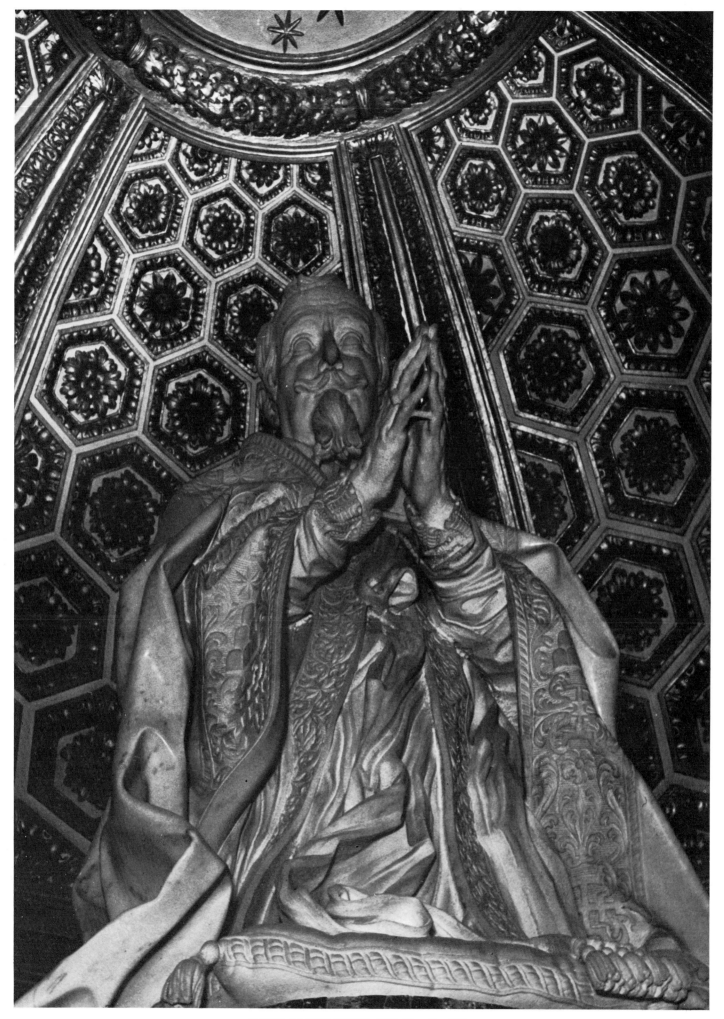

123. POPE ALEXANDER VII. Detail of Plate 122

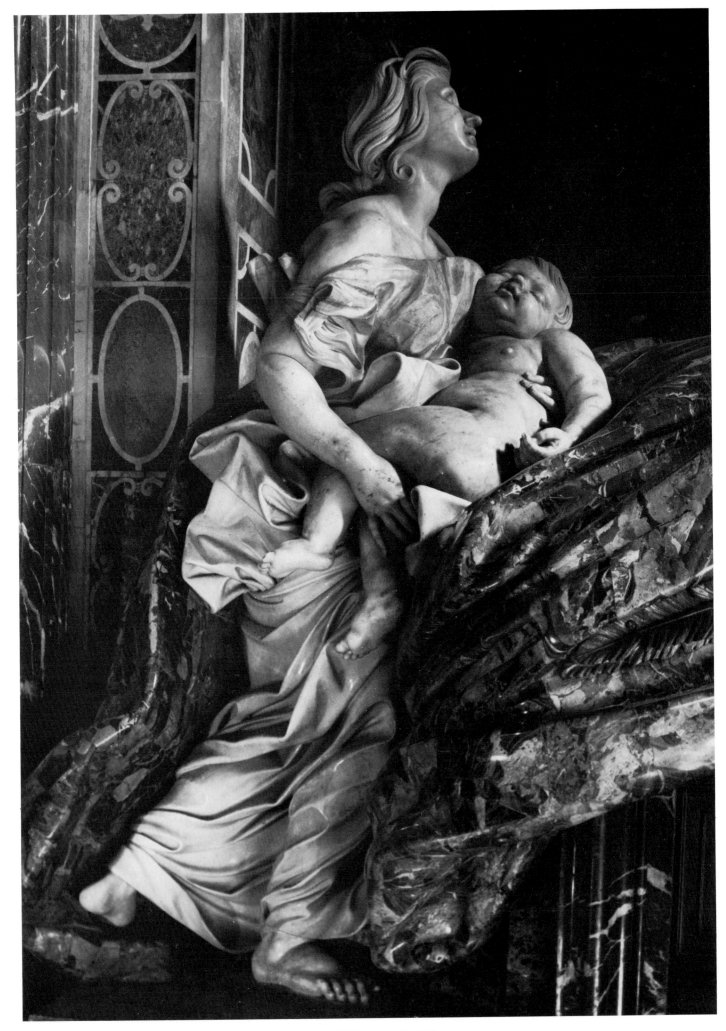

124. 'CHARITY'. Detail of Plate 122

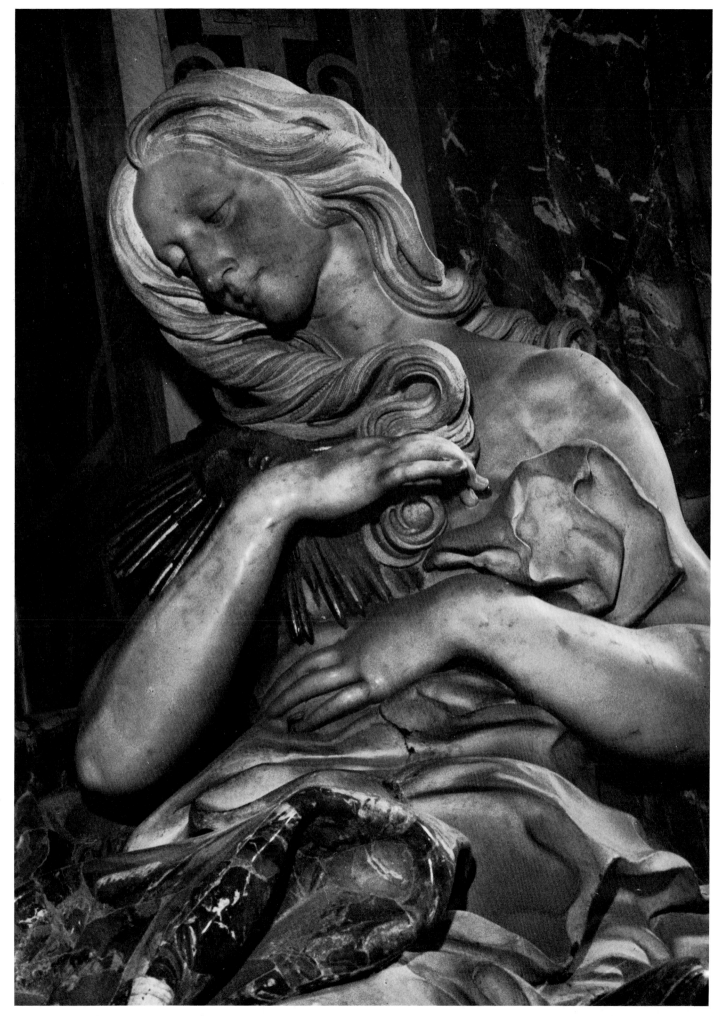

125. 'TRUTH'. The drapery is of bronze. Detail of Plate 122

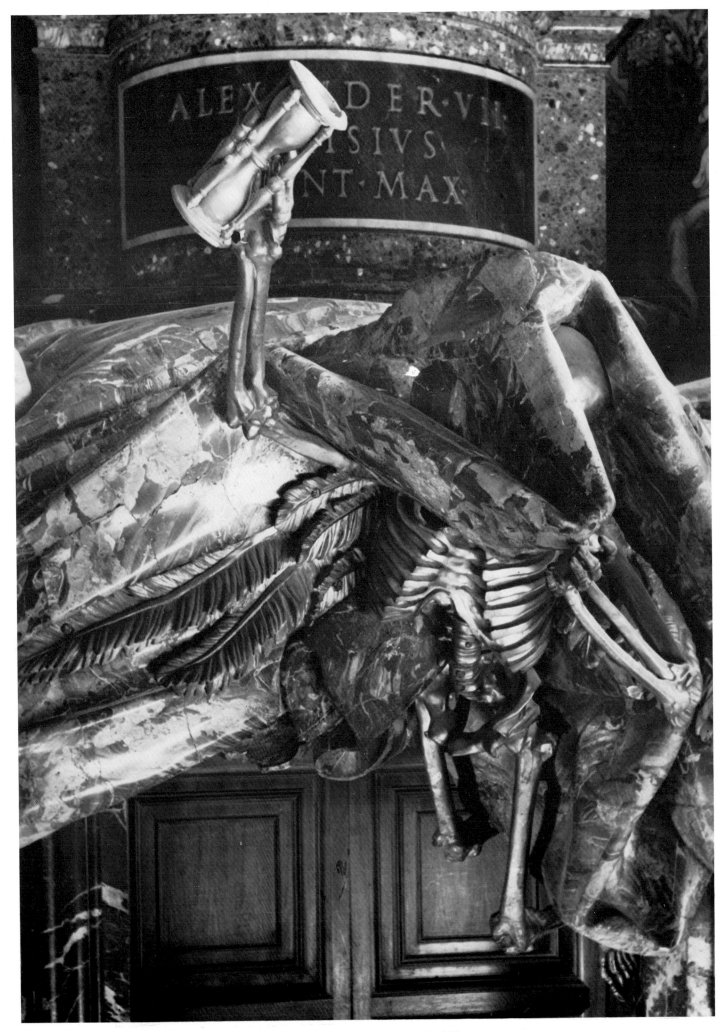

126. 'DEATH'. Gilt bronze. Detail of Plate 122

CATALOGUE

SELECTED BIBLIOGRAPHY
AND ABBREVIATIONS

AF — Archivio della Fabbrica di S. Pietro
AFG — Archivio della Fabbrica di S. Pietro,
 Giustificazioni
AFM— Archivio della Fabbrica di S. Pietro, Mandati

AFS — Archivio della Fabbrica di S. Pietro, Spese
AS — Archivio di Stato, Rome
BN — Bibliothèque Nationale, Paris
BV — Biblioteca Vaticana

Aleandri, V. E. 'Un semibusto di Urbano VIII del Bernini in Camerino', *Arte e Storia*, xxi, 1902, pp. 44–5.

Bacci, P. 'Un bozzetto sconosciuto di Gian Lorenzo Bernini', *Rivista d'Arte*, iv, 1906, pp. 142–7.
 'Giovan Lorenzo Bernini e la statua di Alessandro VII per il duomo di Siena', *Diana*, vi, 1931, p. 37–56.

Baglione, G. *Le vite de' pittori, scultori, architetti . . .* , Naples, 1733 (first ed., Rome, 1642).

Baldinucci, F. *Vita di Bernini*. A cura di Sergio Samek Ludovici, Milan, 1948 (edition quoted in catalogue). First ed., Florence, 1682. English translation by Catherine Enggass. The Pennsylvania State University Press, 1966.

Barton, E. D. 'The Problem of Bernini's Theories of Art', *Marsyas*, iv, 1945–7, pp. 81–111.

Battaglia, R. 'Un opera del Bernini ritrovata: La memoria del Merenda', *Le Arti*, iv, 1941–2, pp. 356–60.
 Crocifissi del Bernini in S. Pietro in Vaticano, Rome, 1942.
 La Cattedra berniniana di San Pietro, Rome, 1943.

Battisti, E. 'Una tomba ed un busto del Bernini', *Commentari*, ix, 1958, pp. 38–43.
 'Aproposito della "Barcaccia" di Piazza di Spagna', *Bollettino d'Arte*, xliv, 1959, pp. 188–9.

Benkard, E. *Giovanni Lorenzo Bernini*, Frankfurt, 1926.

Berendsen, O. P. 'A Note on Bernini's Sculptures for the Catafalque of Pope Paul V', *Marsyas*, viii, 1957–9, pp. 67–9.

Bernini, D. *Vita del Cavalier Gio. Lorenzo Bernino*, Rome, 1713. (Quoted as: Domenico Bernini.)

Bertini Calosso, A. 'Il classicismo di Gian Lorenzo Bernini e l'arte francese', *Arte*, xxiv, 1921, pp. 241–56.

Białostocki, J. 'Gian Lorenzo Bernini i jego poglądy estetyczne', *Sztuka i Krytyka*, ix, 1958, p. 122 ff. (French résumé).

Dwugłos o Berninim (Baldinucci i Chantelou), Wrocław-Warszawa-Kraków, 1962.

B.M. — *Burlington Magazine*.

Boehn, M. v. *Lorenzo Bernini, seine Zeit, sein Leben, sein Werk*, Leipzig, 1927 (second ed.).

Brauer H., and Wittkower, R. *Die Zeichnungen des Gianlorenzo Bernini*, Berlin, 1931.

Brinckmann, A. E. *Barockskulptur*, Berlin-Neubabelsberg, 1919.
 Barock-Bozzetti (quoted BB.), Frankfurt, 1923, 1924.
 'Ein Bozzetto Berninis', *Zeitschrift f. bild. Kunst.*, lx, 1926–7, pp. 264–70.

Brugnoli, M. V. 'Un bozzetto del Bernini per il "San Girolamo" ', *Arte Antica e Moderna*, No.13–16, 1961, pp. 291–3.

Bruhns, L. 'Das Motiv der ewigen Anbetung in der römischen Grabplastik des 16., 17. und 18. Jahrhunderts', *Römisches Jahrbuch für Kunstgeschichte*, iv, 1940, pp. 253–432.

Cantalamessa. 'Una scultura ignota del Bernini', *Bollettino d'Arte*, v, 1911, pp. 81–8.

Casanova, L. 'Un illustre personaggio veneziano in S. Maria della Vittoria a Roma', *Bollettino dei Musei Civici Veneziani*, 1958, 2, pp. 13–14.

Cassirer, K. 'Eine Replik des barberinischen Fauns', *Münchner Jahrbuch f. bild. Kunst*, xii, 1921, pp. 90–7.

Cellini, A. Nava. 'Aggiunte alla ritrattistica berniniana e dell' Algardi', *Paragone*, vi, 1955, No. 65, pp. 23–31.
 'Un tracciato per l'attività ritrattistica di Giuliano Finelli', *ibid.*, xi, 1960, No. 131, pp. 9–30.
 'Ritratti di Andrea Bolgi', *ibid.*, xiii, 1962, No. 147, pp. 24–40.
 'Per l'integrazione e lo svolgimento della ritrattistica di Alessandro Algardi', *ibid.*, xv, 1964, No. 177, pp. 15–36.
 'Una proposta ed una rettifica per Gian Lorenzo Bernini', *ibid.*, xvii, 1966, No. 191, pp. 18–29.

Chantelou, M. de. *Journal du voyage du Cav. Bernini en France*, ed. L. Lalanne, Paris, 1885.

Colasanti, A. 'Un inedito frammento del bozzetto della Dafne del Bernini', *Bollettino d'Arte*, N.S., iii, 1923-4, pp. 416-18.

Cooke, H. L. 'Three unknown Drawings by G. L. Bernini', *Burlington Magazine*, xcvii, 1955, pp. 320-3.

Courajod, L. 'Jean Warin, ses œuvres de sculpture et le buste de Louis XIII du Musée du Louvre', *L'Art*, 1881, 25 Sept., 2 Oct.

Cust, L. 'Notes on pictures in the Royal Collections. The triple portrait of Charles I by van Dyck, and the bust by Bernini'. *Burlington Magazine*, xiv, 1908-9, pp. 337-40.

De Logu, G. La *scultura italiana del Seicento e del Settecento*, Florence, 1932.

De Rinaldis, A. *L'arte in Roma dal Seicento al Novecento*, Bologna, 1948.

Donati, U. 'Gli autori degli stucchi in S. Andrea al Quirinale', *Rivista del R. Istituto di archeologia e storia dell'arte*, viii, 1940, pp. 144-50.
 'Tre fontane berniniane', *L'Urbe*, vi, 1941, ii, p. 11.
 Artisti Ticinesi a Roma, Bellinzona, 1942 (quoted as: Donati).

D'Onofrio, C. *Le Fontane di Roma*, Rome 1957.

Dworschak, F. 'Der Medailleur Gianlorenzo Bernini', *Jahrbuch der Preussischen Kunstsammlungen*, lv, 1934, pp. 27-41.

Einem, H. von. 'Bemerkungen zur Cathedra Petri des Lorenzo Bernini', *Nachrichten der Akademie der Wissenschaften in Göttingen* (I. Philologisch-historische Klasse), 1955, pp. 93-114.

Evers, H. G. *Die Engelsbrücke in Rom*, Berlin, 1948.

Faldi, I. 'Note sulle sculture Borghesiane del Bernini', *Bollettino d'Arte*, 1953, pp. 140-6 (quoted as: Faldi, i).
 'Nuove note sul Bernini', *Bollettino d'Arte*, 1953, pp. 310-16 (quoted as Faldi, ii).
 'I busti berniniani di Paolo Giordano e Isabella Orsini', *Paragone*, 1954, No. 57, pp. 13-15.
 Galleria Borghese. La scultura dal secolo XVI al XIX, Rome, 1954.
 'Berniniana: un nuovo libro e una scultura inedita', *Paragone*, vi, 1955, No. 71, pp. 47-52.
 La scultura barocca in Italia, Milan, 1958.

Fokker, A. T. *Roman Baroque Art. The History of a Style*, London, 1938.
 'The career of Gian Lorenzo Bernini', *The Art Quarterly*, iii. 1940, pp. 245-66.

Forcella, V. *Iscrizioni delle chiese e d'altri edifici di Roma*, Rome, 1869-85, 14 vols.

Fraschetti, S. *Il Bernini*, Milan, 1900.

 'Un altro documento berniniano', *Arte*, v, 1902, pp. 109-11.

G.d.B.A.—*Gazette des Beaux-Arts*.

Gnoli, D. 'Disegni del Bernini per l'obelisco della Minerva a Roma', *Archivio storico dell'Arte*, i, 1888, pp. 398-403.
 'La sepoltura d'Agostino Chigi nella chiesa di S. Maria del Popolo in Roma', *Archivio storico dell'Arte*, ii, 1889, pp. 317-26.

Golzio, V. *Documenti artistici sul Seicento nell'archivio Chigi*, Rome, 1939 (quoted as: Golzio).

Gould, C. 'Bernini's Bust of Mr. Baker: The Solution?', *Art Quarterly*, xxi, 1958, pp. 167-76.

Grassi, L. 'Disegni inediti del Bernini e la decorazione di Ponte S. Angelo', *Arti figurative*, ii, 1946, pp. 186-99.
 Gianlorenzo Bernini, Rome, 1962.
 'Bernini: Two Unpublished Drawings and Related Problems', *Burlington Magazine*, cvi, 1964, pp. 170-8.

Grigaut, P. L. 'A Bozzetto for St. Peter's "Cattedra"', *The Art Quarterly*, 1953, pp. 124-30.

Haendcke, B. 'Berninis Famiglia Cornaro und der niederländische Einfluss', *Monatshefte f. Kunstwissenschaft*, ix, 1916, pp. 137-40.

Haskell, F. *Patrons and Painters. A Study in the Relations between Italian Art and Society in the Age of the Baroque*, Oxford, 1963.

Heckscher, W. S. 'Bernini's Elephant and Obelisk', *The Art Bulletin*, xxix, 1947, pp. 155-82.

Hibbard, H. 'Nuove note sul Bernini', *Bollettino d'Arte*, xliii, 1958, pp. 181-3.
 'Un nuovo documento sul busto del cardinale Scipione Borghese del Bernini', *Bollettino d'Arte*, xlvi, 1961, pp. 101-5.
 Bernini, Penguin Books, 1965.

Hibbard, H. and Jaffe, I., 'Bernini's Barcaccia', *Burlington Magazine*, cvi, 1964, pp. 159-70.

Huse, N. *Gianlorenzo Berninis Vierströmebrunnen*. Dissertation, Munich, 1965 (unpublished).

Incisa della Rocchetta, G. 'Notizie sulla fabbrica della chiesa collegiata di Ariccia', *Rivista del R. Istituto di archeologia e storia dell'arte*, i, 1929, pp. 349-77.

Junquera, M. L. 'Sobre el bronce de Bernini en el Prado', *Archivo Español de Arte*, xxii, 1949, pp. 281-5.

Kauffmann, H. 'Romgedanken in der Kunst Berninis', *Jahresberichte der Max Planck Gesellschaft*, Göttingen, 1953-4, pp. 55-80.
 'Das Tabernakel in St. Peter', *Sitzungsberichte. Kunstgeschichtliche Gesellschaft zu Berlin*, Oct. 1954—May 1955, pp. 3-8.
 'Berninis Tabernakel', *Münchner Jahrbuch*, vi, 1955, pp. 222-42.

'Berninis Hl. Longinus', *Miscellanea Biblio-thecae Hertzianae*, Munich, 1961, pp. 366–74.

'Die "Aeneas-und Anchises"–Gruppe von Gianlorenzo Bernini (1598–1680) in der Galleria Borghese', *Festschrift für Theodor Müller*, Munich, 1965, pp. 281–91.

Krohn, M. 'Tø Buster fra Berninis Atelier i Glyptotheket', *Tidskrift för Konstvetenskap*, i, 1916, pp. 59–62.

Kurz, O. 'An unnoticed Work by Giovanni Lorenzo Bernini', *Burlington Magazine*, lxxv, 1939, pp. 70–5.

Lavin, I. Review of Wittkower, 'Bernini', *Art Bulletin*, xxxviii, 1956, pp. 255–60.

Longhi, R. 'Precisioni nelle Gallerie Italiane', *Vita Artistica*, i, 1926, pp. 65–7.

Maclagan, E. 'Sculpture by Bernini in England', *Burlington Magazine*, xl, 1922, pp. 56–63, 112–20.

Mâle, E. *L'art religieux après le Concile de Trente*, Paris, 1932.

Mariani, V. 'Bozzetti berniniani', *Bollettino d'Arte*, ix, 1929–30, pp. 59–65.

'Note berniniane', *Bollettino d'Arte*, x, 1930–1, pp. 57–69.

'Bernini e la Cattedra di San Pietro', *Bollettino d'Arte*, xxv, 1931, pp. 161–72.

Martinelli, V. 'Contributi alla scultura del Seicento. IV. Pietro Bernini e figlio', *Commentari*, iv, 1953, pp. 133–54.

Bernini, Milan, 1953.

'Contributi fiamminghi alla scultura italiana della prima metà del Seicento', *Actes du XVIIme congrès international d'histoire de l'art*, The Hague, 1955, pp. 367–76.

'Il busto di Urbano VIII di Gian Lorenzo Bernini nel Duomo di Spoleto', *Spoletium. Rivista di arte storia cultura*, i, 1955, pp. 43–9.

'Capolavori noti e ignoti del Bernini: I ritratti dei Barberini, di Innocenzo X e di Alessandro VII', *Studi Romani*, iii, 1955, pp. 32–52.

'I busti berniniani di Paolo V, Gregorio XV e Clemente X', *ibid.*, pp. 647–66.

I ritratti di pontefici di G. L. Bernini, Rome, 1956 (Quaderni di storia dell'arte, iii, Istituto di Studi Romani). Revised reprint of the two previous articles.

'Novità berniniane. Un busto ritrovato: La madre di Urbano VIII. Un Crocefisso ritrovato?', *Commentari*, vii, 1956, pp. 23–40.

Novità berniniane. 3. Le sculture per gli Altieri', *ibid.*, x, 1959, pp. 204–27.

'Contributi alla scultura del Seicento. Andrea Bolgi a Roma e a Napoli', *ibid.*, x, 1959, pp. 137–58.

'Bernini', in *Encyclopedia of World Art*, 1960, cols. 459–71.

'Novità berniniane. 4. "Flora" e "Priapo", i due termini già nella Villa Borghese a Roma', *Commentari*, xiii, 1962, pp. 267–88.

Matzulevitsch, G. 'Tre bozzetti di G. L. Bernini all'Ermitage di Leningrado', *Bollettino d'Arte*, xlviii, 1963, pp. 67–74.

Mercati, A. 'Nuove notizie sulla tribuna di Clemente IX a S. Maria Maggiore da lettere del Bernini', *Roma*, xxii, 1944, pp. 18–22.

Messerer, W. 'Zu Berninis Daniel und Habakuk', *Römische Quartalschrift*, lvii, 1962, pp. 292–6.

Mirot, L. 'Le Bernin en France', *Mémoires de la société de l'histoire de Paris*, xxxi, 1904, pp. 161–288.

Misciattelli, P. 'Un documento inedito dell'architetto Carlo Fontana', *Repertorium für Kunstwissenschaft*, xxxii, 1909, pp. 247–57.

Modigliani, E. 'I busti del cardinale Scipione e una scultura berninesca alla Galleria Borghese', *Bollettino d'Arte*, ii, 1908, pp. 66–73.

Mucchi, A. M. 'Un 'opera ignorata di Lorenzo Bernini', *Nuova Antologia*, cliv, 1911, pp. 283–7.

Muñoz, A. *Roma barocca*, Milan, 1921.

'Un' opera del Bernini ritrovata. Il busto di Gregorio XV', *Vita d'Arte*, viii, 1911, pp. 183–92.

'La scultura barocca a Roma', *Rassegna d'Arte*, iii, 1916, pp. 158–68, 208–22; iv, 1917, pp. 68–80, 131–47; v, 1918, pp. 78–104.

'Studi sul Bernini', *Arte*, xix, 1916, pp. 99–114.

'La scultura barocca e l'antico', *Arte*, xix, 1916, pp. 129–60.

'Nuovi studi sul Bernini', *Arte*, xx, 1917, pp. 45–51.

'Alcune opere sconosciute del Bernini', *ibid.*, pp. 185–94.

'Alcuni ritratti a busto del Seicento Romano', *Dedalo*, iii, 1922–3, pp. 671–94.

G. L. Bernini architetto e decoratore, Rome, 1925.

Niño, F. 'Bernini en Madrid', *Archivo Español de Arte*, xviii, 1945, pp. 150–61.

Norton, R. *Bernini and other Studies*, New York, 1914.

Pane, R. *Bernini architetto*, Venice, 1953.

Panofsky, E. 'Die Scala Regia im Vatikan und die Kunstanschauungen Berninis', *Jahrbuch d. Preussischen Kunstsammlungen*, xl, 1919, pp. 241–78.

Pascoli, L. *Vite de'Pittori, Scultori ed Architetti*, Rome, 1730.

Passeri, G. B. *Die Künstlerbiographien*, Leipzig and Vienna, 1934, ed. J. Hess (first ed. *Vite de' Pittori*, Rome, 1772).

Pastor, L. von. *Geschichte der Päpste*, vols. 12–14.

Pergola, Paola della. 'Il fauno di Villa Borghese', *Capitolium*, xxxvii, No. 11, 1962, pp. 724–7.

Pollak, O. 'La fontana detta la Barcaccia in Roma', *Vita d'Arte*, iv, 1909, pp. 515–20.
Die Kunsttätigkeit unter Urban VIII, Vienna, 1927, vol. i: Kirchliche Bauten und Paläste (quoted as: Pollak, i).
Die Kunsttätigkeit unter Urban VIII, Vienna, 1931, vol. ii: Die Peterskirche in Rom (quoted as: Pollak, ii).

Pope-Hennessy, J. *Italian High Renaissance and Baroque Sculpture*, London, 1963 (3 vols.).
Catalogue of Italian Sculpture in the Victoria and Albert Museum, London, 1964.

Popp, A. E. 'Der Barberinische Faun', *Jahrbuch für Kunstgeschichte*, Vienna, i, 1922, pp. 215–35.

Previtali, G. 'Il Costantino messo alla berlina o bernina su la porta di S. Pietro', *Paragone*, xiii, 1962, No. 145, pp. 55–8.

Ragghianti, C. L. 'Bernini scultore', *Sele Arte*, vii, 1959, No. 41, pp. 33–43. (Review of Wittkower, 'Bernini').

Rev.—Revue de l'art ancien et moderne.

Reymond, M. *Le Bernin*, Paris (1911).
'Le buste du Cardinal de Richelieu par le Bernin au Musée du Louvre', *Bulletin des Musées de France*, 1910, pp. 65–8.
'L'autel du Val-de-Grâce et les ouvrages du Bernin en France', *Gazette des Beaux-Arts*, v, 1911, pp. 367–94.
'Une "Madone" du Bernin à Paris', *ibid.*, vi, 1911, pp. 299–313.
'Le Pont Saint-Ange par le Bernin', *Revue de l'art anc. et mod.*, xxxii, 1912, pp. 99–112.
'La statue équestre de Louis XIV par le Bernin', *ibid.*, xxxiv, 1913, pp. 23–40.
'Les sculptures du Bernin à Bordeaux', *ibid.*, xxxv, 1914, pp. 45–60.

Riccoboni, A. *Roma nell'arte. La scultura*, Rome, 1942.

Richardson, E. P. 'Two Bozzetti by Gian Lorenzo Bernini', *The Art Quarterly*, 1953, pp. 3–10.

Riedl, P. A. *Gian Lorenzo Bernini. Apollo und Daphne*, Stuttgart, 1960.

Riegl, A. *F. Baldinucci. Vita des Gio. Lorenzo Bernini*. Mit Übersetzung und Kommentar von Alois Riegl. Herausgeg. von A. Burda und O. Pollak, Vienna, 1912.

Sacchetti Sassetti, A. 'Gian Lorenzo Bernini a Rieti', *Archivi d'Italia*, xxii, 1955, pp. 214–27.

Sant' Ambrogio, D. 'Un artistico busto eneo ascrivibile al Bernini nel Museo Poldi-Pezzoli', *Rassegna d'Arte*, vi, 1906, pp. 77–9.

Santangelo, A. 'Gian Lorenzo Bernini (attr.): "Baccante"', *Bollettino d'Arte*, xli, 1956, pp. 369–70.

Schiavo, A. *La donna nelle sculture del Bernini*, Milan, 1942.
'Il viaggio del Bernini in Francia nei documenti dell' Archivio Segreto Vaticano', *Bolletino del Centro di Studi per la Storia dell' Architettura*, 1956, No. 10, pp. 23–80.

Schudt, L. 'Berninis Schaffensweise und Kunstanschauungen nach den Aufzeichnungen des Herrn von Chantelou', *Zeitschrift für Kunstgeschichte*, xii, 1949, pp. 74–89.

Sestieri, E. 'Una caricatura di Gian Lorenzo Bernini', *Commentari*, viii, 1957, pp. 113–17.

Sirén, O. *Nicodemus Tessin d. y:s studieresor i Danmark, Tyskland, Holland, Frankrike och Italien*, Stockholm, 1914.

Sobotka, G. 'Filippo Baldinuccis Vita des Gio. Lorenzo Bernini', *Repertorium f. Kunstwissenschaft*, xxxvi, 1913, pp. 107–13.
Die Bildhauerei der Barockzeit. Herausgegeben von H. Tietze, Vienna, 1927.

Somers, S. 'Bernini as a Sculptor', *Burlington Magazine*, c, 1958, pp. 284–8 (Review of Wittkower, 'Bernini').

Tetius, H. *Aedes Barberinae*, Rome, 1642.

Titi, F. *Studio di pittura, scoltura et architettura nelle chiese di Roma*, Rome, 1674 (ed. of 1686 with title: *Ammaestramento utile e curioso . . .*).

Tormo, E. 'Los cuatro grandes Crucifijos de bronce dorado del Escorial', *Archivo Español de Arte*, i, 1925, pp. 117–45.

Tosatti, Q. 'L'evoluzione del monumento sepolcrale nell'età barocca', *Bollettino d'Arte*, vii, 1913, pp. 173–86.

Venturi, A. 'Lorenzo Bernini in Francia', *Archivio storico dell'Arte*, iii, 1890, p. 143.

Venturi, L. 'Note sulla Galleria Borghese', *Arte*, xii, 1909, p. 50.

Viligiardi, A. 'Bozzetti in terra cotta di Gian Lorenzo Bernini rinvenuti a Siena', *Rassegna d'Arte Senese*, xiii, 1920, pp. 36–8.

Voss, H. 'Über Berninis Jugendentwicklung', *Monatshefte f. Kunstwissenschaft*, iii, 1910, pp. 383–9.
'Berninis Fontänen', *Jahrbuch d. Preussischen Kunstsammlungen*, xxxi, 1910, pp. 99–129.
'Ein vergessenes Werk Lorenzo Berninis', *Zeitschrift f. bildende Kunst*, lviii, 1924–5, pp. 35–8.

Weibel, W. *Jesuitismus und Barockskulptur in Rom*, Strasbourg, 1909.

Weisbach, W. *Der Barock als Kunst der Gegenreformation*, Berlin, 1921.

Wittkower, R. 'Le Bernin et le baroque romain', *Gazette des Beaux-Arts*, xi, 1934, pp. 327–41.
Bernini's Bust of Louis XIV, London, 1951.
'Bernini Studies—1: The Group of Neptune

and Triton', *Burlington Magazine*, xciv, 1952, pp. 68–76.
'Bernini Studies—II: The Bust of Mr. Baker', *ibid.*, xcv, 1953, pp. 19–22, 138–41.
'Bernini', in *Les sculpteurs célèbres*, ed. Lucien Mazenod, Paris, 1954.
Art and Architecture in Italy 1600–1750, Harmondsworth, 1958 (second ed., 1965).
'Melchiorre Cafà's Bust of Alexander VII', *The Metropolitan Museum of Art Bulletin*, xvii, 1959, pp. 197–204.
'The Vicissitudes of a Dynastic Monument: Bernini's Equestrian Statue of Louis XIV', in *De Artibus Opuscula XL*, Essays in Honor of Erwin Panofsky, New York, 1961, pp. 497–531.
'The Role of Classical Models in Bernini's and Poussin's Preparatory Work', *Studies in Western Art. Acts of the Twentieth International Congress of the History of Art*, Princeton, 1963, pp. 41–50.
See: Brauer, H.
Zeri, F. 'Gian Lorenzo Bernini: un marmor dimenticato e un disegno', *Paragone*, x, 1959, No. 115, pp. 61–4.

Literature published since the appearance of the second edition is mentioned in the Addenda to the Catalogue on pp. 273–8.

PREAMBLE

PURPOSE OF THE CATALOGUE

An attempt has been made to list here the authentic sculptural works by Bernini. The intention has been not only to summarize our present knowledge, but also to clarify some of the many problems which are in a state of flux. Preparatory drawings, bozzetti and replicas have, as a rule, been summarily mentioned. Only in some special cases have they been discussed in detail.

AUTHENTICITY

To decide what should be regarded as a 'work by Bernini' is even more difficult than in the case of Rubens. There is an indeterminable area between wholly authentic works and those which Bernini designed, but for the execution of which he cannot be held responsible. As a rule, all those works have been included in the Catalogue in which his participation and supervision is proved by published and unpublished source material and/or by drawings and bozzetti. It remains to a certain extent arbitrary what to include or exclude at the 'lower margin', and the reader may find works listed which he did not expect, and vice versa. The entries have been kept as brief as possible when, in the author's view, studio hands or assistants were given a relatively free hand.

CHRONOLOGY

The arrangement is on the whole chronological. Since at most periods of Bernini's life many enterprises ran concurrently and occupied him over many years, a strict chronological sequence was not possible. The Chronological Table (pp. 276–7) will help to correct any false impression which the sequence of the catalogue entries may give.

ATTRIBUTIONS

It seemed unnecessary to refute singly all the wrong traditional attributions to Bernini. Only in a few exceptional cases have they been included. But attributions, made by scholars since the first edition of this book (1955), not acceptable to the author, have been treated at some length in the new entry No. 82.

DESTROYED WORKS

Of the destroyed works only those have been separately discussed which are sufficiently well documented. The others, together with occasional works such as catafalques and festival decorations, have been summarily listed at the end of the Catalogue (No. 81).

CHARACTER OF THE ENTRIES

The entries contain mainly factual material in condensed form. As a rule, references have been limited to sources and documents. For new facts and new finds, only the key publication has been quoted, so as to avoid the accumulation of bibliographical data. For brevity's sake I abstained—so far as possible—from controversies in the first edition. The rich critical literature of the last ten years made it sometimes necessary to abandon in the present edition this self-imposed restraint. Stylistic, iconographic and historical observations have had to be included in many entries. For reasons of space these remarks have often been unduly brief.

SOURCES AND DOCUMENTS

The most important sources for Bernini's life and work are, first, the contemporary biographies by Baldinucci and Domenico Bernini and, in addition, the Sieur de Chantelou's trustworthy record of Bernini's stay in Paris. Baldinucci collected his material with care and discrimination; his principal informant was Bernini's beloved pupil, Giulio Cartari. Domenico was an eyewitness to the later events of his father's life. The present Catalogue is, therefore, to a considerable extent based on the material contained in these writings.

Secondly, the Catalogue makes full use of the immense mass of documents published by Fraschetti, Oskar Pollak, Golzio, Battaglia, Incisa della Rocchetta and others, added to by the author's own researches in Roman archives. As far as it appeared necessary, the content of the documents has been summarized in the entries.

MEASURES AND MONEY VALUES

As a rule, indications of 'life-size', 'over life-size' and 'under life-size' seemed to be a better help for the imagination than precise measurements, which are often difficult to obtain. Whenever possible, precise measurements have been added in metres and centimetres (1 inch = 2·54 cm.). The present value of the Roman *scudo* is not easy to determine with any degree of exactness. Its purchasing power was probably somewhat greater than £1 (present value).

CATALOGUE

***1. THE GOAT AMALTHEA NURSING THE INFANT ZEUS.** Galleria Borghese, Rome PLATE 1

Small marble group. H. 45 cm.

This work, showing the resting goat nursing the infant Zeus and a young satyr, was first described by Sandrart (*Teutsche Academie*, ed. Peltzer, p. 285), who collected his material in Rome in 1629. Later sources are silent, and in the descriptions of the Villa Borghese from Manilli (1650) to Nibby (1838) the group is mentioned as anonymous. R. Longhi (*Vita Artistica*, i, 1926, p. 65f.) rediscovered it and dated it quite early, about 1615. This date was challenged by V. Martinelli (*Commentari*, iv, 1953, p. 147, note 20), who advocates a later origin, *c.* 1620. Faldi (i, p. 144), however, found a payment of 1615 for the (lost) pedestal.

Neither the attribution nor the date 'about 1615' can be doubted. The convex base resembles that of the Aeneas group (No. 8) and the 'sliding' of the children may be compared with the uncertain stance of the young Ascanius. The treatment of the hair is reminiscent of that of the Santoni bust (No. 2) and the St. Lawrence (No. 3), and the realistic goat's skin recurs, more developed, on David's quiver (No. 17). Finally, the type of the children is closely paralleled by the Cherubs' heads in the framework of the Santoni tomb. In spite of the realistic vitality of the group, which may be contrasted with the polished elegance of a similar group by Pietro Bernini (ill. by Faldi), the juvenile crudities of attitudes, proportions and surface treatment (such as the hair) cannot be overlooked. Full bibliographical references in Faldi, *Galleria Borghese*, 1954, p. 25, No. 30.

***2. TOMB OF BISHOP GIOVAN BATTISTA SANTONI.** S. Prassede, Rome PLATE 2, FIG. 1

Life-size marble bust and architectural setting.

Baldinucci (p. 74) mentions as the first work of the young Bernini in Rome a bust in S. Pudenziana, apparently a slip of the pen, for in his catalogue of Bernini's works he opens the list of portrait busts with that of the 'Majordomo di Sisto V in S. Prassede' (p. 176). Fraschetti (p. 9ff.) related this entry to the Santoni tomb. In 1568 Santoni was consecrated Bishop of Alife and in 1586 Bishop of Tricarico, but immediately after ascending the papal throne Sixtus V appointed him his major-

domo. Santoni died in 1592. (Biographical data in S. Ehses and A. Meister, *Nuntiaturberichte aus Deutschland 1585–90*, Paderborn, 1895, p. lxiii; see also A. Grisebach, *Römische Portraitbüsten*, Leipzig, 1936, p. 152). Santoni signed his letters 'Sanctonius' or 'Santonius', but, as Howard Hibbard informs me, is called Sanctorius in various papal briefs and bulls. He is listed as Santori in Gulik-Eubel, *Hierarchia catholica*, iii, p. 338, and in Gams, *Series episcoporum ecclesiae catholicae*, p. 935,

1. *TOMB OF GIOVAN BATTISTA SANTONI.* S. Prassede, Rome (No. 2).

while the inscription on his tomb ('Santonius') concurs with his usual signature.

According to Baldinucci, Bernini made the bust at the age of ten. But apart from the obvious tendency to turn Bernini into an unrivalled prodigy, Baldinucci's early chronology is full of contradictions. Everybody agrees, however, that this work stands at the beginning of Bernini's career. Dates between 1613 and 1616 have been suggested. It is evident that the bust is close in style to that of the Goat Amalthea (No. 1), but it seems to be slightly more developed. In order to assess Bernini's advance towards a new interpretation of the human head one should compare the work with contemporary portraits of high quality such as the bust of Baldassare Ginanni in S. Agostino (Grisebach, fig. 61; see also Hibbard, *Bernini*, 1965, p. 30).

It is generally overlooked that the rather crude decorative heads in the Mannerist framework of the tomb are also by Bernini's hand.

***3. ST. LAWRENCE ON THE GRILL.** Contini Bonacossi Collection, Florence PLATE 4

Under life-size marble. H. 66 cm., L. 1·08 m.

Baldinucci (p. 77f.) says that at the age of fifteen Bernini made a St. Lawrence on the grill for Leone Strozzi, and he seems to date it just before the Aeneas and Anchises (No. 8). The figure remained until recently in the Strozzi family (first in their Roman villa, later in their Florentine palace).

In connection with this piece, Domenico Bernini (p. 15) relates an anecdote of which this much is certainly true, that at that moment the young Bernini was passionately interested in physiognomical studies (see also No. 7). In addition, Domenico is probably correct in stating that Gian Lorenzo made the figure as homage to the saint whose name he bore. According to Domenico Bernini, it was only after the work was finished that Leone Strozzi saw it and liked it so much that he secured it for himself.

It is probable that this work is earlier than the St. Sebastian (No. 4), which appears to be more developed (see, e.g. the handling of the hair). Date, therefore, 1616-17.

***4. ST. SEBASTIAN.** Thyssen-Bornemisza Collection, Lugano (from the Palazzo Barberini) PLATE 5

Under life-size marble figure.

Baldinucci in his catalogue (p. 178) mentions two marble figures of St. Sebastian, one in the Palazzo Barberini, the other in the possession of the Princess of Rossano. The latter cannot be traced. Muñoz (*Arte*, xix, 1916, p. 154f.) was the first to relate Baldinucci's entry to the Barberini Sebastian, no doubt correctly. The description in the Barberini inventory of 1629-40 (Pollak, i, p. 334)

of a 'St. Sebastian 4½ palmi high by Cav. Bernini' can only refer to the present figure (4½ palmi = 112 cm.). Riccoboni's attribution to Duquesnoy (p. 172) is without foundation, as is also the date 1626. Muñoz dated the work *c.* 1625. But for reasons of style it should be dated much earlier, after the St. Lawrence (No. 3) and certainly before the Aeneas group (No. 8), i.e. 1617-18. This appears to be Faldi's view (i, p. 145; see also Martinelli, *Bernini*, p. 16).

An early date can be supported from another side. It seems possible to reconstruct the original destination of the statue. The church of S. Andrea della Valle was built on the site of an old church dedicated to St. Sebastian and suppressed in 1590 (Christian Hülsen, *Le chiese di Roma nel medio evo*, 1927, p. 460f.). The first chapel on the left, commissioned by Maffeo Barberini, later Urban VIII, has in its left wall a recess of *c.* 2×1·50 m. (*c.* 6½×5 feet) quite close to where the apse of the old church had been (see Hibbard's reconstruction in *Art Bulletin*, xliii, 1961, p. 293). In small niches of the shorter walls stand Francesco Mochi's Carlo Barberini and Cristoforo Stati's Monsignor Francesco Barberini; on the altar is Passignano's picture (*c.* 1·80 m. high) which may well have been placed in front of a niche (information Ilaria Toesca). It is more than likely that Bernini's Sebastian was planned for this altar; it was, however, never placed there and remained in the Barberini palace. Maffeo Barberini's dedicatory inscription under Passignano's picture is dated 1616 (Forcella, viii, p. 264, No. 663). But this is not necessarily the exact date of the completion of the statue.

Bernini followed in this work not only Hellenistic models (hair), but also Michelangelo. The position of the legs almost corresponds to that of the Florentine Pietà which at that time was still in Rome (G. D. Ottonelli & Pietro da Cortona, *Trattato*, 1652, p. 210). For the position of the left leg he may have been stimulated by Sabbatini's painting after the Pietà in the Sacristy of St. Peter's, while the head and left arm are reminiscent of the Pietà in St. Peter's.

Muñoz was the first to notice the connections with the Barberini Faun, and Neusser (*Studien über die Ergänzung antiker Statuen*, Vienna Dissertation, 1926, p. 117) regarded the Sebastian as a kind of preparatory study for the restoration of that work. The relation to the Faun is puzzling since the latter seems to have been found long after the completion of the Sebastian (further to this problem: No. 11).

***5. BUST OF GIOVANNI VIGEVANO ON HIS TOMB.** S. Maria sopra Minerva (left aisle, pillar between third and fourth chapel), Rome

PLATE 3, FIG. 2

Life-size marble.

*See Addenda, pp. 273ff.

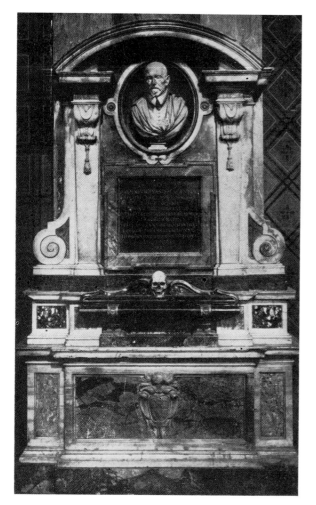

2. *TOMB OF GIOVANNI VIGEVANO.*
S. Maria sopra Minerva, Rome (No. 5).

6. BUSTS OF POPE PAUL V

PLATE 8, FIGS. 3, 4

(1) Galleria Borghese, Rome

Marble, 35 cm. high.

The bust has always been in the Villa Borghese, where it was mentioned in Baldinucci's catalogue (p. 177). As suggested by Muñoz (*Arte*, xix, 1916, p. 99ff.), it must be earlier than the second bust mentioned below. Extrinsically and intrinsically 1618 seems to be the most likely date. (This date has been accepted by V. Martinelli, *Ritratti*, 1956, p. 11, correcting his earlier opinion, and by I. Faldi, *Galleria Borghese*, 1954, p. 26, No. 31). I would place it after the Vigevano (No. 5) and at the beginning of Borghese patronage; this is also supported by Domenico Bernini (p. 17).

The present base with the Borghese coat of arms is modern (1920). See Faldi, *loc. cit.*, for fullest information about the work.

(2) Unknown Private Collection, formerly Gesù and Villa Borghese, Rome

Marble, 79 cm. high.

Baldinucci (p. 177) mentions among Bernini's 'marble figures' a Paul V in the Gesù. Fraschetti (p. 18) had reason to believe that this was the bust which was later transferred from the church to the Villa Borghese (see also Faldi, ii, p. 311; Fraschetti's identification not accepted by Martinelli, *op. cit.*, p. 16), and Muñoz (*loc. cit.*, fig. 3) showed that a bust of Paul V was sold from there in 1893 as by Algardi. According to documents published by Faldi (i, p. 146, ii, p. 314 and fig. 1), Bernini was paid in 1621 for a bust of the Pope. Although definite proof is lacking, it is tempting to relate this payment with the Gesù bust (last heard of in a Viennese collection) which must have been commissioned shortly before the Pope's death (28 January 1621). Paul V seems older than in the small Borghese bust. Moreover, the cutting of the bust and the decoration of the cope are so close to the bust of Gregory XV that not much time can have elapsed between the two.

A bronze bust, corresponding to the marble bust, is in the Ny Carlsberg Glyptotek, Copenhagen (Fig. 4. H. 66 cm. without base. See M. Krohn, *Tidskrift f. Konstvetenskep*, i, 1916, p. 59f.; H. Olsen, *Italian Painting, Paintings and Sculpture in Denmark*, Copenhagen, 1961, p. 101f.). It comes from the Palazzo Borghese (Faldi, ii, p. 311) and has, therefore, a first-rate pedigree. This must be the bronze which Sebastiano Sebastiani cast in 1621–2, probably from Bernini's model of the marble bust, together with a bust of Gregory XV (see No. 12). A bronze-coloured cast taken from the bronze is in the Salone dei Canonici in S. Maria Maggiore, Rome (Muñoz, *op. cit.*, p. 103, fig. 4. Phot. Gab. Fot. Naz.,

Vigevano died, almost 90 years old, on 21 December 1630 (Fraschetti, p. 86, note 3). The tomb was, according to the inscription, erected by his son, i.e. probably in 1631. It is evident that the bust has no place in Bernini's development of that period, and it has therefore almost generally been regarded as a school piece. However, it fits well into his early career. In addition, Baldinucci mentions it in his catalogue (p. 176). Only Reymond (*Rev.*, xxxi, 1914, p. 58) dated the bust *c.* 1620 and accepted it as authentic, and this was supported with new arguments by the present author (*B.M.*, 95, 1953, p. 21). It would appear that a bust made during the sitter's lifetime was later used for his tomb—by no means an unusual practice.

The Vigevano is evidently close to the earliest group of works and, in particular, to the St. Sebastian. Date, therefore, *c.* 1617–18. The early date has now been generally accepted, for instance by Martinelli, *Studi Romani*, 1955, p. 36; A. Nava Cellini, *Paragone*, vi, 1955, No. 65, p. 24.

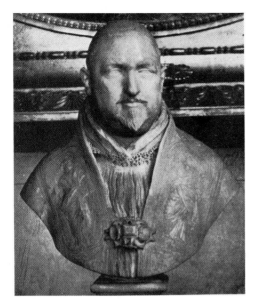

3. *POPE PAUL V.*
Galleria Borghese, Rome (No. 6–1).

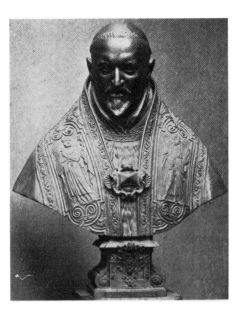

4. *POPE PAUL V.*
Museum, Copenhagen (No. 6–2).

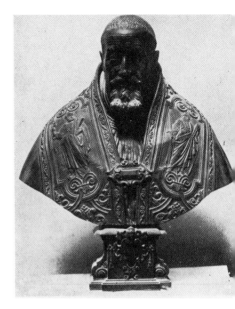

5. *POPE GREGORY XV.*
Museo Civico, Bologna (No. 12–3).

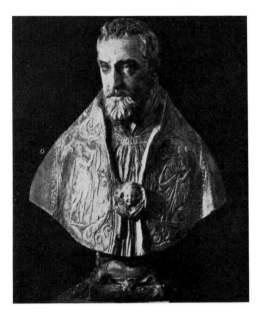

6. *CARDINAL DE SOURDIS.*
St. Bruno, Bordeaux (No. 14).

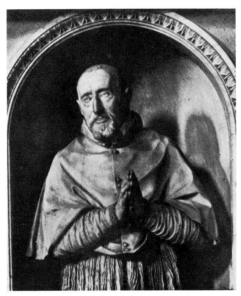

7. *CARDINAL ROBERTO BELLARMINE.*
Gesù, Rome (No. 15).

8. *CARDINAL GIOVANNI DOLFIN.*
S. Michele all'Isola, Venice (No. 16).

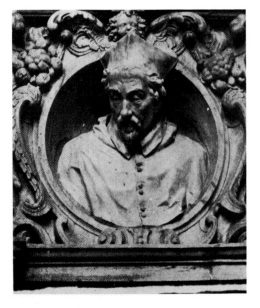

9. *CARDINAL MELCHIOR KLESL.*
Cathedral, Wiener Neustadt (No. 22).

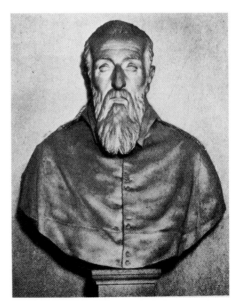

10. *CARDINAL AGOSTINO VALIER.*
Seminario, Venice (No. 25).

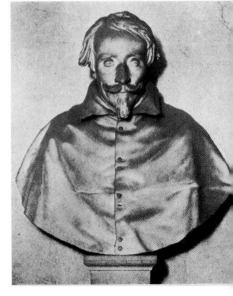

11. *CARDINAL PIETRO VALIER.*
Seminario, Venice (No. 25).

C 9627, 9628). It is unlikely that this cast imitating bronze was made after the (lost) marble bust, as Martinelli, *op. cit.*, p. 18, note 26 suggests.

7. ANIMA BEATA AND ANIMA DANNATA. Palazzo di Spagna, Rome PLATES 6–7

Life-size marble busts.

Baldinucci mentions in his catalogue (p. 178) the two heads of the 'saved' and the 'condemned soul' in S. Giacomo degli Spagnuoli. They were transferred to S. Maria di Monserrato together with the Montoya tomb (No. 13), and later to the Palazzo di Spagna.

Little attention has been paid to these important works, which have been even ascribed to Bernini's school (Sobotka, *Monatsh. f. Kunstw.*, vi, 1913, p. 257; Benkard, p. 40). They must be regarded primarily as physiognomical studies (see No. 3) under an iconographical cloak. The 'Anima Dannata' may possibly have been worked before the mirror.

It is reasonable to suggest that these heads came into S. Giacomo through the agency of Monsignor Montoya and their date cannot be far from that of his bust. But there are indications that they were made one or two years earlier, i.e. about 1619. (Some authors date them a little later, e.g., J. Pope-Hennessy, *It. High Ren. and Bar. Sculp.*, 1963, Catal., p. 123: *c.* 1621.) There are connections with the earliest group of works (e.g. the 'doughy' hair of 'Anima Beata', the treatment of the eyes, of the wreath, etc.), while other features point forward to the Borghese groups (cavities of Pluto's and Daphne's mouths, the tense expression of David).

Fine gilt bronze copies, probably by Massimiliano Soldani, were in the Liechtenstein Collection, Vienna (Tietze-Conrat, *Jahrb. d. kunsthist. Instituts*, xi, 1917, p. 100), but the 'Anima Dannata' was sold at Lepke's, Berlin (3 December 1929).

Good marble copies are in the Spanish Seminary of S. Maria di Monserrato.

*8. AENEAS, ANCHISES AND ASCANIUS. Galleria Borghese, Rome PLATES 9, 10, 15, 16

Life-size marble group. H. 2·20 m.

Baldinucci (p. 78), quite correctly, declared this to have been Bernini's first work for Cardinal Scipione Borghese. Although he saw that it was 'somewhat in the manner of Pietro, his father', he had a clear understanding of its new realistic quality. Modern critics have shown a tendency to attribute the group to Pietro Bernini. This view, first submitted by Muñoz (*Vita d'Arte*, iv, 1910, p. 446f.), was more forcibly stated by R. Longhi (*Vita Artistica*, i, 1926, p. 66) who adduced a passage in Sandrart's *Academie* in support of it (Sandrart

was in Rome in 1629). Most scholars followed Longhi (summary of the whole question in A. de Rinaldis, *L'Arte in Roma*, 1948, p. 203ff.). The present author (*B.M.*, 1952, p. 71) argued in favour of Gian Lorenzo's authorship, which was also maintained by Martinelli (*Commentari*, iv, 1953, pp. 146f., 151f.). The latter, moreover, advocates, perhaps too rigidly, a strict separation between the father's and the son's studios even at this early date. Documents, however, prove that Pietro was not only keenly interested in Gian Lorenzo's affairs, but was also at the latter's disposal when needed (see Nos. 12, 21, etc.).

More recently Gian Lorenzo's authorship has been unequivocally established. Faldi (i, p. 146) published a payment for the pedestal of the *statua di Enea*, dated 14 October 1619, and under the same date Gian Lorenzo received 350 scudi 'for a statue made by him'. Because of the singular ('statua'), the latter document, first published by L. Venturi (*Arte*, 1909, p. 50), had always been referred to the David. But such reasoning is evidently fallacious. Even Baldinucci talks of the *statua dell'Enea*. It appears therefore that the Aeneas group was probably begun in 1618 and, in any case, finished in the autumn of 1619, and this fact shatters the chronology, until recently held, of Bernini's early works.

The original pedestal, an ancient piece decorated with bucrania and garlands and reworked in 1619, is still in the Villa Borghese (Faldi, i, fig. 3), serving as base for a classical figure.

As regards the theme of the group: the connotations with Christian ideas of the *Imago Pietatis* and imperial Roman concepts of this illustration of the Virgilian text (*Aeneid*, ii, 707ff.), have been admirably discussed by H. Kauffmann, 1953–4, p. 67ff., who has also devoted a recent paper to the 'Aeneas and Anchises' iconography (in *Festschrift für Theodor Müller*, Munich, 1965, p. 281 ff.). For further references, see Faldi, *Galleria Borghese*, 1954, pp. 26–9, No. 32.

*9. NEPTUNE AND TRITON. Victoria and Albert Museum, London PLATES 11, 18, 21

Life-size marble group. H. 1·82 m.

Baldinucci mentions in his catalogue (p. 178) a 'Neptune and Glaucus in Villa Montalto'. In seventeenth-century engravings the group can be seen in the garden of the villa, crowning an older fish pond (Wittkower, *B.M.*, xciv, 1952, p. 75, figs. 6, 7). Cardinal Alessandro Peretti, who commissioned the group, died on 3 June 1623. I have attempted to show (*loc. cit.*) that for stylistic reasons the Neptune should be dated immediately after the Aeneas group. This remains essentially correct, although the new documents published by Faldi have altered the chronology. If the Neptune group belongs to

★See Addenda, pp. 273ff.

the period after the completion of the Aeneas group (autumn 1619) and before the beginning of the Pluto (early 1621), 1620 suggests itself as date. This dating has been generally accepted with the exception of D'Onofrio (*Fontane di Roma*, 1957, p. 270: 1622–3) and Pope-Hennessy (*It. High Ren. and Bar. Sculp.*, 1963, p. 123: *c.* 1621; *id.*, *Catalogue*, 1964, p. 596ff., No. 637: after 1622).

The group left Rome in 1786 (for its history, Maclagan, *B.M.*, xl, 1922, p. 112ff. and my above-cited paper), was acquired on speculation by Sir Joshua Reynolds and sold after his death to Lord Yarborough, in whose family it remained until 1950. The most comprehensive discussion of the group's history, in Pope-Hennessy, 1964, *loc. cit.*

Baldinucci's wrong title 'Neptune and Glaucus' has clung to the group. But already Reynolds knew that this Virgilian group was meant to represent 'Neptune and Triton' (*Aeneid*, i, 132ff.). It illustrates Virgil's often represented 'Quos ego' (see Wittkower, *loc. cit.*). Pope-Hennessy (1964, p. 600) argues that the group 'agrees more closely with a passage in Ovid' (*Met.*, i, 330–42). Although in some respects this passage seems well suited, it states explicitly that Neptune laid down his trident (see also Hibbard, *Bernini*, 1965, p. 235). It is not unlikely that Bernini made use of both texts. L. Grassi (*B.M.*, cvi, 1964, p. 174ff.) made the interesting observation that engravings after Polidoro da Caravaggio's *sgraffiti* influenced Bernini's Neptune and Triton and to a certain extent also the Pluto and David.

Small replicas in bronze and other materials are common. One of these, a bronze version (52 cm.) in the Villa Borghese (on loan from the Gall. Nazionale, Rome; Faldi, *Villa Borghese*, 1954, p. 42f., No. 39), was regarded by Muñoz (*Arte*, xix, 1916, p. 107ff.), without sufficient reason, as being by Bernini himself. For other replicas, see Pope-Hennessy, 1964, pp. 600 and 609 (No. 642).

★10. PLUTO AND PROSERPINA. Galleria Borghese, Rome PLATES 12, 17, 20

Over life-size marble group. H. 2·25 m.

Baldinucci, in his catalogue (p. 177f.), enumerates the Aeneas group, the Rape of Proserpina, David, and Apollo and Daphne, in this order, which is by and large the correct sequence. Until recently it had been generally assumed that the David was earlier than the Rape of Proserpina. Only R. Longhi (*Precisioni nelle Gallerie Italiane*, i, Rome, 1928, p. 11f.) pleaded for dating the Rape before the David. New documents published by Faldi (i, p. 146, ii, p. 314) clarify the position once and for all. In June 1621 Bernini received 300 scudi for the Rape and a portrait bust of Paul V (see No. 6) and another 150 scudi on 15 September. In the summer of 1622 the group

was finished (Faldi, ii, p. 310). Final payment not until 3 April 1624 (Hibbard, *Boll. d'Arte*, 1958, p. 183). An important preparatory drawing (Brauer-Wittkower, p. 18, pl. 5a) shows that Bernini, in the beginning, fell back upon Mannerist conceptions of rape groups (Giovanni Bologna).

Cardinal Scipione Borghese presented the group to Cardinal Ludovico Ludovisi, Gregory XV's nephew. Since the Pope died in the beginning of July 1623, it would have been presented before that date. A payment of 23 July 1623 (Faldi, *loc. cit.*) seems to refer to its transfer to the Villa Ludovisi. At the beginning of the twentieth century the group returned to the Villa Borghese. The present pedestal dates from 1911.

A bozzetto for the head of Proserpina is discussed under No. 18. Small bronze replicas of the group are known; one was in the Schloss Museum, Berlin. An interesting wooden replica with brownish-black lacquer patina (H. 65 cm.) was recently with G. Cramer in The Hague. For further references and bibliography, see Faldi, *Villa Borghese*, 1954, p. 29ff., No. 33.

11. RESTORATIONS OF ANTIQUE STATUES PLATE 22, FIGS. 12, 13, 14

Before the dawn of nineteenth-century archaeology, collectors wanted their antiques complete, and restoration was therefore an important source of income for the rank and file of sculptors. But although a devoted student of classical antiquity, Bernini had neither need nor time often to undertake this kind of work. The few restorations due to him belong to his early period; later, his public position and the constant pressure of large commissions excluded such subordinate occupation.

12. *HERMAPHRODITE*. Louvre, Paris (No. 11–1).

★(1) *Hermaphrodite*. Louvre, Paris. From the Villa Borghese.

Bernini's main contribution is the extremely realistically rendered mattress for which he was paid on 9 March 1620. The document published by Faldi (i, p. 146) has settled an old problem. In recent years scholars usually attributed the restoration to Pietro Bernini. (A second Hermaphrodite still in the Villa Borghese was restored after the mid-eighteenth century by Bergondi.)

★See Addenda, pp. 273ff.

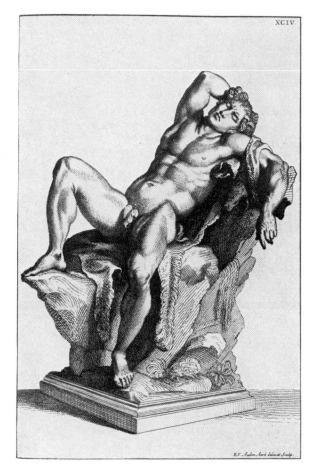

13. *BARBERINI FAUN*. From Maffei, 1704 (No. 11–2).

(2) *Barberini Faun*. Glyptothek, Munich. From the Palazzo Barberini.

According to a later tradition Bernini restored part of the rock in marble (studio work) and added in stucco the right leg, most of the left leg and of the left arm. The stucco restorations were somewhat altered when Pacetti replaced them in marble after 1799. For Bernini's restoration of the figure compare the engraving in Maffei's *Raccolta di statue antiche e moderne*, 1704. It may also be seen in Bouchardon's marble copy of the Faun (Louvre) of 1726–30 (Roserot, *Bouchardon*, 1910, p. 16, pl. 4). In an interesting but entirely misguided study, A. E. Popp (*Jb. f. Kunstgesch.*, i, 1923, p. 215ff.) tried to reconstruct two restorations by Bernini from different periods of his life, basing her hypothesis on Tetius's fanciful illustration of the Faun in a recumbent position (*Aedes Barberinae*, 1642, p. 215). Popp's deductions were refuted by M. Neusser as early as 1926 (*Studien über die Ergänzung antiker Statuen*, Vienna Dissertation, p. 117). If archaeologists are correct in maintaining that the Faun was found between 1624 and 1628 (Bulle, *Jb. d. archäol. Inst.*, 1901, p. 1ff.), Bernini must have anticipated certain of its features in his St. Sebastian of *c.* 1617–18 (No. 4). On the other hand, K. Cassirer (*Münchener Jahrb.*, xii, 1921–2, p. 90ff.) has shown that another

*See Addenda, pp. 273ff.

version of the Faun, now lost, was known as early as the second half of the sixteenth century.

★(3) *Ares Ludovisi*. Museo delle Terme, Rome. From the Villa Ludovisi.

Main restorations: right foot of Ares, head of Eros, his left arm and right forearm. The restoration is mentioned in the Ludovisi inventory of 1633 (T. Schreiber, *Bildwerke der Villa Ludovisi*, 1880, p. 82ff. with further details). Older authors, Vasi, Volkmann and others, attributed the restoration to Bernini. More recently it has usually been given to Algardi. Faldi (i, p. 141f.) and, before him, Posse (*Thieme-Becker*, iii, p. 462) returned, correctly, in my view, to the old attribution. The style of the restoration points to the years of the Ludovisi pontificate, 1621–3: the foot is similar to those of Pluto and David, the head of Eros is still related to the heads in the Amalthea group (No. 1) but more advanced than that of Ascanius (No. 8).

14. *ARES LUDOVISI*. Detail.
Museo delle Terme, Rome (No. 11–3).

(4) *Head of the memorial statue for Carlo Barberini*, 1630. This work, discussed under No. 27, is not a restoration in the narrow sense of the word.

★12. BUSTS OF POPE GREGORY XV

PLATE 28, FIG. 5

According to Baldinucci (p. 79) Bernini made three busts of the Pope in marble or bronze. In his catalogue (p. 177) Baldinucci mentions only a marble and a bronze bust, then in the 'casa' Ludovisi, while Domenico Bernini (p. 22f.) locates three busts there. Bernini made,

in actual fact, at least three busts. This is clear from a diary entry of 18 November 1622 by Francesco Bernini in Florence, who noted that his cousin Pietro Bernini had informed him that Gian Lorenzo had made three portraits of the Pope in marble and metal and that, in recognition, the Pope had bestowed upon him the Cross of the 'Cavalierato di Cristo' (Fraschetti, p. 32).

Bernini is first called 'Cavaliere' in a document of 25 September 1621 (Faldi, ii, p. 315, doc. xiv). Since Alessandro Ludovisi ascended to the papal throne as Gregory XV on 9 February 1621, the *post* and *ante* of the marble bust is defined. It was executed between February and September 1621 (Faldi, p. 312f.). The Ludovisi collection has been dispersed and there is no trace of the marble bust.

According to documents in the Borghese Archive, the bronze-founder Sebastiano Sebastiani, who worked for Bernini also on other occasions, cast two papal bronzes, one of Paul V the other of Gregory XV, between September 1621 and September 1622 for Scipione Borghese (Faldi, *loc. cit.*). The latter apparently wished to have in his collection twin busts of the recently deceased papal uncle and of the reigning Pope. The bronze of Paul V was certainly made after Bernini's marble (see No. 6) and that of Gregory XV possibly after the (lost) marble of the Ludovisi palace (see below). Of three busts of Gregory XV claimed by the sources, we have so far accounted for two: the lost Ludovisi marble and the Borghese bronze.

In actual fact, four almost identical bronze busts of Gregory XV survive:

(1) Formerly Muñoz Collection, Rome. (Recently exported to U.S.A.). H. 64 cm. Plate 28.
Published by Muñoz (*Vita d'Arte*, viii, 1911, p. 183ff.). Ex Stroganoff Collection, into which it came from a noble Bolognese family related to the Ludovisi (Faldi, *loc. cit.*); hence originally doubtless in the Palazzo Ludovisi.

(2) Musée Jacquemart-André, Paris. H. 64 cm.
From the Borghese and Bardini Collections. See *Catalogue*, 1899, pl. 71. (The correct pedigree in my first edition; see also Martinelli, *Ritratti*, 1596, p. 18, n. 27 and pl. vii).

(3) Museo Civico, Bologna. H. 60 cm. Fig. 5.
See Muñoz, *Arte*, xix, 1916, p. 104.

(4) Palazzo Doria-Pamphili, Rome. H. 59 cm.
See Fraschetti, p. 32.

The three busts (2) to (4) have the same type of base (with the Ludovisi arms between scrolls) and an exactly corresponding base with the Borghese coat of arms supports the Copenhagen Paul V (Figs. 4, 5). I believed with Faldi (*loc. cit.*, note 24) that the present circular base of the Muñoz-Stroganoff bust (not visible on pl. 28) was a later substitute for the decorated square base of the other busts, but I now tend to regard it as original because of its virtual identity to the bases of the Maria Barbadori bust (24-c) and some Urban VIII busts (19-1a, 2a,b). (The bust has, however, been slightly 'displaced', for the square block on which it rests should partly disappear behind the lower rim of the vestment).

The busts of Paul V in Copenhagen and of Gregory XV in Paris were originally in the Palazzo Borghese and, since they are of almost equal height, have the same shape, the same dress—a pluvial with the 'embroidered' Apostles Peter and Paul—and exactly corresponding bases, they must be the pendants cast by Sebastiani in 1621–2. So far I am in agreement with Martinelli (*Ritratti*, p. 18). We also agree in that the versions in Bologna (3) and the Palazzo Doria-Pamphili (4) are slightly weaker. Martinelli (p. 20) tried to account for this by a not entirely convincing technical explanation: because plaster has a tendency to shrink, he argues that the slightly diminishing sizes of the busts are due to the fact that consecutive casts were made from a lost form taken from the previous bronze (which also leads to an increasing loss of sculptural finesse). If this were a correct reconstruction of procedure, Martinelli should have concluded that busts (1) and (2) being equally high cannot depend one on the other, but are in the same category; he might have claimed that two lost forms taken from the marble served for their casting. At this point, however, he does not pursue his argument, because, one suspects, it cannot be used against the Muñoz-Stroganoff bust and in favour of the Paris bust. He finds the former not entirely satisfactory (claiming the help of assistants) and in an enthusiastic passage praises the latter as infinitely superior.

When I studied these busts in the early fifties I came to the conclusion that Muñoz was correct in regarding the bust then in his collection as the best version. Martinelli has rightly drawn attention to the Paris bronze, but its promotion should not have led him to depreciate the Muñoz-Stroganoff bust. The surfaces of bronzes even from the same mould often differ considerably. Bernini's contribution after a cast had left the foundry would be the chasing, which is decisive for the vitality and crispness of the surface and also permits a great deal of freedom in the handling of minor details. The face of the Muñoz-Stroganoff bust seems more expressive than that of the Paris bust, while the latter is superior in the chasing of some details (e.g. the alb). In both busts much of the chasing would have been done by Bernini.

It is therefore possible to claim the Muñoz-Stroganoff bust as the third bust mentioned in the sources. This is supported by its pedigree which leads back to the Palazzo Ludovisi. A bronze bust of the Pope was in the

palace (it disappeared before 1731, see Martinelli, p. 22, note 39). There is no reason to believe with Martinelli that this bronze is lost. There is every reason to believe that it is preserved in the Muñoz-Stroganoff bust. The bust cast for Gregory XV was probably not meant to be a pendant and may have been placed (as suggested above) on the present simple bronze base.

The question remains to be answered whether Bernini's (lost) marble was the model for the bronzes. This has been claimed by every author who has written about these busts. If it were true, one would have to suppose, that the marble executed for Gregory XV in 1621 had been devised by Bernini as a pendant to the marble bust of Paul V (which served for the bronze in Copenhagen). Common-sense excludes such a possibility. It is much more likely, that Bernini created the Gregory pendant to the existing bust of Paul V by special order of Scipione Borghese. One would expect, therefore, that he varied the Ludovisi marble at least in the lower part (so as to make it conform to the Paul V). One would also expect that a model had to be made for the Gregory bust (an at least partially new creation), while a mould could be taken from the Paul V marble. This hypothesis may help to explain, why four bronzes of the same Gregory bust are extant and only one of its counterpart.

Muñoz (*Vita d'Arte, loc. cit.*) also mentions busts of Gregory XV with the Roman art dealers Sangiorgi and Simonetti, and one—of smaller size—in the Palazzo Massimi, Rome (*Arte*, xix, 1916, p. 104). The bust, formerly in the Barsanti Collection, now in the Palazzo Venezia, is later and not connected with Bernini (L. Pollak, *Raccolta Alfredo Barsanti, Bronzi*, Rome, 1922, p. 149, pl. xlix). For these busts, see also Martinelli, *Ritratti*, p. 21, note 35. Another later bronze bust of Gregory XV is in the Museo Correr, Venice, and exhibited there as a bust of Urban VIII (Alinari 38909).

★13. TOMB OF MONSIGNOR PEDRO DE FOIX MONTOYA. Refectory adjoining the church of S. Maria di Monserrato, Rome

PLATES 29, 30, FIG. 15

Life-size marble bust.

The Spanish jurist Montoya died in 1630. Some time before his death he gave Bernini the commission for his tomb. It was erected in the Spanish national church S. Giacomo degli Spagnuoli, but, together with other monuments, was taken to its new place at the end of the nineteenth century, when the Spanish Church became French property.

Baldinucci (p. 76; see also Domenico Bernini, p. 16) reports that, when the tomb was inspected by cardinals and prelates, one of them exclaimed 'This is Montoya petrified!' At this moment Montoya himself appeared.

★See Addenda, pp. 273ff.

15. *TOMB OF MONSIGNOR PEDRO DE FOIX MONTOYA*. S. Maria di Monserrato, Rome (No. 13).

Cardinal Maffeo Barberini greeted him with the words: 'This is the portrait of Monsignor Montoya', and turning to the piece of sculpture: 'And this is Monsignor Montoya'. Bernini himself told virtually the same story in Paris, many years after the event (Chantelou, 17 August 1665).

The anecdote proves that the bust was finished before Maffeo Barberini had become Pope Urban VIII (6 August 1623). Scholars (with the exception of Fraschetti) agree that it must belong to the beginning of the twenties. The year 1621, just before the Bellarmine (No. 15), is probably the correct date. The mood of the bust is close to the second Paul V bust. It is also noteworthy that in the second Paul bust, in those of Gregory XV, in the Proserpina and the Montoya, the chiselling of iris and pupil is virtually identical.

The architecture of the tomb is not by Bernini, but probably by Niccolò Turriani (see Hibbard, *Bernini*, 1965, p. 237).

14. BUST OF CARDINAL ESCOUBLEAU DE SOURDIS. Church of St. Bruno, Bordeaux

FIG. 6

Life-size marble. Slightly damaged.

Baldinucci (Catalogue, p. 176) lists a bust of 'Cardinal Serdi' at Paris. The obvious identification with 'Sourdis' is owed to Reymond (Rev., xxxv, 1914, p. 45ff.). De Sourdis was Archbishop of Bordeaux from 1598 and Cardinal from 1600; he visited Rome on several occasions. Reymond established that his last visit of about eighteen months took place between the end of 1620 and October 1622. He died on 8 February 1628. The bust was not sent to Paris, as Baldinucci believed, but to Bordeaux together with the Angel and Virgin of an Annunciation by Pietro Bernini. These figures were first mentioned in 1669 by Charles Perrault, who also attributed the bust to the father. But it is so close to those of Cardinal Bellarmine (No. 15) and Gregory XV (No. 12) that its authenticity and date—1622—are not open to doubt. As in the case of the Bellarmine and Dolfin monuments, the figures were executed by the father, while the son took charge of the portrait likeness, for which he had shown so early such extraordinary skill. Bernini's familiarity with de Sourdis is proved by an anecdote related by him forty years later in Paris (see No. 18).

*15. BUST ON THE TOMB OF CARDINAL ROBERTO BELLARMINE. Apse, Gesù, Rome

PLATE 31, FIG, 7

Life-size marble.

The famous Jesuit, Cardinal Bellarmine, died on 17 September 1621. On the initiative of Gregory XV and under the auspices of Cardinal Odoardo Farnese his tomb was erected in the Gesù. Girolamo Rainaldi was responsible for the architecture. The sculptural decoration consisted of the bust and allegories of Religion and Wisdom. Pietro Bernini executed either both allegories (Baglione, p. 194) assisted by Giuliano Finelli (Passeri-Hess, p. 247) or only Wisdom (Baldinucci, pp. 76, 177 and Domenico Bernini, p. 16, attribute Religion to Gian Lorenzo). The bust, which alone survives, has always been given to Gian Lorenzo.

The tomb was destroyed during the rebuilding of the apse in 1843; the bust was then placed in an unsuitable neo-classical setting. A seventeenth-century drawing (National Library, Rome) gives an idea of the original appearance of the tomb (Fraschetti, p. 35; Bruhns, fig. 237).

As early as 12 March 1622, the diarist Gigli mentions the tomb as existing (Fraschetti, p. 33, note 2). But the work cannot have been finished at that date. It was not unveiled until 3 August 1624 (Pollak, i, p. 126).

*See Addenda, pp. 273ff.

The type of the portrait, showing the body to the hips, the hands folded in prayer and the head gently turned in the direction of the congregation, represents a new departure. Bruhns (p. 315ff.) discussed the place of the tomb in the general development. It should be noted that the tomb of Cardinal Paolo Sfondrato in S. Cecilia (d. 1618), which seemed to anticipate the type of the Bellarmine tomb, was erected between 1623 and 1627 (Martinelli, Commentari, iv, 1953, p. 148) and is therefore dependent on the latter.

16. BUST OF CARDINAL GIOVANNI DOLFIN. S. Michele all'Isola, above the entrance (inside), Venice

FIG. 8

Life-size marble.

Giovanni Dolfin began his career as ambassador of the Venetian Republic to the Holy See. After having been ordained, he became Bishop of Vicenza (1603) and later Cardinal, and as such resided in Rome from 1606 to his death in 1622 (Cardella, Memorie stor. de' Cardinali, 1793, vi, p. 205). According to the inscription on his tomb, he was seventy-seven when he died (Ciaconius, Vitae et res gestae Pontificum, 1677, iv, col. 357). It is therefore not to be wondered at that Pietro Bernini was commissioned to execute the tomb. But—as in the case of the Bellarmine—he only made the allegories of Faith and Hope (Baglione, p. 194) and left the execution of the bust to his son. Apart from this bust, Baldinucci (Catalogue, p. 176) also mentions a 'profile', i.e. probably a relief showing the head in profile, which cannot be traced. He also lists an 'angel on the tomb of Cardinal Delfino' (p. 178) which may possibly be a mix-up with one of the allegories by Pietro Bernini.

Although the bust is somewhat dry and has not the supreme quality of the Montoya or Bellarmine, it may well be by Bernini's own hand. Stylistic idiosyncrasies connect it with the busts of about 1622. The treatment of the hair is similar to the Montoya; the eye-sockets and wrinkles round the eyes recall the Bellarmine; and the rigid lines of the forehead are reminiscent of the first Urban bust (No. 19–1).

V. Martinelli, Ritratti, 1956, p. 27f., also accepts the bust as authentic, but dates it a little earlier, c. 1620.

17. DAVID. Galleria Borghese, Rome

PLATES 13, 23, 25, 27

Life-size marble. H. 1·70 m.

The dating of this figure, previously wrongly related to a payment of 1619 (see No. 8), has now been corrected on the basis of new documents (Faldi, i, p. 146). On 18 July 1623 Bernini received 200 scudi for the work then in progress and 60 scudi for the marble block. On 31 January 1624 a stone mason was paid an instalment

for the pedestal; the final settlement for it is dated 2 May 1624.

Baldinucci (p. 78) as well as Domenico Bernini (p. 19) are particularly well informed about this figure. Both report that Bernini worked the face before the mirror and that Cardinal Maffeo Barberini on some occasions held it for him. Most likely they heard the story from Bernini himself, and if it is true—and there is no reason why it should not be—it must have happened before 6 August 1623 (Barberini's accession to the papal throne). Baldinucci, moreover, tells us that Bernini completed the work in the short period of seven months; and we know that he was perfectly capable of such a *tour de force*. It may, therefore, be suggested that the David was executed between the summer of 1623 and the beginning of 1624 (see also H. Hibbard, *Boll. d'Arte*, xliii, 1958, p. 182). In any case, as Hibbard (*loc. cit.*) has shown, Bernini received his final payment on 3 April 1624.

When the figure was put on to its modern pedestal (1910), the marble plinth was adapted to the form of the pedestal by plaster additions. Originally, the toes of the right foot gripped the edge of the plinth and the lyre projected much further beyond it (see the engraving in P. A. Maffei, *Raccolta di statue antiche*, Rome, 1704, pl. 82). The change is important, because Bernini had intentionally avoided a regularly shaped plinth; he had made it as insignificant as possible in order to increase the illusion of the figure moving in space. The plinth of the Apollo and Daphne group was similarly changed (No. 18). A bronze replica of the David (52 cm.), in the Museo Nazionale, Rome, shows the form of the original plinth. For further information and bibliography, see Faldi, *Galleria Borghese*, 1954, pp. 31–4, No. 34.

18. APOLLO AND DAPHNE. Galleria Borghese, Rome PLATES 14, 19, 24, 26

Life-size marble. Height of group: 2·43 m.

More than forty years after the event, Bernini told Chantelou (p. 31, 12 June 1665) that Urban VIII, then still Cardinal Maffeo Barberini (i.e. before 6 August 1623), came with Cardinal de Sourdis to inspect the group. The French Cardinal left Rome in the autumn of 1622 (see No. 14). According to Passeri (Hess, p. 246f.) Giuliano Finelli came to Rome in 1622 and helped Bernini with this work (Muñoz, *Vita d'Arte*, xi, 1913, p. 33ff.). From these data it had been inferred that the group was in essentials finished by the end of 1622 or beginning of 1623. However, this was not the case. New documents published by Faldi (i, p. 146, ii, p. 315) show that this group was begun before the David and finished after it. In August 1622 Bernini had the work in hand. He must have made rapid progress for the

memorable visit to have taken place a month or two later. In February 1623 (payment) Bernini was apparently still working at the group. But soon after there was an interruption of about a year. Much of this time was devoted to the statue of David. In 1624 work on the Apollo and Daphne was taken up again. A considerable payment (150 scudi) dates from April 1624. Other payments of 4 July and 28 September, published by Hibbard (1958, p. 183), show that Bernini now dedicated a great deal of time to the group. But my previous assumption that it was then entirely finished, has been disproved by documents (Hibbard, *loc. cit.*). The pedestal was finished in March 1625, while the transport of the group to the Villa Borghese was not paid for until 15 September 1625 (Hibbard, doc. viii). Although the group must have been close to completion in the late summer 1624, new and greater tasks began to absorb Bernini's energy at this time and led to a second lengthy interruption. A final payment of 450 scudi on 14 October 1625 (Fraschetti, p. 26, note 1; Hibbard, doc. vii) settled all Bernini's claims for works made for Cardinal Scipione Borghese. The Cardinal's patronage temporarily came to an end. He knew that in the foreseeable future no more could be expected from his sculptor. For from the summer of 1624 onwards Bernini was fully occupied with the Baldacchino in St. Peter's and the St. Bibiana.

Like the other Borghese groups, the Apollo and Daphne originally stood close to a wall. A sheet with original drawings of the pedestal, published by Hibbard (p. 181), precisely indicates the chosen location (for a reconstruction of the room showing the original position of the group, see Hibbard, *Bernini*, 1965, fig. 1). Only the famous cartouche of the pedestal, with the moralizing epigram improvised by Urban VIII on the occasion of the above-mentioned visit, is by Bernini. The cartouche opposite with the lines from Ovid's *Metamorphoses* is—as Faldi has shown—a neo-classical addition (1785).

The rocky base from which the bark of the tree rises was in more recent times (1785?) enlarged by plaster which softened the transitions to the pedestal (see No. 17. Best illustr. of the original base in E. Q. Visconti, *Illustr. de' monumenti scelti Borghesiani*, 1821, pl. 31).

P. A. Riedl's little monograph (1960) contains an able summary of most of the problems concerning this work. See also Faldi's exhaustive entry in *Galleria Borghese*, 1954, pp. 34–7, No. 35.

The group illustrates the famous lines from Ovid, *Met.* i, 453ff., but Hibbard (1965, p. 235f.) has made it appear likely that Bernini was also influenced by the contemporary poetry of 'Marinism', particularly in regard to thematic ambiguities so cleverly transposed in the marble medium.

An impressive terracotta fragment of a head (from Palazzo Bernini, now Busiri Collection) was published

by Colasanti (*Boll. d'Arte*, iii, 1923–4, p. 416ff., with ill.) as a bozzetto for Daphne (not seen by the author), but is, in fact, for Proserpina (Laven, *Art Bull.*, xxxviii, 1956, p. 260). The bozzetto of Apollo in Venice, publ. by Voss (*Monatsh. f. Kunstw*, iii, 1910, p. 387f.), is however a signed piece by Canova (Malamani, *Canova*, 1911, p. 12). Early replicas and versions of the group testify to its enormous popularity. A full-size copy was in Berlin (Fraschetti, p. 26ff.). A large copy in silver was in the collection of Louis XIV (Guiffrey, *Inventaire*, 1885, i, p. 68, No. 543). An early bronze copy (85 cm. high) is in the Museum at Montpellier, another (75 cm.) in the Dresden Albertinum (Holzhausen, *Jb. d. Pr. Kstslg.* 1939, p. 175), a third (80 cm.) was with Duveen Brothers in 1960 (*Art Quarterly*, Spring, 1960). A terracotta copy by Nicholas Stone was later in the collection of the sculptor Francis Bird. Bronze versions, among others, in the Albertinum, Dresden (43 cm.) and (formerly) Volpi Coll., Florence (not supervised by Bernini, as Muñoz believed, *Vita d'Arte*, 1913, p. 35f.).

19. BUSTS OF POPE URBAN VIII

PLATES 32, 36–39, 50, FIGS. 16–21, 25, 26

Baldinucci (p. 86) as well as Domenico Bernini (p. 42) mention 'many busts' of the Pope made by Bernini; the former lists in his Catalogue three marble busts and one of bronze in the Palazzo Barberini (p. 176), a marble bust in the Casa Giori and a bronze bust in the possession of Abbate Braccesi (p. 177). The three marbles as well as the bronze from Palazzo Barberini can still be traced (1, 2a, 2b, 3). The Giori bust can probably be identified with our No. 2c, while the Braccesi bust seems to be lost.

The dating of Bernini's busts of Urban VIII is not without problems; they may ultimately be resolved by a judicious examination of the Pope's richly documented iconography. When he ascended the papal throne on 6 August 1623 Urban was in his fifty-sixth year; he had the relatively unwrinkled face and the vigorous expression of a middle-aged man in excellent physical shape (Pl. 32). The tomb portrait (Pl. 51), in preparation from the end of 1629 onwards (after his sixtieth birthday)—though by its very nature not a fully reliable testimony—still displays this youthful energy. Soon after, a change set in. Its first witness is Claude Mellan's engraving of 1631 after Bernini's design showing Urban at 63; the face has become longer and more bony, the cheeks have lost their comfortable roundness, many wrinkles appear round the eyesockets and the mood is more pensive. In the course of the 1630's these traits soon become increasingly manifest. Coriolanus' engraving of 1639 shows him at the age of 71 as a suffering old man and the same is true of Vouillemont's engraving

of 1642 after an (undated) drawing by Guidobaldo Abbatini.

In addition to such criteria there exists an external reason for supplying fairly reliable dates. The Pope was in the habit of fashioning his beard with greatest care, an idiosyncrasy that elicited popular satire such as the Pasquinade: 'Papa Urbano della barba bella. . . .' Before 1630 the beard is full and soft and the moustache waves down into the beard (The portrait of the tomb still shows this early fashion). A change of style is first manifest in Mellan's engraving of 1631. The moustache is no longer joined to the beard; the beard itself is narrower at the top than at the bottom and the wisp is not clearly separated from the beard. A little later room is made for the divided wisp in the centre under the lower lip. It would seem that about 1640 the moustache is more widely separated from the beard, which is given a more pronounced bell-shape form (visible also in the Memorial Statue (Fig. 53) which, though begun in 1635 and finished in 1640, shows the late fashion). While the relatively slight changes after the Mellan engraving of 1631 may permit of different interpretations, it is certain that paintings and busts with the moustache separated from the beard have to be dated after 1630. This is true for all the busts listed below with the exception of Nos. (1) and (1a) which display the earlier fashion.

The iconographic data must, of course, be used in conjunction with stylistic criteria. A summary of my chronology of all dated and datable portraits in sculpture associated with Bernini's name may facilitate orientation: *1623*: 19–1a; *1623–4*: 19–1; *1625*: SS. Trinità de'Pellegrini, lost; *1627–33*: Velletri, lost; see No. 38; *1628–31*: 30; *1635–40*: 38; *1637–8*: 19–2a, 2b; *c. 1640*: 19–4; *after 1640*: 19–2c; *1640–44*: 19–5; *1643*: 19–6; *1643–4*: 19–3, –7; *c. 1678*: 19–4a (S. Maria di Monte Santo).

(1) Marble. Principe Urbano Barberini, Palazzo Barberini, Rome. Plate 32.

Life-size. First published by Muñoz (*Arte*, xx, 1917, p. 185f.).

The lively expression and the vitality of the bust prepare for the Scipione Borghese later. This is, in my view, the first wholly authentic bust of the Pope. Type and expression are close to Mellan's engraving of 1624 after Vouet's lost portrait and to Leoni's engraving of 1625. On grounds of style a date soon after Urban's accession is indicated: 1623–4. Martinelli, *Ritratti*, p. 26, dates it 1624, after (1a). Pope-Hennessy's date 'late 1620s' (*It. High Ren. and Bar. Sculp.*, 1963, p. 124) is certainly too late.

(1a) Marble. H. 65 cm. A room adjoining S. Lorenzo in Fonte, Rome. Fig. 16.

This bust was published by Fraschetti (p. 149 with ill.) as an excellent original. Muñoz (*Vita d'Arte*, viii, 1911, p. 192 and *Arte*, xx, 1917, p. 187f., ill.) regarded it as studio work. It shows all the characteristics and idiosyncrasies of handling of Bernini's early papal busts (close connections with those of Paul V and Gregory XV) and was probably done immediately after Urban's accession, but its quality is less convincing than that of (1). It also lacks the 'speaking' likeness which fascinates in Bernini's best busts of Urban VIII. I am inclined to believe that it was executed with the help of Finelli, who joined Bernini's studio in 1622. (A. Nava Cellini, *Paragone*, xi, 1960, No. 131, p. 12, does not see here Finelli's hand). Martinelli (*Ritratti*, p. 25) insists on complete authenticity. He connects this bust with an inventory entry of 1626, published by Fraschetti (p. 141, note 1), according to which a bust by Bernini was at that time in the Quirinal Palace. It is possible, but cannot be proved that the Quirinal bust was transferred to S. Giovanni in Fonte.

★(2a) Marble. H. 83 cm. Principe Enrico Barberini (from Palazzo Barberini). Plate 39, Fig. 17.

A bust of the highest quality. It may be the one praised by Tetius (*Aedes Barberinae*, 1642, p. 170). It had escaped attention before 1955. When I first published this piece, I dated it 'about 1630', mainly on the analogy with the Mellan engraving of 1631. This date was accepted by Faldi (*Paragone*, vi, 1955, No. 71, p. 50) and Pope-Hennessy (in the Catalogue of *It. High Ren. and Bar. Sculp.* while in his text, p. 124, he suggested '*c.* 1635'). Martinelli (*Ritratti*, p. 37f.) dates it 1641–2, and so does Lavin (*Art Bull.*, xxxviii, 1956, p. 259). I am now inclined to regard my original dating as too early and 1641–2 as too late. For various reasons 1637–8 seems to me the most likely period. The Pope appears here much aged and ailing. It may be tempting to date this penetrating and moving characterization in the last years of Urban's life, but valid arguments make this view unacceptable. In the summer of 1637 the Pope fell gravely ill and was on the brink of death (see No. 32). Bernini's bust seems to show him at this period. The expression of suffering in the face is peculiarly close to the engraving by Coriolanus of 1639. Judging from the portraits around and after 1640, the Pope recovered some of his old, more robust countenance. The cut of the beard in 2a is also similar to that in the Coriolanus engraving. Although moustache and beard are separated and the wisp is in evidence, the beard is still relatively broad and not 'bell-shaped' as in the portraits after 1640. The treatment of the lower part of the bust clearly prepares for the first Innocent X bust (No. 51–2), but is less advanced than the Urban bust 2c. Lavin (*loc. cit.*) argues that there is no reason to separate chronologically the Camerino bronze of 1643 (6) from the marble 2a. But models

were often used for recasting in the Vatican foundry, even after an interval of many years.

(2b) Bronze. H. 81 cm. Vatican Library. Plate 36.

Until 1902 in the Palazzo Barberini, where Teti (*op. cit.*, p. 31) mentions it in 1642. First published in 1955. This excellent bronze was cast from the model which served for (2a). The model may have been the one recorded in the inventory of Bernini's house (Fraschetti, p. 431). For another later cast, see (6).

(2c) Marble. Life-size. H. 72 cm. Palazzo Spada, Rome. Plates 37, 38.

This bust has only been mentioned once in the Bernini literature. Riccoboni (1942, p. 167) listed it briefly as 'in Bernini's manner'. Italo Faldi, who discovered that it was an original work of the highest quality, generously allowed me to publish it. Its pedigree is obscure, but it can only be the bust from Casa Giori (below (6)). As a type it is obviously closely connected with (2a), but the Pope looks less care-worn. It must be dated a few years after (2a), probably shortly after 1640 at the period of the official Spoleto bust (5). The date is suggested not only by the Pope's features, but also by the treatment of the mozzetta, which is distinctly later than (2a). The cut and shape of the beard, too, conform with the portraits of *c.* 1640 rather than with (2a).

(3) Marble. H. 86 cm. Palazzo Barberini (Galleria Nazionale). Fig. 19.

Opinions regarding this bust vary considerably. Fraschetti (p. 146, note 1), who regarded the bust as studio work, identified it without valid reasons with one recorded in the Quirinal in an inventory of 1626 (see (1a)). Riccoboni (1942, p. 156) as well as others dated it *c.* 1625. I have previously dated it in the thirties. My reasons for dating it now in the forties are given under (4). The quality of the bust is not of the highest order; it is essentially the work of an assistant, who must be held responsible, above all, for the ill-defined and un-Berninesque lower part.

(4) Bronze. H. 1·02 m. Louvre, Paris. Fig. 20.

This bust must have reached France at a very early date. A bronze bust of the Pope (3 [Paris] feet high, i.e. close to the height of the Louvre bust) was in the collection of Louis XIV (Guiffrey, *Invent. général*, 1885–6, ii, p. 35, No. 51, inventory of 1684. In *Les sculptures au Musée du Louvre*. Guide du visiteur, Paris, 1957, p. 152, Mlle Charageat mentions that the bronze appears in all the inventories of the Royal Collection from 1663 onwards. For further details the reader must be referred to the forthcoming Louvre Catalogue.) Maclagan (*B.M.*, xl, 1922, p. 116, note 47) regarded the bust as a copy after

★See Addenda, pp. 273ff.

Bernini. Vitry (*G.d.B.A.*, v, 1922, p. 24) erroneously tried to identify it with the one formerly in the hospital of Trinità de'Pellegrini, Rome, and all later authors followed him, down to Martinelli (*Bernini*, 1953, and *Studi Romani*, 1955, p. 39). The inscription of 1625 is still *in situ* (Forcella, vii, p. 207, No. 426), while Bernini's bust has been replaced by a nineteenth-century plaster. Fraschetti (p. 146), probably correctly, held that the SS. Trinità bust was destroyed by Napoleon's soldiers. It is worth noting, however, that Nibby (*Roma nell'anno MDCCCXXXVIII*, 1841, ii, p. 152) still mentions it, but he is not always reliable. Vitry's identification of the SS. Trinità with the Louvre bust forced him and all those who accepted his view to date the Louvre bust in 1625. We do not know what Bernini's bust in SS. Trinità looked like, but other busts of the mid-twenties prove without doubt that the Louvre bust cannot belong to the same period (see, e.g. Nos. 16, 22, 24, 25, and 1, 1a of this entry). The correct pedigree of the bust, as given above, opens the way for its unbiased study and dating.

In the first edition of this book I had come to the conclusion, that the model of the Louvre bust was Bernini's and that it should be dated about 1640. A new examination has not led to any different result. The body of the bust contains a suggestion of contrappostal movement (see above, p. 14), a conception not incorporated by Bernini in any busts of the twenties and thirties. It appears for the first time in the Louvre Richelieu of 1640 (No. 42) and thereafter in all original busts. Moreover, the Louvre bronze shows the Pope aged and wrinkled, not much different, in fact, from Nos. 2c and 5, and, finally, the character of the wisp and beard fully agree with the late date.

This affirmation has become necessary, because in 1956 Martinelli, changing his earlier opinion, dated the Louvre bronze shortly after 1630 and regarded it as a cast after a lost original by Bernini of *c*. 1630 (*Ritratti*, pp. 30, 36). At the same time, he changed his ideas about the marble bust No. 3, which in 1953 (p. 71) and 1955 (p. 44) he had called 'largely autograph' of *c*. 1630, while in 1956 (p. 55f.) he followed me in judging it mainly a school-piece and dating it later. But, what is more important, he now advanced the hypothesis that this bust, too, was derived from Bernini's lost original of *c*. 1630. The latter, he maintained without any documentary backing, was created in order to replace the early Quirinal bust which had been transferred to S. Lorenzo in Fonte (see No. 1a).

In his 1956 publication Martinelli was apparently led to postulate a lost prototype for both busts 3 and 4, because he had correctly observed that these busts have a number of features in common, such as the decoration of the stole, the knotted cord holding the stole together and the long horizontal fold in the camaura. Without

any question, therefore, the two busts are interrelated. But Martinelli's hypothesis is only one of three: both busts may derive—as he believes—from a lost prototype, or 4 may depend on 3, or 3 on 4. I favour the last alternative for the following reasons: next to the bust 2a, the model of No. 4 must have enjoyed a tremendous reputation, for apart from the Louvre bronze we know three casts from the same form (4a, 7) and there may have been others. If 4 were derived from a marble (like 2b from 2a), the latter would be known to us, if not in the original, at least from the sources. No. 3 is largely studio work and cannot have served as model for an original. Thus one is led to assume that the model of 4 (which must have remained in Bernini's studio) was used by an assistant for the bust 3.

Since I have dated the Louvre bronze *c*. 1640, one would have to date the marble No. 3 after 1640. To this one may not readily agree because of the rather youthful appearance of the Pope's face. The face of the Mellan engraving of 1631 seems similar. But this impression may be delusive, for the bust is idealized and formalized and lacks the directness and freshness of original creations. Making allowance for this weakness, one may discover the type of the Louvre bust behind the generalized interpretation of the face. Indeed, a careful study confirms this impression: in the process of translation the eye has taken on a simple almond-shape, the brow forms a rigid arc and the nose is too narrow and lacks modulation. It is only in the lower part of the bust that the sculptor broke away from his model. He must have felt that the appearance of the cope had to conform to 'modern' taste and introduced those meandering folds for which Bernini's *œuvre* offers no parallel. Nor would it be easy to find a similar treatment anywhere in the 1630's (let alone in the twenties). Not until the 1640's was such an interpretation possible.

(4a) Bronzes. Palazzo Corsini, Florence; S. Maria di Monte Santo, Rome.

Casts from Bernini's model corresponding to the Louvre bust. The Roman bronze for which Bernini's pupil, Girolamo Lucenti, was responsible has been replaced in the church by a plaster cast and cannot now be traced (see Martinelli, *Ritratti*, p. 31, note 57).

(5) Bronze. H. 1·32 m. Cathedral, Spoleto. Plate 50, Figs. 25, 26.

Above the entrance door. On 15 February 1640 Urban VIII ordered money to be put aside for his bronze bust 'which We have orally commissioned the Cavaliere Bernini to execute and which We have decided to present to the Cathedral of Spoleto' (AS., Cam. Chir. ix, 1635–42, p. 295). Bernini was paid 335·50 scudi in two instalments, on 18 February 1640 and 22 March 1642. Between 1640 and 1644 Ambrogio Lucenti, father

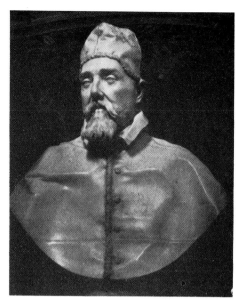

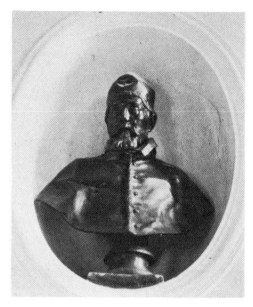

16. *BUST OF POPE URBAN VIII.*
S. Lorenzo in Fonte, Rome (No. 19–1a).

17. *BUST OF POPE URBAN VIII.*
Principe Enrico Barberini, Rome (No. 19–2a).

18. *BUST OF POPE URBAN VIII.*
Palazzo Comunale, Camerino (No. 19–6).

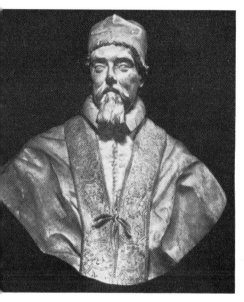

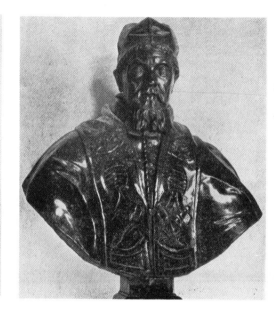

BUST OF POPE URBAN VIII.
Palazzo Barberini, Rome (No. 19–3).

20. *BUST OF POPE URBAN VIII.*
Louvre, Paris (No. 19–4).

21. *BUST OF POPE URBAN VIII.*
Principe Enrico Barberini, Rome (No. 19–7).

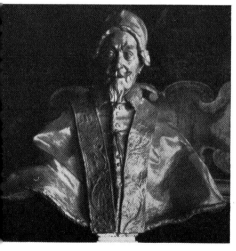

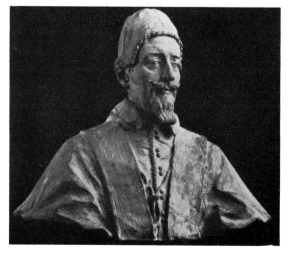

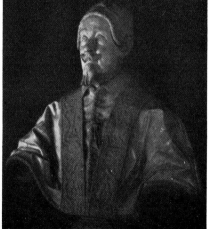

2. *BUST OF POPE ALEXANDER VII.*
Palazzo Chigi, Ariccia (No. 65–1).

23. *BUST OF POPE ALEXANDER VII.*
Antonio Muñoz Coll., Rome (No. 65–4).

24. *BUST OF POPE ALEXANDER VII.*
Marchese Incisa della Rocchetta, Rome
(No. 65–6).

of the better known Girolamo, received payments for casting the bust (Martinelli, in *Spoletium*, 1955, p. 44). The inscription of 1644 records the restoration of the Cathedral on the Pope's initiative. This is the grandest surviving portrait of the Pope. Powerful and dignified, it shows him with tiara and in ceremonial dress. Muñoz (*Arte*, xix, 1916, p. 107), for stylistic reasons, suggested dating the model of the bust *c*. 1630. This is hardly tenable in view of the above-mentioned document. A bronze-coloured cast is in the Museum of Castel S. Angelo.

(6) Bronze (painted black). H. 81 cm. Palazzo Comunale, Camerino. Fig. 18.

Commissioned by decision of the Camerino Council on 11 January 1643, and sent from Rome on 24 February 1643. Possibly negotiated by Cardinal Giori, who in these years presided over the execution of Urban's tomb (No. 30) and was therefore well acquainted with the artist. Bernini received payment of 300 scudi (Aleandri, *Arte e Storia*, xxi, 1902, p. 44f., documents). This proves that Bernini was responsible for the bust. The rapidity of the consignment, however, indicates that he had it ready

or almost ready in the studio. It appears, in fact, that the bust is a cast from the same form as (2b) above.

Bernini's relations to Cardinal Giori are discussed by B. Feliciangeli (*Il Cardinale A. Giori e Bernini*, 1917). As guest of the Cardinal in Camerino, Bernini drew a portrait of Urban VIII on one of the walls of the house. Giori kept his bust of the Pope (Baldinucci) in his villa on the Gianicolo in Rome, where it is mentioned in his testament of 8 September 1658. It is probably the bust (2-c).

(7) Dark-bronze head set on to a porphyry bust. H. 81 cm. Principe Enrico Barberini (from Palazzo Barberini). Fig. 21.

Life-size. See Fraschetti, p. 146. Often mentioned in Roman guide-books, e.g. by G. Roisecco, *Roma antica e moderna*, 1745, ii, p. 111, as 'con disegno del Bernini'. An antique porphyry bust was worked over in the studio. The bronze head is a cast from the model that had previously served for the Louvre bust (4), but the bronze was left unpolished. Difficult to date; but probably very late.

25-26. *DETAILS FROM THE BRONZE BUST OF POPE URBAN VIII*. Cf. Plate 50. Cathedral, Spoleto (No. 19-5).

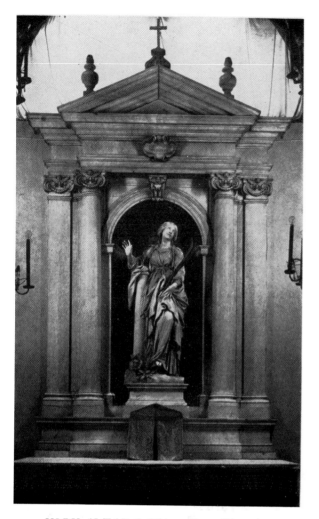

27. *HIGH ALTAR*. S. Bibiana, Rome (No. 20).

20. ST. BIBIANA. High altar, S. Bibiana, Rome

PLATES 40, 42, FIG. 27

Life-size marble statue.

According to Fedini (*La vita di S. Bibiana*, 1627, p. 70) the reconstruction of the church of S. Bibiana was begun on 8 August 1624. By order of the Pope, Bernini received his first payment of 60 scudi for the marble block of the figure on 10 August 1624 (Pollak, i, p. 27). On 20 July 1626, he was paid 350 scudi for the completed statue (total payment 600 scudi). The figure appears as frontispiece in Fedini's book. (See also the summary of the documentation in Pope-Hennessy, *It. High Ren. and Baroque Sculpt.*, 1963, Catal., p. 126f.).

Passeri (ed. Hess, p. 247), who was well informed, mentions Finelli's collaboration. Muñoz (*Vita d'Arte*, xi, 1913, p. 42) suggested that Bernini used him for the less important parts, the base, bush and column, and this may be correct. Finelli's name, however, does not occur in the documents.

*See Addenda, pp. 273ff.

The figure is placed in an architectural aedicula of classical forms designed by Bernini. On the vaulting above the altar a painted God the Father spreads out His arms.

A drawing in the Albertina, Vienna, was published by Wickhoff (*Jb. d. A. H. Kaiserh.*, xiii, 1912, Quellen, p. ccxliv) as Bernini's design for the Bibiana. Others (Boehn, Brinckmann) followed him. But the drawing, a studio work, is for the St. Barbara at Rieti (No. 60). A terracotta copy in the Louvre was incorrectly regarded as an original bozzetto for the statue (Michel, *G.d.B.A.*, xiii, 1917, p. 62ff.; Maclagan, *B.M.*, xl, 1922, p. 116, note 47; Boehn and Benkard). In the first edition I listed a terracotta in the Hermitage, Leningrad, which I had studied in 1931, as a replica. G. Matzulevitsch (*Boll. d'Arte*, 1963, p. 73f.) defends the originality of this piece. I cannot agree with her opinion: the terracotta has all the characteristics of a late copy.

*21. BALDACCHINO. St. Peter's, Rome

PLATES 44–8, FIGS. IV, 62

Mainly bronze, partly gilt. Principal sculptural parts: four giant bronze angels above the columns, two pairs of putti with tiara and St. Peter's keys and two pairs with sword and book, emblems of St. Paul, between the scrolls; further small bronze putti on the shafts of the columns, marble coat of arms on the pedestals; in addition a great mass of minor emblematic detail in bronze. Whole height: 28·5 m.

The documents for the Baldacchino have been fully published by Pollak, ii, pp. 327–423. Its genesis has been reconstructed by Brauer-Wittkower, pp. 19–22. The work developed slowly to its present form. Bernini was commissioned in 1624, shortly after Urban VIII's election. Payments begin on 12 July of that year. The four bronze columns were unveiled in St. Peter's on 29 June 1627. After that date Bernini's attention was focused on the crowning parts and the figures. Inauguration on 29 June 1633, but minor details of the decoration dragged on until 1635. Total expense was over 200,000 scudi, the columns alone costing more than 80,000 scudi. Bernini received 10,000 scudi over the whole period. The immense quantities of bronze were partly looted from the portico of the Pantheon (Pollak, i, p. 175ff.) and from the ribs of the dome of St. Peter's itself.

This was the first work in which Bernini showed his extraordinary gift as an organizer. But he himself was more actively engaged than on similar jobs at a later period. According to a statement of 1627 he had spent three whole years on the manual work of preparing the models and helping to cast the columns. Work, in the beginning, must have been overwhelming. He pressed his family into service; his father, Pietro, seems to have

28. *HIGH ALTAR*. S. Agostino, Rome. Detail (No. 23).

been constantly at his side (Pollak, p. 346) and even helped with the book-keeping. His brother, Luigi, was engaged on models and also supervised work. His principal assistants in making the models and preparing them for the founders were Bolgi, Speranza, Finelli, G. A. Fancelli, Niccolò Cordier (probably a namesake of the well-known sculptor who died, according to Baglione, in 1612) and Duquesnoy; the latter had a relatively small share. In 1630 the large models of the angels were ready for casting, but it is impossible to identify the hand of any of the collaborators. Speranza was mainly responsible for the models of the putti with the papal insignia (1633), Bolgi for the touching up of the marble coats of arms of the pedestals (1628) and the older Stefano Maderno for models of small putti for the columns (1624). Finelli's models of SS. Peter and Paul (1628) to be placed in front of the Baldacchino were not cast. It is not clear from the documents (Pollak, p. 368) whether the large figure of Christ which was being planned at a late stage for a position over the Baldacchino, was ever cast. Bernini himself alludes to it in his talks with Chantelou (p. 114). The iconography of the

Baldacchino has been investigated in an important paper by H. Kauffmann, 1955, p. 222ff.

22. BUST OF CARDINAL MELCHIOR KLESL. Cathedral, Wiener Neustadt FIG. 9
Life-size marble.

This bust, placed into a niche of the Cardinal's tomb (the work of local masons), is not mentioned in any of the sources. It may, however, be one of the fifteen unspecified busts summarily listed in Baldinucci's catalogue (p. 179). It was first published by O. Kurz (*B.M.*, lxxv, 1939, p. 70f.), but local tradition had always called it Bernini. Cardinal Klesl, Bishop of Wiener Neustadt, died in 1639. He had been in Rome from 1623 to 1627. The bust shows the style of this early period, though its detailed realism and painterly surface treatment reveal the hand of Giuliano Finelli. As in the case of the S. Agostino angels (No. 23), Bernini seems to have handed the work on to this able assistant without himself losing control. Finelli's entirely authentic works (e.g. his Bandini bust in S. Silvestro a Monte Cavallo, Rome) lack the psychological depth of the Klesl bust.

A. Nava Cellini (*Paragone*, xi, 1960, No. 131, p. 12) accepts my dating (1626, see Chronological Table) and the collaboration of Finelli.

23. TWO ANGELS. Above the high altar, S. Agostino, Rome FIG. 28

Life-size marbles (wings slightly gilded).

In Baldinucci's Catalogue (p. 179) these angels are listed as by Bernini. The attribution is supported by a document according to which the altar, begun in 1626, was finished on 2 April 1628 (De Romanis, *La chiesa di S. Agostino*, 1921, p. 22f.). Bernini is named as the sculptor of the two angels and Santi Ghetti as stonemason of the altar. According to Donati (1942, p. 355ff.), the architect of the altar was Orazio Torriani, who was paid for appraising it in 1630 when he was appointed architect to the monastery of S. Agostino. An anonymous writer of 1660 (BV, Urb. lat. 1707, fol. 107) also attributes the architecture of the altar to Torriani (Communication H. Hibbard). Passeri adds further information; he relates (ed. Hess, p. 247) that Bernini was given the commission, but that he handed the execution of one angel to Giuliano Finelli, and of the other to his brother Luigi. In the end, however, Finelli executed also the second angel. (The same story, probably based on Passeri, in Titi, 1686, p. 372). No doubt, Passeri is correct: these angels were the first large commission wholly carried out by assistants from Bernini's designs. At this period Bernini had his hands full with the Baldacchino (No. 21). But the S. Agostino angels show Bernini's spirit; they foreshadow the late ones on the altar of the Sacrament (No. 78).

24. BUSTS OF MEMBERS OF THE BARBERINI FAMILY

After having ascended the papal throne, Urban VIII seems to have wanted to commemorate deceased members of his family by having their busts made by Bernini. Baldinucci (p. 176) lists busts of Monsignor Francesco Barberini, Urban VIII's uncle, of the Pope's parents, and of Donna Lucrezia Barberini, all in the family palace.

(a) *Francesco Barberini*, Urban VIII's uncle. Until after the second War in the Palazzo Barberini, now National Gallery of Art (Samuel H. Kress Collection), Washington.

Life-size marble. H. 79·6 cm. PLATE 34, FIG. 29

The bust is mentioned in the Barberini inventory of 1627 as 'made by Bernini' (Fraschetti, p. 140; also Pollak, i, p. 334). Fraschetti (*loc. cit.*) published the work, but it remained as unnoticed as the bust of Antonio Barberini, (b). Although it is a posthumous portrait—

29. *FRANCESCO BARBERINI*. National Gallery, Washington (Samuel H. Kress Collection) (No. 24a).

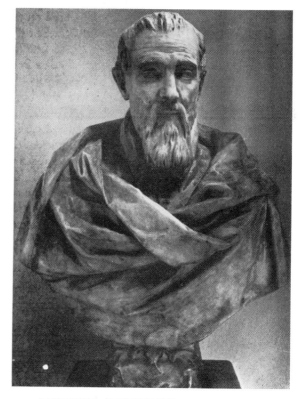

30. *ANTONIO BARBERINI*. Galleria Nazionale, Rome (No. 24b).

Francesco died in 1600—the bust offers a convincing picture of this sturdy character, who had founded the family fortune. Our plate 34 gives a good idea of the brilliant sculptural quality of the work, but it has been observed (Lavin, *Art Bull.*, xxxviii, 1956, p. 259; Pope-Hennessy, *It. High Ren. and Bar. Sculp.*, Text, 1963, p. 123) that the bust somewhat lacks the intimate expressive qualities, for the rendering of which Bernini needed personal contact with the sitter. Pope-Hennessy (*op. cit.*, Catalogue, p. 127) dates the bust too early: 1624–5. My old date, *c.* 1626, has to be maintained (see also Martinelli, in *Encyclopedia of World Art*, 1960, col. 465.)

(b) *Antonio Barberini*, Urban VIII's great-uncle. Galleria Nazionale, Rome. Formerly in the collection of Principessa Henrietta Barberini. FIG. 30

Life-size marble. H. 80 cm.

This bust, before 1955 only noticed by Muñoz and attributed by him to Bernini (*Dedalo*, i, 1920, p. 303f.), appears neither in Baldinucci's list nor in any Barberini inventory. It may have been in the palace of Carlo Barberini, the Pope's brother. The latter had a memorial for the great-uncle, who had been murdered in 1559, put up in S. Giovanni de' Fiorentini, dated in the inscription 1629 (Forcella, vii, p. 24, No. 56), but not finished until 1630 (payment published by K. Noehles, in *Arte Antica e Moderna*, 1964, No. 25, p. 95, note 20). The copy of Bernini's bust of Antonio, placed on the memorial, was not yet *in situ* in March 1630. But this fact does not allow us, as Noehles suggests, to date the original after 1630. Bernini's bust must surely date from the late 1620's.

The peculiar use of the drill in the hair and beard (though not unknown in Bernini's œuvre), and the mass of folds of the mantle (rare or even unique for Bernini) belong to Algardi's repertory. The spirit of the bust however differs from Algardi's works and points to Bernini. Also the relation of the head to the chest, the cut of the bust and even the cartouche of the base are typical of Bernini. (Such cartouches, not used by Algardi, are common with Bernini; see, e.g. busts of Francesco Barberini and Urban VIII, Pl. 32). It is probably not even correct to say that Bernini here tried to take a leaf out of Algardi's book, for at this moment—about 1627—Algardi had hardly made his début as a portrait sculptor. Some slight doubt as to the full authenticity of the bust, however, remains.

Martinelli (*Ritratti*, 1956, p. 34, and *Commentari*, vii, 1956, p. 24) regards the bust as an entirely authentic masterpiece by Bernini. Following suggestions made in other contexts by R. Longhi and G. Fiocco, he tried to explain the distinctive features of the bust by reference to Alessandro Vittoria busts with which Bernini would

have become familiar via Camillo Mariani (*Commentari*, p. 31). But while there is no similar bust by Mariani in Rome (see Fiocco, in *Le Arti*, iii, 1940–1, p. 74ff.), Bernini certainly knew the anonymous Frangipani busts in S. Marcello al Corso (dating from the 1560's; see A. Grisebach, *Römische Portraitbüsten*, Leipzig, 1936, p. 66ff., pls. 17–20), which are romanized versions of a Venetian type of bust. The draperies and even the cut of these busts are reminiscent of the Antonio Barberini, but the comparison also serves to throw light on Bernini's new awareness of a vigorous and sculpturally exciting treatment of the lower part as a lively foil for the head. Sheila Somers (*B.M.*, c, 1958, p. 288) and Pope-Hennessy (*It. High Ren. and Bar. Sculp.*, Catal., 1963, p. 127) suggest, in my view without sufficient reasons, an attribution of the bust to Giuliano Finelli. On the other hand, L. Bigiavi's assumption of a collaboration of Finelli (*Arte Antica e Moderna*, 1961, Nos. 13–16, p. 294ff.) probably comes nearest the truth. This seems also to be A. Nava Cellini's view (*Paragone*, xvii, No. 191, p. 25), who attributes a fairly considerable share to Finelli. Her dating of the bust—'shortly after 1623'— seems to me three or four years too early.

★(c) *Camilla Barbadoni*, Urban VIII's mother. R. Museum of Fine Arts, Copenhagen. PLATE 33

Life-size marble. H. 59·5 cm.

Rediscovered by Martinelli (*Commentari*, vii, 1956, p. 23ff.), the bust mentioned by Baldinucci and in the Barberini inventories of 28 July 1628 (Fraschetti, p. 140, note 2) and 29 November 1635 (Pollak, i, p. 335) still stands on the yellow pedestal paid for on 4 March (1628?) (Fraschetti, *loc. cit.*, note 3). It was in the Palazzo Barberini until after 1731. (For its further history, see Martinelli, p. 26.) Martinelli confirmed the traditional identification of the sitter as Camilla Barbadoni (H. Olsen, *Italian Paintings and Sculpture in Denmark*, Copenhagen, 1961, p. 102) on the basis of the porphyry medallions of Urban VIII's parents (in the narrow passage leading from the Barberini Chapel to the second chapel in S. Andrea della Valle), first published and attributed by him to Tommaso Fedele (*Studi Romani*, iii, 1955, p. 40f. and pl. 5). The medallions were paid for in March and June 1627 (Fraschetti, p. 142, note 1. Inscriptions dated 1629; Forcella, viii, p. 266, Nos. 668, 669). Martinelli's conclusion that the Copenhagen bust served as model for the medallion is fully supported by the closeness of the medallion to the bust. The latter may therefore be dated just before 1627.

By inference, one is led to assume that also the medallion of Urban VIII's father Antonio was derived from Bernini's (lost) bust of the parent. It is worth recording that in the medallion he is shown wearing a heavily folded mantle, not unlike that of the great-uncle

★See Addenda, pp. 273ff.

Antonio (b), an indirect argument in favour of Bernini's authorship of the latter bust.

The Copenhagen bust impresses by its utter simplicity and psychological reserve. It is reminiscent of Florentine (Domenico Poggini) rather than Roman late sixteenth-century portrait busts, but perhaps finds its closest parallels in the classicizing realism of the Carracci circle and in such contemporary portraits as Reni's mother in the Bologna Pinacoteca.

A. Nava Cellini (op. cit., p. 28f.) advocates a much earlier date for the bust: about 1622. But in spite of its deliberately archaizing character, certain features—viz. the deep undercutting of the widow's weeds—make such an early date most unlikely. Moreover, the programme of the commemorative Barberini busts was surely not devised until after Urban VIII's election.

Martinelli (1955, p. 41f., pl. vi) attributes to Bernini the 'living' winged skeletons which are holding the frames of the inscription tablets of Urban VIII's parents in the passage referred to above. It is likely that his was at least the conception, which prepares that of the Valtrini tomb (see No. 43; also No. 48).

*(d) *Maria Barberini*, Urban VIII's niece.

In his Life of Finelli, Passeri (Fraschetti, p. 142f.; Muñoz, in *Vita d'Arte*, xi, 1913, p. 42; Hess, 1934, p. 247) mentions a bust of Urban VIII's niece, Carlo Barberini's daughter Maria, who had died in 1621, aged 20, as the wife of the Bolognese Tolomeo Duglioli. According to the well-informed Passeri, Bernini employed Finelli for the execution of this bust. A rather dry work, much drier than a good Finelli, it was at some unspecified time transferred to Maria's tomb, now in the Certosa, Bologna (originally in the Duglioli Chapel of the Chiesa dell'Osservanza. I have been unable to establish when the bust was installed there. Even the manuscript records of the Osservanza in the Archivio di Stato, Bologna, investigated for me by Mira Merriman, have not yielded the secret). It is now generally assumed that Finelli's bust was in Bologna as early as 1627, see A. Nava Cellini, *Paragone*, xi, 1960, No. 131, p. 12f., fig. 11, but if Passeri was not mistaken, it was still in the Barberini Palace when he compiled his *vita*, about 1670.

A bust of Maria Barberini is noted in the Barberini inventory of 1627 (Fraschetti, p. 142, note 2), into which the compiler entered: '. . . bust received from the Cavaliere Bernini' ('testa havuta . . .'). Fraschetti remarked that this phrasing was chosen, because the sculptor of the bust was not the young master himself, but his assistant Finelli. What was more obvious than to relate the entry of the inventory to the Finelli bust discussed by Passeri? Fraschetti's identification has always been accepted, but it is open to doubt. The inventory relates that the bust was protected by a glass

case (Fraschetti, p. 143, note 1) and also by a cage of wire, probably a permanent feature, for it is still mentioned in the inventory of 1631 (BV, cod. Barb. lat. 5635, f. 73ʳ. Communicated to me by K. Noehles). It would seem strange to have Finelli's bust enshrined like a precious jewel. One would expect such safety measures to be used for an important and fragile object.

A bust worth being protected was in the Palazzo Barberini when N. Tessin visited it in 1688 (Sirén, 1914, p. 169). It must have been a work of extraordinary attraction, for no other bust was described by Tessin in equal detail. He calls it the 'bust of a niece of the old cardinal by Bernini' (Maria was a niece of the old Cardinal Antonio, brother of Urban VIII, but Tessin had difficulties in sorting out Barberini personalities correctly). This bust, he writes, has a pierced collar round the neck like a fine lace, so that one can look through it from both sides. It was inconceivable how such a work could have been carried out without the slightest break. The sitter had a bouquet in her hair and both were beautifully worked. She is young and on the left of her dress, which is open in front, there is a bee, instead of a decoration, which fastens a string of pearls, the other end of which is fastened at the side. The whole dress shows the pattern of real material and so does the lower garment, whose uppermost button-holes are open. This description conforms only partly with Finelli's bust (bouquet in the hair, string of pearls and bee; the rest differs). It appears, therefore, that Bernini himself made a bust of Maria Barberini, apparently a work of the greatest technical perfection. We do not know when and why it left the palace. It was still there in 1700, when Rossini (*Mercurio errante*, Rome, p. 57) described it as 'a beautiful marble portrait of a princess by Bernini, remarkable for its finesse'.

Bernini's bust belonging to the series of commemorative family portraits was meant to remain in the palace. It is most probably this bust that Baldinucci lists as Lucrezia Barberini. (The only Lucrezia in the family was not a Barberini, but a Barbadori, a sister of Urban VIII's mother.) Whether this is true or not, Bernini's bust was the model for Finelli's simplified version made specifically for Maria's tomb (but if Passeri can be trusted not placed there immediately). The sequence of events as here reconstructed would parallel the case of Antonio Barberini (above (b)) where both the original for the palace and the copy for the memorial monument are preserved.

It would now appear that Bolgi's Laura Frangipani bust of 1637 (ill. in *Paragone*, xiii, 1962, No. 147, pl. 21) and other busts of this type—such as the Lucrezia Naro in S. Maria sopra Minerva (*ibid.*, fig. 226)—were derived from Bernini's Maria Barberini bust, which may survive hidden in the private apartment of a Roman palace.

*See Addenda, pp. 273ff.

*(e) *Cardinal Francesco Barberini*, nephew of Urban VIII. The Toledo Museum of Art, Toledo, Ohio.

Life-size marble. H. 82 cm. FIG. 31

The bust represents Urban VIII's nephew, Cardinal Francesco (1597–1679, created Cardinal in 1623) as was convincingly demonstrated by A. Nava Cellini, in *Paragone*, xvii, 1966, No. 191, p. 21f., and therefore does not belong to the series of commemorative Barberini busts. In 1928 it was in the O. Huldschinsky Collection in Berlin. The bust was attributed to Giuliano Finelli in Colnaghi's Catalogue (*Exhibition of Seventeenth and Eighteenth Century Italian Sculpture*, 19th February to 17th March 1965, No. 2). Nava Cellini now attributes it to Bernini and dates it correctly *c*. 1628. The bust is not mentioned in any of the sources, but it certainly is Berninesque and, though it seems to me far from wholly authentic, it is not unlikely that Bernini had a hand in it. For much of the detail he can hardly be made responsible, *viz.* the abrupt and coarse way the hair grows out of the skin of the forehead and the metallic collar with the indented parallel grooves which do not recur in any original bust (compare the corresponding parts in earlier and later busts, e.g. the Montoya, Pl. 30, and the Scipione Borghese, Pl. 57). Not a single one of Bernini's busts shows a similar handling of the folds which are here often broken at acute angles. The horizontal pleat drawn as with a ruler across the mozzetta reveals a mind more pedantic than Bernini's : this pleat intersects at rectangles the vertical pleats which separate the parts falling loosely over the arms from the rest of the mozzetta. Bernini's handling of such pleats (see e.g. the Agostino Valier, Fig. 10, and the side view of the Camilla Barbadoni) is infinitely more lively and sophisticated. Also the relationship of the head to the lower part of the bust is unparalleled in Bernini's *oeuvre*. Nevertheless, the bust must have been made in his orbit and probably with some support by him particularly in the face.

Contrary to A. Nava Cellini I believe that the pedantic Bolgi had the main share. Idiosyncrasies similar to those mentioned above are found in his work (see e.g. the handling of the drapery in the bust of Cardinal Gregorio Naro in S. Maria sopra Minerva and of the iris and pupil in the Laura Frangipani bust).

25. BUSTS OF CARDINALS AGOSTINO AND PIETRO VALIER. Oratory, Seminario, Venice FIGS. 10, 11

Life-size marbles: Agostino Valier H. 64 cm., Pietro Valier H. 59 cm.

Baldinucci (catalogue, p. 176) lists a bust of 'Cardinal Valiero at Venice'. G. Martinioni, in his *Giunte alla Venetia del Sansovino*, published in 1663, i.e. at a time when Bernini was at the height of his reputation, says

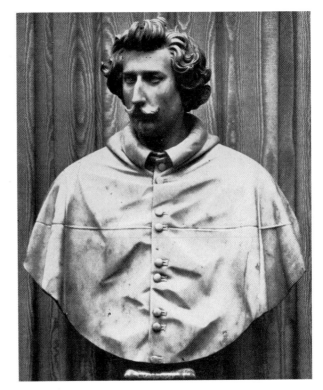

31. *CARDINAL FRANCESCO BARBERINI.*
The Toledo Museum of Art, Toledo, Ohio (No. 24–*e*).

that the busts of Cardinals Agostino and Pietro Valier were made by Bernini 'in Rome with diligence and particular care' (p. 229). The famous Cardinal Agostino died in 1606, his less-distinguished nephew, Cardinal Pietro, in 1629 (Cardella, *Mem. stor. de' Cardinali*, 1793, v, p. 199, vi, p. 206ff.). Martinioni adds that the former's bust was made from a portrait and the latter's from nature. This shows that the author had precise information at his disposal. Pietro seems to have wanted the busts for the family chapel which he had built in S. Maria delle Grazie (Ciaconius, *Vitae et res gestae Pontificum*, 1677, iv, col. 456) and from where they were later transferred to the Seminario.

We know that Pietro was in Rome for the conclaves of Gregory XV and Urban VIII, but it seems that the busts were made on neither of these occasions. Their style indicates a slightly later date. Pietro was Archbishop of Candia (4 December 1623), and also Cardinal of S. Salvatore in Lauro (1621) and of S. Marco (1624). He must therefore have visited Rome regularly. Pietro's bust is probably Bernini's in conception, but the execution might be Andrea Bolgi's first enterprise in the Bernini studio (Bolgi came to Rome in 1626). Agostino's bust is probably to a large extent by Bernini himself. (My interpretation would also account for the incongruity between Baldinucci and Martinioni.) The bust is in some respects similar to that of Antonio Barberini (No. 24). The fall of the soutane prepares for that of the

*See Addenda, pp. 273ff.

32. *MEMORIAL FOR CARLO BARBERINI.* S. Maria in Araceli, Rome (No. 26).

Scipione Borghese (No. 31), and, on the whole, the bust may perhaps best be described as being half-way between the Bellarmine and the Borghese busts. One may presume that the commission for both busts went to Bernini about 1627.

A. Nava Cellini (*Paragone*, xiii, 1962, No. 147, p. 26) agrees with my dating and also with the attribution of Agostino Valier's bust to Bolgi. Martinelli's claim (*Commentari*, x, 1959, p. 154, note 43) that Finelli was the artist of this bust, is not tenable and has been refuted by A. Nava Cellini in *Paragone*, xi, 1960, No. 131, pp. 12 and 28, note 6.

After this edition had gone to press, A. Nava Cellini's paper in *Paragone*, xvii, No. 191, p. 23f. appeared, in which she named the busts correctly: owing to an old confusion the names of Agostino and Pietro had always been exchanged. The mistake has been corrected in this entry. Nava Cellini now suggests to date the bust of Agostino Valier 'about 1623' and that of Pietro '1629–30'. I cannot concur with this opinion. As before, both busts would seem to me to belong to the same stylistic phase in the late twenties.

26. MEMORIAL FOR CARLO BARBERINI.
Entrance wall, S. Maria in Araceli, Rome FIG. 32

Marble allegories crowning a cartouche with inscription, 4·30 × 3·50 m.

The memorial was erected for Urban VIII's brother, General of the Church, Carlo Barberini, who died at Bologna in February 1630. On 3 August 1630 his body was buried in S. Maria in Araceli and for the occasion Bernini erected a large and splendidly decorated catafalque. As early as 30 September 1630, he received the final payment—altogether 800 scudi—for the marble memorial (Fraschetti, p. 94).

The two allegories, similar in pose and expression, and with the same type of helmet, may possibly represent *Ecclesia militans* and *triumphans*; the left-hand one is shown with the papal insignia, while the right-hand one rests a hand on a shield with a laurel wreath and lightning and treads on a sphere surrounded by the signs of the Zodiac, probably symbolizing the all-embracing power of the Church. (Muñoz believed this figure personified 'Truth' which is not tenable, *Arte*, xix, 1916, p. 108ff.).

The development of Bernini's conception, from a preliminary drawing at Leipzig showing a traditional tablet with heraldically arranged figures of Fame, through the intermediary stage of the bozzetto in the Fogg Art Museum (1937, 75), to the freedom of the final stage with personifications mourning over the deceased, has been discussed by Brauer-Wittkower, p. 25f.

Ecclesia militans (left) was executed by Bernini's studio hand Stefano Speranza (Baglione, p. 237f.; Titi, ed. 1674, p. 215). The sources do not mention the right-hand allegory as Speranza's work; it seems, in fact, of superior quality. In any case, the Fogg bozzetto is proof of Bernini's careful preparation of this figure, and the considerable payment indicates that he probably had a hand in its execution.

27. HEAD OF THE MEMORIAL STATUE FOR CARLO BARBERINI. Palazzo dei Conservatori, Rome PLATE 35, FIG. 33

Marble, life-size.

The Romans lost no time in deciding to erect a memorial statue on the Capitol to Urban VIII's deceased brother (see No. 26). The matter was decreed in a secret session of the Roman *Conservatori* and confirmed by public council on 6 March 1630 (G. A. Borboni, *Delle Statue*, Rome, 1661, p. 313f.).

It was a fitting *concetto* to transform an ancient torso of Julius Caesar into a commemorative figure of the General of the Church. Alessandro Algardi was commissioned to supply the extremities and Bernini the head. It seems that both artists began working simultaneously. Algardi received his first payment on 19 July 1630, and the rest (together 160 scudi) on 12 September. Bernini was paid a final sum of 150 scudi on 28 September. When the pedestal was paid for on 23 September the statue was already standing on the Capitol (documents in Fraschetti, p. 96).

The division of labour is interesting. Algardi, who had come to Rome in 1625, had by 1630 the reputation of a first-rate restorer of antiques (Neusser, *Belvedere*, xiii, 1928, p. 3ff.), but had hardly yet made a name as a portrait sculptor. According to general opinion, the realistic likeness of a face could only be done by Bernini. (For different views see Posse, *Jahrb. d. Preuss. Kunstslg.*, 1905, p. 181; Muñoz, *Atti Accademia di S. Luca*, ii, 1912, p. 45ff., and *Arte*, xix, 1916, p. 142f.).

The head is small in relation to the body. This may be due to the fact that Bernini worked on the portrait without having the torso in the studio. On the other hand, this relation, paralleled in the Longinus (No. 28), may have been intentional. It gives the whole figure non-classical individuality and virility. The head is a work of high quality and certainly by Bernini himself.

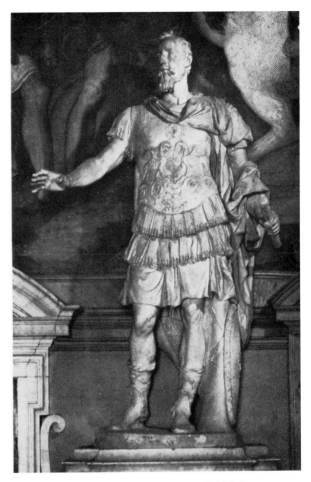

33. *MEMORIAL STATUE OF CARLO BARBERINI*. Palazzo dei Conservatori, Rome (No. 27).

*28. ST. LONGINUS. Niche of the N.E. pillar of the dome, St. Peter's, Rome PLATES 41, 43, FIG. 34

Marble statue, about 4·40 m. (14½ feet) high.

On 7 June 1627 the Congregation of St. Peter's resolved to build monumental altars in the niches of the pillars supporting the dome (Pollak, ii, doc. 1621). On 15 May 1628 Bernini's design, made for the S.E. pillar (now occupied by Duquesnoy's St. Andrew), was accepted (*ibid.*, doc. 1624). At that time it must have been decided to have the altars in the crypt and to reserve the niches for colossal statues of those venerable persons whose names, according to the legend, were connected with the relics kept in the pillars (see No. 29). On 10 December 1629 it was resolved to have large stucco models by different artists placed in the four niches (*ibid.*, doc. 117).

Bernini's work on the Longinus, the only statue he contributed, proceeded in two stages. Between the end of 1629 and the summer of 1631 he completed the large stucco model with the aid of Stefano Speranza (payments 19 December 1629 to 5 April 1632, Pollak, ii,

*See Addenda, pp. 273ff.

p. 454). The model was finished on 5 July 1631, and inspected by the Pope in St. Peter's on 8 February 1632 (F. M. Torriti, *Le Sacre Grotte Vaticane*, 1639, p. 219).

The payments for the purchase of marble begin in 1630 and run on to 1634. In June 1634 the Congregation sent men to Carrara to convey the marble to Rome (Pollak, ii, doc. 1723). Two years previously it had been decided, in order to facilitate transport, to use two pieces of marble for each of the four statues (*ibid.*, doc. 1718). In actual fact, Longinus consists of four pieces: the bulk of the body to which are joined (i) the raised right arm (ii) the great cloak at the right side of the body, (iii) the cloak at the back of the body on its left side.

It appears that the work on the marble cannot have begun until the autumn of 1634 and probably not before the summer of 1635, for in May and June of that year men were paid for putting the marble in position in the studio (*ibid.*, docs. 1785, 1786). Before 1 May 1638 the Pope went to see the statue (Fraschetti, p. 76) which to all intents and purposes seems to have been finished.

If we interpret the documents correctly, Bernini was not engaged on the Longinus during the four years between the summer of 1631 (completion of the model) and the summer of 1635 (beginning of execution in marble). During the interval, in 1633, the Congregation had reconsidered the distribution of the relics: Longinus was moved from the S.E. to the N.E. pillar.

Each of the four artists received 3,300 scudi for his statue.

Apart from a problematical drawing at Bassano (Ragghianti, *Critica d'Arte*, iv–v, ii, 1939–40, p. xvi, fig. 5), which is either a copy after an original sketch or after a model, and a terracotta bozzetto in the Fogg Art Museum (1937.51) nothing survives of Bernini's preparatory work. The extreme care which he lavished on the preparation is affirmed by Sandrart (*Academie*, ed. A. R. Peltzer, 1925, p. 286) to whom Bernini showed no less than twenty-two small models for the figure.

The Fogg bozzetto (Fig. 34) was made for the original position in the S.E. pillar (see H. Kauffmann's analysis, 1961, p. 370f.). It is particularly valuable since it documents a typical stage in the development of Bernini's thought (Wittkower, 1963, p. 47f.). Although by comparison calm and classical, its attitude approaches that of the marble. Also the pose of the left arm essentially corresponds, and this shows that Weibel's (p. 26) supposition, that Bernini must have blundered during the execution, is wrong. In fact, in hardly any other monumental work is Bernini's mastery of marble treatment so fully revealed. The payments prove that he alone was responsible for the execution. It is evident that he must have spent much of his time between 1635 and 1638 working on this figure.

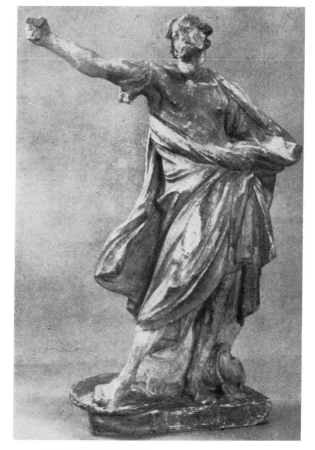

34. *ST. LONGINUS*. Bozzetto.
Fogg Museum of Art, Cambridge, Mass. (No. 28).

★29. THE BALCONIES IN THE PILLARS OF THE DOME OF ST. PETER'S FIG. 35

Simultaneously with the decision to erect the Baldacchino above the tomb of St. Peter, Urban VIII contemplated giving the whole area under the dome a new aspect (Brauer-Wittkower, p. 22). These plans developed into the idea of concentrating the most treasured relics under the dome and decorating the four pillars coherently in such a way that they would express the symbolic import of the early relics. The year 1628 marks the beginning realization of this project (see No. 28). Above the niches with the four giant figures, balconies were to be built, accessible by means of staircases inside the pillars, which would serve for the exhibition of the relics on certain festive occasions (Holy Thursday, Good Friday and Easter Day).

In his designs for these loggias Bernini concentrated upon displaying a stone image of the relic whose corresponding protagonist is represented in the niche below. Under the aediculae for which were used the (restored) twisted columns from the old Basilica of St. Peter's (Pollak, ii, p. 474ff.), large angels, supported by putti, appear carrying images of the Cross of St. Andrews, the

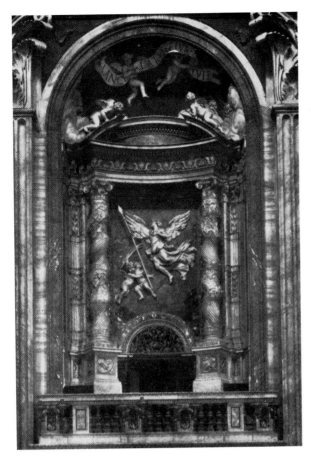

35. *BALCONY ABOVE THE STATUE*
OF ST. LONGINUS. St. Peter's, Rome (No. 29).

Sudary of St. Veronica, the Lance of St. Longinus and the True Cross of St. Helena. The white marble figures are set against polychrome marble ground suggesting the inaccessible realm of heaven. In the oddly shaped spaces above the aediculae the clouds have, as it were, been materialized (stucco) and flying putti carry explanatory inscriptions.

The work on these loggias, requiring expert craftsmen in many different fields, was carried out between 1633 and 1640 (documents, Pollak, ii, pp. 467–508). Only the more important sculptors can here be named:

Stefano Speranza, Putti carrying the Cross of Helena (1635);
Luigi Bernini, Angel carrying the Cross of Helena (1635–9), finished by Niccolò Sale (1639–40);
Matteo Bonarelli, relief above Longinus (1636–8);
Domenico de Rossi, relief above St. Andrew (1637–8);
N. Menghini, relief above Veronica (1636, not delivered until August 1641).

The putti above the aediculae are mainly by Bonarelli, but Domenico de'Rossi, Orfeo Buselli, Bolgi and Luigi Bernini contributed.

★See Addenda, pp. 273ff.

★30. TOMB OF POPE URBAN VIII. Apse,
St. Peter's, Rome PLATES 49, 51–55, 58

Statue of Pope and figure of Death dark bronze, partly gilt; sarcophagus gilt bronze and dark marble; 'Charity' and 'Justice' (double life-size), white marble.

The tomb of Urban VIII occupied Bernini intermittently for twenty years. It was probably planned at the end of 1627 and not finished until 1647. The pre-history of the tomb has been reconstructed by Brauer-Wittkower, p. 22ff. Its genesis can be followed in documents published by Pollak (ii. pp. 590–610; here supplemented by documents in BV, Arch. Barberini, Mazzo 57 *bis*, No. 30, and 'Ristretto d'alcune spese fatte in S. Pietro...' 5 March 1628–10 June 1649).

Urban VIII entrusted Monsignor, later Cardinal, Angelo Giori from Camerino (see No. 19–6) with the supervision of the work. The execution proceeded in two main stages:

(I) 1628–31

During this period the niche was built (completed mid-1629) and the stonemason's work was finished, on which, among others, Borromini was engaged (September 1630: marble incrustation, cornices, base of monument, etc.). In May 1631 the marble for the sarcophagus was trimmed. In July transport of the marble blocks for the allegories was paid for. (It is worth recording that Bernini's father, Pietro (d. 29 August 1629), helped with the purchase of the marble.) Bernini himself was mainly engaged on the statue of the Pope. From December 1628 onwards the large model was in preparation, by October 1630 the casting of the figure was imminent. It may have been finished in April 1631.

After the summer of 1631 there was an almost complete interruption in the work for many years, broken only in the summer of 1634, when Giacomo Balsimelli, one of Bernini's trusted studio-hands, spent some time on trimming the block for the Charity.

(II) 1639–47

From the spring of 1639 onwards the casting of the remaining bronze parts was prepared intensively. The 'Death', planned as early as 1630, was finished early in 1644, and the decorative bronze parts of the sarcophagus (lid, legs, etc.) were finished in September of the same year. The marble portion of the sarcophagus, for which Niccolò Sale was partly responsible, was completed at the end of 1642. Work on the Charity was resumed early in 1639, while the Justice was not begun till after May 1644; both figures were polished at the end of 1646. In 1646 Sale executed the coat of arms and Lazzaro Morelli the two putti belonging to it (October 1646–February 1647). Final settlements with all the workmen and artists, based on detailed specifications, followed in January and February 1647. During this period Bernini

was assisted by his brother Luigi. On 9 February 1647 the tomb was unveiled.

A report drawn up on 20 May 1644 shortly before the Pope's death, for the express purpose of forcing Bernini to finish the tomb in three years, reveals that, apart from subordinate parts, 'Justice' had not yet been begun. In this document Bernini detailed his own contribution which may be summarized under the following five items: (i) small and large drawings together with drawings of all the details, (ii) small models and touching up of the large models (including the large wax models of the Pope and Death), (iii) help in, and direction of, the casting of the bronzes, (iv) execution of 'Charity', (v) future execution of 'Justice'.

The development of Bernini's thought can be followed in a few drawings (Brauer-Wittkower, pls. 13b, 18, 151, p. 24f.). It appears that in 1628 only the idea of the papal statue had taken final shape. According to a document of 25 March 1630 Bernini had not yet made up his mind whether the allegories should be accompanied by two or three putti. While the design for 'Charity' seems to have been fixed in 1631, those for 'Death' and 'Justice' probably did not reach their final stage until 1639 and 1644 respectively.

Of the three bozzetti connected with Charity and published by Brinckmann (BB., i, pl. 38, ii, pl. 14) as originals, that in Berlin is not related to the tomb; it can probably be attributed to Cafà (see A. Nava Cellini, in *Paragone*, vii, 1956, No. 83, p. 24), while the two in the Vatican (from the Palazzo Chigi), though difficult to judge since they are covered by a thick coat of bronze coloured paint (see No. 58), seem to be from Bernini's hand. They illustrate different preparatory stages for the marble. In both bozzetti the figure has one bare breast corresponding to Baldinucci's description of the executed work ('Charity is holding in her arms a suckling child'). For the original appearance of this figure, see, among others, seventeenth-century engravings of the tomb published by Gio. Giacomo de Rossi and in Bonanni, *Numismata summorum pontificum*, Rome, 1696, pl. 35. Howard Hibbard informs me that the dress now covering the breast of the marble is made of stucco probably dating from the late seventeenth century.

31. TWO BUSTS OF CARDINAL SCIPIONE BORGHESE. Galleria Borghese, Rome

PLATES 56, 57, FIGS. 36, 37

Over life-size marbles. H. 78 cm.

The sitter is Pope Paul V's powerful nephew, Bernini's faithful patron, who died aged fifty-seven in October 1633. Both Baldinucci (p. 77) and Domenico Bernini (p. 10f.) tell the dramatic story of the working of the bust, how, when it was almost finished, the marble showed a crack across the forehead and how Bernini, in all secrecy, quickly copied this bust, according to Baldinucci, in the short span of a fortnight, according to the son in only three days. It must have been a staggering performance whatever the duration, but the

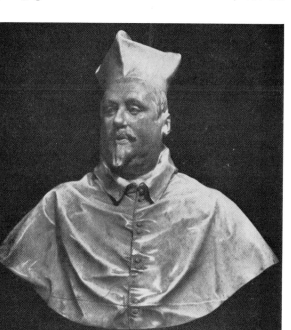

36. *FIRST BUST OF CARDINAL SCIPIONE BORGHESE.* Galleria Borghese, Rome (No. 31).

37. *SECOND BUST OF CARDINAL SCIPIONE BORGHESE.* Galleria Borghese, Rome (No. 31).

second bust lacks the animation and vitality of the first one. Pope-Hennessy, *It. High Ren. and Bar. Sculp.*, Catal., 1963, p. 129, stressed the fact that in the second bust the handling of the lower part is simpler and more unified.

Baldinucci and Domenico Bernini place the bust very early in Bernini's career. This is impossible for reasons of style. Moreover, a despatch sent to the Este court on 8 January 1633 (Fraschetti, p. 107) reports on the bust (it should be remembered that the Este were always *en rapport* with latest artistic events in Rome). The date of the busts is therefore 1632. This is confirmed by a payment to Bernini of 500 scudi on 23 December 1632 (Hibbard, *Boll. d'Arte*, xlvi, 1961, p. 101). The total payment, however, seems to have been 1000 scudi, as stated in Fulviò Testi's letter of 29 January 1633 to Count Francesco Fontana (Campori, *Gli artisti italiani e stranieri negli stati estensi*, Modena, 1855, p. 66f.). See also Faldi's full entry with extensive bibliographical notes (*Galleria Borghese*, 1954, p. 37ff., No. 36).

An invaluable document exists in the preparatory drawing of the Morgan Collection, the only surviving sketch of this class (Brauer-Wittkower, pl. 11). When working on the portrait bust of Louis XIV, Bernini vividly described the purpose of such drawings (see p. 15).

32. FONTANA DEL TRITONE. Piazza Barberini, Rome PLATES 59, 60

Monumental size, travertine.

Although my original discussion of the fountain is no longer correct, I have decided to reprint most of it, because it contains some still valid information and, moreover, illustrates the hazards one runs in construing data from indirect evidence: 'It was in the 1620's that Urban VIII had had the water supply of the Acqua Felice considerably enriched. The abundance of water served not only for the new fountains in the garden of the palace on the Quirinal, commemorated in an inscription of 1628, but also for the Fontana del Tritone. Domenico Bernini (p. 61) makes two important statements about this fountain: first, that it was put up by order of Urban before the Palazzo Barberini was finished. The palace was completed to all intents and purposes in 1633, but minor work dragged on until 1638 (Hempel, *Borromini*, 1924, p. 24; Pollak, i, p. 265ff.). Secondly, that the Pope went to see the fountain although he was ailing at the time (*benchè allora cagionevole*). The Pope fell gravely ill in May 1637 and everybody believed he was dying. In June he was transported from Castel Gandolfo to his palace on the Quirinal (Pastor, xiii, ii, p. 726), and on this occasion he may well have passed Bernini's new fountain.'

It now appears that my previous reconstruction of events was mistaken. A papal decree of 19 August 1643,

published by D'Onofrio (*Fontane*, 1957, p. 191ff.), mentions the fountain as finished; preparations for its execution were well on the way in the summer of 1642 (*ibid.*, p. 193, and Hibbard-Jaffe, in *B.M.*, cvi, 1964, p. 168, note 51).

A studio drawing at Windsor (Brauer-Wittkower, p. 35, pl. 152c) represents a preparatory stage. A small drawing (11·5×7·5 cm.) in the Lanciani Collection, Biblioteca di Archeologia e Storia dell'Arte, Rome, is close to the execution (first publ. by D'Onofrio, *loc. cit.*). The two drawings in the Ambrosiana, Milan, published by Lamberto Donati (*Miscellanea Bibliothecae Hertzianae*, Munich, 1961, p. 439, fig. 312) as preparatory studies by Bernini for the fountain, are without doubt later derivations of poor quality. In order to assess the scale of the fountain in its original surroundings one should look at the engraving in G. B. Falda's *Fontane di Roma*, 1691, pl. 16. The fountain is now dwarfed by the tall buildings along the Piazza.

The emblematical interpretation of the fountain, discussed on p. 29, was suggested by H. Kauffmann ('Romgedanken', 1953–4, p. 56ff.).

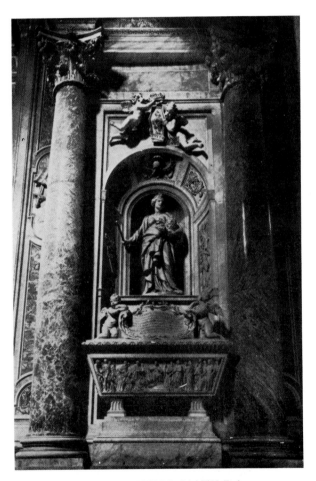

38. *TOMB OF COUNTESS MATILDA.*
St. Peter's, Rome (No. 33).

*33. TOMB OF THE COUNTESS MATILDA OF TUSCANY. Right aisle, St. Peter's, Rome

PLATE 62, FIGS. 38–40

Over life-size marble figures of Matilda and four putti (the figures of the sarcophagus relief are half life-size).

Urban VIII, who profoundly venerated the great benefactress of the Holy See, decided to have her body transferred from Mantua to Rome and buried in a stately tomb in St. Peter's (Pastor, xiii, ii, p. 932). The documents published in Pollak (ii, pp. 204–15) make possible a very detailed reconstruction of the history of the monument. Bernini was commissioned at the end of 1633. According to papal orders of December 1633 and March 1634, 2,000 scudi were put aside to which another 1,500 scudi were added in May 1638.

During the spring of 1634 the execution in marble began with great vigour. All the figures, with the exception of the two putti above the niche, were finished before 20 March 1637, the day the monument was unveiled. But work mainly on subordinate parts seems to have dragged on until early 1644.

39. *PEN AND WASH SKETCH FOR THE TOMB OF THE COUNTESS MATILDA.* Musée des Beaux-Arts, Brussels (No. 33).

Apart from Bernini himself, two stonemasons and the French sculptor Niccolò Sale received payments (the latter a small sum) for the figure of the Countess. The relief on the sarcophagus was worked by Stefano Speranza (195 scudi between March 1634 and February 1636). For the putti above the sarcophagus Bolgi and Luigi Bernini each received 50 scudi (March and May 1634). According to Baldinucci (p. 86) Bolgi was responsible for the one on the left and Luigi Bernini for that on the right. In the same year Bolgi was also paid for the tablet with wreath bearing the inscription. The putti with crown and coat of arms are due to Matteo Bonarelli and Bolgi (1637–8). The latter's angel was finished by the stonemason Lorenzo Flori (1642), who was connected with many of Bernini's enterprises in St. Peter's.

In a document of 1644 Bernini himself specified his contribution to the monument under four items: (1) small- and large-scale drawings, (2) models of all the decorative parts, (3) models of all the figures, (4) retouching of all the figures, in particular of the relief and the figure of the Countess 'which is almost entirely by him since there is no part that he has not worked over and finished'. He adds as (5) that it took a long time to finish the monument because many features are curved and 'in aria' (i.e. free in space).

It follows from these documents that the traditional dating (1635, based on the inscription) and the distribution of hands (based on Baldinucci, pp. 86, 178) are not correct. Even if Bernini somewhat overstated his own part and even if his brother Luigi helped him with the figure of the Countess, as Baldinucci (p. 152) maintains, his share is more considerable than is generally realized.

A hitherto unpublished sketch for the monument in the Musée des Beaux-Arts, Brussels, was brought to my attention by Sir Anthony Blunt (Fig. 39). Its authenticity is beyond doubt; it shows the same manner of rapid abbreviations in pen as the contemporary sketches for the 'Pasce Oves Meas' (Brauer-Wittkower, pls. 12, 13). As a first idea of the monument, datable at the end of 1633, the drawing is of exceptional importance. The allegories (Faith and Justice, later replaced by putti) resting on scrolls return to the disposition of the Carlo Barberini memorial (Fig. 32); certain features of the sarcophagus of the Urban tomb reappear (lion's feet, scrolls connected by garlands). The outsize cartouche, whose design is reminiscent of that on the base of Longinus, remained similarly *mouvementé* in the execution, but its height was considerably reduced in favour of an enlargement of the statue. It is of particular interest that at this early stage Bernini laid down the compositional pattern of the relief.

The relief represents the Emperor Henry IV kneeling before Pope Gregory VII at Canossa. The execution is

*See Addenda, pp. 273ff.

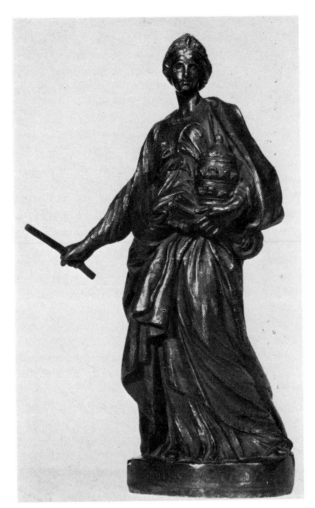

40. *BRONZE STATUETTE OF THE*
 COUNTESS MATILDA.
 North Carolina Museum of Art, Raleigh, N.C. (No. 33).

definitely weak and some of the unduly elongated figures recall Mannerist prototypes. Here the master's retouching was love's labour lost. K.-A. Wirth ('Imperator Pedes Papae Deosculatur', in *Festschrift für Harald Keller*, Darmstadt, 1963, p. 206) has shown that representations of the Emperor kissing the Pope's foot begin to appear in the third quarter of the sixteenth century as counter-reformatory symbols of the triumphant papacy. There can hardly be any doubt that the relief was influenced by Francesco Salviati's fresco (finished after his death in 1566 by Giuseppe Porta) in the Sala Regia of the Vatican showing Barbarossa at the same ceremony.

Three almost identical bronzes of Matilda (H. 40·5 cm.) are not reduced replicas of the marble, but certainly casts after Bernini's preparatory terracotta model as their backs clearly show. Although in general agreement with the execution, these bronzes differ from it in significant details as well as in the more attenuated proportions. The best of the three bronzes (in the collection

of Principe Urbano Barberini) was published by Muñoz in *Arte*, xx, 1917, p. 188f. Always in the Palazzo Barberini, the bronze was in all likelihood made as a memento for Urban VIII personally. The two other contemporary casts have recently come to light. One of them, now in the North Carolina Museum of Art at Raleigh, North Carolina (Fig. 40) has on the back of the base the formal inscription OPUS EQUITIS BERNINI; both this cast and that in the collection of Mr. Max Falk in New York have the words CONTESSA MATILDA hammered in at the front of the base.

34. 'PASCE OVES MEAS.' Inside the portico above the central door, St. Peter's, Rome

PLATE 63, FIG. 41

Marble relief, 4·90 × 5·58 m.

First payments to Bernini for the relief 'which he executes in marble' on 28 September and 5 December 1633 (400 scudi, Pollak, ii, p. 175). Thereafter there is a gap of more than five years. A new series of payments runs sporadically from March 1639 to November 1644. On 30 September 1645 a block of marble for the relief was purchased (AFS, vol. 245) and in the spring of 1646 the relief was finished. But ten years later the Congregation of St. Peter's still owed Bernini 1,400 scudi of his total fee of 3,000 scudi; this sum was paid on 6 March 1656 (Fraschetti, p. 325).

Owing to Fraschetti's incomplete publication of the documents, the relief has always been dated much too late (1644–56). The model in any case must have belonged to the period of the Matilda monument (No. 33). Only Benkard (p. 20) noticed the connection.

Since the relief is placed very high, it is not easy to decide how much Bernini himself contributed to the execution in marble. There is no valid reason for attributing the relief to Paolo Naldini, as Riccoboni (p. 192) did. It is much more likely that the young Cosimo Fancelli had a considerable share in the execution. Bernini seems to have touched up at least the principal figures of Christ and St. Peter and, possibly, the Apostle in the background nearest to Christ. The part of the relief in which figures appear consists of three marble blocks, one for St. Peter, one for Christ and the two Apostles in the background, and one for the three (not two) Apostles on the left. It may be surmised that this is the block purchased in 1645. The quality of these figures is poor and was hardly supervised by the master. It should be remembered that Bernini at this period was entirely absorbed by the disastrous affair of the towers of St. Peter's. Execution of this block possibly by the weak Luigi Bernini.

The relief was placed in 1646 above the entrance door *inside* the church (see ill. in BV., cod. Vat. lat. 4409, fol. 3 and engraving in Paolo de Angelis, *Descriptio*

Vaticanae Basilicae, Rome, 1646, showing the relief with square top. Also documents AFM, 1646, No. 42 and AFS, vol. 245). In 1649 it was transferred to its present position (see Marsilio Honoratis, *Fida scorta dei Pellegrini nel cammino a' luoghi santi di Roma*, 1650, p. 120). Preparatory sketches and the transformation of the composition are discussed in Brauer-Wittkower (p. 30f., pls. 12, 13).

An interesting marble copy (seen by me before the War in the Palazzo Spada, Rome, but no longer traceable, see Faldi, *Paragone*, VI, 1955, No. 71, p. 49), which I would tentatively attribute to Giovan Battista Maini, was probably made after Bernini's model. The proportions of the copy indicate that Bernini, in designing the relief for its high position, carefully considered fore-shortenings.

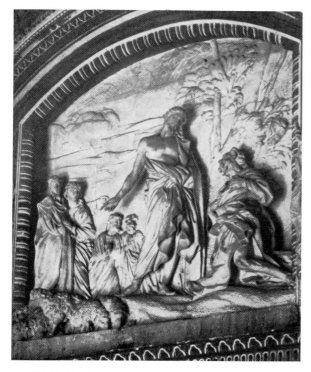

41. '*PASCE OVES MEAS*.' St. Peter's, Rome (No. 34).

The conception of the relief was taken up and developed in the bronze reliefs 'Pasce Oves Meas' and 'Christ handing the Keys to St. Peter' of the Cathedra (Battaglia, p. 102).

35. BUST OF COSTANZA BONARELLI.
Museo Nazionale, Florence　　　　PLATE 61, FIG. 43
Life-size marble. H. 72 cm.

The bust represents the wife of Bernini's studio hand Matteo Bonarelli. Bernini was violently in love with her and this affair seems to have been the talk of the town. Domenico Bernini (p. 27) reports on it with consider-

*See Addenda, pp. 273ff.

able frankness, and in a letter of 1640 (Fraschetti, p. 49) we hear that Bernini made the bust 'mentre di lei stava fieramente innamorato'. Bernini married in 1639, whereupon he presented the bust to Monsignor Bentivoglio who, in 1640, gave it to the Duke of Modena (Fraschetti, *ibid.*). As early as 1645 it was in the grand ducal collection at Florence where John Evelyn saw it (*Diary*, 23 May 1645).

The work is usually dated in the twenties (Riegl, p. 106ff.; Benkard, p. 43; A. Schiavo, *La donna nelle sculture del Bernini*, 1942, p. 42; and others), but that is impossible for reasons of style. A later date has been suggested by the author in *B.M.*, 1953, p. 20, and by Martinelli, *Bernini*, p. 51. Moreover, it seems that Matteo Bonarelli did not start working for Bernini until 1636 (Pollak, ii, p. 505). External and internal evidence, therefore, point to a date about the mid-thirties.

A fine marble bust in the Contini Bonacossi Collection, Florence, is a late seventeenth-century replica, to which an un-Berninesque enlargement of the body of the bust was added.

An entry in the 1706 inventory of the Palazzo Bernini seems to refer to a double portrait (at that time cut in two) of Bernini and his mistress (Fraschetti, p. 48). This second document of Bernini's escapade does not survive.

*36. BUSTS OF PAOLO GIORDANO II ORSINI, DUKE OF BRACCIANO, and HIS WIFE, ISABELLA ORSINI.

In his catalogue (p. 177) Baldinucci lists the portrait bust of 'Don Paolo Giordano Duca di Bracciano in casa Orsini'. The work was believed lost until recently rediscovered by I. Faldi (*Paragone*, September 1954, p. 13ff.) in the Orsini castle at Bracciano. The identity of the sitter is ascertained by Ottavio Leoni's engraved portrait (Faldi, fig. 8) and a series of medals, ten in all, issued between 1611 and 1635 (see Mazzuchelli, *Museum Mazzuchellianum*, Venice, 1763, ii, p. 51, pl. III, and Litta, *Famiglie celebri Italiane*, fasc. lxii; that of 1631 published by F. Dworschak, *Jahrb. d. Preuss. Kunstslg.*, lv, 1934, pl. i).

New documents published by F. Haskell (1963, p. 387ff.) have revealed that Bernini made the model of a bronze bust of the Duke in the summer of 1623. The work was cast in September 1624 by Sebastiano Sebastiani, whom Bernini employed at this time also on other occasions (Nos. 6, 12). Baldinucci's catalogue entry, however, probably refers to the marble, since he did not say 'di metallo', his usual designation for bronze busts.

*(a) Bronze bust. Cyril Humphris Ltd., London.

　　　　　　　　　　　　　　　FIG. 42

H. 18·5 cm. The corselet is silvered except for the

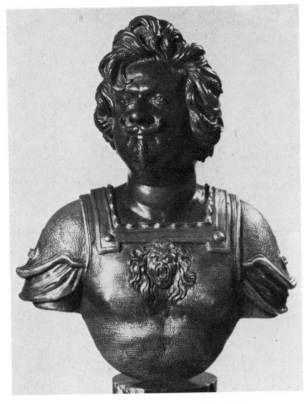

42. *BRONZE BUST OF PAOLO ORSINI,*
DUKE OF BRACCIANO.
Cyril Humphris Ltd., London (No. 36–a)

Medusa head. The strap-work ornament and undershirt were originally thinly gilded (worn off).

In spite of its miniature size, this seems to be the bust for which Bernini made a model in 1623. Although the phrasing of the letter of 27 June 1623 published by Haskell contains some ambiguities, the statement that the bronze-caster Sebastiani was to receive only up to 25 scudi is clear enough. For a life-size bust he was paid between 130 and 150 scudi (see Faldi, i, 1953, p. 315, doc. xvi). Thus the Duke's bust must have been extremely small. Moreover, the remark in the letter of 21 September 1624 'ci si veggono tutti i colpi della cera rinettata' may well refer to the thousands of indentures representing the chain mail cuirass. The Duke fashioned a rather untidy hair style until the early 1630's. His hair style of the 1620's is best documented by Leoni's reliable engraving of about 1625. It is evident that the hair fashion shown in the bust belongs to the same period. At the time of the little bust the Duke was thirty-two years old. Even then he inclined to fatness, see particularly the fat neck with the indented crease around it—not exactly a beautiful feature which, however, appears more pronounced in the later marble (*b*). Thus documentation and iconography support rather than contradict originality. But the forcefulness and vigour of the bust are the strongest argument in favour of its

acceptance. Also the symmetry of the lower part of the bust is characteristic of Bernini's busts of the twenties. The hard break between the stumps of the arms and the rounded-off chest would seem unusual, but Bernini apparently wanted to dress up the Duke as a counterpart to antique heroes. The non-antique shirt-sleeves emerging from under the shoulder-pieces strike one as a typical Berninesque device of avoiding the impression of arm amputation (an impression one often has before antique busts). Indeed, the conception of the triple break formed by the shoulder-piece, the sleeve and the lower edge of the arm is ingenious and novel. Except Bernini, there was no one else in Rome at that time who would have transformed classical antiquity in this original way. Equally Berninesque is the idea of feigning the perforated armour by the pouncing device which hides as well as reveals the beautifully modulated body underneath. An even more convincing Berninesque conceit is expressed by the deliberate contrast between the head of the Medusa and the slightly ridiculous head of the sitter with the disorderly, 'medusa-like' hair style. Moreover, the explosive energy of the Medusa calls to mind the *Anima Dannata* (Pl. 6) and the deep holes for the iris are found in some early portrait busts. A judicious reading of the letters does not allow us to conclude—as Haskell, p. 96f. did—that Bernini modelled the head of wax. Without any doubt, he made a most carefully executed terracotta model, which may have been similar in character to such later bozzetti as those shown in Figs. 34 and 85. In the bronze, the terracotta model can still be sensed, particularly in the area of the Duke's right ear and on the crown of the head.

(*b*) Life-size marbles of the Duke (H. 88 cm.) and his wife (H. 84 cm.). Castle, Bracciano.
PLATE 67, FIGS. 44, 45

Faldi dates the bust of the Duke 'about 1630', just before the Scipione Borghese (No. 31) and although this date has much to recommend it, it seems to me a few years too early. A date about or soon after 1635 is more likely. Only after the Scipione Borghese bust was Bernini capable of such witty, almost burlesque interpretation of a sitter, and the similarity of approach between this and the Baker bust (No. 40) is so close that it hardly needs stressing. A scrutiny of the medals leads to the same conclusion. Although the Duke never abandoned the bold forelock, the 1635 medals give the hair at the sides rather straight—corresponding to the bust (and contrasting with the earlier hair style, see above). Paolo Giordano was then forty-four years old (1591–1656) and this seems to accord very well with the age of the sitter. Moreover, as in the bust, he appears in the 1635 medals dressed *all'antica*. (There is, therefore, little reason to accept the dating 1632–33 recommended by Haskell, p. 97). The unfinished draped chest is

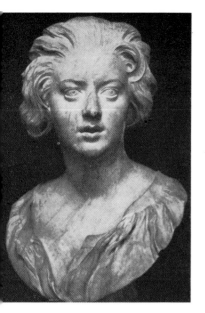

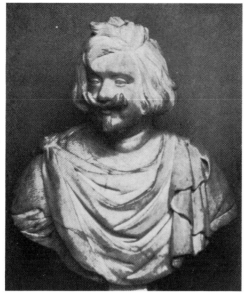

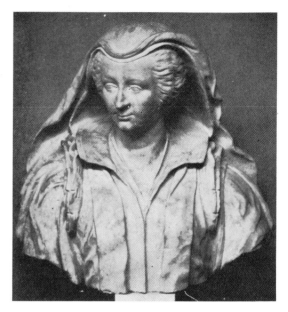

3. *COSTANZA BONARELLI.*
Museo Nazionale, Florence (No. 35).

44. *DUKE PAOLO GIORDANO ORSINI.*
Castle, Bracciano (No. 36).

45. *DUCHESS ISABELLA ORSINI.*
Castle, Bracciano (No. 36).

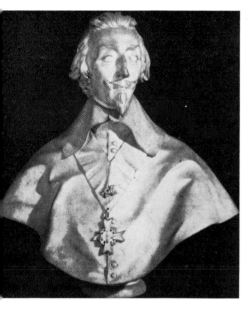

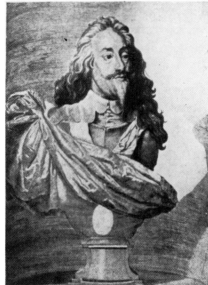

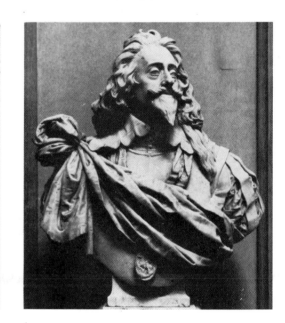

6. *CARDINAL RICHELIEU.*
Louvre, Paris (No. 42–1).

47. *KING CHARLES I.*
Unfinished engraving (reversed)
(No. 39–1).

48. *KING CHARLES I.* Copy by Thomas Adye (?).
Windsor Castle (No. 39–2).
By Gracious Permission of H.M. The Queen.

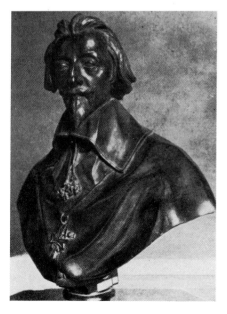

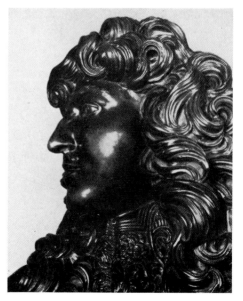

49. *CARDINAL RICHELIEU.*
Sanssouci, Potsdam (No. 42–2).

50. *Attempted reconstruction of Bernini's
design for the pedestal of Louis XIV's
bust.* (No. 70.)

51. *BUST OF LOUIS XIV.* Detail.
French bronze copy. National Gallery of Art,
Washington (No. 70).

probably largely due to a studio hand (Bolgi ?). In any case, the pleats of the drapery have a somewhat hard and metallic quality, not unlike those of the Baker bust. According to Posse (Thieme-Becker, iii, p. 462) a porphyry copy is in the park of Sanssouci (Potsdam).

The Duke's bust has a counterpart in the bust of the Duchess, Isabella Orsini. It too was first published by Faldi as Bernini's work. But Baldinucci does not mention it. It was probably to a large extent carried out in the studio with the exception of the (not entirely finished) face, the handling of which reveals a close affinity to the Medusa (No. 41). This bust confirms the date 'about 1635'; Isabella, who had first been married to her uncle Giorgio di Mendozza, Conte of Binasco, was Principessa of Piombino. She was born before 1590, the year of her father's death. Consequently she was older than her second husband, and the bust shows her, in fact, as a matron of advanced age.

V. Martinelli (Commentari, vii, 1956, p. 32, note, and x, 1959, p. 148) ascribes both busts to Bolgi. He advances the theory that the Duke's bust was copied after a lost original by Bernini. A. Nava Cellini (Paragone, xiii, 1962, No. 147, p. 33 and note 11) has refuted this hypothesis as untenable. Neither author knew about the bronze bust documented for 1623–24. On my part, it would be repetitive to argue that the marble cannot be a copy after the bronze even if my identification of the latter were wrong.

37. MEMORIAL INSCRIPTION FOR URBAN VIII. Entrance wall (covering the whole width of the nave), S. Maria in Araceli, Rome

FIG. 52

Two giant figures of Fame holding the scroll with the inscription, white stucco.

On 11 February 1634, the Roman Senate decided to commemorate in an inscription the return of Urbino to the papal states and the Pope's great services to the city of Rome (Pollak, i, p. 165). The long inscription is, in fact, dated 1634 (Forcella, i, p. 234, no. 902), but the work was not finished until 1636, when Bernini was paid 100 scudi (Fraschetti, p. 99). This low fee proves that his own contribution was small. To be sure, the figures of Fame are weaker than almost any other work supervised by Bernini, but since they are high above ground level no finesse of detail was required. Martinelli (Commentari, iv, 1953, p. 154) suggested, probably correctly, Bernini's brother Luigi as the author of these figures. And yet the work deserves special notice, since it was here for the first time that Bernini incorporated into his composition an existing window. It forms the armorial field of the papal coat of arms and shows the Barberini bees set in blue glass 'as if flying through the air' (Baldinucci, p. 147)—a typical Baroque concetto. The

52. *MEMORIAL INSCRIPTION FOR URBAN VIII.*
S. Maria in Araceli, Rome (No. 37).

idea of using a window as part of a sculptural whole was to become of the utmost importance, first in the *Cathedra* and later in innumerable works of northern Baroque art.

38. MEMORIAL STATUE OF POPE URBAN VIII. Sala dei Capitani, Palazzo dei Conservatori, Rome

PLATE 69, FIG. 53

Monumental marble statue.

In 1635 the Roman Senate revoked the decree of 1590 according to which memorial statues of popes should not be erected on the Capitol during their life-time. This opened the way to honouring Urban VIII by a memorial statue, a resolution agreed upon in secret session on 13 October 1635 (Borboni, *Delle Statue*, 1661, p. 265). Bernini was commissioned and a fee of 2,000 scudi was fixed (Fraschetti, p. 151). During the night of 24 June 1640, the finished statue was transported from Bernini's studio to the Capitol, lifted through the large first-floor window of the Conservatori Palace and placed on its base (Pollak, i, p. 340). The statue was unveiled on 29 September. Its eventful later history was reported by Fraschetti, p. 154. Removed in 1798, the statue was put back on to a new base in 1817 (Malamani, *Canova*, 1911, p. 216). Bernini's slightly different original base is shown in Borboni's engraving. The inscription expresses the grateful feelings of the people and senate for Urban's benefactions. On both sides of the old base were the names of the officials under whom the statue was decreed and finished (Forcella, i, p. 53, no. 126). For further details see E. Steinmann, 'Die Statuen der Päpste', *Misc. F. Ehrle*, Rome, 1924, ii, p. 490ff.

The execution of the statue is to a large extent studio work (Martinelli, in *Commentari*, x, 1959, p. 154, suggests Bolgi's name). Subordinate parts are rather dry, but the sophisticated and ample use of the drill, which produces the impression of flickering light on the many pleats of the papal shirt, must have been closely watched by Bernini. As in the Longinus, the grooves of the toothed chisel were left standing in the face and not

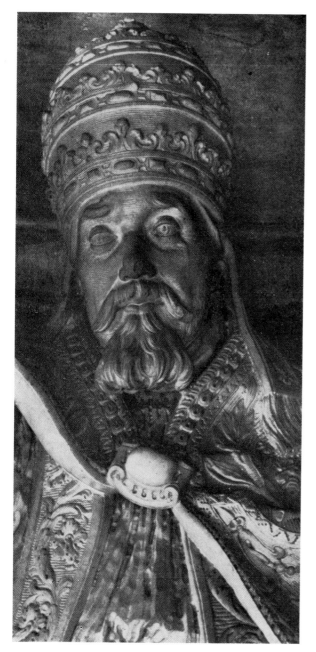

53. *MEMORIAL STATUE OF URBAN VIII.* Detail. Palazzo dei Conservatori, Rome (No. 38).

smoothed down with rasps—a method chosen to enliven the features for a fairly distant viewpoint.

Bernini's bronze memorial statue of Urban VIII, decreed in 1627 and erected in 1633 in the Piazza at Velletri, was destroyed in 1798 and no record of the work remains (Fraschetti, p. 147; W. Hager, *Die Ehrenstatuen der Päpste*, Leipzig, 1929, p. 60). Since 12,000 scudi were spent on this work, it must have been of considerable importance.

A stucco memorial statue of the Pope, at one time in the courtyard of the Collegium Romanum, Rome, was

*See Addenda, pp. 273ff.

destroyed after Urban's death (Fraschetti, p. 154). Whether it was by Bernini and served as model for either the marble or the bronze statue, as has been surmised, is impossible to establish.

★39. BUST OF KING CHARLES I. Formerly Whitehall Palace, London, Destroyed FIGS. 47, 48

Life-size marble.

The bust of Charles I was most probably destroyed in the fire of Whitehall Palace in 1698 (Vertue, *Walpole Society*, xviii, p. 27, xx, pp. 50, 52, 75 and xxiv, pp. 36, 77), but sufficient records exist to give a fairly precise idea of it.

(For the history of the bust see Baldinucci, p. 88f.; Domenico Bernini, p. 64ff.; Fraschetti, p. 110f.; L. Cust, *B.M.*, xiv, 1909, p. 337ff.; and, above all, Maclagan *B.M.*, xl, 1922, p. 63ff., to be supplemented by a great number of letters in the Barberini Archives.)

First mention of the bust appears in a letter by Gregorio Panzani, special Vatican envoy to Queen Henrietta Maria, of 13 June 1635: 'the King is extremely satisfied about the papal permission given to Bernini to execute his bust' (BV, cod. Barb. lat. 8634, fol. 114). On 17 March 1636, the King wrote a flattering letter to Bernini asking him to execute the bust after the painting 'which we shall send you without delay' (Domenico Bernini, with wrong date 1639). Van Dyck's triple portrait (Windsor Castle, usually dated too late, but see *Flemish Art 1300–1700*, Catalogue, Royal Academy 1953–4, no. 138) was taken to Rome, possibly by Thomas Baker (see No. 40). The bust was executed in the summer months of 1636 (Barb. lat., 8637, fol. 248). Sent off from Rome in April 1637, it arrived in London at the end of July. As papal present to the Queen, it was regarded as an object of great political significance. Cardinal Francesco Barberini's circumstantial instructions for its transport survive (Barb. lat., 1625, fol. 1–3). The King's enthusiasm for the bust was boundless (Barb. lat., 8641, fol. 41v); the Queen sent Bernini a diamond worth 4,000 scudi (Barb. lat. 8645, fol. 326r) and now wanted a portrait bust of herself. Paintings for the purpose were in preparation in August 1638 (Barb. lat. 8643, fol. 67r; see also the above-mentioned Catalogue, no. 154). But not until a year later did she approach Bernini officially. The Civil War prevented the project from being pursued any further.

The following records of Bernini's bust survive:

(1) Robert Van Voerst (?), unfinished engraving in the British Museum (Cust, *op. cit.*, p. 340).

(2) Thomas Adye (?), marble bust, eighteenth century, probably made from a cast of the original in Francis Bird's possession. Windsor Castle (Esdaile, *B.M.*, lxxii, 1938, p. 164 and xci, 1949, p. 13).

(3) and (4) Drawings by Jonathan Richardson in the Sutherland Collection, formerly Bodley, Oxford, now Ashmolean Museum (Toynbee, *B.M.*, xliv, 1924, p. 93ff. Inscribed: 'after a cast . . .') and in the Roger Warner Collection (Snelgrove, *Connoisseur*, ci, 1938, p. 126f. Inscribed: 'K. Ch. I, from Bust of Bernini, 19 June 1733').

(5) and (6) Roubiliac's marble bust, made for George Selwyn, 1759, now Wallace Collection, and the similar terracotta atttributed to him, in the Lee of Fareham Collection (Courtauld Institute, London), are based on Bernini's bust, but do not follow it closely (Esdaile, *B.M.*, 1949, figs. 19, 20).

40. BUST OF THOMAS BAKER. Victoria and Albert Museum, London　　　　PLATES 64, 66

Life-size marble. H. 81·6 cm. including base carved in one with the bust.

This work, first published by L. Cust (*B.M.*, xiv, 1909, p. 339) can without any reasonable doubt be identified with the bust of an Englishman on which Bernini was engaged in 1638. Since its mention in 1680 in the catalogue of Sir Peter Lely's collection as 'the head and bust of Mr. Baker in white marble, by Cavalier Bernini', its history can be followed without a break (Maclagan, *B.M.*, xl, 1922, pp. 56–63, 120). It has been shown (Pope-Hennessy, *B.M.*, xcv, 1953, p. 130) that 'Mr. Baker' was Thomas Baker of Whittingham Hall, Suffolk (1606–58), who was connected with English court circles and may have been the one who conveyed Van Dyck's triple portrait of Charles I to Rome (see Vertue, *Walpole Society*, xviii, p. 27).

Nicholas Stone's entry in his diary in Rome on 22 October 1638 (*Walpole Soc.*, 1917–18, p. 170), Baldinucci's (p. 89) and Domenico Bernini's (p. 66f.) accounts, and Bernini's own words to Chantelou (p. 204), when carefully evaluated together, indicate that work on the bust was interrupted by papal interdict and that the marble was largely executed by a pupil (probably Andrea Bolgi), who seems to have followed Bernini's model for the head rather than the lower part. The convincing characterization of this supercilious dandy was surely due to Bernini's careful touching up of the head, while the rather formalized lower part, which varies the motif of the Vigevano (No. 5), appears to be largely the pupil's contribution. The literary and stylistic evidence has been fully discussed by the author in *B.M.* 1953 (pp. 19–22, see also the controversy pp. 138–41).

In his recent *Catalogue of Italian Sculpture in the Victoria and Albert Museum* (1964, p. 600ff., No. 638) Pope-Hennessy has once again surveyed the entire evidence and added a great deal of new material regarding Thomas Baker's movements. In other respects the entry obscures rather than clarifies what the contemporary references to the bust so clearly reveal. I find, therefore, no reason to change my original entry, particularly since Pope-Hennessy concedes to me the correctness of my original observation (*B.M.*, 1953) that—in his words—'the execution of the lower part of the bust, exclusive the gloved hand, is weaker than that of the upper part, and is certainly due to an assistant, perhaps Bolgi, though the case in favour of Bolgi's authorship is not thoroughly conclusive'. (It may here be mentioned that Martinelli, *Commentari*, x, 1959, p. 149, and A. Nava Cellini, *Paragone*, xiii, 1962, No. 147, p. 29, accept my analysis of the bust and Bolgi's collaboration and that these references are not included in Pope-Hennessy's entry.)

Before closing the controversy, I feel moved to restate what has been and still is the main burden of my argument, namely that the head of the bust goes well with Bernini's style, while the lower part is conceived in a different spirit; in other words, that there is not only a difference in execution, but a definite stylistic break between the lively head and the less accomplished lower part. I have previously pointed out that Bernini's sense of organic movement would never have permitted to cut off the left arm at the elbow and that the lower part of the Baker bust lacks the consistency of its much earlier prototype, the bust of Giovanni Vigevano (No. 5; see *B.M.*, 1953, p. 20f.). By way of an ingenious, but in my view mistaken interpretation of Nicholas Stone's report, C. Gould (*Art Quarterly*, xxi, 1958, p. 167ff.) suggested that Bernini had himself completed a large part of the head and hair at the time of the papal embargo. However, in the last analysis it is not important, whether Bernini carved the face and glove alone or touched them up later, as I concluded on the basis of technical idiosyncracies (*B.M.*, 1953, pp. 20, 21). Those who have studied Bernini's procedure (for which see my remarks in *B.M.*, 1953, p. 140, and in *Italian Art and Architecture*, p. 110ff.) will know that many of his 'originals' were to a large extent prepared by assistants and that it is the degree of his touching up that is decisive for the appearance of the work. I have always maintained that Bernini had his share in the Baker bust; this is not only amply proved by every word I have said about it, but also by the large plate I have given it. But it is equally true that this bust—even in the face, hair and glove—lacks something of the brilliance of such works as the almost contemporary Costanza Bonarelli, executed by Bernini himself from first to last.

41. MEDUSA. Palazzo dei Conservatori, Rome
　　　　　　　　　　　　　　　　　　PLATE 65

Over life-size marble head.

The Medusa is mentioned neither by Baldinucci nor by

Domenico Bernini. It was first heard of when it was presented to the Museum in 1731 by Marchese Francesco Bichi. The Latin inscription, which relates this fact, says that it was by the hand of 'a very celebrated sculptor' (*celeberrimus statuarius*). Once in a public gallery, Bernini's name was soon given to this spectacular work and, to my knowledge, its authenticity has never been seriously doubted. And yet, the work contains more than one strange feature. The hair (mainly on top of the head) has a woolly quality different from Bernini's precise sense of form. The piece of drapery on the right shoulder shows the same limpness. Moreover, the ornamental rendering of natural forms (e.g. eye-brows and mouth) seems at variance with Bernini's style.

On the other hand, the brilliant surface treatment, the technical wizardry of the serpents' bodies curling free in space, the powerful and convincing transformation of an ancient tragic mask into the head of Medusa, the play with transitions between hair and snakes (an ingenious interpretation of Ovid's text, *Metamorphoses*, iv, 794ff.) —all this favours the traditional attribution.

Stylistic parallels may be found in certain works of the mid- and late 1630's, such as the Baker bust and the bust of Isabella Orsini. The above-mentioned weaknesses as well as the silence of the sources may perhaps be explained by the following consideration: Domenico Bernini reports (p. 49) that at the age of 37 (i.e., 1636) his father fell gravely ill and that, during the period of recuperation, he worked a few marbles in his room 'some of which are still in his house'. The Medusa may have been one of these works.

The same claim cannot be made for the *Vita* and *Morte*, a child (polished white marble) and a skull (yellow marble) each placed on a black marble cushion with gilt border (40×70 cm. each), in the Chigi Collection. (Farnesina). In spite of the mention in an old Chigi inventory as works by Bernini and the close connection of the putto with the children on the tomb of Urban VIII, there are weaknesses in the treatment of the child's face and body which indicate that the execution is largely by a studio hand (Fraschetti, p. 291; phot. Gab. Fot. Naz. C 6348, 6349).

*42. BUSTS OF CARDINAL RICHELIEU.
(1) Louvre, Paris, (2) Sanssouci, Potsdam

FIGS. 46, 49

Life-size (1) Marble, (2) Bronze.

According to Baldinucci (p. 89f.) Richelieu begged Cardinal Antonio Barberini to approach Bernini to make his portrait. Domenico Bernini (p. 67) talks of a portrait in marble. It seems that in July 1640 the 'profils de son Eminence' were ready to be sent to Rome (Magne, *Rev.*, xxxiv, 1913, p. 225). The bust was executed between the autumn of 1640 and the summer of 1641 (it is usually dated too late), and Bernini's studio hands Giacomo Balsimello and Niccolò Sale conveyed it to Paris. On 21 August 1641, Mazarin wrote to Cardinal Barberini announcing its arrival. On 3 September 1641, Mazarin confides to his brother that the bust is quite unlike Richelieu; but in a letter of 18 December, addressed to Bernini, he praises it to the skies (all documents in Courajod, 'Jean Warin', *L'Art*, 1881, p. 298ff.). Together with the bust Bernini's envoys had taken a polite letter along to Paris (printed without date in Baldinucci and with the wrong date, 16 March 1642, by D. Bernini). In February 1642 presents from Richelieu and Mazarin had reached Bernini (Fraschetti, p. 112, note 2). And on 24 May 1642, Bernini himself thanked Richelieu (printed by Baldinucci and D. Bernini, original in BN, cod. Ital. 2083, fol. 53).

In all this correspondence there is talk only of a marble bust. But Baldinucci in his catalogue (p. 180) also mentions a bronze bust of the Cardinal in Paris. An undated letter written by M. de Lionne to Cardinal Pallavicini (BN, cod. Ital. 2082, fol. 12f.) may possibly refer to the bronze. In any case, M. de Lionne had secured for himself a portrait bust of Richelieu by Bernini.

The identification of both marble and bronze has met with great difficulties. The first to attribute the Louvre marble to Bernini was M. Reymond (*Bull. Mus. de France*, 1910, p. 65ff. and *G.d.B.A.*, v, 1911, p. 389f.). Until then it was given to Coysevox (Barbet de Jouy's Catalogue, 1873), Girardon (Courajod) or called 'anonymous French' (Michel). Reymond's attribution was accepted by Riegl, Vitry, Benkard, v. Boehn, Wittkower, Martinelli (see *Commentari*, ii, 1951, p. 232) and others. But Ingersoll-Smouse (*Rev.*, xli, 1922, p. 402) attributed the bust to Francesco Mochi and was followed by P. della Pergola (*Arte*, 1938, p. 172ff.) and Mlle Charageat (in: *A travers l'art italien. Revue des études italiennes*, Paris, 1949, p. 153ff.; id., in *Les sculptures du Musée du Louvre*, Guide du visiteur, 1957, p. 153f.). Mochi, in fact, executed a statue of Richelieu (fragment publ. by Charageat).

The contesting claims are based on the following facts. Bernini's bust passed from Richelieu to the Duchess of Aiguillon, in whose inventory it is mentioned (2 feet, 3 inches [Paris measure], i.e. c. 73 cm., while the present bust is 84 cm. high). According to an old tradition, the Duchess presented the bust to the chapter of Notre-Dame, and it is a fact that the present bust was taken to the Louvre from Notre-Dame during the Revolution (for further details see Courajod and Charageat). Mochi's name first appeared after the discovery on the back of Philippe de Champaigne's triple portrait of Richelieu (Nat. Gallery, London, No. 798, see M. Davies, *Catalogue, French School*, 1946, p. 13) of an old Italian inscription stating that the portrait was made for Francesco Mochi to work from. (Before relining, the inscription

*See Addenda, pp. 273ff.

seems to have been on the turn-over of the original canvas). In addition, Charageat published (p. 158) a second marble bust of Richelieu (Museum, Bayeux), purchased in Florence at the end of the nineteenth century; this bust derives from the same model as the Louvre bust, and is inscribed at the back 'Mochi' (I have not seen the bust; the inscription seems to be of recent date).

A connection between Philippe de Champaigne's picture and the Louvre bust appears very likely. Domenico Bernini never mentioned that his father worked from Champaigne's triple portrait, as is persistently maintained (Pergola, Davies, Charageat, and others). The lack of any such reference might therefore be regarded as supporting the old inscription.

The Gordian knot presented by these facts can for the time being be cut only by stylistic arguments. For reasons of style it is impossible to give the Louvre bust to Mochi. It shows, on the contrary, Bernini's characteristic idiosyncrasies. The difference between the expansive mood of the marble and the restraint of the painted portrait is reminiscent of the relation between Van Dyck's portrait of Charles I and Bernini's bust of the King. The body and cut of the bust should be compared with the Louvre bronze of Urban VIII and others. The execution, however, must to a large extent have been due to a pupil. (Bolgi's participation suggested by Martinelli, in *Commentari*, x, 1959, p. 154, seems doubtful).

A terracotta bust of the Cardinal—probably the model for the cast—is mentioned in the 1706 inventory of Bernini's house (Fraschetti, p. 432).

The bronze bust at Sanssouci was purchased by Frederick the Great in 1742 as by Bernini from the Polignac Collection (Seidel, *Französische Kunstwerke des 18. Jahrhunderts*, 1900, pp. 30, 168; Henschel-Simon, *Katalog*, 1930, p. 49). It is close to the Louvre marble. Muñoz (*Arte*, xix, 1916, p. 107) surmised incorrectly that Bernini began with a bronze bust. The artist of the Sanssouci bronze may possibly have used Bernini's model (as did also the artist of the Bayeux marble), which was still in the latter's house after his death (see above). But the bronze lacks vitality and the formalized rendering of the chest alone excludes any close supervision by the master.

*43. TOMB OF ALESSANDRO VALTRINI.
S. Lorenzo in Damaso (entrance wall), Rome FIG. 54

MEMORIAL TO IPPOLITO MERENDA.
S. Giacomo alla Lungarna, Rome FIG. 55
Life-size skeletons. Marble reliefs.

Baldinucci mentions a 'memorial of Marenda in S. Lorenzo in Damaso' and 'a similar one in the Con-

*See Addenda, pp. 273ff.

vertite' (p. 180f.). Fraschetti (p. 84) identified the former with the tomb of Alessandro Valtrini and believed that the latter had been destroyed. Every author followed him, until R. Battaglia (*Le Arti*, iv, 1941-2, p. 356ff.) rediscovered the second monument in S. Giacomo alla Lungarna, the church belonging to the monastery of the Convertite (Trastevere). This monument, erected to Ippolito Merenda, is, of course, Baldinucci's 'Marenda' (it appears that he mixed up the two memorials).

Both monuments were due to the generosity of Cardinal Francesco Barberini (Ciaconius, *Vitae et res gestae Pontificum*, 1677, iv, col. 526). Valtrini died in 1639, which supplies the date *post quem* for his tomb. Ippolito Merenda, an ecclesiastical councillor ('avvocato concistoriale'), left a bequest of 20,000 scudi to the church of S. Giacomo alla Lungarna (*Roma antica e moderna*, 1765, i, p. 151), when he died on 13 May 1636 (Galletti, *Necrologio Romano*, BV, cod. Vat. 7879, car. 56). In 1635 Cardinal Francesco Barberini had begun rebuilding this church, and by 1641 it seems to have been well enough advanced for the Pope to pay it a visit (Pollak, i, p. 183; Battaglia, p. 356, note 4). There is, therefore, reason to believe that the Merenda memorial dates from 1640-1 rather than from 1636 (inscription in Forcella, vi, p. 325, No. 1068, without date—Merenda was buried in S. Maria della Vittoria).

The idea of both monuments is strikingly similar: in one 'Death' is flying in front of a wind-swept drapery holding up a medallion with the relief bust of the deceased; in the other Death appears spreading out a shroud which carries the inscription. These monuments mark a radical break with the traditional architectural tomb. Although the transformation of the skeleton from a static symbol of Death into the dramatic agent of death has to be attributed to Bernini himself, the execution of both monuments must be due to assistants. (Martinelli, *Commentari*, x, 1959, p. 154, attributes tentatively the medallion of the Valtrini tomb to Bolgi. The monument to Evangelista Masi di Caldarola [d. 1664] in the Cathedral at Faenza [Alinari 48078], sometimes attributed to Bernini, is derived from the Merenda memorial).

The figure of Death on these monuments anticipates that of the tomb of Alexander VII, where the skeleton is lifting the shroud (Plate 126). But on the early monuments, as on the tomb of Urban VIII, Death serves to commemorate the deceased (see E. Panofsky, in *Festschrift für L. L. Heydenreich*, Munich, 1964, p. 223f.), while on the late tomb, raising an hour-glass run out, he appears as triumphant over life (see pp. 22, 23).

After 1640 the drapery motif took on increasing importance for Bernini. He used it also for the monument of Maria Raggi (No. 44), the decoration of the Sala Ducale (No. 59), the chapel of the de Silva family

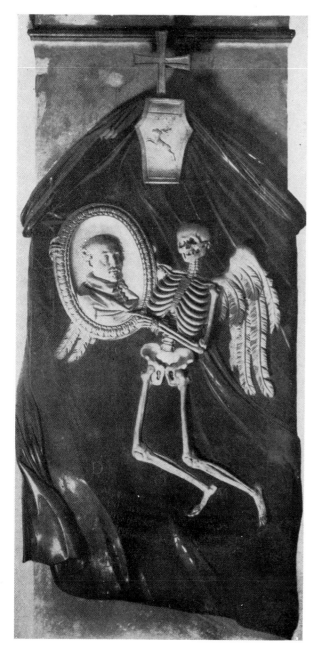

54. *TOMB OF ALESSANDRO VALTRINI.*
S. Lorenzo in Damaso, Rome (No. 43).

(Fig. 56, No. 5586, Brauer-Wittkower, pp. 151, 171), where the flying figure of Time—in an attitude close to the Merenda skeleton—is also shown holding a drapery; but here it is a curtain which Time draws to reveal in a mirror the decay of one's own beauty and youth: a different interpretation of Time unmasking Truth with a suggestion of Death thrown in. Bernini invented this not exactly flattering concept for a mirror for Queen

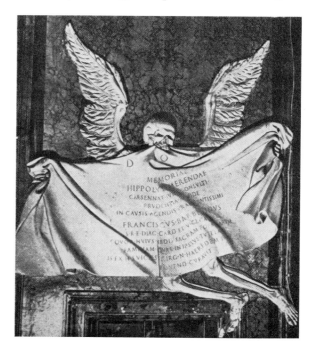

55. *MEMORIAL TO IPPOLITO MERENDA.*
S. Giacomo alla Lungarna, Rome (No. 43).

(No. 66), the Constantine (No. 73), and the bust of Clement X (No. 78a).

Following a long tradition (E. Panofsky, *Studies in Iconology*, 1939, p. 69ff.), Bernini conceived Death and Time as closely allied (see the bozzetto publ. by Mariani, *Boll. d'Arte*, 1930–1, p. 68; Brauer-Wittkower, p. 150f.): Time, the revealer of Truth, also brings about destruction and death. It is for this reason that Bernini returned to the motif of the Merenda skeleton when planning the Chronos (i.e. Time) of his *Veritas* group (No. 49).

Even more intimately related is a drawing at Windsor

Christina of Sweden, which was, in fact, executed in a slightly different form. A copy of the work by N. Tessin in Stockholm (Fig. 57; first published by R. Josephson, *Nicodemus Tessin d. y.*, Stockholm, 1930–1, i, fig. 40), inscribed 'Mirror in the room of Queen Christina. Invention of Bernini', shows that the drapery motif was given much greater prominence than in the preliminary drawing. For stylistic reasons the mirror cannot be dated before 1670. Jennifer Montagu put at my disposal a passage transcribed by her from Tessin's *Traité de la Décoration intérieure de maisons Royales* (1717, MS. in the Royal Library, Stockholm), in which Tessin mentions the mirror in a room of the *piano nobile* of the Queen's palace in Rome. Of extraordinarily large size, the mirror consisted of several pieces of glass and their joints were hidden by the drapery (a typical Berninesque device). He carries on that the large figure of Time lifting the curtain 'pour faire connoître la verité' was carved almost in the round and entirely gilded. In a similar design, also in Stockholm, the mirror rests on a stand formed by two Tritons; Time swinging a large scythe has unveiled a clock in addition to the mirror. This

56. *DESIGN OF A MIRROR FOR QUEEN
CHRISTINA OF SWEDEN.*
Royal Library, Windsor Castle (No. 43).

57. *COPY AFTER THE MIRROR FOR
QUEEN CHRISTINA OF SWEDEN.*
Nationalmuseum, Stockholm (No. 43).

project is derived from Bernini's mirror and not an
original by Bernini's hand as Josephson (*op. cit.*, fig. 39a)
believed.

***44. TOMB OF MARIA RAGGI.** S. Maria sopra
Minerva, on the sixth pillar of the left aisle, Rome
 PLATES 68, 70

Life-size relief portrait and putti, gilt bronze, before a
black marble drapery with yellow border.

In his catalogue Baldinucci lists 'la memoria di Suor
Maria Raggi alla Minerva' (p. 181). A preparatory
drawing (Brauer-Wittkower, pl. 153) confirms the
attribution. According to the inscription (Fraschetti, p.
85) the memorial was erected in 1643.

Here the new ideas of the Valtrini and Merenda memo-
rials (No. 43) were given their most accomplished
realization. The form of the Cross above the dark bronze
medallion is echoed in the arrangement of the black
marble shroud, the movement of which is accompanied
and accentuated by the two bronze putti. (Sheila Somers,
B.M., c, 1958, p. 288, noticed that the putto on the right
is closely modelled on the right-hand putto of Duques-
noy's Van den Eynde monument in S. Maria dell'Anima,
but the similarity may be incidental.) The sensitive
relief portrait of the nun represents her with both hands

pressed to her breast. Bernini chose a similar attitude for
the (destroyed) S. Francesca Romana (No. 45) and,
much later, for the Blessed Lodovica Albertoni (No. 76).
This is the first time that Bernini showed a medallion
portrait supported in mid-air by heavenly messengers,
—ultimately derived from the *imago clipeata* on Early
Christian sarcophagi (W. Messerer, in *Römische Quartal-
schrift*, lvii, 1962, p. 296)—and this conception of
materialized vision had infinite potentialities. Soon
after, he varied it innumerable times when faced with
the decoration of the pillars of St. Peter's (No. 47);
later he adapted the idea to his designs for altars (Figs. 93
and 113).

In contrast to the Valtrini and Merenda memorials, this
work was planned and executed with extreme care and
every detail shows the stamp of Bernini's genius. Never-
theless, the large models were probably carried out by
a studio hand, and one would be inclined to attribute
them to Antonio Raggi, if in 1643 he were not rather
too young (b. 1624). He definitely appears in Bernini's
orbit in 1647. His Bragadin monument in S. Marco
(*c.* 1658, Donati, figs. 363, 365) is a variation of that of
Maria Raggi.

A papier mâché version of the medallion is in the Palazzo
Venezia, Rome (A. Santangelo, *Museo di Palazzo
Venezia. Catalogo*, 1954, p. 92).

*See Addenda, pp. 273ff.

★45. S. FRANCESCA ROMANA. Formerly S. Francesca Romana (S. Maria Nuova), Rome FIG. 58

Gilt bronze relief (destroyed) inside a semi-circular screen of coloured marble.

In 1608 the Blessed Francesca Buggi de'Ponziani (d. 1440) was canonized (Fraschetti, p. 213f., Pastor, xii, p. 184f.). On 2 April 1638, her body was found in the church which now bears her name. It was immediately resolved to build 'a chapel or altar' over her tomb (17 April 1638, see also the inscription Forcella, i, p. 56, No. 134). The finished monument showed the saint full-length, kneeling in mystic contemplation, accompanied by her guardian angel. Both Baldinucci (p. 106) and Domenico Bernini (p. 93) claim the model for Bernini, but not the execution. This is correct, for documents (published by P. Lugano in *L'Urbe*, v, 1940, March, p. 7ff.) reveal that the work was executed between 1644

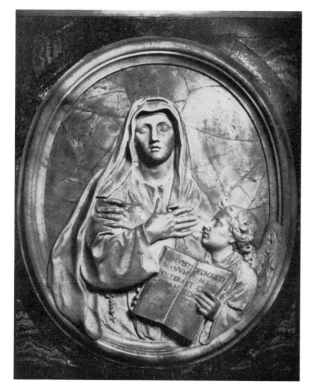

58. *S. FRANCESCA ROMANA.*
 By Ercole Ferrata. S. Francesca Romana, Rome (No. 45).

and 1649 by G. M. Fracchi (or Franchi) whom Bernini subsequently employed on the Four Rivers Fountain (No. 50). The sculptural decoration was paid for by Innocent X's sister, Agata Pamphili, a nun of the monastery of 'Tor de' Specchi', founded by S. Francesca Romana (*Roma antica e moderna*, 1765, ii, p. 387 and Forcella, ii, p. 14, no. 50). At the beginning of May 1649 the saint's body was transferred to the finished tomb. Bernini was amongst those present (Gigli's diary, BV, Vat. 8717, p. 368f.).

★See Addenda, pp. 273ff.

The figures were destroyed in 1798 and only the architectural screen survives. An eighteenth-century engraving (*Disegni di vari altari e cappelle*, pl. 29, see Muñoz, *Arte*, xx, 1917, p. 192) gives an idea of the monument. The present group, set up in 1869, follows roughly the arrangement of the original. Ferrata's marble relief in the crypt (Fig. 58) is derived from Bernini's work.

★46. RAIMONDI CHAPEL. S. Pietro in Montorio, Rome FIGS. 59–61

The source material for the Raimondi Chapel is rather scanty. Baldinucci (p. 180) lists it under 'mixed and architectural works' and according to Passeri (Hess, p. 334), the Marchese Raimondi from Savona commissioned the work from Bernini in the last years of the reign of Urban VIII. There are no inscriptions in the chapel, but F. M. de Raymondi (*Roma*, i, 1923, p. 37ff.) found that one of the tombs (left wall) was erected for Monsignor Francesco (d. 1638), the other (right wall) for Monsignor Girolamo Raimondi (d. 1628). In 1648 the body of the latter was transferred to the chapel. By combining these dates, one is led to date the chapel between 1638 and 1648 (see also Brauer-Wittkower, p. 34).

From other evidence, this period can be narrowed down. Three artists were responsible for the sculptural

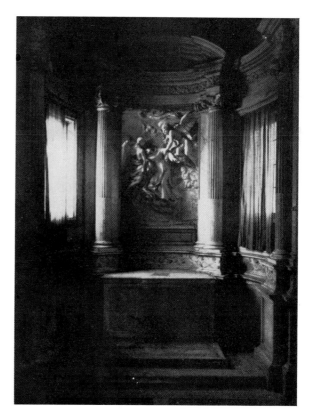

59. *VIEW OF THE ALTAR.*
 Raimondi Chapel, S. Pietro in Montorio, Rome (No. 46).

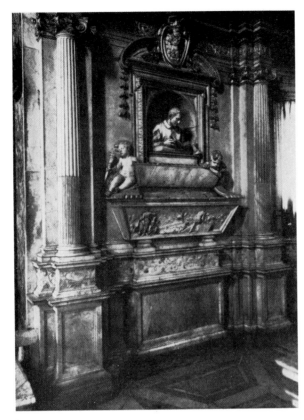

60. *THE LEFT-HAND TOMB.*
Raimondi Chapel, S. Pietro in Mentorio, Rome (No. 46).

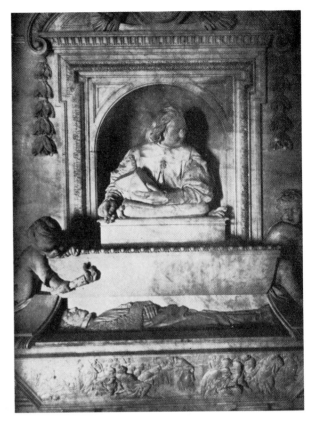

61. *THE RIGHT-HAND TOMB.*
Raimondi Chapel, S. Pietro in Montorio, Rome (No. 46).

decoration: Andrea Bolgi for the busts and putti, Niccolò Sale for the reliefs on the sarcophagi (Domenico Bernini, p. 112) and Francesco Baratta for the relief over the altar (Passeri-Hess, p. 334). None of these artists was available after 1646, Bolgi not before 1639, Sale not before 1642. About Baratta we know too little: this relief seems to have been his first major work. Execution, therefore, was probably between 1642 and 1646. (For Bolgi's contribution, see A. Nava Cellini, in *Paragone*, xiii, 1962, No. 147, p. 33, who dates Bolgi's busts between 1645 and 1648; see also Martinelli, in *Commentari*, x, 1959, p. 150f.). But Bernini's design may date from the end of the 1630's, for a number of features are connected with works of those years: the aedicula of the altar with those of the loggias under the dome of St. Peter's (No. 29), the vault above the altar with the niche of Urban VIII's tomb, the trapezoid reliefs of the sarcophagi with that of the Matilda tomb, etc. Moreover, up to the cornice the chapel is of white marble; it shows the comparatively classicizing tendencies of these years.

The chapel is dedicated to St. Francis, and his ecstasy is represented in Baratta's relief. (For the iconography see Mâle, *L'art religieux*, p. 177f.) Under the columns runs a beautiful emblematic frieze of roses and burning hearts, probably executed by Bolgi.

Two points are worthy of note: (i) this chapel is the first large unit designed by Bernini in which sculpture and architecture are entirely co-ordinated, (ii) Bernini introduced here for the first time a concealed window (on the left side) which throws a beam of light on the altar, a device which he used thereafter, whenever possible. Further to this problem, p. 33f.

The idea of showing on the same tomb the deceased both 'alive' and 'dead' was French in origin and such tombs are common in France from the late Middle Ages onwards. Perhaps the Frenchman Sale suggested this type of tomb. But its ingenious transformation into a baroque *concetto*—the raised lids of the sarcophagi permit a sight of the outstretched 'bodies' inside, illuminated and inspected by putti—can only be due to Bernini himself.

The quality of the figures is uneven and none of them seems to have been worked over by Bernini. Apart from a studio drawing (Brauer-Wittkower, pl. 152b) and the bozzetto for Sale's relief of the 'Last Judgment' (probably more correctly an illustration of Ezechiel 37, 4ff.) on the left-hand sarcophagus (sacristy, S. Maria in Trastevere, Brinckmann, *BB.*, ii, pl. 15) no preparatory work survives. The rather brilliant bozzetto seems somewhat too fussy for Bernini. It was probably worked by the assistant (Sale?) from Bernini's design and corrected by him.

The relief opposite, which has not been satisfactorily explained, shows three scenes: left, bacchantes dancing

near a herma of Pan (carnival?); centre, the markation of the cross on Ash Wednesday (on which occasion the priest says: 'Memento, homo, quia pulvis es, et in pulvem reverteris'); right, death of a young man. The relief therefore would represent 'Carnival, Lent and Death'. The theme is exceedingly rare, if not unique, in Italy. In the North 'The Battle between Carnival and Lent' had a long tradition (H. Swarzenski, in *Bull. of the Boston Mus. of Fine Arts*, xlix, 1951, p. 2ff.). The left scene of the relief seems to be derived from Poussin's 'Dance of Human Life' (then in the Palazzo Rospigliosi, Rome) dating from the late 1630's (D. Mahon, *Poussiniana*, Paris-London, 1962, p. 106). If this relation is correct, it would supply another date *post quem* for the execution of the Raimondi Chapel.

★47. DECORATION OF CHAPELS AND NAVE OF ST. PETER'S FIG. 62

Gregory XIII (1572–85) had begun the marble incrusta-tion of the small order of pilasters, and his successors continued the work in choir, transept and adjoining chapels. When Innocent X ascended the papal throne (1644), the pilasters under the arches dividing Maderno's nave from the chapels, as well as those in the chapels themselves, had not yet been so decorated. In 1645 the Pope charged Bernini with this work (its story, on the basis of documents, in Brauer-Wittkower, p. 43ff.).

Bernini introduced a new system of decoration. Instead of the older flat incrustation, he designed three-dimensional sculpture, and replaced static geometrical patterns with a dynamic up-surging movement. Each pilaster decoration consists of two pairs of putti, carrying oval medallions with papal portraits and framing a third pair with tiara and keys or book and sword. These vigorously active sculptures in white marble are set against a polychrome ground. The series of papal portraits, thirty-eight in all, representing the martyrs from St. Peter to

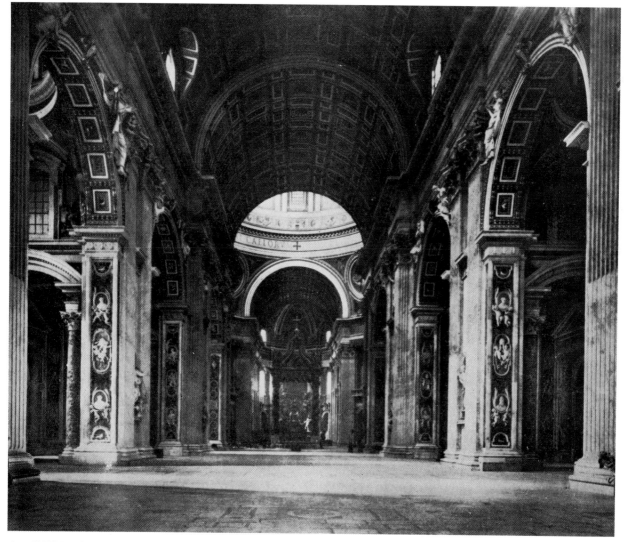

62. *INTERIOR OF ST. PETER'S*. Rome (No. 47).

★See Addenda, pp. 273ff.

Benedict I, takes up the tradition of Early Christian cycles.

In October 1645 the Congregation of St. Peter's inspected Bernini's designs. To assist in the judging Guidobaldo Abbatini painted two alternative full-scale models in January 1646. Between 1647 and the end of 1648 this tremendous enterprise was carried out by a veritable army of masons and sculptors, thirty-nine in all. Among them appear all the well-known names of the Bernini studio—Giacomo Balsimello, Matteo Bonarelli, Francesco Baratta and Niccolò Sale; further, the more distinguished of the rising generation of sculptors such as Bolgi, Ferrata, Raggi, Cosimo and Jacopo Antonio Fancelli, Girolamo Lucenti, Lazzaro Morelli, Giuseppe Peroni, and even men of the older generation. Bernini seems to have pressed into his service every available sculptor. It was the first time that he had used help on this scale. Only one original sketch for a pair of putti exists (Brauer-Wittkower, pl. 19c), probably a chance survival of many similar preparatory sketches for the other pilasters. If the overall impression of these decorations is not wholly satisfactory, it is due at least partly to the fact that they had to be harmonized with the already existing decoration.

Above the third arch of both aisles should be mentioned Luigi Bernini's *Fame*, with the coat of arms of Innocent X, for which he received payment between October 1649 and November 1651 (BV, cod. Chig. H.II.22, f. 271v.).

In the spandrels above the arches of the nave are gigantic stucco allegories of Christian virtues executed by Bolgi, Lazzaro Morelli, the two Fancellis and lesser known sculptors (Chattard, *Nuova descrizione del Vaticano*, Rome, 1762, i, p. 131ff.). Payments (AFM, 42) permit most of these figures to be dated in 1647. (Only the figures above the first three arches of each wall belong to this period.) Although supervised by Bernini, they show less of his manner than any other work of this kind.

*48. CORNARO CHAPEL. Left transept, S. Maria della Vittoria, Rome

PLATES 71–5, FIGS. VI, 63–67

Life-size marble of St. Teresa and an angel, and reliefs of eight members of the Cornaro family behind prie-dieus.

The Venetian Cardinal Federigo Cornaro settled in Rome in 1644, where he died in 1653. Soon after his arrival in Rome, he commissioned Bernini to transform the left transept of S. Maria della Vittoria into a sepulchral chapel for himself and his family. F. Travani's medal of 1647 (Mazzuchelli, *Mus. Mazz.*, 1763, ii, pl. 110, viii) was cast, it seems, to commemorate the completion of the architecture. (See also the inscription of 1647, formerly in the floor of the chapel, removed

*See Addenda, pp. 273ff.

63. *DESIGN PROBABLY FOR THE TOMB OF DOGE GIOVANNI CORNARO.*
Sir Anthony Blunt Collection, London (No. 48).

in 1853, printed by Muñoz, *Rassegna d'Arte*, xvi, 1916, p. 218, note). The chapel was not finished until the summer of 1652 (BV, cod. Ottob. lat. 2458, see *Roma*, xvi, 1938, p. 528) but had already been opened in 1651 (*Roma antica e moderna*, 1653, p. 385.)

S. Maria della Vittoria was a Carmelite church, and representations of the visions of St. Teresa, the founder of the Discalced Carmelite Order, appear frequently after her canonization in 1622 in all the churches of the Order. In choosing here to represent the supreme moment of Teresa's visions, her 'transverberation' (the piercing of her heart by the arrow of Divine Love), Bernini—like other artists—was following the highest authority, since it was this ecstatic vision that was specially singled out in her Bull of canonization (Mâle, pp. 100, 163).

A preliminary stage of the Teresa group can be reconstructed from drawings (Brauer-Wittkower, p. 36f.). A damaged bozzetto of the whole group in the Hermitage, Leningrad (47 × 42 cm.) was recently published by G. Matzulevitsch (*Boll. d'Arte*, xlviii, 1963, p. 69ff., figs. 1, 2) as an original. Since I have not seen this bozzetto, I must reserve judgement. Wrongly attributed

to Bernini: the bozzetto of the group in the Palazzo Venezia, Rome (A. Santangelo, *Catalogo*, 1954, p. 90); the drawing published by J. Meder (*H. Egger Festschrift*, Graz, 1933, p. 76ff.); and a pen and ink sketch over black chalk from the collection of Count Algarotti (23·4 × 15·5 cm.) that has come to my knowledge.

The well-informed Domenico Bernini (p. 83) stresses that only the Teresa group is by Bernini's hand, while Baldinucci (p. 178) also attributes to him 'the last Cardinal Cornaro'. This tradition may contain a grain of truth. Seven of the eight figures behind the 'balconies' represent cardinals, six of them having lived in the sixteenth century (Bruhns, 339). 'The last Cardinal Cornaro', Federigo, the builder of the chapel, is the second figure on the right-hand side, whose striking individualized features with strong cheekbones and prominent nose catch the beholder's eye (identification by L. Casanova, *Boll. dei Musei Civici Veneziani*, 1958, 2, p. 13f.). It is not impossible that Bernini had a hand in this portrait from life but it does not come up to the quality of his original creations. All the other portraits are generalized and idealized and are shown with blank eyeballs, in contrast to Cardinal Federigo whose incised pupils and irises are, however, too mechanical for Bernini himself. The portraits on the left-hand side may well be by Ercole Ferrata, those on the right-hand side are perhaps by a different hand (see the more angular treatment of folds as well as other differences). The only secular personality is Federigo's father, the Doge Giovanni, who appears in the farthest corner on the left. Uncomfortably squeezed into a corner, the head looks like an afterthought. But it was not an unpremeditated addition of the last hour, for it appears in a different position in the brilliant, rapidly executed, bozzetto in the Fogg Art Museum (Fig. 64).

The painting of the vault showing angels adoring the Holy Dove is by Guidobaldo Abbatini, whom Bernini

regularly employed on similar jobs. The two inlaid wildly gesticulating skeletons of the floor (to which Weibel, pp. 39, 66, etc., first drew attention) are magnificent plastic conceptions translated into a two-dimensional medium (Figs. 66–67). Bernini returned to this idea in the Cappella Chigi (No. 58), another sepulchral chapel. The sculptured figure of Death as an actively participating agent, first devised for the tomb of Urban VIII about 1639 (No. 30; see also No. 24-c), appears soon after in the Valtrini and Merenda tombs (No. 43) and, much later, on the tomb of Alexander VII (No. 77). The relief of the Last Supper under the mensa is not by Bernini (Battaglia, p. 102, note 1).

The literature about the Cornaro Chapel is vast. Bibliographical hints in Bruhns, p. 338.

On a later occasion Francesco Cornaro, Cardinal Federigo's brother, seems to have intended to erect a monument to his father, the Doge Giovanni Cornaro, in the family chapel in S. Nicolò da Tolentino, Venice, from Bernini's design. A large pen and brush drawing (41·6 × 29·5 cm.) by Bernini in the Sir Anthony Blunt Collection, London (to be discussed by him in a forthcoming volume of essays prepared for the 65th birthday of the present writer) appears to be the only record of the project (Fig. 62), which was not executed. The Doge Giovanni Cornaro had died in 1630, but the tomb was probably not planned until after the completion of the Cornaro Chapel in S. Maria della Vittoria. The conception of the tomb is strikingly similar to the Pimentel

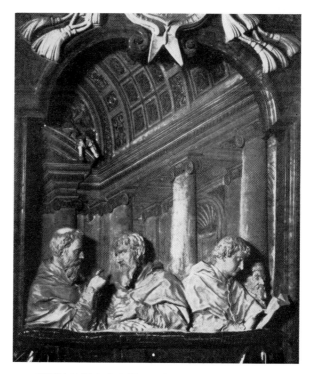

64. *MEMBERS OF THE CORNARO FAMILY.*
Bozzetto. Fogg Museum of Art, Cambridge, Mass. (No. 48).

65. *MEMBERS OF THE CORNARO FAMILY.*
Cornaro Chapel, left wall (No. 48).

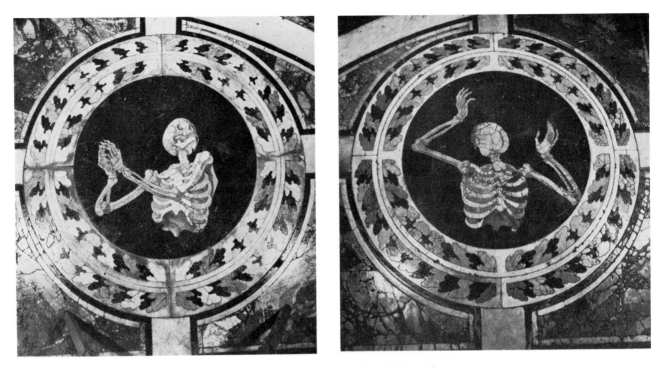

66–67. *INLAID MARBLE SKELETONS.* Floor of the Cornaro Chapel (No. 48).

tomb of 1653 (No. 56), translated, however, into a two-storey structure jutting out far into the chapel. It is tempting to assume that Bernini wanted to accomplish in the Giovanni Cornaro tomb what space restrictions had prevented him from carrying out in the Pimentel tomb. The allegories of Charity and Justice closely resemble those of the Pimentel (see, above all, the putto with the fasces), while the 'neutral' profile of the kneeling Cardinal, unavoidable in the narrow passage, was turned into the frontal pose of the Doge in keeping with Bernini's desire, observable from his earliest works onwards, of establishing contact between the work and the beholder. Much later, in the project of Alexander VII's tomb for S. Maria Maggiore (see No. 77) Bernini reverted to the Giovanni Cornaro design (see Brauer-Wittkower, pl. 129). Moreover, in the execution of Alexander VII's tomb in St. Peter's he used again the entrance to the tomb-chamber, the skeleton with raised hour-glass and the frontal figure of the deceased in prayer, but brought these elements of the design into a telling dramatic relationship. Many other features of the drawing link up with various projects by Bernini. Thus the tuba-blowing winged *Fame* holding the coat of arms recur in the 1660's and 1670's (Scala Regia, 1663, B.-W., p. 165b; Beaufort catafalque, 1669, B.-W. pl. 121; Alexander VII tomb design, 1672, B.-W., pl. 183). It seems likely that the Giovanni Cornaro tomb project dates between 1653 and 1656 (after the Pimentel and before Francesco Cornaro's death).

*See Addenda, pp. 273ff.

***49. TRUTH UNVEILED.** Galleria Borghese, Rome

PLATES 76, 77

Over life-size marble figure. H. 2·80 m.

On 23 February 1646, the Congregation of St. Peter's decided to pull down Bernini's tower (Brauer-Wittkower, p. 37ff.). The concerted attacks on him, culminating in the demolition, were the only frustrating experience of his brilliant career.

Domenico Bernini's report (p. 80f.) makes it evident that, as a result, the artist wished to vent his feelings. It should be remembered that in the seventeenth century such expression always took the form of a conventional allegory. Bernini chose to carve a huge marble group showing Time unveiling Truth. A letter by G. Poggi to Duke Francis I of Modena, dated 30 November 1652 (Fraschetti, p. 172), indicates that the Truth was then almost finished, whereas the Time had not yet been begun. The untouched block for this figure was still in the house after Bernini's death (Baldinucci, p. 106). The finished portion of the group—the figure of Truth—can confidently be dated 1646–52 (Brauer-Wittkower, p. 45). In Paris Bernini mentioned (Chantelou, p. 116) that his model of the group showed 'columns, obelisks and mausoleums and these, ruined and destroyed by Time, serve to support him (i.e. Father Time) in the air'. (For Bernini's description, see I. Lavin, in *Art Bull.*, xxxviii, 1956, p. 259). Bernini therefore wanted to combine in the group the two traditional concepts of Time, the

revealer of Truth and the relentless destroyer (see No. 43). The *Vanitas* theme, always so much on his mind, would have been given prominence in this personal allegory, when completed. (For the Christian connotations of Bernini's interpretation of Truth see F. Saxl in *Philosophy and History*. Essays presented to Ernst Cassirer, Oxford, 1936, p. 216f.)

The development of Bernini's thought has been reconstructed on the basis of preparatory drawings in Brauer-Wittkower, p. 45f. Time with his scythe would have flown in from the right gripping the lifted drapery, and Truth, with an expression of unearthly happiness, would have appeared welcoming her liberator to whom she raises her symbol, the sun.

Bernini left the figure as an inalienable possession to his family not only as a token of his work, but also to remind his descendants, as he said in his will, that Truth is the greatest virtue on earth. Until 1924 the figure stood in the Palazzo Bernini.

The bozzetto of a head, related by Brinckmann (BB., ii, pl. 24) to that of the Truth is for the St. Barbara at Rieti (No. 60). None of the three other bozzetti, which have been published as originals, is by Bernini; (i) Vatican (formerly Palazzo Chigi): copy, (ii) Louvre (Mucchi in *Nuova Antologia*, 1911, p. 286, and Vitry, *G.d.B.A.*, v, 1922, p. 22ff. and *Mélanges Bertaux*, 1924, p. 339ff.): copy, (iii) Museum, Schwerin (Steinmann, *Münchner Jahrb.*, II, ii, 1907, p. 39, Brinckmann, BB., i, pl. 39): later derivation. The relation of a bronze Chronos at Dresden (Grünes Gewölbe) to the figure of Time in the Veritas group, maintained by W. Holzhausen (*Jahrb. der Preuss. Kunstslg.*, lx, 1939, p. 177), is without foundation. But the work is Berninesque and may well be, as Holzhausen suggests, a cast after a terracotta model made in Bernini's studio. A marble replica (37·5 cm.) is in the Palazzo Diamanti, Ferrara.

For further bibliographical references, see Faldi, *Galleria Borghese*, 1954, p. 39ff., No. 37.

*50. FOUNTAIN OF THE FOUR RIVERS.
Piazza Navona, Rome PLATES 78–82, FIG. VIII

Rock, animals and vegetation: travertine. The four giant figures and the coat of arms: marble.

Rich historical and illustrative material makes it possible to reconstruct the character of the Piazza Navona before the Pontificate of Innocent X (L. de Gregori, *Piazza Navona prima d'Innocenzo X*, Rome, 1926). The erection of the Four Rivers Fountain under Innocent X set the seal to one of the most sweeping and extravagant baroque transformations of an urban site. Large quantities of water were needed, and as early as 1635 Innocent planned to conduct the waters of the Acqua Vergine to the Piazza Navona (BV, cod. Capp. 63, f. 285). On 11 April 1647 the Pope seemed determined to work with

Borromini. A few days later, the obelisk lying in several pieces in the Campagna near the monument of Cecilia Metella was inspected by the Pope (Fraschetti, p. 180). He decided to have it erected in the centre of Piazza Navona. Somehow Bernini succeeded in supplanting Borromini (Baldinucci, p. 102; Fraschetti, p. 180, note 2; Brauer-Wittkower, p. 48), and on 10 July 1648 Bernini's design was officially approved (papal chirograph; verbal transcript in D'Onofrio, *Fontane*, 1957, p. 204). Immediately work on the foundations was begun. From then on the story of the fountain can be followed in detail (documents in Fraschetti, p. 181ff., supplemented mainly by cod. Corsini, 31-B-14 and 15).

In June and July 1648 the obelisk was transported to Piazza Navona, but it was not erected until August 1649. Between July 1648 and January 1649 the travertine from Tivoli was paid for. It took a considerable time to finish the elaborate rock formations enlivened with animal and plant life, worked *in situ* by G. M. Fracchi (December 1649–July 1651) straight out of the travertine blocks. Payments for the four Rivers run from February 1650 to July 1651: Danube (with arms raised) by Raggi, Nile (head hidden under cloth) by Jacopo Antonio Fancelli, Ganges (with oar) by Claude Poussin (not by Claude Adam as is always maintained), and River Plate (moor) by Francesco Baratta. Each sculptor received 750 scudi. Between August 1649 and March 1650 N. Sale was paid for the marble coat of arms and the models of dove, lilies, etc. On 9 June 1651 Abbatini was paid for colouring rock, palm tree and plants. A. Cassio (*Corso dell'Acqua*, 1756, p. 299), who prints the inscriptions after Kircher (*Obeliscus Pamphilius*, 1650), maintains that they were never placed. However, M. A. Inverno was paid on 10 June 1651 for gilding them. They were, as early engravings show, on the block projecting from the pedestal of the obelisk, and, though faded, can still be detected. (D'Onofrio, *op. cit.*, p. 211ff., published an appendix of documents which do not add to the above material.)

The fountain was unveiled on 14 June 1651. Bernini received 3,000 scudi. The entire cost was more than 29,000 scudi of which the sculptors and stonemasons received less than 10,000.

According to an old tradition, doubted in recent literature, but supported by Baldinucci (p. 104) and Domenico Bernini (p. 89), Bernini himself executed the rock, palm tree, lion and horse. The old authorities were probably correct. In a meeting of the Congregation of St. Peter's on 17 March 1657 it was explicitly stated that Bernini executed 'with his own hands the horse and other things' (BV, cod. Chig. H.II.22, f. 136v). Of course, he only touched up what the stonemason Fracchi had prepared.

For the genesis of Bernini's ideas and preparatory drawings see Brauer-Wittkower, p. 47ff. The drawing in the

*See Addenda, pp. 273ff.

Lanciani Collection, Biblioteca di Archeologia e Storia dell'Arte, Rome, published for the first time by D'Onofrio (p. 205, fig. 178) is not a copy after an early project by Bernini as the author tries to prove; it is so obviously a later *pasticcio*, combining elements from the Windsor drawing Brauer-Wittkower, pl. 27, with those from the Fontana delle Tartarughe, that no further discussion is necessary (similar adaptations of Berninesque ideas are common among the Tessin drawings in Stockholm; see also the volume of the Stadtbibliothek, Leipzig [Art. fol. 104] with no less than forty-six Berninesque fountain drawings of the late seventeenth century). Two nude studies published by Martinelli in *Commentari*, i, 1950, figs. 184, 191 may be connected with the river-gods. An important early bozzetto for the whole fountain is in the Giocondi Collection, Rome (Fraschetti, p. 206, Brinckmann, BB., ii, pls. 17, 18). Bozzetti for Nile and River Plate are in the Cà d'Oro, Venice (Brinckmann, BB., pls. 19-23). For the enormous excitement created by the fountain see F. Cancellieri, *Il Mercato*, Rome, 1811, p. 46ff., and Fraschetti, p. 198ff. A useful collection of material in E. Gerlini, *Piazza Navona, Catalogo*, Rome, 1943, p. 98ff. (D'Onofrio's chapter, pp. 201-12, while lacking new information, contains a strangely insensitive criticism of the fountain). Further to the iconographical problem, discussed on p. 30, see H. Kauffmann, 'Romgedanken', 1953-4, p. 68ff. and Norbert Huse, *Gianlorenzo Berninis Vierströmebrunnen*, 1965 (unpublished Munich dissertation). Huse also gives in extenso the earliest descriptions of Bernini's model and executed fountain, published in Michelangelo Lualdi, *Istoria Ecclesiastica*, Rome, 1650, 1651, vols. i and ii, and makes it likely that Lualdi acted as an iconographic counsellor to Bernini.

A copy of the fountain in small dimensions is in the garden at Blenheim. It arrived in London in 1710, having been sent from Rome as a present to the Duke of Marlborough, and has ever since been wrongly regarded as an authentic work. A small version of the fountain was in the collection of the Marchese del Carpio in Naples (Haskell, *Patrons*, 1963, p. 191, note 2). Another copy in marble and bronze was made by Francesco Righetti in 1806; its present whereabouts is unknown.

51. BUSTS OF POPE INNOCENT X. Palazzo Doria-Pamphili, Rome PLATE 83, FIGS. 68-70

Baldinucci (p. 177) and Domenico Bernini (p. 93) report that a marble bust of Innocent X was in Bernini's house. They disagree, however, about the number of busts in the Palazzo Pamphili, the Pope's family palace. Baldinucci mentions there only one marble bust, Domenico talks of several busts without specifying their number or material.

In the Palazzo Doria-Pamphili there are now no fewer than five busts of the Pope. Since they present a considerable problem they will be discussed together.

(1) Terracotta, painted red and partly gilt, over life-size (Gab. Fot. Naz. E 9257).
(2) Marble (Fig. 68).
(2a) Marble (pl. 83).
(3) Marble (Anderson 3011; A. Nava Cellini, in *Paragone*, xv, 1964, No. 177, pl. 27).
(4) Bronze (Fraschetti, p. 209; Cellini, pl. 28).
(5) Bronze with porphyry chest (Fig. 69 and Alinari 29778).—For No. (6) see below.

Of these busts, (1), (2) and (2a) are in a category of their own. No. (1), with the papal mantle deeply grooved and in violent movement, is of inferior quality and probably of later date; in (2) and (2a) the Pope looks firmly ahead, the body has breadth and a lively silhouette and the Pope appears more energetic than in the busts (3) to (5). Nos. (3), (4) and (5) belong fairly close together. In all three busts the Pope is represented in pensive mood, bending forward and looking down. In (3) the head is turned slightly to the right; in (4) and (5) slightly to the left. The marble (3) is the most restrained of all the busts. The head of the bronze (4) is so close to that of the marble (3) that the same model may have been used for both. In spite of its superficial similarity to (3) and (4), the bronze-porphyry bust (5) is a separate creation.

While before the appearance of the first edition of this book the marbles (2) and (2a) were unknown, one or the other of (1), (3) to (5) was ascribed to Bernini at random (see, e.g. Martinelli, *Bernini*, 1953, p. 103, who revised his opinion in 1955). It was usually overlooked that the well-informed Bellori (*Vite*, first ed., p. 398) talks of portraits of the Pope in marble and bronze by Algardi in the Palazzo Pamphili. The question, therefore, arises which of the busts are Algardi's and which Bernini's? This question was first clearly posed in my first edition, but Riccoboni (p. 178) and A. de Rinaldis (*L'arte in Roma*, 1948, p. 207) attributed (1), (3) and (4) to Algardi, and Eleanor Barton (*A preliminary Study of Alessandro Algardi*, Harvard Ph.D. thesis, 1952, p. 202, unpublished) strongly advocated Algardi's authorship for the busts (3) and (5).

Of all these busts only (2) and (2a) can be attributed to Bernini. They show the vitality, spirit and handling of his work. (The 'filigree' beard, characteristic of his treatment of hair, is unfortunately mutilated in both busts). It is evident that (3) and (4) are by a different hand. Not only the 'low' key in which the busts are given, but also definite idiosyncrasies make Algardi's authorship certain (see, above all, the angular cut of the busts, the chiselling of the eyes and the form of the iris— exactly corresponding to Algardi's busts of Panfilo and Olimpia Pamphili and never to be met with in Bernini's

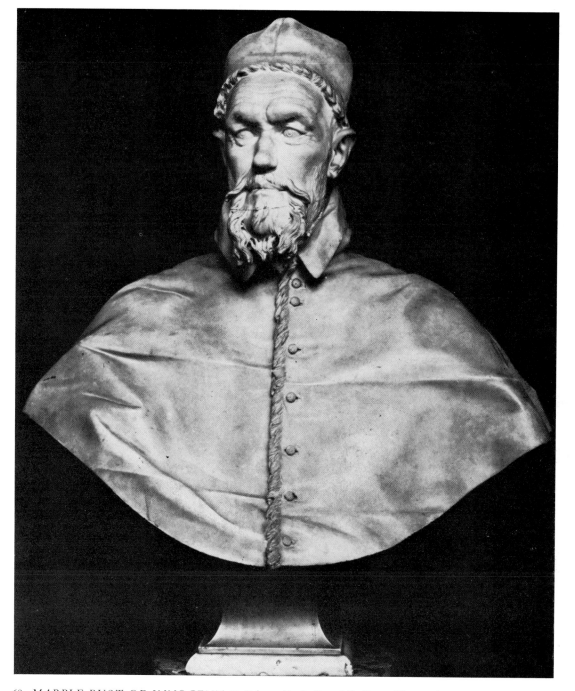

68. *MARBLE BUST OF INNOCENT X*. Palazzo Doria-Pamphili, Rome (No. 51-2).

busts). Bust (5), probably of slightly later date (after 1650), represents a somewhat different case. Here the relation of the head to the bust and the curved lower edge are characteristic of Bernini rather than Algardi. But it was Algardi who took a leaf out of Bernini's book. The comparison of the bust with the head of his memorial statue of Innocent X (Figs. 69–70) allows no doubt as to Algardi's authorship.

I. Faldi added to these busts by Algardi a terracotta in the Palazzo Giustiniani Odescalchi at Bassano di Sutri

(*La scultura barocca*, 1958, p. 113f., pl. 30). It clearly takes its place between the earlier busts (3, 4) and the later bust (5) (see also A. Nava Cellini, *op. cit.*, p. 21). Recently (1964) Nava Cellini summarized the question of Algardi's busts of Innocent X (*op. cit.*, p. 15ff.). She dates, probably correctly, bust (3) 1646, i.e. before Bernini's first bust. The bronze (4) is definitely assured as Algardi's by an inventory of 1666 (*op. cit.*, p. 32, n. 4).

In 1955 only one Bernini bust (2a) was known to me; I identified it with that mentioned by Baldinucci in the

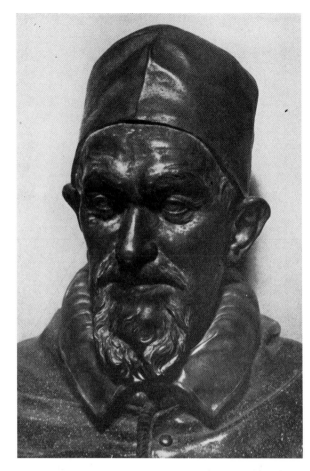

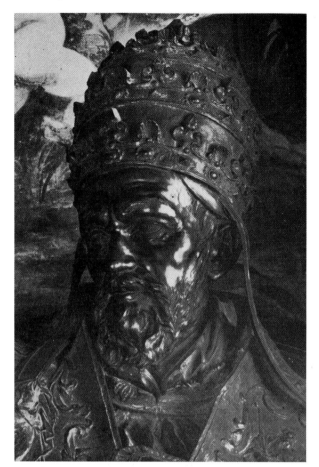

69. *POPE INNOCENT X*. Detail of bust by Algardi.
Palazzo Doria-Pamphili, Rome (No. 51-5).

70. *POPE INNOCENT X*. Detail of Algardi's bronze
memorial statue. Palazzo dei Conservatori, Rome (No. 51)

palace. Later, Italo Faldi discovered the second bust (2) in the Palazzo Doria-Pamphili a Piazza Navona (*Paragone*, vi, 1955, No. 71, pp. 47–52). Both busts are now in the Galleria Doria, where they can conveniently be compared. They are very similar, but not identical. Bust (2) has a break going through the lower jaws and the chin, and it is likely that this mishap made a repetition necessary. It is a fair assumption that the spoilt bust remained in Bernini's house where it was seen by Baldinucci. It was left by Bernini to his 'protettore cordialissimo' (Baldinucci), Cardinal Decio Azzolino, and, according to Faldi, transferred to the Palazzo Doria-Pamphili not until the nineteenth century. The two busts have almost the same height (78 cm.). In (2), bust and pedestal (15 cm.) are of one piece, in (2a) the pedestal is added. The case of these busts is reminiscent of that of the two Scipione Borghese busts (No. 31). Once again Bernini used the first bust (2) as model for its substitute (2a). But owing to pressure of other work some time seems to have passed between the first and second version: he freely incorporated changes, so that the second bust has the character of a new creation.

Above all, the Pope appears slightly older and the more dynamic folds on the left-hand side of the mozzetta are closer in conception to the bust of Francis I (No. 54). The dates suggested by Faldi, *c.* 1647 for bust (2) and *c.* 1650 for (2a) would seem entirely acceptable. It is not unexpected that the substitute bust appears somewhat bland (observed by I. Lavin, in *Art Bull.*, xxxviii, 1956, p. 259) compared with the more vigorous first version, but its authenticity cannot be questioned.

The busts of Innocent X in the Victoria and Albert Museum (Pope-Hennessy, *Catalogue*, 1964, p. 625f., No. 660), the Cleveland Museum of Art (H. H. Hawley in *Bull. of the Cleveland Mus. of Art*, il, 1962, p. 80ff.), the Metropolitan Museum and the Morgan Collection (Bode, *Coll. Morgan. Bronzes*, 1910, ii, No. 164, pl. 113) are later casts from the same Algardi model that was also used (with a different head) for the bust of Alexander VII in Vienna (No. 65). The bust in the Museum at Ravenna, published by C. Ricci as Bernini (*Racc. art. di Ravenna*, 1905, fig. 122) is evidently a work of the Algardi studio and is similar in handling to the bust of the Museo Civico at Bologna.

52. 'NOLI ME TANGERE.' First chapel right, SS. Domenico e Sisto, Rome · FIG. 71

Life-size marble statues of Christ and Magdalen; angel and putti, stucco.

The chapel was begun in 1649 with money provided by Sister Maria Alaleona (*Chronique du Monastère de San Sisto . . .*, 1920, ii, p. 202). Fraschetti's date 1641 (p. 440) as well as Guidi's date 1657 (*Roma*, v, 1927, p. 485) have therefore to be revised. Maria Alaleona may have chosen the subject in order to atone for the sins, long past, of a nun in the same family, whose sinister love affair in 1636 is reported by the diarist Gigli (Fraschetti, p. 90).

Bernini supervised the execution by Antonio Raggi (Pascoli, i, p. 249 and *Chronique*) and supplied the design (Baldinucci, p. 180 and Titi, 1674, p. 312). This survives in the large wash drawing of the Uffizi (probably by a studio hand, see Brauer-Wittkower, p. 36). A classici-

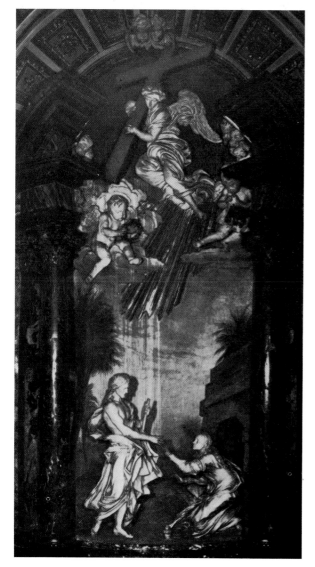

71. *'NOLI ME TANGERE.'*
SS. Domenico e Sisto, Rome (No. 52).

zing terracotta (44 cm.) in the Palazzo Venezia, Rome, has been published as a bozzetto by Raggi for the group (A. Santangelo, *Catalogo*, 1954, p. 88, fig. 99; accepted by Martinelli, in *Il Seicento Europeo. Mostra*, Rome, 1956–7, p. 274, No. 362). But it is neither closely connected with Bernini's design nor with Raggi's well known Baroque manner. An eighteenth-century date would seem more appropriate.

The group of Christ and the Magdalen differs in details from the Uffizi drawing. Its lyrical and Correggiesque quality seems to be due to Raggi rather than Bernini. The arrangement of the two figures, in particular that of Christ, is closely related to the reliefs of the 'Pasce Oves Meas' inside the portico of St. Peter's (No. 34) and on the Cathedra (No. 61–7). But the comparisons also show that the style of these figures is nearer to the Cathedra than to the relief of the portico: the sharply broken folds of Christ's drapery are characteristic of Bernini's style, *c.* 1650.

In the execution the number of putti and angels shown in the Uffizi drawing was much reduced; the large (stucco) angel with the Cross now predominates. The size of the principal group, compared with the drawing, was also considerably diminished; it appears too small in relation to the framing aedicula and to the stucco putti above. Possibly the donation (3,000 scudi) did not allow for a larger marble group.

The architecture of the altar—a simplified version of that of St. Teresa—corresponds essentially to the drawing. But the background to the group, planned as a simple marble or alabaster slab (similar to the S. Teresa altar), was not executed and was later filled in with a painted landscape. As de Rossi's engraving shows (*Disegni di vari altari e cappelle . . .*, s.a., pl. 20) such a background existed at the beginning of the eighteenth century. It is this painted background that gives the group the appearance of a tableau vivant—an unpardonable distortion of Bernini's intentions. When N. Tessin copied the altar in 1688 the painted background was much simpler (Sirén, 1914, pl. 83).

53. VIRGIN AND CHILD. St. Joseph des Carmes, Paris · FIG. 72

Over-life-size marble group.

In his Paris diary, Chantelou mentions the design of this work as Bernini's, implying that the execution was by another hand (28 July and 11 August 1665). According to tradition (Reymond, *G.d.B.A.*, vi, 1911, p. 308) the group was ordered by Cardinal Antonio Barberini, who had fled to France in 1646, became Bishop of Poitiers in 1652, Archbishop of Reims in 1657 and died in 1671 (Cardella, *Mem. stor. de'Cardinali*, 1793, vi, p. 280). The old tradition has proved correct. We now know (see Amédée Boinet, *Les églises parisiennes*, Paris, 1962, ii,

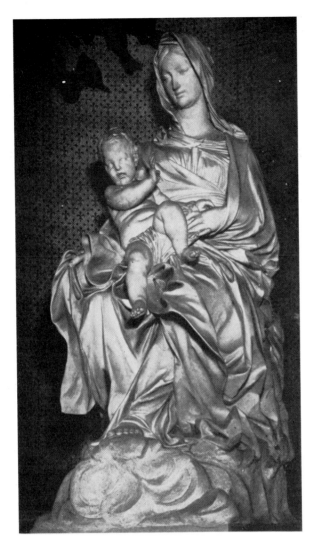

72. *VIRGIN AND CHILD.*
St. Joseph des Carmes, Paris (No. 53).

p. 46f.) that, according to the contract of 24 March 1655 Guillaume de Lubert, later Prior of Paris and Senlis, commissioned the altar, for which Bernini made a design; that the foundation stone was laid on 27 July 1656; that Cardinal Antonio Barberini commissioned the Virgin and Child shortly before 1656 and that it was executed by Raggi from Bernini's model. The statue arrived in Paris by water on 10 August 1663.

Reymond (*loc. cit.*), who was the first to reconstruct the history of the work—in his time attributed to Bouchardon—saw more of Bernini in it than can be admitted (see also Donati, p. 435). Raggi must have had a comparatively free hand in the execution, for the marble is a characteristic and very attractive piece of his early manner recalling the style of the 'Noli me Tangere' (No. 52).

The statue remained until 1793 in the Carmelite Church, rue de Vaugirard, where it stood in Bernini's setting of the Cornaro Chapel type and to which it has been

returned after having been exiled for more than 150 years to a chapel in Notre-Dame. (The copy which took its place is now in a Carmelite convent near Paris.)

54. BUST OF DUKE FRANCIS I D'ESTE.
Museo Estense, Modena PLATE 84, FIG. 73

Over life-size marble. H. 100 cm. with base.

Fraschetti (pp. 221–6) has given a fully documented history of the bust. On 8 July 1650, Francis I wrote to his brother, Cardinal Rinaldo, in Rome, asking him to try to induce Bernini to make his portrait bust. Bernini must have agreed almost immediately, for on 20 August work on the bust had already begun. The sculptor had to work from painted portraits, two profiles by Sustermans and one *en face* by the Frenchman Boulanger. The painted portraits have so far not been traced (Pierre Bautier, *Juste Suttermans*, 1912, p. 68; Fraschetti in *Arte*, v, 1902, p. 110, note 2).

On 31 August the Cardinal reported rapid progress and mentioned the difficulty of producing a bust from painted portraits of unequal quality. Throughout September Bernini worked with great intensity under the constant supervision of the Cardinal. On 7 January 1651, the Cardinal wrote to his brother that the bust was well advanced. After this date Bernini's enthusiasm seems to have slackened somewhat. The bust was not finally completed until the end of September of the same year. Bernini himself mentioned to the Duke's agent that the bust had occupied him for fully fourteen months and that he would never again undertake to work from painted portraits. During the month of October the bust was seen by connoisseurs in Bernini's studio. Finally, on 1 November it was despatched and arrived at Modena on 17 November (Paris, B.N. Ital. 2082, f.86). The question of financial compensation was rather delicate and was discussed between the brothers as early as November 1650. In the end the Duke sent Bernini the incredibly large sum of 3,000 scudi for which the latter thanked him profusely on 13 January 1652.

The immediate effect made by the bust is reflected in several incidents. The Grand Duke Leopold of Tuscany asked for a drawing after it almost before it had arrived at Modena. The Duke of Bracciano described it in a letter to Queen Christina of Sweden (22 May 1652, Borsari in *Fanfulla*, 1891, 4–5 October). A picture of the bust, formerly wrongly attributed to Guidobaldo Abbatini (Fraschetti, *Arte*, v, 1902, p. 109ff.) is now in the Minneapolis Institute of Arts, where it is attributed to Subleyras.

The relation of this bust to the later one of Louis XIV (No. 70) has often been misinterpreted. It seems strange nowadays that Reymond (p. 109f.) and Brinckmann (ii, p. 246) regarded the later work more or less as a copy of the earlier one.

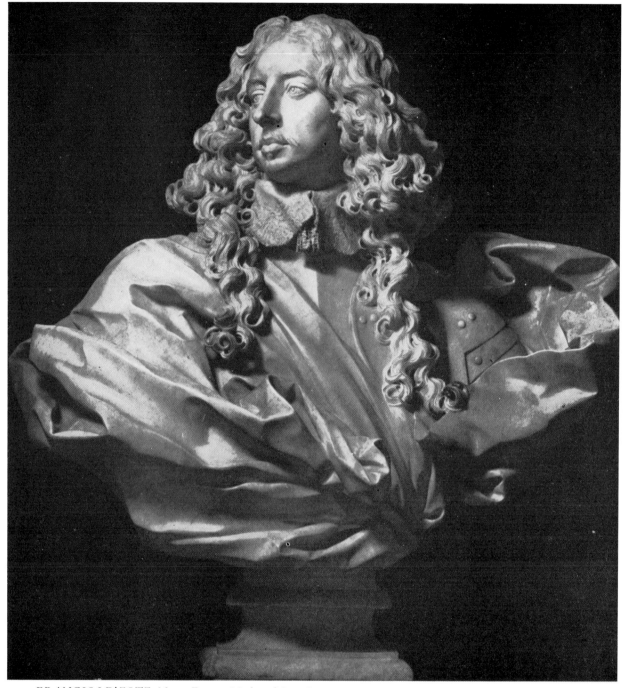

73. *FRANCIS I D'ESTE*. Museo Estense, Modena (No. 54)

55. FONTANA DEL MORO. Piazza Navona, Rome
PLATE 88, FIGS. 74, 75

Over life-size statue in the centre of an older fountain. Marble.

After completion of the great fountain in the Piazza Navona, Bernini was asked to turn his attention to the old fountain opposite S. Giacomo degli Spagnuoli. As early as September 1651 the Pope had money put aside for its restoration (Brauer-Wittkower, p. 50, note 3). In

1652 Bernini designed a large shell as centre of the fountain; it was actually put into position, but found to be too small (documents Fraschetti, p. 202). Bernini's design of 1652 is preserved in a drawing at Windsor (Brauer-Wittkower, pl. 32. For other drawings connected with the shell design, *ibid.*, p. 50f.). A papal order of 2 May 1653 required the replacement of the shell by a statue after Bernini's model. The shell was presented by papal chirograph of 29 July 1653 to Innocent X's sister-in-law, Olimpia Maidalchini, for the decoration

74. *FONTANA DEL MORO*. Detail.
Piazza Navona, Rome (No. 55).

75. *HEAD OF THE 'MORO'*. Bozzetto.
Palazzo Venezia, Rome (No. 55).

of a fountain in her garden (verbal transcript in G. Briganti Colonna, *Olimpia Pamphili*, Milan, 1941, p. 287) and was rediscovered by D'Onofrio (*op. cit.*, p. 71f., figs. 53, 54) in the garden of the Villa Pamphili on the Gianicolo. In July 1653 money was put aside for the statue, which—contrary to Baldinucci's and Domenico Bernini's assertions—is not by Bernini's hand but by Giovan Antonio Mari. The latter was paid 300 scudi in instalments between 8 August 1653, and 19 July 1655, for 'the Triton, fish and shell conforming to the model of Signor Cav. Bernini' (Arch. Corsini, cod. 31-B-14, fol. 122ff.). In July 1655 the statue was *in situ* (see also Bernini's letter, Fraschetti, p. 203, note 1). A few months later Alexander VII gave orders for Bernini to be paid 300 scudi for his restoration of the fountain, for his models of the Moro, and for the assistance he had given to G. A. Mari (Golzio, *Archivi d'Italia*, i, 1933-4, p. 138). The fountain into which the 'Moro' was placed had been designed by Giacomo della Porta. It can best be studied in Israel Silvestre's engraving of 1642. Bernini first contemplated changing the complex polygonal form of the basin and loosening the stiff axiality of the accessory figures and decorations (Brauer-Wittkower, pl. 159c), but this idea was abandoned, apparently in favour of an enlargement of the area of the old fountain: by papal order of 11 November 1654 Bernini

surrounded the original basin by a second water basin of the same shape (Fig. VIII; D'Onofrio, *Fontane*, p. 76). The 'Moro' is not now quite 'at home' in the old Mannerist setting (the accessory figures were replaced by copies in the nineteenth century).

A studio drawing at Windsor (A. Blunt and H. L. Cooke, *The Roman Drawings of the XVII & XVIII Centuries . . . at Windsor Castle*, London, 1960, p. 24, No. 42, pl. 12) showing Neptune on a shell carried by dolphins may be an alternative project for the Moro. The figure of Neptune is reminiscent of the contemporary Neptune at Sassuolo (Nos. 80-5) and also of a studio drawing at Leipzig (Brauer-Wittkower, p. 52, note 2) inscribed 'à Piazza Navona in luogo del Tritone' to which Blunt-Cooke drew attention in this context.

A brilliant bozzetto by Bernini (Fig. 75), first published by Brinckmann (BB,. ii, p. 57) and now in the Palazzo Venezia, Rome, is a study for the head of the 'Moro' (Fig. 74). Another original bozzetto (with modern left arm), also in the Palazzo Venezia (A. Santangelo, *Catalogo*, 1954, p. 80), may be connected with ideas for replacing the accessory Tritons. A bozzetto in Berlin (Brinckmann, BB., i, pl. 41), which is closely related to the Windsor drawing Brauer-Wittkower, pl. 33 (a copy in the Biblioteca di Archeologia e Storia dell'Arte,

Rome, see D'Onofrio, *op. cit.*, fig. 55), may belong to the preparatory stages for the same fountain (*ibid.*, p. 52). The two bozzetti in the Detroit Institute of Arts (E. P. Richardson, *The Art Quarterly*, 1953, p. 3ff.) may also be related.

Small replicas of the 'Moro' are common. One was published as a bozzetto by Muñoz, *Rass. d'Arte*, xvii, 1917, p. 78. A bronze copy was in the Rosenberg Collection, Vienna, another is in the Palazzo Schifanoia, Ferrara (52·5 cm.). A silver copy was in Louis XIV's collection (inventory 1684, Guiffrey, *Mobilier sous Louis XIV*, i, p. 68, No. 539).

56. TOMB OF CARDINAL DOMENICO PIMENTEL. S. Maria sopra Minerva (in a narrow passage at the east end), Rome FIGS. 76, 77

Over life-size marble figures, setting of coloured marble.

The Spanish Dominican Domenico Pimentel was created Cardinal 19 February 1652 and died 2 December 1653. His tomb, probably commissioned soon after his death, is mentioned in Baldinucci's Catalogue (p. 181). Recently a hitherto unknown Bernini drawing of the whole tomb was acquired by the Morgan Library, New York (Fig. 66a, black lead and brown wash; see *Art in Italy 1600–1700*, ed. F. Cummings, The Detroit Institute of Art, 1965, p. 46, No. 29). It represents an early stage of the design: the shape of the sarcophagus still corresponds fairly exactly to that of the Countess Matilda tomb (No. 33) and some of the figures differ considerably from the execution, particularly 'Faith' (right background), who is shown turning away from the beholder. R. Enggass, the author of the entry in the Detroit Catalogue, therefore suggested that at this stage Bernini planned a free-standing tomb. Such a conclusion is not permissible, but this detail supports the assumption (submitted above, p. 23) that he used a free-standing type of tomb for a wall-tomb. Enggass's suggestion is disproved by the Windsor drawing representing the tomb of Alexander VII as planned in

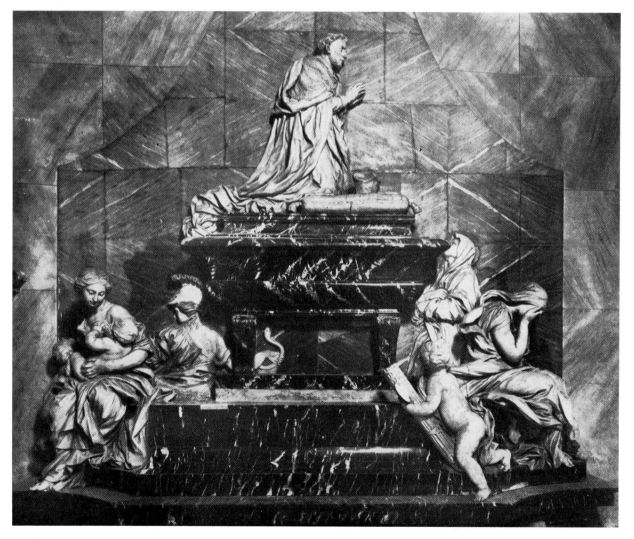

76. *TOMB OF CARDINAL PIMENTEL.* S. Maria sopra Minerva, Rome (No. 56).

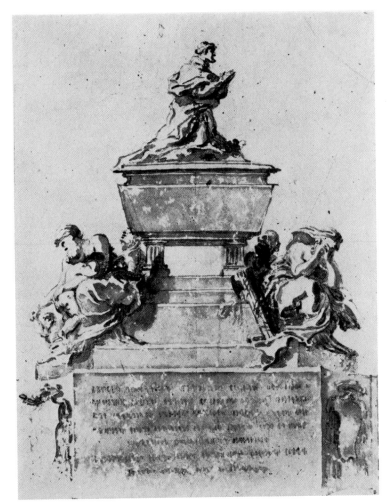

77. *LEAD AND WASH DRAWING FOR THE
TOMB OF CARDINAL PIMENTEL.*
Pierpont Morgan Library, New York (No. 56).

the choir of S. Maria Maggiore (Brauer-Wittkower, pls. 129a, 130). In this drawing, which is very similar to the Morgan Pimentel, the seated personifications at the far corners of the tomb turn away from the onlooker, while at the same time the architecture against which the tomb was to be placed is indicated. After the Morgan drawing Bernini seems to have worked out the details of the Pimentel tomb in many sketches, of which some for the problematical allegory of Faith survive: they illustrate the transition from a three-dimensional to a relief-like conception (Brauer-Wittkower, p. 54f., pls. 39, 40). The execution, probably supervised by him, was entirely due to pupils. The figure of the Cardinal and the allegories of Faith and Wisdom are by Ercole Ferrata; Justice is by G. A. Mari and Charity by Raggi. Here the child is suckling Charity's bare breast (see also the early Budapest copy, ill. in *Handzeichnungen alter Meister aus der Albertina . . .*, vol. v, pl. 484) taking up a motif from the Charity of Urban VIII's tomb.
Inscription: Forcella, i, p. 499, no. 1924.

57. BRONZE CROSSES

Bernini made designs for bronze Crucifixes at different periods of his career. Three or even four of these can be traced.

(1) Crucifix for Philip IV (figure 1·40 m.). Sacristy of the Colegio, Escorial. FIG. 78

Both Baldinucci (p. 179) and Domenico Bernini (p. 64) mention that this work was made for the altar of the sepulchral chapel of the Spanish kings. Baldinucci (p. 108) seems to assume that it was commissioned shortly before Innocent X's death (7 January 1655). This tallies with the building history of the *Panteón de Reyes*, which was finished in 1654. Francisco de Santos described the Crucifix on the altar of the chapel in 1657 (without mentioning Bernini's name). Shortly afterwards the work was transferred to the Sacristy. (For its history see H. Voss, *Zeitschr. f. bild. Kunst*, lviii, 1924–5, p. 35ff. and E. Tormo, *Archivo Español de Arte*, i, 1925, p. 117ff.)

Louis XIV's inventory of 1684 (i.e. only four years after Bernini's death) lists a bronze Crucifix by Bernini, with the figure 4½ feet (c. 1·50 m.) high (Guiffrey, *Mobilier sous Louis XIV*, 1885, ii, p. 35, No. 53). This work may have been a replica of the Escorial Crucifix.

This is the place to mention that no other works by Bernini for the Spanish court survive. The bronze equestrian statuette of King Carlos II in the Prado, attributed to him (F. Niño, *Arch. Español de Arte*, xviii, 1945, pp. 150ff.; M. L. Junquera, *ibid.*, xxii, 1949, p. 281ff.), is by G. B. Foggini, 1698 (K. Lankheit, *Florentinische Barockplastik*, Munich 1962, p. 78, with further literature). It has certain features in common with the bronze version of the Constantine mentioned under No. 73. The Bernini signatures and dates (1643 and 1645) on the two bronzes of Hercules and Perseus in the Palacio de Oriente (Niño, *loc. cit.*) are clumsy eighteenth-century fakes.

(2) and (3) Bronze Crucifixes for the altars in St. Peter's, Rome FIGS. 79, 80, 82

H. of figures: 45 cm.

The documents fully published by R. Battaglia, *Crocifissi del Bernini in S. Pietro* (Rome, 1942) reveal that in 1658 Ferrata made a model of a 'dead Christ' on the Cross and in 1659 one of a 'living Christ' from Bernini's designs. These models were cast in bronze twenty-five times, and twenty-three bronzes are still *in situ* above the altars of the basilica. At the end of 1660 all the casts were finished. The documents prove that Bernini closely supervised the work, but it may be indicative of the extent of Ferrata's contribution that the moulds of both types of Crucifixes are mentioned in the inventory of Ferrata's workshop compiled after his death (V. Golzio, *Archivi d'Italia*, ii, 1935, p. 74).

Compared with Algardi's Crucifix in S. Marta, the Escorial and the St. Peter's 'dead Christ' separated by only three years, seem to have much in common. A careful scrutiny, however, shows how different they really are. In the St. Peter's Crucifix the head has sunk lower, the arms appear longer and are raised higher and the face is more emaciated. Despite such 'Berninesque' increase of tension, there are features obviously alien to him: the pronounced emphasis on anatomical detail and the limp legs bent in the knees weaken the tense energy unifying the Escorial Cross, and the loose drapery points in the same direction of lessened vitality. These are Algardesque characteristics introduced, no doubt, by Ercole Ferrata. No wonder, therefore, that replicas of the St. Peter's 'dead Christ' are attributed to Algardi (e.g. the bronze Crucifix in the Istituto di Belle Arti, Bologna). On the other hand, the 'living Christ' with His slender body writhing in a complicated S-curve is an invention entirely in Bernini's spirit recalling the

preparatory studies made a few years before for the Daniel (No. 58).

★(4) Bronze Crucifix. Palazzo Pallavicini, Rome.
 FIGS. 81, 83

H. of figure: 72·4 cm. The arms are cast separate and the joints are clearly visible. At the foot of the Cross a bronze skull without lower jaw.

In 1665 Bernini presented a bronze Crucifix, which he had made for himself, to Cardinal Sforza Pallavicini (Baldinucci, p. 148). This work was regarded as lost until F. Zeri thought he had found it in the chapel of the Palazzao Pallavicini on the Quirinal (*Paragone*, vi, 1955, No. 71, p. 52). It was subsequently published by V. Martinelli (*Commentari*, vii, 1956, p. 34ff.), but not without reservations.

The work presents a critical problem of extraordinary toughness. Baldinucci's wording does not appear sufficiently conclusive either to support or refute the attribution. 'Bernini', he writes, 'made another Crucifix for himself similar to the one executed for the King of Spain and during his stay in France he gave orders that it be presented to Cardinal Pallavicini' (1607–67). By their very nature Crucifixes are 'similar'—or would Baldinucci have applied a modern art historian's yardstick? From our point of view the Escorial and Pallavicini Crucifixes could hardly be more different. The latter is half the size of the former; the Spanish Crucifix represents the dead Christ, the Pallavicini Crucifix the living and suffering Christ; the facial types are dissimilar; the body of the one swings out to the left, that of the other to the right. Finally, in the Escorial Crucifix the drapery is pulled tight around His loins and points forward to the treatment of drapery in such figures as the Magdalen in Siena (No. 63). An entirely different spirit informs the rich, decorative drapery of the Pallavicini Cross with the free-flying piece of material on the left-hand side. Thus if Baldinucci applied the term 'similar' critically, he must have had a Crucifix other than the Pallavicini in mind. But I suggest not to make his choice of terminology the touch-stone of authenticity. If this can be agreed upon, the way is open for an unbiased assessment of elements favouring as well as contradicting an attribution to Bernini.

Points in favour of Bernini's authorship: (1) According to a family tradition, the Crucifix has always been given to Bernini (see Martinelli, *loc. cit.*). (2) There is definitely a close connection with the 'living Christ' in St. Peter's (Figs. 82, 83). Not only is the treatment of the anatomy very much alike, but the body also shows a similar swing, although it has to be emphasized that in the Pallavicini Crucifix the twisting S-curve is less pronounced and the head is less vigorously thrown back. (3) The facial types of the two Crucifixes closely correspond. The Pallavicini head is perhaps less tense and seems

★See Addenda, pp. 273ff.

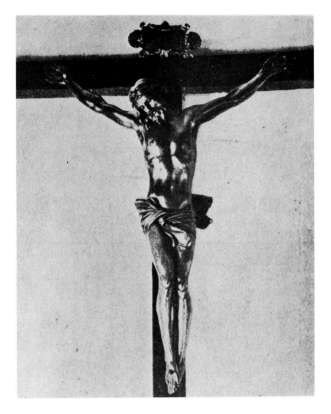

78. *CRUCIFIX FOR PHILIP IV.*
Escorial (No. 57-1).

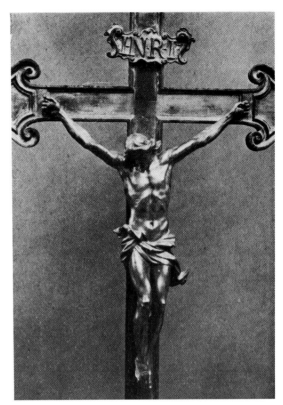

79. *CRUCIFIX FOR AN ALTAR*
IN ST. PETER'S, ROME (No. 57-2).

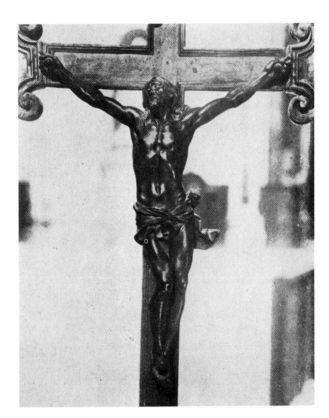

80. *CRUCIFIX FOR AN ALTAR*
IN ST. PETER'S, ROME (No. 57-3).

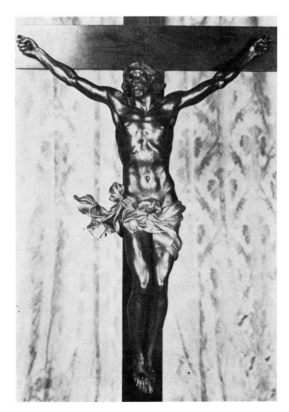

81. *CRUCIFIX.*
Palazzo Pallavicini, Rome (No. 57-4).

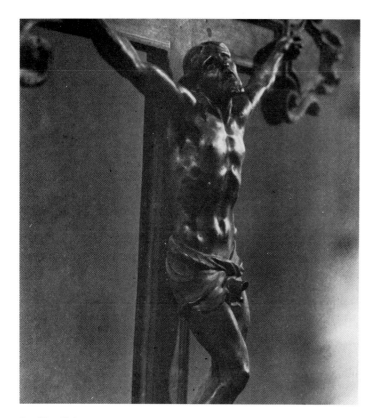

82. Detail from Fig. 80.

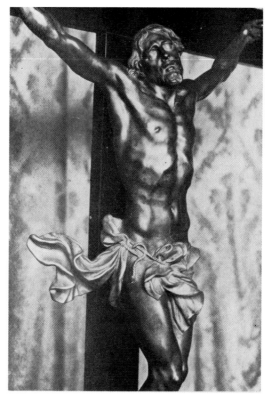

83. Detail from Fig. 81.

slightly broader, but in all other respects—treatment of eyebrows, eyeballs, nose, hair, moustache and beard—the similarity is most striking. (4) The expressive handling of the skull at the foot of the Cross (not shown here, but see Martinelli's illustration) closely resembles other representations of the same symbol in Bernini's work (see Figs. 2, 32).

Points militating against an attribution to Bernini: (1) Jennifer Montagu found two engravings after the Pallavicini type Crucifix, one in the Bibliothèque Nationale, Paris, the other in Vienna, with inscriptions attributing it to Algardi. (I gratefully acknowledge that her important discovery influenced considerably the character of this entry). Both engravings date from the late seventeenth or early eighteenth century: the first was published by the heirs of Domenico de Rossi, the second was engraved by Giuseppe Baroni (d. 1730). In addition, the bronze Crucifix in the sacristy of S. Carlo ai Catinari, Rome, which corresponds to the Pallavicini Crucifix, is traditionally attributed to Algardi (see Riccoboni, 1942, p. 176, who dates it for reasons unknown to me in 1630). (2) The drapery with the round curving of folds and the free-flying piece would be unique in Bernini's œuvre, but by no means in Algardi's (see, e.g. the fire-dogs in Aranjuez, Spain, and the S. Michael in the Museo Civico, Bologna). But it might be argued that the wind-blown piece of drapery—

derived from an exposition of Luke xxiii, 44, 45 and Matthew xxvii, 51—is common in the iconography of the Crucifixion of the Renaissance and the Baroque (see, e.g. Guido Reni's paintings in the Modena Gallery and in S. Lorenzo in Lucina, Rome; Gnudi-Cavalli, *Guido Reni*, 1955, pls. 164, 179) and that Bernini followed this tradition. Nevertheless, it must be admitted that the drapery motif is the strongest argument in favour of an attribution of the Pallavicini Cross to Algardi rather than Bernini. (3) The 'toning down' of Bernini's tense movement of the 'living Christ' may be interpreted as characteristic of Algardi (but Algardi did not know Bernini's St. Peter's design, for he had died five years before its invention). Also the transformation of the head (discussed above) may be regarded as an Algardi contribution. Moreover, similarities between the facial type of the Pallavicini Cross and Algardi heads do exist (see, e.g. the Baptism of Christ relief in the nave of S. Giovanni in Laterano). It could even be argued that the head of the St. Peter's Crucifix, too, is Algardesque owing to Ferrata's contribution. In any case, the facial type of Bernini's Escorial Cross is different. (4) Those who accept Algardi's authorship of the Pallavicini Crucifix will find support in the drawing of the Breschi Collection (Labò, *Dedalo*, xi, 1930–1, p. 1398; Vitzthum, *Boll. d'Arte*, xlviii, 1963, p. 76), which shows that Algardi was capable of such an invention.

The drawing, dated 1647, represents the 'living Christ' with elongated proportions and a curve of the body similar to the Pallavicini Crucifix and, in addition, with the flying piece of drapery. (5) Algardi, in the authentic Crucifix in S. Marta, used two nails for the feet; Bernini in the Escorial Crucifix and in both types of the St. Peter's Crosses used only one. The Pallavicini Crucifix has two nails.

Points militating against an attribution to Algardi: (1) Algardi's conception of the 'dead Christ' survives in the Crucifix in S. Marta, Rome. This work served as model for the (lost) bronze at Bologna and for the bronze in the Franzoni Chapel in SS. Vittore e Carlo in Genoa (Labò, *op. cit.*, p. 1392ff.; A. Arfelli, *Arte Antica e Moderna*, No. 8, 1959, p. 464; G. Gallo Colonni, *Arte lombarda*. Studi in onore di G. Nicco Fasola, 1965, p. 161ff.). The cast for Bologna dates from 1644 and this means that ten years before his death Algardi regarded this type of Crucifix as representative of his artistic ideas. Christ's body is classically balanced and classically proportioned and no possible link exists between this 'dead Christ' and the 'living Christ' of the Pallavicini Cross. Also the facial type, the hair and beard differ markedly. (2) It is not easy to reconcile the development from the S. Marta to the Pallavicini Crucifix with Algardi's development of the last decade of his life. The drawing of 1647 is a rapid sketch; if executed it would appear like a freak in his sculpted work. One can hardly imagine that Algardi on his own account and without Bernini's example would have invented the movement and slender proportions of the Pallavicini Crucifix. But Bernini's Crucifixes date from after Algardi's death.

This is as far as we can go at the present moment, without a full knowledge of the many Crucifixes attributed to Algardi. The balance seems slightly in Algardi's favour (see mainly points 1 and 2, p. 231). But there are other aspects to the Pallavicini Crucifix. A number of other casts and/or replicas are in existence (see Martinelli, *loc. cit.*) and nobody has yet tried to catalogue and investigate them. A bronze Crucifix of inferior quality acquired in 1962 by the Museum für Kunst und Gewerbe in Hamburg corresponds to the Pallavicini Christ, but is slightly larger (82 cm.); it is of specific interest because the Algardesque flying piece of drapery has been omitted. More important is the beautiful silver Crucifix in the Treasury of S. Lorenzo, Florence, published by K. Lankheit (*Florent. Barockplastik*, 1962, p. 126, figs. 163, 164) as an authentic work by Massimiliano Soldani. If Lankheit's identification of this Crucifix with the one mentioned in a letter by Soldani (June 1688, *ibid.*, p. 279, doc. 322) is correct, Soldani would have worked from a cast he had obtained of the Pallavicini Crucifix type. Lankheit, who was unaware of the connection of the S. Lorenzo with the Pallavicini Crucifix, noted that the former was derived from Bernini's 'living Christ' in St. Peter's. By placing the S. Lorenzo Crucifix in Bernini's orbit, Lankheit, unintentionally, supported an attribution of the Pallavicini Crucifix to Bernini.

If the Pallavicini Crucifix or its model is by Algardi, one would have to date it in the last years of his life. If it is by Bernini, a date at the period of the Escorial Crucifix is most likely. In any case, its style clearly points to a date before the designs for the St. Peter's Crosses and not after them. Martinelli's proposed date (p. 30f.) in the early 1660's does not appear acceptable.

58. DECORATION OF S. MARIA DEL POPOLO

DANIEL and HABAKKUK WITH THE ANGEL. Chigi Chapel, S. Maria del Popolo, Rome

PLATES 85-7, FIGS. 84, 85

Daniel and Habakkuk: over life-size marble figures; the decoration of the church mainly stucco.

In 1652 Cardinal Fabio Chigi began restoring his family chapel in S. Maria del Popolo. It was then that the oval reliefs were placed on the pyramids which formed part of Raphael's design. In 1655, after his election to the papacy, he immediately extended the programme, not only by deciding to fill two vacant niches with statuary, but also by turning his attention to the whole church. Gnoli (*Arch. stor. dell' Arte*, ii, 1889, p. 322f.) discusses the appearance of the Chigi Chapel before 1652 (see also John Shearman, 'The Chigi Chapel in S. Maria del Popolo', *Journal of the Warburg and Courtauld Inst.*, xxiv, 1961, p. 129ff.). Cugnoni (*Archivio della Soc. Romana di storia patria*, vi, 1883, pp. 523-39) published the documents relating to the whole work of decoration in chapel and church. The direction of the entire enterprise was in Bernini's hands; but he was personally responsible only for the two statues of Daniel and Habakkuk.

The stucco figures of female saints and martyrs above the arcades of the nave were executed between August and December 1655 by Ercole Ferrata, Francesco Rossi, Lazzaro Morelli, Paolo Naldini, Giovan Antonio Mari, Antonio Raggi and Giuseppe Peroni, all artists of distinction who had a more or less important share in other enterprises by Bernini. In the same year, 1655, Alexander VII placed an inscription above the entrance door of the church. But the work was not yet finished. After that date Ferrata executed the figures of Fame supporting the frame of the circular window of the entrance wall and Raggi the corresponding 'Victories' with the papal coat of arms above the arch at the far end of the nave (1656). Raggi also executed the spirited but bizarre decoration of the organ in the right transept (1656-7), for which Bernini was probably not entirely responsible (see Brauer-Wittkower, p. 57, n. 3). In addition, Ferrata,

Mari, Raggi and the otherwise little known Northerner Arrigo Giardé were selected for the execution of the four over life-size marble angels in the transept (1657 until beginning of 1659). Preparatory drawings for various parts of the decorations are discussed in Brauer-Wittkower, p. 56f. Bernini's design for Mari's stucco figure of St. Ursula (*ibid.*, pl. 41) gives an idea of the considerable share he had in planning the details. But in contrast to such works as the Cathedra or the tomb of Alexander VII, artists were here allowed to assert their individual styles.

A letter by Fabio Chigi—later Pope Alexander VII—of 26 December 1626 mentions that Lorenzetti's Renaissance statues of Jonah and Elijah were standing in the niches close to the entrance to the Chigi chapel, while those next to the altar were empty (Cugnoni, *op. cit.*, iv, 1881, p. 58; Gnoli, *op cit.*, p. 321). It is therefore unlikely that before 1626 Jonah occupied the niche right of the altar (now taken up by Bernini's Habakkuk) as shown in the Uffizi drawing 166A ascribed to Dosio. Another drawing, purchased in 1951 by the Smith College Museum of Art (Northampton, Mass.), represents a view into the chapel with Elijah left and Jonah right of the altar (Fig. 84). At the time of the drawing Bernini's balustrade and decoration of the arched entrance vault together with the coat of arms of the Chigi Pope had been completed. The highly finished sheet must date after 1655 and before the autumn of 1661 when Habakkuk was placed in his niche. It was probably executed for Bernini who seems to have contemplated for a brief moment to vacate the niches near the entrance in order to make room for his own statues. Later he decided to leave Elijah in his niche right of the entrance and transfer Jonah from the niche left of the entrance to the niche left of the altar. In this way the two Renaissance as well as the two Baroque statues face each other diagonally across the chapel. It could be argued that Bernini, when designing the Daniel, his first statue for the chapel, planned it with the idea on his mind of placing Elijah left of the altar (the movements of the two figures would then have been complementary).

On 26 June 1657 Bernini received 1,000 scudi for his figure of Daniel, which was then already standing in its niche. In October 1656 a payment was made for the transport of two pieces of marble 'per fare una statua nella Cappella'. This can only refer to the Habakkuk, which was not in position until November 1661 (Golzio, *Archivi d'Italia*, i, 1933–4, p. 140). Compositionally, Bernini now conceived the Habakkuk as counterpart to Lorenzetti's Jonah, but psychologically Habakkuk is connected with Daniel in the niche diagonally opposite, left of the entrance.

For the theological message, which determined the choice of the prophets, see above p. 9, and W. Messerer

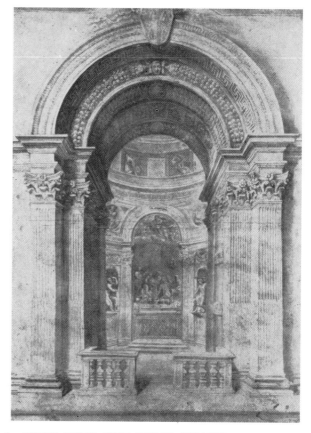

84. *VIEW INTO THE CHIGI CHAPEL.*
Pen and wash drawing. Smith College of Museum of Art, Northampton, Mass. (No. 58).

(*Römische Quartalschrift*, lvii, 1962, p. 294ff.), who regards Antonio Bosio's *Roma sotterranea* (1632 and 1651) as the most likely source for the selection of the figures and their symbolism. (For the impact the new discipline of Early Christian archaeology made on Baroque imagery, see also Wittkower, in *The Minneapolis Institute of Arts Bulletin*, xlix, 2, 1960, p. 29ff.). Shearman (*op. cit.*, p. 153f., note 109) suggested that both prophets might also be regarded as prefigurations of the incorrupt Virgin, to whom the chapel is dedicated. An important series of preparatory drawings for the Daniel (Brauer-Wittkower, pls. 42–7; Wittkower, in *Studies in Western Art*, 1963, iii, p. 47f.) gives a rare insight into the development of Bernini's conception. Terracotta bozzetti of Daniel (H. 42 cm.) and Habakkuk (H. 51·5 cm.) are in the Vatican (Brinckmann, BB., ii, pl. 29), where they were transferred from the Palazzo Chigi at a relatively recent date together with the two bozzetti for Urban VIII's tomb (No. 30). These four bozzetti are thickly coated with a bronze-coloured oil paint which makes judgement difficult. Brinckmann regarded the oil coat as modern. I have now come to the conclusion that it dates back to the seventeenth century, when these perishable cimelia of Bernini's art were

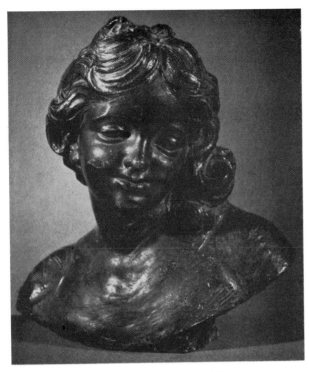

*85. HEAD OF THE ANGEL OF THE
HABAKKUK GROUP.* Bozzetto.
J. M. Trusted Collection, London (No. 58).

protected in this manner. My opinion has been reinforced by the appearance in a Sotheby's sale (June–July, 1961) of a hitherto unpublished beautiful bozzetto for the angel of the Habakkuk group with an identical oil coating (Fig. 85, now in the J. M. Trusted Collection, London). It is almost certain that this bozzetto, too, was in the Palazzo Chigi and got separated from the others at the time of the transfer. The bozzetto is close to the execution, but shows many minor differences and reveals under the oil coat, in my view without doubt, Bernini's characteristic handling, particularly in the hair at the back of the head and around the shoulders. By inference, this bozzetto allows a more favourable assessment of the other Chigi bozzetti than I was prepared to admit in the first edition of this book. I was then inclined to attribute the Habakkuk as well as the Daniel bozzetto to the hand of an assistant. While I cannot suppress considerable doubts as to the authenticity of the Habakkuk, I now believe that the Daniel bozzetto is by Bernini's hand. This bozzetto commands particular interest, because it belongs to a preparatory stage similar to that of the drawing Brauer-Wittkower, pl. 44.

59. PUTTI LIFTING A LARGE DRAPERY.
Sala Ducale, Vatican, Rome FIG. 86

Putti: white stucco; drapery: stucco painted (coat of arms modern).

Bernini's work in the Sala Ducale was mainly architec-

tural (Baldinucci, p. 110, Domenico Bernini, p. 108). He knocked two rooms into one. Pillar-like remains of the old wall had to be left standing, probably for reasons of structural stability. He made a virtue of necessity by placing between these pillars the suggestive motif of the large curtain which seems to have just been raised by zealous putti, who also support the Chigi coat of arms. Bernini's design was carried out by Antonio Raggi between October 1656 and January 1657 (Ozzola, in *Archivio della R. Società Romana di Storia Patria*, xxxi, 1908, p. 16; Donati, p. 444).

60. ST. BARBARA. Cathedral (fourth chapel right), Rieti FIG. 87

Over life-size marble figure.

Previously known documents regarding Bernini's work for Rieti (Brauer-Wittkower, p. 133f.) have been supplemented by A. Sacchetti Sassetti (*Archivi d'Italia*, xxii, 1955, p. 214ff.). In the summer of 1652 Bernini seems to have been briefly at Rieti, where three of his nieces were in the monastery of S. Lucia. On 17 August 1652 Bernini promised to make designs for the new chapel of S. Barbara in the Cathedral. These were sent to the Congregation of the Cathedral before 14 January 1653. In August 1653 the foundation stone of the chapel

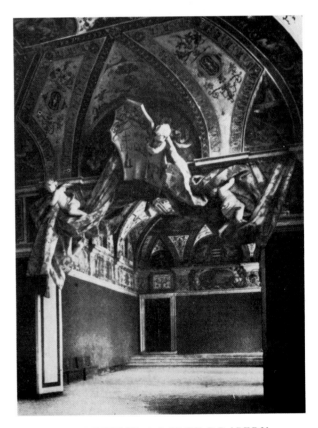

86. PUTTI LIFTING A LARGE DRAPERY.
Sala Ducale, Vatican (No. 59).

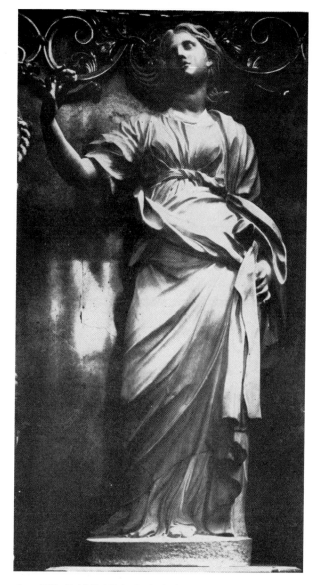

87. *ST. BARBARA.* Cathedral, Rieti (No. 60).

After delivery of the work, Bernini wrote to the board responsible for the commission: 'The praise which you have lavished on my statue is due to your courtesy rather than to my direction. I have done everything possible to find a man who would fully satisfy the taste of your city and it seems that I was not mistaken.'

The chapel was rebuilt in the beginning of the eighteenth century, when Lorenzo Ottoni's relief of the Assumption was placed above the altar. It seems that, apart from the statue, the architecture of the altar, which corresponds to that of the 'Noli me Tangere' (No. 52), is the only surviving part of Bernini's chapel design.

★61. CATHEDRA PETRI. St. Peter's, apse.

PLATES 93–100, FIGS. 62, 88–91, IV

Base: coloured marble; Fathers of the Church and Chair: bronze partly gilt; the Glory: stucco figures and some bronze figures on stucco clouds, all gilt.

The Cathedra signifies in every respect the climax of Bernini's career. It is a work of infinite complexity, and for a detailed study the reader must be referred to Battaglia's excellent monograph. Although much remains puzzling, the genesis of Bernini's project and its execution can—to a certain extent—be reconstructed by means of surviving drawings and bozzetti, and through the documents of the *Fabbrica di S. Pietro* (printed *in extenso* by Battaglia, pp. 153–233). No more than a skeleton of key data can be given here.

3 March 1656. Decree of the Congregation to transfer the relic—the old chair of St. Peter—from the Baptismal Chapel to the apse of the church.

(1) *Bernini's first design*

3 March 1657. The Congregation accepts Bernini's design. During the same month a small model is in preparation. Ferrata, Raggi and Lazzaro Morelli are responsible for the models of the Fathers of the Church. The drawing Brauer-Wittkower, pl. 166a, gives an idea of this relatively modest design, in which the niche with the Cathedra is conceived as an almost equal third unit between the tombs of Paul III and Urban VIII.

(2) *Growth of the scheme*

An important step towards an increase in scale survives in a drawing known through an engraving by Metz (Brauer-Wittkower, pl. 166b). The original appeared recently on the London art market (P. L. Grigaut, *The Art Quarterly*, 1953, p. 129, fig. 5).

(3) *The first large model*

From March 1658 onwards Peter Verpoorten, Faydherbe's pupil, and a little later Ferrata, Raggi and Morelli

was laid and on 16 September 1654 the building was finished. Correspondence regarding the statue of the saint began on 1 April 1655. Bernini offered to have it executed by one of his assistants for 150 scudi. He selected Giovan Antonio Mari, for whom he requested an on account payment of 50 scudi on 8 May 1655. In September 1657 a licence was granted for the transport of the finished statue, at that time in Bernini's house, where 'it had been executed under the Cavaliere's direction'. The statue arrived in Rieti before 20 September.

A small drawing in the Albertina from Bernini's studio (B.-W., pl. 101a) and an original bozzetto for the head (which Brinckmann, BB., ii, pl. 24 related wrongly to the head of the Truth) testify to Bernini's part in the work. Although Mari toned down Bernini's conception, the head at least shows qualities close to the Truth.

★See Addenda, pp. 273ff.

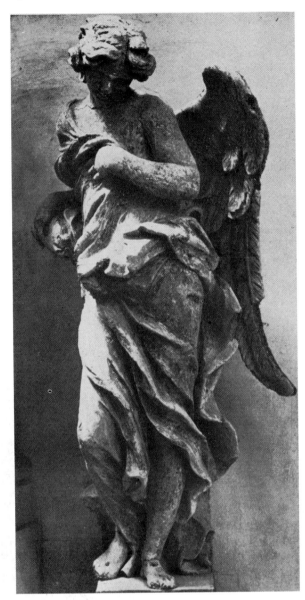

88. *FIRST LARGE MODEL OF THE ANGEL TO THE RIGHT OF THE CHAIR OF ST. PETER.* Raggi (?), 1660 (No. 61–3). Museo Petriano, Rome.

are engaged on full-scale models of the figures, which, it seems, were used in the wooden model of the structural parts built *in situ* by the carpenter Cosimo Carcani. Nevertheless the overall dimensions of this model, finished in April 1660, were considerably smaller than those of the final design.

It is this model that Andrea Sacchi saw, probably in 1660, and criticized as being too small (Pascoli, i, p. 19f. Sacchi died in 1661).

Bernini's important bozzetto for the 'Chair', now in the Detroit Institute of Art (Grigaut, *loc. cit.*) represents a stage between the Metz design (2) and the model of 1660. The full-scale models of the two angels standing next to the chair of the Cathedra survive in two different versions (Museo Petriano, Mariani, *Boll. d'Arte*, xxv, 1931, p. 161ff.): one set corresponding to the size of the angels as executed; the other, one third smaller. The smaller angels belong to the model of 1660. Although the attitudes of the two sets of angels are almost identical, the difference in style is very considerable.

(4) *The first casts*

Between March and the summer of 1660 Giovanni Artusi cast two bronze angels, and casts of other bronzes followed in the course of 1661. Artusi's assistant, Angelo Pellegrini, received payments until January 1662 for the preparation of the wax models and the cleaning and polishing of the bronzes. The payments must refer to the six bronzes (identified by Battaglia, p. 23) which were later incorporated into the Glory. It is obvious that these bronzes, now lost amongst the stuccoes of the Glory, were planned for a different design. An attempt to reconstruct their original purpose has been made by Brauer-Wittkower (p. 107, note 6).

(5) *Final enlargement of the design*

Between 1660 and 1661 Bernini must have decided to enlarge the scale of the design still further. Consequently, new models became necessary. In making them, Morelli seems to have been his principal assistant (payments until April 1662). In spite of this new change, nothing less than revolutionary, the casting of the above-

89. *LARGE MODEL OF THE HEAD OF ST. ATHANASIUS.* Museo Petriano, Rome. Cathedra Petri (No. 61–6).

90–91. 'HANDING OVER OF THE KEYS TO ST. PETER' and 'WASHING OF THE FEET'. Reliefs on the Chair of the Cathedra Petri (No. 61–7).

mentioned bronzes (4), devised for a less extensive project, was continued.

(6) The Fathers of the Church

In the autumn of 1661 Artusi prepared the cast of St. Augustine. The first cast was a failure, and the second only partly successful, for the head had to be done separately (February 1662). The casting of all four figures was finished in the beginning of 1663 (for the problems presented by their sequence, see Battaglia, p. 30ff.). In April 1663 Carlo Mattei began the cleaning and polishing of the bronzes.

Brilliant chalk studies of the Fathers of the Church survive, probably belonging to the period of the first large model (Brauer-Wittkower, p. 107, pls. 75–77). The bozzetto of St. Augustine (Brinckmann, BB., i, pl. 40) was dated by Battaglia as late as 1660–1. Full-scale models of the heads of the Greek Fathers of the Church were in the Museo Petriano (Fig. 89).

(7) The Chair

Artusi prepared the casting in the summer of 1663. The cleaning and gilding dragged on until the end of 1665. In fact, only in that year were the two angels cast which show obvious stylistic affinity to those of Ponte S. Angelo (No. 72). Also in 1665 Giovan Paolo Schor provided the design for the floral ornamentation below the seat. Bernini's responsibility for the three reliefs, two at the sides of the chair ('Washing of the Feet' and 'Handing over of the Keys to St. Peter', Figs. 90, 91) and one at the back ('Pasce Oves Meas'), was established by Battaglia (p. 100ff.).

(8) The Glory

The principal assistants in executing the stuccoes of the Glory were Lazzaro Morelli (November 1663 to January 1666) and Raggi (January 1664 to October 1664). Less important were the contributions by Pietro Sassi (December 1663 to February 1665) and Paolo

Naldini (May and June 1665), who replaced the former when he accompanied Bernini to Paris. Vincenzo Coralli was responsible for the gilding (May to December 1665) and Schor for the painting of the Holy Dove in the window (January 1666). Preparatory drawings by Bernini: Bauer-Wittkower, pls. 79–81.

When Bernini went to Paris, he left his brother Luigi and Lazzaro Morelli in charge. At the time, the Fathers of the Church were in position, the Chair was not yet in its place, and work on the stuccoes of the Glory was proceeding.

(9) Unveiling of the Cathedra

On 16 January 1666, the relic was transported to its new place; on the following day the work was unveiled. Total costs were over 106,000 scudi, of which sum Bernini received 8,000 and the bronze caster Artusi 25,000. In addition to an army of subordinate helpers, about thirty-five collaborators were engaged on the execution, some of them continuously over a number of years.

Characteristically, Bernini developed his scheme from comparatively 'classical' beginnings towards a sublime dynamic intensity, a process of spiritualization that can be followed in the preparatory drawings. The colour scheme, so important for the composition, the unity and also the content of the work, has been analysed by Benkard (p. 31) and Battaglia (pp. 75, 80f.). For the place of the Cathedra in the religious thought of the Restoration period, see E. Mâle, L'art religieux après le Concile de Trente, p. 50ff., Battaglia, p. 70ff., and, above all, H. von Einem, 1955, 108ff. He recognized that Bernini aimed at recapturing the spiritual content of the apse of Old St. Peter's. The central motif of the Cathedra betokens a return to the 'empty throne', symbol of divine power, a common representation in apsidal mosaics of Roman churches from the fifth century onwards.

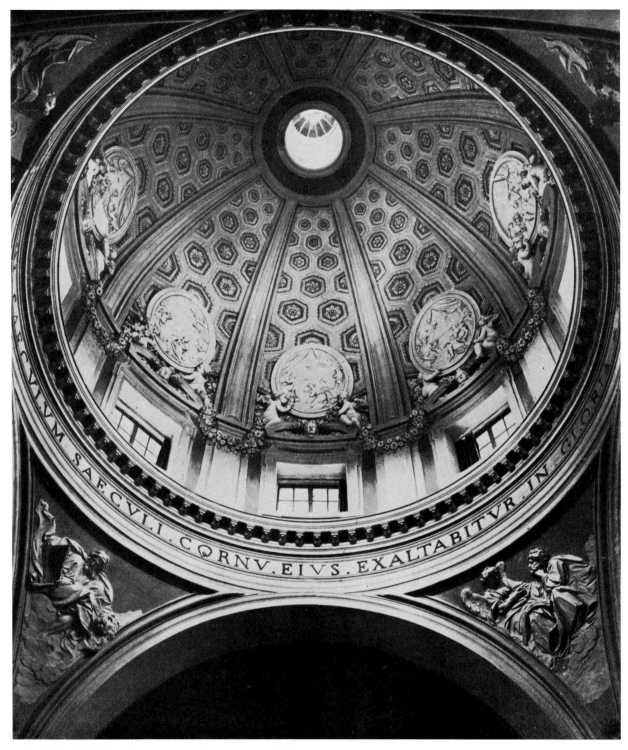

92. *DOME OF THE CHURCH AT CASTEL GANDOLFO* (No. 62–1).

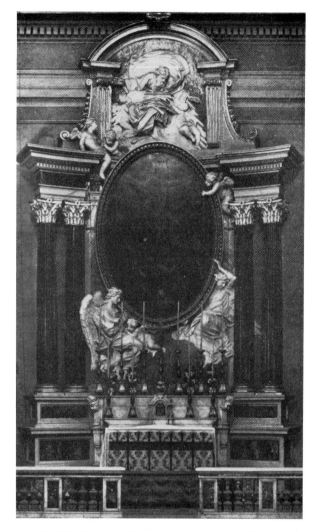

93. *HIGH ALTAR*. Church at Castel Gandolfo (No. 62–1).

62. THREE CHURCHES FIGS. 92–98, VII

Between 1658 and 1670 Bernini completed three churches: that at Castel Gandolfo (1658–61), the hill town of the papal summer residence; that at Ariccia (1662–4), belonging to the Chigi family; and S. Andrea al Quirinale (1658–70), the church of the Jesuit Noviciate in Rome.

In these churches architecture and sculpture form an indivisible unity. A few surviving drawings show how much thought Bernini spent on the details of the sculptural decoration (Brauer-Wittkower, pls. 84–7, 93b, 97a and the studio drawings based on his designs 169c, d. 174b; see also *ibid.*, pp. 110–26 for the history of these churches).

(1) *Castel Gandolfo*

All the stuccoes of the church are by Antonio Raggi. Payments from October 1660 to September 1661. Final settlement on 13 November for sixteen putti, eight

medallions with stories of St. Thomas of Villanova, four Evangelists in the pendentives, and God the Father, six putti and two angels on the high altar, altogether 811 scudi (Golzio, p. 402f.).

(2) *Ariccia*

The twelve putti and four angels with garlands between them (all white stucco) were executed by Paolo Naldini in 1664 (final payment of 242 scudi, 7 December) (G. Incisa della Rocchetta, *Rivista del R. Istituto*, i, 1929, pp. 349–92).

(3) *S. Andrea al Quirinale*

Most of the stuccoes in the church are by Raggi. Between August 1662 and April 1665 he carried out St. Andrew, twelve putti and eight figures above the windows, and twenty-eight cherubs under the lantern for 580 scudi. The competent Giovanni Rinaldi was responsible for the two figures of Fame with the Pamphili coat of arms and inscription above the entrance door (1670), and for the gilt stuccoes of angels, putti and cherubs in the large high-altar recess (1668–70). (Donati, *Riv. d. R. Ist.*, viii, 1941, p. 144ff. and *idem*, pp. 445, 501).

94. *PUTTI AND GARLANDS.*
 Detail from the dome at Ariccia (No. 62–2).

95. *PART OF DECORATION OF THE DOME.* Church at Ariccia (No. 62–2).

96. *CUPOLA DECORATION.* S. Andrea al Quirinale, Rome (No. 62–3).

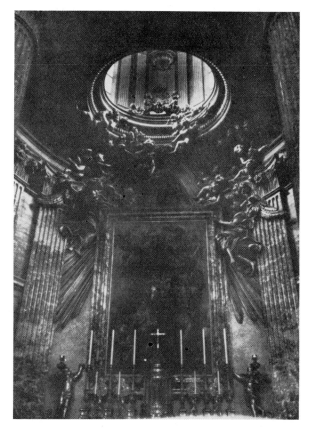

97. *THE CHAPEL OF THE HIGH ALTAR.*
S. Andrea al Quirinale, Rome (No. 62–3).

98. *FIGURES OF FAME WITH PAMPHILI
COAT OF ARMS.*
S. Andrea al Quirinale, Rome (No. 62–3).

63. SS. JEROME AND MARY MAGDALEN.
Chigi Chapel, Cathedral, Siena

PLATES 89–92, FIG. 99

Over life-size marble statues. H. 1·95 and 1·89 m.

The Chigi Chapel in the Cathedral at Siena was erected
from 1659 onwards according to the designs of Bernini.
The entire decoration was planned and supervised by

him (Golzio, p. 79ff. with full documents). The only
foreign elements are the early eighteenth-century reliefs
above the four niches. It is these narrow niches that
contain the principal works of the chapel: Bernini's
SS. Jerome and Mary Magdalen, designed for the niches
near the entrance, and Ferrata's St. Catherine and
Raggi's St. Bernard for those near the altar.

Payments for delivery of marble blocks to the sculptors'
studios were made in August 1662. But there is no
reason to doubt that this was a belated settlement, since
Ferrata and Raggi received their first instalment for the
statues in February 1662. It is, therefore, likely that
work on the statues began at the end of 1661. The four
finished figures left Rome for Siena on the last day of
June 1663. Shortly before that date Alexander VII had
inspected Bernini's figures in the sculptor's studio
(Domenico Bernini, p. 106). It follows that Bernini can
hardly have spent more than eighteen months working
his figures, and must therefore have had considerable
assistance from studio hands. But one cannot follow
Pope-Hennessy (*It. Sculpture of the High Ren. and
Baroque*, 1963, p. 113), who wants to make Bernini's son
Paolo mainly responsible for the execution of the
Magdalen. Paolo, an extremely weak sculptor, was
13 years old when the work was begun and 15 when it

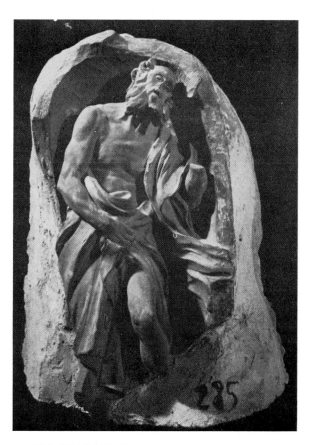

99. *ST. JEROME.* Bozzetto.
Museo Civico, Termini Imerese (No. 63).

was finished. Surviving drawings make it possible to follow very closely the development of Bernini's ideas (Brauer-Wittkower, pls. 49–50). For his two statues Bernini received 2,128 scudi in two crimson damask purses as a mark of special recognition.

A splendid bozzetto for the head of St. Jerome is in the Fogg Art Museum (1937.77) and a terracotta bozzetto of the whole figure (34·5 cm., Fig. 99) was recently discovered in the Museo Civico at Termini Imerese (M. V. Brugnoli, in *Arte Antica e Moderna*, 1961, p. 291ff.). The terracotta in the Victoria and Albert Museum (5863–1859, Maclagan, *B.M.*, xl, 1922, p. 116; Pope-Hennessy, *Catalogue*, 1964, p. 608, No. 641) is a replica. For other replicas after St. Jerome, see Bacci, *Diana*, vi, p. 56. A drawing in Warsaw (see M. Mrozinska, *Disegni veneti in Polonia*, Venice, 1958, No. 18) is a copy after the statue, perhaps by G. B. Gaulli.

64. MEMORIAL STATUE OF POPE ALEXANDER VII. Right transept, Cathedral, Siena FIG. 100

Monumental marble statue.

Baldinucci reports (p. 110) that Bernini made the model for this figure and that it was executed by Antonio Raggi. The information is correct. Documents referring to this work have been fully published by P. Bacci (*Diana*, 1931, pp. 37–55). It appears that the commission was given to Bernini, that the marble block was in Rome at the beginning of June 1661, and that Raggi was paid 400 scudi between November 1661 and July 1663. Payments for the transport of the statue to Siena began 17 July 1663. The date 1655 mentioned in the inscription of the base has misled critics. It refers to the year of Alexander's accession to the papal throne.

A large preparatory chalk drawing by Bernini's hand survives (Brauer-Wittkower, pl. 51); in addition there are two studio drawings (*ibid.*, pl. 160a, b) which are concerned with clarification of the niche and base.

The powerful sweep of the papal mantle with its deep cavities and angularly breaking folds is characteristic of Bernini's late manner. For the stylistic difference between Bernini's statues of Urban VIII and the present one see Brauer-Wittkower, p. 63. Raggi's execution is somewhat dry and it seems unlikely that Bernini had any share in it. According to an early local tradition, reported by N. Tessin in 1688 (Sirén, p. 150), Bernini had worked the Pope's face.

65. BUSTS OF POPE ALEXANDER VII
FIGS. 22–4

Baldinucci and Domenico Bernini do not agree about the number of busts of Alexander VII (1655–67) executed by Bernini. The former (p. 177) mentions two

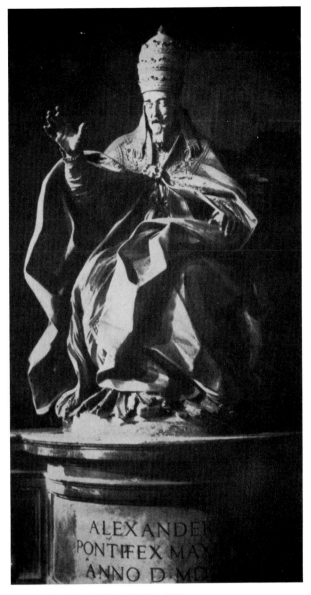

100. *POPE ALEXANDER VII.*
Cathedral, Siena (No. 64).

in the Palazzo Chigi and one in Bernini's house, the latter (p. 108) writes emphatically of very many busts without being more explicit.

The surviving number of busts of Alexander VII is, indeed, large. In the first edition of this book I attempted for the first time to catalogue and discuss the busts then known to me. This attempt was followed up by V. Martinelli in 1956 (*Ritratti*, p. 43ff.). Even ten years after my first edition these busts have not yielded all their secrets. None of them approaches the grandeur and dignity of the Pope's head on his tomb and none of those I have seen gives the impression of a completely authentic work. A list of Berninesque busts—though probably incomplete—may follow.

(1) Terracotta (75 cm.). Palazzo Chigi, Ariccia. Fig. 22.

(2) Bronze. Siena Cathedral (Riccoboni, p. 165, and Martinelli, *Bernini*, 1953, fig. 109, as Bernini).

(2a) Bronze (75 cm.). Metropolitan Museum, New York.

(3) Bronze. Formerly W. v. Dirksen Collection, Berlin. Sale Lepke's, 28 April 1931 (Catalogue, No. 464, pl. 57, height with base 97 cm.).

These four busts are closely related. They show one half of the mozzetta (the right of the figure) projecting, as if the arm were raised, and the other half receding; the projecting half with bold folds and a curved sweep of the lower edge. This conception, developing that of the Richelieu, is entirely in Bernini's spirit. But these busts are not by him. Martinelli, reversing his earlier opinion (*Bernini*, 1953, p. 136), attributed No. 2 to Melchiorre Cafà (*Studi Romani*, 1955, p. 52, note 49). This happy intuition was confirmed when the Metropolitan Museum acquired bust No. 2a with the following inscription at the back, cast together with the bronze: MELCHIOR. CAFA MELITENSIS FAC. AN. DOM. MDCLXVII. (For this work and the relationship of Nos. 1 to 4, see Wittkower, in *The Metropolitan Mus. of Art Bull.*, 1959, p. 197ff.).

*(4) Terracotta (68 cm.). Formerly L. Pollak and A. Muñoz Collections, Rome. In 1958 with Sestieri, Rome. (At this time the broken-off lower edge on the left was restored). Fig. 23.

Similar to the previous series of busts, but a different conception and, though a fine work, of less high quality. Accepted as original by Martinelli (*Ritratti*, p. 44f.), who regards it as close to the F. Poilly engraving after Bernini's early (lost) drawing of the Pope. But the terracotta lacks the depth of compassionate characterization which Poilly knew how to render in his medium and which one also finds in P. de Jode's engraving after Bernini's (lost) painting of 1659. In addition, the treatment of the lower part with the indecisive meandering folds of the mozzetta cannot be by Bernini's hand (compare the vigorous 'Berninesque' treatment of the same parts in Cafà's bust). At this stage of our knowledge, I am, however, not able to offer a convincing alternative name.

(5) Marble. Appartamenti Borgia, Vatican. In Fraschetti's days in the Bibl. Chigiana (illustr. p. 291). Derives from the type (1) to (3), but much weaker.

(6) Marble (80 cm.). Marchese Incisa della Rocchetta Collection, Rome. From Palazzo Chigi. Fig. 24. A different type: both 'arms' projecting; agitated, deep folds; marble highly polished. Good quality.

*(7) Bronze (79 cm.). Farnesina, Rome. (Fraschetti, illustr. p. 287). An isolated type: broad bust; nervous folds; good quality. Probably later than the other busts. To these should be added three busts of poor quality:

(8) Marble (79 cm.). Palazzo Chigi, Ariccia.

(9) Marble (76 cm.). Palazzo Chigi, Ariccia.

(10) Marble. In Fraschetti's days in the apartment of Prince Chigi (illustr. p. 290).

(8) and (9) are Berninesque, while (10) is only loosely connected with Bernini's studio.

Two busts of Alexander VII are listed in the inventory of Bernini's house made in 1706 (Fraschetti, p. 431). One of these had been presented to Pope Alexander VIII. The 'portrait of Alexander VII' which Cardinal Flavio Chigi acknowledged in a letter to Bernini, dated 27 April 1655 (BN., cod. Ital. 2082, fol. 82), may have been painted.

In 1688 N. Tessin (Sirén, 1914, pp. 176, 177) was shown two busts of the Pope by Bernini in the Palazzo Chigi, one in marble, the other in bronze. The marble is difficult to identify, but the bronze may be the one now in the Farnesina (7). In spite of the early date of the attribution —eight years after Bernini's death—the Farnesina bronze is surely by another hand. Alternatively, there may have been in the palace a bronze of the Pope, of which a poor bronze-coloured plaster after an original bronze cast by Lucenti survives in the choir of S. Maria di Monte Santo. Martinelli (*Ritratti*, p. 47, pl. 23), who drew attention to this cast, claims in my view correctly that an original Bernini creation lies behind it.

A bust of Alexander VII by Bernini's pupil, Giuseppe Mazzuoli, is mentioned in an old Chigi inventory and in Pascoli's *Life* of the artist (ii, p. 481). The bust (6) of our list shows idiosyncracies of his style and may be the bust to which the sources refer (first suggested by Martinelli, p. 46).

A bronze bust in Vienna (33 cm.), mentioned in the inventory of 1659 of the collection of Archduke Leopold Wilhelm, was published as Cafà's work by Schlosser (*Werke der Kleinplastik*, i, p. 15; see also Planiscig, *Bronzeplastiken*, 1924, No. 293). Its arrival in Austria before 1659 excludes this attribution. The bust may possibly be dependent on an Algardesque model (see No. 51) that was also used for busts of Innocent X.

66. MEMORIAL CHAPEL OF THE DE SILVA FAMILY. S. Isidoro (right of choir), Rome

FIGS. 101, 102

Double portraits of the founders in low relief framed like pictures, on l. and r. wall. Two over life-size allegories in full relief at the sides of each frame. Marble.

According to the inscription (left wall) the chapel was dedicated in 1663 (Forcella, ix, p. 11, Nos. 16, 17). The left wall shows the founder Roderigo Lopez de Silva and his wife Beatrix, accompanied by the allegories of Mercy and Truth; on the right wall is represented Roderigo's son Francesco Niccolò and his wife Giovanna, accompanied by the allegories of Justice and Peace. The

*See Addenda, pp. 273ff.

101. *DE SILVA CHAPEL, left wall.*
S. Isidoro, Rome (No. 66).

102. *DE SILVA CHAPEL, right wall.*
S. Isidoro, Rome (No. 66).

theme of the allegories illustrates the words of Psalm 85 (referred to in the inscriptions): 'Mercy and truth are met together; righteousness and peace have kissed each other.' The narrow chapel was quite unsuitable for the arrangement of memorial monuments. For this reason Bernini hit upon the idea of making the allegories so large and life-like that the beholder, who cannot step back, feels dwarfed by their overwhelming presence, while the portraits of the deceased seem to exist in a less tangible world. The development of his thought can be followed in sketches (Brauer-Wittkower, pp. 139–41). The allegories are joined physically and spiritually to the framed reliefs by the large black and white marble shrouds, the lower parts of which also bear the inscriptions.

Truth was originally nude, trying to free herself from the shroud, and Mercy pressed milk from her breast with both hands. The later additions of metal dresses painted black go far to spoil these figures and interfere with their meaning. In addition, eighteenth-century medallions with busts of members of the family placed above the framed reliefs even more disturb the original conception. One of the inscriptions explicitly mentions Bernini as the creator of the work: 'Immortale Bernini Equit. Ingenium Omnes Aeternat.' But Bernini's part cannot have gone beyond sketches for the altar (see Fonseca, No. 75) and the walls (Baldinucci, p. 180, lists the work under 'Opere di architettura, e miste'). Execution of the sculpture was, according to Titi (1674, p.

370) due to 'a son of Bernini'. This can only refer to Paolo, who was however too young at the time (fifteen years old) to have had a considerable share in the work. Judging from the style of the allegories, it seems that Bernini's devoted pupil Giulio Cartari was largely responsible and Paolo may have worked under him. It is also likely that Paolo Naldini contributed. He worked at the same time for Bernini at Ariccia and a drawing, possibly by him (Brauer-Wittkower, pl. 174b), shows side by side motifs of Ariccia and of the de Silva chapel.

★67. STATUES OVER THE COLONNADES OF THE SQUARE OF ST. PETER'S.

FIGS. I, III

Travertine, monumental size.

On 31 July 1656 Bernini was commissioned to make a design for the Square of St. Peter's. In the following years his scheme went through a number of stages (see Brauer-Wittkower, p. 69ff.). Between April 1659 and January 1660 a large wooden model of the colonnades was made, which corresponded to all intents and purposes with the colonnades as executed (*ibid.*, p. 81). As early as March 1659 the northern (right) arm of the colonnades was under construction and in June of this year all the columns of the inner ring were standing on this side.

At this stage Bernini had to consider the giant travertine figures of the martyrs and saints that were to crown the

★See Addenda, pp. 273ff.

103. *STUCCO DECORATION OF THE SCALA REGIA.* Vatican (No. 68).

columns. The wooden model showed small wax statu-
ettes (*ibid.*, p. 87, note 6), which in all likelihood were
based on Bernini's designs. Excluding the figures stand-
ing above the corridors which link the colonnades with
the church, 96 statues were needed; and it seems that
every one of them was carefully prepared by the master
(Titi, 1686, p. 3). A small number of surviving drawings
bears witness not only to Bernini's thoroughness, but
also to the fact that the sculptors who worked the figures
closely followed his designs (Brauer-Wittkower, pls.
65–7, 184a: studies for S. Fabiola, S. Maria Egyptiaca,
St. Mark).

The execution of these figures dragged on for a good
many years. According to a survey of 10 March 1667
only 32 of the 96 statues had been paid for (BV, cod.
Chig. H.II.22, f. 221). By that time Lazzaro Morelli,
Paolo Naldini, Andrea Baratta, J. A. Fancelli, Francesco
and Domenico Mari, Giovanni Cesare, Giovan Maria
Rossi and Nicola Artusi—most of them well-known
names—had taken part in the work (*ibid.*, f. 239r). In
the same document the names of other artists are sug-
gested in order to speed up completion. From experi-
ence it was estimated that it would take two months

to finish a figure (working in travertine is, of course,
much quicker than working in marble).

Lazzaro Morelli had the lion's share. Between 1661 and
1668 he executed at least nineteen figures (AFM) and
one more, St. Joseph, between January and May 1672
(AFG, 370). An unspecified number of figures was
placed in position between May 1667 and August 1668
(AFG, 362), others in the summer of 1669 (*ibid.*, 366)
and those in the centre of the northern arm in May 1671
(*ibid.*, 369) and July 1672 (*ibid.*).

The figures on the southern arm of the colonnades be-
long to a later stage. This colonnade was erected after
Alexander VII's death, between 1667 and 1671 (AFG,
362, 366, 368, 369). The figures above the corridors, not
executed until the early years of Clement XI's reign
(M. Loret, *Archivi d'Italia*, iii, 1936, p. 54ff.), are not
based on Bernini's designs.

68. STUCCO DECORATION OF THE
SCALA REGIA. Vatican, Rome FIGS. 103, V

The Scala Regia, the ceremonial entrance to the Vatican
Palace, formed an integral part of Bernini's planning of

the Square of St. Peter's. The new staircase was erected between 1663 and 1666 (Brauer-Wittkower, p. 93ff.). Sculptural decoration, suitable to its character and importance, was required. Two large stucco figures of Fame supporting the papal arms greet the visitor from the height of the arch under which the staircase proper begins. They announce the eternal glory of the Vicar of Christ, before whom the Emperor Constantine had bowed his knee. The latter here appears on horseback, on the right-hand side, at the moment of his conversion (see No. 73). The Constantinian theme is carried on in the medallions of the ceiling, which are supported by youthful genii: one of the medallions shows the Baptism of Constantine, the other Constantine laying the foundation stone of St. Peter's. Drawings prove that Bernini studied carefully the position and attitudes of the figures of Fame (Brauer-Wittkower, p. 96 and pl. 70b). They were executed by Ercole Ferrata as early as 1664 (AFM, No. 57).

The putto decoration on the ceiling at the turn of the staircase higher up is due to Paolo Naldini (1665, AFM, No. 106).

*69. THE VISITATION. Cappella Siri (third chapel left), S. Maria della Misericordia near Savona

FIG. 104

Marble relief, c. 3 × 2 m.

In 1642 the brothers Giambattista and Alessandro Siri secured designs from Bernini for the architecture of their chapel. Baldinucci (p. 180) lists the work under 'opere di architettura, e miste'. Behind the altar of the chapel is the large marble relief of the Visitation which, according to the contemporary Savona historian Angelo Lamberti, was carved by Bernini and put up in 1665 (Verzellino, *Delle memorie particolari . . . della città di Savona*, 1891, ii, p. 391f.). The relief, in fact, reached Savona in the autumn of 1664 (Bertolotti, *Gori's Archivio*, ii, p. 153). Bernini had probably agreed to making it. But in this case he must have handed the commission to another studio. Apart from Reymond, nobody has ever accepted this classicizing work without strong reservation. It is even unlikely that Bernini made a design for it or supervised the execution. Most probably the sculptor was Cosimo Fancelli, who had worked for Bernini on several previous occasions (C. Mezzana in *Atti del V Congresso Nazionale di Studi Romani*, iii, 1942, p. 531ff.).

*70. BUST OF LOUIS XIV. Versailles

PLATE 101, FIGS. 50, 51

Life-size marble. (80 cm.)

Bernini arrived in Paris on 2 June 1665, on the invitation of Louis XIV, who wanted him, there and then, to plan

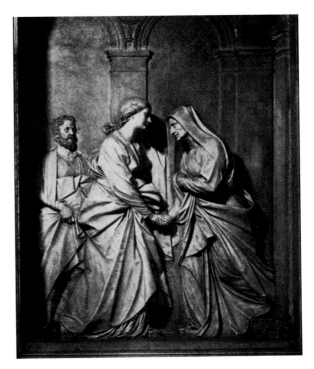

104. *THE VISITATION.*
S. Maria della Misericordia near Savona (No. 69).

the rebuilding of his residence, the Louvre. When he returned home five months later, he left nothing behind except the marble bust of the King. His plans for the Louvre were abandoned and none of his other Paris projects was taken up. The gradual evolution of the bust is better documented than almost any other work in the history of art, mainly owing to the diary entries of Bernini's French companion and interpreter Paul Fréart, Sieur de Chantelou. A chronological chart may indicate the course of events.

1665

11 June Preparatory moves made, leading up to the commission.

20 June Official commission.

21 June Choice of marble block.

23 June Bernini studies the King during his customary occupations. He repeats this on several subsequent dates.

24 June–12 July. Bernini makes a number of small models in order to clarify his general conception.

6 July Giulio Cartari begins the rough blocking-out of the bust. Later he worked most of the drapery, which was finished on 30 September.

8 July Bernini studies a suit of armour by Giulio Romano from the royal armoury, to be used as model for the bust.

14 July Bernini begins working the marble. He spends in all forty working days on it.

*See Addenda, pp. 273ff.

27 July A piece of taffeta is brought to serve as model for the drapery.

11 Aug.–5 Oct. The King sits for Bernini, the first of 13 sittings, each of about one hour.

10 and 13 Sept. Bernini designs the pedestal and explains its meaning. The bust should stand on a large globe, which was to rest on a drapery with emblems of victory and virtue in relief. Drapery and globe were to be enamelled and coloured; the land on the globe was to be gilded, and the water to be enamelled in blue. Across the globe was to appear the inscription: *Picciola Base*, expressing the idea that the whole world was but a small base for this monarch to stand upon.

21–4 Sept. Bernini works the Venetian bone-lace stock from a piece in the King's wardrobe.

1 Oct. A provisional wooden pedestal is provided.

5 Oct. Bernini declares the bust finished.

6 Oct. and following days, Bernini considers most carefully the right place for the bust.

13 Oct. Transport of the bust into the Louvre.

Later, when the King made Versailles his residence, he took the bust with him. The present simple pedestal reflects Bernini's conception in one respect: it is flanked by trophies.

Further to the history of the bust: Wittkower, *Bernini's Bust of Louis XIV*, London, 1951. See also *Arch. de l'art franç.* N.S., xvi, 1929–30, pp. 49–53.

An impressive early French copy in bronze (84·2 cm.) is in the National Gallery of Art, Washington (Fig. 51). It was perhaps made from a plaster cast which the King himself presented to the Academy (see *Mémoires inédits sur la vie et les ouvrages des membres de l'Académie Royale de Peinture et de Sculpture*, Paris, 1854, i, p. 236). Charles Seymour, Jr., *Masterpieces of Sculpture from the National Gallery of Art*, New York, 1949, p. 182, No. 49, claims a different pedigree and has reasons to believe that this unique bronze was not made from an early plaster cast.

*71. ELEPHANT AND OBELISK. Piazza S. Maria sopra Minerva, Rome

PLATE 102, FIGS. 105, IX

The elephant life-size, marble.

In 1665 a small obelisk was found in the garden of the Dominican monastery of S. Maria sopra Minerva. Alexander VII commissioned Bernini, immediately after his return from Paris, to erect it in the square in front of the church. The work was begun in April 1666 (Fraschetti, p. 306; Gnoli, *Arch. di stor. dell'arte*, i, 1888, p. 403; Brauer-Wittkower, p. 143) and unveiled on 11 July 1667 (Rossi, *Roma*, vii, 1929, p. 372). Execution was put into Ercole Ferrata's hands (Baldinucci, *Notizie*

*See Addenda, pp. 273ff.

105. *ELEPHANT AND OBELISK.* Bozzetto. Monument planned for the garden of Palazzo Barberini. Corsini Coll., Florence (No. 71).

dei Professori, 1847, v, p. 382), who closely followed Bernini's design.

In the impressive series of preparatory drawings Bernini revived two different unexecuted projects dating back to the pontificate of Urban VIII. As a surviving drawing and an original bozzetto (from Palazzo Barberini, now Corsini Collection, Florence; Fraschetti, p. 305) prove, Bernini had planned in the 1630's an elephant to carry an obelisk for the garden of the Palazzo Barberini. It was this old project that furnished the basis for the new design (full discussion of the whole complex problem in Brauer-Wittkower, pp. 143–7, pls. 14a, 109–12, 176, 177; see also Pane, pl. 116).

It is most unlikely that the three sketches of elephants on a sheet of the Gabinetto Nazionale delle Stampe e Disegni, Rome, published by H. L. Cooke (*B.M.*, xcvii, 1955, p. 320, fig. 21) are related to the monument.

Alexander VII was devoted to the conception of this monument. He concerned himself with the inscriptions of the base (BV, cod. Chig. I, vi, 205, fols. 340–1) and turned to the learned Athanasius Kircher for an interpretation of the obelisk; this was forthcoming before the monument was finished (*Obelisci Aegytiaci . . . interpretatio*, Rome, 1666).

The Pope's enthusiasm must be understood in terms of the emblematical message which the monument expounds. William S. Heckscher has discussed it in a learned paper (*Art Bulletin*, 1947, pp. 155–82), in which he concludes: 'Perhaps only the greatest artist of the Italian High-Baroque could resolve the paradox: to

portray in terms of a wild beast and a pagan obelisk the mental and spiritual aspirations of a forever ailing, scholarly Pope and beyond these, man's yearning for the intangible realm of Divine Wisdom.' The inscriptions on which Heckscher dwells at great length, supply the key to this interpretation. The poem from Kircher's work, printed on p. 31, is quoted from Heckscher's translation.

*72. ANGELS WITH THE CROWN OF THORNS and WITH THE SUPERSCRIPTION. S. Andrea delle Fratte, Rome

PLATES 103–6, 109, FIGS. 106, 107, II

ANGEL WITH THE SUPERSCRIPTION. Ponte S. Angelo, Rome PLATES 107, 108

Over life-size marble statues.

In 1536 Paul III commissioned Lorenzetti and Raffaello da Montelupo to place eight stucco figures on the Ponte S. Angelo for the reception of the emperor Charles V. These statues soon disappeared, but the idea of statues for the bridge, this time permanent ones, was taken up by Clement IX after his accession to the papal throne on 20 June 1667. He decided to have the bridge modernized and decorated with eight, later ten marble angels shown meditating over the Instruments of the Passion. On 11 November 1667 he had 10,000 scudi put aside for this purpose (Brauer-Wittkower, p. 160; Golzio, *Archivi d'Italia*, i, p. 143). Bernini was to direct the enterprise, and the most prominent Roman sculptors were invited to participate. In actual fact, twelve figures were executed, the two, now in S. Andrea delle Fratte, and ten presently on the bridge, two of which were commissioned as 'copies' after the Fratte angels.

In the first edition of this book I reconstructed the history of this enterprise mainly from documents published by Fraschetti (pp. 368, 370 and notes). My reconstruction encountered some criticism (Lavin, *Art Bull.*, xxxviii, 1956, p. 259f.), which seemed well considered, but left me unconvinced. In order to resolve the impasse, one had to return to the original documents. They have been checked and transcribed for me by Howard Hibbard, and it appears that Fraschetti, apart from supplying only excerpts (a fact that had aroused my suspicion), had blundered over some of the key documents. Since the events can now be recorded correctly, reference to the faulty chronology in previous publications has been dispensed with. The relevant data are supplied in the following chart (unless otherwise stated, from AS, Camerale I, *Giustificazioni di Tesoreria*, 169, no. 9).

1667
22 Sept. First payment for the purchase of eight blocks of marble for the statues. Payments for marble (later for ten pieces) continue through 1668.

17 Nov. Beginning of payments for construction on the bridge.

1668
27 July First payments to two of the sculptors (Naldini and Fancelli) who carve angels. First payments to Ferrata, Giorgetti, Lucenti, and Guidi were made by mid-August, to Raggi in November, and to Morelli in January 1669. Sculptural work, therefore, began between summer and autumn 1668. Regular payments to the eight sculptors run to July-November 1669, when their angels were finished. Final settlement of accounts on 20 July 1670. Neither Bernini nor his son Paolo received *a conto* payments (see below).

28 July *Avviso*: Clement IX inspects the bridge and, later, pays a visit to Bernini's studio, where he sees the Constantine, but not the angels for the bridge (as believed by Pastor, xiv, i, p. 541, note 3, and, following him, by me.)

1669
4 July One piece of marble ordered to Bernini's specifications, i.e., for one of the copies.

13 Sept. The first of the ten angels—that with the lance by Domenico Guidi—has been placed on the bridge; in the following days four more angels were in position (Fraschetti, p. 368, note 3). These five were inspected by the Pope on 21 September (Pastor, *loc. cit.*, note 6). Judging from the *a conto* payments these were, after Guidi's, the angels by Ferrata (with the Cross), Giorgetti (with the Sponge), Morelli (with the Scourge), and Naldini (with Garment and Dice). Fancelli's (with the Sudarium), Raggi's (with the column), and Lucenti's (with the Nails) seem to have been finished a few weeks later.

15 Dec. Second *a conto* payment of 150 scudi for two blocks of marble, which have arrived, for the copies of two angels (final payment, 2 August 1670). Payment for transport of these blocks 'to the houses of the two sculptors who make the copies of Cav. Bernini's two angels' only on 14 July 1670.

1670
10 and 23 July. First payments to Naldini and Cartari for their copies. The first *a conto* payment to Naldini states that his copy of the angel with the Crown was already finished ('già fatto da lui'). This seems to have been somewhat euphemistic, since the marble for the wings of this angel was not paid for until 16 May 1671. Both sculptors received final *a conto* payments on 15 September 1671 and final settlement for the two 'copies' to the total amount of 700 scudi on 12 November 1671.

20 July Final settlement for eight statues (see above, 27 July 1668), bringing the payment for each figure to 700 scudi.

*See Addenda, pp. 273ff.

17 Aug. Bernini and his son Paolo are each paid the whole sum of 700 scudi for the statues of angels 'made for the bridge'.

1671

10 Oct. Payment for two pieces of marble 'to make dowels for the angels being made for the bridge'.

28 Oct. *Avviso*: 'Now that the Cav. Bernini has finally finished his angel, the bridge is being visited by one and all . . .' (Fraschetti, p. 370, note 12).

14 Nov. Final settlement for putting up the two angels (i.e., the 'copies' by Naldini and Cartari) on the bridge; work was carried out between 12 October and 7 November.

We learn from these documents that eight angels and, by inference, also the two Bernini angels, i.e., ten altogether, were finished between July and November 1669 and that the marble for one of the replacement angels was ordered as early as July of that year. It would, therefore, appear that the decision to have the two Bernini angels copied was taken in June 1669, when they were close to completion.

Although Paolo, Bernini's son, who was twenty at the beginning of the undertaking (while all the other artists were middle-aged), received full payment, he cannot have done more than prepare the marble for his father. Paolo's few works (e.g. his relief of the Christ Child in the Louvre) bear out the opinion that he was a fumbling and less than mediocre sculptor. He has not a single work of any importance to his credit. He can neither have conceived nor fully executed one of the two angels now in S. Andrea delle Fratte. The contemporary sources ascertain that at the time of their completion both angels were regarded as exquisite creations by Bernini's own hand; moreover, the document of 14 July 1670 (see above, under 15 December 1669) mentions 'Cav. Bernini's two angels', and it is, indeed, impossible to discover any difference in quality between them (Lavin, *loc. cit.*, believes that Paolo prepared the angel with the Superscription, and Pope-Hennessy, *It. High Ren. and Bar. Sculp.*, 1963, Catal., p. 136, that he prepared the one with the Crown: one guess is as good as the other).

Baldinucci (p. 129) reports that when the Pope saw these two angels in Bernini's studio, he declared them to be too precious to be exposed to the inclemencies of the weather and commissioned two copies to replace them on the bridge. Baldinucci's source was probably Giulio Cartari (to whom he owed a great deal of information for his *Life*), Bernini's most beloved assistant in later years and an active participant in the events. The absolute trustworthiness of Baldinucci's account has now been proved by the documents. We have to assume that the Pope paid not only a visit to Bernini's studio on 28 July 1668, but also one—though unrecorded

—in June 1669, when he saw the two angels and pronounced his historic embargo. These two angels were, of course, never placed on the bridge, for if they had been, they would have been taken from there to the Palazzo Rospigliosi, Clement IX's family palace, since they were the Pope's property (Baldinucci, p. 178). Instead, they remained in Bernini's house until 1729, when his grandson presented them to the nearby church of S. Andrea delle Fratte (Brauer-Wittkower, p. 160, note 2). In consequence of the papal veto, Bernini prepared the angels for close indoor inspection. Their highly finished surface (contrasting with the treatment of the angels on the bridge) does not provide sufficient reason to doubt that until June 1669 Bernini had intended them for exhibition in the open air.

Baldinucci (*loc. cit.*) and, following him, Domenico Bernini (p. 139) explicitly state that Bernini made in all secrecy a second version of the angel with the Superscription, because 'he absolutely insisted that a papal enterprise should not be without a work by his hand'. The 'secret' seems soon to have leaked out and was generally known at the time the angel was being put up on the bridge (see the above mentioned *avviso* of 28 October 1671). The angel referred to in the sources can be only the second angel with the Superscription on the bridge. It is also listed in Baldinucci's catalogue as by Bernini. One is therefore led to conclude that Bernini designed the second angel with the Superscription and had it prepared by Cartari who, like Paolo Bernini, belonged to the household. The procedure of Paolo's angel was repeated: Bernini granted full payment to his amanuensis, but finished the angel himself late in 1671. It must be emphasized that the Bernini-Cartari 're-placement' is an entirely new creation, while Naldini's angel with the Crown is essentially a simplified version of Bernini's original. (H. G. Evers, *Die Engelsbrücke in Rom*, Berlin, 1948, p. 15ff. [Der Kunstbrief No. 53] has come to similar conclusions). Like Paolo, Cartari had never before been given a monumental task. He seems to have satisfied Bernini more fully than the son, for it was Cartari and not Paolo, who became a sculptor in his own right and a trusted executor of his master's ideas (tomb of Alexander VII).

It has now become quite clear that Bernini's work for the bridge proceeded in two separate stages, a first one during the summer of 1668, when he conceived the two angels now in the church, and a second at least a year later (between July 1669 at the earliest and July 1670), when he planned the angel now on the bridge. (I emphasize the time lag between the two phases in view of the hypothetical reconstruction of procedure suggested by Lavin, *loc. cit.* and, following him, Hibbard, *Bernini*, 1965, p. 243 f.) The time lag between the completion of the two angels in the church and that on the bridge was probably even more than two years.

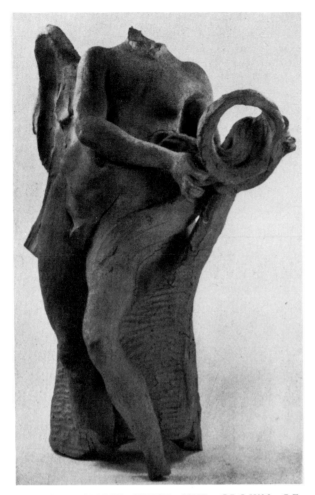

106. *THE ANGEL WITH THE CROWN OF THORNS*. Bozzetto.
Fogg Museum of Art, Cambridge, Mass. (No. 72).

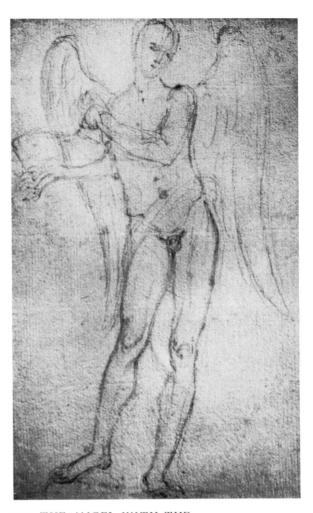

107. *THE ANGEL WITH THE SUPERSCRIPTION*. Drawing.
Galleria Nazionale, Rome (No. 72).

Bernini developed the first two angels in conjunction, as a unified closely interrelated task. This can be abundantly proved by some drawings (Brauer-Wittkower, pl. 120a, b) and many bozzetti, which allow a rare insight into his working method (i. Palazzo Venezia, Rome; Santangelo, *Catalogo*, 1954, p. 78f., fig. 87; ii. Louvre; iii. Two bozzetti, Richard S. Davis Collection, London; iv. Two bozzetti, Hermitage, Leningrad; v. Five bozzetti, Fogg Art Museum, Cambridge, Mass.: 1937. 57, 58, 67, 68, 69; see Norton, 1914, pls. 19b, 21, 22, 23a, b).★ In most of the preparatory work and in the execution the heads of the angels are turned away from their symbols. Throughout the whole series of preparatory studies as well as in the execution the angel

★ The Louvre bozzetto and the bozzetti of the Davis Collection were first mentioned by Irving Lavin in his unpublished Harvard Dissertation *The Bozzetti of Gianlorenzo Bernini*, 1955. The hitherto unpublished Leningrad bozzetti were brought to my attention in a term paper written for me by Theodore Feder in 1961.

with the Crown is holding his symbol to his left, while the angel with the Superscription is holding his symbol to his right. In all the studies for the latter angel the left leg carries the weight of the body and the right leg moves freely. The stance is reversed in the early drawings and bozzetti for the angel with the Crown so that both angels are holding their symbols over the free-moving leg and form balanced counterparts in every respect. At first and for some time Bernini, reverting to the angels framing the Cathedra (Pl. 94), planned these angels as a complementary pair clad in comparatively unruffled chiton-like garments. The bozzetto and the drawing illustrated here (Figs. 106–107) belong to a stage in the development during which both angels, studied as nudes, were still almost heraldic counterparts. But it is likely that at this moment the garments were to be given stronger accents as shown in the bozzetto of the angel with the Superscription in the Davis Collection; in any case, the nude drawing Fig. 107 has a curving diagonal sweeping from the left hip around the right leg corresponding to a tight piece of cloth in the Davis

bozzetto. Later, Bernini abandoned bilateral symmetry: two bozzetti of the angel with the Crown (Fogg 1937. 57, Norton, pl. 22, and Davis Collection) show the final stance of the legs corresponding to, and no longer reversing, that of the angel with the Superscription. The original concept of creating a complementary pair is still noticeable in the marble angels, but it was superseded by an emphasis on contrasts in expression, proportion and the treatment of garments. The angel with the Crown, relatively massive and 'round' like the symbol he is holding, combines the wind-blown drapery of the Cathedra angels with the new motif of the boldly projecting arc of drapery which almost bisects the body. The other angel, a 'neurotic', fittingly with extremely slender proportions (first conceived of in the drawing, Fig. 107), is dressed in a garment with flatter folds which break, crumble and roll up in circular patterns. Further to the contrast now intended, above p. 10.

When planning the second angel with the Superscription, Bernini was no longer thinking in terms of a dual creation. This angel has to be considered alone, without reference to a counterpart. As pointed out in the text, features from both earlier angels were here combined. Two bozzetti (Fogg 1937. 67, Norton, pl. 23b, and Leningrad) prepare this solution. A second bozzetto in Leningrad shows that Bernini also considered the new version of the angel with the Crown: Naldini's simplifications are based on suggestions made by the master himself.

It is not easy to assess precisely Bernini's relation to the work of the other sculptors. Apart from some drawings by various hands (Brauer-Wittkower, p. 160, note 3, to which a red chalk drawing with three angels in the Witt Collection No. 3047, Courtauld Institute, London, should be added), there are three sheets with five angels in the Pallavicini Collection, Rome (i. Angel with the Superscription; ii. with the Scourge and with Garment and Dice; iii. with the Crown and with the Nails; first published by L. Grassi, *Arti figurative*, ii, 1946, p. 186ff.; see also Zeri, *La Galleria Pallavicini in Rome*, Florence, 1959, Nos. 40–2) and two others formerly in the Rospigliosi Collection (i. Angel with the Cross; ii. with the Sponge; see Fraschetti, pp. 372, 373). This series of seven angels is probably original (the two sheets with two angels each are already mentioned as by Bernini in the Pallavicini inventory of 1713, see Zeri, pp. 312, 313. —Of the two drawings *ex* Richardson, C. Rogers, J. McGowan, H. Harris collections, sale Christie's 18 June 1937, that of the angel with the Cross is a replica of the Rospigliosi drawing and that of the angel with the Column most likely a replica after a lost original).†

† After the proofs had come to hand, Mark Weil informed me that he had found the original in the Gabinetto Nazionale Stampe, Rome.

★See Addenda, pp. 273ff.

The Pallavicini-Rospigliosi series must have been sketched by Bernini in the autumn of 1667, quite at the beginning of his occupation with this enterprise, for all the angels are shown standing on square bases rather than on clouds (Zeri's dating 'between about 1665 and 1669' has to be corrected). Bernini seems to have distributed such sketches among his team to insure coherence of the work by many hands. In support of this assumption Raggi's (?) drawings of the angels with the Cross and with the Column at Düsseldorf (I. Budde, *Beschreibender Katalog der Handzeichnungen in der Staatl. Akademie in Düsseldorf*, 1930, Nos. 117, 118) may be quoted, which are derived from Bernini's originals. In some of the marbles the dependence on Bernini's designs is fairly obvious. Lazzaro Morelli's angel with the Scourge, for instance, is closely akin to one of the bozzetti in the Fogg (1937.68). Other masters appear to have worked more independently as revealed by personal idiosyncrasies of style. For the distribution of angels among the individual sculptors, see above, p. 248 and F. Bonanni, *Numismata summorum pontificum*, 1699, ii, p. 716 (Reymond's attempt, *Rev.*, xxxii, 1912, p. 99f. was not quite successful; see also A. Nava, *Illustr. Vaticana*, vii, 1936, p. 619ff. and Evers, *op. cit.*, p. 16).

★73. CONSTANTINE THE GREAT. Scala Regia, main landing, Vatican
 PLATES 110, 112, 114, 115, FIGS. 108, 109

Monumental equestrian statue, marble, in front of a painted stucco drapery.

As early as 1654 Bernini had been commissioned by Innocent X to create a statue of Constantine in St. Peter's as a counterpart to the monument of the Countess Matilda (Fraschetti, p. 318, note 4). On 5 September 1654 Cardinal Fabio Chigi entered into his diary that Bernini had come to see him and shown him the design of the Constantine (Rossi, in *Roma*, xvii, 1939, p. 176). Up to August 1657 he had received 900 scudi (Brauer-Wittkower, p. 103, note 2). During the reign of Alexander VII the work was at first abandoned, and when it was taken up again, conditions had changed. It was no longer planned for inside the church, but was to become on the 'piano reale' of the newly designed Scala Regia the point of focus from the portico of St. Peter's. In the summer of 1662 Bernini was again working on the giant equestrian monument. At that time both Queen Christina of Sweden and the Pope saw him engaged on this task (Domenico Bernini, p. 103ff.; for the date of the Pope's visit see Pastor, XIV, i, p. 511, note 10). On the occasion of a later visit to Bernini's studio the Pope inspected the finished statues for Siena (No. 63) and, according to Domenico Bernini (p. 106), also the finished Constantine. But since this visit cannot have

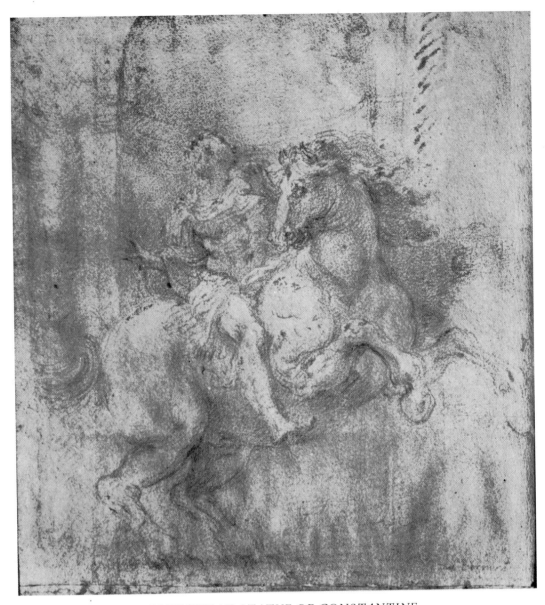

108. *STUDY OF THE EQUESTRIAN STATUE OF CONSTANTINE.*
Academy of S. Fernando, Madrid (No. 73).

taken place later than the early summer of 1663, Domenico must have been mistaken: while in Paris in 1665 Bernini himself mentioned the work as being still in progress (Chantelou, p. 205). Even in November 1667 it was not entirely finished (AFG, 1667); but on 13 July 1668, when he received a payment of 1,000 scudi, the statue is described as *fatta* (*ibid.*, 1668). On 28 July 1668 the Pope inspected it in Bernini's studio (Rossi, *op. cit.*, p. 543). It remained there, while the large marble pedestal was being worked. Preparations for the pedestal had begun in October 1666 (Brauer-Wittkower, p. 103, note 7); in August 1668 it was in course of execution (AFG, 362); between December 1668 and January 1669 the statue was transported to the Vatican (*ibid.*, 362 and 366); it arrived at its destination on 12

January (Pastor xiv, i, p. 541, note 4) and on 1 November 1670 it was unveiled by the Pope (Fraschetti, p. 318, note 5). On 14 December 1671, Bernini received a final payment of 2,100 scudi in settlement of the total sum of 7,000 scudi (AFG, 369). This large sum indicates that the execution must have been essentially his. Moreover, no payments to other sculptors are mentioned in the documents. See also Girardon's letter of 4 February 1669 (Francastel, *Girardon*, p. 45).

One would be tempted to believe that the monument planned by Innocent X for an unspecified place in St. Peter's *ad similitudinem* (as the document says) to that of Matilda (29 October 1654, AFM, 163) and the present equestrian monument were two separate commissions. One may wonder where a suitable place for a Constan-

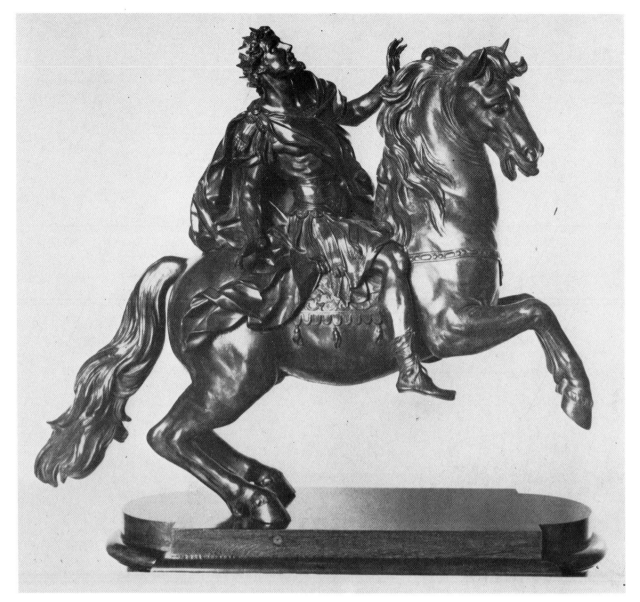

109. *FOLLOWER OF BERNINI: CONSTANTINE ON HORSEBACK*. Bronze.
Ashmolean Museum, Oxford (No. 73).

tine on horseback inside the church can be found. Such doubts, however, have to be dismissed. Filippo Frugoni, the agent who transported the marble in 1654 (AFM, 59, f. 31), mentions in a document of 6 March 1656 (AFM, 163, f. 73), that the weight of the marble was over thirty 'carretate' (roughly 'cartloads') and this corresponds precisely to what Domenico Bernini (p. 107) quotes as the weight of the block of the present monument. In the first edition of this book I had surmised that the monument planned for the basilica was represented in the drawing Brauer-Wittkower, pl. 164a. This assumption is confirmed by a hitherto unpublished original chalk drawing in the Academy of S. Fernando in Madrid (Fig. 108), which corresponds almost entirely with the studio drawing, just mentioned, but—in

contrast to the latter—shows the niche in St. Peter's for which the monument was planned. The niches in St. Peter's identical to that of the Countess Matilda are about 3 m. wide without the framing columns and about 5·50 m. with them (they are visible in the drawing, a fact that dispels any doubt as to the locality). The horse's trunk, slightly exceeding the width of the niche, would be over 3 m. long. This is, in fact, the present size of Constantine's horse. A revealing observation can now be made: the block which Bernini had begun in 1654 made it impossible for him to alter the scale of the monument when, after an interruption of five years, the new position on the main landing of the Scala Regia was chosen for it. The area that had now to be filled, was too large for the monument already in *statu*

nascendi. Bernini solved this problem by devising the magnificent drapery motif as a foil for the equestrian statue. The drapery forms optically part of the monument and thus helps to enhance its actual size. As so often, starting from necessity, Bernini hit upon a new and most effective idea (further to the 'function' of the drapery, Wittkower, *Art and Architecture,* 1965, p. 105). The niche in St. Peter's originally selected for the Constantine was most likely that of the first pillar of the right aisle (Matilda occupies the second pillar). This niche, now taken up by Carlo Fontana's monument to Queen Christina, was empty at the time and would have been the obvious choice for the project.

The drawings Brauer-Wittkower, pls. 71 and 72, and a splendid, but very damaged terracotta bozzetto in the Hermitage, Leningrad (45×28 cm.), recently published by G. Matzulevitsch (*Boll. d'Arte,* xlviii, 1963, p. 71f.), which incorporate changes and adapt the monument to its present position, open the second stage of 1662. Such changes of attitude were possible since—according to Domenico Bernini (p. 93)—the monument was only blocked out in the rough ('abbozzato') during the reign of Innocent X. Bernini's concern with historical 'correctness' is revealed by an excerpt in his own hand from Nicephorus' *Ecclesiasticae historiae libri XVIII* (bk. 8, ch. 55) referring to a description of Constantine's appearance (BN., cod. Ital. 2084, f. 195). A rare bronze of the Constantine (36×36 in. Whitehead Sale, Christie's, 10 May 1898; Leopold Hirsch, Christie's, 8 May 1934; W. R. Hearst), now in the Ashmolean Museum, Oxford (Fig. 109), has some features in common with the Leningrad bozzetto (horse's mane; Constantine's cuirass), but others lead away from Bernini and point in the direction of Giovanni Battista Foggini, who studied in Rome under Ferrata between 1673 and 1676. The sculptor may have used a Bernini bozzetto as a starting point for his version.

Immediately after the statue had been put up it was savagely criticized. Both its hypertrophic realism and its lack of realism were attacked. Bernini, it was said, reached here a climax of errors: Constantine could not maintain himself in this position without stirrups and reins; he had the beard of a satyr and looked like a man from the Campo di Fiore, etc. (*Avvisi* published by Rossi, in *Roma,* xvii, 1939, p. 543f., and xviii, 1940, p. 58). A lengthy polemic tract, recently published by Previtali (*Paragone,* xiii, 1962, No. 145, p. 55ff.), pulls the entire work to pieces: Constantine has the airs of a St. Francis receiving the stigmata, while the Cross is invisible; he is too small for the horse and looks like an ape on a camel; the head is miserable and the face resembles a groom rather than an emperor; the horse is suitable for a Pegasus, its neck is too slender and its tail without proportion, etc. Sarcastic innuendoes are made also against other works: Bernini's love, Costanza

Bonarelli, appears as Charity on the tomb of Urban VIII; in the Teresa a pure virgin had been pulled down to earth and become Venus not only prostrate, but also prostituted. For a different interpretation of the Constantine, see above, p. 23f. (also Wittkower, in *Miscellanea Bibliothecae Hertzianae,* Munich, 1961, p. 466ff.).

74. EQUESTRIAN STATUE OF LOUIS XIV.
Versailles, Gardens, behind the Bassin des Suisses
PLATES 111, 113, FIGS. 110-112

Monumental marble.

The idea of a monumental equestrian statue of the King first occurs in talks with Chantelou on 13 August 1665 (p. 96). From 1667 onwards the project becomes tangible. We can follow its realization in a veritable flood of letters, despatches and memoirs, of which only a part had been published in 1955. The entire documentation is now available in my paper of 1961 (in *Essays in Honor of Erwin Panofsky,* p. 497ff.). The following note gives the barest outline of the tragic story of the monument. (References in brackets refer to my paper.)

First a skeleton of dates: May 1669 payment for marble (doc. 20); after July 1669 transport of marble to Bernini's studio (docs. 21, 22, 24 and p. 501, note 10). After 30 December 1669 terracotta model (doc. 24). May 1671 work on the marble has begun (doc. 33); August 1673 the statue is almost finished (doc. 57); November 1673 Bernini's friend, the Jesuit General Padre Oliva, gives an enthusiastic description of the statue (doc. 60).

These dates tally with Baldinucci's statement (p. 126) that the work was carried out in four years. But from the circumstantial report of the eye-witness Domenico Bernini (pp. 148, 152) it can be inferred that the statue was not entirely completed until 1677 (p. 511, note 66). For many years it remained in Bernini's studio. Transport began in July 1684 (doc. 72) and Parisians saw it in March 1685 (doc. 78). It was taken straight to Versailles (doc. 80), where the King saw it for the first time (doc. 81). He was extremely dissatisfied and wanted to have it broken up. Later he banished it to the farthest corner of the garden at Versailles. Finally, by changing the headgear and turning the rock beneath the horse into flames, Girardon in 1688 transformed it into a Marcus Curtius (p. 514).

In a letter of 6 December 1669 (doc. 23) Colbert asked Bernini to make the statue similar to that of Constantine, but not to copy it, to execute the head himself and to use the students of the French Academy in Rome to do the rest, but to touch up the whole, 'so that one can truly say that it is a work by your hand'. Bernini answered on 30 December (doc. 24) explaining that he would first make the terracotta model himself. This splendid model fortunately survives (Gall. Borghese, Rome. H. 76 cm. Brinckmann, BB., pls. 30-3; Faldi,

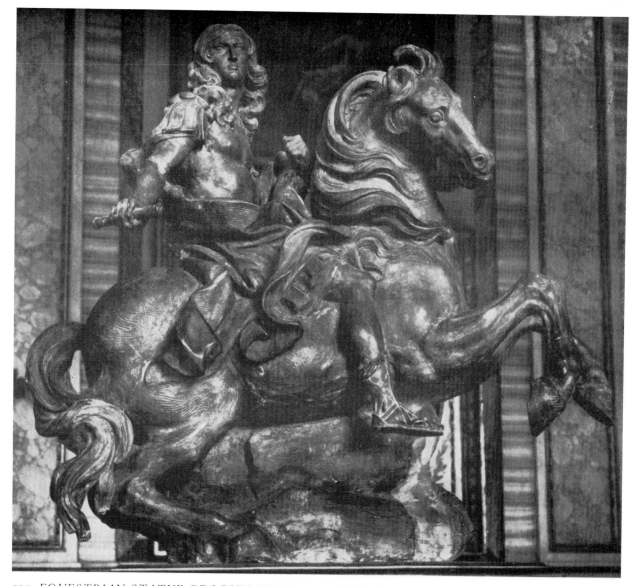

110. *EQUESTRIAN STATUE OF LOUIS XIV.* Bozzetto. Galleria Borghese, Rome (No. 74).

Gall. Borghese, 1954, p. 41f., No. 38). Bernini goes on: 'I shall assist continuously those young men who are going to copy the model. . . . Then I shall make the head of His Majesty entirely myself. . . . This statue will be completely different from that of Constantine, for Constantine is represented in the act of admiring the vision of the Cross and that of the King will be in the attitude of majesty and command.'

But Bernini wanted more than this. He had in mind a literary conceit, and the knowledge of this is essential for the understanding of his design. By combining his own words to Chantelou with Baldinucci's and Domenico Bernini's explanations, it appears that he interpreted the monument in terms of Hercules symbolism: Hercules-Louis has reached the summit of the steep hill of virtue and glory. (Further to Bernini's *concetto*, Wittkower, *op. cit.*, p. 505ff.). The piece of rock

under the horse's body (see in the bozzetto) must be regarded as the summit of the large rock mentioned by Bernini. An idea for the formation of the rock is shown in a preparatory drawing at Bassano (Fig. 111; Degenhart, *Kunstgesch. Jahrb. d. Bibl. Hertziana*, i, 1937, p. 245).

Two hitherto unpublished drawings in the Department of Prints and Drawings, National Gallery of Scotland, Edinburgh (D. 3208. 49×37·5 cm.), brought to my attention by Mr. Keith K. Andrews, show front and back of the monument (Fig. 112). They do not entirely agree with the execution and seem to represent a stage of Bernini's design following directly after the Bassano drawing. Two scales on top of Fig. 112 according to Roman palmi and French piedi indicate that the drawings were done in Rome to be sent to Paris in order to furnish the French with a 'photographic' likeness of the work. A design to be made for precisely this purpose is

111. *EQUESTRIAN STATUE OF LOUIS XIV.*
Drawing. Museo Civico, Bassano (No. 74).

112. *DRAWING AFTER THE EQUESTRIAN MONUMENT OF LOUIS XIV.*
National Gallery of Scotland, Edinburgh (No. 74).

first mentioned on 8 December 1671 (doc. 36) and again on 14 September 1672 (doc. 47), but on 27 October 1673 Colbert had not yet received it (doc. 58). After Bernini's death, Colbert, on 19 February 1682, peremptorily requested 'a most exact drawing' (doc. 71). It is more than likely that the Edinburgh drawings were made in answer to this request (by an Italian as the Italian inscriptions of the scales reveal), but instead of copying solely the finished work, as Colbert directed, the draughtsman must also have made use of late working drawings in the studio, probably dating from 1673. Clearly visible signs of tracing may indicate that more than one set of these drawings was circulated. The drawing here illustrated is of particular interest because it supplies the only reliable documentation for the head of the King as executed by Bernini.

75. BUST OF GABRIELE FONSECA.
S. Lorenzo in Lucina (fourth chapel to the right), Rome
PLATES 116-8, FIG. 113

Over life-size marble.

The Portuguese Gabriele Fonseca was Innocent X's physician until 1654, when he fell out of favour (Fraschetti, p. 376). About 1663 Fonseca, whose family

commanded considerable wealth, must have procured designs by Bernini for his chapel in S. Lorenzo in Lucina. Although not mentioned by Baldinucci or Domenico Bernini, the chapel appears as the work of Bernini as early as 1668 in Franzini's *Roma antica e moderna* (p. 114). By 1664 the decoration of the chapel must have been fairly well advanced, for the shape of Giacinto Gimignano's picture on the right-hand wall, signed and dated 1664, is conditioned by the character of the architecture. The altar wall, showing the oval painting carried by gilt bronze angels in high relief (prepared in a studio drawing now at Windsor, 5599, Fig. 113), is closely related to the main altar at Castel Gandolfo (1660-1) and to that of the Cappella de Silva at S. Isidoro (1663). Jubilant putti and angels in white stucco populate the flat vault. All this is characteristic of Bernini's style of the early 1660's. The stucco decoration may be, as Donati (p. 501) suggested, by Giovanni Rinaldi, whom Bernini employed in S. Andrea al Quirinale and on the tomb of Alexander VII.

The four deep square niches, placed at eye level, were destined for busts of the Fonseca family. But Bernini executed only the bust of the donor for the left-hand niche. Critics disagree as to its date (e.g. Riccoboni, p. 162: 1661; Brinckmann, p. 248: c. 1665;

Fraschetti, p. 441: 1668; Benkard, p. 44: 1669–70). We may presume that this bust (and possibly others) was commissioned together with the chapel as early as 1663. But its style clearly shows that Bernini did not execute it at that time. It is more intimately connected with the works of the 1670's than with those of about 1665; the formal and spiritual similarity to such works as the Beata Lodovica Albertoni (No. 76) or the engraved frontispiece to the third volume of Padre Oliva's *Prediche* of 1677 (Brauer-Wittkower, pl. 197b) is indeed very great. But Fonseca died on 20 May 1668, and this portrait, of the highest quality and entirely worked by Bernini himself, was surely done from life. It seems reasonable to suggest that the bust was begun before 1668, but that its completion dragged on until after the sitter's death. It may even be that the bust was placed in its niche after 1674, for in his reliable guide of that year, Titi does not mention it, although he lists the paintings in the chapel.

113. *DRAWING FOR THE ALTAR OF THE FONSECA CHAPEL.*
Royal Library, Windsor Castle (No. 75).

*See Addenda, pp. 273ff.

***76. THE BLESSED LODOVICA ALBERTONI.**
Altieri Chapel, S. Francesco a Ripa, Rome

PLATES 120, 121, FIG. 114

Over life-size marble figure.

The Altieri Pope Clement X was raised to the papacy on 29 April 1670. Shortly after that date Cardinal Paluzzo degli Albertoni seems to have commissioned this work from Bernini (Baldinucci, p. 130). The date *post quem* is probably 28 January 1671, when Clement X sanctioned by a *breve* the cult of the Blessed Lodovica Albertoni (Pastor, xiv, i, p. 637; see also Brauer-Wittkower, p. 165). To regard 1671 as the year of the beginning of the work finds support in the fact that Bernini used the reverse of a sheet with a sketch of the Blessed (Brauer-Wittkower, pl. 127a) for his composition of the *Sangue di Cristo* of that year (*ibid.*, p. 166f.). When Titi prepared his guide-book of 1674, the statue was not quite finished (p. 54). But Bernini's pupil, Giulio Cartari, speaks of it in a letter of 14 October 1674, as if it were completed (BN, cod. Ital. 2084, f. 114). Thus the work is fairly accurately datable: 1671–4. (As a rule, it is dated too late, see Fraschetti, p. 396f.)

Martinelli (in *Il Seicento Europeo*. Exhibition Catalogue, Rome, 1957, p. 257f. and *Commentari*, x, 1959, p. 221) obscured the intrinsic logic of these data by reference to an *avviso* of 17 February 1674 which was known to me since it had been published by Rossi (*Roma*, xix, 1941, p. 29), but to which I did not refer in the first edition because it is not a reliable source for the dating of the work. The *avviso* says verbally: 'When Cardinal Altieri wished to erect a statue in relief (*sic!*) in honour of the Beata Albertoni, a number of artists competed, but the Cavaliere Bernini was preferred because he offered to work without pay.' The *avviso* was clearly written by one of Bernini's detractors who intended to debase the artist. If anything, it reveals by implication that everyone knew that this work was in course of execution and that it was timely to let it out why Bernini had been commissioned. It is not permissible, as Martinelli wants, to conclude from the *avviso* that at first a relief composition was planned (*avvisi* are notoriously unreliable) nor that the work was begun in 1674 and finished in 1675. More substantial proof is needed to disqualify the above quoted statement by Cartari, who was very close to Bernini. In addition, a fairly long period must be allowed for this work essentially carved by Bernini himself, for through the years 1672 and 1673 he was intensely engaged on such major works as the equestrian statue of Louis XIV (No. 74), the tomb of Alexander VII (No. 77) and the altar of the Cappella del Sacramento (No. 78). If the *avviso* is useless as a primary source for the dating of the work, it may still be correct with regard to the information it intended to circulate. Martinelli himself has shown (*op. cit.*, 1959,

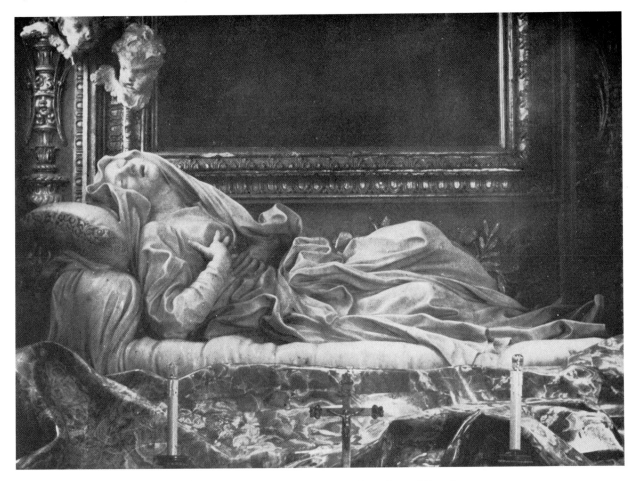

114. *THE BLESSED LODOVICA ALBERTONI.* S. Francesco a Ripa, Rome (No. 76).

p. 208ff.) that Bernini often worked for the Altieri without compensation in the course of the 1670's—as a kind of 'bribe', in order to suppress publicity concerning a criminal offence committed by his brother Luigi. The latter's misconduct took place on 20 December 1670 and through the following months Bernini tried everything in his power to avert a public scandal.

Paluzzo degli Albertoni's nephew Gaspare had married the Pope's niece Laura Caterina—sufficient reason for Clement X to grant the Cardinal permission to adopt the family name Altieri (Pastor, *loc. cit.*, p. 619). But the Cardinal honoured the name of his own family by commemorating the Blessed Lodovica Albertoni.

G. B. Gaulli's painting of the Virgin and Child with St. Anne, behind and above the statue, is not yet mentioned in Titi's edition of 1674. A drawing by Gaulli in the Musée Atger at Montpellier shows the design for the gilt frame of the picture. He also drew the figure of Lodovica, evidently from the finished marble, in order to study—it seems—its relation to the frame behind. This might be interpreted as an indication that Gaulli's picture was an afterthought. A sketch by Bernini, however (Brauer-Wittkower, pl. 93a) proves that he con-

cerned himself with the plastic decoration of the frame, and fragments of an original drawing at Leipzig (58–117, 59–118, unpublished) show details of the frame itself.

The statue is placed at the far end of the Altieri chapel in an isolated recess behind the altar. The recess is brilliantly lit by a concealed window on the left. (Hibbard, *Bernini*, p. 244f., observed that there was originally also a window on the right which is now almost entirely walled up). Since the chapel itself is fairly dark, the visitor standing in the nave of the church is looking through darkness into light: above the altar he finds lit, as by magic, the mirage of the dying Blessed. A colourful drapery, spreading in large folds in front of the couch on which she lies, forms a tangible link between her and the chapel. The custom of placing under the altar the sculpted figure of the saint to whom it was dedicated, was not rare after Maderno's S. Cecilia (1600). But to have the figure lying above the altar and to transform, at the same time, the altar itself into a *sepulcrum* by giving it the form of a sarcophagus—that was probably without precedent. Camillo Pacetti's St. Anne in S. Andrea delle Fratte, made in imitation of Bernini's Lodovica Albertoni, was placed again under

the altar, marking a return to the traditional practice. A small replica in marble is in the Giocondi Collection, Rome (Fraschetti, p. 396).

Martinelli selected a terracotta bozzetto in a Roman private collection (38 cm. long) for inclusion in the 1957 Seicento Exhibition (*op. cit.*, No. 338), although according to the text of his catalogue entry he did not seem to regard it as by Bernini's hand. In *Commentari*, x, 1959, p. 221, he described it as 'very close to the lost original'. It varies slightly from the execution and may well be by one of Bernini's assistants, e.g. Cartari.

*77. TOMB OF POPE ALEXANDER VII.
St. Peter's, Rome PLATES 122–6

Over life-size marble figures; the figure of Death is in gilt bronze.

The commission for the tomb was given by Alexander himself (Baldinucci, p. 130; Domenico Bernini, p. 154). After his death Cardinal Flavio Chigi became the executor of his uncle's wishes. Alexander's successor, Clement IX, wanted the tomb to be erected in the choir of S. Maria Maggiore (Brauer-Wittkower, p. 168). Drawings for this early stage survive (*ibid.*, pls. 129, 130) containing ideas which were incorporated into the final design: namely, four allegories and the kneeling statue of the praying Pope above a tomb-chamber.

In 1670, shortly after the death of Clement IX (1669), the idea of erecting the tomb in S. Maria Maggiore was abandoned together with Bernini's plans for reconstructing the choir (Mercati, *Roma*, xxii, 1944, p. 18ff.), and a place in St. Peter's was chosen. The choice fell on a relatively narrow passage of the south transept where the tomb had to be fitted into a niche containing a door, which Bernini brought forward. A fresco by Romanelli had to be transferred (Passeri, ed. Hess, p. 307, note 3).

The present tomb is one of the great combined enterprises of Bernini's studio. Its history, based on the documents of the Chigi archive, was first given by Fraschetti (pp. 384–91) and more fully by Golzio (pp. 117–47). From the documents it is possible to piece together Bernini's procedure at a time when the subdivision of labour had reached its climax.

Bernini himself made drawings and a small model of the whole tomb. On 7 October 1672 he received 1,000 scudi for the design and model. A preliminary design, made in the studio, incorporating the principal features of the tomb, survives in the Royal Library at Windsor (Brauer-Wittkower, p. 169f., pl. 183). An original bozzetto of 'Charity' is in the Istituto delle Belle Arti Siena (Vigliardi, *Rass. d'Arte Senese*, xiii, 1920, p. 36ff.; Brinckmann, BB., ii, p. 74ff.), another, for the figure of the kneeling Pope, in the Victoria and Albert Museum (A 17–1932; see Pope-Hennessy, *Cat. of the Ital. Sculptures*, 1964, p. 606f., fig. 633).

Payments for the tomb begin on 16 December 1671. Between January and September 1672 Giovanni Rinaldi was paid for the large models of the four allegories, of Death, and of the shroud. In addition, Giuseppe Mazzuoli had a hand in preparing the model of Charity and Lazzaro Morelli in that of the shroud.

In the execution of the figures four stages must be differentiated: (1) the preparation of the marble blocks in the rough, done by a stonemason; (2) the chiselling of the figures, done by sculptors of repute; (3) the finishing work with the rasp, i.e. the smoothing off of the surfaces for which a young and not very experienced sculptor was used; and (4) the final polishing of surfaces, a specialized job done by a 'lustratore'. In addition, Bernini himself had a hand, at least, in the statue of the Pope (Golzio, p. 144): he probably put the finishing touches to the face.

The stonemason Tomaso Santi prepared the blocks for Charity, Truth and the figure of the Pope. Pietro Balestra, who acquired some fame in later years, did all the rasp work and Domenico Sicurati was the 'lustratore'. Charity was carried out by Giuseppe Mazzuoli between May 1673 and November 1675; Truth first by Lazzaro Morelli between November 1673 and December 1674, when the figure was handed over to Giulio Cartari, Bernini's favourite, who finished it between April and November 1675. Michele Maglia, a Romanized Frenchman, was responsible for the figure of the Pope, on which he worked between July 1675 and December 1676. Specialists were required for the ornamental parts of shirt, mantle and crown; they were done by Cartari and a Domenico Basciadonna between March and June 1677. Prudence, the half-figure behind Truth, was begun by Giuseppe Baratta in August 1675; he belonged to a well-known family of Carrarese sculptors, but his work seems to have been unsatisfactory, for Cartari took over and received payments from January 1676 to November 1677. Justice, the half-figure behind Charity, was executed during 1677, again by Cartari.

The figure of Death caused particular difficulties. Between May and July 1676 Morelli was concerned with adjusting the model in the final position. Girolamo Lucenti, a highly qualified specialist who often worked for Bernini, cast the bronze between July 1675 and July 1676, and from September onwards Carlo Mattei was concerned with the chiselling and gilding of the bronze. Greatest care was taken with the shroud, which was tackled before the figures were begun. Morelli executed it in travertine and, from May 1673 onwards, the stonemason Gabriele Renzi covered this foundation with coloured marble ('diaspro di Sicilia'). Among other artists engaged on this tomb, it is worth mentioning Filippo Carcani, who, although an accomplished sculptor, agreed in 1678 to execute such minor work as the wings framing the coat of arms above the tomb, the

wings of the hour-glass (no longer existing) and the mirror of Prudence.

Early in 1678 the tomb was practically finished. It was then that Pope Innocent XI objected to the nakedness of Truth (Baldinucci, p. 131f., D. Bernini, p. 166f.) and Bernini was obliged to 'dress' the figure. Carcani made the model of the drapery and Lucenti cast it in bronze at the end of the year 1678. Painted white, it is difficult to discover that this drapery was an 'afterthought'. The figure of Charity, too, had originally bare breasts as shown in the Siena bozzetto, mentioned above, and the school drawing published by Fraschetti, p. 387 (see also the engraving in Bonanni, *Numismata summorum pontificum*, Rome, 1696, pl. 37 facing p. 93).

Every single payment is specified and justified in a statement written by Bernini himself. This shows how vigilantly he supervised every stage of the work.

E. Panofsky (*Tomb Sculpture*, London, 1964, p. 95, and in *Festschrift für L. H. Heydenreich*, Munich, 1964, p. 224ff.) has investigated the meaning of the figure of Truth, a rare occurrence among the allegories of tombs. He stresses the link between Time, Death and Truth (see also above, No. 43): 'While proclaiming the triumph of Time over Life, Death achieves, however unwillingly, the triumph of Truth over Time.'

*78. THE ALTAR OF THE CAPPELLA DEL SACRAMENTO. St. Peter's, Rome

PLATE 119, FIGS. 115-117

Principal sculptural decoration: two over life-size angels and, on the Tabernacle, Christ and the twelve Apostles, all gilt bronze.

The idea of decorating the altar goes back to the time of Urban VIII. Innocent X and Alexander VII returned to it (Brauer-Wittkower, p. 174), but it was not until the pontificate of Clement X that it reached the stage of realization. Bernini developed his scheme on a lavish scale. In order to express the mystery enshrined in the tabernacle, he first toyed with the idea of letting it hover in the air (like the Chair of St. Peter), poised lightly on the supporting hands of the four large angels who also carry candlesticks (Fig. 116, drawing, Hermitage, Leningrad). In the next stage, the tabernacle was to be surrounded by three or four angels on each side who combine expressions and gestures of devotion with their task as carriers of candlesticks. Finally, he decided to free the angels of all practical duties and make them reflect, in their abandonment to their emotions, the delight and wonder at the eucharistic miracle contained in the tabernacle. Their roles differ: one is looking at the door of the tabernacle, the other towards the Communion rails. The present altar with only two adoring angels should be regarded as part of a con-

*See Addenda, pp. 273ff.

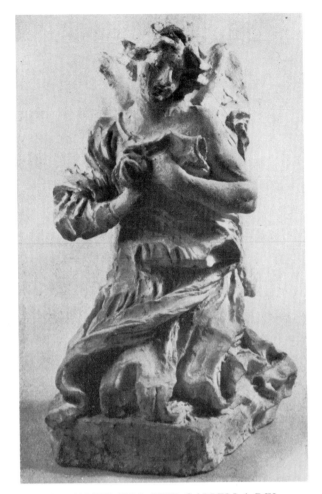

115. *AN ANGEL FOR THE CAPPELLA DEL SACRAMENTO.* Bozzetto.
Fogg Museum of Art, Cambridge, Mass. (No. 78).

siderably larger scheme. (The development of Bernini's thought is fully discussed in Brauer-Wittkower, p. 172ff., but the important Leningrad drawing had not been published before the first edition of this book.)

H. Hibbard (*Bernini*, 1965, p. 207, fig. 112) suggests that Bernini's final solution was stimulated by similar Renaissance altars, such as that attributed to Jacopo Sansovino in S. Croce in Gerusalemme, Rome.

The documents show (AFS, 373 and AFG, 376) that the work was begun early in 1673 and finished to all intents and purposes late in 1674. Between April 1673 and September 1674 Girolamo Lucenti, who worked shortly afterwards on the tomb of Alexander VII, cast figures and tabernacle in bronze (payments dragged on until March 1675). In December 1674 Carlo Mattei finished the furbishing and gilding of the tabernacle, Christ, the Apostles, the angels and the coat of arms. A master Geri was paid for the rich lapis lazuli work from March 1673 to December 1674. The new stuccoed lantern which lights the previously dark chapel was finished in September 1674. Bernini received 3,000 scudi in

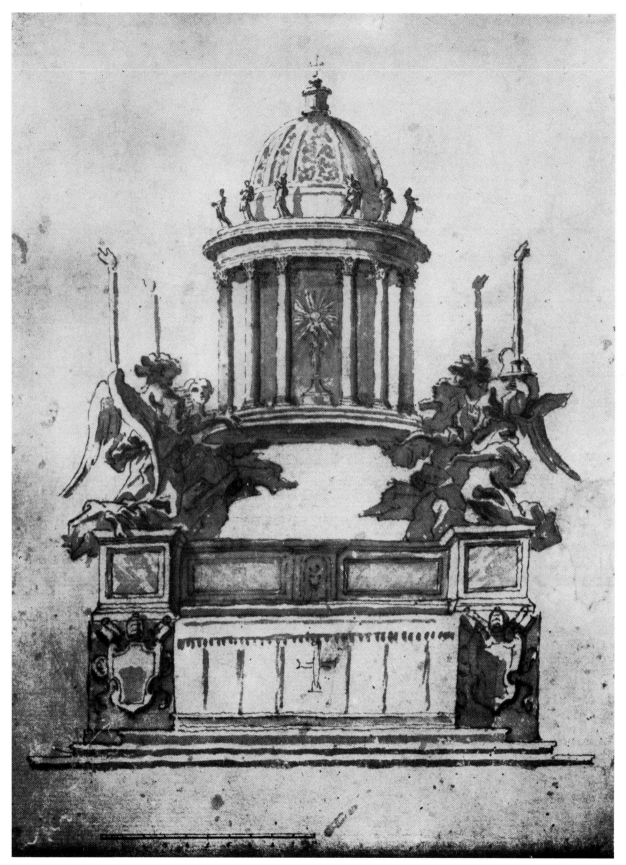

116. *DESIGN FOR THE ALTAR OF THE CAPPELLA DEL SACRAMENTO.* Hermitage, Leningrad (No. 78).

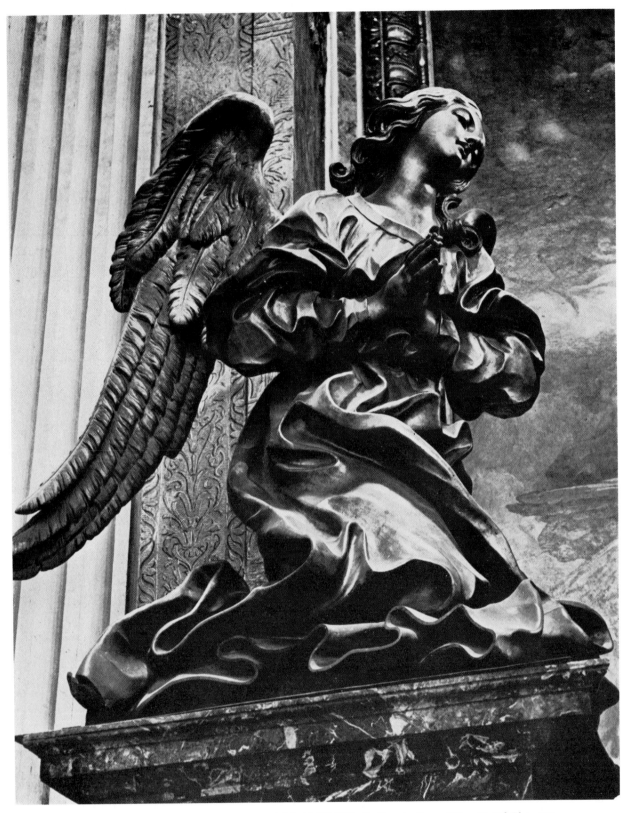

117. *ANGEL FROM THE CAPPELLA DEL SACRAMENTO*. St. Peter's, Rome (No. 78). Cf. Plate 119.

instalments long after the altar was completed (March and October 1675 and May 1676).

It is peculiar that no names of sculptors for the large models of the angels appear in the documents. Whether entirely correct or not, a document tells us that Bernini 'made by his own hand the small as well as the large models' (Brauer-Wittkower, p. 174, note 3). It is certainly true that Bernini lavished particular care on this work. Apart from a splendid series of drawings (ibid., pls. 131–6), nine bozzetti survive to prove it (all in the Fogg Art Museum: two, Nos. 1937.65, 66, for angels of the first project; two, Nos. 1937.62, 64, for the left-hand angel of the final design; one for the right-hand angel, No. 1937.63, Fig. 115; and four, Nos. 1937.52–5, for Apostles on the tabernacle). In addition, the full-scale models of the angels also survive (Museo Petriano).

78a. HALF-FIGURE OF CLEMENT X. Palazzo Altieri (Archive), Rome FIGS. 118–119

Over life-size marble. H. 1·05 cm.

In his catalogue Baldinucci (p. 177) mentions a bust of Clement X without indicating its locality. In his text (p. 137), however, he declared that Bernini left in his will a bust of the Pope to the 'Eminentiss. Altieri', i.e. to the Pope's nephew, Cardinal Paluzzo Altieri. This information is surely reliable, since Baldinucci's work was published two years after the master's death. An even more important piece of evidence is supplied by the erudite Carlo Cartari, archivist of the Castel S. Angelo and librarian to Cardinal Paluzzo Altieri. He gave the following description of a visit to Bernini's studio: 'On 5 May 1676 I was with Monsignor Montecatini in the workroom of the Signor Cavaliere Bernini. He was working on a bust of Pope Clement X and said that Cardinal Altieri wanted it for his room. Another marble was being roughed out to make one like it, to be placed in the refectory of SS. Trinità de' Convalescenti [e de' Pellegrini], and he said that one will be made for the library' (i.e. of the Palazzo Altieri). (See L. Sandri, in Strenna dei Romanisti, Rome, 1955, p. 330f.; Martinelli, Ritratti, 1956, p. 49; A. Schiavo, The Altieri Palace, Italian Bankers' Association, 1965, p. 91ff.). According to this eye-witness report there should eventually have existed the marble for Cardinal Altieri and two replicas. One conclusion can be drawn with a high degree of certainty: the bust for Cardinal Altieri, on which Bernini himself worked at that moment, was the one which, on the evidence of Baldinucci, was given to the cardinal from Bernini's estate. We may safely assume that the bust was still unfinished when the Pope died, less than three months after Cartari's visit, on 22 July 1676. Bernini probably hoping to find time to finish it would have kept it in his studio to the end of his days.

Thus the Cardinal Altieri bust should most likely be an unfinished work.

The replica formerly in the refectory of SS. Trinità de' Pellegrini disappeared—together with all other papal busts—when the refectory was looted during the French occupation and was in all likelihood destroyed (documents referring to this bust in Martinelli, Commentari, x, 1959, p. 222f.). The replica for the library, on 5 May 1676 mentioned as being planned, may never have been begun owing to the Pope's untimely death. On the other hand, a bust or rather half-figure of the Pope was discovered by Martinelli (Ritratti, p. 50) in a niche high up in the centre of the east end of the large hall which was originally the library but now contains the archive in the private apartment of the Palazzo Altieri. Not illogically, Martinelli identified this piece with the second replica mentioned by Carlo Cartari. Though this identification may be correct, it is by no means conclusive.

Martinelli was unaware of the fact, that eight years after Bernini's death N. Tessin, when visiting the palace, saw this half-figure in a frescoed room (Sirén, 1914, p. 178). He described it as 'Bernini's portrait of the Pope in marble down to the middle which however was not entirely finished owing to the Pope's death'. The latter piece of information was surely supplied by a cicerone on the staff of the palace. Moreover, it is also correct, that there are unfinished areas in the face and elsewhere; not even the marble linking the fingers of the blessing hand has been removed. Would not this unfinished work, then, be the bust made for Cardinal Altieri rather than the replica of which we know no more than that it was contemplated?

In 1688, at the time of Tessin's visit, the niche in the library was ready to take the bust (and may have been ready long before). On his tour through the palace Tessin also saw the library. He describes at some length the niche into which 'the above mentioned bust by Bernini will be placed' (Sirén, p. 179). We learn that a gallery along the walls of the library belonged to its original outfit and that the niche opened over the door to the gallery. (The door is now closed and filled in and the gallery has been removed, so that the present position of the bust has become rather senseless). Tessin also attributes to Bernini the rich stucco decoration which still encompasses the niche. A large piece of drapery, held in place by flying putti, spreads like a canopy from the vaulted ceiling down to long twirling ends at both sides of the niche. Once again, the reliability of Tessin's report cannot be doubted: this decoration, reminiscent of the wind-swept drapery behind the Constantine (Pl. 110) and even more of the drapery motif used for Queen Christina's mirror (Figs. 56, 57), was surely designed by the master himself. The strange puzzle of the empty niche on the top floor while the bust for it

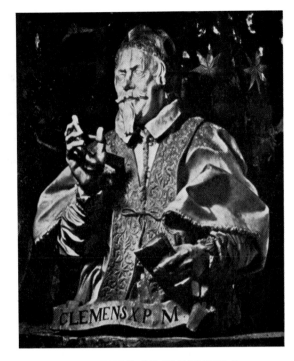

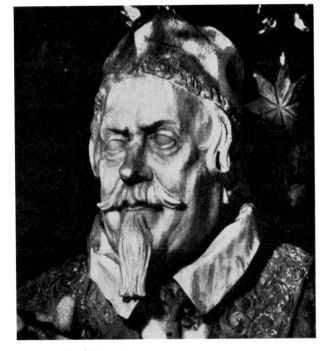

118. *HALF-FIGURE OF CLEMENT X.*
Palazzo Altieri, Rome (No. 78a).

119. Detail of Fig. 118.

was kept in a room of the *piano nobile*, can be resolved
by assuming that the cardinal had made arrangements
for the bust belonging to him to be removed from his
apartment at a time of his choice, probably after his
death (in 1698), and to be placed into the niche prepared
for a replica that was never executed.

The evidence of the marble does not contradict this
reconstruction of events. The conception is most extra-
ordinary and typically Berninesque: the beholder
imagines he looks at a full-size statue in the act of bene-
diction. Its power and gravity allies the work closely
to the figure of Alexander VII on his tomb (Pl. 123) as
well as to the chalk drawing of the Pope in Leipzig
(Brauer-Wittkower, pl. 125). The execution of the head
and the hands was probably largely Bernini's, while the
rest was done by assistants, perhaps (as Martinelli, p. 53,
suggests) by the same men, who were responsible for
the sepulchral statue of Alexander VII.

It still remains to clarify whether the unlocated bust of
Baldinucci's catalogue and that discussed in his text are
one and the same work or two different creations.
Tessin also saw in the Palazzo Altieri a bronze bust of
the Pope ascribed to Bernini (Sirén, p. 181); and the
same bust is still mentioned in 1725 (Martinelli, *Ritratti*,
p. 53, note 106). Obviously, this bronze cannot be
identical with the marble half-figure. Baldinucci, there-
fore, referred to two different busts, the marble now in
the archive of the palace and a bronze, now lost. It is not
unlikely that a bronze by Girolamo Lucenti, placed with
other papal busts in the choir of S. Maria di Monte Santo,
was cast from Bernini's model. In the 1670's Bernini

employed Lucenti for all his important bronze work.
But the bronze of Clement X in the church is no longer
extant. It has been replaced by an extremely weak
bronze coloured plaster behind which, twice removed,
Bernini's bronze in the Palazzo Altieri may be fathomed.
(For further references to Lucenti's work in S. Maria di
Monte Santo, see Martinelli, *Ritratti*, p. 47, note 95 and
pl. 26.)★

★ After this book had been set up in proof, E. A. Barletta
published new documents referring to the bust formerly in
Trinità de' Pellegrini ('Note su Clemente X di G. L. Bernini',
Commentari, xvi, 1965, pp. 282–6). It appears that Bernini
presented the Pope's bust to the hospital early in April 1680,
requesting only 150 scudi as compensation for the cost of the
marble and the payment of his assistant ('le fatighe e sbozzature
del detto ritratto fatto dal suo giovine'), but the bust was not
placed in the refectory until 1685. Barletta concludes (1) that
the Trinità bust was Bernini's original on which Carlo
Cartari saw him at work on 5 May 1676; (2) that Baldinucci's
catalogue entry of a bust of Clement X without indication of
its whereabouts was due to the fact that at the time of writing
(i.e., in 1682) the bust was not yet in its place; (3) that only
one of the two replicas mentioned by Carlo Cartari was
executed; and (4) that the bust presently in the Palazzo Altieri
is this replica.

Barletta's and my conclusions coincide regarding point 3,
but are at variance regarding all other points. Above all, I do
not believe that Barletta's doc. 4, dated 9 April 1680, establishes
unequivocally the primacy of the lost Trinità bust. Not only
is the wording of the document inconclusive but Baldinucci's
and Tessin's texts lend support to the intrinsic probability
according to which the best version would have gone to
Cardinal Altieri.

120. *SALVATOR MUNDI*. Drawing.
Galleria Nazionale, Rome (No. 79).

*79. SALVATOR MUNDI FIG. 120

Half-length of Christ, over life-size, marble. The work cannot be traced at present.

The Salvator Mundi seems to have been Bernini's last work in marble. According to Baldinucci (p. 132), it was executed by the octogenarian for Queen Christina of Sweden. She refused to accept it, but Bernini bequeathed it to her, and it remained in the Queen's Collection until her death in 1689. She left it to Pope Innocent XI, and the latter's heir, Don Livio Odescalchi, kept it in the Palazzo Odescalchi, where it is mentioned in an inventory of 4 December 1713 (Brauer-Wittkower, p. 178ff.). Soon after that date the Odescalchi sculptures were sold to the Spanish king and Bernini's Salvator was probably amongst them.

According to Domenico Bernini (p. 167), the figure showed the right hand 'somewhat raised as if in the act of blessing'. According to the Odescalchi inventory, only one arm was visible; the bust was about 106 cm. (3½ feet) high, standing on a base about one foot high and 53 cm. (1¾ feet) wide. This was placed on a 182 cm. (6 feet) high pedestal of gilded wood with two angels raising their hands as if to support the bust. (See also the detailed description given by N. Tessin in 1688; Sirén, 1914, p. 184).

The drawing in the Galleria Nazionale, Rome, gives a fairly precise idea of the finished work. This sheet, together with the literary tradition, allows us to reconstruct the marble into which Bernini 'pose tutti gli sforzi della sua cristian pietà' (Baldinucci). A copy in pen and wash after the head of the figure is at Chatsworth (unpublished).

For half-figures of Christ dependent on Bernini's work, see Brauer-Wittkower (*loc. cit.*). A copy reached France, it seems, while Bernini was still alive; this also is lost (see S.S. Ludovici's note in Baldinucci, p. 259). A free variation of the work was published in an engraving by

Faucci after A. D. Gabbiani, illustr. in Ignazio Enrico Hugford, *Vita di Anton Domenico Gabbiani*, Florence, 1762, No. xvi.

80. A NOTE ON FOUNTAINS

Bernini's four great fountains with figures have been discussed above (Nos. 9, 32, 50, 55). His other fountains belong only marginally in this book and references to them can be brief. The following fountains survive:

*(1) *Barcaccia*. Piazza di Spagna, Rome FIG. 121

Payments: 1627–29 (Pollak, i, p. 12ff.); execution: mid-1628 to mid-1629 (Hibbard-Jaffe, 1964, p. 167). According to the documents, executed under the direction of Pietro Bernini. Baglione (p. 194) calls him the inventor of the fountain, but Baldinucci (p. 83) and Domenico Bernini (p. 58) explicitly attribute the invention to Gian Lorenzo; so also the older literature, even during his life-time (*Ritratto di Roma moderna*, 1638, p. 336; *Roma antica e moderna*, 1668, p. 103). But O. Pollak (*Vita d'Arte*, 1909, p. 515ff.), Riegl (p. 36ff.) and others supported Pietro's authorship. Although Martinelli (*Commentari*, iv, 1953, p. 150f.) correctly re-established Gian Lorenzo's claim, an opinion shared by Pane (1953, p. 15ff.), D'Onofrio (*Fontane*, 1957, pp. 175–84), followed by E. Battisti (*Boll. d'Arte*, xliv, 1959, p. 188f.), returned to the attribution to Pietro Bernini. The question has now been finally settled in favour of Gianlorenzo by the careful investigation of Hibbard-Jaffe (1964). Their paper is mainly concerned with the typically Berninesque *concetto*, to which I have briefly referred on p. 29.

(2) *Fontana delle Api*. Vatican, Rome

Formerly in the Cortile del Belvedere, now at the side of S. Anna dei Palafrenieri. This small fountain showing jets of water issuing from the mouths of five bees (the Barberini emblem), arranged in a semicircle, has always been attributed to Bernini (also in my first edition and by D'Onofrio, *Fontane*, 1957, p. 188f.) on the strength of its mention by Domenico Bernini (p. 60). But Hibbard-Jaffe (1964, p. 169f.) have shown with new documents that the design came out of Maderno's studio and that it was executed in 1625–6 by Borromini, who at that time was still mainly employed as a stonemason and carver.

(3) *Fontana delle Api*. Piazza Barberini, Rome FIG. 122

Three bees, perched at the base of a huge shell of impressive design, spouting water, a similar idea to (2), but infinitely grander. Erected in 1644 (inscription), shortly before Urban's death. Fraschetti, p. 120ff. Originally placed at the corner of Via Sistina (see D'Onofrio, *Fontane*, fig. 166), now free-standing at the corner of Via Venti Settembre.

*See Addenda, pp. 273ff.

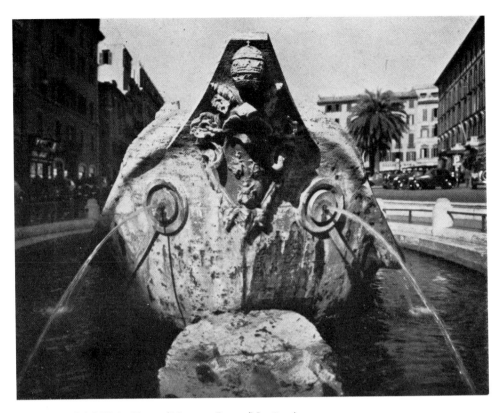

121. *BARCACCIA*. Piazza di Spagna, Rome (No. 80–1).

122. *FONTANA DELLE API.*
Piazza Barberini, Rome (No. 80–3).

123. *FOUNTAIN.*
Palazzo Estense, Sassuolo (No. 80–5).

(4) *Acqua Acetosa*. Outside Porta del Popolo, Rome

The attribution of this fountain to Bernini, accepted by most scholars (see N. Wibiral, *Palladio*, v, 1955, p. 62, note 14), was due to the caption under the engraving in Falda, *Fontane di Roma*, 1691, pl. 33, but the work is mentioned neither by Baldinucci nor by Domenico Bernini. Wibiral (*op. cit.*) has shown on the basis of documents (published *in extenso*, pp. 63–5) that the painter Andrea Sacchi and not Bernini was the architect of the fountain. Payments for its construction begin 11 April 1661; final payment 2 August 1662. Sacchi died 21 June 1661, and his assistant, the virtually unknown Domenico Legendre (active 1633–77), was appointed architect. Legendre made the preparatory drawings preserved in BV, cod. Chig. P. VII.13, f. 21–4, and analysed by G. Matthiae, in *Roma*, xx, 1942, p. 368ff. For the inscriptions, see Wibiral, p. 61, note 4.

(5) *Three Fountains*. Palazzo Estense, Sassuolo (Modena).

FIGS. 123–124

Fraschetti, p. 229, refers to letters of August and September 1652 and March 1653 which reveal that Bernini designed some fountains for the palace of the Duke of Modena. The drawings were despatched and the Duke expressed his satisfaction. I. Lavin (*Art. Bull.*, xxxviii, 1956, p. 260) related this correspondence, no doubt correctly, to the Este Palace at Sassuolo, where three fountains in poor condition are in existence in the atrium and the courtyard. Original drawings by Bernini for two of these fountains have survived: for the

124. *DRAWING FOR A FOUNTAIN.*
Victoria and Albert Museum (No. 80-5).

Neptune in the right-hand niche of the atrium (Brauer-Wittkower, pl. 36) and for a maritime divinity in the central niche of the courtyard (Fig. 124; Brauer-Wittkower, pls. 34, 159a). So far no original drawings have been traced for the Galatea fountain in the left-hand niche of the atrium. Bernini's Neptune stands on an elaborate shell design carried by Tritons. It is therefore likely that at some stage he wanted this fountain to be the principal attraction in the courtyard on the main axis of the palace. This view is supported by alternative designs of a two-figure fountain with Neptune and Amphitrite (B.-W., pls. 37, 38), for which there would have been no place in the atrium. The fountain eventually executed in the courtyard (Fig. 123) is only a faint reflection of one of Bernini's boldest conceptions of fountains: ideas of the Four Rivers Fountain (bridge formed of rocks; pose of figure similar to Danube, Pl. 82) are combined with those of the Fontana del Moro (Pl. 88; struggle with the dolphin). Because of these relationships, the project, Fig. 124 (perhaps by a studio hand, based on Bernini's chalk sketch, B.-W., pl. 34) was dated by Brauer-Wittkower in 1652–3, corresponding to the above mentioned documentation. U. Donati (*L'Urbe*, vi, 1941, ii, p. 11; also *id.*, *Art. Tic.*, 1942, p. 443) discovered the connection between Bernini's drawings and the Sassuolo fountains. Their execution lay in Antonio Raggi's hands, but the poor craftsmanship of the figures indicates that he engaged inferior local help to a very considerable extent.

(6) *Fountain with the Antamoro coat of arms*. Palazzo Antamoro. Via della Panetteria 15, Rome

A rather dry bozzetto of the fountain (42 × 35 cm., Brinckmann, BB., i, pl. 42) Berninesque in conception but probably not by Bernini's hand (now in the Museo Nazionale, Florence) was until 1796 in the Palazzo Rospigliosi, where it was regarded as a model by Bernini for a fountain planned by the Rospigliosi Pope Clement IX (1667–9) for his native city Pistoia (Bacci, *Rivista d'Arte*, iv, 1906, p. 142ff.). The bozzetto shows the Rospigliosi coat of arms held by two Tritons in a recess enlivened by artificial rocks. The engraving in Falda (*Fontane*, 1691, iii, pl. 28) and a drawing made in 1688 by N. Tessin (Sirén, 1914, pl. 51) ascertain that, like the bozzetto, the fountain in Via della Panetteria contained the Rospigliosi coat of arms. It was later replaced by that of the Antamoro family who acquired the palace in the eighteenth century (D'Onofrio, *Fontane*, p. 199f.). D'Onofrio argued, in my view convincingly, that the fountain was planned from the start for its present position rather than for Pistoia. In Clement IX's days the palace belonged to Paolo Strada, the Pope's 'cameriere segreto', who was granted the use of water from the Acqua Felice by special papal command of October 1667 and July 1669, no doubt for

the purpose of feeding the new fountain. It was probably owing to the Pope's personal involvement that Strada was allowed to use the papal coat of arms. The fountain survives in poor condition and badly restored.

The most important of Bernini's non-figurative garden fountains are the Fontana del Bicchierone and the great Cascade of the Water Organ in the Villa d'Este at Tivoli, dating from 1660–1; see D. R. Coffin, *The Villa D'Este at Tivoli*, Princeton, 1960, p. 113.
No attempt can here be made to list Bernini's various fountain projects, but reference may at least be made to his unexecuted projects for the Fontana Trevi, about which see Brauer-Wittkower, p. 147ff.
Of the destroyed fountains the most important were the Eagle and Triton fountains in the garden of Villa Mattei (Falda, *Fontane*, iii, pls. 18, 19, Voss, *Jahrbuch d. Preuss. Kunstslg.*, xxxi, 1910, p. 105ff.) and the fountain in the garden of Cardinal Antonio Barberini's villa (Muñoz, *Arte*, xix, 1916, p. 157f.).

81. LOST, DESTROYED and OCCASIONAL WORKS (in roughly chronological sequence).

(1) Two nude putti, life-size. Lost (Barberini inventory, Pollak, i, p. 334).

★(2) Hercules killing the snakes (?) ('putto quale tiene un drago'). Lost (Barberini inventory, Pollak, i, p. 334).

(3) St. Sebastian, for Princess Rossano. Lost. See No. 4.

(4) Bust of Paul V, marble. Present whereabouts unknown. See No. 6.

(5) Bust of Gregory XV, marble. Lost. See No. 12.

★(6) A crying marble putto sitting among flowers, bitten by a snake on a base of coloured marble, by the hand of the Cavaliere Bernini. Entry in the Ludovisi inventory of 1633, hence probably done for the Ludovisi Pope Gregory XV (1621–3). T. Schreiber, *Die antiken Bildwerke der Villa Ludovisi in Rom*, Leipzig, 1880, p. 31. Lost.

(7) Bust of Cardinal Montalto (Alessandro Peretti), marble. Baldinucci, p. 176. Whereabouts unknown, possibly in an English private collection.

★(8) Bust of Monsignor Carlo Antonio dal Pozzo (1547–1607). Baldinucci, p. 176. See Sheila Somers, *B.M.*, c, 1958, p. 288. Lost.

★(9) Stucco figures on the catafalque for the exequies of Paul V in S. Maria Maggiore. December 1621–February 1622. Faldi, ii, p. 315f. Bernini made 20 putti and 16 female allegories, all life-size, for the catafalque. Designs after the allegories engraved by Dietrich Krüger are preserved in: *Breve racconto della transportatione del Corpo di Papa Paolo V della Basilica di S. Petro à quella di S. Maria Maggiore* . . . , Rome, 1623. See O. P. Berendsen,

Marsyas, viii, 1959, p. 67ff., who directed attention to the little book.

(10) Portrait of Cardinal Giovanni Dolfin in relief (?) Lost. See No. 16.

(11) Bronze bust of the Duke of Bracciano, 1623–4. In my view to be identified with the bust No. 36(a), which came to my attention after this book had gone to press.

★(12) Decoration in St. Peter's on the occasion of the canonization of the Blessed Elizabeth of Portugal, 1625, Fraschetti, p. 251.

(13) Busts of Urban VIII: (a) in the hospital of Trinità de' Pellegrini, Rome, 1625, (b) in the possession of Abbate Braccesi, (c) in Casa Giori—(a) and (b) lost; (c) is probably the bust mentioned under No. 19–2c.

(14) Marble bust of the Virgin. Barberini inventory, 1626. Fraschetti, p. 51. Cannot be traced. Not to be identified with the bust in the Museo Estense, Modena, see Salvini, *B.M.*, xc, 1948, p. 94.

(15) Figure of Charity, marble. 1626. Fraschetti, p. 138, note 3. Lost.

(16) Bust of the father of Urban VIII. See No. 24–c. Lost.

(17) Bronze Crucifix for St. Peter's. Fraschetti, p. 41f., published a document of 14 May 1624, according to which Bernini was to make a Crucifix for the Chapel next to the Porta Santa (i.e. first chapel right). Fraschetti's date is probably mistaken, for the commission is mentioned in a document of 14 May 1627 (AF, No. 159, f. 93v.). It was in all likelihood this Crucifix for which Bernini had an ivory pedestal with precious stones made by the goldsmith Marco Chiavacci, whom he paid on 20 March 1628 (BV, Arch. Barberini, Sez. I, Indice 4°, Mazzo 57bis, No. 30).

(18) Pietà for S. Maria Maggiore, 1628. Pollak, i, p. 174. According to a document of 23 January 1628 (AS, Cam. I, Gius. tes. 61) a shed over the marble block for the Pietà existed in front of Bernini's house (Information Howard Hibbard). Cannot be traced.

★(19) Decoration in the Cappella Paolina, Vatican, for the 'Forty Hours' Devotion'. Described in an *avviso* of 6 December 1628 (BV, Urb. lat. 1098, f.701). See Hibbard, *Bernini*, 1965, p. 240.

★(20) Decoration of St. Peter's on the occasion of the canonization of the Blessed Andrea Corsini, 1629. Brauer-Wittkower, p. 136, note 5.

(21) Memorial statue of Urban VIII, 1627–33. Velletri. Destroyed. See No. 38.

★(22) Catafalque for Carlo Barberini, 1630. Pastor, XIII, i, p. 258, note 4; Brauer-Wittkower, p. 162, note 6. See No. 26.

(23) Bust of Charles I. Destroyed. See No. 39.

★See Addenda, pp. 273ff.

*(24) Processional float with a representation of the Santa Casa di Loreto, 1639. Pollak, i, p. 173.

(25) Designs for frames, 1640. Pollak, i, p. 400.

(26) S. Francesca Romana. Destroyed. See No. 45.

(27) Eagle, Palazzo Ducale, Modena. Destroyed. Fraschetti, p. 228.

(28) Assumption of the Virgin, relief, silver altar frontal, Reggio Cathedral. Destroyed. Fraschetti, p. 229.

*(29) Design of coach for Queen Christina of Sweden. 1655–6. Domenico Bernini, p. 103. Documents in Ozzola, *Archivo della R. Società di Storia Patria*, xxxi, 1908, p. 55f.

*(30) Carnival float with allegorical figures for Prince Agostino Chigi, 1658. Incisa della Rocchetta, *Roma*, vi, 1928, p. 271; Brauer-Wittkower, p. 136.

*(31) Decoration on the occasion of the birth of the Dauphin, 1661. Brauer-Wittkower, p. 138.

(32) Bronze Crucifix presented in 1665 to Cardinal Pallavicini. For a possible identification, see No. 57–4.

*(33) Catafalque for Muzio Mattei in S. Maria Maggiore, 1668. Brauer-Wittkower, p. 162.

*(34) Catafalque for the Duc de Beaufort in S. Maria in Araceli, 1669. *Ibid.*, p. 161f.

(35) Design for a gilt bronze Cross with red enamelled inlay (probably the Cross of the Maltese Order) and gilt bronze angels for Grand Duke Cosimo III of Tuscany, 1671. Fraschetti, p. 114. Letters of 22 July and 11 August 1671, communicated to me by Klaus Lankheit, reveal that the work was designed by Bernini in connection with a plan he made for S. Stefano de' Cavalieri at Pisa (Arch. di Stato, Florence, Med. 1132. Carteggio Cosimo III. Particolari diversi dal 1670 al 1683, cc. 178, 1018).

(36) Works for Clement X.

(a) Equestrian statue of Clement X's nephew Don Gaspare Altieri, planned for the courtyard of the Palazzo Altieri, but probably never begun (*Avviso*, 11 October 1670, see E. Rossi, *Roma*, xviii, 1940, p. 58; Martinelli, *Commentari*, x, 1959, p. 207).

(b) Statues and reliefs for the garden of the Palazzo Altieri (*Avviso*, 17 January 1671, see Rossi, *op. cit.*, p. 27; Martinelli, *op. cit.*, p. 211).

(c) Papal commission of six statues from Bernini, all for the Palazzo Altieri: the Four Seasons and Adam and Eve (*Avviso*, 24 October 1671, see Rossi, *loc. cit.*; Martinelli, p. 212). These statues were finished on 6 January 1673 (Rossi, p. 427; Martinelli, p. 212).

(d) Papal commission of four figures of Roman emperors from Bernini, again for the palace (*Avviso*, 11 March 1673, see Rossi, *loc. cit.*; Martinelli, p. 213).

*See Addenda, pp. 273ff.

Of all the work (a) to (d) Martinelli (p. 219f.) traced in the palace two imperial busts—those of Alexander the Great and Septimius Severus—but they show so little connection with the Bernini studio, that they probably do not belong to the set of four busts mentioned under (d).
For the busts of Clement X, worked in Bernini's studio and now lost, see No. 78a.

(37) Model for six firedogs for Cardinal Flavio Chigi, 1678. Golzio, p. 348.

(38) Salvator Mundi, 1679. See No. 79. Possibly in Spain.

No approximate date can be given for the following:

(39) Silver bust of St. Eustace, in S. Eustachio, Rome. Cannot be traced. Baldinucci, p. 179.

For destroyed fountains, see No. 80.

Baldinucci's mention in his Catalogue (p. 177) of the bust of 'Costanza Piccolomini in Galleria del Granduca' must be a slip of the pen. Since he does not list the Costanza Bonarelli in the Grand Duke's Collection (No. 35), he surely had this bust in mind.

82. ATTRIBUTIONS MADE TO BERNINI AFTER THE APPEARANCE OF THE FIRST EDITION OF THIS BOOK AND NOT ACCEPTABLE TO THE AUTHOR.

(1) *Bacchic Head*. Palazzo Venezia, Rome.

Oval marble relief. 35 × 36 cm.

Presented by the Galleria Sangiorgi to the Italian State and published by A. Santangelo (*Boll. d'Arte*, xli, 1956, p. 369f.) as a possible original of Bernini's earliest period (*c.* 1615). According to Santangelo this piece belonged together with two others formerly in the Galleria Sangiorgi, one of which was published by Faldi (i, p. 144, fig. 7) as by Pietro Bernini (the other cannot be traced). There is considerable doubt whether the Bacchic Head can be dated so early nor does it seem permissible to connect it with Gianlorenzo's name, even at the period of the Goat Amalthea.
The work published by Faldi came to Sangiorgi from the Palazzo Cardelli, where Fraschetti had seen it. It is listed in the 1706 inventory of Bernini's house (Fraschetti, p. 431).

(2) *Head of a Faun*. Villa Borghese (Giardino del Lago), Rome.

Marble. Life-size.

Hypothetically published by Paola della Pergola (*Capitolium*, xxxvii, No. 11, 1962, p. 724ff.) as a work

of the young Bernini (between 1615 and 1619). I fail to discover any connection with his *juvenilia*. The ample and clumsy use of the drill alone militates against the attribution. Nor can this head have belonged to the Priapus herma as the authoress suggests; see the following entry (3).

★(3) *Priapus and Flora*. Private Collection, New Jersey, U.S.A.

Two marble hermae. H. 2·60 m.

Martinelli (*Commentari*, xiii, 1962, p. 267ff.) correctly identified these hermae as the ones originally standing inside the garden of the Villa Borghese opposite the Porta Pinciana entrance gate at the near end of a semi-circular esedra formed by cut hedges. Documents published by him (p. 281f.) show that Gianlorenzo's father, Pietro, received payments for two hermae for the Villa in the spring and summer 1616 (final payment: 9 July; documents iv, v, vii, viii). Since no one else was paid for these works Pietro's authorship would seem certain. Martinelli, however, maintains that the idea and design of the hermae are Gianlorenzo's, and that the Priapus was entirely executed by him and the Flora to a considerable extent. Gianlorenzo's non-appearance in the documents is, according to Martinelli, due to the fact that he was under-age at the time. In support of his claim Martinelli quotes the guide to the Villa Borghese by Manilli, who mentioned during Bernini's life-time (1650) that the young man contributed the fruit and flowers of the hermae made by Pietro (i.e. the fruit and flower baskets they carry and the wreaths in their hair). Such a tradition may have had a factual basis, but Manilli's rather modest statement is very far from Martinelli's pan-Gianlorenzo conclusions.

Martinelli's attribution rests, in fact, solely on stylistic deductions. He follows up this line of argument with a steam-roller technique of persuasion, but in checking the words against the illustrations one remains un-convinced. Despite my lack of autopsy of the hermae (whose precise whereabouts is not revealed), I recognize in the illustrations the long, thin folds of the draperies so characteristic for Pietro's manner (see his caryatids at the monument of Clement VII in S. Maria Maggiore); also the way the massive wreaths surround the heads is closely reminiscent of the hair-style one regularly finds in Pietro's works of this period. Nevertheless, Gian-lorenzo may have assisted his father in these works. Final judgment as to the amount of collaboration has to be reserved until other students of Bernini have been given a chance to form an opinion before the originals.

(4) *Bust of St. Philip Neri*. Victoria and Albert Museum, London.

Terracotta. H. 67·9 cm. FIG. 125

★See Addenda, pp. 273ff.

The bust was recently purchased by the Victoria and Albert Museum. A strong plea is made by J. Pope-Hennessy (*Catalogue*, 1964, p. 607f., No. 640, fig. 634) for an attribution to Bernini and a date in the early 1620's. I find it impossible to agree that there are any serious points of comparison with original works by Bernini.

The morbid countenance of the face as if the saint were ailing is far removed from the deep and sincere ex-pression of emotions which Bernini always rendered with such mastery. The weak incisions of iris and pupil are un-Berninesque and the treatment of the moustache and beard has no more than a general likeness to that of Antonio Barberini (No. 24), Pope-Hennessy's main support for the attribution. While all this may be open to discussion, because one eye discovers similarities where another does not see them, the lower part of the bust attests conclusively that Bernini's name has to be ruled out. Although this part has been considerably restored (see Pope-Hennessy's entry), a judicious analysis is not invalidated. All early busts by Bernini have a simple rhythmic and symmetrically developed silhouette along the lower edge. The London terracotta does not conform: its uneven lower contour would be a unique feature in Bernini's work of the 1620's. More-over, in all busts by Bernini the beholder senses the body under the dress. By contrast, the sculptor of the Saint's bust hollowed out large areas of the chasuble and 'mutilated' the body beneath the dress, particularly on the left-hand side. These sunk-in areas produce an effect of inorganic decorative patterns, so different from Bernini's unfailing sense for the living organism. Such

125. *TERRACOTTA BUST OF S. PHILIP NERI.*
Victoria and Albert Museum, London (No. 82-4).

treatment would be unprecedented in the 1620's or at any other period of Bernini's career. The handling of the detail, too, is un-Berninesque. Although the alb is largely restored, enough remains to reveal the indecisive modelling of the lace collar and the purely draughtsman-like character of the parallel pleated folds. (Compare Bernini's Antonio Barberini for the three-dimensional lively quality, which he was able to give to material that seemed to defy sculptural treatment.) The collar of the amice above the alb with its many painterly folds has no counterpart in Bernini's work (compare his way of handling the same feature in such busts as the early Paul V, No. 6–1, and the Cardinal de Sourdis, No. 14), but is most characteristic for Algardi.

The entire conception of the bust bespeaks a much later date than Pope-Hennessy assumed. In my view, it cannot have originated before the 1640's, and at that time there were sculptors in the Bernini and Algardi circle capable of executing this kind of work. Pope-Hennessy argues that the terracotta does not conform to Algardi's St. Philip Neri type. In actual fact, it seems to me closely related to Algardi's famous full-size statue of the Saint in the sacristy of the Chiesa Nuova, dated 1640. It would, therefore, appear that a sculptor in Algardi's circle, inspired by the Chiesa Nuova statue, isolated—as it were—its upper part in the terracotta. This diagnosis would also account for the oddity of the sunk-in areas of the chasuble to be found similarly in Algardi's work. But here they are an integral part of the full-length dress.

★(5) *Male bust*. Palazzo Barberini (Apartment of the late Principessa Maria), Rome.

Marble. H. 48 cm.

Published by Ettore Sestieri (*Commentari*, viii, 1957, p. 113ff.) as a deliberately grotesque portrait head by Bernini and dated in the early 1620's. The shape of the lower part of the bust with one truncated arm and an entirely un-Berninesque silhouette disqualifies this attribution. The character of the deeply furrowed 'pictoresque' drapery makes is likely that the bust dates from about 1680.

★(6) *Bust of Bernardino Naro*. Naro Chapel, S. Maria sopra Minerva, Rome.

Life-size marble.

Attribution by A. Nava Cellini (*Paragone*, vi, 1955, No. 65, p. 23ff.) who dates the bust *c*. 1640 and rightly sees connections with the style of some of Bernini's works such as the Baker bust. But her attribution of the bust to Bernini is unacceptable. The bust entirely lacks the surface qualities of original works nor can he have been responsible for its design. More correctly, Martinelli refers to the bust as in the manner of Finelli (*Commentari*, vii, 1956, p. 32, note).

★See Addenda, pp. 273ff.

(7) *Four Grotesque Heads*. Heirs of Bernini, Rome.

Bronze. Each 15 cm. high.

According to a tradition, related by Fraschetti (p. 197f.), these little bronze masks decorated the carriage in which Innocent X attended the inauguration of the Four Rivers Fountain. But Fraschetti maintained that they did, in fact, adorn the artist's own carriage, for they are mentioned in the 1706 inventory of Bernini's house as: 'Four little heads cast in bronze with their stands of stone, at one time the "noses" (*nasi*) of the Cavaliere's carriage.' The heads, though very much alike, vary slightly in the casting and chiselling. All are equally reminiscent of the 'Anima Dannata' (No. 7). Despite the inventory entry (which, significantly, does not mention Bernini as author) and the immaculate pedigree, one hesitates to attribute these trifling objects to the master himself. They were shown at the Exhibition jointly organized by the Ministero della Pubblica Istruzione, Rome, with the Rijksmuseum, Amsterdam, and the Arts Council of Great Britain. The catalogue called these pieces 'fully authenticated' (*Italian Bronze Statuettes*, The Victoria and Albert Museum, London, 17 July–1 October 1961, No. 187A-D).

A few other casts of these heads have recently appeared on the art market.

(8) *Bust of Cardinal Carlo Emanuele Pio*. Villa Pio, Mombello.

Marble. H. 80 cm.

This fine bust of the high cleric, whose identity is warranted by the coat of arms on the base, was published as Bernini by E. Battisti (*Commentari*, ix, 1958, p. 41f., figs. 6, 7). A. Nava Cellini (*Paragone*, xv, 1964, No. 177, p. 27) has pointed out that the work belongs into the Algardi circle and this fact is so obvious that no further discussion is needed.

Battisti was led astray in his attribution of the bust by an important discovery he had made. He found in the Villa Pio an autograph payment by Bernini to the stone-mason Filippo Renzi, dated 24 July 1650, for the tombstone of Cardinal Carlo Emanuele Pio, which survives in the pavement of the nave of the Gesù in Rome (Battisti, p. 38ff., figs. 2–5). The Cardinal, holder of various bishoprics and finally Decan of the Sacro Collegio (the inscription on the tombstone reads: OSSA. CAROLI. CARD. PII/SAC. COLLEG. DECANI), died in 1641, aged 73. His nephew, Cardinal Carlo Pio the Younger (d. 1689), apparently commissioned the tombstone after his return from foreign assignments which kept him away from Rome between 1641 and 1649. A drawing probably by Bernini's hand at Holkham Hall, Norfolk (Fig. 126), unknown to Battisti and never published, proves that Bernini was responsible for the design of the tombstone (including the present coat of arms, which Battisti assumed to be of later date).

126. *DRAWING FOR THE TOMBSTONE OF
CARDINAL CARLO EMANUELE PIO.*
Earl of Leicester, Holkham Hall, Norfolk (No. 82-8).

The drawing, which is closely related to the execution, displays characteristics of a wall-monument rather than of a horizontal slab. Type and function of the personifications of Justice and Prudence are still connected with the allegories on the tomb of Urban VIII (compare, in particular, the crossed legs and the head resting on the back of the hand in the Justice of the tomb, begun after 1644). Bernini returned to the conception of the Pio tomb design when planning the Cathedra with two angels leaning against the Chair and with a curved top of the chairback which ends in similar large scrolls (see Pl. 94).

★(9) *Bust of Cardinal Decio Azzolino*. Nationalmuseum, Stockholm.

Marble. H. 1·04 m. FIGS. 127, 128

The bust, originally in the Villa Azzolino at Empoli Vecchio, was acquired by the Nationalmuseum, Stockholm, in 1950. It was first published as Cardinal Azzolino's bust by Bernini in the Catalogue of the Museum of 1958 (*Äldre utländska Målningar och Skulpturer*, p. 248) and dated *c*. 1660. F. Zeri, who republished it with persuasive arguments in favour of Bernini's authorship, suggested a later date: *c*. 1665–70 (*Paragone*, ix, 1959, No. 115, p. 61ff.).
Azzolino was born in 1623; in 1654 he was created cardinal and from 1655 onwards, after Queen Christina's arrival in Rome, there developed the warm friendship

between the sovereign and the Cardinal that has brought the latter's name to the attention of a wide public. No doubt is possible regarding the sitter's identity (see Azzolino's portrait by J. F. Voet in Berlin, probably of 1670; for the medals representing him, see Baron de Bildt, *Les médailles romaines de Christine de Suède*, Rome, 1908, p. 129ff., and Gaetani, *Museum Mazzuchellianum*, 1761–3, ii, pls. 135, 136). But in spite of the fairly rich supporting iconography it does not seem easy to determine the sitter's age in the bust. According to one opinion, the bust shows him not yet forty years old, according to the other he would be in his mid-forties. In the medals of 1681, at the age of 58, he seems to have hardly aged. I suggest that at the period of the bust Azzolino was about 50; in any case, his appearance would not contradict dating the bust in the mid-1670's.
Bernini was connected with Queen Christina by ties of close friendship and, certainly through her, also with the Cardinal. Baldinucci reports (pp. 135, 137) that Azzolino often paid visits to Bernini at the time of his last illness and that Bernini, on his part, left to Azzolino, his 'protettore cordialissimo' a bust of Innocent X (see No. 51-2). Thus the argument would seem convincing that at some time after 1655 Bernini made a portrait bust of his 'protector' and that the splendid Stockholm bust with its pedigree leading back to the Cardinal's heirs is precisely this piece. But a weighty reason makes an acceptance of the bust as an authentic work by Bernini virtually impossible. Baldinucci's *Life* of Bernini was commissioned by Queen Christina and dedicated to her, and it is unthinkable that he would have left a bust of her favourite by the master's own hand unmentioned if it had existed. Even if Baldinucci were guilty of this sin of omission, Christina would hardly have written a letter to him expressing her satisfaction with the book (Arkenholtz, *Mémoires concernant Christine reine de Suède*, Amsterdam, 1751–60, iv, p. 39f.).
Nevertheless, the surface quality of the bust is distinctly Berninesque. The face has the lustre and porous warmth of Bernini's works and the treatment of the hair shows his idiosyncrasies: in front it is worked with a fine tooth-chisel and between the locks there are deep excavations. Also the Cardinal's cap reveals great mastery in reproducing the character of velvety material. On the other hand, there are features which one cannot easily associate with Bernini. The hard cut of the eyelids, the hole at the inside of the eye near the bridge of the nose, the curved, sharp line of the mouth between the lips and the linear parallel incisions in the collar—all this reveals an un-Berninesque draughtsmanlike precision. While the contrapposto embodied in the turn of the head and the dress, blown as if by a strong wind in the opposite direction, is in Bernini's spirit, the somewhat thin meandering of the folds with repetitive up and down

★See Addenda, pp. 273ff.

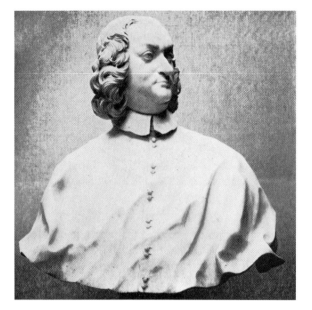

127-128. *BUST OF CARDINAL DECIO AZZOLINI.* Nationalmuseum, Stockholm (No. 82-9).

motifs and ridges with curling ends has no parallel in Bernini's work. By contrast, all the authentic busts of the middle and late periods abound in strong, plastic motifs in the lower part.

Since there do not exist points of close comparison with Bernini's authentic busts, the correct dating of the Azzolino encounters difficulties. But it would seem that the interest in ornamentalization so evident in the lower part of the bust cannot be dissociated from Bernini's style of the early 1670's. We found that such a date is not at variance with the appearance of the sitter.

In conclusion, I am of the opinion that the bust was executed by a young sculptor, fully trained in Bernini's late manner, but with certain ideas of his own. Filippo Carcani, Giuseppe Mazzuoli and Giovan Battista Foggini (who worked under Ferrata in Rome from 1673 to 1676) might be candidates. But I would not exclude the possibility that Bernini himself intervened and lent a

hand to his pupil. In support of my conclusions it may be mentioned that both the Queen and the Cardinal were interested in young artists. In 1681 they employed Soldani, while he was staying in Rome as a student.

(10) *Self-portrait.* Hermitage, Leningrad.

Terracotta. High relief.

Published by G. Matzulevitsch (in *Iskusstvo*, 1961, No. 1, p. 69ff. in Russian) as an authentic self-portrait and dated *c.* 1675. According to the author the bust was destined for Bernini's own tomb as represented in a drawing in Rome (Fraschetti, p. 254), which she accepts as an original. The authenticity of the drawing has already been refuted by Brauer-Wittkower (p. 54, note 2). Judging from the illustrations, the terracotta is derived from Westerhout's well-known engraving after Gaulli, which served as frontispiece for Baldinucci's *Vita.* A reversal of this relationship is impossible to imagine.

ADDENDA TO THE CATALOGUE

1. THE GOAT AMALTHEA NURSING THE INFANT ZEUS

I. Lavin ('Five New Youthful Sculptures by Gian Lorenzo Bernini and a Revised Chronology of his Early Works', *Art Bull.*, l, 1968, pp. 228–9) suggests a date of early 1609 for the sculpture on stylistic grounds and because of a new interpretation of an invoice dated 1615 that records a payment in that year for the *Amalthea's* lost pedestal.

2. TOMB OF BISHOP GIOVAN BATTISTA SANTONI

I. Lavin, in his revised chronology of Bernini's early works (*Art Bull.*, l, 1968, pp. 223–48), assigns this bust to 1610. C. D'Onofrio (*Roma vista da Roma*, 1967, p. 114ff.) attributes it to Pietro Bernini. For Wittkower's response to these views, see note 2 to Chapter 8 in *Art and Architecture in Italy 1600–1750*, fourth rev. ed., 1980, p. 524.

3. ST. LAWRENCE ON THE GRILL

Lavin (*Art Bull.*, l, 1968, p. 233) suggests a date of 1614 for this sculpture. A. Gonzalez-Palacias ('Bernini as a Furniture Designer', *Burl.*, Dec. 1970, pp. 719–22, with ill.) attributes the pedestal to Bernini.

4. ST. SEBASTIAN

Lavin (*Art Bull.*, l, 1968, pp. 233–4) suggests 1615 as the date of this sculpture.

5. BUST OF GIOVANNI VIGEVANO ON HIS TOMB

Lavin (*Art Bull.*, l, 1968, pp. 237–8) assigns the bust to 1620.

8. AENEAS, ANCHISES AND ASCANIUS

C. D'Onofrio (*Roma vista da Roma*, 1967, pp. 241–72) argues that the sculpture is by Pietro Bernini, worked over by Gian Lorenzo. For an iconographic interpretation, see D'Onofrio (pp. 226–38) and also R. Preimesberger, 'Pignus Imperii: Ein Beitrag zu Berninis Aeneasgruppe', *Festschrift Wolfgang Braunfels*, Tübingen, 1977, pp. 315–25.

9. NEPTUNE AND TRITON

W. Collier (*Journal of the Warburg and Courtauld Institutes*, xxxi, 1968, pp. 438–40) identifies lines 276–92 from Book I of Ovid's *Metamorphoses* as the source of the image.

10. PLUTO AND PROSERPINA

S. Howard ('Identity Formation and Image Reference in the Narrative Sculpture of Bernini's Early Maturity . . .', *Art Quarterly*, xi, 1979, pp. 140–71) makes new proposals for antique sources for this and for early groups. A bozzetto for Proserpina, mentioned in Cat. entry no. 18, is now in the Cleveland Museum: see H. Hawley in *The Bulletin of the Cleveland Museum of Art*, April, 1971, pp. 107–11.

11. RESTORATIONS OF ANTIQUE STATUES

(1) *Hermaphrodite*. Italo Faldi ('Il mito della classicità e il restauro delle sculture nel XVII secolo a Roma', *Barocco fra Italia e Polonia*, Warsaw, 1977, ed. J. Slaski) publishes and illustrates a terracotta model for this sculpture. He also publishes and illustrates a head of the Laocoön in the Galleria Spada as a juvenile work by Bernini.

(3) *Ares Ludovisi*. Yves Bruand ('La restauration des sculptures antiques du Cardinal Ludovisi (1621–1632)', *Mélanges d'Archéologie et d'Histoire*, Ecole Française de Rome, 68, 1956, p. 400) found a payment of 20 June 1622 to Bernini for this restoration. Bruand believes that a statue of a sitting warrior in the Ludovisi collection was also restored by Bernini (*op. cit.*, p. 403).

12. BUSTS OF POPE GREGORY XV

A marble bust of Gregory XV sold at Sotheby's, London, on 11 December 1980 (lot 215) was attributed to Bernini. No. 12(1) is now at the Carnegie Museum, Pittsburgh, Pa.

13. TOMB OF MONSIGNOR PEDRO DE FOIX MONTOYA

Lavin (*Art Bull.*, l, 1968, p. 240) shows that documents from the Confraternity of the Resurrection (which was the proprietor of S. Giacomo, where the tomb originally was) indicate that the bust was probably finished by the end of 1622.

The architecture of the tomb is by Orazio, not Niccolò Turriani.

15. BUST ON THE TOMB OF CARDINAL ROBERTO BELLARMINE

Lavin (*Art Bull.*, l, 1968, p. 242) gives a more precise dating for the tomb. Bellarmine died on 17 September 1621 and was buried in the common grave of the Jesuits in the Gesù. His body was exhumed on 14 September 1622 and the new sepulchre was begun on 3 August 1623. Thus Bernini's monument must have been made between then and its unveiling on 2 August 1624.

19. BUSTS OF POPE URBAN VIII

(2a) R. Wittkower ('A New Bust of Pope Urban VIII by Bernini', *Burl.*, cxi, 1969, pp. 60–64) publishes and illustrates what he considers to be the first version of this bust, and discusses again the vexed problems of dating. The bust (which is now in the Galleria Nazionale, Palazzo Barberini) could, as Wittkower mentions, be the one discussed in a letter of 1633, published by D'Onofrio (*Roma vista da Roma*, 1967, p. 381ff.).

21. BALDACCHINO

Since the second edition of this book was published in 1966, two important publications on the baldacchino have appeared: Heinrich Thelen, *Zur Entstehungsgeschichte der Hochaltar-Architektur von St. Peter in Rom*, Berlin, 1967, and Irving Lavin, *Bernini and the Crossing of St. Peter's*, New York, 1968. Both books treat in detail Bernini's project for the baldacchino and the various projects for the crossing and apse of St. Peter's prior to the reign of Urban VIII. Thelen emphasizes what he believes to have been Borromini's role in the creation of the monument. Lavin also provides a discussion of the decoration of the crossing as a whole, including the changes in the placement of the relics and the statues in the niches, and the effect these changes had on the scheme for the crossing. Both books are extensively illustrated.

Philipp Fehl ('The "Stemme" on Bernini's Baldacchino in St. Peter's: A Forgotten Compliment', *Burl.*, July 1976, pp. 484–91) gives an interpretation of the coats of arms on the pedestals of the baldacchino as an allegory of the advent of the Barberini papacy.

24. BUSTS OF MEMBERS OF THE BARBERINI FAMILY

(c) *Camilla Barbadoni*. Lavin (*Art Bull.*, l, 1968, p. 236) publishes a payment of 26 April 1619 to Bernini for this bust, and a payment of 22 February 1620 for the lost bust of Urban's father, Antonio (p. 237).

(d) *Maria Barberini*. J. Montagu ('Antonio and Gioseppe Giorgetti: Sculptors to Cardinal Francesco Barberini', *Art Bull.*, lii, 1970, pp. 290–91) publishes documents which show that the bust on the tomb of Maria Barberini is by Gioseppe Giorgetti, was finished by September 1670, and was placed on the tomb around 1678. Miss Montagu believes that Bernini never made a bust of Maria Barberini and that the one described by Tessin was by Finelli. Nevertheless, the entry quoted from Giorgetti's account book reads that his bust was 'copiato da uno che e nelle camere del Sig.re Card.le Carlo de mano de Caualiere Bernino'.

(e) *Cardinal Francesco Barberini*. I. Lavin ('Duquesnoy's "Nano di Créqui" and Two Busts by Francesco Mochi', *Art Bull.*, lii, 1970, p. 138) documents this work as by Mochi, *c.* 1629–30. The bust is of Antonio, not Francesco, Barberini.

28. ST. LONGINUS

I. Lavin (*Bernini and the Crossing of St. Peter's*, New York, 1968, pp. 24–38) discusses the meaning of the *Longinus*, and the changes in its composition with respect to the scheme for the Crossing. See also A. Sutherland Harris, 'New Drawings by Bernini for "St. Longinus" and other Contemporary Works', *Master Drawings*, vi, 1968, p. 383ff.

29. THE BALCONIES IN THE PILLARS OF THE DOME OF ST. PETER'S

A. Blunt ('Gianlorenzo Bernini: Illusionism and Mysticism', *Art History*, i, 1, 1978, pp. 71–2) suggests that Pirro Ligorio's tomb of Paul IV in the Caraffa Chapel in S. Maria sopra Minerva influenced the naturalistic way Bernini used coloured marbles in the galleries of the piers.

See Lavin, *Bernini and the Crossing of St. Peter's*, pp. 19–22, for information on the planning and the sources of the balconies.

30. TOMB OF POPE URBAN VIII

C. Wilkinson ('The Iconography of Bernini's Tomb of Urban VIII', *L'Arte*, iv, 1971, pp. 54–68) suggests that the tomb illustrates the Catholic doctrine of justification. A. Schiavo ('Iscrizioni inedite del monumento di Urbano VIII', *Studi Romani*, 3, 1971, pp. 307–8) publishes an inscription on the pedestal of the statue of Urban VIII and suggests that the cartello which Death is placing on the tomb is covering up another cartello which refers to Clement VIII, not to Gregory XV.

33. TOMB OF THE COUNTESS MATILDA OF TUSCANY

R. Wittkower ('Two Bronzes by Bernini in the National Gallery', *Art Bulletin of Victoria*, 1970, pp. 11–18) publishes and illustrates all five of the bronze statuettes by Bernini of the Countess Matilda. Wittkower believes that all of these bronzes reproduce Bernini's terracotta maquette for the *Matilda*.

36. BUSTS OF PAOLO GIORDANO II ORSINI, DUKE OF BRACCIANO, and HIS WIFE, ISABELLA ORSINI

A. Radcliffe ('Two Bronzes from the Circle of Bernini', *Apollo*, Dec. 1978, pp. 418–23) publishes and illustrates a small bronze of the Duke, similar to No. 36(a), now in the Plymouth City Art Gallery, England. Radcliffe suggests that this bronze was made by Bernardino Danese *c.* 1675 from a model by Bernini. No. 36(a) is now in a private collection, New York.

39. BUST OF KING CHARLES I

M. Vickers ('Rupert of the Rhine: A New Portrait by Dieussart, and Bernini's Charles I', *Apollo*, cvii, 1978, pp. 161–9) proposes a different group of busts which echo Bernini's statue, and considers the bases on the Van Voerst and Adye busts, 39(1) and (2), to be typical of Dieussart, not of Bernini. Vickers suggests that a bronzed terracotta attributed to Roubiliac (his Fig. 12) may be the closest reflection of Bernini's lost bust.

42. BUSTS OF CARDINAL RICHELIEU

The most recent article on the Bernini-Mochi question concerning the Louvre bust is J.-R. Gaborit, 'Le Bernin, Mochi et le buste de Richelieu du musée du Louvre: un problème d'attribution', *Bulletin de la société de l'histoire de l'art français*, 1977 (1979), pp. 85–91. It includes a valuable discussion of the previous literature. Drawing on documents published by M. Laurain-Portemer ('Mazarin militant de l'art baroque au temps de Richelieu', *Bulletin de la société de l'histoire de l'art français*, 1975 (1976), pp. 74–80), Gaborit concludes that the bust is by Bernini and that the Champaigne triple portrait was sent to Bernini for him to work from. R. Wittkower ('Two Bronzes by Bernini in the National Gallery', *Art Bulletin of Victoria*, 1970, pp. 11–18) publishes a bronze statuette of Richelieu in Victoria and says that it and the Sanssouci bust were derived from a preparatory model, not from the Louvre bust. Wittkower observes that both bronzes are closer to Champaigne's triple portrait than to the Louvre bust and therefore reflect a stage in the project before the marble bust was completed.

43. VALTRINI AND MERENDA TOMBS

J. Montagu ('Antonio and Gioseppe Giorgetti: Sculptors to Cardinal Francesco Barberini', *Art Bull.*, lii, 1970, p. 282) publishes payments made in 1640 for the

Merenda tomb, and in 1641 for that of Valtrini, who died in 1633, not 1639.

44. TOMB OF MARIA RAGGI

As both J. Bernstock ('Bernini's Memorial to Maria Raggi', *Art Bull.*, lxii, 1980, p. 243ff.) and I. Lavin (*Bernini and the Unity of the Visual Arts*, New York and London, 1980, pp. 67–70) have pointed out, the inscription of the memorial states that Cardinal Ottaviano Raggi left the memorial as a legacy in 1643, not that it was erected in 1643. Thus the cenotaph must have been begun after 1643 and could not have been installed before 7 October 1647, when Lorenzo Raggi was created cardinal, as he is called in the inscription. For the text and translation of the inscription, see Bernstock, pp. 247–8 and note 24. See both Bernstock and Lavin for background and interpretation of the monument.

As Bernstock observes, the new dating resolves Wittkower's hesitation in attributing the large models for the monument to Antonio Raggi.

45. S. FRANCESCA ROMANA

I. Lavin (*Unity*, 1980, pp. 58–62 and 185–7) provides a summary chronology of the monument and suggests that the original bronze group illustrated a specific incident in the life of the saint.

46. RAIMONDI CHAPEL

I. Lavin (*Unity*, 1980, pp. 22–49 and 188–92, with ills.) gives a detailed, mostly iconographic discussion of the monument, dates it to 1640–47, and provides documentation. He identifies the left-hand tomb as Girolamo's and the right-hand tomb as Francesco's, and mentions an unpublished drawing by Testa in the Metropolitan Museum that may be related to the relief that shows Carnival, Lent, and Death.

For a succinct summary of the novel features of the chapel, and for suggestions of sources, see A. Blunt, 'Gianlorenzo Bernini: Illusionism and Mysticism', *Art History*, i, 1, 1978, p. 73.

47. DECORATION OF CHAPELS AND NAVE OF ST. PETER'S

R. Enggass ('New Attributions in St. Peter's: The Spandrel Figures in the Nave', *Art Bull.*, lx, 1978, pp. 96–108, with ills.) publishes documents establishing attributions for all sixteen of the stucco figures, fourteen of which are by artists in Bernini's workshop.

48. CORNARO CHAPEL

The chapters on the Cornaro Chapel form the main part of I. Lavin's new book (*Unity*, 1980, pp. 77–145 and 196–210) and focus on the chapel's iconography. Lavin provides a summary chronology, documentation, and a list of the types of marble employed in the chapel. He gives 1647 as the date of commencement of work on the chapel and notes that Trevani's medal commemorates

the foundation of the chapel, not the completion of the architecture. Extensive illustrations. See also A. Blunt, 'Gianlorenzo Bernini: Illusionism and Mysticism', *Art History*, i, 1, 1978, pp. 73–8; W. Ranke, 'Berninis Heilige Teresa', *Das Kunstwerk zwischen Wissenschaft und Weltanschauung*, Cologne, 1970, pp. 12–25; and R. Kuhn, 'Die Unio mystica der Hl. Therese von Avila von Lorenzo Bernini in der Cornarokapelle in Rom', *Alte und Moderne Kunst*, xii, 94, 1967, pp. 2–21.

R. Cocke ('A Drawing by Bernini for the Cornaro Chapel, S. Maria della Vittoria', *Burl.*, Aug. 1972, p. 553, with ill.) publishes Bernini's sketch for the fresco in the vault.

49. TRUTH UNVEILED

See M. Winner, 'Berninis Verità, *Festschrift H. Kauffmann. Minuscula Discipulorum*, Berlin, 1968, p. 393ff. for an important iconographical study, and M. Laurain-Portemer, 'Mazarin et le Bernin à propos du "Temps qui découvre la vérité"', *Gazette des Beaux-Arts*, lxxiv, 1969, p. 185ff. for new documents concerning the sculpture. See also Lavin, *Unity*, 1980, pp. 70–74.

50. FOUNTAIN OF THE FOUR RIVERS

The major iconographical points of N. Huse's dissertation have now been published: see 'La Fontaine des Fleuves du Bernin', *Revue de l'Art*, 7, 1970, pp. 6–17. Another detailed iconographical study, by R. Preimesberger ('Obeliscus Pamphilius', *Münchner Jahrbuch für Kunstgeschichte*, 1974, pp. 77–162), includes much information on the earlier projects for the fountain, particularly Borromini's. See also G. Pochat, 'Ueber Berninis "Concetto" zum Vierströmebrunnen auf Piazza Navona', *Konsthistorik Tidskrift*, xxxv, 1966, p. 72ff. S. Zamboni (*Da Bernini a Pinelli*, Bologna, 1968, pp. 11–25) publishes a newly found bozzetto for the fountain; Zamboni dates the bozzetto to Spring 1650.

57. BRONZE CROSSES

(4) A. Nava Cellini ('Note per l'Algardi, il Bernini e il Reni', *Paragone*, 207, 1967, pp. 35–52) considers the Pallavicini crucifix to be definitely by Algardi, dates it to 1647–50, and suggests that Algardi's crucifix influenced Bernini's.

61. CATHEDRA PETRI

K. Rossacher ('Das fehlende Zielbild des Petersdomes, Berninis Gesamtprojekt für die Cathedra Petri', *Alte und Moderne Kunst*, Nov.–Dec. 1967, pp. 2–21) publishes, illustrates, and attributes to Bernini a terracotta bozzetto of the *Transfiguration*, which subject, he suggests, was originally planned for the window over the Cathedra. See F. Negri Arnoldi, 'Iconologo allo sbaraglio', *Paragone*, 251, 1971, pp. 83–9 and R. Wittkower, *Art and Architecture in Italy 1600–1750*, 1980, note 26 to Chapter 8, p. 525.

65. BUSTS OF POPE ALEXANDER VII
(4) Now in the Galleria Nazionale d'Arte Antica, Rome. (7) D. Bershad ('A Series of Papal Busts by Domenico Guidi', *Burl.*, Dec. 1970, p. 805) attributes this bust to Guidi.

67. STATUES OVER THE COLONNADES OF THE SQUARE OF ST. PETER'S
J. Montagu ('Two Small Bronzes from the Studio of Bernini', *Burl.*, 109, Oct. 1967, pp. 566–71) publishes, illustrates, and attributes to Bernini a small bronze in the Palazzo Doria that corresponds to the *St. Agnes* on the colonnade of St. Peter's. She also mentions another version in the collection of the Marchese Sacchetti.

69. THE VISITATION
I. Lavin (*Unity*, 1980, pp. 65–6) too attributes the design of the Cappella Siri to Bernini.

70. BUST OF LOUIS XIV
I. Lavin ('Bernini's Death', *Art Bull.*, liv, 1972, pp. 178–81 and 'Afterthoughts on "Bernini's Death"', *Art Bull.*, lv, 1973, pp. 434–5) suggests that the ancient Roman monument, the 'Colonna Claudius', was the source for Bernini's unexecuted pedestal for the bust. D. Rosenthal ('A source of Bernini's Louis XIV Monument', *Gazette des Beaux-Arts*, Dec. 1976, pp. 231–4) suggests the image of 'Monarchia Mondana' from Ripa's *Iconologia* as the source for the pedestal.

71. ELEPHANT AND OBELISK
See C. D'Onofrio, *Gli Obelischi di Roma*, Rome, 1967 (second ed.), pp. 230–37. D'Onofrio argues against Bernini's authorship and publishes (p. 236) an 'Avviso di Roma' of 11 June 1667 which attributes the monument to Padre Giuseppe Paglia.

72. THE PONTE S. ANGELO, ROME
M. Weil, *The History and Decoration of the Ponte S. Angelo*, Penn. State, 1974, gives full documentation, *œuvre* lists for the other sculptors who worked on the decoration of the bridge, and bibliography. Extensively illustrated.

73. CONSTANTINE THE GREAT
K. Rossacher ('Berninis Reiterstatue des Konstantin an der Scala Regia: Neues zur Werkgeschichte', *Alte und Moderne Kunst*, xii, 1967, pp. 902–11) publishes a terracotta bozzetto for the monument that shows reliefs in the base. See R. Wittkower, *Art and Architecture in Italy 1600–1750*, 1980, note 22 to Chapter 8, p. 525.

76. THE BLESSED LODOVICA ALBERTONI
See notice and ill. of a hitherto unknown terracotta model newly acquired by the Victoria and Albert Museum (*Burl.*, 123, Jan. 1981, pp. 63 and 64). N. Kosareva ('A terracotta Study by Gianlorenzo Bernini for the statue of the Blessed Ludovica Albertoni', *Apollo*, Dec. 1974, pp. 480–85) publishes, illustrates and attributes to Bernini a terracotta bozzetto in the Hermitage. F. Sommer ('The Iconography of Action: Bernini's *Ludovica Albertoni*', *Art Quarterly*, 23, 1970, pp. 30–38) suggests that an emblem from H. Hugo's book *Pia Desideria* influenced the composition of the sculpture. R. Preimesberger ('Ein Bozzetto Melchiorre Cafà's', *Wiener Jahrbuch für Kunstgeschichte*, xxii, 1969, pp. 178–83) suggests that Cafà's bozzetto for his *St. Rose of Lima* influenced Bernini's sculpture of the Beata. Wittkower and Preimesberger believe that the sculpture depicts the death of the Beata. Sommer and A. Blunt ('Gianlorenzo Bernini: Illusionism and Mysticism', *Art History*, i, 1, 1978, pp. 79–80) believe that it depicts the Beata in ecstasy.

77. TOMB OF POPE ALEXANDER VII
P. Fehl ('Bernini's "Triumph of Truth over England"', *Art Bull.*, xxxxviii, 1966, pp. 404–5) notices a topical meaning in the figure of Truth and identifies the sculpture behind Truth as Justice and the sculpture behind Charity as Prudence.

78. THE ALTAR OF THE CAPPELLA DEL SACRAMENTO
M. Weil ('A Statuette of the Risen Christ designed by Gian Lorenzo Bernini', *The Journal of the Walters Art Gallery*, xxix–xxx, Baltimore, 1966–7, pp. 6–15) publishes and illustrates a statuette that corresponds to the *Risen Christ* on the ciborium in the Chapel of the Holy Sacrament. He also provides documentation for work on the chapel.

79. SALVATOR MUNDI
I. Lavin ('Bernini's Death', *Art Bull.*, liv, 1972, p. 159ff., with ills.) identifies a bust in the Chrysler Museum, Norfolk, Va., as Bernini's lost bust. He also (*ibid.*, lv, 1973, p. 429f.) identifies a bust in the Cathedral of Sées as the lost copy in France. He later (*ibid.*, lx, 1978, p. 548f.) identifies an unpublished drawing in Leipzig as a project by Bernini for the pedestal (ill.).

80. A NOTE ON FOUNTAINS
(1) *Barcaccia*. See C. D'Onofrio (*Roma vista da Roma*, Rome, 1967, pp. 319–98). D'Onofrio attributes the fountain to Pietro Bernini.

81. LOST, DESTROYED and OCCASIONAL WORKS
(2) I. Lavin (*Art Bull.*, l, 1968, pp. 229–30) publishes and illustrates what he believes to be this lost work. The piece under discussion was originally published by A. Nava Cellini ('Un'opera di Pietro Bernini', *Arte Antica e Moderna*, 1961, pp. 288–90) as by Pietro Bernini. (6) This sculpture is now in the Berlin Museum: see U. Schlegel, 'Zum Oeuvre des jungen G. L. Bernini', *Jahrbuch der Berliner Museen*, 9, 1967, p. 274ff., with ill.

Lavin (*Art Bull.*, l, 1968, p. 233, note 67) identified the work as that mentioned in the Ludovisi inventory, and dated it *c.* 1617.

(8) S. Reinhart ('A Bernini Bust at Castle Howard', *Burl.*, 109, 1967, p. 437ff., with ills.) publishes what she believes to be this lost work.

(9) See catalogue entry in M. Fagiolo dell'Arco, *L'effimero barocco*, Rome, 1977, pp. 46–53. Fagiolo dell'Arco provides ills., documents, and bibliography. See additional catalogue entries for works not mentioned by Wittkower: fireworks in honour of the birth of the Infanta of Spain, pp. 146–9; decoration of St. Peter's for the canonization of Thomas of Villanova, pp. 176–80; catafalque for Alexander VII, pp. 234–7; fireworks for the Peace of Aquisgrana, pp. 242–3; catafalque for François Guiron de Ville, pp. 246–7; decoration of the Cappella Paolina for a Forty-Hours devotion, p 252.

(12) See Fagiolo dell'Arco, pp. 66–8.

(19) *Ibid.*, pp. 74–5.

(20) *Ibid.*, p. 76.

(22) *Ibid.*, pp. 79–81.

(24) *Ibid.*, p. 119.

(29) *Ibid.*, pp. 164–8.

(30) *Ibid.*, pp. 171–3.

(31) *Ibid.*, pp. 185–93.

(33) *Ibid.*, p. 296. See also M. Worsdale, 'Bernini Studio Drawings for a Catafalque and Fireworks, 1668', *Burl.*, July 1978, pp. 462–6.

(34) Fagiolo dell'Arco, pp. 248–52.

82. ATTRIBUTIONS MADE TO BERNINI AFTER THE APPEARANCE OF THE FIRST EDITION OF THIS BOOK AND NOT ACCEPTABLE TO THE AUTHOR

(3) *Priapus and Flora.* See C. Sloane, 'Two Statues by Bernini in Morristown, N.J.', *Art Bull.*, lvi, 1974, pp. 551–4, with ills.) for most recent article and bibliography for these two sculptures, which are currently on loan to the Metropolitan Museum, New York.

(5) *Male bust.* Documented as by Duquesnoy by I. Lavin ('Duquesnoy's "Nano di Créqui" and Two Busts by Francesco Mochi', *Art Bull.*, lii, 1970, p. 132).

(6) *Bust of Bernardino Naro.* Lavin (*Unity*, 1980, pp. 66–7 and 182–4) documents that the tomb of Cardinal Gregorio Naro in the Naro Chapel was designed by Bernini, and publishes a payment on 20 December 1642 to Antonio Fancelli for the bust of Cardinal Gregorio.

(9) *Bust of Cardinal Decio Azzolino.* The catalogue entry (No. 703) for this sculpture in the exhibition catalogue, *Christine, Queen of Sweden*, Stockholm, 1966, states that K. Lankheit has suggested Pietro Balestri as the author of this bust.

NEW ATTRIBUTIONS NOT MENTIONED ELSEWHERE

(1) *Bust of Antonio Coppola.* S. Giovanni dei Fiorentini, Rome. I. Lavin (*Art Bull.*, l, 1968, pp. 224–8, with ills.) publishes this bust as by Gian Lorenzo; payments in July–August 1612. The document mentions only Pietro, but the wording implies that he may not have been the sculptor. D'Onofrio (*Roma vista da Roma*, Rome, 1967, p. 109) interprets Lavin's documents as referring to a bust by Pietro, not Gian Lorenzo. Lavin's attribution was accepted by H. Hibbard (*Bernini e il barocco*, Milan, 1968, Tav. VIII and p. 7).

(2) *Bust of Antonio Cepparelli.* S. Giovanni dei Fiorentini, Rome. Lavin (*Art Bull.*, l, 1968, p. 241) documents this bust as by Gian Lorenzo, with payments of 1622–3.

(3) *A Faun Teased by Cupids.* Metropolitan Museum, New York. O. Raggio ('A New Bacchic Group by Bernini', *Apollo*, 1978, pp. 406–17, with ills.) publishes the group as by Gian Lorenzo and dates it *c.* 1616–17.

(4) *Cherubs.* Barberini Chapel, S. Andrea della Valle, Rome. I. Lavin (*Art Bull.*, l, 1968, pp. 234–6) attributes two cherubs over the pediment on the right wall to Gian Lorenzo; they were in place by July 1618. D'Onofrio (*Roma vista da Roma*, p. 159f.) attributed them to Pietro and thought that those on the left side were by Gian Lorenzo; but the latter seem to be replacements by Mochi of *c.* 1629 (Lavin). Mochi was given marble for at least one cherub by the Barberini at this time.

(5) *St. John the Baptist.* Museo Nazionale, Florence. N. Huse ('Ein Jugendwerk des Gianlorenzo Bernini', *Mitteilungen des Kunsthist. Inst. in Florenz*, xiii, 1967, pp. 165–72) dates this work to the early 1620s.

(6) *The Apse and High Altar of S. Maria in Via Lata.* Rome. I. Lavin (*Unity*, pp. 50–53 and 169–81) publishes documents which show that the design of the apse and high altar is by Bernini. He dates the project between February 1634 and April 1636; execution: May 1639–February 1643. The present apse has been considerably modified; a studio drawing (Lavin, ii, Fig. 87) may record Bernini's final conception.

CHRONOLOGICAL
TABLE

*Titles printed in italics indicate works datable
by documents or other irrefutable proof. Numbers
in brackets refer to the catalogue.
Where more than one year was devoted to a work
the date of completion is shown by an arrow.*

Year	BUSTS (also on tombs)	FIGURES, GROUPS AND RELIEFS	TOMBS	CHAPELS, CHURCHES, LARGE DECORATIONS AND COMPOSITE WORKS	FOUNTAINS AND MONUMENTS
1615		Goat Amalthea (1)			
1616	Santoni (2)	St. Lawrence (3)			
1617	Vigevano (5)	St. Sebastian (4)			
1618	Paul V (6)	Aeneas and Anchises (8)			
1619		Anima Beata e Dannata (7)			
1620		Neptune and Triton (9); Hermaphrodite (11)			
1621	Paul V (6-2); Gregory XV (12); Gregory XV (12, 1-4); Montoya (13)	Rape of Proserpina (10)			
1622	De Sourdis (14); Bellarmine (15); Dolfin (16)	Cupid, Ares Ludovisi (11)			
1623	Urban VIII (19-1)	Apollo and Daphne (18); David (17)			
1624	Duke of Bracciano (36)	Bibiana (20)		Baldacchino (21)	
1626	Klesl (22); Francesco Barberini (24); Camilla Barbadoni (24)	Angels, S. Agostino (23)			
1627	Cardinals Valier (25)	Urban VIII, Velletri (38)			
1628	Antonio Barberini (24)		Urban VIII, first phase (30)		Barcaccia (80)
1629					
1630	Carlo Barberini (27)	Longinus, model (28); Memorial Carlo Barberini (26)			
1631					
1632	Scipione Borghese (31)				Fontana del Tritone (3)
1633		Pasce Oves, 1st stage (34)	Countess Matilda (33)	Balconies, St. Peter's (29)	
1634		Memorial inscription (37)			
1635	Costanza Bonarelli (35); Duke of Bracciano (36)	Longinus, execution (28); Urban VIII, Capitol (38)			
1636	Charles I (39)				
1637	Medusa (41); Urban VIII (19-3)				
1638	Baker (40)				
1639	Urban VIII (19-4)	Pasce Oves, 2nd stage (34)	Urban VIII, 2nd phase (30); Valtrini (43)		
1640	Urban VIII (19-5); Richelieu (42)		Merenda (43)		
1641	Urban VIII (19-2)				
1642				Raimondi Chapel (46)	Fontana del Tritone (3)
1643	Urban VIII (19-6)		Maria Raggi (44)		
1644	Urban VIII (19-7)		S. Francesca Romana (45)	Cornaro Chapel (48)	Fontana delle Api, Piazza Barberini (8)
1646		Truth unveiled (49)			
1647	Innocent X (51)			Decoration pillars St. Peter's (47)	
1648					Four Rivers Fountain
1649		Noli me Tangere (52)			
1650	Francis I d'Este (54)		Cardinal Pio (82-8)		
1651					
1652					
1653					Fontana del Moro (55)
1654		Cross for Philip IV (57); Constantine, 1st stage (73)	Pimentel (56)		
1655		Virgin, Paris (53); Daniel (58); Barbara, Rieti (60); Habakkuk (58)		Decoration, S. Maria del Popolo (58)	
1656				Decoration, Sala Ducale (59)	
1657	Busts Alexander VII (65)			Cathedra Petri (61)	
1658		Cross, St. Peter's (57)			Restoration Fountain P... S. Maria in Trasteve...
1659		Cross, St. Peter's (57)			
1660		Figures, Square of St. Peter's (67)		Decoration, Castel Gandolfo (62)	Fountains, Villa d'Es...
1661		Alexander VII, Siena (64)			
1662		St. Jerome (63); Magdalen (63); Constantine, 2nd phase (73)		Decoration, S. Andrea (62); De Silva Chapel (66)	
1663				Fonseca Chapel (75)	
1664				Decoration Ariccia (62); Siri Chapel (69); Decoration Scala Regia (68)	
1665	Louis XIV (70)				
1666					Elephant and Obelisk
1667					Rospigliosi fountain
1668	Fonseca (75)	Angels, S. Andrea (72)			
1669		Louis XIV (74); Angel, Ponte S. Angelo (72)			
1671		Lodovica Albertoni (76)			
1672			Alexander VII (77)		
1673				Cappella del Sacramento (78)	
1674					
1675					
1676	Busts of Clement X (78a)				
1677					
1678					
1679		Salvator Mundi (79)			

OCCASIONAL WORKS	ARCHITECTURE AND PROJECTS	BIOGRAPHICAL AND ADDITIONAL DATA
		1598 (7 Dec.) Bernini born at Naples
		1604–5 Family settles in Rome
		1605–21 POPE PAUL V BORGHESE
		1609–14 Pietro Bernini's work in Paul V's Chapel, S. Maria Maggiore
		1615
		1616
		1617
		1618
		1619
		1620
'21 *Catafalque, Paul V* (81)		1621 POPE GREGORY XV LUDOVISI Bernini President Accademia di San Luca
		1622
		1623 POPE URBAN VIII BARBERINI (24 Aug.) Bernini appointed 'commissario e revisore dei condotti fontane di P. Navona (1 Oct.) Appointed Master of the papal Foundry (7 Oct.) Appointed Sopraintendente Acqua Felice
'24	1624 *Façade S. Bibiana*	1624
'25 *Canonization Elisabeth of Portugal* (81)	1626 *Campanili, Pantheon* (pulled down 1882)	1625
		1626
		1627
		1628
'29 *Canonization Andrea Corsini* (81)	1629 Palazzo Barberini (continued after Maderno's death)	1629 (30 Jan.) Death of Maderno (5 Feb.) Bernini appointed Architect of St. Peter's (August) Death of Pietro Bernini (3 Sept.) Bernini appointed Architect Acqua Vergine
'30 *Catafalque Carlo Barberini* (81)	1630 Plans fortification of the Borgo	1630
		1631 Frontispiece for Urban VIII's *Poemata*
		1632
	1633	1633 Death of Cardinal Scipione Borghese Brother Luigi appointed Soprastante, Fabbrica di S. Pietro
	1634 *Church, Propaganda Fide* (rebuilt by Borromini)	1634
		1635
	1636 Portal of garden, papal palace, Castel Gandolfo	1636
	1637 *Bernini's southern tower on the façade of St. Peter's*	1637
	1638 *High altar and apse, S. Lorenzo in Damaso* (destroyed)	1638 Frontispiece for Urban VIII's *Poemata*
'39 *Processional car Sta. Casa di Loreto* (81)		1639 Bernini marries Caterina Tezio
		1640
	1641 Third tier of Bernini's tower taken down *Projects for the Fontana Trevi*	1641
	1642 *Consulting architect, façade Propaganda Fide*	1642
	1643	1643
	1644	1644 POPE INNOCENT X PAMPHILI
		1645
	1646 Remaining tiers of the tower taken down	1646
		1647
		1648 (14 Feb.) Son Paolo Valentino, sculptor, born
	1649 Pio Chapel, S. Agostino	1649
	1650 *Palazzo Ludovisi, later Montecitorio, begun*	1650
	1651 Consulting architect, Palazzo Ducale, Modena	1651
		1652 Frontispiece for N. Zucchi's *Optica philosophia*
		1653 Death of Cardinal Federico Cornaro
		1654
'55 *Coach, Christina of Sweden* (81)	1655 Porta del Popolo redecorated	1655 POPE ALEXANDER VII CHIGI (29 Dec.) Queen Christina of Sweden enters Rome (Sept.–April 1656) Bernini's illness
	1656 Square of St. Peter's planned	1656
	1657 (28 Aug.) Foundation stone, Square of St. Peter's Plan to isolate the Pantheon and redecorate the interior Project to reorganize Piazza di Monte Cavallo	1657 (3 Aug.) Domenico Bernini born
'58 *Carnival car, Agostino Chigi* (81)	1658 Church at Castel Gandolfo S. Andrea al Quirinale	1658
	1659 *Arsenal, Civitavecchia* *Project to erect an equestrian statue of Francis I of Este at Modena*	1659
	1660 *Alteration of façade of papal palace, Castel Gandolfo* Project for a St. Bartholomew for the church at Ancaiano near Siena	1660
'61 *Decoration, birth of Dauphin* (81)	1661 Consulting architect, fountains Villa d'Este, Tivoli	1661
	1662 Church at Ariccia	1662
	1663 *Scala Regia*	1663 St. Joseph and Child, painting, Chapel, Palazzo Chigi, Ariccia
	1664 Additions, Hospital Santo Spirito in Sassia *Plans for the Louvre* *Palazzo Chigi-Odescalchi*	1664 Frontispiece for G. P. Oliva's *Prediche*, Vol. II.
	1665 Project for a statue of Philip IV of Spain for S. Maria Maggiore	1665 Bernini in France (Sept. 5) Member of the Académie de peinture et de sculpture, Paris
	1666	1666
	1667	1667 POPE CLEMENT IX ROSPIGLIOSI
68 *Catafalque Mattei* (81)		1668
69 *Catafalque Beaufort* (81)	1669 *Design for tribune, S. Maria Maggiore*	1669
		1670 POPE CLEMENT X ALTIERI
		1671 Composition of the 'Sangue di Cristo'
		1672
		1673 Death of his wife
		1674
		1675
		1676 POPE INNOCENT XI ODESCALCHI
		1677 Frontispiece for Padre Oliva's third volume
		1678
		1679
	1670 Cappella Poli, S. Crisogono	1680 (28 Nov.) Bernini's death

SOURCES OF THE PHOTOGRAPHS

By Gracious Permission of Her Majesty the Queen: *Frontispiece, Figs.* 48, 56, 113

Alinari, Florence: *Pls.* 4, 59, 67, 73, 75, 78, 84, 89, 90, 119; *Figs.* i, v, 7, 12, 15, 37, 62, 69, 71, 86, 96, 104, 105, 122

Anderson, Rome: *Pls.* 1, 10, 14, 19, 26, 41, 42, 49, 62, 63, 69, 72, 77, 88, 94, 103, 104, 121; *Figs.* viii, 19, 35, 36, 41, 52, 58, 65, 76, 92, 93, 95, 101, 102

Bologna, Museo Civico: *Fig.* 5

Brogi, Florence: *Pl.* 61

Cambridge, Mass., Fogg Art Museum: *Figs.* 34, 64, 106, 115

Copenhagen, Glyptothek: *Fig.* 4

Copenhagen, Royal Museum of Fine Arts: *Pl.* 32

Courtauld Institute, London: *Figs.* ii, 39, 63, 82, 126

Danesi, Rome: *Figs.* 16, 54

Faraglia, Rome: *Pls.* 15, 17, 20, 25

Ferruzzi, Venice: *Figs.* 8, 10, 11

Raymond Fortt, London: *Fig.* 85

Gabinetto Fotografico Nazionale, Rome: *Pls.* 9, 22, 27, 35, 38, 50, 67, 74, 81, 82, 85, 86; *Figs.* 1, 2, 14, 25, 26, 28, 33, 44, 45, 66, 67, 68, 81, 83, 87, 94, 111

Giordani, Rome: *Pls.* 44, 95-100; *Figs.* 79, 82.

Giraudon, Paris: *Pls.* 101, 111; *Figs.* 6, 20, 46, 72

Grassi, Siena: *Pls.* 91, 92

Marchese Incisa della Rocchetta: *Fig.* 24

Dr. O. Kurz: *Fig.* 9

Dr. Lehmann-Brockhaus: *Pls.* 52-55

Leningrad, Hermitage: *Fig.* 116

Lombardi, Siena: *Fig.* 100

London, Victoria and Albert Museum: *Pls.* 11, 18, 21, 64, 66; *Figs.* 124, 125

Dr. G. Marchini: *Fig.* 18

Mas, Barcelona: *Fig.* 108

L. von Matt: *Pls.* 93, 117; *Fig.* iii (from the volume Die Kunst in Rom)

Moscioni, Rome: *Pls.* 3, 102; *Fig.* 32, 103

Munich, Staatliche Bildstelle: *Fig.* 49

New York, Pierpont Morgan Library: *Pl.* 56; *Fig.* 77

Northampton, Mass., Smith College Museum of Art: *Fig.* 84

Oxford, Ashmolean Museum: *Fig.* 109

Prof. Paola della Pergola: *Pls.* 23, 24

Dr. A. Raichle: *Fig.* 117

Raleigh, North Carolina Museum of Art: *Fig.* 40

Mrs. I. Schneider-Lengyel: *Pls.* 6-8, 12, 13, 16, 28-31, 39, 43, 45, 47, 51, 57, 58, 60, 70, 71, 76, 79, 80, 83, 87, 105-109, 110, 112-116, 118, 120, 122-126; *Figs.* vii, ix, 3, 17, 21, 30, 38, 53, 70, 75, 97, 98, 110, 114

Schwerin, Museum: *Fig.* vi

Tom Scott, Edinburgh: *Fig.* 112

Stearn & Sons, Cambridge: *Fig.* 42

Stockholm, National Museum: *Figs.* 57, 127, 128

Thyssen Collection, Lugano: *Pl.* 5

Vasari, Rome: *Pls.* 2, 32, 40, 68, 109; *Figs.* 23, 27

Vatican, Rome: *Pls.* 36, 46, 48; *Figs.* 88-91

Washington, D.C., National Gallery of Art: *Figs.* 29, 51

D. Wright: *Fig.* 43

INDEX OF PLACES

INDEX OF NAMES